American Sublime

Landscape Painting in the United States
1820–1880

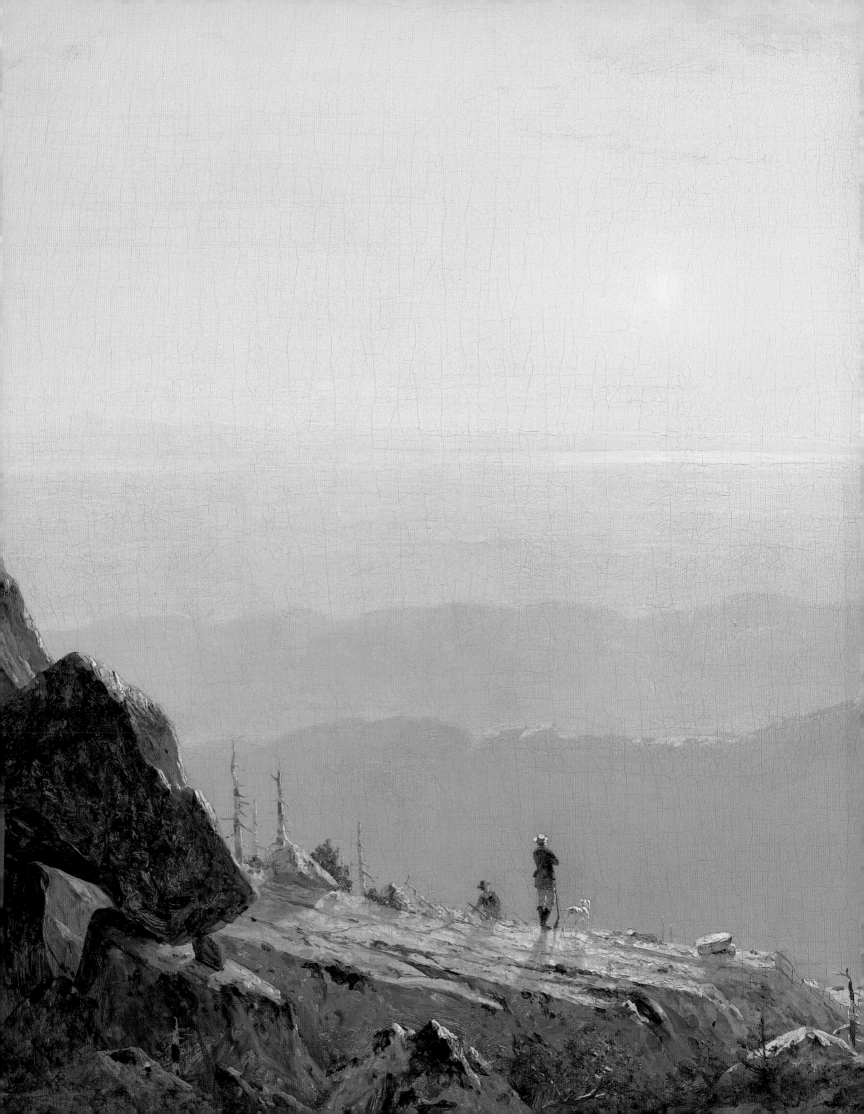

American Sublime

Landscape Painting in the United States
1820–1880

ANDREW WILTON
& TIM BARRINGER

Princeton University Press

Cover:
Frederic Edwin Church
Cotopaxi 1862 (no.86, detail)

Frontispiece:
Sanford Robinson Gifford
Mount Mansfield 1858 (no.31, detail)

Published by order of the Tate Trustees
on the occasion of the exhibition at Tate Britain, London
21 February – 19 May 2002
and touring to
Pennsylvania Academy of the Fine Arts, Philadelphia
17 June – 25 August 2002
Minneapolis Institute of Arts
22 September – 17 November 2002

Published in 2002 by Tate Publishing,
a division of Tate Enterprises Ltd,
Millbank, London SW1P 4RG

Published in North America by
Princeton University Press
41 William Street
Princeton, New Jersey 08540
www.pupress.princeton.edu

ISBN 0-691-09670-8

Library of Congress Control Number: 2001098792

Project editor: John Jervis
Production manager: Sophie Lawrence
Picture researcher: Fran Matheson
Designed by Susan Wightman at Libanus Press
Printed and bound by Conti Tipocolor, Italy

Contents

Foreword

Nineteenth-century American landscape painting is surprisingly little known in Britain today. Frederic Edwin Church's *Niagara Falls from the American Side* hangs in the National Gallery of Scotland and Thomas Moran's *Nearing Camp, Evening on the Upper Colorado River, Wyoming* was recently acquired by the Bolton Museum and Art Gallery, but much of the remarkable work of these and other great artists of the school – Bierstadt, Cole, Cropsey, Durand, Gifford, Heade, Kensett, Lane – has remained unseen by the British public and, until lately, unexplored by British scholars. Yet the early master of the group, Thomas Cole, was British-born, and it may be held that their work as a whole grew directly from the British tradition of romantic landscape painting which reached its height with Turner and Constable, Martin and Danby. Indeed it was in just such a light that American landscapes were initially quite well known and admired in contemporary London (notwithstanding the doubts of Ruskin and others). Curiously, perhaps, their subsequent obscurity in Britain was mirrored by a lack of interest in America too for much of the twentieth century. From the 1960s, however, American scholars such as David C. Huntington, Barbara Novak, Theodore E. Stebbins, Jr., and John Wilmerding, among many others, undertook new research in the field, and in more recent years the work of Angela Miller and Alan Wallach in particular has contributed to a sophisticated and compelling body of analysis on many aspects of the school. Through such means the range and character of the art and its progress through the nineteenth century has been located as part of a wider process – the forging and expression of American national and cultural identity. William Truettner's *The West as America*, an exhibition at the Smithsonian American Art Museum, Washington DC, in 1991 was one notably brave but also controversial uncovering of the historical and ideological framework which informed the production of landscapes and other kinds of 'frontier' imagery. Other exhibitions – for example *American Light* at the National Gallery of Art,

Washington DC, in 1980 and *American Paradise* at the Metropolitan Museum of Art, New York, in 1987 – as well as books such as Robert Hughes' *American Visions*, 1997, have meanwhile helped to secure a high degree of enthusiasm amongst the American public today for works which operate for many, more simply, as celebrations of the sublimity and antiquity of the native landscape itself: from the Hudson River Valley and the Niagara Falls in the east, to the Rocky Mountains, the Grand Canyon and the Yellowstone and Yosemite Valleys in the west.

To a limited degree, exhibitions of American painting staged at the Grand Palais in Paris in 1984 and the Österreichische Galerie Belvedere in Vienna in 1999 have prepared the ground in Europe for the present exhibition at Tate Britain, but I believe it will nonetheless be a significant revelation. Proposed, conceived and magisterially led by Andrew Wilton, formerly keeper of the British Collection at the Tate Gallery and since 1998 senior research fellow, the project has been in the making for many years and I am very pleased that it should feature so early on in the new exhibitions programme of Tate Britain, signalling our interest in engaging with the art of other countries wherever connections and contrasts with British art are especially revealing. The exhibition does certainly explore its subject in part from a distinctively European perspective: Andrew Wilton's catalogue essay focuses on the enveloping concept of the Sublime and its expression in art and literature across the preceding two centuries, and that of Tim Barringer, assistant professor in the history of art, Yale University, compares the evocation of national identity through art in America with the equivalent process in Britain. But their selection of works, which has been deliberately confined to ten major artists so that each may be explored in some depth, also aims to provide an even survey of the school at its very best, one whose authority will, it is hoped, register as strongly in Philadelphia and Minneapolis, the second and third venues of the exhibition, as in London.

Andrew Wilton's leadership of this ambitious project has been complemented by the important contribution of his co-curator Tim Barringer in selection, research and authorship. I am indebted to them both, not just for their vision and knowledge but also for their powers of persuasion in negotiating the loan of so many exceptional paintings to the show. To have secured more than ninety of the most distinguished works of all nineteenth-century American art is a great feat, but this is of course above all a tribute to the enthusiasm and exceptional generosity of the many lending institutions and individuals. Andrew and Tim worked closely too with the exhibition's organisers at Tate Britain, Christine Riding and Katharine Stout, to whom I would like to offer heartfelt thanks for handling the diverse complexities of the project with a sometimes incredible patience and good humour.

I am very pleased to record our gratitude to GlaxoSmithKline plc for their magnificent sponsorship of the London showing of the exhibition. GSK has become one of Tate Britain's most loyal allies: this project simply would not have been possible on this scale without their support. We are further indebted to the Trustees of the Henry Luce Foundation for their significant financial assistance, and we are honoured that Tate Britain is the first museum outside the United States to benefit from their generosity. The Henry Luce Foundation is committed to scholarship and the overall enhancement of American art, and their support for *American Sublime*, right from the early stages of its research and planning, has been crucial to its successful realisation.

STEPHEN DEUCHAR
Director, Tate Britain

Acknowledgements

This exhibition has been a dream of mine for nearly twenty years. It grew in my mind after I had had the great pleasure of living and working in the United States for five years, and also the opportunity to become familiar with a school of painters who are all too little known in Britain. I was particularly spurred in the endeavour by the sumptuous exhibition *American Light* at the National Gallery of Art in Washington in 1980, which brought together a spectacular and provocative survey of the greatest landscape painting of the American mid-nineteenth century. Earl A. Powell's essay in that catalogue on 'Luminism and the American Sublime' provided me with a title.

When I first tentatively mentioned the idea in England, it seemed an almost impossibly unfashionable subject, but several friends urged me on and held me to it, proving that there was interest, and that it needed only to be nurtured. After a lapse of some years, American nineteenth-century painting does not seem so remote from what is now a broader and more receptive public taste than existed a decade or so ago. I wish to acknowledge the long-standing encouragement of Hugh Brigstocke, David Brown, Judith Bumpus, Peter de Barra, Richard Dorment, Caroline Elam, David Ekserdjian, William Feaver, Sarah Fox Pitt, Bamber and Christina Gascoyne, Charlotte Gere, Richard Godfrey, the Countess Jellicoe, Paul Josefowitz, Alastair Laing, Christopher Le Brun, Huon Mallalieu, Susan Moore, Peter Nahum, William Packer, Andrea Rose, John Southern, MaryAnne Stevens, Robert Tear and Marina Vaizey. When I submitted my proposal to the Trustees of the Tate in 1992 they were characteristically broad-minded and gave full support to the project. To them too I owe warm thanks.

Such an ambitious project would not have been possible without the enthusiastic and learned help of many colleagues in the United States, whose readiness to share knowledge and to facilitate loans has been remarkable. A few must be singled out for continuing help and patient willingness to respond to all manner of problems over many years. Without them the exhibition could never have taken the shape it has done: Nancy K. Anderson, Gerald L. Carr, Nicolai Cikovsky,

Helen Cooper, Linda S. Ferber, Diane Fischer, Eleanor Jones Harvey, Franklin Kelly, Elizabeth Mankin Kornhauser, Ross Merrill, Theodore E. Stebbins, Jr., Richard P. Townsend and Carol Troyen. It has also been a pleasure to work with Patrick Noon at Minneapolis and Derek Gillman at the Pennsylvania Academy, and I am especially grateful to Tim Barringer for his incalculably important contribution to the whole process of assembling and cataloguing the show as my co-curator.

Others, on both sides of the Atlantic, to whom he and I owe much thanks for help and advice of many kinds are Colin Amery, Julie Aronson, Alexander Asavedo, Jonathan Boos, Michael K. Brown, Mary Ann Burdett, Debra Berke, Sarah Cash, Floramae McCarron Cates, Jim Cuno, Kevin and Vicki Driscoll, Lady Dufferin & Ava, Richard Emerson, Melissa Franklin, Hardy George, George Gurney, the late Rollin Hadley, David Hill, Fred Hill, Adrian Jenkins, Stephan Koja, Julian Kreimer, Patrick McCaughey, Carol Lynn McCurdie, Dr David A. Moss, Anne Morand, Richard N. Murray, John Neff, Alex Nemerov, Maureen O'Brien, Catherine Pagani, Mr and Mrs Jan Piggott, David Posnett, Jules Prown, Jock Reynolds, Beth Riely, John Riely, Christopher Riopelle, James Ryan, William S. Rodner, Joan Rosasco, Cordelia Rose, Jack Rutland, Marilyn Symmes and Rebecca Tierney.

Of staff at the Tate, the following have all contributed much hard work and careful thought: Joanna Banham, David Dance, Sionaigh Durrant, Mark Edwards, Claire Eva, Jim France, Richard Guest, Sophie Harrows, Christopher Holden, Tim Holton, Mary Horlock, Sarah Hyde, John Jervis, Rica Jones, Sioban Ketelaar, Sophie Lawrence, Ben Luke, Fran Matheson, Judith Nesbitt, Katherine Rose, Christine Riding, Andy Shiel, Alison Smith, Katharine Stout, Nadine Thompson, Sheena Wagstaff, Glen Williams and Simon Wilson.

Finally, we are particularly indebted to the generosity of Elizabeth Gosnell, Richard Manoogian, Mrs Nancy B. Negley, Lawrence B. Salander and Theodore E. Stebbins, Jr.

ANDREW WILTON

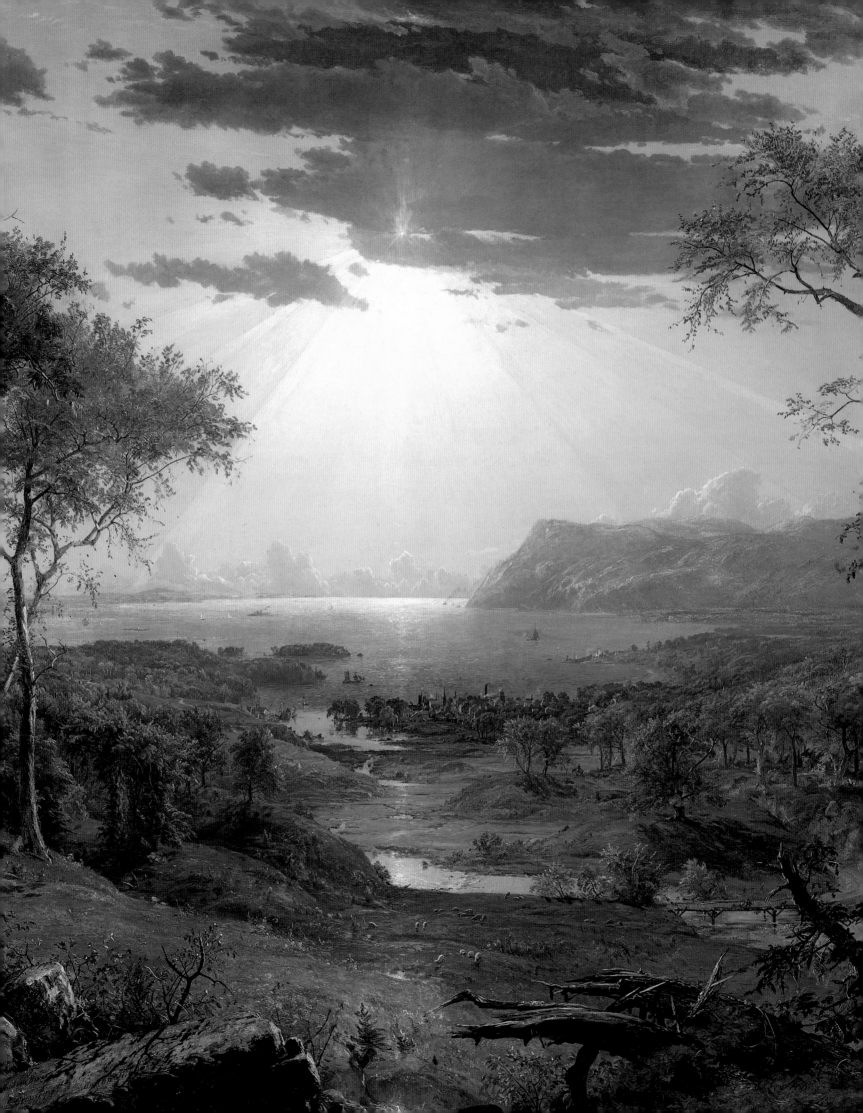

ANDREW WILTON

The Sublime in the Old World and the New

On 13 June 1805 Lieutenant William Clark came upon the Great Falls of the Missouri River, in the foothills of the Rocky Mountains, and carefully described them in his journal. He added: 'After wrighting this imperfect description I . . . wished for the pencil of Salvator Rosa or the pen of Thompson [sic], that I might be enabled to give to the enlightened world some just idea of this truly magnificent and sublimely grand object, which has from the commencement of time been concealed from the view of civilised man . . .'[1]

Clark, with Captain Meriwether Lewis, was one of the leaders of the famous Government expedition appointed by President Thomas Jefferson to trace the course of the Missouri from its confluence with the Mississippi at Saint Louis to its sources in the Rocky Mountains, cross the Continental Divide and follow the Columbia River to the Pacific Coast. Their journey lasted from 1804 to 1806, and was the first organised attempt to chart the farther territories of North America. Its purpose was scientific, and Lewis and Clark devoted much of their journal to descriptions of the flora and fauna, the geology and the anthropology of the territories through which they passed. But at the moment when nature produced an effect beyond prosaic description, the stalwartly practical Clark wished for the powers of poet and painter. In particular, he invoked a seventeenth-century Italian landscape painter, Salvator Rosa, and an eighteenth-century British poet, James Thomson. He also remembered the aesthetic notion of the Sublime. The mental equipment required to meet and comprehend the most astonishing natural phenomena of the New World had been forged over the preceding two centuries in the art and literature of Europe. This exhibition traces the growth, over the seventy years or so after Lewis and Clark's expedition, of

an indigenous American pictorial language fashioned to describe and convey emotional responses to American landscape.

The Theory of the Sublime

The concept of the Sublime can be traced back to the ancient world, and in modern times the ancient civilisations provided the benchmarks of sublimity. In the early years of the eighteenth century Joseph Addison used the term to describe the events of Homer's epics, the *Iliad* and the *Odyssey*: the doings of heroes, the struggles of noble beings – whether gods or men – were capable of raising the mind to a higher plane of contemplation, and bringing it closer to the divine. The most sublime literature of all was the Bible, closely followed, in eighteenth-century opinion, by Milton's modern Christian epic *Paradise Lost*.[2]

The English eighteenth century was a period of rapid cultural growth, stimulated by the new prosperity won by overseas expansion both military and mercantile. Philosophers and scientists had begun to order the world of experience into hierarchies and categories in the previous century, and by 1700 there was a thriving practice of scientific enquiry under the auspices of a body sanctioned by the Crown, the Royal Society (incorporated in 1662). In this climate of experiment, categorisation and description whole areas of thought and experience were subjected to analysis and exegesis. The subject of aesthetics was no exception, and the Sublime was discussed and defined in many different ways over the next hundred years. It was clear that the cosmic discoveries of Newton, for instance, were of an order to enlarge the understanding beyond

anything previously imagined, and so qualified as sublime in their own right. Science itself had an aesthetic dimension, and aesthetics might legitimately be put to the service of scientific enquiry.

James Thomson was a poet who exemplified this blending of art and scientific description. His famous quartet of poems, *The Seasons*, first published in 1730, was an abiding classic until the late nineteenth century. Its descriptions of geography, climate, agriculture, social life and every aspect of the known world were intended to be informative, to analyse and explain, while at the same time functioning as uplifting poetry. When he thought of Thomson at the Great Falls, Clark perhaps had this passage from *Winter* in mind:

> Wide o'er the brim, with many a torrent swelled,
> And the mixed ruin of its banks o'erspread,
> At last the roused-up river pours along:
> Resistless, roaring, dreadful, down it comes,
> From the rude mountain and the mossy wild,
> Tumbling through rocks abrupt, and sounding far . . .
> . . . till again, constrained
> Between two meeting hills, it bursts a way
> Where rocks and woods o'erhang the turbid stream;
> There, gathering triple force, rapid and deep,
> It boils, and wheels, and foams, and thunders through.[3]

If poetry could function as the handmaiden of science, so the visual arts could assist literature. What is striking about Thomson's descriptions of the landscape is that they depend surprisingly often on existing depictions in painting, in particular the works of the great masters of seventeenth-century Ideal landscape, among whom Claude Lorrain (*c.*1604–1660) and Salvator Rosa (1615–1673) were particularly important. Salvator, the painter invoked by Captain Clark in the same breath as Thomson, was an artist particularly associated with the Sublime (fig.1). In the words of the influential Swiss history painter, practising in London, Henry Fuseli (1741–1825), 'In landscape he was a genius. His choice is the original scenery of Abruzzo, which he made often, though not always, a vehicle of terrour: he delights in ideas of desolation, solitude, and danger, impenetrable forests, rocky or storm-lashed shores; in lonely dells leading to dens and caverns of banditti, alpine ridges, trees blasted by lightning or sapped by time, or stretching their extravagant arms against a murky sky, louring or thundering clouds, or suns shorn of their beams.'[4]

The Sublimity of Salvator was usually contradistinguished from the Beautiful as exemplified in the work of Claude Lorrain (fig.2). Claude's landscapes are created from elements of natural scenery observed in the Roman countryside, combined into purely imaginary views. These views are formed on a compositional principle of elegant balance, and

1 Salvator Rosa, *River Landscape with Apollo and the Cumaean Sibyl*, *c.*1650s. Oil on canvas, 173.7 × 259.5 (68 ½ × 102 ½). Trustees of the Wallace Collection, London

2 Claude Lorrain, *Landscape near Rome with a View of the Ponte Molle*, 1645. Oil on canvas, 73.7 × 96.5 (29 × 38). Birmingham City Museums and Art Gallery (1955 P111)

on a subtle understanding of the depiction of light, which is diffused, often from a visible sun, over the scene with exquisite gradations, achieving a luminosity new in the history of art. The careful asymmetries of his balanced groups of trees, used as repoussoirs in the foreground to flank a distance in which the light is reflected from the surface of lake, sea or river, became a device for presenting landscape within the confines of a rectangular frame so well-known and frequently resorted to that it came to seem as natural as nature itself.

The opposition of the Sublime and the Beautiful was well established by the beginning of the eighteenth century. Addison, for instance, found it natural to refer to the Sublime of Homer and the Beautiful of Virgil.[5] But the twin concepts were given new philosophical substance in 1757 when the young Edmund Burke published his *Philosophical Enquiry into the Origin of our Ideas of the Sublime and Beautiful.* Burke's contention was that we apprehend beauty as a function of 'generation' – our desire to reproduce our species; we define it in terms of physical attraction. In a male-dominated society, then, beauty is governed by what men find desirable in women: smoothness, gentleness, softness and so on. The Sublime, on the other hand, refers to the other basic human instinct, that of self-preservation: 'Whatever is fitted in any sort to excite the ideas of pain or danger, that is to say, whatever is in any sort terrible, or is conversant with terrible objects, or operates in a manner analogous to terror, is a source of the *sublime*; that is, it is productive of the strongest emotion which the mind is capable of feeling.'[6] Burke listed the main causes of the sublime: darkness, obscurity, privation, vastness, succession, magnificence, loudness, suddenness and so on. Much debate ensued as to whether the term 'sublime' was to be understood as referring to the object of contemplation – the storm, the precipice, the waterfall – or whether it denoted the state of mind induced by such contemplation.

Immanuel Kant, writing in Germany at the end of the eighteenth century, took the subjective position, arguing that sublimity was a function of the extreme tension experienced by the mind in apprehending the immensity or boundlessness of the grandest conceptions: 'The sublime is that, the mere capacity for thinking which evidences a faculty of mind transcending every standard of sense.'[7] Kant summed up Burke's Sublime as 'a sort of delightful horror, a sort of tranquillity tinged with terror',[8] but argued that such a

definition depended on the sensations of individuals, and that what is 'absolutely great', as he more succinctly defined the Sublime,[9] requires a transcendent scale of reference. 'If . . . we call anything . . . without qualification, absolutely, and in every respect (beyond all comparison) great, that is to say, sublime, we soon perceive that . . . It is a greatness comparable to itself alone. Hence . . . the sublime is not to be looked for in the things of nature, but in our own ideas.'[10]

Burke and Kant intended their observations to refer to our experience in general, but they were much concerned with our responses to natural phenomena. The growing interest in the natural world ensured that much eighteenth-century writing on the Sublime and the Beautiful is explicitly associated with landscape and its representation in art and literature. The Beautiful as exemplified in the paintings of Claude became a model for the new breed of landscape gardeners who emerged during the century. Lancelot 'Capability' Brown (1716–1783) was employed by landowners all over England to transform their parks into views that Claude might have painted, creating lakes, hills and clumps of trees to achieve that object. This new art-form bred its own theorists, who enunciated rules by which nature might be 'improved,' and it inspired the Revd William Gilpin (1724–1804), schoolmaster and Prebendary of Salisbury, to articulate a complete theory of aesthetics on the principle of the Picturesque – 'that particular quality, which makes objects chiefly pleasing in painting'.[11] Variety, rough textures, small scale: these were the elements in his definition of the Picturesque, which was essentially a specialised branch of the Beautiful. For Gilpin, a Claudean balance of hills, lakes and trees was important. A monotonous or empty landscape could not be picturesque: 'Among the *smaller* lakes of Italy and Switzerland, no doubt, there are many delightful scenes; but the *larger* lakes, like those of America, are disproportioned to their accompaniments: the water occupies too large a space, and throws the scenery too much into the distance.'[12] This was an important reservation which the Americans had to come to terms with when confronting their own land.

It follows from the observations of these theorists that the concept of the Sublime incorporated a further dimension: the imagination has an important part to play in our perception of what is immense, nebulous, beyond exact description. This idea was central to the Romantic response to nature. From an early stage in the eighteenth-century discovery of landscape,

travellers and artists found their delight in particular scenes best formulated in terms, not simply of bare description, but of historical, mythological and pictorial associations. In 1739 the poet Thomas Gray visited the Grande Chartreuse in the French Alps, thrilling to the associations with Salvator Rosa and invoking the Sublime at every turn: 'not a precipice, not a torrent, not a cliff, but is pregnant with religion and poetry. There are certain scenes that would awe an atheist into belief, without the help of other argument. One need not have a very fantastic imagination to see spirits there at noon-day; you have Death perpetually before your eyes, only so far removed, as to compose the mind without frighting it . . .'[13] Gray's suggestion of the mind being stretched by something ineffable and essentially numinous is characteristic of the Sublime, and conforms with both Burke's and Kant's accounts of it. His invocation of historical and literary ideas was a response that came to have its own designation in the theoretical literature: 'associationism'.[14]

The American landscape could yield no 'associations': it was empty, virgin, devoid of history and the nuances that sentiment or scholarship found everywhere in Europe. But as Lieutenant Clark showed, it was difficult for the early explorers of the American wilderness to accept nature in a naked, non-referential condition. They needed to relate their experience to others that had received the endorsement of European civilisation as a whole. A characteristic specimen of this process occurs in Washington Irving's *A Tour on the Prairies* (1835). Irving describes the landscape of what was to become Oklahoma in terms that evoke not simply a parallel aesthetic experience in Europe, but also, and significantly, the historical resonances of that experience, which are transferred by association, as it were, to the New World:

> We were overshadowed by lofty trees, with straight, smooth trunks, like stately columns; and as the glancing rays of the sun shone through the transparent leaves, tinted with the many coloured hues of autumn, I was reminded of the effect of sunshine among the stained glass windows and clustering columns of a Gothic cathedral. Indeed there is a grandeur and solemnity in some of our spacious forests of the west, that awaken in me the same feeling that I have experienced in those vast and venerable piles, and the sound of the wind sweeping through them, supplies occasionally the deep breathings of the organ.[15]

3 Thomas Cole, *Landscape Scene from the Last of the Mohicans*, 1827. Oil on canvas, 63.5 × 78.7 (25 × 31). Fenimore Art Museum, Cooperstown, New York

The instinct to find spiritual significance in nature was not only an insight of evangelical religious groups. It was inherent in the broadly devout American consciousness. The first of the country's great Romantic landscape painters, Thomas Cole (1801–1848), who early in life ventured as far as Ohio but whose principal interests centred on the scenery of New York and New England, enunciated the point for all artists in his 'Essay on American Scenery' of 1835: 'Prophets of old retired into the solitudes of nature to wait the inspiration of heaven. It was on Mount Horeb that Elijah witnessed the mighty wind, the earthquake, and the fire; and heard the "still small voice" – that voice is YET heard among the mountains! St John preached in the desert; the wilderness is YET a fitting place to speak of God.'[16]

These ideas could be developed into a systematic account of the workings of the divine in the spectacular natural phenomena of the remoter regions of the earth, including the Americas. Such an account was actually undertaken by one of the great European minds of the age: the German naturalist and explorer Alexander von Humboldt had made a pioneering journey into the northern part of South America from 1799 to 1804 and published his *Personal Narrative* of it.[17] Humboldt was really the last of the Enlightenment philosophers: passionately committed to science and the value of accurate description in uncovering truths about the natural world, he

subsumed all that he discovered under a comprehensive system of religious belief.[18] For him, God was the originator and central point of all life, and everything in creation could be taken as evidence of the divine order of the universe. Nature was 'a harmony, blending together all created things, however dissimilar in form and attributes; one great whole . . . animated by the breath of life.'[19] It was to develop this idea in detail that he wrote *Cosmos: Sketch of a Physical Description of the Universe*, which appeared in an English translation in 1849. In a very eighteenth-century spirit, he sought to subject the whole of life to the control of reason. His work was quickly rendered obsolete by the theories of an enthusiastic follower of Humboldt's, Charles Darwin, whose revolutionary theory of evolution by natural selection was described in his book *On the Origin of Species*, which appeared in 1859, the year of Humboldt's death.

Humboldt's vision of a divinely ordained universe chimed perfectly with the world-view of the American landscape painters of the 1840s and 1850s. We have seen Cole expressing his sense of the immanence of a universal divinity in nature. Humboldt himself saw the places that he had newly charted as supplying subjects for artists, whom he envisaged penetrating previously unrecorded regions: 'Are we not justified in hoping that landscape painting will flourish with a new and hitherto unknown brilliancy when artists of merit shall . . . be enabled, far in the interior of continents, in the humid mountain valleys of the tropical world, to seize, with the genuine freshness of a pure and youthful spirit, on the true image of the varied forms of nature?'[20] Not surprisingly, some of them took up his suggestion and followed in his footsteps to South America, revelling in the luxuriance and strangeness of landscapes that could be seen as extreme manifestations of God's creative fecundity.

A Pictorial Language of the Sublime

If a painting was to overwhelm the spectator with the sublimity of its subject, logic demanded that it should partake of at least some of the attributes of sublimity itself. The most obvious was size. By the third quarter of the eighteenth century it was not uncommon for artists, influenced by Renaissance and Baroque painting, to adopt a large scale for historical subjects. James Barry (1741–1806) executed his

murals for the Great Room of the Royal Society of Arts in London on a highly ambitious plan: *The Progress of Human Culture* (1777–84) begins with *The Progress of the Civilisation of Ancient Greece from Its Origins to Its Zenith* and moves, via contemporary England, to *The State of Final Retribution*, a Last Judgment on human history and culture; all these subjects were executed on a huge scale.[21] Another prominent history painter, Benjamin West (1738–1820), created a classic example of the genre in his *Death on the Pale Horse* (1817; fig.4).[22] West was one of many Americans who, during the eighteenth and early nineteenth centuries, trained in London as a matter of course. He remained to spend his career in England, attained the Presidency of the Royal Academy and was extensively patronised by the King, demonstrating what his countrymen could achieve in the British art establishment.

He showed his vast apocalyptic canvas, which measures some 4.5 by 7.5 metres, in the gallery he had built for the display of his own work. He designed this to lend maximum impact to scenes painted life-size or larger, hung low, dramatically lit, and framed in draperies so that the event seemed to be happening as though on a stage. West's picture was one of several late paintings in which he presented dramatic Biblical subjects, consciously exploiting the traditional association of religious ideas with the Sublime. Other artists, notably West's fellow Americans John Singleton Copley (1738–1815), Mather Brown (1761–1831) and John Trumbull (1756–1843), made similar arrangements for the showing of their most important pictures. The degree of structural modification varied, but the painter would ensure that visitors were introduced to large canvases in such a way as to enhance their impact and create a *coup de théâtre*.

The eighteenth-century recognition that sublimity was as much an attribute of the natural world as of heroic myth meant that landscape painters began to think in terms of a comparable enlargement of their sphere of action. The 360-degree panorama, invented by Robert Barker (1739–1806) in the 1780s and installed in a purpose-built gallery at London's Leicester Square in 1793, was more than a popular sensation. It reflected exactly the drift of contemporary aesthetic debate. Even topographical landscape might be spectacular in such a way that visitors were moved to a more elevated contemplation of the world. Scenes of battle, or distant outposts of the ever-expanding Empire, filled the spectator

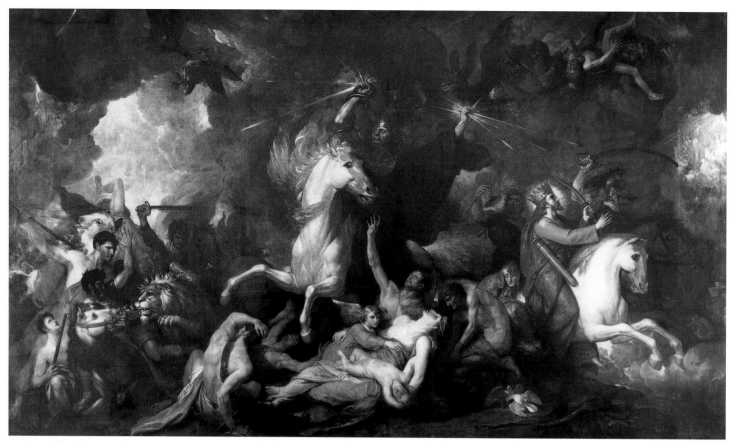

4 Benjamin West, *Death on the Pale Horse*, 1817. Oil on canvas, 447 × 764.5 (176 × 301). Pennsylvania Academy of the Fine Arts, Philadelphia. Pennsylvania Academy Purchase 1836.1

with ideas that carried him far beyond the humdrum and the local. Views that comprehended whole cities – like Barker's own first panorama of London (1791) – were impressive as meditations on the awesome heights to which human civilisation could rise; a panorama of the *Storming of Seringapatam* by Robert Ker Porter (1777–1842), exhibited in 1800, shortly after the famous siege during the fourth Mysore War in India, was a turbulent battle-scene of immediate topical interest.[23] In due course pure landscape made its appearance: a 'Grand Panorama of the View from Ben Lomond' was painted by the Scottish artist John Knox (1778–1845) and shown in Edinburgh in 1811. In this instance, the point of the subject was simply the frisson obtained from standing on a mountain-top and surveying a wide and wild landscape.

Despite the immense labour and skill that went into these panoramas, they were essentially ephemeral. Artists of more serious ambitions sometimes essayed them, as did Thomas Girtin (1775–1802) in his *Eidometropolis* of London. But such paintings, however beautifully conceived and executed, were subject to the wear and tear of a travelling show, and few now

survive.[24] There were also dioramas, stage-like paintings in which scenery, sometimes with moving parts, and effects of light which might change during a 'performance', were viewed through a proscenium. Philippe Jacques de Loutherbourg (1740–1812), who came to London from France in 1771, experimented with these, but continued to reserve his main energies for framed pictures of a traditional kind, establishing himself in the last decades of the century as a specialist in the Sublime: he painted storms and avalanches and tempestuous seas in a highly accomplished style which had its due effect on the young J.M.W. Turner (1775–1851).

Encouraged by Loutherbourg, and even more by his experience in 1802 of the Old Masters that Napoleon had brought to the Louvre from all over Europe, Turner produced a series of large-scale landscapes and seascapes in the grand manner during the early years of the new century. In 1812 he exhibited *Snow Storm. Hannibal and his Army Crossing the Alps*, a work that had the effect of redefining Romantic landscape (fig.5).[25] The vast mountain setting, the awe-inspiring depiction of the storm, the receding perspective of fighting men, are all

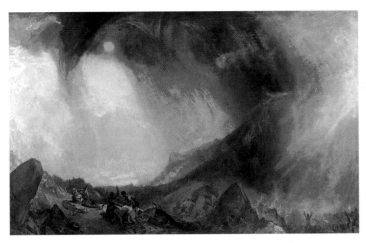

5 J.M.W. Turner, *Snow Storm. Hannibal and his Army Crossing the Alps*, exhibited 1812. Oil on canvas, 146 × 237.5 (57 ½ × 93 ½). Tate, London

realised with an unprecedented technical conviction and vividness of imagination. Significantly, Turner demanded that the picture should be hung low – not with its lower edge 'on the line', that is, at six feet, but with its top edge *under* the six-foot line.[26] This was a matter of great importance to him. It reflected the practice of the history painters, who had begun, as we have seen, to hang their large figure-subjects low. Turner was making his favourite point that landscape should enjoy the same esteem in exhibitions as history. Perhaps more important, he was making the aesthetic point that such works require to be hung so that the spectator can 'enter' them, allowing the eye to explore the recession and penetrate the perspective of the view, rather than looking up at them as though they were altarpieces. Landscape was no longer to be contemplated from afar, but participated in as an immediate experience.

Turner's use of large scale for landscape was taken up by others, though rarely with the same impact.[27] In this same year, 1812, John Martin (1789–1854) exhibited an experimental work that, like *Hannibal*, pushed out the boundaries of the possible in landscape. *Sadak in Search of the Waters of Oblivion*[28] involved no milling throngs of humanity, but only a single desperate figure lost in an eerie mountain landscape. At almost the same moment, another ambitious artist, James Ward (1769–1859), was working on a very different exercise in the landscape sublime. Ward was a painter of animals, modelling himself on that master of the large-scale composition, Peter Paul Rubens (1577–1640). He had produced a colossal work that might be considered a specimen of the 'animal sublime', *The Serpent of Ceylon*, which he submitted to the Royal Academy exhibition

of 1804, and had it refused. He then showed it in a private gallery, along with other works, and sold it to a Mr Earle of Philadelphia, who exhibited it in America to some acclaim.[29] In 1812 he had probably begun work on *Gordale Scar* (fig.6), which he exhibited in 1815. A view of a high limestone precipice near Malham in North Yorkshire, through which a small river falls in a succession of cascades, *Gordale Scar* has for staffage only a herd of cattle who graze unconcernedly at the base of the beetling cliff. Most of the composition is taken up by the colossal rock-face, which towers over the spectator almost as it would do in reality, for Ward's canvas is 3.3 metres tall and 4.2 metres wide. This is to endow the pure landscape with some of the attributes of the most elevated history painting.

Gordale Scar remained an exceptional work in the canon of British landscape. Turner occasionally used large canvases even as late as the 1820s and 1830s; his largest, measuring over 2.5 by 3.5 metres, for a *Battle of Trafalgar* (1823–4), followed precedents set by both Loutherbourg and West in the heroic depiction of a sea battle. Another very large work, *England: Richmond Hill, on the Prince Regent's Birthday* (1819), was a topographical and national pastoral, with overtones of both Claude and Jean-Antoine Watteau (1684–1721).[30] John Martin's outsize works, on the other hand, should be classed as histories rather than landscapes. The immense trio of paintings that he produced towards the end of his life, *The Great Day of His*

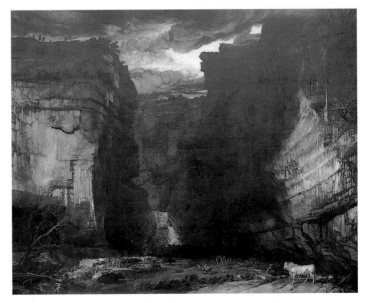

6 James Ward, *Gordale Scar* (*A View of Gordale, in the Manor of East Malham in Craven, Yorkshire, the Property of Lord Ribblesdale*), ?1812–14, exhibited 1815. Oil on canvas, 332.7 × 421.6 (131 × 166). Tate, London

Wrath, The Last Judgement and *The Plains of Heaven* (1851–3),[31] are apocalyptic subject pictures, although landscape plays an important part in them. Indeed their imagery is close to that of some of the visionary works of Thomas Cole and Asher Brown Durand (1796–1886); Cole's *The Voyage of Life* of 1840, for instance,[32] and Durand's *God's Judgement upon Gog* (no.9), though the direct influence here must be from the mezzotints of similar subjects that Martin had been publishing for several decades.[33] These were among the most powerful and well known of Romantic prints, and had the advantage of being original works by Martin himself, conveying his own intentions more vividly than was possible through the medium of the reproductive print by a professional engraver.

Sources and Techniques

Martin's triptych was exhibited in New York in 1856. It was a relatively rare opportunity for Americans to see important new work from England in the original. There were occasional exhibitions or displays: for instance, another British apocalypse painter, Francis Danby (1793–1861), had exhibited a large subject from the Book of Revelation, *The Opening of the Sixth Seal*, in New York in 1833–4.[34] The year after Martin's exhibition, in 1857, a large number of British paintings and watercolours were taken on tour to East Coast cities, in a much-publicised Loan Exhibition chosen from the work of a wide range of contemporary artists.[35] German paintings were more often seen, accessible during the 1850s in the exhibitions of the Düsseldorf Gallery, which opened in New York in 1849. These highly finished canvases treating academic subject matter were an important influence on many Americans.[36] But it was a fundamental condition of life for the painter in America that authentic examples of European painting by masters of any renown were exceedingly hard to come by. Some artists could afford to visit Europe, and often spent much time in England, as well as in Italy and elsewhere. A few sent work for exhibition at the Royal Academy in London. But most, history painters and landscape painters alike, relied to a large extent on the prints that made their way across the Atlantic. Of these there were many, though their value varied. The mezzotints of Martin were a very adequate medium through which his art could be appreciated; its interest lay largely in its extravagantly

sensational imagery, not in the qualities of the painted surface. J.M.W. Turner and John Constable (1776–1837), on the other hand, were painters for whom the handling of the medium itself was crucial. Both addressed the problem of reproduction with great assiduity, and ensured that substantial bodies of fine prints – mezzotints in Constable's case, line engravings predominantly in Turner's, but also mezzotints, besides other media – were distributed to a wide audience.[37] The Americans subscribed to the English art magazines, such as the *Art-Union* and the *Art-Journal*, which had their imitations in the United States. These periodicals regularly published engravings, of varying quality but some excellent, after works by old masters and contemporaries. But a painter could learn little of colour or brushwork from monochrome reproductions. He might absorb ideas about subject matter and general style, but in the practical matter of applying pigment to canvas he generally trained himself by a process of experiment, with technical procedures evolved by empirical stages, measured always against the truth of the reality that he was attempting to describe.

The theatrical art of Turner, like the expressive naturalism of Constable, was dependent on a highly personal handling which, it needs to be said at once, was rarely adopted by the Americans. They employed a pragmatic building up of the picture surface touch by touch which varies greatly in effect from painter to painter, but which rarely obtrudes itself as a distinct painterly 'style'. A majority of the works have a cool, uninvolved handling that is sometimes strikingly at odds with dramatic subject matter and can strike unaccustomed eyes as dry and academic. But although there are certainly parallels with the work of European academic landscape painters, there is in the best of these artists a fitness of technique to expression that conveys the power of their ideas with lean clarity and force.

In the work of Cole, for example, the paint surface is manifestly functional: it strives neither to efface itself nor to create an expressive network of meaning on its own account. Each stroke performs a distinct yet unobtrusive part in building up the statement that is the whole picture. In this Cole's surfaces do not have the eloquent brio of Salvator, nor the enamel finish of Claude. He is, moreover, unlike the more sophisticated interpreters of Claude in the English eighteenth century: Richard Wilson (c.1713–1782), for example, used creamy paint as a means of consolidating a neo-classical clarity of

design in his compositions. On the other hand, Cole's technique has much in common with that of some lesser eighteenth-century landscape painters; for instance George Lambert (1700–1765), whose *View of Copped Hall in Essex* (1746; fig.7) is representative of a topographical tradition that extends through the whole century. This is a pragmatic use of paint far removed from the idiosyncratic brushwork of Cole's Romantic contemporaries in England, Constable, Ward or Turner. But when the actual paint surface is a conspicuous element in the aesthetic effect of an American landscape, the difference of character is striking. This is the case with certain (though not all) works by Thomas Moran (1837–1926), who on occasion pursued his love of Turner further than any of his colleagues in imitating technique as well as subject matter (see nos.65, 95–97).

Many of the artists under review here were masters of the oil sketch, which fulfilled the same function in America as it did in Europe. It was used as an easily portable means of making notes from nature while on tour, or as a way of organising ideas for a picture. In the 1820s and 1830s, Cole planned the compositions of his more elaborate subjects with the help of small oil sketches, later essaying some open-air studies in the medium, giving lessons in the art to Durand and to his sole official pupil, Frederic Edwin Church (1826–1900). Durand, like

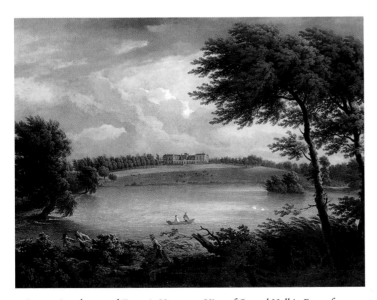

7 George Lambert and Francis Hayman, *View of Copped Hall in Essex, from across the Lake*, 1746. Oil on canvas, 91.7 × 121.5 (36 ⅛ × 47 ⅞). Tate, London. Purchased with assistance from the Patrons of British Art through the Tate Gallery Foundation, the National Art Collections Fund and a group of donors, 1999

John Frederick Kensett (1816–1872), was aware of the example of Constable in his use of oil as a medium for recording the growth of trees and the fresh light of pastoral subjects. Church became a virtuoso of the medium, and produced hundreds of sketches in the course of his career: 'of all employments,' he told Cole, 'I think [painting from nature] the most delightful.'[38] By the 1850s, most landscape painters were making oil sketches out of doors as a regular part of their practice on tour. The support was often board or panel; it might also be a small canvas. Church and Albert Bierstadt (1830–1902) often worked on paper, using a buff, grey or pink ground. As in Europe, not all oil sketches were 'first thoughts', and some elaborated small studies are not easy to categorise. Church's detailed study of *Niagara*, for example (no.45) is clearly a highly evolved preparation for his large picture of 1857. Much of the detail of the latter is already in place, so that the process of transferring the image from paper to large canvas seems to some degree a mechanical one, though there are many refinements in the finished work, including an important alteration in the proportion of sky to land.[39]

Despite his extraordinary facility in the spontaneous notation of effects with the brush, Church made a practice of beginning his finished pictures by making a detailed drawing, in chalk, pencil or charcoal, on the canvas itself, on which he would first lay in a ground of the traditional earth or buff-grey colour, or even an off-white shade. Moran, too, seems to have employed pencil or charcoal as the medium in which he drew his subjects on even his largest canvases, incorporating all the principal details of the image, including light and shade, in this monochrome foundation.[40]

American artists, like Europeans, carried sketchbooks with them, making notes of scenery and natural details. Pencil was the medium in which they recorded mountain skylines, tree forms, clumps of weeds, skies, boats, buildings and lakeside jetties, often with accompanying verbal comments and colour notes. In this they followed a tradition that had been fundamental to British landscape practice since the early eighteenth century, using the methods and aesthetic models that European art centres provided, or that painting and drawing manuals proposed, but adapting their practice to the circumstances in which they found themselves. In so far as they were inventive in their technical approach, it was under the pressure exerted by the character of the landscape they

were depicting. Their adoption of a large scale was the most obvious consequence of that pressure.

The early American painters were conscious that the scenery of their country supplied much that aesthetic theory demanded, without their having to make elaborate compromises. Picturesque ruggedness and variety were intrinsic to their subject matter. Views of Niagara Falls, for instance, nearly always allow the drama of the subject to dictate composition and excuse all formal unorthodoxy. This apparently naïve willingness to be guided by topography was to become an important principle of pictorial design in the early nineteenth century, in Europe as well as America. Many of the great landscapes of the high Romantic period in England are distinguished for their flouting of pictorial conventions;[41] the same holds true for the American school.

Most landscapes produced in America in the eighteenth century had been strictly topographical: views of towns or beauty spots drawn by artists, often military men, who in general had little ability to make more than pedestrian transcriptions of what they saw.[42] In the first decades of the nineteenth century, a few artists began to throw aside topographical representation altogether, and experimented with pure, or ideal, landscape. The Philadelphia artist Thomas Doughty (1793–1852) applied the principles of picturesque composition to nominally American scenes that are often generalised to the point of being fantasies rather than 'views'. The historical painter Washington Allston (1779–1843) trained in London, and was a conduit by which the dominant aesthetic ideas of the time entered America. In his lectures Allston articulated a principle of the Sublime as an 'Infinite Idea', of which we are not necessarily even aware, but which operates as the 'true cause' of the 'ever-stimulating, yet ever-eluding' nature of experience that, following Kant, or perhaps more likely Henry Fuseli, 'the imagination cannot master' and which will thus 'master the imagination'.[43] Allston's landscapes in the Ideal style attain considerable sophistication, sometimes taking classical myth or Biblical episodes for their subject matter (fig.8). Rooted in the Italian tradition as it had become naturalised in Britain, they provide the intellectual basis for Thomas Cole's ambitious programme to create a uniquely American landscape art.

By the 1820s the wilderness of the Northeastern States was beginning to acquire its own literary associations. It was described in evocative prose by James Fenimore Cooper in his early 'Leather-Stocking' novels, *The Pioneers* (1823) and *The Last of the Mohicans* (1826). Washington Irving had already published, in 1819 and 1820, his two famous tales of the Catskills, 'Rip Van Winkle' and 'The Legend of Sleepy Hollow'. These stories instantly created myths of the national life in colonial times. They are set in a Dutch village on the shores of the Hudson, and the sense of continuity from old world to new is strong in them. Their reliance on ancient superstitions and folk-tales concerning goblins, ghosts and witches links them to European vernacular culture. In 'Rip Van Winkle' the Catskill Mountains are described in language that celebrates that continuity:

> In a long ramble . . . on a fine autumnal day, Rip had unconsciously scrambled to one of the highest parts of the Kaatskill mountains . . . Panting and fatigued, he threw himself, late in the afternoon, on a green knoll, covered with mountain herbage, that crowned the brow of a precipice. From an opening between the trees, he could overlook all the lower country for many a mile of rich woodland. He saw at a distance the lordly Hudson, far, far below him, moving on its silent but majestic course, the reflection of a purple cloud, or the sail of a lagging bark, here and there sleeping on its glassy bosom; and at last losing itself in the blue highlands.
>
> On the other side he looked down into a deep mountain glen, wild, lonely, and shagged, the bottom filled with

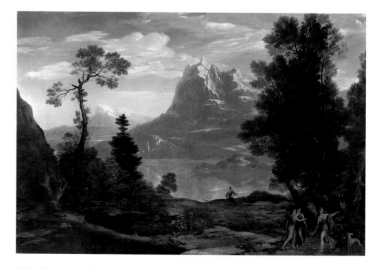

8 Washington Allston, *Diana on a Chase*, 1805. Oil on canvas, 163.83 × 241.3 (64 ½ × 95). Courtesy of the Fogg Art Museum, Harvard University Art Museums, Mrs. Edward W. Moore

fragments from the impending cliffs, and scarcely lighted by the reflected rays of the setting sun.[44]

It was to find just such specimens of picturesque and sublime scenery that Thomas Cole and the landscape painters after him made their way to the Catskills, and they were inspired to produce some of their most characteristic work there. This inspiration is celebrated in a painting by Durand, *Kindred Spirits* of 1849 (no.1). Durand, like Cole, began his career as an engraver, and, though his senior, came under his influence when he turned exclusively to painting in the 1830s. In *Kindred Spirits* he shows Cole admiring the Catskill scenery in company with the writer William Cullen Bryant. Bryant enjoyed a transatlantic reputation in his lifetime, though he is rarely anthologised now. He had celebrated the American landscape in prose and verse ranging from a poetic description of *The Prairies* (1834) to correspondence about the need to bring nature into New York City in the form of a centrally sited park. His *Thanatopsis* (c.1814; first published 1821) provided subject matter for a *Landscape – Scene from Thanatopsis* by Durand, who exhibited it in 1850 with a quotation from the poem:

> The hills,
> Rock-ribbed and ancient as the sun; the vales
> Stretching in pensive quietness between;
> The venerable woods; rivers that move
> In majesty, and the complaining brooks,
> That make the meadows green; and, poured round all,
> Old Ocean's gray and melancholy waste, –
> Are but the solemn decorations all
> Of the great tomb of Man![45]

Kindred Spirits depicts the two great landscape artists of the time, poet and painter, as types of the man 'who in the love of Nature holds | Communion with her visible forms' (*Thanatopsis*, lines 1–2). In Bryant's vision, the landscape is the envelope in which all mankind exists and dies; by attending to 'Nature's teachings' we hear 'a still voice' that enables us to live life more fully, and to approach death more philosophically. We are part of an endless succession of inhabitants of the earth, which we join explicitly in death, when the earth becomes 'one mighty sepulchre':

> As the long train
> Of ages glide away, the sons of men . . .

Shall one by one be gathered to thy side,
By those, who in their turn shall follow them.[46]

The connection between an understanding of nature and the apprehension of long expanses of time stretching both forward and back in an eternally linked sequence is central to the Americans' perception of their landscape. It was to become a significant theme of some of Cole's most important work.

Thomas Cole and his Successors

Cole was born and brought up in England, though not in the metropolis: we cannot suppose that he had access to many original pictures during the adolescent years he spent in his native Bolton, Lancashire. Such training as he had was as an engraver in the shop of a textile designer, and his exposure to high art is likely to have been slight, but he read a good deal of poetry, and will have encountered the descriptions of landscape in Thomson, Wordsworth and Coleridge. When he reached America in 1818, at the age of seventeen, he was able to begin earning a livelihood by making wood-engravings. The following year he travelled to the West Indies, an interlude prophetic not so much of his own career as of those of several of his followers, including Church. His family moved to Ohio, where he joined them and took up painting. Portraits were the obvious way to get on, but he soon determined to be a landscape painter, and when he returned to the East Coast in 1823 that was the profession he adopted. Allston's landscapes will have shown him that topography was not the only way forward, and that the themes of poetry could be incorporated into views of scenery.[47]

Cole made a point of articulating his ideas about art and nature in words as well as paint. His sketchbooks are full of sensitive comments on incidental visual effects, on pictures seen or scenery passed through. At Catskill in 1827, for instance, he wrote down his

> Observations on the Falls of Catskill – on a windy day the clouds flying rapidly – a good deal of water Looking from underneath the arch the water has in falling a pearly [?frosty] appearance – sometimes spreading broad sometimes blown aside in a very grand manner. thrown some time from one side of the cavern to the other –

the [. . .] or flakes very large and extending from one to another – the clouds rushing rapidly in contrary direction from the falls – added to the effect – the velocity of the water falling causes a strong wind which [?makes] a singular effect in the pool into which the water rushes. Streams of spray diverge from the where [sic] the water striked the rock and shoot | accrast the pool.[48]

He travelled to England in 1829, and to the continent of Europe in 1831, making notes and sketches wherever he went, seeking out art galleries and collections. While in London he visited Turner's gallery in Marylebone and saw, among the mouldering pictures there, *Snow Storm: Hannibal and his Army Crossing the Alps*. He showed three works at the Royal Academy in 1830 and 1831, and sent pieces to other public exhibitions. On his return to New York in 1833 he painted a *Scene from Byron's 'Manfred'* (fig.9) perhaps inspired by Martin as well as Byron (fig.10), and embarked on his first large machine – at 2.5 by 4.7 metres actually his largest individual work: *The Angel Appearing to the Shepherds*,[49] a bid to occupy the same exalted ground as Allston and the history painters. But, like Turner, he intended to express his ideas of sublimity in the language of landscape.

His *Essay on American Scenery*[50] of 1835 sets out with energy and some attempt at poetic description the principal arguments for admiring a landscape that he knew was endangered 'In this age, when a meager utilitarianism seems ready to absorb every feeling and sentiment'.[51] 'There are those,' he went on, recording attitudes that went back to the teachings of Gilpin, 'who through ignorance or prejudice strive to maintain that American scenery possesses little that is interesting or truly beautiful – that it is rude without picturesqueness, and monotonous without sublimity.'[52] His career was dedicated to refuting the philistines.

Cole was aware that American scenery was 'an almost illimitable subject',[53] but he quickly established his own approach to it. Inevitably he evolved that approach through the images of nature that other artists had created, or at any rate prints after 'the wild Salvator Rosa, or the aerial Claude Lorrain' whom he was able to cite so easily in his 1835 essay.[54] His early work consists of topographical subjects mixed with more generalised views that evoke the American landscape without being specific. The language in which these various subjects are expressed is already personal, consistent, and

strongly directed. That Cole had read theorists like Gilpin is evident, for the elements of picturesque composition are deployed with imagination and confidence in almost every canvas. We have evidence that he was well versed in Burke and the theorists of the Sublime. His description of Niagara systematically checks his experience of the fall against Burke's list of defining attributes:

And Niagara! That wonder of the world! – where the sublime and beautiful are bound together in an indissoluble chain. In gazing on it we feel as though a great void had been filled in our minds – our conceptions expand – we become a part of what we behold! At our feet the floods of a thousand rivers are poured out – the contents of vast inland seas. In its volume we conceive immensity; in its course, everlasting duration; in its impetuosity, uncontrollable power. These are the elements

9 Thomas Cole, *Scene from Byron's 'Manfred'*, 1833. Oil on canvas, 127 × 96.5 (50 × 38). Yale University Art Gallery, New Haven, Connecticut. John Hill Morgan, B.A. 1894, Fund

of its sublimity. Its beauty is garlanded around in the varied hues of the water, in the spray that ascends the sky, and in that unrivalled bow which forms a complete cincture round the unresting floods.[55]

We know, too, that he had access to at least one English manual, William Oram's *Precepts and Observations on the Art of Colouring in Landscape Painting* (1810).[56] What is striking is that the 'precepts' and landscape elements that figured in his early works have been translated without hesitation into an entirely American language: the dead trees that Thomas Gainsborough (1727–1788), for instance, took from Salvator in his innumerable variations on the Picturesque theme become in Cole's landscapes the rotting remnants of primeval forest, emerging from swamp and lake (nos.3–5). The formulas are applied, but with a clear sense that they are genuinely relevant to the needs of the American landscape artist. We feel, indeed, when looking at the tumultuously dramatic landscapes of the young Cole, that the Picturesque was invented for the purpose of making sense of America.

At the same time, his early pictures have a disarming air of improvisation. The compositions themselves are often awkward – gawky rock-shapes opposed brusquely to open vistas or plunging chasms. Light and shade do not merely oppose, they almost attack each other in Cole's violent dramas of chiaroscuro. Because his workmanlike brushstroke responds so minutely to his intentions at each point in his picture, it registers his immediate vision with vivid clarity. His campaign to make known the beauties of American scenery benefits unexpectedly from his need to forge new tools. Everything emerges freshly minted, a revelation. His brooding swamps, his cloud-swagged hilltops, his autumnal woods gain in conviction from the simplicity with which they are depicted.

By the middle of the 1830s he was subjecting himself to some demanding technical challenges involving the interrelationship of landscape with the human figure not simply as staffage, but as agent in the natural drama. He had already essayed historical landscape, taking subjects from the Bible or from literature (no.10): Cooper's novels were the source of an authentic American mythology that could be fitted quite comfortably into Cole's sublime wilderness (see fig.3). His sequence *The Course of Empire* (nos.11–15), on which he was occupied from 1833 to 1836 for the New York businessman

10 John Martin, *Manfred on the Jungfrau*, 1837. Watercolour, 38.4 × 57.5 (15 ⅛ × 22 ⅝). Birmingham City Museums and Art Gallery (1922 P170)

and patron of the arts Luman Reed, was conceived on an altogether more epic scale as an allegory of the progress of civilisation: a grandiose enterprise in the spirit of James Barry's Royal Society of Arts murals. Whereas the premise of Barry's work is unequivocally optimistic, Cole's position shares the ambivalence felt by many Americans in the period, when President Andrew Jackson's new, expansionist democracy both stimulated patriotism and raised doubts as to the values of a brash, commercialised culture. Even as he lamented the speed with which the forests were being felled, Cole could not help delighting in the prospective cities that would take their place:

> The Rhine has its castled crags, its vine-clad hills, and ancient villages; the Hudson has its wooded mountains, its rugged precipices, its green undulating shores – a natural majesty, and an unbounded capacity for improvement by art. Its shores are not besprinkled with venerated ruins, or the palaces of princes; but there are flourishing towns, and neat villas, and the hand of taste has already been at work. Without any great stretch of the imagination we may anticipate the time when the ample waters shall reflect temple, and tower, and dome, in every variety of picturesqueness and magnificence.[57]

If the American landscape had no associations in the past, it would undoubtedly have them in the future: the dimension of time may be explored both ways, as it was in Bryant's *Thanatopsis*. This is part of the message of *The Course of Empire*. Indeed, the passage just quoted is a text for the first three stages

of the cycle. They describe the evolution of the wilderness into a city. The implication is that the grand metropolis of the central scene of the cycle, *Consummation,* represents an ideal in which Cole believed. But when he painted his sequence he also undoubtedly had in mind Turner's Carthaginian subjects and the doom-laden works of John Martin, as well as of other Romantic moralists: all empires must decline, men's ambitions prove vain and their achievements crumble. It was inherent in the Christian ethos of the time that pride must have a fall: the full story must be told.

Into relatively modest canvases, appropriate to Luman Reed's domestic setting, Cole crammed not only a cycle of human experience but a wide range of technical experiment. *The Savage State* is a depiction of the American wilderness as he had delighted to paint it, all storm-clouds, swirling mists and wind-tossed trees, where the 'savages' stand in for the wild banditti of Salvator Rosa. *The Pastoral or Arcadian State* is an exercise in the Ideal, a Claude-like idyll of serene light and scenic orderliness, nature already obeying the curb of man. In *The Consummation of Empire,* the balanced asymmetry of well-ordered nature is replaced by the geometries of a classical city, the palaces piled high one above another as in the work of Turner (for instance *Dido Building Carthage,* 1815, and *The Decline of the Carthaginian Empire,* 1817 [58]). Landscape is obliterated by architecture, engineering and sheer hubris: the triumphal procession that fills the available spaces of the foreground is splendidly indifferent to nature. In the sequel, *Destruction,* Martin is the model: catastrophe engulfs the imperial city, storm and fire destroy what an invading army does not. After this systematic run through the landscape styles, Cole arrives at his final scene, *Desolation,* in which the ironic message that nature will 'reassume the land' carries with it an aesthetic question: where is landscape painting to go in order to express the truth of America? A few decades later, the desolation of as yet unexplored deserts in the Far West was to supply important subject matter for some of Cole's successors.

Frederic Edwin Church was the only painter actually to work alongside Cole in his studio, but it was a close contemporary, Jasper Francis Cropsey (1823–1900), who was to adopt Cole's methods and forge them into a personal style that would endure throughout his career. Cole was, indeed, a hero hardly second to Turner for him: 'In Turner and our Cole we always have something that abstracts the mind,' he wrote in

his Journal in 1858. 'One is led to forget both self and picture in dreamy or abstract reasoning, which is the result of an intellectual power the picture possesses. This in the best work of Cole and Turner extends to great depth, dealing sometimes in very subtle philosophys and even human passions.'[59] Some of Cropsey's early work is technically and conceptually almost indistinguishable from Cole's, and although he occasionally adopted a suaver technique as in *The Millennial Age* (no.17), his natural idiom was a broken touch closely based on Cole's, which in due course became distinctly his own. It is seen in characteristic form in *Autumn – on the Hudson River* of 1860 (no.27). This picture illustrates Cropsey's fondness for Claudean – or Turnerian – compositional formulas, which he here takes to new expressive heights with the help of a very large canvas and the famous fall colouring of the woods. That he could ring interesting changes on the basic type is clear from, say, *Starrucca Viaduct* (no.28); but this picture only confirms how congenial conventional compositional structures were for him.

In *Autumn – on the Hudson River,* Cropsey produced what is perhaps the central masterpiece of what later, in the 1870s, came to be known as the Hudson River School. This was 'a name given to them by a savage critic who wrote for the "New York Tribune"', according to a member of the group, Worthington Whittredge (1820–1910), who in his autobiography listed a dozen painters, including himself, who had painted the 'more homely scenery' of upper New York State and particularly of its great waterway, the Hudson. Whittredge includes Church and Kensett in this loose and very informal grouping, along with others such as Sanford Robinson Gifford (1823–1880), even though Church often painted more exotic subjects on a far from 'homely' scale. He mentions Durand as a supporter of the principles of these painters.[60] Oddly, he does not include Cropsey, perhaps the most consistently Hudson-based of all of them, which may indicate that the notion of a 'Hudson River School' is an artificial one of limited application.

Cole's pupil Church moved rapidly away from his master in the matter of technique, and in approaches to composition as well. He was born in Hartford, Connecticut, into a prosperous family, and joined Cole in his Catskill studio in 1844, staying with him for two years. His earliest landscapes, like Cropsey's, are imitations of Cole; for instance the 1847 *Storm in the Mountains,*[61] in which the themes of blasted tree-trunk and

mist-wracked mountainside appear just as Cole would have presented them. A little later, in a canvas such as *New England Landscape (Evening after a Storm)* of 1849,[62] a pastoral view that Cole might easily have painted is handled with noticeably greater delicacy of touch. Cole had died the previous year, and Church had immediately saluted his master in an elegiac work, *To the Memory of Cole*.[63] From that point his own manner burgeoned. *Above the Clouds at Sunrise* (1849)[64] shows him treating an ostensibly Colean theme – cloud-wrack and trees against a dawn sky – in a wholly new way. Church has learned to extract an intense poetry from a few simple elements, which transform the structure of the traditional picturesque view into a minimal suggestion of foreground, repoussoir and sky. His willingness to abandon the Claudean model was a turning point, not only for Church but for some of his fellow artists too.[65] The transformation can best be traced in the work of John Frederick Kensett.

Like Church, Kensett began painting in a style closely derived from Cole. But he is immediately distinguishable by a much cooler palette: he professed to 'a most perfect abhorrence' for 'a bright sky and a hot sun'.[66] A picture like his *Reminiscence of the White Mountains* of 1852 (no.6) makes a surprising contrast to the warm-hued Catskill and New England subjects of Cole, Church and Cropsey. These artists had all, in different ways, made the colours of the fall woods the key of their chromatic language, and in doing so had marked out their enterprise from the landscape painting of Europe, where autumn had rarely attracted the Romantic painters.[67] Cole and Cropsey in particular made fall foliage a leitmotif of their work, and indeed thought of it as an outward sign that their pictures were genuinely 'American'. The story of Cropsey ordering specimens of foliage to be shipped to England to persuade Queen Victoria of the veracity of his *Autumn – on the Hudson River* sums up the vital dependence of his art on the natural phenomena it strove to depict.[68]

Kensett reinterpreted the Cole style with a coolness not only of colour but of composition too. He replaced Cole's plunging chasms and rearing cliffs with serene, slate-surfaced lakes and dignified pyramid-like mountains. By the late 1850s he had largely eliminated the busy brushwork inherited from Cole and was painting in a calm, even manner in which texture is subordinated to atmosphere. This process occurs simultaneously with a refining of composition: picturesqueness – variety,

irregularity, unexpectedness – is banished from both technique and subject matter together, as inseparable aspects of a single aesthetic idea. *Shrewsbury River, New Jersey* of 1859 (no.74) represents the point Kensett had reached by the end of the decade. The economy of this work, in palette and design alike, has emerged naturally from the cool restraint of *A Reminiscence of White Mountains*, but now makes an extreme statement, utterly at odds with the hectic sublimity of Cole. Brushwork has been brought under the same rigorous control: there is little or no expressive impasto, only an even application of semi-transparent pigment on a light ground. The apparent intention is to eliminate the membrane of the medium altogether, arriving, perhaps, at the condition of the 'transparent eyeball' to which the philosopher Ralph Waldo Emerson famously compared his receptive imagination, 'all mean egotism' banished, in the presence of creation.[69]

This union of compositional, chromatic and atmospheric serenity is to be found in the work of a number of painters of the 1850s and 1860s. It is a far cry from the sublimity of Church's work in the same period even at its calmest, or from that of Church's newly emerged rival Albert Bierstadt. In the 1950s, one art-historian gave it a name: 'luminism'. Since then, the word has frequently been used to denote a 'school' of painters devoted to such effects, including Martin Johnson Heade (1819–1904), Fitz Hugh Lane (1804–1865), and Kensett himself.[70] However, no such school existed: the painters who produced 'luminist' pictures did not subscribe to a unified theory of landscape painting, and indeed were not even closely associated as artists. One of the most important 'luminists', Fitz Hugh Lane, worked mainly in a small Massachusetts fishing town, remote from the affairs of New York, or even Boston, and derived his style partly from the European marine tradition and partly from a circumscribed topographical practice. Aside from a relatively small group of marine subjects – all, significantly, calms – his work is largely conventional topographical or marine painting, though the best examples have great delicacy of atmosphere. While some consistency of purpose can be discerned in many works by a small group of these artists, it is a distortion to suggest that they worked together or that the output of any of them demonstrates any clear intention to produce landscape painting according to a set of rules perceived as unique to the group. In so far as they show a strong interest in effects of light, they share that interest

with many landscape painters of the nineteenth century. In so far as they deploy, in some of their work, specific technical devices in achieving those effects (most notably a long horizontal format), they do indeed have much in common. One recent writer has spoken of 'atmospheric luminism', which seems to refer to an achieved effect rather than to a historically coherent 'movement', and is therefore a more useful, because more flexible, formulation.[71] But it seems less tendentious to relate these qualities to comparable ones in European art of the Romantic period, and to use a term which applies to Europe as well as to America, while having its own specifically American connotations: the transcendental.

The concept of 'luminism' was invented and developed in order to give identity and prominence to the American school at a period when it was in danger of being overlooked. That period is now, we hope, past. But if we reject one 'ism' (without going so far as to say that the word 'luminist' may not sometimes be useful as shorthand for a certain type of American landscape), we need not replace it with another. Kensett, Lane and the others never belonged to the philosophical movement known at the time as Transcendentalism. This was headed by Emerson, a Unitarian minister in Boston who came to question fundamental aspects of his faith and became the advocate of a kind of intense rationalist pantheism. Emerson does, however, supply a verbal account of the subjective experience of nature that corresponds in important respects to the salient characteristics of these artists. In particular his emphasis on the rapt calm of the soul in the presence of nature is close to their vision. 'The tradesman, the attorney comes out of the din and craft of the street, and sees the sky and the woods, and is a man again. In their eternal calm he finds himself.'[72] The passage continues: 'The health of the eye seems to demand a horizon. We are never tired, so long as we can see far enough.'[73] Emerson identifies the horizon itself as the unifying agent in the landscape: 'There is a property in the horizon which no man has but he whose eye can integrate all the parts, that is, the poet.'[74] Broad horizons are the corollary of wide skies, and of light that comprehends and envelops the scene. For Kensett, Heade and Gifford the horizon became the defining element of the composition: these artists adopted a wide format with the specific intention of allowing the horizon to dominate. In Heade's marsh scenes, it is usually flat; Gifford allows it to undulate expressively, to become indistinct in the glare of the sun, but it always establishes the dominant rhythm of his design.

Emerson too affirms the creative power of light: 'as the eye is the best composer, so light is the first of painters. There is no object so foul that intense light will not make beautiful. And the stimulus it affords to the sense, and a sort of infinitude which it hath, like space and time, make all matter gay.'[75] He describes the sky in terms that recall Heade's paintings: 'I see the spectacle of morning from the hill-top over against my house, from daybreak to sunrise, with emotions which an angel might share. The long slender bars of cloud float like fishes in the sea of crimson light. From the earth, as a shore, I look out into that silent sea.'[76] Lane and Kensett, among others of the period, made considerable pictorial capital of the idea of sky and sea being reciprocal and reflective elements, combining to create an infinitely luminous space into which the eye penetrates without being required to explore. In this, the 'transcendental' painters are at the opposite pole from Cole and Church for whom foreground is an elaborate introduction to middle-ground and deeper background, through which the eye wanders like an explorer, overcoming obstacles and deriving excitement from each turn of the path.

The passages quoted here from Emerson's essay on Nature suggest an important point: that these artists were representative of the city-dweller. They, like the 'tradesman, the attorney' mostly lived and worked in towns and cities, and found their souls expanding to the stimulus of nature defined by light and the wide horizon. Lane's art, while sharing many of the characteristics of the New Yorkers, is different in important respects, and the context of his life in a small fishing community suggests an essentially different spiritual relationship with nature, which is apparent in his painting. This is, perhaps, the condition that makes him capable of transcending his 'provincial' roots to produce such extraordinarily powerful images which are at the same time inward and personal.

Perhaps the most thorough-going of the practitioners of the new technique, the measured application of short strokes of the half-dry brush to build up a hazy network that describes vibrant and luminous air, was Sanford Robinson Gifford. Gifford, though initially under the shadow of Cole, became a supreme master of the depiction of a radiant and diffused sunlight, having studied the optical effects of light directly

received by the eye, and the ways in which colours are modified as they are apprehended in relation to that light. His depictions of mountain flanks at dawn or evening, for instance (nos.21, 31, 32), are essays in the subtle distortion of hues not only as they are transmitted through luminous atmosphere, but as they strike the retina when it is half-dazzled by strong light. It would be interesting to know what effect Church's *The Andes of Ecuador* of 1855 (no.85) had on Gifford's development in this respect, since it tackles a similar problem; but Gifford had already begun his own experiments before Church's great picture appeared.

Martin Johnson Heade, on the other hand, whose work evolved towards a comparable type of horizontally-planned, minimal landscape towards the end of the 1850s, remained, technically, in the pragmatic tradition of Cole, using his brush descriptively, sometimes coarsely, to put in place each element of the view. Heade took over Church's studio in the Tenth Street building in New York where many artists worked, and the two men became good friends.[77] Church encouraged Heade's interest in travelling to South America, and in a few large-scale South American subjects Heade emulates Church. But for the most part he remained a painter of modest ambitions, obsessively pursuing particular themes – orchids and humming-birds occupied a great deal of his time – but making a unique contribution with his quiet, endlessly rearranged groups of haystacks on the coastal marshes of New England. They are presented in an infinity of climatic modes: showery mornings, stormy afternoons and calm sunsets succeed one other, each accompanied by a sacramental sense of wonder that makes every natural event seem fraught with quiet spiritual meaning. But these ideas are most pronounced in two canvases on a larger scale: the storm subjects of 1859 (no.80) and 1868.[78] The black storm cloud becomes the backdrop to an electrically brilliant scene which we take in as if by a flash of lightning, vivid, dreamlike, frozen.

Lane has some of the character of a local naïve, but he attains extraordinary heights of expressive power when his subject matter lies within his technical limits. If he cannot paint a rough sea with true conviction, his calms have an almost surreal intensity of mood. The range of his effects is remarkable: fog, sunset, thunderous half-darkness, the flat light of a humid midday, serene morning. Against these delicate cycloramas he disposes his sailing-ships with fastidious

delicacy, their canvas reflecting or half-occluding the light. In his crowded scenes of shipping in Boston Harbour he is very obviously imitating the marine subjects of an early colleague, Robert Salmon (1775–c.1850; see fig.49), who came to Boston from England in 1828; yet Lane brings his own porcelain-like clarity of vision to bear on every detail. It is not so easy to trace any such influence in the more idiosyncratic subjects: there is no obvious precedent for *Schooners before an Approaching Storm off Owl's Head* (no.70), with its astonishingly fresh vision of the white canvas sails brilliant against a lowering sky. Lane's picture is intensely original in its use of familiar motifs, and in each case the originality is a function of the integrated vision of the artist: as with Kensett, subject, handling and composition are facets of a single pictorial idea. The intensity, emerging as it does from a simple reportorial manner, is unique to its place and time: local and universal at once. Hence the similarities so frequently noted between Lane and the German Caspar David Friedrich (1774–1840), which are certainly coincidental. One might point also to the work of the Norwegian painter Peder Balke (1804–1887), whose stormy coast scenes are close in mood to those of Heade or Lane; and to the Irish artist, Francis Danby (1793–1861), who worked in Bristol, Norway and Switzerland producing, among much else, storm scenes and exquisitely refined calms in which light is the medium by which the incidents of landscape are subsumed in a transcendent whole. The Americans were working in an international idiom, bringing to it the unique intensity of vision that accompanies the investigation of a new-found land.

For Emerson, the process of responding to natural scenery is reciprocal, and indeed demanding: 'Nature stretches out her arms and embraces man, only let his thoughts be of equal greatness.'[79] Such ideas bring him close to the Kantian notion of transcendence. The moral component is crucial for him: 'Beauty is the mark God sets upon virtue.'[80] There is no distinction between our aesthetic sense and our moral sense. Emerson put into words what many Americans felt as they explored the land that God, as it seemed, had given them: it was natural, inevitable, that they should see his imprimatur in its every detail. 'The faith should blend with the light of rising and of setting suns, with the flying cloud, the singing bird, and the breath of flowers.'[81] This perception informed the work of all these landscape artists, but there is an important change of emphasis during the 1850s: the exposition of grand moral and

religious themes in the allegorical and narrative pictures of Cole, Cropsey and the young Church gives way in the work of the 'transcendental' painters to the more intuitive spiritual messages implied in personal odysseys into light and air.[82]

Church and the 'Great Picture'

We have already seen Church adapting Cole's subject matter to his own uses, and noted the abandonment, at least on occasion, of picturesque compositional norms. Church was in fact devoted to the Claudean formula, and used it throughout his life, with almost as much consistency as Cropsey. His *New England Scenery* of 1851 (fig.11) is an example from the moment of his first maturity – its general layout is repeated in a very different circumstances for the South American subject *Cayambe* of 1859 [83] and much later in his *Sierra Nevada de Santa Marta* (1883).[84] The invocation of the Claudean Ideal was no mere habit: it was central to Church's purpose in showing his public the Ideal landscape of a 'paradisal' New World.[85]

Church was exploring alternatives to this format from an early date, and it seems fairly certain that Turner was the inspiration for some of these experiments. We know that Church was influenced by engravings after Turner while he was working on *The Andes of Ecuador* of 1855 (no.85).[86] The picture is a conscious attempt – and a successful one – to open up the limits of vision to a point at which the eye can travel a virtually incalculable distance into the picture space. The point of view is higher than before, so that the foreground drops out of sight and we are drawn immediately into the middle distance, where everything is already immersed in a haze of hot sunlight. The sun hangs blindingly above the far mountains, diffusing its radiance from the central point of the panorama. The absence of prominent topographical features is itself a distinguishing feature of the composition. An immediate precedent for such a scheme is to be found in the view over the *Lake of Lucerne, from Brunnen* (fig.12), engraved in 1854 after one of Turner's late watercolours.

There are some precedents for this development in Church's own work. He had painted New England twilights in which repoussoirs have been eliminated, and an irregular horizon, made more emphatic by being silhouetted dark against the evening sky, dominates the composition. An example is *Twilight, 'Short Arbiter 'Twixt Day and Night'* (no.22). An even more extreme simplification takes place in his picture of *Ira Mountain, Vermont* (1849–50),[87] in which we encounter the preoccupation with the line of the horizon that was to dominate some of Church's work in the later 1850s. Incident is nearly eliminated; the composition is articulated principally by light, or its absence. Paintings like these demonstrate how a 'naïve' topographical approach can merge almost imperceptibly into highly sophisticated commentaries on landscape. But the topographical model is important for Church – as indeed it had been for Turner: *Lake of Lucerne, from Brunnen* is explicitly a topographical view. It enabled Church to forge his own language for the presentation of natural phenomena that were specifically American, and which demanded emancipation from European practice.

The most important example of this process is his great picture of *Niagara* of 1857 (fig.32; also see no.35), which is a return to the spirit of direct topographical recording found in eighteenth-century views of the Falls. Thomas Davies's image of Niagara in the 1760s (fig.13) is a naïve work, though highly effective in its way, because of its determination to give us the most thrilling possible viewpoint. It retains the formal repoussoirs of conventional picture-making, but abandons the politeness of an ideal view. We do not see the phenomenon in the middle-distance, separated from us by a foreground of lake or river bank: we are perched close to the edge of the drop, and the current swirls almost at our feet. The scene is presented as

11 Frederic Edwin Church, *New England Scenery*, 1851. Oil on canvas, 91.4 × 134.6 (36 × 53). George Walter Vincent Smith Collection, George Walter Smith Art Museum, Springfield, Massachusetts

12 Robert Wallis (after J.M.W. Turner), *Lake of Lucerne, from Brunnen*, 1854. Line engraving on steel, 47.6 × 29.2 (18 ¾ × 11 ½). Tate, London

in a lens, to ensure that the whole sweep of the Falls lies under the eye. A few boulders are placed, as if in a countryside car-park, to prevent our straying too far: another formality. Church sweeps these tokens aside, but adopts Davies's bold idea: he places us actually over the water, just at the point where it is about to plunge into the gulf. There is no 'composition', in the traditional sense, at all. Above the wide flat horizon is sky, with trees low on the distant shore; below, the seething water, rendered with astonishing precision of observation. The canvas is some two and a quarter metres wide. Despite the compositional parallels, this is not a painting that belongs with the 'transcendental' group: it is not an inward, private meditation. On the contrary, it is a spectacular public statement, in the tradition of West, Martin and Danby, or of Cole's *The Angel Appearing to the Shepherds*. Church made that clear at once by exhibiting it, with much publicity, in New York, in London, and in many American cities. It is not a meditation on light, but on the power of nature manifested in the grandest geographical phenomena. It celebrates the glory of America, its unique 'antiquities', which are geological and natural rather than man-made – more ancient than anything created by man. It is a hymn to an omnipotent God whose power is most perfectly manifest in such wonders. Church conceived it as a show-piece, a masterpiece in the original sense: a specimen of his own mature powers at their most impressive – a match, perhaps, in a consciously humble way, to God's own. As a public spectacle the picture borrowed something of the character of the panorama: its wide view and its meticulous detail

both allude to panoramic painting, as does its choice of subject.

Church's next large picture, *The Heart of the Andes* of 1859 (fig.14) was even more explicitly a spectacle-picture. It measured over three metres in width, and he showed it, as earlier artists had shown their grand machines in London, in a specially lit room, on its own, with an admission charge. He contrived an architectural frame, to suggest that the visitor was looking out through a window – a direct borrowing from the ideas behind the panorama or diorama. He placed potted palms round the room to enhance the tropical illusion. All this was set off by lavish draped curtains and carefully controlled lighting, accessories that had been used by West and others in London at the turn of the century. Church also supplied viewing tubes through which details of the picture could be examined separately, and suggested that visitors should bring opera-glasses to peer at the vines and humming-birds, pilgrims by a wayside shrine or figures on a distant road. At a later showing, the picture was surmounted by the portraits of three Presidents, to emphasise that this description of a remote jungle was none the less a statement about the very essence of Americanness.[88]

These stratagems were rewarded with huge popularity in New York, and in the many other American cities where the picture was shown. But if showmanship was important to Church's success, it was not a substitute for technical prowess. His *Niagara* is an astonishing and monothematic exercise in the depiction of fast-moving water. In *The Heart of the Andes* he set himself the task of rendering a huge canvas convincing as the

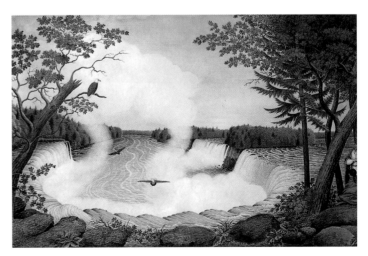

13 Thomas Davies, *Niagara Falls (from above)*, c.1766. Watercolour on paper, 34.3 × 52.7 (13 ½ × 20 ¾). Collection of The New-York Historical Society 1954.2

14 Unknown photographer, *The Heart of the Andes* by Frederic Edwin Church, as exhibited at the Metropolitan Sanitary Fair 1864. Stereograph, 7.6 × 7.6 (3 × 3). Collection of The New-York Historical Society

complete representation of a subject chosen to be as complicated as possible: foreground foliage, with birds and blossoms, middle-ground of forest, plain and river, in the distance bare mountainsides, and beyond snowy peaks. The diffuse and dazzling sun of *The Andes of Ecuador* is replaced here by a cool, clear light in which even the distant details are crisply visible. Critics complained that the picture was too full of detail, but it was Church's intention to demonstrate the sheer wealth of God's creation in the New World. He sent it to London almost immediately after its New York showing – an indicator of the importance of English opinion to these artists – where it was received with considerable enthusiasm. The *Art-Journal* hailed 'a great landscape painter', and delivered a pronouncement worthy of Turner's great apologist John Ruskin (1819–1900) himself: 'Here is a painter (it is delightful to see it) whose modest patience and cheerful industry no amount of labour can weary or deaden.'[89] It is not so certain that Ruskin would have endorsed the same periodical's judgement that 'On this American more than on any other – but we wish particularly

to say it without impugning his originality – does the mantle of our greatest painter appear to have fallen.'[90]

This was, of course, a reference to Turner, part of a campaign by the *Art-Journal* to draw attention to the relative impoverishment of landscape painting in England during the 1850s. Most of the great Romantics were dead; the Pre-Raphaelites, whom Ruskin singled out as having succeeded Turner as serious painters of the real world, were not primarily landscapists, and for many critics their work was problematic. Church seemed to offer not only new talent but that whole repertory of new subject matter which, as Humboldt had urged, was waiting for artists to take possession of. Next to Humboldt, Ruskin was probably Church's strongest theoretical influence. His *Modern Painters*, which had begun to appear in 1843 and eventually attained five volumes, the last published in 1860, 'fell upon the public opinion of the day like a thunderbolt from the clear sky', according to the American journal *Atlantic Monthly* in 1860.[91] Ruskin's book was eagerly devoured by American artists, and Church was an ardent admirer.[92] Ruskin's insistence that the artist's first responsibility was to record with passionate fidelity the beauties of God's creation chimed exactly with the preoccupations of Americans.

It has been suggested that Church prepared himself for the painting of his *Niagara* by reading Ruskin's advice on the depiction of water,[93] and there is certainly visual evidence that by the late 1850s Church was a dedicated Ruskinian, if not by any means technically a Pre-Raphaelite. His handling was perhaps closer to the quintessential Pre-Raphaelite manner earlier in the decade, when, in pictures like *Lake Scene in Mount Desert Island* of 1851 (no.23), he created an effect of luminous twilight by drawing his brush over a ground prepared with a pinkish tone and allowing this to glow through the local colour. There is no reason to suppose that this was a conscious imitation of Pre-Raphaelite technique, which he would not have been able to study at that date (Pre-Raphaelite pictures were first seen in America at the British Loan Exhibition of 1857–8; Church was not to visit England until 1867). It indicates, rather, that in his search for solutions to problems of expression he was moving in parallel with developments in England.

In some of his later exercises in the close observation of nature, Church proves himself an extraordinarily adept pupil of Ruskin. In the view of *Niagara Falls from the American Side* (1867; no.35) he again paints the Falls with a topographer's innocence

(in fact the composition is based on a photograph),[94] studying them at close quarters as though they were a mere stream flanked by a few boulders, recording every clump of moss and every whorl of spray as it falls. Once again, this simplicity of observation is combined with huge scale. Similar comments might be offered about *The Icebergs* (no.88), another enormous exercise in Ruskinian naturalism. Ruskin is said to have been impressed by the fidelity of the painting of water in the 1857 *Niagara*, but he did not recognise Church as a great artist when he saw *The Icebergs* in London in 1863 or *The Aurora Borealis*[95] two years later: 'Niagara, or the North Pole, or the Aurora Borealis, won't make a landscape; but a ditch at Iffley will, if you have humanity enough in you to interpret the feelings of hedgers and ditchers, and frogs.'[96]

Ruskin stated his underlying objection more explicitly in an aside in one of his 1871 *Lectures on Landscape*: 'there are crude efforts at landscape-painting, made continually upon the most splendid physical phenomena, in America, and other countries without any history. It is not of the slightest use.' This was, of course, to remind the Americans of a problem they were already very conscious of, and which they had made titanic efforts to address. The early campaigns of Cole, Durand and the young Cropsey to invest their landscapes with quasi-European symbolism and a strain of mythological or religious narrative had given way to Church's grandiose celebrations of the ancient natural monuments of America, and, following Humboldt, to the message of divine purpose. The transcendental ecstasies of Kensett, Gifford and Heade were a different way of expressing the same sense of awe. But it is as though, after Ruskin, a new initiative was required. If, having described with Ruskinian care the natural details of their country, Americans still faced an inescapable lack of historical authentication, where were they to turn? Wherein lay true authenticity?

Two developments of the 1860s and 1870s offered some answers to such questions. One was an abandonment of old styles and techniques, and the resumption of apprenticeship in Europe: in these years young artists flooded not to Düsseldorf or London but to Paris, to imbibe the ideas of the Barbizon School, the naturalists and the Impressionists. For others, a solution lay in the exploration of territory that lay outside anyone's present experience, even Humboldt's – a wilderness more daunting and empty than anything hitherto described: the vast Far West.

The Great West

Darwin's *On the Origin of Species*, published in 1859, introduced a new dimension into the American debate. The religious frame of reference that had defined attitudes hitherto was forced into defensive mode, against the onslaught of a science utterly at odds with Humboldt. But the effects were not entirely negative: while God's plan seemed to have been obscured, the land the painters were recording was suddenly many millennia older, more mysterious and awe-inspiring than anyone had suspected.[97]

1859 was also the year in which Albert Bierstadt first travelled to the Far West, in company with Frederick W. Lander's expedition to explore the Rocky Mountains. Bierstadt had been born in Germany in 1830, emigrating with his family to America at the age of two. In 1853 he returned to Europe, stopping briefly in London before going on to train as an artist in Düsseldorf, where several other Americans were studying. At that date the Düsseldorf artists formed an influential school on which other nations kept a beady eye. In 1858 the London *Art-Journal*, reporting from the Düsseldorf Annual Exhibition, noted with pleasure that landscape was 'a branch of Art in which Germany is making rapid advances'; the Düsseldorf artists were producing work 'very carefully studied and minutely finished; yet in no degree tainted by "Pre-Raffaelitism", which the artists of Düsseldorf entirely ignore. Mr Ruskin would not find in this Art-city a solitary tree or a single leaf under which to shelter an idea.'[98] That gap between the excesses of Pre-Raphaelitism and the stale work of 'our own ordinary, styleless painters'[99] of the older generation was one that British critics were anxious to see filled. They had been alerted by displays of Church's work in London to the possibilities of an American successor to Turner; Bierstadt quickly followed.

Church had blazed a trail in the commodification of his pictures; Bierstadt became the epitome of the commercially minded painter, 'producing' the display of his large paintings with careful attention to timing as well as appearance. His tactics led to accusations of shameless exploitation, gimmickry and vulgarity: an archetypal American entrepreneur. These qualities are undeniably present in much of his later work; but from his return to America in 1857 until the early 1870s he realised his visions with astonishing vividness and power.

Bierstadt, full of the ambition to pursue a dazzling career as a landscape painter, was well placed to take up the baton of

Church, while occupying slightly different ground on account of his distinctly different training. Like Church, he used the large exhibition picture to head his campaign, and in 1858 he submitted a specimen, not in a private gallery with special effects, but at the Annual Exhibition of the National Academy of Design in New York. It was a view of *Lake Lucerne*[100] that, despite its subject, affirms a landscape tradition very different from that of Turner. It measures over three metres in width, and demonstrates that Bierstadt had completely mastered the principal difficulties presented by such machines. He has studied recession and the question of leading the eye into an extensive view; he has observed mountain light and the forms of trees alike. Paint is employed as a means to an illusionistic end: his finish is not so refined as that of Church, but it does not obtrude for the sake of independent aesthetic effect. Emotionally, despite its breadth and grandeur, the image is curiously cool: the spiritual fire that burns at the centre of Church's pictures is replaced by an impassive objectivity. This allows the painter to inspect every last detail and render it precisely in its place – the glints of light on rock, the growth of trees, the old buildings of a village on a cliff – without comment, as it were. Nature is left to make her own points, courtesy of a brilliant technician.

The lesson of this view of Lake Lucerne is that it was not in America that Bierstadt learned to paint on a large scale. He had found suitable material in Europe. But it is highly likely that he essayed the picture with a view to vying with Church as a painter of the vastness of the American wilderness. The 1859 expedition fitted opportunely into his agenda, offering him distinctive subject matter that would not compete with Church's. The great picture that he produced on his return, *Rocky Mountains, 'Lander's Peak'* (1863),[101] set the pace for the rest of his career. He travelled widely in the West, making rapid sketches in pencil[102] and small, highly accomplished oil studies.

The intensity of these small-scale works is to be found in the details of his larger pictures until the early 1870s. Many of the subjects are imaginary: they convey an idea of the Far West, of the Rocky Mountains or of the Yosemite Valley rather than an exact transcript. Yet there was pressure on Bierstadt and artists like him to present the authentic truth. National pride identified itself with the glories of the western landscape, and the public expected exact transcripts. The expeditions were

equipped with cameras as well as with palettes and brushes. Men like Carleton E. Watkins (1829–1916) and Charles Leander Weed (1824–1903) were exhibiting their large-plate photographs of Yosemite and the Sierra Nevada in the first years of the 1860s. For Bierstadt himself, photography was a familiar skill. His two brothers ran a photographic studio, experimenting with stereoscopic photographs and other ingenious devices. Albert took his own photographs on his way out west, and brought back plates for stereoscopic use by the family firm. He was therefore well acquainted with the idea of objective 'truth', and his paintings are designed to persuade his audience that he was aware of their expectations. Nonetheless, his subjects are largely inventions, capriccios founded on close observation. His fidelity to the truth of geological and botanical forms, of effects of light and climate, helps in the process of persuading us that what he shows is accurate. *Among the Sierra Nevada Mountains, California*,[103] shown in London in 1868, was hailed as 'not fiction but portraiture':[104] the accumulation of specific detail creates a 'real' scene, completely convincing in its entirety, though actually an ideal combination of elements from real locations. That sense of a new Ideal landscape was picked up by critics who pointed out the echoes of European scenery embedded in Bierstadt's perception of the West. His *Mount Hood* (1865)[105] was described by one British writer in these terms: 'The spectator looks from the northern bank of the Columbia river . . . upon a shadowed pool below, which recalls the memory of an Italian lake. Limestone rocks, of the clear bluish-grey familiar to the Scottish landscape-painters, are in the foreground, close by which a troop of deer are tranquilly browsing . . . Beyond, the banks rise in stupendous rifted cliffs, of some basaltic rock, not very dissimilar in its cleavage from the Italian tufa.'[106]

If Church invites us to stand on the very rim of Niagara, Bierstadt proposes a long hike into the wild, where dangerous animals, American Indians and sudden storms contribute to the grandeur of high peaks, waterfalls and glassy lakes. All the elements are orchestrated with a self-conscious sense of the grand symphonic whole, and at times that self-consciousness seems inconsistent with the aim of presenting nature as she is. His invention of names for the mountains in his pictures – 'Mount Rosalie' after the woman he intended to marry, 'Mount Corcoran' for the gallery he hoped would acquire the

picture – betrays the extent to which nature existed for him to exploit. When *Mt Rosalie* (no.91) was shown in London in 1867, a critic rather oddly accused him of 'plotting and planning for purely artistic ends. He is always trying for luminous gradations and useful oppositions', but immediately justified these devices: 'in art of this kind, where the object is to produce a powerful impression of overwhelming natural grandeur, a painter must employ all the resources possible to him. This may be condemned as scene painting . . . [but] No picture that we have ever seen has more entirely conveyed a sense of natural sublimity.'[107] Bierstadt's art is above all theatrical; but it is about the theatricality of nature, and his solutions to the question of naturalness in the context of the Sublime are often subtle. That he could effectively subordinate grandeur to naturalism is shown by such small pictures (or large studies) as *Moat Mountain, Intervale, New Hampshire* (no.63) and *Niagara* (no.36).

Bierstadt was a pioneer among painters travelling to the West. His pictures were successful in large part because they articulated sentiments that Americans wished to hear: they were the inhabitants, the explorers, and, according to divine plan, the conquerors of a vast continent. It was necessary only for him to show America's natural splendours as impressively as possible. But in one extraordinary picture, *Sunset in the Yosemite Valley* of 1868 (no.93), he seems to have tried to express some of the concern that Americans continued to feel at the threat they themselves posed to nature. It is a picture that, with its eerie light and sharp crags lit by an incandescent glow, recalls the fantasy landscape that Cole had created as the setting for his *Expulsion from the Garden of Eden* (no.10). This is a reminiscence of an earlier phase of American landscape painting, recalled under the impact of the glories of the Far West. Bierstadt pinpointed his sense of the fragility of the newly discovered wonders in a letter: 'We are now here in the Garden of Eden I call it. The most magnificent place I was ever in,' he wrote.[108] His picture suggests that the possibility of its destruction was inherent in its discovery, just as had been the case in the East.

Bierstadt demonstrated the grandeur of the West as theatre. But effective conquest required more: the specific, scientific recording of geological and geographical facts. The challenge was taken up by Thomas Moran (1837–1926). Like Thomas Cole, Moran had been born in Bolton, Lancashire, and was

taken to America when his family emigrated to Philadelphia in 1844. It was in or near Philadelphia that he grew up and trained as an artist, and by the late 1850s he was exhibiting landscapes regularly at the Pennsylvania Academy and elsewhere. But he had a strong desire to travel, and in 1860 visited Lake Superior, where he gathered material that he was to incorporate into his *Hiawatha* pictures (nos.95–7). In 1871 his career took a decisive turn when he applied to join Ferdinand V. Hayden's expedition to Yellowstone, and travelled out west that summer.

He was not a member of the official team, but joined the party as an independent artist. Hayden took several specialist record-takers with him: a draughtsman, a topographer, and a photographer, William Henry Jackson (1843–1942), who was to prove himself a master of his medium; his pictures of the Yellowstone region are among the great works of early American photography. Moran seems to have wanted to justify his place with the party by adopting its scientific outlook and aims. He made a large number of drawings on the journey in which he studied geology and natural phenomena with an intense concern for accuracy. He worked these up into presentation drawings in watercolour and gouache on buff or grey paper. Their subjects are the rock formations of the mountains and the river gorges, the hot springs and geysers with their brilliant white calcareous terraces stained brown with iron or sulphur, their amethyst pools of clear water and their jets of steam.

Moran's method in these drawings, with its mixture of watercolour with white gouache on a toned paper, is strongly reminiscent of the techniques used by Ruskin in his studies of Alpine geology. Ruskin would indeed be an apt model for such work: he had laid down the principles the landscape artist should follow, and had himself produced a formidable corpus of drawings demonstrating his procedures. We know that Moran, like most of his colleagues, was acutely conscious of Ruskin. On his visit to England in 1862 he had made a point of studying the works of Turner, and no doubt looked at what examples of Ruskin's own drawings he could find, though these were not often exhibited, and were mostly known by the etched reproductions that appeared in his books. But he had probably visited the Loan Exhibition of British art which went to Philadelphia, New York and Boston in 1857–8, and seen Pre-Raphaelite drawings, including one by Ruskin himself, a *Fragment of the Alps* of about 1854–6,[109] which

combined watercolour and bodycolour and, interestingly enough, shows a limestone boulder stained reddish-brown by iron deposits.

Another artist who characteristically worked in these mixed media on buff paper is David Roberts (1796–1864), who was also represented as a watercolourist in the British Loan exhibition. Roberts is of particular significance for Moran since he was pre-eminently the painter of desert subjects.[110] He has not been cited as an influence since Moran stressed his admiration for Turner; indeed, he made many copies after Turner's drawings (significantly, they tended to be works in gouache) and produced one of the most sophisticated of all imitations of Turner's style as an oil painter (no.97), as well as an extraordinarily inventive paraphrase of Turner's *Ulysses Deriding Polyphemus* (see no.95). These are both works with subject matter taken from Henry Wadsworth Longfellow's *The Song of Hiawatha* (1855), and are conscious exercises in the creation of an indigenous American mythology. When Moran began to tackle the depiction of the Far West with its fantastic rock formations and vast deserts, it would have been natural for so intelligent an artist to turn to the doyen of desert painters. Roberts had begun his career as a theatrical scene-painter and had exhibited a panorama of Cairo in London in 1833.[111] By the middle of the century he was internationally famous for his views in *The Holy Land, Syria, Idumea, Arabia, Egypt & Nubia*, lithographed by the Belgian Louis Haghe (1806–1885) and published in 1842–9. These were reproductions of drawings executed in much the same watercolour and bodycolour medium on buff or grey paper that Ruskin and Moran favoured. They established a prototypical language for the rendering of desert subjects, using ochre washes over the mid-toned ground for the sandy landscape, and opaque white highlights for the reflection of a glaring but muffled sun (fig.15). This way of working is very different from Turner's, even when he employed gouache; the visual evidence suggests that Moran made a conscious decision to follow Roberts rather than his avowed hero, though he assuredly took hints from Ruskin's methods as well.

The importance of Roberts becomes fully apparent in Moran's paintings of the Far West. These followed quickly on the drawings. In February 1872, Moran unveiled his enormous view, measuring more than 2 by 3.5 metres, of the *Grand Canyon of the Yellowstone* (fig.16). When the picture was shown in

Boston, one newspaper, the *Transcript*, decided that it was 'a surprisingly beautiful work of art . . . which is Bierstadt repeated, but perfectly original.'[112] In its ambitious size and its Far Western subject it was indeed like Bierstadt, but in its approach and handling it could not have been more different. Moran's use of oil paint is close to that of Roberts, concerned not with painterly texture but with the clear presentation of the facts of the view – a statement that has all the authority of his drawings: thorough, precise, scientific. In practice, he modified the reality of the Yellowstone gorge to suit his pictorial requirements; the 'truth' of the place was both a precipitous chasm and a large waterfall, and in order to incorporate both these essential features into his view he moved the waterfall from the western to the eastern end of the Canyon.[113]

The vastness of the Canyon is emphasised by two small figures that Moran introduces on a ledge overlooking the gorge – a means of involving the spectator in the sublime view that had been in use since the seventeenth century. In a companion picture of two years later, painted after a journey

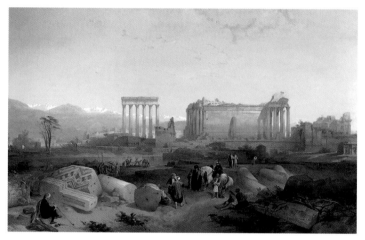

15 David Roberts, *Ruins of the Temple of the Sun at Baalbec*, 1842. Oil on canvas, 152 × 244 (59⅞ × 96). Private Collection on loan to Tate

with John Wesley Powell's expedition to the Grand Canyon of the Colorado in 1873, Moran showed *The Chasm of the Colorado* (fig.17), a work devoid of human life. In this wilderness of rock even the vegetation is minimal; rainstorms and sunlight play over the intricately varied surface of a natural structure that is manifestly the product of long successions of millennia. Such natural architecture could hardly have been comprehended before Sir Charles Lyell and Charles Darwin permitted the

thought that the earth was much more than four thousand years old, as had previously been believed. Powell himself wrote that he conceived the 'cañons of this region' as 'a Book of Revelations in the rock-leaved Bible of geology.'[114] Here is the ultimate celebration of the antiquity of America, and in borrowing the techniques and palette of David Roberts, Moran suggested a parallel with the Middle East that Roberts was famous for depicting: God resides in the rocks and the desert, and these cliffs and pinnacles are the walls and spires of His temples, a New World equivalent of the holy places of Palestine and the monuments of Egypt. The picture that Moran sent to the Royal Academy in London in 1879 was an example of the search for a Christian symbolism in the new lands of Western America: *Mountain of the Holy Cross* (1875)[115] showed a natural cross of snow in crevasses on the side of a mountain peak, a phenomenon regarded by some at the time as of divine origin, and as an implicit blessing on westward expansion in general. It is perhaps no coincidence that when Church finally visited the Old World in 1867–9, he was most excited by the Middle

East and its ancient monuments, and painted many desert subjects.[116]

Roberts was fond of showing ancient buildings caught in the red glow of sunset, for instance in *Remains of the Roman Forum* (fig.18), and Moran borrowed the idea in some of his desert subjects. A favourite scene, the first he sketched in the West, showing the buttes of Green River, Wyoming, recurs in several versions, some of which show the tops of the buttes bathed in hot red light (see no.98). Moran's skies are often of a type which Roberts frequently introduced as a foil to the dun colours of the desert: a piercing blue flecked with white clouds. The figures in these later Western pictures, too, are strikingly reminiscent of Roberts, clustered in animated groups and drawn with a spiky clarity that creates its own dynamism.

But Moran had not forgotten Turner, and in many of his later views of the desert, especially of the Grand Canyon of the Colorado, he used brilliant colours – scarlet, purple, mauve – that recall Turner's intense little gouaches which Moran had copied on his visits to London.[117] Moran died aged

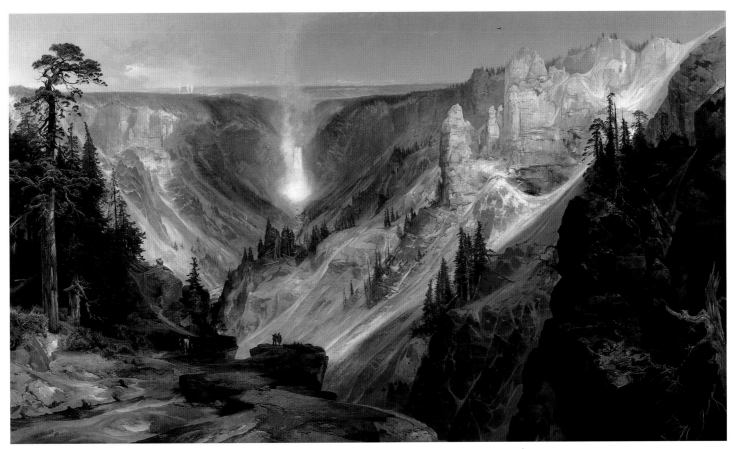

16 Thomas Moran, *Grand Canyon of the Yellowstone*, 1872. Oil on canvas, mounted on aluminium, 213.4 × 365.8 (84 × 144). Lent by the Department of the Interior Museum. Smithsonian American Art Museum, Washington DC

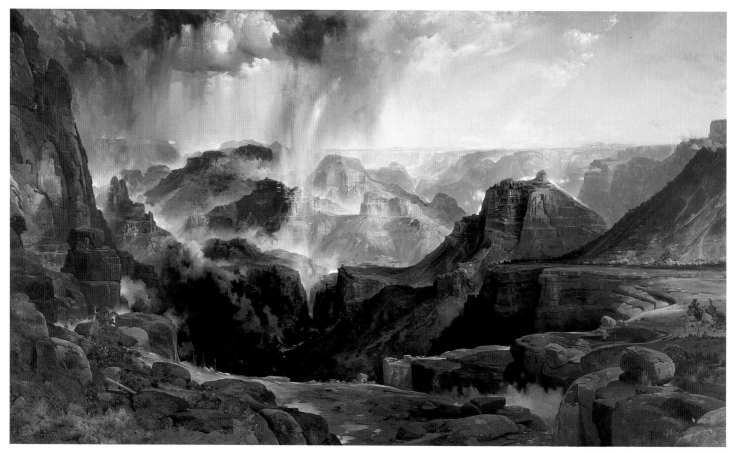

17 Thomas Moran, *The Chasm of the Colorado*, 1873–4. Oil on canvas, mounted on aluminium, 214.3 × 367.6 (84¾ × 144¾). Lent by the US Department of the Interior, Office of the Secretary. Smithsonian American Art Museum, Washington DC

eighty-nine in Santa Barbara, California, having lived long into the twentieth century. He had brought a new scientific spirit to the epic landscape tradition of Cole, Church and Bierstadt, and despite the measurable decline in the standing of those artists from the last two decades of the nineteenth century on, he had maintained an unenfeebled output and continued to attract buyers. His concern for the West, indeed, was a vivifying thread that fortified the old notions of the Sublime in the perception of new scenery, new conditions of light and climate.

The artists we have been examining had their heirs on the seaboard of California, painters of Yosemite and the Sierra Nevada, and the river valleys of the Pacific coast. Some of them, like Thomas Hill (1829–1908), who moved to San Francisco in 1861, and William Keith (1838–1911), who went there in 1859, worked in the grandiose tradition of Bierstadt, painting sometimes very large views of spectacular places.[118] But although they clearly learned much from Bierstadt and Moran, their work reflects the broader tendencies of American

art in the last decades of the century. There is a new consciousness of recent developments in France: their drawing is more generalised, their brushwork is broader, and their palette is blonder, often tending to an Impressionist chalkiness. Their work signals the inauguration of an independent 'West Coast' school, which grew and flourished as part of a new and very different phase in the history of American painting.

The masters of American landscape surveyed here – and numbers of their colleagues for whom there has been no space – were for many decades forgotten and derided. Their works were disposed of by the museums that had formerly collected them with avidity. They were by no means all showmen; some were quiet, retiring men who pursued their art with undemonstrative passion. But all were responding to the stimulus of a new world as it unfolded before them: a landscape that was changing even as they discovered it. The freshness of their vision, the intensity of their invention, the practical energy of their execution, were all born of the urgency they sensed in the life of America. They had to forge

a school of landscape painting in a single generation; in another it had reached maturity and begun to decline. Church died in 1900, and at a memorial exhibition of his life's work held at the Metropolitan Museum in New York, there was already a sense that a long-forgotten way of seeing was being disinterred. When John Ford made his films in the deserts of the Far West in the 1930s, and when the New York School of Abstract Expressionists came into being in the 1940s, the huge landscapes of Church and Bierstadt and Moran, to say nothing

of the less sensational pictures of Lane, Heade or Kensett, were hardly in anyone's mind. Yet in the last half-century they have steadily returned to the public consciousness, and can be seen to take their place as pioneers in a long history of the Sublime in America. We hope that this exhibition will help them to claim an equally honourable place as the culminating achievement of the tradition of landscape painting that had evolved in Europe from the seventeenth century to the Romantic period.

18 David Roberts, *Remains of the Roman Forum*, 1861. Oil on canvas, 59.7 × 120.7 (23 ½ × 47 ½). Collection of the Birmingham Museum of Art; Museum Purchase with donations from the Vann Foundation in memory of Mr and Mrs James Allen Vann, 1984.73

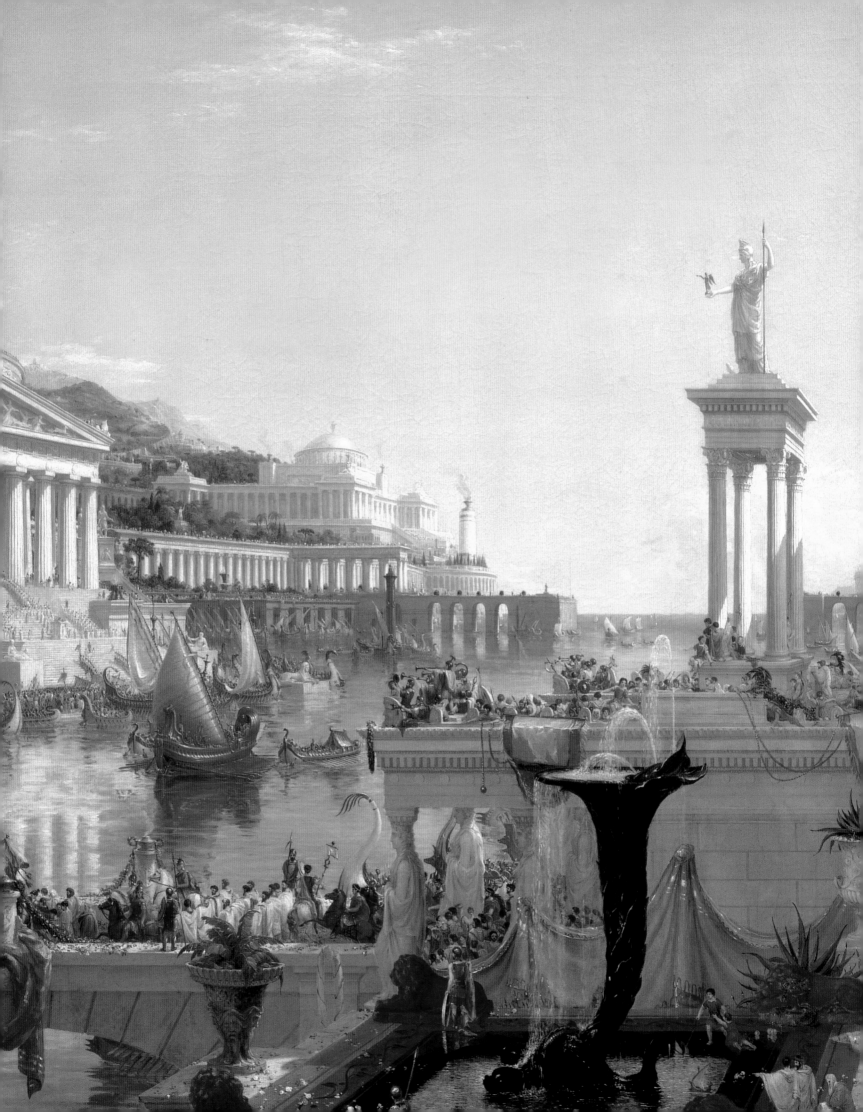

TIM BARRINGER

The Course of Empires
Landscape and Identity in America and Britain, 1820–1880

'The thoroughly American branch of painting, based upon the facts and tastes of the country and people, is . . . landscape.'[1] Few would have disagreed with these words of James Jackson Jarves when his book *The Art-Idea* appeared in 1864. The 'facts of the country' were spectacular indeed: in the century after the Declaration of American Independence in 1776, the thirteen states reaching inland from the eastern coastline expanded to the magnitude of a continental empire, comprising vast areas of landscape scenery whose grandeur and diversity were incomparable. As early as 1816 De Witt Clinton, soon to be Governor of the State of New York, had declared:

> Can there be a country in the world better calculated than ours to exalt the imagination – to call into activity the creative powers of the mind, and to afford just views of the beautiful, the wonderful and the sublime. Here, nature has conducted her operations on a magnificent scale . . . This wild romantic and awful scenery is calculated to produce a corresponding impression on the imagination.[2]

Images of the landscape and ideas of the nation were deeply intertwined. Accordingly, landscape painting assumed an important role in shaping and articulating American identity in the mid-nineteenth century. Yet such a project was fraught with complexities. The United States in the decades before the Civil War of 1861–5 was a nation beset by deep inner tensions. Most profound was that between the abolitionist North and the South where slavery persisted; but a gulf also separated those such as Andrew Jackson, President from 1829 to 1837, who encouraged territorial expansion and the growth of the new industrial cities, from those who still envisaged the United States as the peaceful republic of self-contained rural communities proposed by Thomas Jefferson and the nation's founding fathers.

Against the competing claims of the urban and the rural, of expansion and consolidation, of cultivation and wilderness, landscape painting emerged as the pre-eminent art form of mid-nineteenth-century America.

The American landscape offered different prospects from those of the European nations, where historical tradition, ethnicity, and familial roots in a local geography all remained important. Archetypal American scenery can be seen in *Kindred Spirits* of 1849 (no.1), Asher Brown Durand's posthumous tribute to Thomas Cole, the leading American landscape painter of his generation. Durand's painting portrays Cole on a rocky ledge with his friend, the nature poet William Cullen Bryant, surveying a glorious prospect. In this elemental landscape, untouched by the hand of man, waterfalls and cliffs mediate between the lush, unkempt vegetation of the forest floor and the rocky barrenness of the distant mountain peaks. As Cole had argued in his *Essay on American Scenery* of 1835, 'the primitive features of scenery' remain as yet untouched by human endeavour: they are the 'undefiled works' of 'God the creator'.[3] A comparison of *Kindred Spirits* with an unmistakably English landscape, such as John Constable's *The Cornfield* (fig.19), is instructive. Durand must have known Constable's painting, and perhaps adapted from it the unusual upright format of *Kindred Spirits*.[4] Both works adhere to the traditions of the Picturesque, yet each enshrines a distinctive national myth, rooted in the local landscape. Neither reflects a specific topography with precision. Constable manipulates elements from sketches made in East Bergholt, Suffolk, to produce *The Cornfield*, while Durand combines various features of the Catskill Mountains, in the state of New York, to form an epitome of the American landscape.[5] Where Durand emphasises the untouched nature of the wilderness, Constable presents cultivation and tradition: surrounding the ancient byways of

19 John Constable, *The Cornfield*, 1826. Oil on canvas, 142.9 × 121.9 (56¼ × 48). National Gallery, London. NG 130

is dramatised in Thomas Cole's *View from Mount Holyoke, Northampton, Massachusetts, after a Thunderstorm (The Oxbow)* (fig.20). The left of the composition preserves the storm-shattered landscape of the untouched wilderness, the pure creation of God; on the right, around the nurturing bend of the Connecticut River, is cultivated farmland, an idyll of agrarian plenty and social harmony. The tide of history is, it seems, moving inexorably from right to left, from East to West: the forest is destined to be swept away and the land brought under mankind's rational control. The sublime will yield to the beautiful, chaos to order. Cole, however, held ambivalent views about the onward march of progress, and portrays himself, a tiny figure in a tall hat, perched amid the boulders, an observer of historical process, but a lover of the wilderness. 'There are those', Cole wrote with sympathy,

> who regret that with the improvements of cultivation the sublimity of the wilderness should pass away; for those scenes of solitude from which the hand of nature has never been lifted, affect the mind with a more deep toned emotion than aught which the hand of man has touched.[6]

The Oxbow reveals the paradoxes underlying nineteenth-century American landscape painting, which celebrated the beauty of the wilderness at the moment of its historical transformation.

Old World and New

While a distinctly American culture was formed long before the United States declared independence in 1776, for the next century Britain nonetheless provided a crucial point of reference for developments in the young republic. The historical links and parallels between the two nations are clear. Although the political history of the United States in the nineteenth century took a very different course from that of Britain, the fundamental social and economic transitions from country to city, from agriculture to industry, and from the world of the yeoman and artisan to that of the capitalist and labourer (in factory or field), followed a broadly similar pattern. Moreover, America and Britain can both be recognised as imperial nations, though of a different type. Fuelled by population growth, industrial profits and a collective sense of historical destiny, the United States expanded massively to the west, annexing vast tracts of land to occupy the full width

East Anglia is a landscape almost entirely shaped by man, from gateposts and fences to crops and ancient field systems. Although rural life was changing rapidly in the 1820s, the distant parish church with its squat medieval tower implies the persistence of an immutable social and theological order in Constable's England. In Durand's landscape, the sense of spiritual revelation derives directly from the abundance of God's creation, with no place for squire and parson. Constable constructs a mythical landscape of safe familiarity, tradition and association. Durand's prospect – equally mythical – offers the awesome spectacle of untamed creation.

The very presence of Cole and Bryant (their names carved in the bark of the nearest tree) makes clear that the wilderness was no longer completely untouched. On the contrary, the historical development of the United States took the form of a confrontation between mankind and the environment, an epic of transformation. Inevitably, the interaction – sometimes violent collision – of nature and culture is the major preoccupation of American landscape painting. The meeting of American civilisation with the wilderness

of the continent. Nation and empire were territorially indistinguishable. Britain's nineteenth-century territorial expansion, similarly propelled by the demands of a metropolitan economy, expanding population and imperial ideology, took place overseas, in India, Australasia, Africa and the Middle East. These new acquisitions joined the remaining elements of the 'First British Empire', in Canada and the Caribbean, to form a vast, disparate conglomeration. In landscape paintings of the period, American and British, powerful imaginative responses to the parallel growth of urbanisation and of empire can be found, presenting for a metropolitan public elegiac images of a threatened rural world alongside heroic emblems of conquered terrain.

For decades after independence American culture remained strongly Anglocentric, and many of the patterns of cultural exchange established during the colonial era persisted at least until the Civil War years. For American artists and writers, London continued to be a dominant cultural centre, challenged only by Paris and Rome, while Düsseldorf emerged as a major competing venue for artistic education.[7] It was a natural move for the most talented American artists, following Benjamin West and John Singleton Copley in the eighteenth century, to visit and to exhibit in London, where patronage was more easily obtained. American tastes in literature and in the fine and decorative arts, though proudly distinctive, closely paralleled genteel taste in Britain, tempered perhaps by a residual sympathy for the aesthetics (and politics) of revolutionary France. Nowhere was this more true than in the move from a preference for portraiture and, to a lesser extent, history painting in the eighteenth century to a burgeoning taste for landscape during the nineteenth.

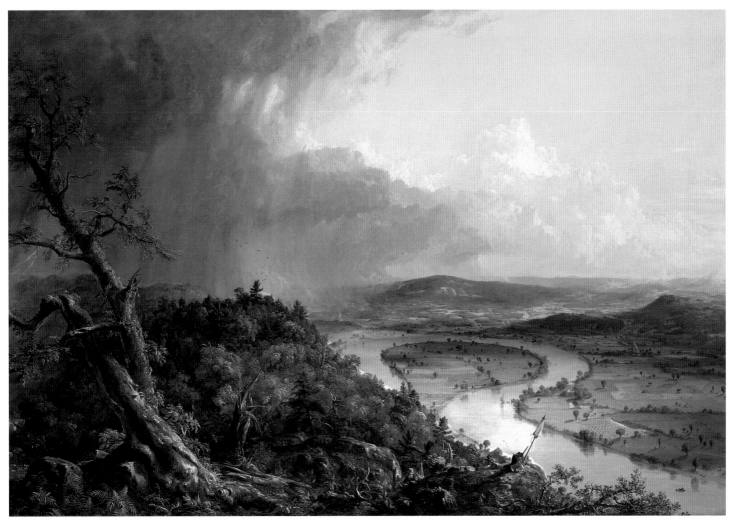

20 Thomas Cole, *View from Mount Holyoke, Northampton, Massachusetts, after a Thunderstorm (The Oxbow)*, 1836. Oil on canvas, 130.8 × 193 (51½ × 76). Metropolitan Museum of Art, Washington. Gift of Mrs Russell Sage, 1908 (08.228)

The rise of landscape painting in both Britain and America was propelled by similar cultural and economic forces. In both cases, a taste for the beauty of landscape emerged from the culture of a modern metropolis at a time of profound social and economic transformation. The parallels are worth exploring. The British case might be outlined thus: in the hands of painters, from Gainsborough to Constable and Turner, landscape painting developed as a major cultural form at the time of the so-called industrial revolution, from about 1780 to the 1850s.[8] The rapid growth of the manufacturing cities of the North, though ultimately resulting in increased prosperity, was accompanied by a range of social and economic problems; indeed, the parents of the two Lancashire-born artists represented in this exhibition, Thomas Cole and Thomas Moran, emigrated with their families to the United States to escape the unsettling consequences of British industrialisation.[9] Amid this changing environment, London, the commercial and trading hub of an empire and the world's largest city, provided a nexus for the exhibition and sale of works celebrating the beauties of rural Britain.[10] Patronage came from a newly influential urban middle class, whose wealth derived from industry, finance and the professions. Restricted from travelling abroad by the wars with France, this new elite foreswore the traditional European Grand Tour of the aristocracy and gentry in favour of travel within Britain. Patterns of tourism were inseparable from new modes of landscape painting, which found subject matter in the Lake District, the Wye Valley and the Scottish Highlands. Artists such as Turner and Thomas Girtin demonstrated that 'picturesque views' of British scenery could rival the Italian subjects favoured by earlier landscape painters such as Richard Wilson. By 1851, the year of Turner's death, more than half the population of England and Wales lived in urban areas, and landscape painting had long replaced aristocratic portraiture as the archetypal British art-form.

American culture followed a broadly similar pattern, with urbanisation and the development of a modern metropolis – New York City – stimulating the growth of new forms of patronage and a distinctive taste for landscape. The wilderness of New York State and New England, like the areas celebrated in William Gilpin's picturesque tours of Great Britain, became the cherished subject of a generation of innovative landscape painters, as well as the haunt of middle-class tourists. The economic transformation of the United States began slightly later than that of Britain, gathering pace, in exact parallel with a growth in the taste for landscape, only in the second decade of the nineteenth century. America's emergence as an economic power was delayed by the War of Independence (1775–83) and the War of 1812, both hard-fought conflicts with the British Empire. Furthermore, the United States in 1800 had a small population (about 5.3 million people) in relation to the vast size of the country (1.8 million square miles),[11] and a large proportion of them were involved in agriculture. America's natural resources, however, vastly outweighed those of Britain, and immigration rapidly increased the population, urban and rural. The years between 1820 and 1850 saw an economic transformation of the northern states, described by a recent historian as a 'market revolution', in which the localised rural economy of the colonial period was superseded by a national financial, commercial and manufacturing infrastructure.[12] By the time of the Great Exhibition of the Works of Industry of All Nations at the Crystal Palace in London in 1851, when a representative selection of the products of American industry was assembled, British opinion noted with some surprise that the United States had become a formidable industrial nation with a remarkable flare for innovation (exemplified by Cyrus Hall McCormick's mechanical reaping machine, the first of its kind).[13] In an unusually pithy phrase, Karl Marx noted: 'The English admit that the Americans carried off the prize in everything' at the Exhibition.[14] Two years later New York built its own Crystal Palace, freely adapted from Joseph Paxton's London design, in which the cornucopia of American industrial production, and the range of raw materials which could be extracted from the vast nation, were proudly celebrated.[15]

Pure landscape painting, and picturesque tourism on the English model, both took some time to establish themselves in America. Although a handful of artist-explorers and military draughtsmen had painted landscapes in America during the eighteenth century,[16] and itinerant European artists had made regular pilgrimages to well-known spots such as Niagara Falls, it was not until about 1820 that the aesthetic qualities of the American landscape came to be widely appreciated and to be represented by artists.[17] The English landscape painter Joshua Shaw (1776–1860), schooled in London and Bath in the conventions of the topographical view, arrived in 1817 at Philadelphia, the largest and culturally pre-eminent city of the first years of the Republic. He bore a recommendation from the native Pennsylvanian, Benjamin West, now President of the Royal Academy of Arts in London.[18] In 1819, Shaw began to publish

a set of aquatints entitled *Picturesque Views of American Scenery*.[19] 'Our country,' declared Shaw, asserting his newfound American identity, 'abounds with Scenery, comprehending all the varieties of the sublime, the beautiful, and the picturesque in nature.' Shaw's introductory letterpress amounts to a manifesto for the project of American landscape painting:

> In no quarter of the globe are the majesty and loveliness of nature more strikingly conspicuous than in America. The vast regions which are comprised in or subjected to the Republic present to the eye every variety of the beautiful and the sublime. Our lofty mountains and almost boundless prairies, our broad and magnificent rivers, the unexampled magnitude of our cataracts, the wild grandeur of our western forests, and the rich and variegated tints of our autumnal landscapes, are unsurpassed by any of the boasted scenery of other countries.[20]

The aquatints, expertly made after Shaw's watercolours by another recent immigrant from England, John Hill (1770–1850), demonstrate Shaw's application of the conventions of English Romantic landscape painting to American scenery. His *View near the Falls of the Schuylkill* (fig.21), the river which flows into the Delaware at Philadelphia, offers an early and dramatic rendering of the American sublime: following the picturesque figure of a traveller with his pack-horse, the eye moves swiftly from a darkened foreground over a dangerous precipice, with the waterfall seen beyond, before reaching redemption in the form of a tranquil wooded vista.[21] Such dramatic scenery was admired by Gilpin and his followers in Britain, but Shaw points up the contrast between his virgin American subjects and the over-worked scenery of Europe:

> Striking however and original as the features of nature undoubtedly are in the United States, they have rarely been made the subjects of pictorial delineation. Europe abounds with picturesque views of its scenery. From the mountains of Switzerland to the tame level of the English landscape, every spot that is at all capable of exciting interest is familiar to the admirers of nature, while America only, of all the countries of civilized man, is unsung and undescribed.[22]

These sentiments, much repeated and rephrased, were to remain the keynote of American landscape painting until after the Civil War. Yet despite Shaw's confident assertions, his portfolio of prints

21 John Hill after Joshua Shaw, *View near the Falls of the Schuylkill* from *Picturesque Views of American Scenery,* 1820–5. Engraving and aquatint, published by M. Carey & Son, Philadelphia 1829, plate 5, 24.7 × 36.8 (9¾ × 14½). Print Collection, Miriam and Ira D. Wallach Division of Art, Prints and Photographs, The New York Public Library, Astor, Lenox and Tilden Foundations (DEAK 314)

appears to have been a financial failure, suggesting that the taste for landscape was not yet fully established.[23]

Among the earliest American patrons to take an interest in landscape painting were the members of the traditional, landed elite of New York State and New England, many of whom were descended from influential colonial families, Dutch as well as English, and tended to perpetuate the tastes of the period before 1776.[24] Thomas Cole's first patrons were among these 'Knickerbocker' grandees. Emphasising a traditional culture of deference, landowners like Stephen van Rensselaer III (1764–1839), known as 'the Patroon', wielded great influence in New York City as well as the rural areas 'upstate'.[25] Daniel Wadsworth (1771–1848), a member of this wealthy elite, commissioned from Cole a view of his country seat, Monte Video (fig.22), a broad prospect

22 Thomas Cole, *View of Monte Video, the Seat of Daniel Wadsworth, Esq.*, 1828. Oil on panel, 50.2 × 66.2 (19¾ × 26⅙). Wadsworth Atheneum, Hartford, Connecticut. Bequest of Daniel Wadsworth (1848.14)

reminiscent of English country-house portraits.[26] A blasted oak at the left – too untidy a feature for the English landscape garden – is a lone symbol of the American wilderness. A considerable philanthropist, Wadsworth bequeathed the work to the art museum which bears his name in Hartford, Connecticut, the oldest in America.[27] Patrician taste, however, allotted only a marginal role to landscape painting. Dissatisfied with these restrictions, Cole harboured great ambitions for the genre in America. Such an enterprise was to find ready support in the vibrant culture of New York City.

The Empire City and the Aesthetics of Landscape

Landscape painting emerged as a significant force in American culture after 1825 amid the anarchic commercial and industrial growth of New York City, the archetypal modern metropolis. A complex relationship between this city and the surrounding countryside, the epitome of progress and the timeless wilderness, lies at the very core of American landscape aesthetics. New York was described in 1851 by an English visitor, Lady Emmeline Stuart-Wortley, as 'the Empress City of the West':[28] for another, Frances Trollope, New York seemed in 1832 to rise 'like Venice, from the sea' and to receive 'into its lap the tribute of all the

riches of the earth'. 'I doubt,' she added, 'if even the pencil of Turner could do it justice, bright and glorious as it rose upon us.'[29] The increasing importance of New York as an economic and trading centre earned it the nickname 'The Empire City', derived from its position as the major population centre of the state of New York – 'The Empire State' – which stretches for hundreds of miles north and west, to the shores of Lake Ontario. A *Panorama of New York from the Steeple of St Paul's Church* (fig.23) by John William Hill (1812–1879), son of the engraver John Hill, gives an impression of the thriving commercial culture of the city in the mid-nineteenth century, its streets of brick and 'brownstone' houses tightly packed into the southern tip of the island of Manhattan.[30] Alongside a wide range of trades and industries, the city boasted the infrastructure for dealings in commodities and in stocks and shares that allowed commerce to flourish almost without restriction. Economic growth was exuberant though uneven, and huge profits were made and lost. Alongside glittering wealth was terrible poverty. New York's Five Points slum district was notorious: Charles Dickens described his visit (accompanied by two policemen) in his *American Notes* of 1842, among the 'hideous tenements which take their name from robbery and murder; all that is loathsome, drooping and decayed is here'.[31] The founding fathers' ideal of the virtuous republic of mutually dependent individual citizens working the land disappeared amid a maelstrom of speculation. Consumerism was rampant: among the myriad of tiny details in Hill's panoramic view of the city described as 'the greatest commercial emporium in the world'[32] are signs for shops selling furniture and glass, shoes, pianofortes, and men's and women's clothes.[33] Nineteenth-century New York presented the unmistakable spectacle of modernity.

New York's lively visual culture encompassed both high and low art-forms, and there was much interaction between the two. Phineas T. Barnum's museum of curiosities, and Matthew Brady's (1823–1896) 'Daguerreian Miniature Gallery' (an early photographic studio which opened in 1844) are both visible in Hill's print; spectacular visual forms such as the panorama also proliferated.[34] The neo-classical painter John Vanderlyn (1775–1852), having trained in Paris, opened a rotunda in New York in 1818, where he displayed his own elegant *Panorama: Palace and Gardens of Versailles* (1818–19),[35] but also more popular works such as an anonymous *View of Hell* (1819) and *The Battle of Waterloo* by the English painter Henry Aston Barker (1774–1856), exhibited in 1820 and again in 1825.[36]

23 Henry Papprill after John William Hill, *Panorama of New York from the Steeple of St Paul's Church, Looking East, South and West, c.1848*. Aquatint printed in colours with hand colouring, second state, 54 × 92.4 (21¼ × 36⅜). Metropolitan Museum of Art, New York. The Edward W.C. Arnold Collection of New York Prints, Maps and Pictures. Bequest of Edward W.C. Arnold, 1954 (54.90.587)

Competing for the attention of the public were dioramas, large canvases painted with opaque and transparent pigments on both sides and displayed with changing light effects from in front and behind. Apocalyptic imagery was especially popular. The English painter John Martin's *Belshazzar's Feast*[37] was plagiarised in a diorama exhibited at Niblo's Garden on Broadway in 1835.[38] Martin's paintings themselves regularly appeared in New York; his vast, valedictory *Last Judgement* triptych (*c.*1851–3) appeared to acclaim at Williams' Gallery on Broadway in 1856.[39] Such British paintings of the apocalyptic sublime had first been introduced to New York audiences, however, when Francis Danby's *The Opening of the Sixth Seal* was shown at the self-consciously elitist American Academy of the Fine Arts in 1833.[40] More than in Europe, audiences for elite and popular cultural forms overlapped, and individual objects took on a hybrid character, blending elements of high and low traditions.[41] In Joseph Kyle (1809–1863) and Jacob Dallas's (1825–1857) 850-foot long 'moving panorama' of

Pilgrim's Progress (1850–1)[42] is found a crude, large-scale version of a composition by the landscape painter and architect Jasper Francis Cropsey (fig.24).[43] The appetite of New Yorkers for huge canvases depicting exotic locations and scenes of catastrophe, as well as for optical innovations of all kinds, also influenced the work in the present exhibition by Cole (no. 14), Frederic Edwin Church (no.86), Albert Bierstadt (no.91) and Thomas Moran (no.99). Even artists who generally worked on a more modest scale, such as Sanford Robinson Gifford (no.31), Martin Johnson Heade (no.82) and John Frederick Kensett (no.77), adopted the wide, low canvases and sweeping perspectives of the popular medium. Furthermore, the major works of Church, such as *The Icebergs* (no.88), and Bierstadt, such as *Storm in the Rocky Mountains – Mt Rosalie* (no.91), were exhibited not at conventional art exhibitions but in private galleries as 'Great Pictures', often with special frames and lighting effects, creating a fee-paying spectacle reminiscent of panoramas and dioramas.

24 Joseph Kyle and Jacob Dallas, design attributed to Jasper Francis Cropsey, *Land Of Beulah; Scene from Pilgrim's Progress*, 1850–1. Distemper on cotton muslin, panorama, 244 × 15240 (96 × 6000). Collection of the Saco Museum of the Dyer Library Association, Saco, Maine

In addition to this lively popular culture, New York established itself as the centre of the American art world. With the exception of works by Fitz Hugh Lane (who lived in Gloucester, Massachusetts, and gained only a local reputation during his lifetime), almost every painting in the current exhibition was either made, exhibited, or sold in New York. The city's boisterous financial condition after 1825 produced a new class of patrons passionately interested in the landscape.[44] Disappointed by the condescension of his patrician supporters, Cole was lucky enough to find in Luman Reed (1748–1836) a patron willing to commission in 1835 the grandiose five-painting series, *The Course of Empire* (nos.11–15). Reed, a millionaire who had made his fortune in the grocery business and retired at the age of forty-eight, had little formal education but became a noted collector, filling his house at 13 Greenwich Street with the work of contemporary artists. Reed and his one-time business partner, Jonathan Sturges (1802–1874), who commissioned Durand's *Kindred Spirits* (no.1), epitomise the self-made New York collector of the mid-nineteenth century.

The growth of New York's economy also supported the development of artistic societies, auction rooms and the art trade; following the pattern established in Britain at the time of the founding of the Royal Academy of Arts in 1768, personal and deferential relationships of artist to patron became less significant as the mechanisms of the art world became more complex. The first significant artistic institution in New York, the American Academy of the Fine Arts, founded in 1802, was the creation of an elite, quasi-aristocratic group of collectors and patrons, and was akin to the British Institution in London.[45] Promoting the values of an 'old master' style, it held regular exhibitions and offered modest patronage to a number of artists. More significant was the National Academy of Design, founded by a group of painters led by Samuel F.B. Morse (1791–1872) and Asher Durand in 1825. Its aims, closely modelled on those of the Royal Academy, were ambitious. Run by artists 'for the purpose of mutual improvement and the instruction of their pupils',[46] the Academy mounted annual exhibitions at which works were sold, and held classes and lectures. Although its main rival, the Pennsylvania Academy of the Fine Arts in Philadelphia, more actively promoted history painting, landscape painting dominated the National Academy's exhibitions.[47] Most of the artists in the present exhibition were members, and Durand served as the Academy's president from 1846 to 1861.[48] A significant innovation, also following a pattern established in Britain, was the American Art-Union, founded in 1840,[49] which aimed to promote American art and to 'influence the character and manners of the whole nation'[50] by means of an art lottery. For a membership fee of five dollars, patrons were promised a fine engraving, and the chance of winning a painting from the Art-Union's exhibition. A newsletter reported the latest developments on the international art scene, with a notably Anglophile bent: articles appeared on J.M.W. Turner, Sir David Wilkie (1785–1841) and the Pre-Raphaelites, and excerpts from Ruskin's *Stones of Venice* (1851–3). Supported by 'energetic merchants'[51] from the New York business community, the Art-Union actively favoured works 'illustrative of American scenery and American manners',[52] and often selected as prizes landscape paintings, including Frederic Edwin Church's *Twilight, 'Short Arbiter 'Twixt Day and Night'* (no.22).[53] Attempts to found an art museum in New York were thwarted, mainly because of the instability and factionalism of the patron class. Looking enviously at Britain's National Gallery, Jonathan Sturges asked in 1844: 'may we not hope that the friends of the Fine Arts here will do as the friends of the Fine Arts have done in London?'[54] The Metropolitan Museum of Art, however, was founded only in 1870, under the patronage of a newly coherent group of financiers and manufacturers who had profited from the Civil War.

New York's lively literary and artistic culture was particularly

congenial for landscape painters. Washington Irving's famous tale 'Rip Van Winkle' (1819)[55] is set in the Catskill Mountains, and though Irving lived in Europe from 1815 until 1832, his works influenced a younger generation in New York. In 1822, a group of artists and writers connected with the novelist James Fenimore Cooper formed the Bread and Cheese Club, a literary salon based on a shared love of American landscape. Cooper's works, such as *The Last of the Mohicans* (1826) are set in the Lake George region of upstate New York (see no.26), and created a vogue for this wild northern landscape. The Bread and Cheese Club folded up when Cooper left for Europe in 1826, but was soon replaced by the Sketch Club, of which Thomas Cole later became a member. The Club took its name from the practice of sketching subjects from literature at each meeting: on 4 February 1830, for example, artist members sketched on a topic from Byron, while their literary brethren were asked to write an essay 'on the Sublime'.[56] William Cullen Bryant – seen with Cole in Durand's *Kindred Spirits* – established himself as a journalist, while publishing volumes of distinctively American nature poetry in the Wordsworthian tradition, which became extremely popular. Among other gentleman's clubs and societies, the Century Club, 'composed of authors, artists and amateurs of letters and the fine arts'[57] of which John Frederick Kensett was a leading member, provided both collegiality and patronage for landscape painters.[58] In 1857, a number of artists – many of them painters of the American landscape – moved into the handsome Tenth Street Studio Building, which soon became a focus for painterly camaraderie, while also allowing patrons and critics to visit the workplaces of Church, Bierstadt, Heade and others to view works in progress at organised receptions.[59]

While the New York art world developed along similar lines to that of London, there were fundamental geographical differences between the two nations which affected the development of landscape painting. Nineteenth-century London was surrounded by the verdant agricultural landscapes of the Home Counties, which became the favoured subjects of Victorian landscape painters.[60] The landscapes of the Thames Valley, peaceful and resonant with historical associations, came to epitomise the nation. As the forest of masts visible in Hill's panorama attests, New York, a seaport, lay at the mouth of a great navigable river, the Hudson, which, like the countryside around it, became an important national emblem. The economic importance of the Hudson was greatly enhanced by the opening on 25 October 1825

of the Erie Canal, which linked the river with Lake Erie at the city of Buffalo, a 363-mile journey. This ensured that New York became the nation's pre-eminent port, providing a nexus between the mid-West, the Northeast and the rest of the world. Forming a vast commercial artery, the Hudson and the Erie Canal allowed for the transportation of iron, timber, stone and crops to the metropolitan centres of the East Coast, and made possible the great westward movement of population. The spectacular journey from New York City up the Hudson River, as witnessed from on board ship, like a moving panorama, is closer to the Rhine than the Thames in feeling. In the mid-nineteenth century, this journey raised fundamental questions about the identity of the young American nation. It offered the spectacle of 'progress' – economic development was rapid in towns like Albany – but steamboat passengers could also glimpse the glorious natural prospects of the Hudson Highlands and areas of wilderness such as the Catskill Mountains. By 1824 there were several steamers a day to Albany, a twelve-hour journey, ensuring a burgeoning tourist trade.[61] Both the industrial and the picturesque are celebrated in the series of almost two dozen coloured engravings which make up William Guy Wall's *Hudson River Portfolio*, published between 1821 and 1825. Wall (1792–1864) had emigrated from Ireland in 1818, and in 1820 had toured the Hudson, producing a series of picturesque watercolours which, when published as aquatints by John Hill, established a visual lexicon of Hudson River scenery. The *View near Hudson* of 1820 (fig.25) presents a

25 John Hill after William Guy Wall, *View near Hudson* from *Hudson River Portfolio*, 1820. New York, Henry McGarrey, 1821–5. Coloured aquatint (second state), 36.8 × 54.3 (14½ × 21⅜). Spencer Collection, The New York Public Library, Astor, Lenox and Tilden Foundations (DEAK 320)

beguiling combination of nature and culture. Carefully framed with repoussoir trees, the composition leads the eye gently down a fenced road towards the broad river dotted with pleasure craft, and then broadens to indicate the mass of the Catskill Mountains beyond. In the middle distance, well-tended fields give way to vast tracts of virgin woodland. The image presents an illusory balance between mankind and nature by ignoring the wholesale transformations which the region was undergoing. Thomas Cole planned to emulate the *Hudson River Portfolio* with a series of 'Views of the Hudson River' to be engraved and published in London, with letterpress by Washington Irving.[62] This potentially important project came to nothing, however, and after 1825 oil painting became the dominant medium for landscape imagery.

The Hudson River Valley, and especially the surrounding mountains and lakes, emerged in the art of Cole, Durand, Cropsey, Gifford and Church as perhaps the most resonant of all national scenery of the period. An entire generation of painters, based in New York City, came retrospectively to be known as the 'Hudson River School' through their enthusiasm for the apparently virgin wilderness of the upland regions of New York State traversed by the River.[63] The artistic exploration of the area bordered by the Hudson was both a cause and a symptom of a boom in tourism from the mid-1820s. The Catskills, especially, became a favourite resort; the Catskill Mountain House Hotel, founded as a dormitory in 1822 but greatly extended in 1824–5, became a centre for fashionable leisure and a base from which artists – who complained of the prices – could explore the mountains.[64] Following Cole's lead, Cropsey (no.8) and Gifford (no.20) painted the hotel itself, which occupied a ledge on an escarpment, commanding magnificent views of the countryside. Particularly admired was the sunrise, which could be enjoyed from the front bedrooms. Many favourite subjects derived from the immediate environs of the Mountain House, notably Catskill (or Kaaterskill) Clove and the Kaaterskill Falls, both seen in *Kindred Spirits* (no.1) and the former also in Gifford's *Autumn in the Catskills* (no.19). Though many artists rented makeshift studios in rural areas, Thomas Cole was the first to abandon New York altogether, moving in 1836 to the township of Catskill by the Hudson River. Like John Linnell, James Clarke Hook and Thomas Sidney Cooper, British artists who established country residences within easy reach of London, Bierstadt erected 'Malkasten' in 1865–6, an impressive pile also commanding

Hudson views.[65] Church purchased a hillside estate near the township of Hudson in 1860, and between 1871 and 1876 perfected 'Olana', his exotic home and studio in a Persian style, from whose windows unfolds a breathtaking panorama of the Hudson River Valley (fig.26; see nos.50 and 53).[66] Not to be outdone by his rivals, in 1867 Cropsey built 'Aladdin', also overlooking the Hudson, at Warwick, New York, but was forced to move in 1885 to the smaller 'Ever Rest' at Hastings-on-Hudson. Communications with New York were good enough by the mid-nineteenth century to enable artists to live in the countryside and maintain close contacts with the metropolitan art market.

The Lure of the Wilderness

Thomas Cole's lecture on American landscape painting, given in 1835, identified 'the most distinctive, and perhaps the most impressive, characteristic of American scenery' as being 'its wildness'.[67] By this time Cole had established himself as the pre-eminent exponent of the wilderness landscape. The paintings which he completed on his return to New York after a trip to the Hudson Highlands in 1825 had so far exceeded the achievement of his predecessors as to establish his reputation. Cole's early wilderness images composed from sketches made in the Catskills, such as his *Landscape with Tree Trunks* of 1828 (no.4),

26 Photograph of Olana, home of Frederic Edwin Church. Olana State Historic Site, New York State Office of Parks, Recreation and Historic Preservation

are recognisably American in character: the geology of the distant peak is distinctive, and nowhere else could the autumn foliage form so scorching a display. The work's dramatic – almost melodramatic – effect is achieved with painterly bravura; the image is bold and novel. Yet the compositional formula is derived from sources in European landscape painting: the blasted oak in the foreground is a typical device of the seventeenth-century painter Salvator Rosa (fig.1), while the great vortex of cloud is clearly reminiscent of Turner (fig.5). The Gothic sensibility of *Landscape with Tree Trunks*, too, belongs to the culture of European Romanticism. The novelty of Cole's art lay in its brilliant adaptation of artistic traditions for the representation of new subject matter. His journal for 6 July 1835 recalls a sketching trip in the Catskills and, echoing the words of Joshua Shaw, emphasises the funda-mental difference between the American landscape and its counterparts in Europe.

> Before us spread the virgin waters which the prow of the sketcher had never curl'd, green woods enfolding them whose venerable masses had never figured in trans-atlantic annuals, and far away the stern blue mountains whose forms were ne'er beheld by Claude or Salvator or been subjected to the canvass by the innumerable dabblers in paint for all time past. The painter of American scenery has indeed privileges superior to any other; all nature here is new to Art.[68]

The American wilderness seemed to Cole an untouched Eden, a theme he had explored in *Expulsion from the Garden of Eden* (no.10), in which the mountains and foliage in the glimpse of paradise, to the right, suggest some undiscovered valley in the American wilderness.

Though the landscape was 'new to Art', Cole was perpetuating a tradition of longing for the wilderness which grew not from the rough and ready experience of the American pioneers, but from European Romanticism's disenchantment with the city and with the tame, indeed tamed, landscapes of Europe. This is evident in European writing from Daniel Defoe's *Robinson Crusoe* (1719) to the works of Jean-Jacques Rousseau and Byron. And it was European travellers in America deeply dyed in the rhetoric of Romantic poetry, such as François-René de Chateaubriand and Alexis de Tocqueville, who responded most ecstatically to America's 'wild sublimities of nature'.[69]

Landscape with Tree Trunks perpetuates a further element of Romantic mythology, the cult of the 'noble savage'. Barely visible in reproduction, but clearly evident on the canvas, is the tiny figure of an American Indian by the bottom of the waterfall.[70] The inclusion of this figure is puzzling, since the extent of European colonisation had for generations made the traditional native American form of life impossible in this area. Indeed, of the Indian people of the Hudson River region, those who spoke the Algonquin language and called themselves 'Mahicans', had mainly been forced to migrate north or west in the seventeenth century, while the Munsee Indians had been decimated by smallpox and by war with the Dutch colonists in the 1670s.[71] In 1830, two years after Cole's painting was completed, President Andrew Jackson signed the Indian Removal Act. Though Jackson's avowed intent was to 'enable [the Indians] to pursue happiness in their own way and under their own rude institutions',[72] the effect was a brutal act of ethnic cleansing, forcing the migration of the major Indian nations from east of the Mississippi River to 'Indian Country', a region located in what are now the states of Oklahoma and Kansas. Cole, doubtless aware of these political developments, had little personal experience of Indian life or culture. Despite the violence to which the native population was being subjected at the time, the Indian was, to many European Americans of the 1820s and 1830s, no more than an evocative emblem of the natural world.

George Catlin, who first made extensive studies of American Indians on an ambitious trip up the Missouri and into the Far West in 1832–4, saw the drastic effects of the expanding western frontier on the indigenous peoples:

> I have closely studied the Indian character in its native state, and also in its secondary form along our Frontiers . . . Such are the results to which the present system of civilization brings that small part of these poor unfortunate people, who outlive the first calamities of their country . . . most of them end their days in poverty and wretchedness, without the power of rising above it . . . surrendering their lands and their fair hunting grounds to the enjoyment of their enemies, and their bones to be dug up and strewed about the fields, or to be labelled in our Museums.[73]

Catlin's commanding representations of Indian figures, such as *Little Wolf, A Famous Warrior* (fig.27), belong both to the nineteenth-century science of ethnology – the study of the human family through the analysis of racial 'types' – and to the European fine-art tradition of portraiture.[74] They closely resemble images of

27 George Catlin, *Little Wolf, A Famous Warrior*, 1844. Oil on canvas, mounted on aluminium, 73.7 × 60.9 (29 × 24). Smithsonian American Art Museum, Washington DC. Gift of Mrs Joseph Harrison, Jr.

South Sea islanders by William Hodges (1744–1797), who travelled with Captain James Cook to the South Pacific in 1772–5.[75] Although often crudely executed, and concerned to specify typical aspects of the dress and behaviour of particular tribes, Catlin's paintings impress upon the viewer a powerful sense of the individual sitter – in the case of Little Wolf conveying an impression of senatorial virtue, the nobility of the 'savage'. His work provides a striking portrayal of an indigenous culture on the verge of extinction, or at least of a transformation beyond recognition. Yet Catlin was both a critic and an agent of these fundamentally imperialist processes; his ethnographic work, despite its protective sentiments towards Indian culture, allowed for greater control to be exerted over the Indians by the US government. Catlin's painting does not reveal the true predicament of Little Wolf, a member of the party of Iowas whom Catlin toured as a performing act (under the management of the New York showman Phineas T. Barnum) round England, where the painting

was made, and France, where Little Wolf's wife died in June 1845.[76] This show was seen in Manchester in 1843 by Thomas Moran, aged six, a year before his family emigrated to Philadelphia – Moran later became renowned for his Western subjects (see fig.16 and no.99).[77] During his earlier travels in the mid-West, Catlin felt a profound ambivalence towards American Indians, analogous to that felt by many British imperial explorers towards the people of the Pacific and Africa. While appealing to Catlin's sense of the nobility of 'savage' life, freed from the constraints of civilisation, the American Indians also presented a major impediment to the expansion of the culture and commerce of the United States. Henry Wadsworth Longfellow's epic poem, *The Song of Hiawatha* (1855), adopts a sentimental and nostalgic, though respectful, view of Indian life, claiming to present a genuine insight into Indian mythology and beliefs; the poem in turn provided the subject for fantastical canvases by Moran (see nos.95–7), and for much American sculpture of the period.[78] American Indian culture – simultaneously endangered and dangerous, exhilarating and horrifying to the painters – was to become a major and ultimately melancholy preoccupation of painters such as Bierstadt and Moran when they travelled to the Far West in search of ever more spectacular scenery from the late 1850s onwards.

Within New England, painters of the generation after Cole had to travel ever further afield to locate wilderness landscapes. By the 1850s, the interior of Maine was one of the last Eastern areas to remain largely untouched by modernisation. Sanford Robinson Gifford probably visited Maine in 1850 on his trek northwards to Labrador in British North America, and sketched the state's remote peak Mount Katahdin, which appears in his broad and evocative landscape *The Wilderness* (1860; no.32). Once again, the figures of Native Americans, though only tiny, underpin the work's meaning, for it was subtitled: 'Home of the red-brow'd hunter race'.[79] Gifford, who had some contact with American Indians on his trip, ornamented *The Wilderness* with a family group, including a wigwam and a baby in a papoose, with the father returning from across the lake in a canoe (behaviour somewhat parallel to the commuter life of the bourgeois New Yorker of the period). Gifford is more likely to have seen this kind of untroubled, idyllic image in popular prints, or ethnological textbooks, than in Maine in 1850. The indigenous people of this region were, in any case, semi-agrarian rather than the nomadic 'hunter race' visualised in *The Wilderness*.[80]

When Church sketched the same Maine scenery, in preparation

for his major work *Mount Ktaadn* of 1853 (no.24), he travelled with 'a squad of lumbermen', the very agents of the destruction of the wilderness.[81] Perhaps this was appropriate, since in the foreground of Church's idyllic painting, illuminated by the dying glow of the setting sun, is an entirely imaginary agricultural settlement. In Church's fantasy, perhaps seen through the eyes of his surrogate in the painting, a youth surveying the scene from a knoll in the lower left corner, a mature agrarian civilisation and the wilderness are able happily to coexist. This was merely an illusion, however, since the expansion of agriculture and industry usually implied the wholesale destruction and transformation of the natural environment. Logging was the lifeblood of Maine's economy; it is a presence even in the preternaturally tranquil works of Fitz Hugh Lane, in whose motionless, esoteric representations the shoreline of Penobscot Bay seems the very antithesis of industry. Yet Lane's ghostly *Lumber Schooners at Evening on Penobscot Bay* (1863; no.72), silently carting planks of spruce and the rare white pine to the Boston building trade, mutely testify to the wilderness's destruction. 'Yankee enterprise', as a correspondent of the *New-York Literary World* put it in 1847, 'has little sympathy with the picturesque, and it behooves our artists to rescue from its grasp the little that is left.'[82] No phrase better evokes the melancholy scene of destruction transcribed by Sanford Robinson Gifford in *Hunter Mountain, Twilight* (no.21), in which charred tree stumps in the foreground contrast with the pristine sky and mountain landscape in the distance. In a perceptive passage, the great French chronicler of America, Alexis de Tocqueville instinctively understood the ultimate reason for the poignancy of the wilderness landscape:

> It is this consciousness of destruction, this *arrière-pensée* of quick and inevitable change, that gives, we feel, so peculiar a character and such a touching beauty to the solitudes of America. One sees them with a melancholy pleasure; one is in some sort of a hurry to admire them. Thoughts of the savage, natural grandeur that is going to come to an end become mingled with splendid anticipations of the triumphant march of civilisation. One feels proud to be a man, and yet at the same time one experiences I cannot say what bitter regret at the power that God has granted us over nature.[83]

America: A Prophecy

'Poetry and Painting sublime and purify thought, by grasping the past, the present and the future,' declared Thomas Cole in 1835, while engaged on painting the five-canvas series *The Course of Empire* (nos.11–15).[84] The culmination of Cole's attempt to produce 'a higher style of landscape',[85] *The Course of Empire* follows an imaginary civilisation through the stages of historical development, from the 'Savage State' (no.11) through a 'Pastoral or Arcadian' era (no.12), and moves on to demonstrate the dangers of overweening luxury in *The Consummation of Empire* (no.13). An elaborate, iconographically loaded canvas, *Consummation* is closely related to the Biblical epics of John Martin from whom Cole had borrowed before (see no.10).[86] The inevitable moral and political consequences of luxury and excess are graphically illustrated through the final canvases, depicting *Destruction* (no.14) and *Desolation* (no.15). There is no question that the history of Rome, as interpreted by Edward Gibbon in *The Decline and Fall of the Roman Empire* (1776–88), was the primary model for Cole's imperial schema, and that the Romantic pessimism of Byron and his generation underscored the notion of a historical cycle inevitably ending in doom. However, recent interpretations have identified Cole's imperial narrative as an allegory of American history.[87] In Alan Wallach's compelling reading, *The Course of Empire* emerges as a commentary on the expansionist, utilitarian and democratic platform of Andrew Jackson, bitterly opposed by Cole and his patrons. Cole roundly condemned

> this age, when a meager utilitarianism seems ready to absorb every feeling and sentiment, and what is sometimes called improvement makes us fear that the bright and tender flowers of the imagination shall all be crushed beneath its iron tramp.[88]

The era dominated by Jackson's ideas and personality (usually dated from about 1824 to 1848) marked a break with the colonial past, and the point at which a uniquely American political, social and cultural identity was cemented. The seventh President of the United States, Jackson (nicknamed 'Old Hickory') came from a humble, rural background and evinced a new liberalism and an enthusiasm for industrial expansion and materialism. The spectacle of modern New York (see fig.23) surely underlies Cole's vision of *Consummation*: working on the architectural aspects of the canvas in 1836, the artist admitted that it was

necessary 'to tear down some of the buildings that were nearly finished in order to make improvements a la mode N York'.[89] Jackson was the scourge of the established financial and mercantile elite, among whom were many of Cole's early patrons, and while 'Jacksonian Democracy' supported commercial development, it did so in the name of the majority. Jackson's mantra was '*The majority is to govern.*'[90] Accused of demagoguery and even despotism, he was caricatured as an aspiring monarch and an American Caesar. It might even be that the conqueror robed in red who triumphally crosses the bridge in the foreground of Cole's *Consummation* represents Jackson himself; for he had first come to prominence as a military hero in the War of 1812.[91]

The transition from wilderness, via the idyll of the early years of the Republic, to the luxurious metropolis of New York in the 1830s, is vividly encapsulated in the first three canvases. *The Savage State* recalls Cole's Catskill wilderness paintings, but even in the idyllic *Pastoral or Arcadian State* the march of progress is implied by the emblematic sawn tree stump, an image which echoes through American art of the nineteenth century (as, for example, in Cole's *View of the Mountain Pass Called the Notch of the White Mountains*, no.5). 'I cannot but express my sorrow,' Cole wrote in his *Essay on American Scenery*, 'that . . . the ravages of the axe are daily increasing: most noble scenes are made desolate, and oftentimes with a wantonness and barbarism scarcely credible in a civilised nation.'[92] An English visitor, horrified by the speed of American forest clearance, bemoaned the 'magnificent trees' standing round him 'with their throats cut, the very Banquos of the murdered forest!'[93] The speed of America's transformation – from its arcadian moment to the present consummation – left Cole astonished:

> A very few generations have passed away since this vast tract of the American continent, now the United States, rested in the shadow of primaeval forests, whose gloom was peopled by savage beasts, and scarcely less savage men.[94]

It comes as no surprise that *The Oxbow* (fig.20), in which this process is represented, was painted while Cole was at work on *The Course of Empire*, re-using the very canvas upon which he had originally sketched *Consummation*.[95]

The idea of America as an empire – common in nineteenth-century writing, though never (as in the case of Britain) an officially acknowledged title – was eminently applicable in the Jacksonian period, when the nation grew incrementally in size.

The American 'empire', however, occupied however a contiguous landmass and not a disparate range of overseas territories like that of Britain. As a general, Jackson had waged an undeclared war against the Spanish which facilitated the acquisition of Florida by sale in 1819. As President, he advocated rapid westward expansion. Like the British during the same period, nineteenth-century Americans continually defended their empire as a beneficent entity resting on moral foundations. While the British Empire existed to defend British economic and political interests, it was often justified in terms of trusteeship and assistance for indigenous peoples, especially with regard to slavery, which had been abolished in Britain and its colonies in 1834.[96] The American constitution, by contrast, was extolled above all as providing a guarantee of personal liberties. David Humphreys, an officer in the Revolutionary army more gifted in diplomacy than poetry, expressed it thus:

> All former empires rose, the work of guilt
> On conquest, blood, or usurpation built:
> But we, taught wisdom by their woes and crimes,
> Fraught with their lore, and born to better time;
> Our constitutions form'd on freedom's base,
> Which all the blessings of all lands embrace;
> Embrace humanity's extended cause,
> A world of our empire, for a world of our laws.[97]

Comparisons between past and present – both optimistic and pessimistic – were a commonplace of nineteenth-century thought. Like Cole's cycle, John Ruskin's *Stones of Venice*, published in 1851–3, offered a comparison between the rise and fall of a past empire and the dangers lying ahead for a contemporary one.[98] Ruskin pitted the medieval and Renaissance maritime empire of Venice against its modern British counterpart, intoning that, unless the lessons of history were learned, the British Empire 'may be led through prouder eminence to less pitied destruction'.[99] Where, as noted above, the English visitor Frances Trollope had seen New York in 1832 as a modern Venice, for Ruskin the Italian city-state's fate foretold that of Victorian Britain. Placed in this tradition (which reaches back through Thomas Carlyle to Robert Southey and Samuel Taylor Coleridge), Cole's *Course of Empire* provides a paradigm of imperial rise and fall, with resonances for more than one contemporary culture. Might not Cole's works also be read as alluding to the overweening ambitions of the empire at whose heart he grew up, and whose crisis and ultimate

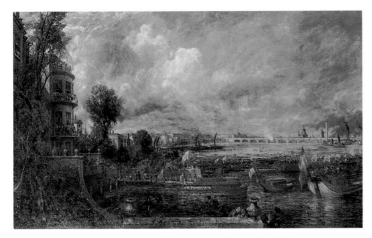

28 John Constable, *The Opening of Waterloo Bridge* ('*Whitehall Stairs, June 18th, 1817*'), 1832. Oil on canvas, 130.8 × 218 (51½ × 85⅞). Tate, London. Purchased with assistance from the National Heritage Memorial Fund, the Clore Foundation, the National Art Collections Fund, the Friends of the Tate Gallery and others 1987

military victory in the Napoleonic Wars he experienced during his adolescence – that of Britain? The British Empire, largely driven by the economic and financial engines of the industrial north (Cole's place of origin) and the gentlemanly capitalists of the City of London, had not yet adopted the lavish pomp and spectacle of the late Victorian era. The loss of the American colonies, ending the 'First British Empire', was a severe blow, but British power was growing in other territories, notably in India and the Pacific. *Consummation of Empire* could easily be read as a parodic vision of Imperial London, with commercial and government buildings astride a fantastic depiction of the River Thames, in the decadent but opulent regency (1811–20) and personal reign (1820–30) of George IV. Cole's vision of consummation has much in common with Constable's likewise panoramic view of the opening of Waterloo Bridge by the Prince Regent (fig.28).[100] The creamy fantasy architecture of *Consummation* has as much in common with the theatrical stucco of John Nash's Cumberland Terrace of 1826 (fig.29) in Regent's Park, London, as with Trajan's Rome or New York in the Jacksonian era. Other hints of a British point of reference can be found in the representation of Stonehenge which appears in the middle distance of the *Pastoral or Arcadian State*, a common focus of Romantic longings for a long-lost arcadian past.[101] Explicit compositional and conceptual debts to J.M.W. Turner and John Martin add to these Anglo-Saxon overtones.[102] There is, furthermore, evidence that the series was originally conceived in 1829 during Cole's unhappy visit to England.[103] Cole proudly referred to the 'great struggle for freedom'[104] as endowing

the American landscape with historical associations: his relish at the collapse of a great empire may, in this context, reflect his republican contempt for the regime from which the United States had bloodily emerged. The critic of the *New-York Mirror*, impressed with Cole's achievement, none the less saw Jacksonian America as the first civilisation to break the cycle of rise and fall:

> The climax in the course of man's progress, which Mr Cole has here represented, is *that* which *has been* and was founded on the usurpation of the strong over the weak; the perfection which man is hereafter to attain, will be based upon a more stable foundation: political equality; the rights of man; the democratick principle; the *sovereignty of the people*.[105]

The First British Empire had fallen, perhaps as a result of the greed and decadence of its monarchy and aristocracy and the inequality of its constitution; the course of American empire was yet to run. The advocates of Jacksonian progress believed that it held boundless promise.

After Cole's death in 1848, a new generation of landscape painters emerged, many of whose works articulate American national myths unencumbered by Cole's ambivalence and underlying pessimism. Among them was Asher Brown Durand (older than Cole, but an engraver for many years before he emerged as a landscape painter), whose *Kindred Spirits* (no.1)

29 Photograph of Cumberland Terrace, Regent's Park, London

30 Asher Brown Durand, *Progress (The Advance of Civilisation)*, 1853.
Oil on canvas, 121.9 × 182.75 (48 × 71¹⁵⁄₁₆). The Warner Collection of Gulf
States Paper Corporation, Tuscaloosa, Alabama

paid homage to Cole and signalled his claim to succeed Cole
as the leading American landscape painter. In *God's Judgement
upon Gog* (no.9), Durand attempted an Old Testament history
painting in Cole's vein; only with *Progress (The Advance of Civilisation)*
(fig.30), however, did he directly address the course of American
empire. Echoing Cole's composition in *The Oxbow* (fig.20), Durand
balances 'the Savage State' of the wilderness on the left (where
American Indians gaze out from the shade of the forest) with a
fantasy of progress to the right. But Durand's modern vista differs
radically from Cole's Jeffersonian idyll of an agrarian republic
peopled by prosperous yeomen. The forward march of progress
leads Durand instead to a Jacksonian utopia; in addition to road
transport and agricultural productivity (alluded to in the genre
scene at the lower right), the composition emphasises the railroad
and the distant industrial city as emblems of America's future.
Telegraph lines – like the railroad, a democratising technology and
striking new features of the landscape – underscore the modernity
of the scene. Durand articulates the progression from past to
future, wilderness to civilisation, within the standard Claudean
landscape formula, complete with framing trees and a distant,
golden vista.

In *Progress (The Advance of Civilisation)* and, more spectacularly,
in Jasper Francis Cropsey's *Starrucca Viaduct* of 1865 (no.28),
the architecture of the railway age assumes the role played by
ancient ruins in the work of Claude. This seamless insertion
of the modern into a classical formula acts as an implicit

endorsement of industrial progress. The New York and Erie
Railroad – successor to the Erie Canal – became one of the
technological wonders of the age; the viaduct, erected in 1848,
was 1,200 feet long and 114 feet high. Such railroads became
the most powerful symbol of national destiny, as their tracks
inscribed a new, rigid geometry on the American continent
from Atlantic to Pacific. Soon railroads linked every major town
in the North: 30,000 miles of track were laid between 1830 and
1860.[106] Cole had derided the intrusion of the railroad in the
wilderness,[107] and Turner, in *Rain, Steam, and Speed* (1844)[108]
created a brilliantly ambivalent vision of Isambard Kingdom
Brunel's Great Western Railway – exhilarated by the awesome
power and speed of the locomotive, but perhaps also anxious
about the revolution it portended. But by the 1860s Romanticism's
abomination of the modern and the industrial has given way to an
aesthetic of technological progress; every vestige of Cole's Byronic
(or Turnerian) pessimism has been swept away. For the critic of
The Knickerbocker, Durand's *Progress* provided an emblem of the
nation, telling 'an American story out of American facts, portrayed
with true American feeling by a devoted and earnest student of
Nature'.[109]

The Politics of Light and Revelation

From the earliest days of English colonisation, religion has played
a central role in American life, and the seventeenth-century
New England Puritan tradition remained profoundly influential
in the 1850s. Religion gave Americans a sense of their distinctive
identity and also provided a rationale for the physical expansion
of the United States. For Frederic Edwin Church, these connections
were vividly personal; in 1636 his ancestor, Richard Church, had
migrated with the Revd Thomas Hooker to Hartford, Connecticut.
Church's painting recreating the scene (fig.31) combines an ecstatic
portrayal of the American wilderness with an awed sense of the
blessings of providence which accompanied the New England
pilgrims. The art historian David Huntington aptly described
Church's paintings as 'cogent parables for God's chosen people';[110]
Church, he argued, conceived of himself as a 'prophet' and shared
with many of his contemporaries a sense that the development
of the United States was itself a divinely-ordained mission.
Church's artistic voyages into the wilderness, like his ancestor's,
seemed blessed by divine providence. Thanks in part to the

'Second Great Awakening', an Evangelical revival in the 1820s and 1830s, the speech of nineteenth-century American Protestants, like their Puritan forefathers, was coloured by the language of the Bible. Most influential was the Book of Revelation, with its imagery of Armageddon, Millennium and Apocalypse. Abandoning the explicit religious and historical subjects of his teacher Thomas Cole, Church scanned the natural world for symbols – fiery sunsets, rainbows, strange formations of rock, lava and ice – which appeared to be visual testimonies to God's presence. He developed a remarkable facility for noting, in swift oil sketches, his observations of natural phenomena, creating images of vivid immediacy. In a sequence of finished works on a grand scale, exhibited alone as 'Great Pictures', Church transformed these essentially private sketches into grandiose public statements, symphonic in complexity and richly inscribed with meanings and allusions both national and religious.

Church explored the sheer might of nature in his spectacular *Niagara* of 1857 (fig.32), a painting which achieves the apparently impossible, being panoramic in breadth yet presenting a wealth of detail as if examined through a telescope.[111] Portraying a scene which was already a national icon, it captures both the spiritual grandeur and the detailed mechanics of God's creation through a natural feature marking the boundary between the American empire and the British.[112] For the critic Adam Badeau, *Niagara* epitomised the robustly masculine spirit of the nation. The painting was:

> a true development of American mind; the result of democracy, of individuality, of the expansion of each . . . inspired not only by the irresistible cataract but by the mighty forest, by the thousand miles of river, by the broad continent we call our own, by the onward march of civilization, by the conquering of savage areas; characteristic alike of the western backwoodsman, of the Arctic explorer, the southern filibuster, and the northern merchant. So, of course, it gets expression in our art.[113]

To universal acclaim, *Niagara* was exhibited alone at Williams' Gallery on Broadway, New York, as a 'Great Picture'. When shown under similar circumstances in London, the painting was admired by Ruskin[114] and attained considerable celebrity in the English press. A chromolithograph, made by Charles Day in London, allowed Church's imagery to spread its gospel throughout America and Europe.[115]

31 Frederic Edwin Church, *Hooker and Company Journeying through the Wilderness in 1636 from Plymouth to Hartford*, 1846. Oil on canvas, 102.2 × 152.8 (40¼ × 60³⁄₁₆). Wadsworth Atheneum, Hartford, Connecticut. Purchased from the artist before 1850 (1850.9)

In the 1840s and 1850s, religious convictions were entirely compatible with scientific interests; indeed, for many, including Church and Ruskin, the insights of geology, botany and meteorology were merely (in the words of the Revd Henry T. Cheever, a New England divine) 'revelations to [mankind] of the way in which God works . . . a slow, gradual and partial tracing of His footsteps'.[116] Church, a devoted follower of the German naturalist Alexander von Humboldt, was deeply affected by *Cosmos: A Sketch of a Physical Description of the Universe*.[117] Church's admiration for Humboldt led him beyond the confines of the United States – he travelled to the most distant and exotic landscapes of the Americas, which Humboldt himself had explored a generation earlier. Indeed, Church first perfected his characteristic fusion of scientific observation, religious faith and symbolic use of light in *The Andes of Ecuador* (1855; no.85). This breath-taking Andean vista, dissolving into pure light, seems to deliver the beholder straight to the Creator; in doing so it utilises techniques derived from the panorama, which still held a particular fascination for New Yorkers of the 1850s. Church envisioned landscapes which, like Humboldt's textual analyses, fixed upon the essential characteristics of a particular environment. *Twilight in the Wilderness* (no.25) epitomised North America, just as *Aurora Borealis*[118] and *The Icebergs* (no.88) did the Arctic. *The Andes of Ecuador*, *The Heart of the Andes* (fig.14), and *Rainy Season in the Tropics* (no.87) all epitomised South America. Church seems to have rejected the American West as a subject because of the

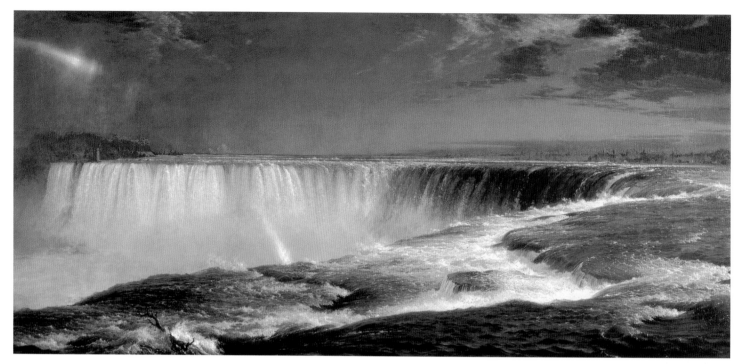

32 Frederic Edwin Church, *Niagara*, 1857. Oil on canvas, 107.95 × 228.87 (42½ × 90½). The Corcoran Gallery of Art, Washington DC. Museum Purchase, Gallery Fund (76.15)

success of his rival, Albert Bierstadt, in painting Western subjects. Eschewing the East-West axis of American imperial growth, the sequence of Church's works instead pursues the fantasy of a pan-American unity from North to South, creating a pantheistic cosmos of the Sublime with the northeastern United States at its heart. Church, ventured an English reviewer, had become 'the artistic Humboldt of the new world'.[119] By looking to the South, Church's works form an artistic analogy for the Monroe Doctrine, the political policy formulated by President James Monroe in 1823 which aimed to bind the Americas together under US protection, and to repel any European colonial interventions in South America.[120]

Although the concept of a 'national' landscape had been contested throughout the nineteenth century, the outbreak of the Civil War in 1861 marked its collapse. After a generation of uneasy compromise, war proved to be the inevitable result of the profound disparity which had grown up between the North, with its new urban cultures largely populated by a proletarian workforce of free labourers, and the South, whose economy still relied heavily upon slavery to fulfil the massive demand for cotton. As divisions widened between North and South, the question of the morality of slavery, and whether the newly acquired territories in the West should become slave or

free states, ignited the final crisis. *Twilight in the Wilderness*, exhibited in 1860, seemed to presage an American apocalypse such as Church's Puritan ancestors had prophesied. When war came, new weapon technologies led to terrible bloodshed: Americans slaughtered Americans in the hundreds of thousands and photo-graphers, draughtsmen and journalists recorded the carnage. As the Civil War raged, Church himself, deeply commit-ted to the Unionist cause, was caught up in what his friend and pastor Horace Bushnell described (in Evangelical language) as 'This immense enthusiasm, bursting forth spontaneous . . . I know of nothing at all in the whole compass of human history at all comparable to it in sublimity.'[121] One of Church's finest achievements, *Cotopaxi* (1862; no.86), reflects this political, military and ideological 'sublimity'; the destructive energies of the volcano (surely emblematic of the Civil War) are balanced by a premonition of 'the newly risen sun', the resurgent American nation (perhaps even a pun on 'the son of God'), which pierces the gloomy cloud of smoke and ash.[122] More explicitly partisan, and affecting despite its naïveté, is *Our Banner in the Sky*.[123] This lurid but strangely compelling propaganda image gained wide currency as a chromolithograph. The flaming clouds of a typical Church sunset with a cluster of evening stars, seen beyond the outline of a barren tree in the wilderness at twilight, form a celestial version of the

stars and stripes – the Union flag. As in the Old Testament, God pledges his covenant to his chosen people through the language of nature. Only after the war had ended, in *Rainy Season in the Tropics* (1866; no.87), was Church able to throw a spectacular double rainbow over the wilderness once more, a symbol of unity and, if not forgiveness, then at least rebirth.

The intersection of religious vision with particular forms of seeing was not confined to the epic canvases of Church: inwardness, as well as the extrovert character of the 'Great Picture', characterised the era. More intimate forms of art, less passionately engaged with the political world, were produced by John Frederick Kensett, Martin Johnson Heade and Fitz Hugh Lane. These artists, who worked independently of each other, produced distinctive images, redolent of a quietist spirituality and articulated by a newly simplified language of form. Scholars have related these developments to the emergence of Transcendentalism, a uniquely American body of ideas which united poetic language and feeling with religious belief, though outside the formal theological context of the churches.[124] Transcendentalism, which emerged from the intellectual and social elite of New England, reached the peak of its influence at exactly the moment that Heade, Kensett and Lane were painting landscapes in that area – especially along the coastlines of Maine, Massachusetts and Connecticut. Unlike Cole's agitated brushwork, which speaks directly of personal emotion, or Church's richly orchestrated pictorial sermons, the works of these artists are small in scale and minutely finished, almost without trace of brushstroke, seeming to echo the famous lines of Ralph Waldo Emerson: 'I am nothing, I see all; the currents of the Universal Being circulate through me; I am part or parcel of God.'[125] For Emerson, as for Ruskin, familiar natural forms can reveal the religious profundities which lie behind or beneath them: in rocks, trees, and water, if 'read' properly, the beginning and the end of time and the attributes of God himself can become legible. While what little we know of Lane and Heade suggests that their work was not consciously conceived in response to Emersonian theory, the silent emptiness of Kensett's *Eaton's Neck, Long Island* (1872; no.78), Heade's *Approaching Thunder Storm* (1859; no.80), or Lane's *Lumber Schooners at Evening on Penobscot Bay* (1863; no.72) seems to indicate a spiritual longing for communion with the divine beyond the limitations of organised religion. Perhaps these works also betray a deeply-felt wish for a healing of the American body politic from the profound divisions revealed by the Civil War. Despite their quietude, the broad, low format

of many of these works harks back to that of the panorama. The baroque, melodramatic elements of popular culture are stripped away, revealing the underlying forms, austere but profoundly original.

Westward Ho! Exploration and Empire

The justification for westward expansion was embedded in the Puritan origins of American culture; indeed, nineteenth-century advocates of American empire reasserted arguments once advanced by the British colonists of America. In 1629 the English colonial settler John Winthrop had explained his departing 'into . . . the wilderness', by recalling God's instruction to man: 'Increase & multiply, replenish the earth, and subdue it.'[126] Man's – and specifically America's – providential mission to tame and cultivate the earth was wholly compatible in the nineteenth century both with the pursuit of personal and corporate profit and with national economic development. Thus, in the extreme formula of William Gilpin, Governor of Colorado, writing in 1873, 'Progress is God . . . [the] occupation of wild territory proceeds with all the solemnity of a providential ordinance.'[127] The phrase which has come to identify the righteous hunger for land in the West was used for the first time in 1845, when John Louis O'Sullivan wrote of 'our *manifest destiny* to overspread the continent allotted by Providence for the free development of our yearly multiplying millions'.[128]

Perhaps the most vivid emblem of 'manifest destiny' is Emanuel Leutze's (1816–1868) bombastic *Westward the Course of Empire Takes Its Way* of 1862 (a finished study is reproduced here – fig.33), a history painting in modern dress. This 'stereochrome'[129] mural in the United States Capitol depicts pioneers at the moment of crossing the Continental Divide: astride the Rockies – depicted in only a schematic manner – they are able to view the great expanse of land beyond.[130] The empowered vision of these missionaries for American civilisation has been described as a 'magisterial gaze'.[131] This sweeping view of a broad terrain implies the power of a colonising force over a subjugated region, a viewpoint entirely consistent with an aesthetic appreciation of the glories of the landscape. Imperial politics and landscape aesthetics are mutually reinforcing. The predella beneath Leutze's mural bears a broad panorama of the Golden Gate of San Francisco Harbour: 'the drama of the Pacific Ocean,' Leutze explained, 'closes our

Emigration to the West'.[132] Process and product, expansion and empire, are vividly linked. The title of Leutze's painting is taken from the same lines as that of Cole's great series: 'Verses on the Prospect of Planting Arts and Learning in America', by George Berkeley, Bishop of Cloyne in Ireland:

> Westward the Course of Empire takes its Way;
>> The first four Acts already past
> A fifth shall close the Drama with the Day:
>> Time's noblest Offspring is the last.[133]

Berkeley's poem, written in 1726 before his own journey across the Atlantic to the American colonies, via the Caribbean, reflects a distinctly British viewpoint, indicating once again the continuities between the expansionism of the First British Empire and that of nineteenth-century America. A Victorian response to that earlier imperial era can be found in *The Boyhood of Raleigh* (1870)[134] by John Everett Millais (1829–1896), in which the theme of westward expansion is accompanied by a romantic nostalgia for a young, Tudor England and for the age of sail. The painting locates in Raleigh's juvenile premonition a point of origin for Britain's position as a nineteenth-century naval superpower, a theme explored in such popular classics as Charles Kingsley's novel *Westward Ho!* (1855). *The Boyhood of Raleigh* also pictures the Elizabethan roots of the British fascination with global exploration. The parallel, imperial progress of the United States towards the Pacific coast is audible in Eugene Lies's verse of 1849, also named *Westward Ho!*, which revisits Bishop Berkeley's theme:

> Westward ho! since first the sun
> Over young creation shone,
>> Westward has the light progressed
> Westward arts and creeds have tended
> Never shall their march be ended,
>> Till they reach the utmost west.[135]

The 'utmost West', the Pacific Coast, was reached remarkably quickly. The USA grew exponentially during the 1840s: in 1845 Texas was annexed;[136] in 1846 the USA made a treaty with Britain to obtain the Oregon Territory;[137] and in 1848, after the war with Mexico, California, New Mexico, Arizona, Utah and Nevada were added to the nation.[138] On 30 December 1853, the Gadsden Purchase from Mexico completed the boundaries of the continental USA.

The harbingers of this great expansion were explorers who

33 Emanuel Gottlieb Leutze, *Westward the Course of Empire Takes Its Way*, 1861. Oil on canvas, 84.5 × 110.2 (33¼ × 43⅜). Smithsonian American Art Museum, Washington DC. Bequest of Sara Carr Upton

traversed and began to map the unknown territory of the West. As, for example, with the exploration of Africa by British missionaries and military men, or the mapping of India, the 'discovery' of the American West was one made with the aid of existing local populations.[139] The 'frontier' – a contact zone between European America and native American culture – became the subject of fascination, just as the frontiers of their own empire came to hold great symbolic importance for the British.[140] The purpose of these exploratory expeditions was to produce new forms of knowledge, making possible the expansion of European authority and dominion, a classic pattern of colonisation also seen in India, Australia and Africa during the nineteenth century. Visual information was paramount, recorded not only in the form of maps, but in prospects of the landscape and images of its inhabitants, flora and fauna.[141] The first, and most celebrated, expedition to cross the continent was that of Captain Meriwether Lewis and Lieutenant William Clark in 1804–6, under the patronage of Thomas Jefferson. Although their published journals included important maps, no artist accompanied them. Thereafter, however, the pictorial recording of new terrain became an essential part of each mission. The Philadelphia-born artist Titian Ramsay Peale (1799–1885) journeyed to the West in 1819–20 with Major Stephen H. Long's expedition. Samuel Seymour's (1775–1823) careful, understated watercolours, also from this expedition, reveal an artist struggling

to adapt European conventions of picturesque draughtsmanship to an alien landscape with unfamiliar features such as basaltic columns.[142] George Catlin produced landscape studies as well as ethnological imagery on his first journey west among the Indians in 1832–4; and John Russell Bartlett, the US-Mexico Boundary Commissioner, wanted Thomas Cole to accompany his party to the South West in 1848, but was forestalled by the artist's death in that year.[143]

Landscape painting, widely circulated through print media such as the chromolithograph, provided topographical information about the West. More importantly, however, the genre could offer an imaginative insight into new terrain for an audience who had never seen it. Landscape, in W.J.T. Mitchell's suggestive phrase, can be thought of as 'the "dreamwork" of imperialism'.[144] Paintings of landscape documented the territories of empire, but were most effective as a medium for expressing the latent fantasies, aspirations and emotions generated by imperialism. Reviewing Thomas Moran's work in 1882, the *Magazine of Art* eloquently summed up the relationship of the artist to westward expansion:

> Never before has there been a nobler opportunity afforded the artist to aid in the growth of his native land, and to feel that, while ministering to his love of the sublime and the beautiful, he was at the same time a teacher and a co-worker with the pioneer, the man of science, and the soldier, who cleared, surveyed and held this mighty continent and brought it under the mild sway of civilization.[145]

Though written about later work, these words fittingly describe the first great Western landscapes, which resulted from Albert Bierstadt's journey west in 1859 with Frederick West Lander's government-sponsored mission to explore the Rocky Mountains.[146] Lander epitomised the combination of private enterprise and government action in exploring and exploiting the West, working both as a railroad surveyor and as a brigadier general in the Union Army; he was to die in 1862 on active duty in the Civil War. After months working on the distant frontier, Bierstadt returned to New York in September 1859 with a large collection of studies and stereoscopic photographs. An oil sketch, *Surveyor's Wagon in the Rockies* (no.60), reveals, with touching intimacy, the flimsy equipment and fallible processes of exploration, yet also acknowledges the grandeur of the landscape. Other sketches by Bierstadt chronicled geological features of the

Rockies, such as 'mighty perpendicular cliffs that rise hundreds of feet aloft'.[147]

Bierstadt was uniquely well-equipped to depict the Rockies, which he found to 'resemble very much the Bearnese Alps'; in 1857 he had explored this most sublime of European ranges in the company of Sanford Robinson Gifford.[148] Three years of tuition at Düsseldorf from 1853 had provided him with a mastery of technique: the Academy prized accurate drawing and instilled an ability to produce oil paintings with a glossy, illusionistic finish.[149] An accomplished artist-explorer in the tradition of William Hodges, Bierstadt was able to incorporate the newly-explored territory within European conventions of the Sublime while also demonstrating its distinct local character, just as Hodges had visualised the South Sea Islands within a Claudean framework.[150] In the massive *Rocky Mountains, 'Lander's Peak'* (1863),[151] Bierstadt balanced a distant mountain landscape, reminiscent of the Alps, with a detailed depiction of an Indian encampment in the foreground. 'Lander's Peak' (see also no.89) does not relate to a real peak in the Rockies, but is rather a hybrid derived from Bierstadt's sketches, and named to honour the deceased general. The Indian scene is equally contrived, though the artist's claims to ethnological accuracy were backed up by 'the very fine collection of arms, implements and dresses which he brought with him from the West' – these were prominently displayed at his rooms in the Tenth Street Studio Building in New York.[152] The photographs of Sioux and Shoshone which Bierstadt had made during Lander's expedition served as another validating archive.

As perceptive contemporaries realised, *Rocky Mountains, 'Lander's Peak'* was a compelling fiction, 'a grand and gracious epitome and reflection of nature on this continent',[153] selectively assembled in traditional academic fashion from myriad sketches and observations made on the spot. '[A]lthough Bierstadt never saw this landscape or witnessed this scene,' the *Chicago Times* conceded, 'the picture contains nothing which he had not seen.'[154] More dramatic in lighting and colour than its predecessors, Bierstadt's *Storm in the Rocky Mountains – Mt Rosalie* of 1866 (no.91), which derived from a second trip west to the Colorado Rockies in 1863, reminded critics of a diorama: 'the light is . . . so singularly pure and effective, that many of the spectators fancy it produced by some artificial means behind the canvas'.[155] Even more than Church's 'Great Pictures', Bierstadt's panoramas straddled New York's interrelated worlds of fine art and popular

culture, high art and low.[156] It is no surprise that, as well as exhibiting *Rocky Mountains, 'Lander's Peak'* at the Metropolitan Fair held in New York to raise funds for the Sanitary Commission (the Yankee equivalent to the Red Cross) in 1864 (fig.34), Bierstadt also acted, like Catlin before him, as impresario for the 'Indian department', a stage show with a troupe of Indians dancing in front of a painted backdrop.

Ultimately, Bierstadt's daringly theatrical compositions were held together not by their 'reality effect' in matters of detail, but by the ideological force of the vision underpinning them, that of manifest destiny. For the *New York Leader*, commenting on *Rocky Mountains, 'Lander's Peak'*, 'the nation's future greatness is somehow dimly seen in the great West. This picture is a view into the *penetralia* of destiny as well as nature.'[157] Perhaps it was this which appealed to a new generation of super-rich New York capitalists who became eager patrons of Bierstadt in the 1850s and 1860s. Among them was the dry-goods magnate A.T. Stewart, more brash and confident than Cole's patron Luman Reed, who displayed Bierstadt's work in the picture gallery of his lavish Fifth Avenue mansion.[158] Bierstadt's work, like Church's, also found favour with wealthy British industrialists for whom the American vision of empire may have echoed their own.[159]

Landscapes from the peripheries of the British empire were constructed in the same fashion, and likewise view their unfamiliar subjects through the conventions of the Sublime. Under the patronage of Lord Northbrook, who had just been made Viceroy of India (the most senior colonial official), Edward Lear (1812–1888) visited the subcontinent in 1873–5. Mount Kangchenjunga in the Eastern Himalayas (known to him as Kinchinjunga, and believed to be the highest mountain in the world) struck Lear as 'so far off, so very God-like & stupendous'.[160] Britain's territorial control of this fantastic frontier terrain was in itself a thing of wonder, although the Mutiny-Rebellion of 1857–8 had shaken the confidence of many in the imperial project. As in similarly panoramic landscapes by Church and Bierstadt, Lear's *Kinchinjunga from Darjeeling, India* (fig.35) contrasts the verdant foreground, fit for cultivation, with the mountain wilderness beyond, though Lear's Romantic and allusive style harks back to the era of Thomas Cole and John Martin. Local figures – perhaps employed in picking tea for the British market – grouped around a Buddhist shrine occupy a different position from Bierstadt's Indians (though the European etymology spuriously links them). For though the British in India had demonstrated their military and technological

superiority when suppressing the Mutiny-Rebellion, the white population was never more than a tiny fraction of the sub-continent's population and British rule left the highly-developed urban and artisanal cultures of Indian civilisation largely intact. Many Americans, remembering their own nation's struggle against the British Empire, were vocal critics of the British Raj, causing one Anglo-Indian, John Lockwood Kipling (father of the poet Rudyard, and head of the School of Art in Lahore) to contrast British treatment of the inhabitants of India with that of the American Indians: 'If I possessed any rupees I could spare,' he thundered in the *Bombay Pioneer* in 1876, 'I would prefer to send [American anti-imperialists] to Sitting Bull, Crazy Horse and Old Cow and other warriors of the Sioux, away on the Yellowstone River, who have been half-exterminated by the possibly beneficent but certainly rowdy and murderous civilisa-tion of America.'[161] Kipling's outrage was hardly justified: recent research into British treatment of the Maori and Aboriginal peoples of New Zealand and Australia, for example, suggests that it probably exceeded in brutality that meted out to the American Indians.[162]

Another parallel with British artistic practice can be discerned in Bierstadt's use of the camera on the 1859 expedition to the Rockies. Photography, which came to prominence in the 1840s, had become less cumbersome by the mid-1850s, allowing travellers to use the new medium. This development profoundly affected notions of visual 'truth'. An exhibition of photographs of the West by Carleton Watkins (1829–1916) was held in December 1862 at Goupil's Gallery in New York, where Church had exhibited

34 *The Metropolitan Sanitary Fair – The Art Gallery* from Frank Leslie's *Illustrated Newspaper*, 23 April 1864. Collection of The New-York Historical Society

Twilight in the Wilderness just two years before. Watkins's technically superb mammoth prints (from plates of 22 by 18 inches) framed the Western landscape in the tradition of the Sublime, using a repertoire of compositional types almost a century old (fig.36). Yet his photographs recorded an unprecedented level of detail, and carried an apparently unimpeachable claim to veracity. For Louis Agassiz, the prominent Harvard naturalist, they provided 'the best illustrations I know of the physical character of any country'.[163] Photography became central to the culture of empire – whether for British, French, German, Belgian or American colonists – used by military surveyors, itinerant commercial photographers and wealthy tourists.[164]

Like Watkins's views of the West, which materially affected attitudes to the region,[165] the work of British photographers of empire was influential across the Anglo-Saxon world.[166] Between 1863 and 1870, Samuel Bourne (1834–1912), a British commercial photographer whose work was deeply rooted in the culture of imperialism, lived in India, which since 1858 had been under the direct control of the British government. Some of his images record explorations of the Himalayas, undertaken (it was emphasised) with manly zeal; others portray favoured resorts of the British, such as the hill town of Simla, where he established his first studio.[167] Both Watkins and Bourne presented exquisitely contrived imperial landscapes as if they represented 'pure' nature, and both drew on the same repertoire of compositional formulae. Bourne's *View in the Wanga Valley (Simla)* (fig.37) and Watkins's *Lower Cathedral Rock* (*c*.1865–6) utilise established conventions of

35 Edward Lear, *Kinchinjunga from Darjeeling, India*, 1879. Oil on canvas, 119.7 × 182.9 (47⅛ × 72). Yale Center for British Art, Gift of Donald C. Gallup, Yale 1934, 1939

the Sublime (the same tropes employed by Lear and Bierstadt) to celebrate newly-acquired landscapes of empire. Their choice of subjects also resulted in shared exclusions. Bourne rarely offers more than a hint of the military infrastructure supporting the British presence in India, while Watkins's photographs give little sense of the environmental and human violence which characterised the American frontier. The indigenous populations, extensively photographed for ethnographic purposes, are also absent here. Yosemite and the Simla region are presented as landscapes of pleasure, spectacular backdrops for the activities of the imperial explorer-tourist.

Watkins's exhibition of photographs in 1862 drew Bierstadt's attention to a subject with which he became closely associated: Yosemite Valley. Once again, a development in landscape aesthetics emerged from the rich visual culture of New York City. Yosemite's unique geological formations, which became favourite subjects for Bierstadt, were dismissed by some Northeasterners: 'No such colossal mountains exist, Mr. Bierstadt,' opined the New York *Leader*. The San Francisco *Golden Era* (viewing matters from the West), however, took an opposite view: 'Why should our artists make their pilgrimages to the Alps for mountains . . . when we have the mountains and skies of California and the valley of Yo-Semite'.[168] Bierstadt's paintings had a profound impact on many who saw them. In 1864, during the Civil War, the landscape architect Frederick Law Olmsted (1822–1903) drafted a bill to preserve Yosemite Valley for the nation, a symbolic gesture of faith at a moment when the nation was threatened with collapse. His report acknowledged:

> It was during one of the darkest hours [of the war] when the paintings of Bierstadt . . . had given to the people on the Atlantic some idea of the sublimity of Yosemite . . . that consideration was first given to the danger that such scenes might become private property and through false taste, the caprice or refinements of some industrial speculation of their holders, their value to posterity be injured.[169]

Moving swiftly, President Abraham Lincoln signed the bill into law, and the area has remained largely untouched by invasive industry or agriculture. This acknowledgement of the vulnerability of the land, and the need for active measures of preservation, was deeply and causally linked to the wilderness aesthetic of landscape painters.

The influence of the art of landscape on official policy became

even clearer in the case of the spectacular Yellowstone region, which first came to prominence through articles in *Scribner's Monthly Magazine* in 1871.[170] The painter-engraver Thomas Moran was employed by the editor, Richard Watson Gilder, to refashion for publication some amateur sketches of the strange landscape of hot springs and geysers. Realising the visual potential of the landscape even from these inadequate drawings, Moran joined an expedition to the area led by the geologist Ferdinand Vandeever Hayden. A series of vivid watercolours record his experience of Yellowstone's springs and geysers, brilliantly coloured rock and rainbows. Moran struck up a friendship with the expedition's young photographer, William Henry Jackson (1843–1942), and the two made studies of similar scenes. Hayden returned to Washington DC to begin a campaign to preserve Yellowstone against the forces of change, as 'a great public park for all time to come'.[171] When a government committee was set up to investigate the matter, Moran's watercolours and Jackson's photographs proved to be 'the most important exhibits'.[172] On 1 March 1872, President Ulysses S. Grant signed a bill preserving Yellowstone from development: as at Yosemite the aesthetic had triumphed over the forces of industrial expansion, and one of the world's great wilderness areas was saved as a direct result of its artistic representation. Greater official recognition for Moran, and for Yellowstone, was not far off. After being exhibited as a 'Great Picture' at Leavitt's auctioneers in New York, Moran's *Grand Canyon*

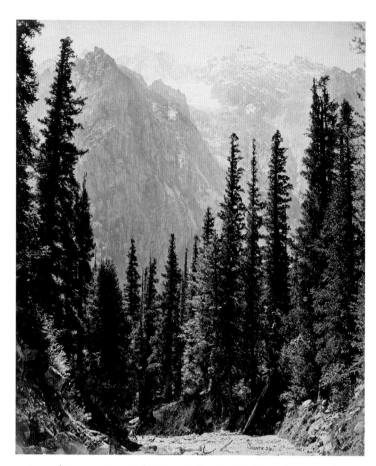

37 Samuel Bourne, *View in the Wanga Valley* (*Simla*), 1863. Albumen print, 29.3 × 24.5 (11 9/16 × 9 5/8). Bourne and Shepherd catalogue number 261, Howard and Jane Ricketts Collection (ELS 2000.6.44)

of the Yellowstone (fig.16) was purchased by the US government in June 1872 for $10,000 and installed in the Capitol building. This work and *The Chasm of the Colorado* (fig.17), which joined it in 1874, are both massive in scale. Overwhelming emblems of a wilderness now under the protecting mantle of the US Government, they mark the culmination of the panoramic tradition of the American Sublime.

Nature versus Culture?

The purchase of Moran's paintings by Congress signalled both official endorsement and its frequent correlative, the beginning of a long decline in critical standing for the artists celebrated in this exhibition. The critic Clarence Cook spoke for many when, in 1883, he rounded on 'this tameness summed up in the newly invented stigma "the Hudson River School"'. Cook moved on to criticise 'our pastoral and chromolithographic art',[173]

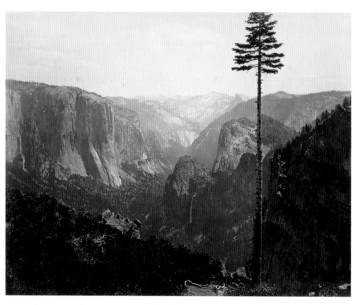

36 Carleton Watkins, *Yosemite Valley from the Best General View, c.*1865–6. Albumen print, 41 × 52.1 (16 1/8 × 20 1/2). The J. Paul Getty Museum, Los Angeles (85.XM.11.3)

surely referring to what now seemed the commercialised vulgarity of Church and Bierstadt, artists who lived to see their once-great reputations collapse. The Philadelphia Centennial Exposition of 1876 confirmed that, in aesthetic as well as broader cultural and political matters, America's lingering adherence to cultural forms of British origin had largely dissipated. The influence of French naturalism and the Barbizon school dominated American taste in painting for the next half century, and the next generation of American painters – such as George Inness (1825–1894) and William Merritt Chase (1849–1916) – took French, rather than British, examples as their point of departure. This shift in tastes and allegiances became vividly apparent when Bierstadt's late work, *The Last of the Buffalo* of 1888 (fig.38), was controversially rejected by the American committee selecting works to be sent to the 1889 Exposition Universelle in Paris. The painting was too large, argued the younger artists, and not representative of contemporary American art.[174] Far from sounding a note of triumphalism, however, Bierstadt's painting was a complex and melancholy reflection on contemporary developments in the West. The painting, whose central event is a heroic battle between a mounted Indian figure and a mighty buffalo, characteristically envisages a wilderness with no hint of European presence. However the title, *The Last of the Buffalo*, probably refers to the dwindling numbers of the mighty animal at the time Bierstadt was painting. The urban fashion for its hide had resulted in excessive hunting – the buffalo was an easy target for the modern repeating rifle. The population had fallen from countless millions – as suggested by the great herds seen in Bierstadt's painting, based on his observations made in 1859 – to near extinction in 1886.[175] By the time *The Last of the Buffalo* was exhibited, public concern was mounting and a conservation campaign had begun. During the same period, the diminished population of Plains Indians had been forced onto reservations. Once again, an artist represented an idealised tableau of life in an American wilderness which no longer existed. It was certainly an unintentional irony, however, that the public failure of this, Bierstadt's last major painting, also symbolised the impending extinction of a cultural aesthetic – the nineteenth-century American Sublime.

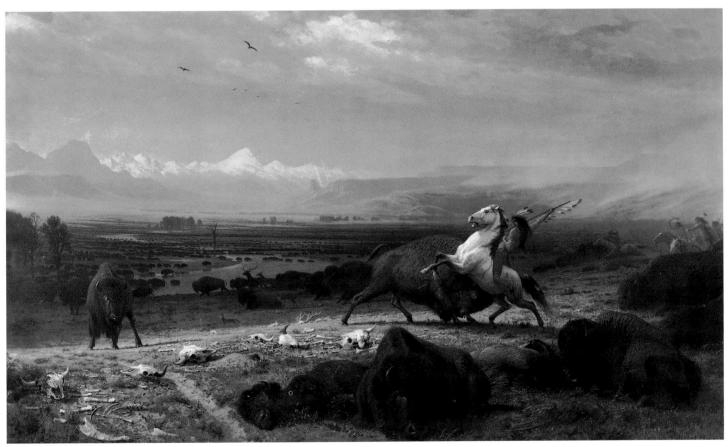

38 Albert Bierstadt, *The Last of the Buffalo*, c.1888. Oil on canvas, 180.98 × 302.9 (74¼ × 119¼). The Corcoran Gallery of Art, Washington DC. Gift of Mrs Albert Bierstadt (09.12)

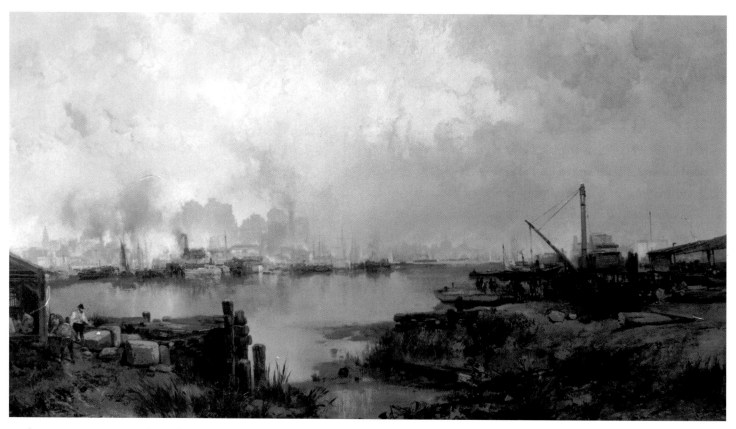

39 Thomas Moran, *Lower Manhattan from Communipaw, New Jersey*, 1880. Oil on canvas, 64 × 114.9 (25³⁄₁₆ × 45¼). Washington County Museum of Fine Arts, Hagerstown, Maryland (A 303 40.01)

The American nation, too, was changing quickly. As large-scale industrialisation fuelled the dramatic growth of new industrial cities such as Chicago and Pittsburgh, a distinctive urban working-class culture developed. Censuses record that the United States, which in 1800 had supported a population of 5.3 million, by 1860 was home to 31 million, and by 1900 had grown to almost 76 million people, far outstripping by this time the small, but densely populated, British Isles. The 13 states of 1776 had grown to 47 by 1900. Massive immigration from Ireland, Germany, Italy and Eastern Europe had, by 1900, produced a polyglot, urban nation with multiple cultural and religious traditions. Leading American industrialists like Henry Clay Frick and J. Pierpont Morgan amassed unprecedented wealth and assembled private art collections to rival those of Europe, and endowed new public art institutions. A rare venture into urban subject matter, Thomas Moran's *Lower Manhattan from Communipaw, New Jersey* (fig.39), announced a new formulation of the Sublime, now borne aloft by the financial and industrial institutions of high capitalism. Skyscraper canyons dwarfing the individual, just as the natural chasms had dwarfed the explorers of the 1850s, became an emblem

40 John Bachmann, *View of Central Park, New York*, c.1875. Tinted Lithograph, 41.4 × 66.1 (16¹⁵⁄₁₆ × 26¹⁄₁₆). I.N. Phelps Stokes Collection. Miriam and Ira D. Wallach Division of Art, Prints and Photographs. The New York Public Library, Astor, Lenox and Tilden Foundations (DEAK 844)

of American identity for the twentieth century. These man-made monuments signified New York's transformation into the capital of a global financial imperium, a final consummation of America's Empire City.[176]

The wilderness, however, was not forgotten, but continues to play a profound role in American culture. The 'Western' has been an important presence from the inception of the film industry (*The Great Train Robbery*, directed by Edwin S. Porter in 1903 – while Thomas Moran was still active – is usually cited as the first example): as a cultural form it is directly descended rom the panoramas and dioramas of the nineteenth century.[177] The visual language of Westerns, from John Ford's classic *Stagecoach* (1939, starring John Wayne) to Clint Eastwood's *Unforgiven* (1992), pays explicit homage to nineteenth-century conventions of landscape representation, framing views just as Bierstadt or Moran might have done. The widescreen format frequently adopted uncannily echoes the panoramas of a century earlier. Nineteenth-century Romantic myths of the wilderness live on in celluloid. Another striking survival, amid the dense urban fabric of present-day Manhattan, is Central Park (fig.40),

the masterpiece of Frederick Law Olmsted, the author of the bill which saved Yosemite, and the architect Calvert Vaux (1824–1895). Boulders, trees and water features contrive a uniquely American sense of the picturesque wilderness quite unlike the manicured and aristocratic Royal Parks of London or the formal public gardens of Paris. The National Park system, whose roots lie in the protection of the Yellowstone and Yosemite regions, now preserves vast areas of the wilderness, providing for modern visitors a form of aesthetic pleasure deeply rooted in the nineteenth-century traditions of the American Sublime. Yet the insatiable hunger of the world's largest industrial economy for the extraction of minerals, oil and gas is constantly at odds with the preservation of the wilderness: the tensions between nature and culture which Thomas Cole envisaged in *The Oxbow* (fig.20) inevitably remain unresolved. At a moment when the contest between industrial growth and environmental protection is once again an issue of fundamental political concern for the American nation, it is apposite to reconsider the contested discovery of the American landscape in the nineteenth century, and the richness of the art it inspired.

1 Wilderness

Ever since Europeans first encountered them, the natural land-scapes of America have been spoken of with awe. 'Here, nature has conducted her operations on a magnificent scale,' wrote a prominent New Yorker in 1816; 'this wild romantic and awful scenery is calculated to produce a corresponding impression on the imagination.' The term 'sublime' describes this imaginative response to immensity or boundlessness, a 'delightful horror' when faced by phenomena of great magnitude, by potential danger or the unknown. These were the attractions of the untamed American landscape, which differed from those of familiar European scenery, where the traces of history – castles, abbeys, battlefields – were commonplace. For Thomas Cole, the first major American landscape painter and a devotee of the wilderness, 'American associations are not so much of the past as of the present and the future.' American history was in the making. The opening of the Erie Canal in 1825 linked the Hudson River with the Great Lakes, creating a major trade route inland from New York and confirming the city's dominance of the American economy. The Hudson passed through wilderness areas of great beauty and there was soon a vogue for rural tourism among wealthy New Yorkers. The Catskill Mountain House hotel (see no.20) was favoured by tourists and artists. A journey to the Catskills in 1825 inspired Thomas Cole to paint a series of wilderness scenes including *Landscape with Tree Trunks* (no.4), a founding masterpiece of the American Sublime. While the use of dramatic contrasts of light and dark derives from European sources, Cole incorporates many distinctive elements in his new vision of landscape – the geology, the autumn colours and the tiny figure of an American Indian. *Kindred Spirits* by Asher Brown Durand (no.1) pictures Cole in the Catskills with his friend, the nature poet William Cullen Bryant. It is a memorial to the birth of a new American aesthetic.

Kindred Spirits, 1849

Oil on canvas 116.8 × 91.4 (46 × 36)
Inscribed lower left 'A.B. Durand, 1849' and on tree at left 'BRYANT | COLE.'
Collection of The New York Public Library, Astor, Lenox and Tilden Foundations. Gift of Julia Bryant

In *Kindred Spirits*, Asher Durand pays homage to the memory of his friend Thomas Cole, whose sudden death on 11 February 1848 represented, according to one newspaper, a 'public and national calamity',[1] and deprived American landscape painting of its undoubted master. Durand's tribute took the form of a posthumous portrait of Cole in a landscape setting, sharing his delight in the natural scene with his eminent literary friend William Cullen Bryant.

Bryant and Cole had met on arriving in New York in 1825: Bryant, a dissatisfied junior lawyer, aspired to become a journalist; Cole, attempting to establish himself as an artist, sought patrons. Soon afterwards, they met Durand, who hoped to abandon his profession as an engraver and become a painter in oils. Bryant was already a published poet: *Thanatopsis*, written at the age of seventeen, was a great success and later formed the subject for a painting by Durand, *Landscape – Scene from Thanatopsis* (1850; Metropolitan Museum of Art, New York), which mixed European with American landscape imagery. The opening of *Thanatopsis* describes exactly the feeling of intimacy with nature celebrated in *Kindred Spirits*:

> To him who in the love of Nature holds
> Communion with her visible forms, she speaks
> A various language; for his gayer hours
> She has a voice of gladness, and a smile
> And eloquence of beauty, and she glides
> Into his darker musings, with a mild
> And healing sympathy, that steals away
> Their sharpness, ere he is aware.[2]

The careers of Cole, Bryant and Durand prospered with their friendship: all three were founder members of the Sketch Club in 1829; all became associated, too, with the National Academy of Design, where Bryant gave lectures on Classical Mythology.[3] By the time of Cole's death Bryant had become editor of New York City's principal daily newspaper, the *New-York Evening Post*, and one of the city's most influential figures; Durand had risen to the status of President of the National Academy of Design. Durand acknowledged his debt to Cole in a letter to the artist's widow Maria on behalf of the Academy:

> It was ever his great aim to elevate the standard of landscape art, and he has been eminently successful. He has advanced it far beyond the point at which he found it among us, and more than this he has demonstrated its high moral capabilities.[4]

Bryant's public tribute to his friend, the funeral oration delivered before the National Academy of Design on 4 May 1848, raised Cole to the status of a national hero:

when I consider with what mastery, yet with what reverence, he copied the forms of nature, and how he blended with them the profoundest human sympathies, and made them the vehicle, as God has made them, of great truths and great lessons, when I see how directly he learned his art from the creation around him, and how resolutely he took his own way to greatness, I say within myself, this man will be reverenced in future years as a great master in art.[5]

In recognition of Bryant's fulsome eulogy for the artist, Jonathan Sturges commissioned Durand to paint *Kindred Spirits*, a memorial to Cole's friendship with Bryant. Once a business partner of Cole's most generous patron, the dry-goods merchant Luman Reed, Sturges became an important collector and Durand's leading supporter.[6] As it came as a complete surprise to Bryant – who chided the delivery men 'I have ordered no picture'[7] – we can surmise that his portrait, like Cole's, was painted from an existing image, perhaps even a daguerreotype. The painting provides a unique document of a network of friendships among New York's cultural elite, and a self-conscious expression of the aesthetics of landscape that they shared.

'Kindred spirits', a phrase which had passed into common usage, derives, as Bryant, Cole and Durand would have known, from John Keats's *Seventh Sonnet*, which first appeared in the collection published in 1817. In addition to providing an evocative title for the painting, the poem offered many suggestive ideas:

> O Solitude! if I must with thee dwell
> > Let it not be among the jumbled heap
> > Of murky buildings; climb with me to the steep, –
> Nature's observatory – whence the dell,
> Its flowery slopes, its river's crystal swell,
> > May seem a span; let me thy vigils keep
> > Mongst boughs pavillion'd, where the deer's swift leap
> Startles the wild bee from the fox-glove bell.
> But though I'll gladly trace these scenes with thee,
> > Yet the sweet converse of an innocent mind,
> > Whose words are images of thoughts refined,
> Is my soul's pleasure; and it sure must be
> > Almost the highest bliss of human kind,
> > When to thy haunts two kindred spirits flee.[8]

Cole and Bryant are, quite literally, placed on 'Nature's observatory', a rocky promontory commanding a spectacular view; the 'crystal swell' of the river can be seen beneath them, and they are 'pavillion'd' by tall trees; doubtless, too, Bryant's 'words are images of thoughts refined'.

For the artist and the poet, the solitude of the Catskills must have provided a welcome contrast to the 'jumbled heap of murky buildings' in New York City. Bryant's funeral oration for Cole explicitly compares the role of poet and painter in celebration of the natural world, paying elaborate tribute to the 'closer familiarity with nature' of the visual artist, who 'studies her aspect more minutely and watches with a more affectionate attention its varied expressions'.[9] Durand's painting stages this dialogue between poetic and pictorial interpreters of natural beauty, and Cole's gesture towards the waterfall suggests that he is extolling the scene to Bryant.[10] As if to make permanent this idyll of companionship in the appreciation of nature, the names BRYANT and COLE are inscribed as though carved in the tree in the left foreground.[11]

The composite landscape provides a gazetteer of the favourite subjects of Cole and Durand in the Catskill Mountains, near the town of Hudson, northwest of New York City. The lower waterfall has been identified as Fawn's Leap, which is found on the south side of Kaaterskill Clove. In the distance lie both the Clove and Kaaterskill Falls, which cannot be seen together in reality. The rock on which the friends stand may be based on a formation now known as Church's Ledge.[12] Nonetheless, the painting has its origins in close observation. The elegant limb of a tree that reaches across the top of the painting derives from a careful pencil sketch from nature,[13] and indeed the entire composition resulted from a trip that Durand took, in homage to Cole, to the Catskills in September and October 1848. Durand had travelled in the early summer to the Adirondacks with the artists John Casilear and John Frederick Kensett. Early in September the same trio arrived at Catskill, lodging at the Mountain House hotel. No doubt they intended to pay their respects to Cole's widow, and perhaps to inspect his remaining works in the studio.[14]

While it avoids the explicit religious references of Cole's later work, *Kindred Spirits* certainly intimates that in the sublimities of the American wilderness can be found spiritual solace. In place of the explicit Evangelical fire and brimstone of works like *Expulsion from the Garden of Eden* (no.10) Durand suggests that the divine can be experienced through the beauty of nature. William Cullen Bryant himself articulated this position in his 'Forest Hymn':

> My heart is awed within me when I think
> Of the great miracle that still goes on,
> In silence round me – the perpetual work
> Of thy creation, finished, yet renewed
> Forever. Written on thy works I read
> The lesson of thy own eternity.[15]

Durand's painting may have been conceived as a response to the tribute painting *To the Memory of Cole* (1848; Des Moines Women's Club, Des Moines, Idaho) by Cole's only student, Frederic Edwin Church, which audaciously claimed for the young artist the mantle of his deceased mentor. Most critics, however, acknowledged Durand as the true successor: as the *New-York Evening Post* put it, 'now . . . Cole has departed he is left alone, at the head of American landscape art'.[16] Although the general tendency of Durand's art during the 1850s was toward a greater naturalism, works such as *God's Judgement upon Gog* of 1851–2 (no.9) clearly indicate a contrary desire to emulate Cole's ambitious historical landscapes.

Kindred Spirits remained with Bryant until his death. It was in the hands of his biographer Parke Godwin in 1854, but had returned to Julia Bryant, the poet's daughter, by 1887. She gave it to the New York Public Library in 1904. Widely reproduced and exhibited, it has become a treasured icon of American landscape painting.
TB

2 ASHER BROWN DURAND 1796–1886
The American Wilderness, 1864

Oil on canvas 64.1 × 101.6 (25¼ × 40)
Inscribed lower left 'A.B. Durand | 1864'
Cincinnati Art Museum. The Edwin and Virginia Irwin Memorial

Asher Brown Durand may, perhaps, have been the first American artist, in the early 1830s, to adopt a systematic practice of making studies in oil directly from nature. He seems to have abandoned the practice towards the end of that decade, only to take it up with renewed vigour in 1844, possibly as a result of reading C.R. Leslie's *Memoirs of John Constable* (1843), which emphasised the importance of oil sketching for the East Anglian artist.[17] Undoubtedly the individual elements in *The American Wilderness*, notably the rocks and tree trunks but also the vegetation in the left foreground, derive from the artist's meticulous oil sketches. The composition, however, acknowledges the time-honoured formula perfected by Claude, with groupings of trees at either side revealing a central vista. The eye moves slowly from foreground to distance, exploring intervening layers of light and shade. The work's tonality, too, follows the Claudean pattern of 'aerial perspective', moving from greens to distant blue. The unusual

precision and sharpness in the foreground here may derive from the influence on Durand of John Ruskin's study of landscape aesthetics, *Modern Painters* (5 vols., 1843–60), though the artist never acknowledged the impact of the English writer, and some critics have been reluctant to make the connection.[18] Nonetheless, Ruskin's particular insistence on the close study of geology seems to have affected Durand's sketching practice, since a large number of his studies feature precise renderings of rock formations and boulders.[19] Durand certainly felt sympathy with Ruskin's view that the close observation of nature constituted a kind of religious duty. While the uncompromising precision of the Pre-Raphaelite landscape exemplified by the English painters John Brett or John William Inchbold is absent, there are close stylistic parallels with the work of other English artists of the period such as Henry Mark Anthony and Benjamin Williams Leader. In his fabrication of an archetypal

American wilderness, Durand, like those artists, balanced the claims of close observation with the traditions of pictorial form.

As befits the title, all hints of human habitation are absent from the painting, a notable (though not unique) departure from Durand's habit of including the figures either of agricultural labourers (as in *The Beeches*, 1845; Metropolitan Museum of Art, New York) or tourists (*Early Morning at Cold Spring*, 1850; Montclair Art Museum, New Jersey). In 1860, Frederic Church had exhibited the great *Twilight in the Wilderness* (no.25), a hugely influential canvas depicting an entirely unpeopled wilderness landscape. Church had exhibited a sketch for *Twilight in the Wilderness* at the National Academy of Design (of which Durand was President), but snubbed the institution by presenting the finished painting at Goupil's Gallery as a 'Great Picture'. While the wish to emulate Church's success may have played a part in Durand's choice of a desolate image of the American wilderness, the immediate political context may also have been a factor. This work was painted in the depths of the Civil War, when any sense of a unified American identity was shattered. *The American Wilderness*, which unusually cites the nation, rather than a single place or region, in its title, perhaps aimed to present an image of an essential America around which all could unite. In 1864, however, this could only be achieved by evacuating any human presence from the scene. As Durand was painting, in May and early June 1864, over 100,000 men were lost; it may be no coincidence that one bloody encounter in Virginia came to be known as 'The Battle of the Wilderness'.

While there is no direct allusion to the war here, Durand envisions the wilderness as a markedly more hostile environment than the hospitable Eden of his earlier, pre-war, works. Jagged rocks, brambles and the gnarled, twisted trunks of oaks in the foreground disrupt the eye's familiar progress from foreground to placid river vista in the distance. Although it is the early summer, the uppermost branches of the tree to the left are barren of leaves, and a gash in the trunk perhaps bears witness to a recent lightning strike. Shattered and broken timber on the ground indicates a lack of human husbandry, perhaps even a recent conflagration. The sharply angled and forcefully articulated shapes in the foreground belong more to the Sublime than to Durand's usual aesthetic mode of the Beautiful.

The American Wilderness was purchased from the artist by Percy Musgrave of Stockbridge, Massachusetts, and remained with his family until its acquisition by the Cincinnati Art Museum in 1968.[20]
TB

Mountain Sunrise, Catskill, 1826

Oil on panel 46.4 × 61.9 (18¼ × 24⅜)
Inscribed 'T Cole 1826' and on the reverse in pencil 'J.L. Morton, Sec. NA 1825 from his friend T. Cole NA'
Private Collection. Courtesy Berry-Hill Galleries, New York

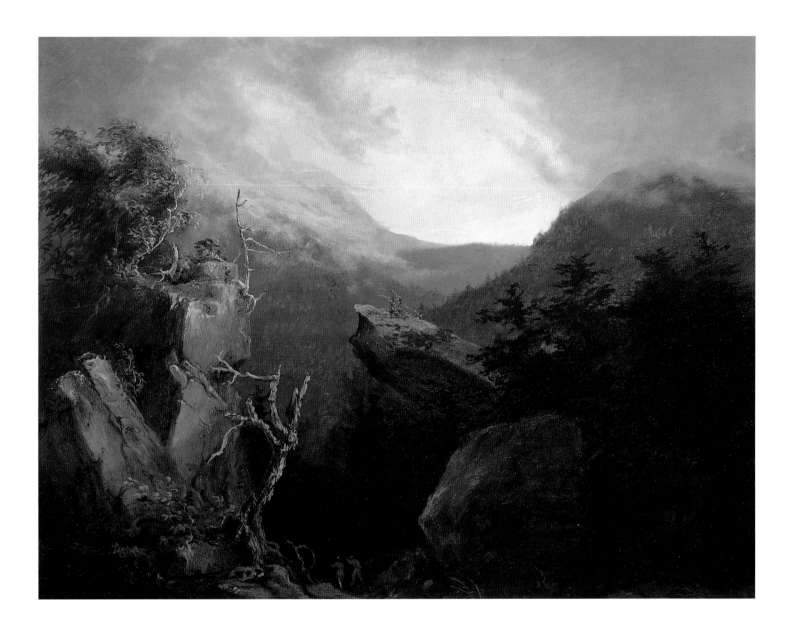

Mountain Sunrise, Catskill probably derives from sketches made either on Cole's first, epoch-making trip up the Hudson River Valley in 1825, or from his return to the area the following year. Right at the end of Cole's list of works from 1825–6, a key source, appears a note recording a 'Sunrise & Sunset – small', which may refer to the present work: if so, the matching sunset painting is, unfortunately, lost.[21] In a short period, inspired by the powerful visual stimulus the Hudson River landscape had provided, Cole advanced from replicating standard picturesque compositions (as in *Kaaterskill Falls*, 1826;

Wadsworth Atheneum, Hartford, Connecticut) to the creation of a vein of highly original American landscape painting. *Mountain Sunrise, Catskill* probably does not represent an identifiable location, but rather a composite of elements observed in the field. Although such elements as the dramatic contrasts of light and dark and the gnarled trees derive clearly from the work of Salvator Rosa, Cole initiated the new form of dialogue between foreground, middle-ground and distant vista which gives these works their peculiar aesthetic force.

At this time Cole was also exploring the literary associations of the

New York landscape, drawing subject matter from James Fenimore Cooper's *Last of the Mohicans: A Narrative of 1757* (1826).[22] The two tiny figures in the foreground of *Mountain Sunrise, Catskill* appear to be Americans of European descent, rather than the Indian figures Cole often included (see no.4). Unlike the solid nineteenth-century bourgeois figures of Cole and Bryant in Durand's *Kindred Spirits* (no.1), it is not fanciful to suggest that these active figures, perhaps clad in rugged leather outfits, represent eighteenth-century pioneers, the characters of Cooper's 'Leatherstocking Tales' (1823–6) or Washington Irving's 'Rip Van Winkle' (1819–20), for whose carefree outdoor life the literary culture of New York in the 1820s felt a profound nostalgia. Cole had in 1826 painted a tribute to *Col. D. Boone, the First Settler in Kentucky* (1826; Mead Art Museum, Amherst College, Massachusetts), a fanciful tribute to the popular exemplar of this rustic way of life.[23] The juxtaposition of diminutive, barely legible figures with a massive, overpowering landscape, as in *Mountain Sunrise, Catskill*, was a formula typical of the European Sublime. But here, Cole surely also draws on his recent experience of traversing the wilderness landscape by foot to give an extra dimension of reality to the scene: perhaps, walking alone in the highlands, he even envisaged himself as a latterday pioneer.[24]

The Hudson River landscape presented Cole with a repertoire of new forms and shapes, among which he became preoccupied with the dark, dome-like hills and spectacular mists rising from below. Various permutations of these dramatic elements dominate a series of major paintings from the period immediately following his 1826 journey. The group culminates in the superb, melodramatic *Sunny Morning on the Hudson River* (1827; Museum of Fine Arts, Boston), where the grim silhouette of a mountain in the foreground gives way to a redemptive vista of the sunlit river behind. In Bryan Jay Wolf's brilliantly provocative reading of this type of image, the Sublime is understood as 'a vocabulary of conflict and resolution' – 'Behind the terror and exhilaration of Cole's paintings, the viewer encounters a moment of psychological reversal when an oppressive burden is lifted and the soul receives an influx of power, which it experiences in an ecstasy of liberation and release.'[25] This drama is the key to *Mountain Sunrise, Catskill*, where the viewer is positioned on a sunlit promontory – our surrogates in the painting are the two figures of pioneers, menaced by a massive boulder to the right. Some hope is offered by a rocky outcrop in the middle-ground, a secure vantage point from which to survey the landscape, prefiguring that in *Kindred Spirits*. But between us and the distant horizon is absolute darkness, a plunging chasm and a seemingly impenetrable forest, depicted in Cole's characteristic manner of an instantly recognisable pattern of stipple, a shorthand for the wilderness. Only by raising our eyes to the pink and gold of the distant sunrise is redemption possible, providing exactly the sense of 'liberation and release' Wolf describes. The revelatory qualities of the sunrise were keenly appreciated by Romantic artists in Europe and America, from Caspar David Friedrich (of whose work Cole was probably unaware) to Turner. The tradition continued in the work of Cole's student, Frederic Church, whose Hudson River landscape *Above the Clouds At Sunrise* (1849; Gulf States Paper Corporation, Tuscaloosa, Alabama) pays homage to these early works of Cole, though Church disavowed the intense psychological drama of Cole's work and the agitated allusiveness of his brushwork in favour of a more direct and scientific vision.

According to an inscription on the reverse, *Mountain Sunrise, Catskill* was presented by Cole to J.L. Morton, the secretary of the National Academy of Design, though the stated date of the gift, 1825, before Cole's journey up the Hudson, seems implausible, since the Academy itself was not founded until 1826. Morton's family, at any rate, owned the work until 1913. More recently, *Mountain Sunrise, Catskill* was owned by Alfred H. Barr, Jr., the founding director of the Museum of Modern Art and an apostle of modernism in the USA. Though he recognised early the merits of then-neglected artists, Barr chose to present Cole's work as an emanation of a uniquely American genius rather than as a distinctive contribution to the long-established European tradition of the Sublime.[26]

TB

4 THOMAS COLE 1801–1848
Landscape with Tree Trunks, 1828

Oil on canvas 67.3.6 × 82.5 (26 ½ × 32 ½)
Inscribed 'T. Cole | 1828 | Boston'
Museum of Art, Rhode Island School of Design, Walter H. Kimball Fund

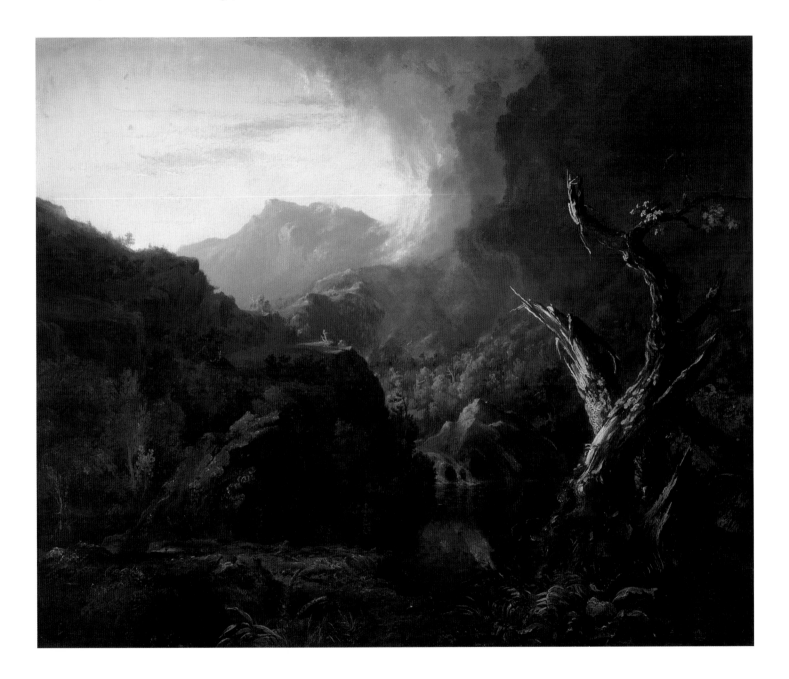

In the summer of 1828 Cole, desperate to sell his two major *Garden of Eden* canvases (see no.10), made a trip to Boston. Although the one-man exhibition at the Old Atheneum met with warm reviews, his paintings remained unsold. However, by the time he returned to New York, Cole had painted and sold two new landscapes, one of which is the present work, now known as *Landscape with Tree Trunks*.

To his signature Cole made the unusual addition, 'Boston', to denote one of relatively few works to be painted outside his studios in New York, and later in Catskill. In a letter to Daniel Wadsworth, Cole 'found the Bostonians liberal and possessing a great deal of taste',[27] a judgement not unaffected by the sale of his landscapes for $175 and $150. Unfortunately, there is no record of the second work,

nor of which sold for the higher price.

Landscape with Tree Trunks is among Cole's finest early essays in the Sublime, clearly influenced by Salvator Rosa. Cole's access to Rosa's work was largely limited to prints, though his Baltimore patron Robert Gilmor possessed a painting entitled Augures, then thought to be by Rosa.[28] The shattered trunk of a tree, seemingly echoing the contortions of a human body in agony, was a characteristic device of Rosa's, often accompanied by intense black stormclouds. Cole adapts this motif to the American landscape with considerable flair, producing a dramatic contrast between a thunderstorm to the right and a beatific vision of sunshine on a secluded valley to the left. The presence of the tiny figure of an American Indian warrior by the falls is emblematic rather than documentary; the Indian population of the area had long been forced away to the north and west.[29] The russet colours of the American fall catch the light in the centre, while the peak in the distance – though composite, rather than topographically accurate – is of a type Cole derived from his observations in the White Mountains.

Though an important autograph work by Cole, this painting does not have a clear provenance. The title, in use since 1945, is probably not original to the work; this might be the painting dated 1828 and lent by Rollin Sanford of Brooklyn to Yale University in 1858 as Clearing off after a Storm in the Catskills.[30]

TB

A View of the Mountain Pass Called the Notch of the White Mountains (Crawford Notch), 1839

Oil on canvas 101.6 × 156.2 (40 × 61 ½)
Inscribed at lower left 'T. Cole | 1839'
National Gallery of Art, Washington DC. Andrew W. Mellon Fund 1967.8.1
LONDON ONLY

During the summer of 1839 Thomas Cole made a trip to the White Mountains of New Hampshire in the company of his friend Asher Brown Durand.[31] On 3 July 1839 Durand made a sketch of Crawford Notch, and Cole's elaborate pencil sketch of the same scene (fig.41), probably executed at exactly the same time, formed the basis for this painting. Verbal annotations specifying colour and texture are scribbled on top of a very precise topographical outline. The finished painting departs to a considerable degree from the drawing, notably through the addition of the dramatic atmospheric effect of storm-clouds in the upper left. Cole also chose in the final work to portray the scene with autumn colours, a uniquely spectacular feature of the American landscape, though his visit was made in July.

Cole's trip to the White Mountains took the place of a proposed voyage to Europe, which he was still contemplating as late as 9 June 1839.[32] In the end, domestic considerations won out: his wife Maria, with a young son to care for, was again pregnant and Cole did not wish to leave for a long period. But there were other reasons, too, for preferring the American landscape to that of Europe, which Cole had forcefully laid out in his 'Essay on American Scenery' of 1835. In the White Mountains Cole found 'the sublime melting into the beautiful, the savage tempered by the magnificent'.[33] Especially notable were areas where 'the bare peaks of granite, broken and desolate, cradle the clouds, while the vallies [sic] and broad bases of the mountains rest under the shadow of noble and varied forests; . . . nature has nowhere so completely married together grandeur and loveliness'.[34]

The principal peak of the White Mountains, Mount Washington, rises to 6,288 feet (1,917 metres), the highest point in the northeast of the United States. In the years before the Rockies became widely known, the White Mountains were thought of as the most dramatic and inhospitable of American environments. Despite this, by the time of Cole's first visit in 1827 the region had already become accessible to intrepid tourists.[35] The famous mountain pass known, as Cole's title indicates, as the 'Notch' is formed by a natural gap between the Presidential and Franconia ranges of the Mountains. The Notch, with its small area of flat land suitable for clearing, had attracted early settlers, and in 1803 the Tenth New Hampshire Turnpike was incorporated, forming a reliable transportation route. In the same year one Abel Crawford founded an inn there, which became well known to travellers; Cole and Durand stayed there in 1839. During the succeeding decades he gained a reputation as 'Patriarch of the Mountains'[36] and the area came to be known as 'Crawford's Notch'.

Cole had made his first sketching trip to the White Mountains in 1827 on the recommendation of Daniel Wadsworth, a significant patron who had provided him with a copious itinerary of picturesque and sublime sites. The resulting *View in the White Mountains* (1827; Wadsworth Atheneum, Hartford, Connecticut) sets a lushly wooded foreground against the distant snowy peak. *A View of the Mountain Pass Called the Notch of the White Mountains*, painted quite late in Cole's short career, is a more complex work that acknowledges recent developments in the area. The foreground bears the signs of heroic labour: large trees have been cleared to make way for agriculture and settlement, the wood still pale from the motion of the saw and axe. About whether this constitutes progress or a despoliation of the wilderness, Cole remained ambivalent. A lone rider follows the turnpike towards the Notch, approaching the Crawford inn, the white building to the left, from which a stagecoach has just departed. By the inn can be seen tiny figures of a woman gaily dressed in red holding the hand of a small child. This small-scale settlement typifies the Jeffersonian ideal of an egalitarian nation of smallholders, each cultivating his own property.

But the terrible power of nature is not to be underestimated; Cole described the White Mountains as a 'battle-ground' of the elements.[37] Among Cole's public, many would have recalled the avalanche, caused by sudden flooding on 29 August 1826, which buried and killed Samuel Willey and his family in Crawford Notch, leaving their house intact. This narrative made a deep impression on Cole:

> The sight of that deserted dwelling the Willey House standing with a little patch of green in the midst [of] the dread wilderness of desolation called to mind the horrors of that night . . . when these mountains were deluged with rocks and trees were hurled from their high places down the steep channelled sides of the mountains . . . A dreadful mystery hangs over the events of that night – We walked among the rocks and felt as though we were but as worms insignificant and feeble for as worms a falling rock could crush us – We looked up at the pinnacles above us and measured ourselves and found ourselves as nothing [38]

This event had been recorded by artists:[39] Cole himself had produced a drawing (now lost) for *Distant View of the Slides That Destroyed the Willey Family, White Mountains*, a lithograph published by Anthony Imbert in 1828. Certainly memories of this disaster permeate no.5. A hint of this untamed natural power can be perceived in the black stormcloud that looms over the left of the composition. The landslide which killed the Willey family began on the barren slopes of Mount Webster whose austere form rises behind the Notch, flanked in wispy clouds. The blasted oaks, to the left and right of the foreground, neither of them apparent in Cole's pencil study, bear witness to the violence of nature.

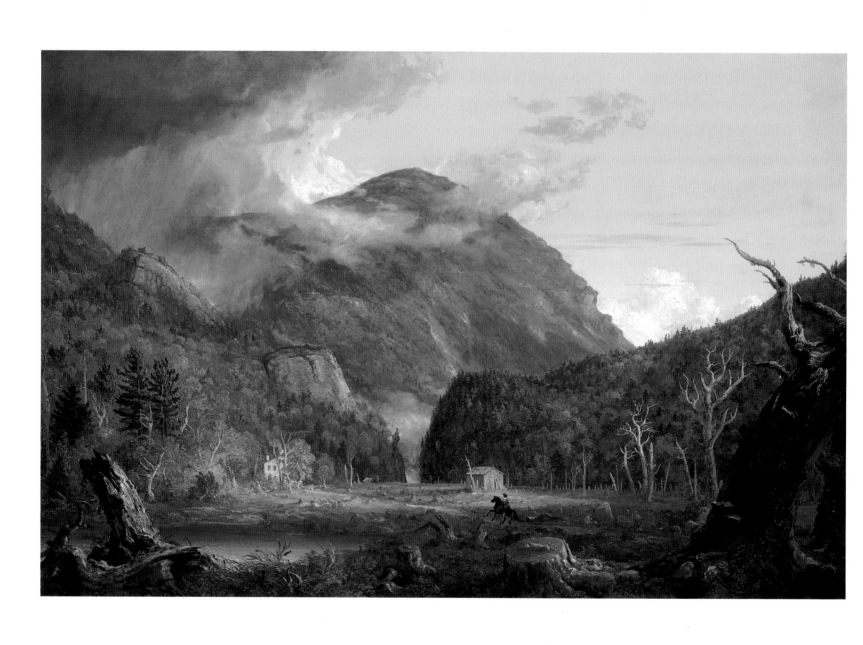

Cole's interest in Crawford Notch may also have had a scientific element. Like several of his patrons, Cole was a keen geologist and collected specimens of rock and fossil.[40] Geological science still operated within a strictly Christian framework at this time: its leading American protagonist was Benjamin Silliman of Yale College, with whom Cole corresponded. Silliman sought evidence in geology of the Biblical Flood. This theory drew particular attention to geological features such as Crawford Notch, which, it was believed, might have been caused by a great inundation of floodwater. Written on the landscape was a history even more grandiose and tragic than that of the Willeys.

A View of the Mountain Pass Called the Notch of the White Mountains was painted in response to a commission from Rufus L. Lord, an important patron whom Cole had met in 1831 while living in Italy. In 1832 Cole had painted for him a *Landscape Composition, Italian Scenery* (Memorial Art Gallery, University of Rochester). In 1839 Lord commissioned 'a picture as a companion to the one he now possesses – size 5ft. by 3ft., 4in. subject American scenery'.[41] He paid Cole $500 for the work in March 1840. Hanging together in Lord's New York residence, the two paintings drew attention to the contrast between the old world and the new: a landscape replete with references to ancient European civilisation, juxtaposed with another representing an America whose associations, Cole had written, 'are not so much of the past as of the present and the future'.[42] When exhibited to considerable success at the National Academy in New York in the spring of 1840, critics immediately recognised the particular national resonances of *A View of the Mountain Pass*, not only in the subject but also in the manner in which it was represented:

41 Thomas Cole, *Notch in the White Mountains from above|with the Notch House (Crawford Notch)*, 1839. Pencil, 28.4 × 43 (11⅛ × 16⅞).
The Art Museum, Princeton University. Gift of Frank Jewett Mather, Jr.

This is truly an American picture. The boldness of the scenery itself, the autumnal tints which are spread over the forest, and the wild appearance of the heavens, gives it a character and stamp that we never see in foreign schools; and we pronounce the artist a master, without rival among his own countrymen.[43]

Having passed through various private collections, the painting was acquired by the National Gallery of Art, Washington DC, in 1966.
TB

6 JOHN FREDERICK KENSETT 1816–1872

A Reminiscence of the White Mountains, 1852

Oil on canvas 90.2 × 127 (35 ½ × 50)
Manoogian Collection

In the summer of 1850 Kensett took a sketching trip to the White Mountains with his artist friends John Casilear (1811–1893) and Benjamin Champney (1817–1907).[44] Like Cole and Durand before them, they were thrilled by the scale and grandeur of Mount Washington, which at over 6,000 feet (1,800 metres) was the tallest peak in the northeastern United States. Kensett, who had returned from Europe in 1847 with a polished technique and a good knowledge of British, French and Old Master paintings, found himself competing for attention with a generation of talented young landscape painters including Frederic Edwin Church, Jasper Francis Cropsey and Sanford Robinson Gifford. In *A Reminiscence of the White Mountains* Kensett demonstrated his ability to produce works in the tradition of Cole and Durand, the acknowledged masters of American landscape. The curling stormclouds in the upper right, energising the composition, are reminiscent of Cole, while the tranquil passages in the foreground surely recall Durand.

Kensett's first major work to result from the 1850 trip – a distant view of the *White Mountains From North Conway* (Wellesley College, Wellesley, Massachusetts) – emphasised the contrast between a lush, agrarian foreground scene with a village and church, and the forbidding snow-capped peaks in the distance. In *A Reminiscence of the White Mountains* there is no sign of human habitation, but rather an unspoiled vista of the American wilderness, the silence disturbed only by the sound of ducks taking to the air in the foreground. The landscape is probably a composite, created in the studio from a number of different sketches made in the White Mountains; as the title acknowledges, this is 'a reminiscence'. It has been suggested that the mountain may represent Camel's Hump Mountain in Vermont (see no.18) or Mount Chocorua in New Hampshire, but it is most likely that Kensett invented it, distilling its form from his observations of the White Mountains.[45] The following description indicates that this work was, almost certainly, exhibited at the National Academy of Design in 1852:

> In the distance of this picture rises a characteristic mountain peak. In the upper right a mass of storm clouds recoil, and on the left the serene bars of summer vapor float in the sky. A broad, still stream bends out to the front from the blue mistiness of the mountain shadow. Upon the right foreground is a lower hillside, receding from the stream, and dotted with fine trees, and directly in the left corner of the foreground lies a mass of shrubby rock, steeply rising from the water.[46]

A clear demonstration of Kensett's accomplishment, the critic judged it 'one of the three finest landscapes in the exhibition'.
TB

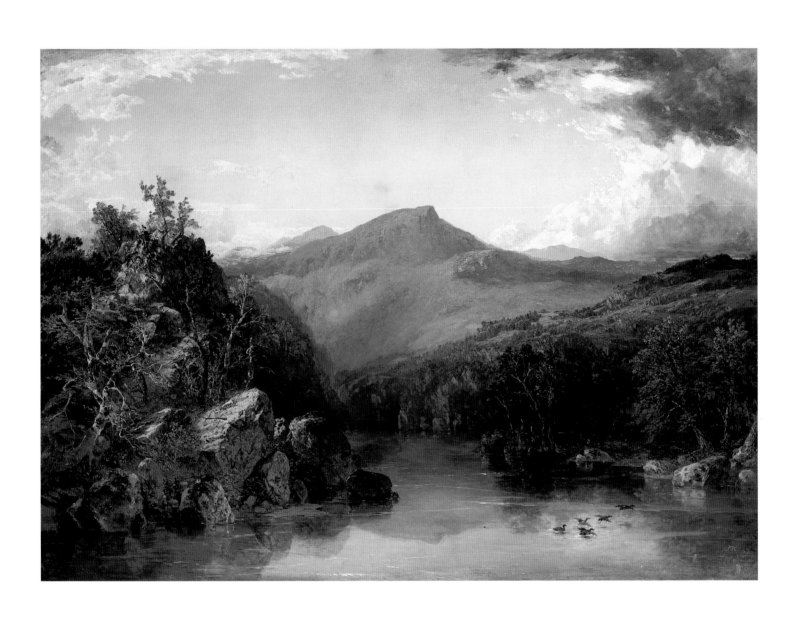

7 JASPER FRANCIS CROPSEY 1823–1900

High Torne Mountain, Rockland County, New York, 1850

Oil on canvas 58.4 × 101.6 (23 × 40)
Inscribed lower left 'J.F. Cropsey | 1850'
The Saint Louis Art Museum, Eliza McMillan Fund

Cropsey began his career as a painter strongly influenced by Cole, an artist he much admired. He modelled both his colour and brush-work on Cole's, and adopted subject matter that reflected the awe in which Cole had contemplated the wilderness of upper New York scenery. This is one of the most romantically wild of Cropsey's early landscapes, in which the spirit of Cole is vividly felt. The artist's use of black to express the threatening presences of nature recalls Cole's Salvator Rosa-like palette (compare no.4 for example), while fore-shadowing the symbolic use of black in an explicitly mythological picture, Thomas Moran's *Hiawatha* of 1867–8 (no.95). Indeed,

Cropsey's evocation of the brooding power represented by the looming crag seems to imply the presence of just such an immanent spirit as the character of Megissogwon in Longfellow's poem. Here, however, the mythology is latent, and apprehension of the painter expressed simply as a response to natural phonomena. *High Torne Mountain, Rockland County, New York* was formerly known as *Eagle Cliff, New Hampshire*, a subject which occurs in a picture by Cropsey in the Museum of Fine Arts, Boston, exhibited at the National Academy of Design in 1851.
AW

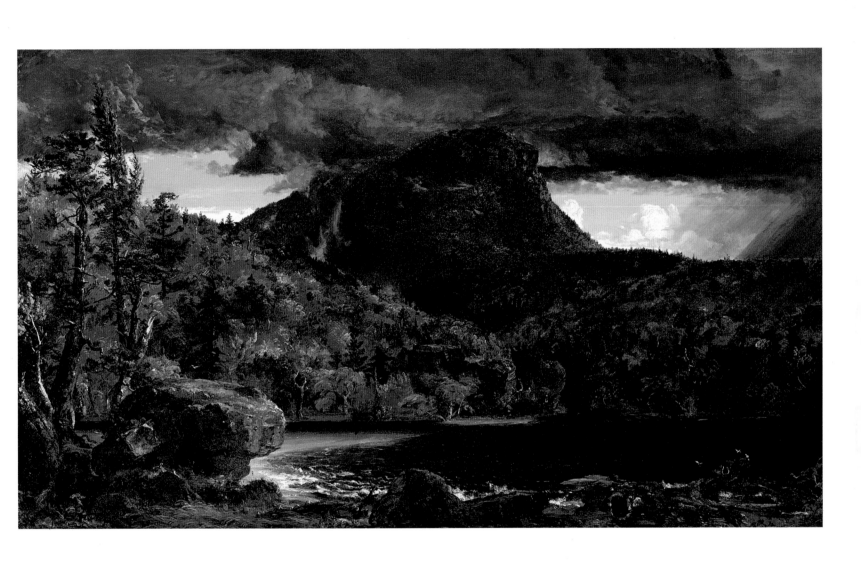

Catskill Mountain House, 1855

Oil on canvas 75.3 × 114.3 (29 5/8 × 45)
Inscribed lower right 'J.F. Cropsey | 1855'
Lent by The Minneapolis Institute of Arts, Minneapolis, Minnesota.
Bequest of Mrs Lillian Lawhead Rinderer in memory of her brother
William A. Lawhead, and the William Hood Dunwoody Fund

The Catskill Mountains in upper New York State were a popular destination for the picturesque traveller, equivalent to the Lake District in late eighteenth-century England. Tourists and artists flocked there from the early nineteenth century on, and in 1822 a substantial hotel was begun to accommodate them. It opened in 1824. It was built by the Catskill Mountain Association on South Mountain, 2,200 feet (670 metres) above sea level, and provided good food and wine, with a spectacular view from its Pine Orchard – 'the view which the angel Michael was polite enough, one summer morning, to point out to Adam, from the highest hill of Paradise'.[47] For a view by Gifford showing the panorama from the Mountain House, see no.20.

This picture shows Cropsey following in the footsteps of Cole, who had painted an almost identical *View of the Two Lakes and Mountain House, Catskill Mountains, Morning* in 1844 (Brooklyn Museum of Art, New York). In technique as well as composition he imitates his predecessor closely. Palette and handling are easily mistakable for Cole's own; compare *A View of the Mountain Pass Called the Notch of the White Mountains* (no.5). Other artists too had depicted the scene from

this spot. Nevertheless, he made his own drawing of the view in June 1852 (Museum of Fine Arts, Boston, Karolik Collection, 54.1642) and clearly thought of this as an independent work, and in no way a copy. It is thought that he painted it on commission for James Edgar, who appears in his account book as having paid him $350 for it, framed, in December 1855. Another version appears to have belonged to E.H. Sheldon of Chicago.

The picture has been seen as the view of 'a classical ruin in an American Arcadian forest',[48] but this seems to stretch the facts unnecessarily. The Mountain House was as much a token of modern improvement extending into the wilderness as the New York and Erie Railroad, and Cropsey no doubt relished the contrast here as he was to do the following year at Starrucca (see no.28). At the same time he was also no doubt fully aware that a view of the hotel (which was by no means a ruin, of course) would appeal to those who had holidayed there.

AW

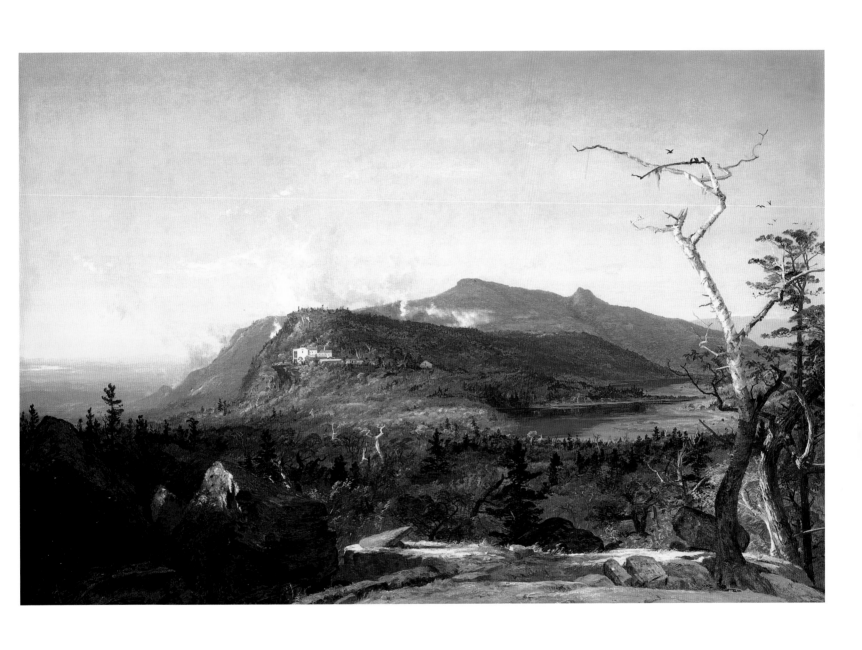

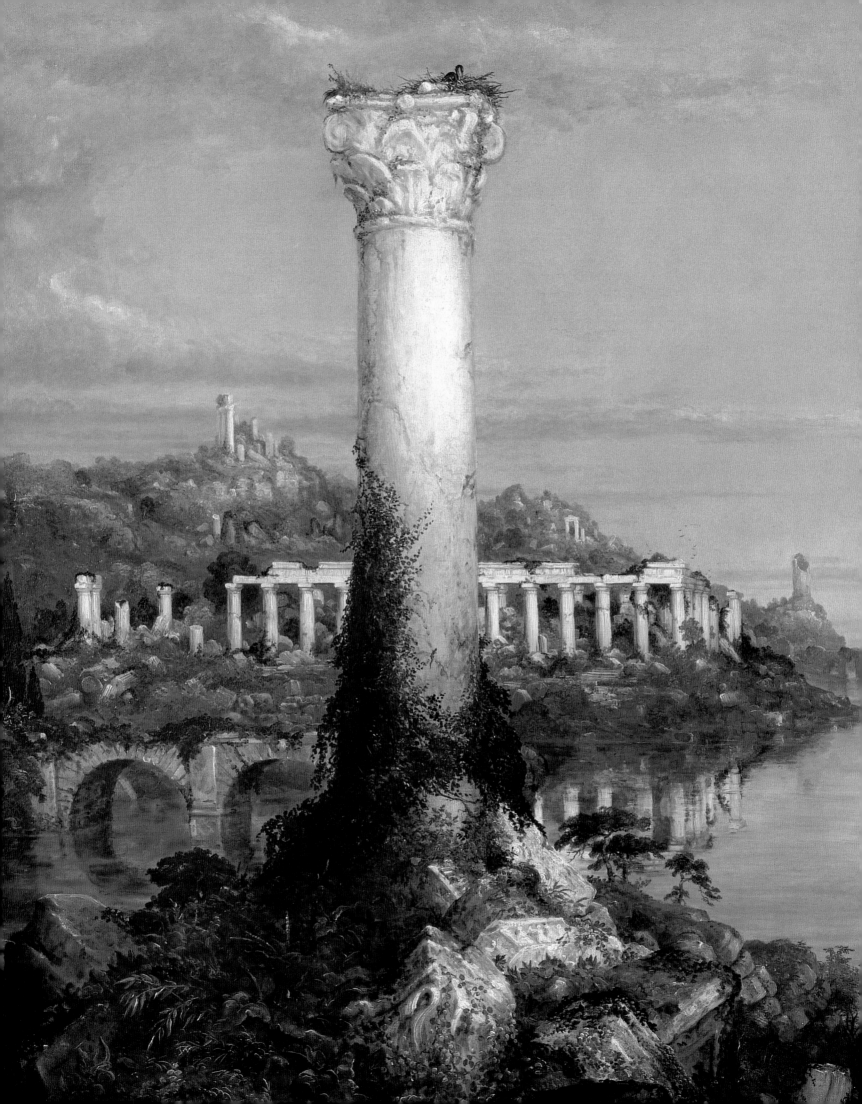

2 The Course of Empire

Encouraged by the success of his wilderness paintings, Thomas Cole aspired to create 'a higher style of landscape'. Following English painters such as J.M.W. Turner and John Martin, he expanded the range of American landscape to embrace religious, moral and mythological themes usually reserved for history painting. Treating biblical subjects like *Expulsion from the Garden of Eden* (no.10) as landscapes, Cole adopted a fiery, dramatic style ultimately derived from Salvator Rosa. Cole's most ambitious work, the five-painting series *The Course of Empire* (nos.11–15), charts the history of an imaginary nation, clearly alluding to the rise and fall of ancient Rome but with implications for modern London and even contemporary America under the expansionist President Andrew Jackson. Politically conservative figures like Cole were horrified by the rapid transformations caused by industrialisation, territorial expansion and the unrestrained growth of cities. A distinctive mountain peak provides a backdrop before which the historical pageant unfolds. The opening canvas depicting a primitive *Savage State*, with a hunting scene, is followed by a classical idyll reflecting the *Pastoral or Arcadian* stage of civilisation. Wealth and military power have reached their zenith in *The Consummation of Empire*. In *Destruction* and *Desolation* the empire suffers the consequences of decadence and corruption. In Cole's cycle, American landscape painting emerged as an art both of aesthetic quality and of intellectual ambition. Artists influenced by Cole, notably Asher Brown Durand and Jasper Francis Cropsey, constructed their own apocalyptic or allegorical commentaries on the state of civilisation and their expectations for it (nos.9, 16 and 17).

Detail from *The Course of Empire: Desolation* (no.15)

9 ASHER BROWN DURAND 1796–1886
God's Judgement upon Gog, 1851–2

Oil on canvas 154.3 × 128.3 (60¾ × 50½)
Chrysler Museum, Norfolk, Virginia. Gift of Walter P. Chrysler, Jr.

God's Judgement upon Gog, Durand's most ambitious essay in historical landscape, was exhibited at the National Academy of Design in 1852 as no.139 with a subtitle from the Book of Ezekiel (39: 17):

> And thou, son of man, thus saith the Lord GOD: speak unto every feathered fowl, and to every beast of the field, Assemble yourselves, and come; gather yourselves on every side to my sacrifice that I do sacrifice for you, even a great sacrifice upon the mountains of Israel, that ye may eat flesh, and drink blood.

Chapter 38 of the Book of Ezekiel opens with God appearing to the prophet and saying 'set thy face against Gog, the land of Magog, the chief Prince of Meshech and Tubal, and prophesy against him'. According to Ezekiel's account, Gog, prince of a territory known as Magog, had mobilised 'a great company and a mighty army' from remote northern regions in order to mount a final onslaught on the chosen people of Israel. God's vengeance would be terrible:

> Surely in that day there shall be a great shaking in the land of Israel; So that the fishes of the sea and the fowls of the heaven, and the beasts of field, and all creeping thing that creep upon the earth, and all men that are upon the face of the earth, shall shake at my presence, and the mountains shall be thrown down and the steep places shall fall, and every wall shall fall to the ground . . . And I will plead against him with pestilence and with blood; and I will rain upon him and upon his bands, and upon the many people that are with him, an overflowing rain, and great hailstones, fire and brimstone.[1]

Durand responded with aptly theatrical lighting effects, placing the prophet in a shaft of sunlight and plunging much of the composition into dark shadow illuminated only by lightning and perhaps a volcanic eruption. Ezekiel stands on a stone ledge that acts as a natural pulpit, curiously similar to the 'Nature's observatory' on which Cole and Bryant are standing in *Kindred Spirits* (no.1), completed three years earlier. Durand uses the Turnerian device of rendering the scene of battle on a Lilliputian scale in relation to the towering mountains and the effects of the storm clouds above them. Here, Gog's army panics at the terrible sights and sounds of divine vengeance and falls into chaos and mutiny. As with Turner's *Snow Storm. Hannibal and his Army Crossing the Alps* (1812; fig.5), the major figure cited in the title is not identifiable in the painting, a subversion of the norms of history painting. But while Gog himself does not appear, his armies, from Persia, Ethiopia, Libya and elsewhere, 'all

of them with shield and helmet', are about to be given up by God 'unto the ravenous birds of every sort and to the beasts of the field to be devoured'.[2] Durand's composition depicts the very moment that flocks of birds descend on the army; lions and tigers are approaching the battle scene from the foreground. The people of Israel will be delivered from this attack, and the weapons of Gog's army will serve as firewood for seven years. Ten years later it was the latter-day chosen people, those of America, who would be turning upon one another with great brutality in the Civil War, but to see *God's Judgement upon Gog* as presaging that calamity would be to attribute supernatural powers of foresight to Durand. Rather, many Americans of the 1840s and 1850s believed in the providential destiny of their own nation, a new chosen people performing God's work.

Undoubtedly the work represents a gambit on the part of Durand, now President of the National Academy of Design, to assume the mantle of Cole as the leading painter of imaginative landscape. Even more than in 1848–9, when he painted *Kindred Spirits* as an assertion of his own closeness to Cole, Durand must have perceived a competitor in Cole's ambitious young student, Frederic Edwin Church.[3] But by the early 1850s Church was moving away from historical landscapes in the tradition of Cole or John Martin. Grandiose Old Testament subjects like *God's Judgement upon Gog* seemed apposite in the fervent religious atmosphere of the 1820s, but in the early 1850s such subjects for historical landscape seemed, to some critics at least, heavy-handed and old-fashioned. The *Home Journal* acknowledged its rootedness in the earlier British tradition: 'This picture would not dishonour masters of more renown than the artist who produced it . . . the battle array would challenge, if alive, the admiration of the great masters of England.'[4] Church's ally among the critics, George William Curtis, attacked *God's Judgement upon Gog* in the *New-York Tribune*,[5] and Henry T. Tuckerman judged that although 'Durand studied it earnestly . . . it cannot be called entirely successful'.[6] *The Knickerbocker*, however, found the work 'the best he has exhibited . . . a most thoroughly studied composition, showing a right and just conception of the grand'. The reviewer acknowledged: 'It is a subject which few of Durand's friends would have selected as favourable for the display of his peculiar excellences; yet it has made a most successful picture . . . really and entirely an ideal landscape.'[7] The *Home Journal* reassured its readers that 'the worthy president has gone beyond himself, and not "beside himself" as an envious critic murmured in our hearing'.[8] Whether discouraged by the mixed responses or simply more interested in other, more naturalistic subjects, Durand was

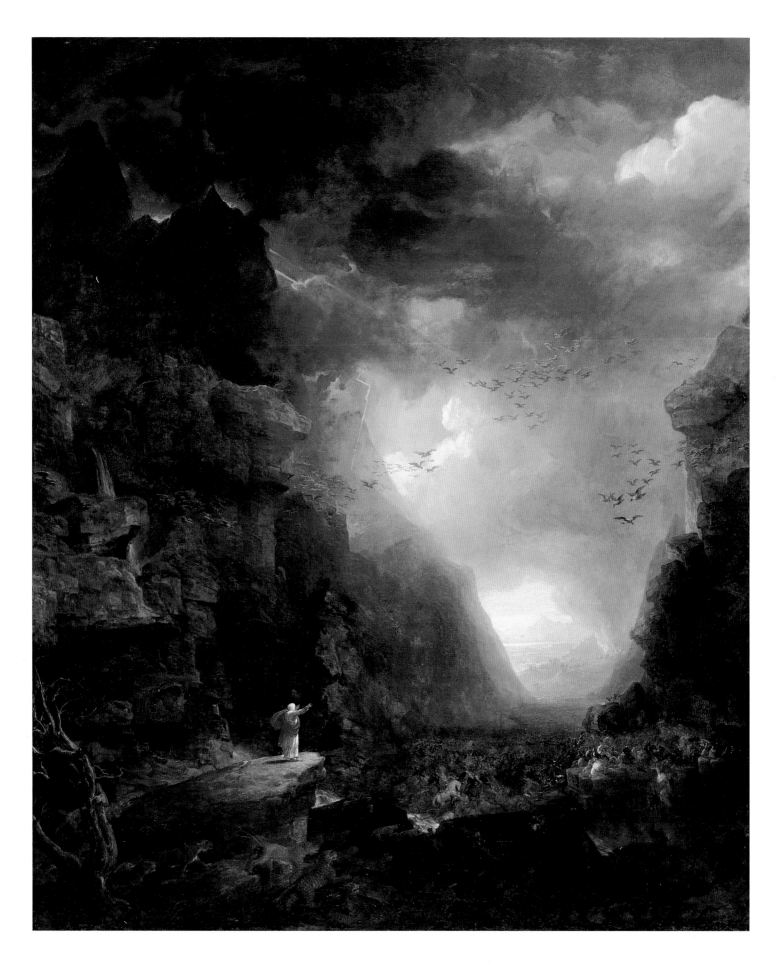

never to attempt such a subject again. After his death in 1886, Daniel Huntington, his successor as President of the National Academy of Design, singled out the work for praise, adding a vivid description:

> It represents a scene of darkness and desolation in the valley of graves. The hosts of Gog are scattered and falling in terror, while the blackened air is horrid with the ominous birds of prey snuffing the blood of the slain oppressors of Israel . . . There is something of an awful and demoniac spirit about this scene, the widest departure from Durand's favourite themes.[9]

The work was purchased by Jonathan Sturges, who had commissioned *Kindred Spirits*, and passed from his family to the Metropolitan Museum in 1895. After deaccessioning, it was acquired by Walter P. Chrysler, Jr., and passed to the museum he founded. TB

Expulsion from the Garden of Eden, 1827–8

Oil on canvas 100.9 × 138.4 (39 ¾ × 54½ inches)
Inscribed lower left 'T. Cole'
Museum of Fine Arts, Boston. Gift of Martha C. Karolik for the M. and M. Karolik Collection
of American Paintings, 1815–1865. 47.1188

In the spring of 1828 Thomas Cole, aged twenty-seven and enjoying
a growing reputation, was engaged on his most ambitious project to
date. On 21 May he announced to his Baltimore patron Robert Gilmor
that, among the eight works he was showing at the annual exhibition
of the National Academy of Design, 'are two attempts at a higher style
of landscape than I have hitherto tried. The subject of one picture is
the Garden of Eden . . . the subject of the other is The Expulsion from
the Garden.'[10] The former is now in the collection of the Amon Carter
Museum, Fort Worth (fig.42); no.10 is the latter. Moving away from
the topographical landscapes with which he had made his name,
Cole had decided to explore the possibilities of 'historical landscape'.
This term describes works of the imagination engaging, like history
painting itself, with historical, Biblical and mythological themes, but
conceiving of them within the format of landscape painting, rather
than principally as figure subjects. Historical landscape was favoured
by the English painters J.M.W. Turner and John Martin, both of
whom Cole was to meet in London in 1829, and whose work he
already knew through the circulation of prints. By pairing works
linked by a narrative, Cole also set an important precedent for his
later serial works such as The Course of Empire (see nos.11–15). The
Eden paintings can be seen as pivotal in Cole's development, marking
a departure which was to change the direction of his career.

The first evidence we have of Cole considering these subjects is a
page from his sketchbook of 1827 on which are jotted ideas for future
subject matter; both subjects are mentioned, but not yet as a pair.
The Garden of Eden (fig.42) was painted first, between November 1827
and March 1828. On 11 March, Cole informed his patron Daniel
Wadsworth that 'the Labour I have bestowed on it is great – and I
hope not without effect',[11] but Cole does not yet mention Adam and
Eve's expulsion from Eden as a pendant. Only in April did he write to
Wadsworth: 'I am endeavouring to finish for Exhibition a companion
picture . . . "The Expulsion of our First Parents from Eden".'[12] The
work, finally titled Expulsion from the Garden of Eden, was completed
with remarkable dispatch that April, yet the composition seems
nonetheless to have troubled Cole, and a number of drawings record
his exploration of the various possible ramifications.[13] The most
spectacular among these experiments is a large unfinished oil
painting, now known as Expulsion – Moon and Firelight (1828; Museo
Thyssen-Bornemisza, Madrid), which Cole abandoned before adding
the figures.[14] The final version of the Expulsion, as befits the subject,
was to be a dramatic work, boldly conceived, and Cole foreswore the
loving intricacy of The Garden of Eden (which celebrates Creation
through an abundance of detail) in favour of broader effects.

Cole's principal textual source for both works was the Book of
Genesis, but he also certainly knew John Milton's re-telling of the
Creation story in Paradise Lost, a favourite subject of British artists.[15]
While The Garden of Eden offers a tranquil and idyllic vision of a tropical
paradise, possibly influenced by Cole's visit to the Caribbean island of
St Eustatia in 1819, Expulsion is the more interesting composition. The
narrative of the Expulsion reads from the right, where Cole offers a
glimpse of the prelapsarian world of the Garden, repeating from the
earlier canvas the lush tropical vegetation, palm trees and smooth
waters overlooked by tall mountains (curiously reminiscent of the
Rockies, which Cole had never seen). The composition is bisected by
a rock formation creating a huge gateway, an opening in the wall to
the Garden, which is shaped like a Gothic arch. Through it, rays of
light indicate the wrath of God and seem physically to propel the
tiny figures of Adam and Eve across a natural bridge, above a plunging
waterfall. Though Cole never rose to distinction as a figure painter,
he succeeds in conveying Adam's grief and Eve's shame through
conventional gestures. In contrast to the light tonality of the upper
right, the rest of the composition is saturated in black, a colour
Edmund Burke associated with the Sublime, heightened with reds,
oranges and brown. The volcano erupting in the background repeats
a favourite image of eighteenth-century painters of the apocalyptic
Sublime, and provides an effective emblem of divine vengeance for
original sin. Cole exploits to the full the dramatic potential of multiple
light sources: the rays of God's anger through the gateway and flare
from the volcano contrast with the pale, even light in the Garden.
To the extreme left a wolf or hyena stands over the carcass of its prey,
with a vulture flying nearby, again in marked contrast to the peaceable
kingdom of The Garden of Eden where deer wander freely without
danger of predators.

Although the Expulsion was evidently only conceived after The
Garden of Eden was on the way to completion, the two works provide
an instructive contrast. Cole could assume that his audience was
sufficiently familiar with the Biblical narrative of the expulsion to
understand the 'before' and 'after' scenes without the intervening
action – the serpent and the apple, the temptation and fall of Eve and
Adam, and the shame of Adam at his nakedness (Genesis 3: 1–18) –
being spelled out. The paintings offer a moral and theological contrast
between a world without sin and a world defined by it; aesthetically,
they also contrast the Beautiful (Eden) with the Sublime (Expulsion),
relying respectively on the heritage of Claude and that of Salvator
Rosa. This set of balancing opposites is replayed, however, between
the two sides of the single composition of Expulsion, the more effective
of the two works, which, accordingly, stands alone in the present
exhibition.

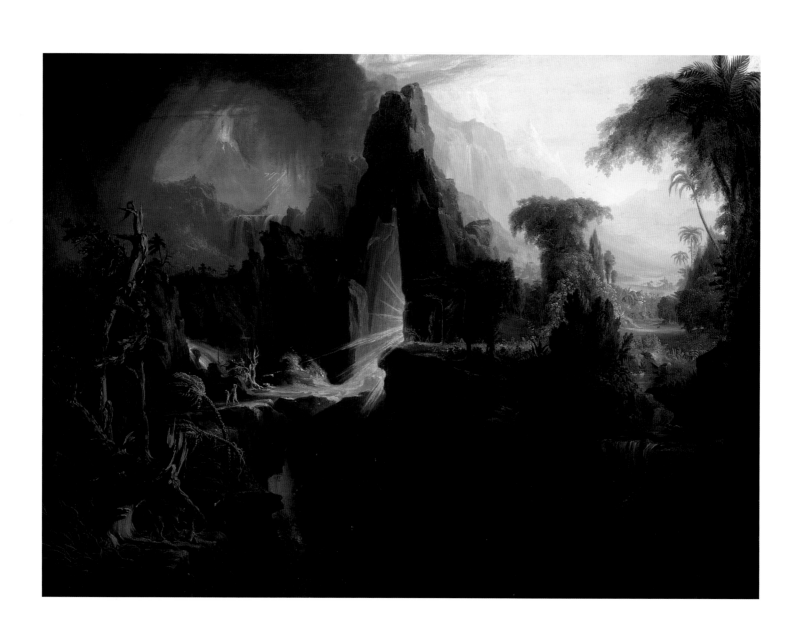

For this first foray into historical landscape, Cole relied heavily on visual precedents, particularly John Martin's illustrations (1826–7) to Milton's *Paradise Lost*, published as mezzotints by George Henry Philips. It is clear that Cole was profoundly influenced not only by Martin's aspiration to create a Romantic form of historical landscape, but also by specific compositions. Cole's *Expulsion* took as its starting point Martin's *Adam and Eve – Driven out of Paradise* (fig.43). Martin, however, does not include any reminiscence of Eden; and Cole reduces the scale of the figures and omits other elements of the narrative such as the serpent, which appears prominently in the lower right of Martin's composition. When the paintings were exhibited at the National Academy of Design in 1828, the hostile critic for the *New-York Morning Courier*, writing as 'MIDDLE-TINT', accused Cole of plagiarism, claiming that 'the whole of the expulsion is a literal copy of the celebrated MARTIN'S picture'.[16] Cole hotly denied these charges in a letter to *The American*, which was quickly reprinted in the *Morning Courier*, claiming that 'my picture was conceived and painted *long before I knew that such a print was in the country*'.[17] Yet despite the considerable originality of Cole's final composition, which is in no sense a direct copy, it is impossible to imagine that Martin's composition was unknown to him. The large oil study, *Expulsion – Moon and Firelight*, is even closer to Martin's composition, and that might explain Cole's decision to abandon it. The choice of Martin as an exemplar was, in itself, provocative; the sheer extravagance of Martin's compositions aligned him with elements of popular culture in Britain, such as the

43 John Martin, *Adam and Eve – Driven out of Paradise* (Illustration to Milton's *Paradise Lost*), 1827. Mezzotint and etching, image size 19.1 × 27.6 (7½ × 10⅞). Yale Center for British Art, Paul Mellon Collection

panorama, the stage spectacle or firework displays, and the critic of the *American Monthly Magazine* warned Cole against 'the degradation' of being seen as 'an imitator of *Pandaemonium* Martin'.[18]

What, if anything, then, is American about Cole's *Expulsion*? It seems certain that Cole intended to draw an analogy between Biblical history and the providential history of the United States. 'We are still in Eden,' Cole believed; 'the wall that shuts us out of the garden is ignorance and folly.'[19] Rapid economic change and the market revolution were transforming America before his eyes; the Garden was being industrialised. If the Garden of Eden, with a few tropical additions, resembles the Catskill or Adirondack landscape, there are also some native elements in the world beyond the wall. The natural bridge and the deep waterfall, as well as the lofty mountains, had been identified as key elements of American scenery at least since Joshua Shaw's *Picturesque Views of American Scenery*.[20] The natural bridge may, indeed, relate to an overhanging rock in the White Mountains of New Hampshire which Cole had called 'The Bridge of Fear' when he sketched it in the summer of 1827.[21] The blasted oak, though deriving from Rosa, was already becoming an important element in Cole's conception of the American wilderness (see the contemporaneous *Landscape with Tree Trunks*, no.4). The painting could be understood as an allegory of America's fall from grace, as the wilderness was increasingly destroyed by westward expansion and industrialisation.

42 Thomas Cole, *The Garden of Eden*, 1828. Oil on canvas, 97.8 × 134 (38½ × 52¾). Amon Carter Museum, Fort Worth, Texas

Despite the intervention of 'MIDDLE-TINT', the critical reception of the Eden paintings was generally positive. The *New-York Mirror*, for example, paid Cole florid compliments:

> we should be required to dip our pen in lightning in order to convey a just impression, to one who has not seen the Expulsion, of the fiery arms that flash through the gate, forbidding the return of the parents of mankind; or, to borrow the hues of the rainbow, while describing that portion of the canvas where a part of Paradise is seen, unparched and verdant.[22]

However, the paintings remained unsold, a particularly vexing turn of events for Cole, who had hoped to fund an eighteen-month trip to Europe on the basis of these sales.[23] The artist lamented to Wadsworth on 5 June 1828: 'Though I have been labouring hard for many months past trusting that by doing so I should accomplish my voyage – I begin to think I shall have to content myself under a disappointment . . . I was perhaps unwise in taking such subject[s], but I felt them, and was led away, without calculating on what I might lose.'[24] After the close of the Academy's exhibition Cole exhibited the works in Boston, again without success, and finally took up a suggestion from his Baltimore patron Robert Gilmor and arranged a raffle for them in order to raise $800 by selling forty $20 tickets. Even this desperate gambit failed. Cole finally sold the works to separate buyers in May 1829; the *Expulsion* passed to Dr David Hosack, an important New York doctor. Whereas *The Garden of Eden* seems not to have been exhibited between 1831 and its dramatic rediscovery and acquisition by the Amon Carter Museum, Fort Worth, in 1990, the *Expulsion* has remained before the public for most of its existence. Hosack lent it to Cole's memorial exhibition in 1848; it passed to Dr J. Kearny Rodgers in 1849, and in 1870 entered the collection of James Lenox, who had in 1845 purchased Turner's *Staffa, Fingal's Cave* (1832; fig.51). Presented by him to the Lenox Foundation, New York Public Library, it was sold in 1943 to Mr and Mrs Maxim Karolik. The Karolik Collection, donated to the Museum of Fine Arts in Boston in 1945, with Cole's *Expulsion* at its heart, became the cornerstone of the popular and scholarly revival of interest in nineteenth-century American art in the succeeding decades.[25]

TB

The Course of Empire

The five large paintings which make up *The Course of Empire*, completed in 1836, represent the summit of Thomas Cole's achievement in historical landscape and one of the great monuments of nineteenth-century American art. Contemporaries immediately recognised its unique ambitions: the novelist James Fenimore Cooper, for example, deemed *The Course of Empire* 'the work of the highest genius this country has ever produced', and found it 'quite a new thing to see landscape painting raised to a level with the heroic in historical composition'.[26]

Cole's biographer, Louis L. Noble, provides a suitably romantic account of the genesis of the series in a moment of profound rumination as Cole surveyed the ruins of ancient Rome in 1832:

> Returning, once, from a long walk with a few friends, he seated himself on the fragments of a column to enjoy the sunset. As its splendours faded into the twilight, all lapsed into a stillness suited to the solemn repose peculiar, at that time, to a scene of ruin. There came through the deepening shadows few sounds louder than the beating of their hearts. After some minutes of silent, mournful pleasure, seated a little apart by a lady, Cole, a thing rather unusual with him, was the first to speak. This he did in his own low, quiet voice, but with such earnestness as told the depth of his emotions and the greatness of his thoughts. The subject was that of the future Course of Empire . . . he passed from point to point in the series . . . until he closed with a picture that found its parallel in the melancholy desolation by which, at that moment, they were surrounded. Such was Cole, the poet-artist, at Rome.[27]

While the spectacle of Rome's ruins heightened Cole's sensibilities, the idea of a cycle of large paintings representing the rise and fall of a civilisation had in fact been in his thoughts for several years. During a visit to London, only days before he visited Turner's studio on 12 December 1829, Cole wrote a lengthy memorandum in his sketchbook describing

> a series of pictures . . . illustrating the mutation of Terrestrial things. The cycle should commence with a picture of an utter wilderness . . . The human figures should be savages . . . indicating in their occupations that their means of subsistence is the chase. The second picture should be a sunrise – partially cultivated country . . . here & there groups of peasants in the field . . . The third picture should be a noonday scene – a gorgeous City with piles of magnificent Architecture. A port crowded with vessels – splendid procession &c., & all that can be combined to show the fullness of prosperity (wealth & luxury). The fourth should be a stormy battle & the burning of a city – with all concomitant scenes of horror. The fifth should be a sunset – a scene of ruins, rent mountains, encroachment of the sea, dilapidated temples, &c – sarcophagi . . . All these scenes are to have the same location.[28]

This historical cycle, Cole speculated, could provide no less than 'an Epitome of Man': *The Course of Empire* was already formed in Cole's mind. During 1831–2, while in Florence, Cole made an abortive start on this grand scheme, painting *A Wild Scene* (Baltimore Museum of Art), which draws together elements from his American work but also alludes to elements gleaned in Europe. Since leaving America in June 1829, he had greatly added to his knowledge of artistic traditions, studying works by Claude, Gaspard Poussin and Salvator Rosa, as well as John Martin and J.M.W. Turner.

Before returning to New York he had written to his patron Robert Gilmor a detailed exposition of the series, adding 'you will probably smile at my castles in the air, for probably they are nothing more: it is likely I shall never have the means of executing this subject'.[29] *A Wild Scene* was sent to New York for exhibition at the National Academy of Design, where Cole hoped Gilmor would accept it in settlement of a loan given earlier to Cole, and commission the rest of the series. The Baltimore patron, a retired financier of considerable intellectual sophistication who had amassed perhaps the finest art collection in America, preferred Cole's naturalistic landscapes. Although he accepted *A Wild Scene* he could find no space for it, and hung it instead in his sister-in-law's house. Lack of space provided his

excuse for being unable to commission the rest of the series, as he informed the disappointed artist on his return to New York in November 1832.

Late in 1832 Cole met Luman Reed (1748–1836), who had made a fortune in the grocery business and retired at the age of forty-eight. Reed had little formal education and, despite his wealth, lived modestly. Reed's meeting with Cole came shortly after he had moved into a newly constructed house, 13 Greenwich Street, and, fortuitously for Cole, was in the process of filling the third-floor gallery with paintings. Luman Reed was to prove an ideal benefactor, constantly encouraging Cole to follow his own artistic instincts and, unlike earlier patrons such as Gilmor, rarely dictating the artist's choice of subject matter. In September 1833, Cole persuaded Reed to commission for the large sum of $2,500, the five paintings forming *The Course of Empire*, though Reed held back from Cole's even more ambitious scheme to decorate the entire room with a total of thirty paintings.[30] Nonetheless, Cole was thrilled, acknowledging to Reed: 'your liberality has opened an opportunity & I trust nothing will now prevent me from completing what I have so long desired'.[31] Cole provided Reed with a diagram, detailing his plan for installing the paintings around a doorway in the Greenwich Street residence (fig. 44). This indicates that *The Savage State* (upper left) and *The Pastoral or Arcadian State* (lower left), and *Destruction* (upper right) and *Desolation* (lower right) were intended to flank the larger canvas, *The Consummation of Empire*. Above them were to be three long, narrow paintings of sunrise, noon and sunset, echoing *The Course of Empire* series, in which the cycle of history follows the same natural pattern of birth and death as the times of day or the seasons of the year. At this stage in 1833, however, the vague compositional outlines within each frame indicate that Cole had only a hazy notion of how his grand design would take shape.

Cole's pessimistic view of the historical cycle, according to which all nations must rise and fall according to the pattern of human life from birth to death, was deeply rooted in European culture. This view was shared by many of his contemporaries, not least J.M.W. Turner, whose unfinished epic poem 'Fallacies

44 Thomas Cole, *Drawing of planned installation of The Course of Empire in Luman Reed's Picture Gallery*, 1833. Pen and brown ink over pencil, 26.7 × 32.4 (10 ½ × 12 ¾). Detroit Institute of Arts. Founder's Society Purchase, William H. Murphy Fund

of Hope' expresses analogous sentiments.[32] In September 1833 Cole explained to Luman Reed: 'The philosophy of my subject is drawn from the history of the past, wherein we see how nations have risen from the Savage State to that of Power & Glory & then fallen & become extinct.'[33] Cole's title is taken from 'Verses on the Prospect of Planting Arts and Learning in America' (1726) by George Berkeley, Bishop of Cloyne:

> Westward the Course of Empire takes its Way;
> The first four Acts already past
> A fifth shall close the Drama with the Day:
> Time's noblest Offspring is the last.[34]

In Berkeley's poem, written before his journey across the Atlantic, the ruin of a decadent Europe is offset by the limitless potential of the American colonies. Other obvious possible literary influences include Edward Gibbon's *The Decline and Fall of the Roman Empire* (1776–88), whose appearance coincided with American independence, an event marking a defeat for one empire and, in the view of some, the founding of another. Scholars have also cited the influential French text *Les Ruines: ou, Méditations sur les révolutions des empires* (1791) by

Constantin-François de Chasseboeuf, comte de Volney, as a possible source. The frontispiece pictures Volney evolving his historical theory while contemplating the ruins of Palmyra, just as Cole did those of Rome.[35] However, the most immediate literary source was Byron's *Childe Harold's Pilgrimage* (1812–18), from which Cole quoted lines in his newspaper advertisements for *The Course of Empire*:

> There is the moral of all human tales;
> 'Tis but the same rehearsal of the past.
> First freedom and then Glory – when that fails,
> Wealth, vice, corruption, – barbarism at last.
> And History, with all her volumes vast,
> Hath but *one* page.[36]

The reason for the popularity of such speculative historical schemes surely relates to the epic events of recent history – the American Revolution, the French Revolution and Napoleonic period, and the turbulent social effects of the industrial revolution. These traumatic developments gave Cole and his contemporaries a vivid sense of history in the making, a turbulent process which they aspired to comprehend by identifying its repeating and recognisable pattern. The details of Cole's narrative are examined in the following catalogue entries, and readings of the work in terms of contemporary politics are discussed on pp.51–4.

It was such a historical cycle that Cole's *Course of Empire* offered to the New York public in October 1836, when the series was exhibited at the National Academy of Design in Clinton Hall. The death of Luman Reed on 7 June 1836 denied him the pleasure of seeing the series completed, but Asher Brown Durand wrote to Cole on 19 June with the welcome news that Reed's family wished to take on the commission.[37] Altogether Reed and his family paid Cole the handsome sum of $4,500. Furthermore the exhibition proved to be both a defining financial and a critical success for the artist. Reed's son-in-law Theodore Allen informed Cole after it closed in December 1836 that the exhibition 'will clear for you

nearly $1,000 in cash and a *Million* in fame. It has been from what I can learn the most successful exhibition of the works of a single American artist ever held in this city.'[38] These financial rewards, and the consolidation of his reputation, allowed Cole to leave New York City and move to the small rural town of Catskill where, three months later, he married Maria Bartow. From this point, his interests turned away from the historical and political concerns of *The Course of Empire* towards religion, and, although he experimented with paired Gothic subjects in *The Departure* and *The Return* (1837; Corcoran Gallery of Art, Washington DC), and *Past* and *Present* (1838; Mead Art Museum, Amherst College, Massachusetts), the main preoccupation of his later years was the journey to salvation. This was the theme of his subsequent cyclical works, *The Voyage of Life* (1842; National Gallery of Art, Washington DC) and the projected *The Cross and the World* of c.1846–8.

After Luman Reed's death his collection became the focus of attempts, led by Jonathan Sturges, to create a permanent art museum in New York. Sturges formed an interim organisation, the New-York Gallery of Fine Arts, supported by significant merchants and financiers. In the Gallery's catalogue it was argued:

> That New-York, with her wealth, enterprise and general intelligence should be destitute of one of the features which indicate, in other cities, a liberal and refined people, has been a source of regret and mortification for all who feel a just pride in her character and prosperity . . . may we not hope that the friends of the Fine Arts here will do as the friends of the Fine Arts have done in London?[39]

Nothing was done, however, until the founding of the Metropolitan Museum of Art after the Civil War. *The Course of Empire* was, instead, presented to the New-York Historical Society in 1858.

TB

The Course of Empire: The Savage State, 1836

Oil on canvas 99.7 × 160.7 (39¼ × 63¼)
Inscribed lower right 'T. Cole.'
Lent by the New-York Historical Society, Gift of the New-York Gallery of Fine Arts, 1858.1

The composition of *The Savage State* is based directly on Cole's earlier work, *A Wild Scene* (1831–2; Baltimore Museum of Art), though with considerable modifications. Two intermediate sketches record Cole's process of revision.[40] *The Savage State*, along with *The Pastoral or Arcadian State*, was largely completed in 1834, although even the final painting shows signs of uncertainty: a pentimento of a large figure of a huntsman can be seen in the centre foreground, by the leaping stag. The removal of this figure ensured that the finished work successfully draws the eye from left to right, in order to focus attention on the larger painting, *The Consummation of Empire*, which was intended to be hung to the right of it (see fig.44). Drawing together a range of elements from Cole's paintings of the American wilderness, *The Savage State* is among his finest essays in the Sublime: the rough, uncultivated landscape and dark rolling clouds pay homage to Salvator Rosa, and the work conjures an atmosphere of dangerous exhilaration, with nature red in tooth and claw.

Also known as *The Commencement of Empire*,[41] *The Savage State* introduces the viewer to the landscape against which Cole's historical pageant is to be acted out. In the distance is a distinctive, though entirely fictional, mountain, with a huge boulder at its top, which will recur in each subsequent image. Pinkness in the clouds and the low sun indicate that it is shortly after dawn, with the mist still rising, implying perhaps that the world has just come into being. We are witnessing the dawn of civilisation, though much of the foreground still lies in darkness. The season is early spring, with new leaves on the trees. This is no Eden, however, but rather an untamed wilderness, inhabited by the hunter-gatherers, the savage peoples who, in Cole's scheme, first inhabited the earth. The single figure of a bowman in the foreground, whose arrow has struck a deer, strikes a noble pose, perhaps borrowed from the famous classical sculpture the *Borghese Gladiator*, which Cole would have seen in Rome in 1832, and which reappears as the colossal statue in the fourth painting of the series,

Desolation.[42] We might imagine that this wild figure, clad in animal skins, represents the brutally individualistic 'war of every man against every man' that the seventeenth-century English political theorist Thomas Hobbes imagined as the natural state of man, to be found among 'the savage people in many places of *America*'.[43] There are signs of social collaboration elsewhere in the composition, however: as Cole notes in his catalogue essay 'we have the first rudiments of society. Men are banded together for mutual aid in the chase &c.'[44] Perhaps Cole's vision of the origins of society is closer to that of the 'social contract' imagined by Jean-Jacques Rousseau.[45] Simple conical huts arranged in a circle at the far right, surrounding a fire, are reminiscent of the tepees of the American Indians, though Cole might have derived them from William Chambers's *A Treatise on Civil Architecture* (London·1759), in which is illustrated a similar structure.[46] Cole's allusion to the native population of America, already driven westwards by the course of American empire, is underlined by the canoes plying the river.

Cole's interest in reconstructing the life of 'savages' echoes the concerns of the science of the human races, known as ethnology, at this time. In the early nineteenth century, before Darwin's theory of evolution, it was already widely believed that the culture of 'primitive' peoples closely paralleled earlier and superseded forms of western social development.[47] Whether this represented an inferior, godless form of life or the ideal, Edenic world of the 'noble savage' was hotly debated. Ethnologists and explorers were interested not only in the question of race – Cole's huntsman seems to represent a Caucasian type – but also of culture and behaviour. Cole's imaginary scene of savages dancing round the fire closely resembles both ethnological illustrations and contemporary paintings by explorers and settlers, such as the British artist John Glover's images of Australian aboriginal peoples.[48]

TB

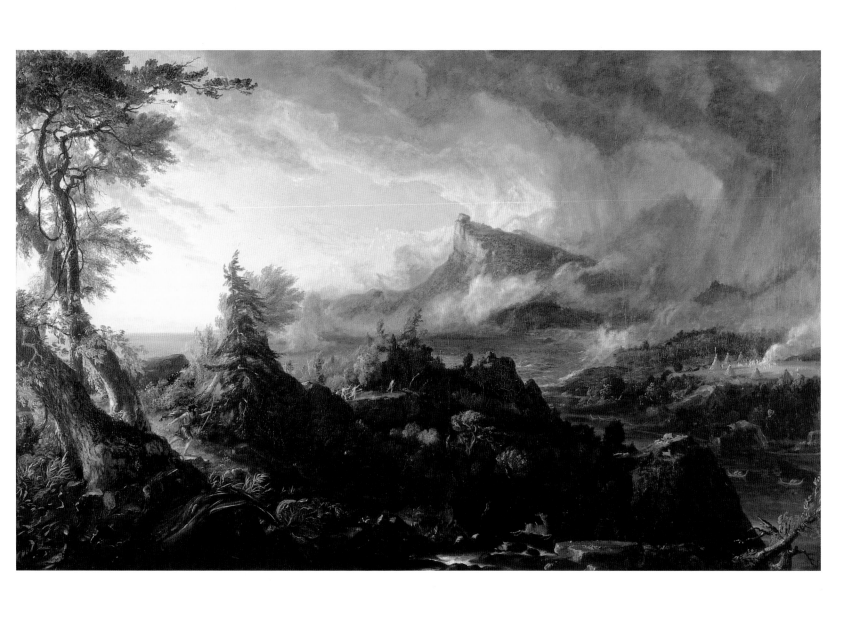

The Course of Empire: The Pastoral or Arcadian State, 1834

Oil on canvas 99.7 × 160.7 (39¼ × 63¼)
Inscribed lower centre 'T.C.'
Lent by the New-York Historical Society. Gift of the New-York Gallery of Fine Arts, 1858.2

For *The Pastoral or Arcadian State* the Sublime mode derived from Salvator Rosa is replaced by that of the Beautiful, which Cole's contemporaries recognised as a homage to Claude Lorrain, whose seventeenth-century vision of an ideal pastoral world had a profound influence on later artists. Turner's *Dido and Aeneas* (1814; Tate Gallery, London), which Cole had admired on his recent trip to Britain, was one of many modern re-interpretations of the Claudean pastoral. Cole introduced the work as follows:

> The simple or Arcadian State, represents the scene after ages have passed. The gradual advancement of society has wrought a change on its aspect. The 'untracked and rude' has been tamed and softened. Shepherds are tending their flocks, the ploughman with his oxen is upturning the soil, and commerce begins to stretch her wings.[49]

The familiar vista has indeed been transformed. Seen under the even light of the early summer is an idyll of the simple, rural culture much like that described by Virgil and other classical poets of the pastoral. Children are at play to the right, entertained by a rural pipe-player, a pastoral figure which appealed particularly to the Romantic imagination (as in William Blake's *Songs of Innocence* of 1789). This group indicates that music and dance have become more refined than the untamed antics around the fire in *Savage State*. The circle of huts from the earlier work has been replaced by a fishing village; boats move across the wide river and a large wooden craft is being built by its banks; maritime trade is under way. In the foreground the arts, science and industry are in their infancy; a boy scratches a comical stick figure of the white-clad lady holding a distaff. They represent respectively the birth of painting and of manufacturing. In a charming gesture Cole placed his monogram directly under the childish artist, suggesting perhaps that he still had much to learn. Ellwood Parry has related this to Vasari's story of Giotto as a shepherd boy being discovered by Cimabue drawing with a stick on a smooth piece of rock, and, in turn, to Cole's own discovery narrative, in which his 'genius' at an early age was recognised by Colonel John Trumbull.[50]

A striking element is the round stone temple in the middle distance, clearly based on Stonehenge, the only identifiable topographical feature in the entire cycle. The mysterious English monument exerted a considerable influence over the imagination of Romantic writers and painters, from James Barry to Blake, for whom it provided a tantalising glimpse of a distant, pagan antiquity.[51] Despite Cole's undoubted wish to allow his paradigmatic narrative to provide, in the best traditions of history painting, an illustration of a general principle rather than a specific instance, the use of Stonehenge here clearly relates *The Course of Empire* to Britain, the land of Cole's birth, where he had returned from 1829 to 1831. Cole's scheme of rise and fall raised important questions about the course of the British empire, which after the defeat of Napoleon in 1815 continued to grow in size throughout the nineteenth century.

A few details disrupt Cole's idyllic view of pastoral society, foretelling the future course of history. A soldier in arms can be seen in the centre foreground, indicating that war is a constant of human civilisation, a reminder of the natural aggression also manifested by two rams clashing behind the flock of sheep. Most of all, the tree-stump (as in *A View of the Mountain Pass Called the Notch of the White Mountains*, no.5) to the extreme right, indicates that man's quest for progress is won at the cost of the natural environment. Cole's ambivalent attitude to such progress became the subject of his next major topographical landscape, *View from Mount Holyoke, Northampton, Massachusetts, after a Thunderstorm (The Oxbow)* (1836; fig.20).

Cole showed the completed works, *The Savage State* and *The Pastoral or Arcadian State*, to Luman Reed in the winter of 1834–5, and the journalist William Dunlap wrote an article 'in praise of Cole's recent pictures' in the *New-York Mirror* on 6 December 1834. Dunlap reported that the 'great conception' of five paintings 'will probably be completed in another year'. He was particularly taken with 'the quiet harmony of rural happiness, the effects of cultivation [and] the bounties of nature' in *The Pastoral or Arcadian State*, concluding that 'This is the poetry of landscape painting.'[52]

TB

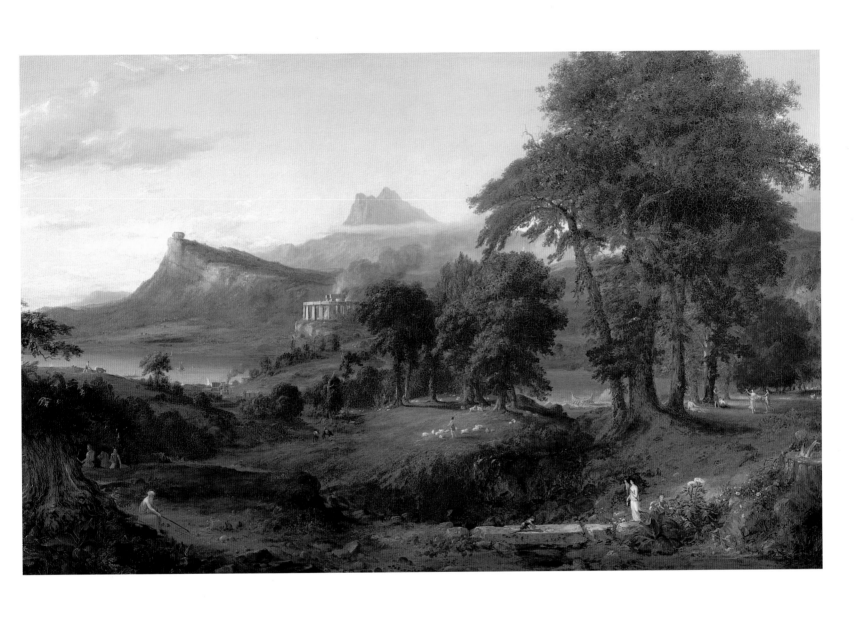

The Course of Empire: The Consummation of Empire, 1835–6

Oil on canvas 130.1 × 193 (51¼ × 76)
Inscribed right centre 'T. Cole | 1836.'
Lent by the New-York Historical Society. Gift of the New-York Gallery of Fine Arts, 1858.3

The Consummation of Empire, painted on a larger canvas than the other four works, was intended to stand as the centrepiece of the series (see fig.44). It presents a vivid panorama of the vainglorious maturity of a powerful empire. The imperial city stands astride a great river, with the familiar outline of the mountain distantly visible to the right. Although the natural world has almost disappeared under marble and gold, we can discern that it is the end of summer, as the noonday sun beats down on a spectacular celebration. To a fanfare of trumpets from above, a returning conqueror, robed in red,[53] crosses the bridge on a chariot pulled by an elephant. He is surrounded, in Cole's words, 'by captives on foot, and a numerous train of guards, senators &c. – pictures and golden treasures, are carried before him. He is about to pass beneath the triumphal arch, while girls strew flowers around.' In a direct allusion to Roman mythology a statue of Minerva, holding a victory figure in her right hand, appears on a columned pedestal to the centre right; in a Doric temple to the left (an invention of Cole's), we see 'a multitude of white robed priests'. Cole acknowledged that the scene represents the 'summit of human glory', where 'wealth, power, knowledge and taste have worked together, and accomplished the highest meed of human achievement and empire'.[54] From a throne at the right an 'imperial personage', perhaps the empress herself, enjoys the spectacle, surrounded by attendants. Beneath her, by an elaborate fountain, is seated a pensive bearded figure with a scroll: his role may be that of the historian, like Cole the recorder of the historical drama unfolding before him.

Inevitably, the seeds of destruction are present even at the moment of the empire's triumph. The returning victor's subjugation of neighbouring states indicates an empire acquired through territorial aggression (in contrast, perhaps, to the expansion of the United States at least in part by treaties and by financial transactions such as the Louisiana Purchase of 1803, but prefiguring the Mexican–American War of the 1840s, which Cole abhorred) and liable to future rebellion. The showy pomp and circumstance would also have seemed especially horrifying to an American audience, for whom, in addition to its obvious links to imperial Rome, it might have had more recent echoes of George III, the last British king to reign over the American colonies, and his flamboyant son George IV, who had died only in 1830. The scene is overwhelmingly one of hubris, inexorably leading to the nemesis of the final canvases in the series. The excessive population, crowding every balcony and parapet, also implied a future catastrophe: such a vast sea of people would have put contemporaries in mind of the millenarian population theories of Robert Malthus, who in a famous essay of 1798 had predicted mass starvation for Britain, and by implication all industrialising countries,

if the population growth continued at its current rates.[55] A quaint but telling omen of future trouble can be found in the left foreground, where a small boy has been sailing a toy boat, but an older boy sinks it with a stick; such cruelty will be acted out on a grand scale in the next painting.

This ambitious work gave Cole considerable trouble and absorbed his attention from April 1835 until the following May. As his correspondence with Luman Reed attests, the extreme elaboration of detail and the complexity of the architectural setting taxed his resources to the limit. No preparatory works survive, but the outlines of an early version of the composition were drawn in April 1835 on another canvas the same size, which was re-used in 1836 for *View from Mount Holyoke, Northampton, Massachusetts, after a Thunderstorm* (*The Oxbow*) (fig.20). Reed travelled to Cole's rural studio at Catskill on 21 November 1835 to examine the work as it progressed. Their conversation must have clarified Cole's thinking, for he wrote soon afterwards: 'I have made great alterations in the architecture on both sides of the picture, something in the manner I contemplated when you were here.'[56] By February he thought the work was almost complete but, carrying it downstairs to take advantage of the better light, he was disappointed. On 19 February he wrote despondently that he was 'tired of the gaud & glitter of the large picture & not quite in the humour for the tumult & so forth'[57] and continued to retouch it; by 2 March he reported 'I think [a] good day's work would finish it'.[58]

Cole's most eclectic production, *The Consummation of Empire* inevitably draws on a wide range of sources, only a few of which can be noted here.[59] The basic compositional idea, the representation of a busy seaport, derives from two works Cole had seen in London, Claude's *Seaport with the Embarkation of Saint Ursula* (1641; National Gallery, London) and Turner's *Dido Building Carthage, or the Rise of the Carthaginian Empire* (1815; National Gallery, London). Cole had particularly admired Turner's 'splendid composition', noting enthusiastically:

> Magnificent piles of architecture, some finished and some incomplete, fill the sides of the picture while the middle of it is a bay or arm of the sea that comes to the foreground, glittering in the light of the sun which rises directly over it. The figures, vessels, sea are very appropriate.[60]

Turner's composition was particularly relevant to *The Course of Empire* because it had, in *The Decline of the Carthaginian Empire* (1817; Tate Gallery, London), a companion piece: Turner explicitly paired imperial rise and fall, sunrise and sunset, appending to the title a stanza of his own poetry drawing out the moral.[61]

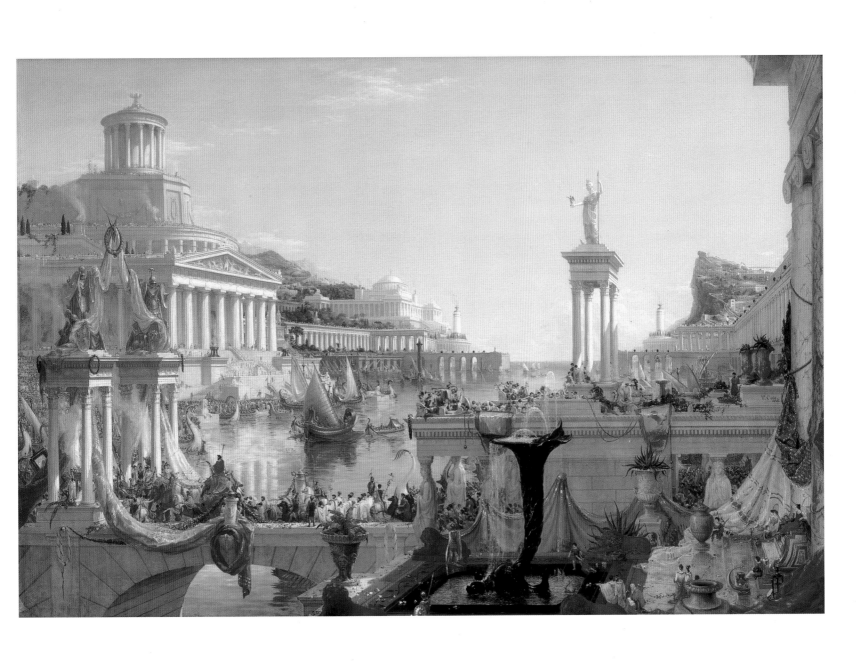

Like Turner's elaborate compositions, Cole's *The Consummation of Empire* is richly ornamented with quotations of archaeological detail, though unlike later painters such as Lawrence Alma-Tadema (1836–1912) he was not aiming for an illusionistic recreation of a specific time or place, but rather to create an 'epitome' or archetype of all civilisations. Architectural elements are drawn from a range of published sources: the caryatid figures, which hold up the musicians' balcony in the centre foreground, like those on the facade of the distant, gold-domed palace, must derive from the Erectheum in Athens, which could have been known to Cole from published sources.[62] He must also have seen W. & H.W. Inwood's St Pancras Church (1819–22) during his time in London from 1829 to 1831, where a portico was adorned with full-scale copies of the caryatids of the Erectheum.[63] Many details are identifiable, such as the Hellenistic marble sculpture the *Diana of Versailles* (Louvre, Paris), which Cole inserted as the central figure in the pediment of his Doric temple, and the *Borghese Vase*, another treasure from the Louvre, which is appropriated as a grandiose plant-pot on the terrace to the right. The procession in the foreground is distilled from a number of sources, including Andrea Mantegna's *Triumphs of Caesar* (c.1486–1505; Royal Collection, Hampton Court), which Cole had seen in 1829.

When the series was exhibited in 1836, *The Consummation of Empire* won the warmest acclaim. Most gratifying, perhaps, for Cole was the response of the *New-York Mirror*, which encapsulates Cole's intended meaning for the work:

This splendid picture represents man's attainment of a high state of comparative perfection: but we see the causes of *decline* and *fall* upon the face of it. Mingled with the triumph of art is the triumph of the conqueror, and with the emblems of peace and religion we see the signs of war and display of pride and vanity. The ostentatious display of riches has succeeded to the efforts of virtuous industry, and the study of nature and truth. We see that man has attained power without the knowledge of its true *use*: and has already abused it.[64]

There were clearly implications for the America of Cole's own time. The city of New York was growing rapidly and establishing itself as the centre of a new market economy, in which enormous fortunes could be made quickly; civic architecture was keeping up with this rapid growth, although there were also slums, overcrowding and disease. Politically, the figure of the conqueror could be understood as an allusion to Andrew Jackson, whose Presidency was marked – so his opponents argued – by corruption and the arbitrary exercise of power. Cole was committed to a conservative, Federalist political outlook, which upheld the gentlemanly values of the traditional landowning class who were suspicious of commerce and speculation. Perhaps, then, *The Consummation of Empire* alludes to the triumph of the brasher, urban, capitalists of New York city, who thrived under Jackson's presidency, a triumph that, Cole felt, would lead the nation to inevitable disaster.[65]

TB

14 THOMAS COLE 1801–1848

The Course of Empire: Destruction, 1836

Oil on canvas 99.7 × 161.3 (39 ¼ × 63 ½)
Inscribed lower right 'T. Cole 1836'
Lent by the New-York Historical Society. Gift of the New-York Gallery of Fine Arts, 1858.4

'I have been engaged in Sacking & Burning a city ever since I saw you,' wrote Cole to his friend Asher Brown Durand on 30 August 1836, '& am well nigh tired of such horrid work.'[66] *Destruction*, fourth act in the epic drama of *The Course of Empire*, had been under way since January that year, before the death of Luman Reed. In his first moments of enthusiasm Cole had written to his patron: 'I am in hopes that you will consider [*Destruction*] the finest picture. I believe I am best in the stormy & wild.'[67] Cole took up work on the painting again after hearing late in June 1836 that the commission would be honoured, despite his patron's death, and the work was completed in the late summer of the same year.

Although we return to the location depicted in *Consummation*, order has given way to chaos. Cole's own description is as vivid as any:

> Luxury has weakened and debased. A savage enemy has entered the city. A fierce tempest is raging. Walls and colonnades have been thrown down. Temples and palaces are burning. An arch of the bridge over which the triumphal procession was passing in the former scene has been battered down, and the broken pillars, and ruins of war engines, and the temporary bridge that has been thrown over, indicate that this has been a scene of fierce contention . . . Along the battlements among the ruined Caryatids, the contention is fierce, and the combattants fight amid the smoke and flame of prostrate edifices.[68]

Individual figures play a more important role here than in *Consummation*; on a terrace in the right foreground the invaders attack not only the imperial army, but the women of the city. One is pulled by her hair down some steps, while another, presumably from her white dress a virtuous maiden, leaps to her death to avoid the rapacious or murderous attentions of a soldier who grabs her cloak.

The composition moves the eye from right to left, propelled by the dynamic, diagonal emphasis of the colossal statue and leading towards the sun breaking through the clouds at the upper left. When hung in the original positions (fig.44), *Destruction* would have drawn the eye towards *Consummation* and to *The Savage State*, which hung in the upper register to the left. The right-hand side of the composition, now occupied by the great headless statue, was troubling to Cole. An early composition drawing shows a massive fountain, in the form of a lion, occupying this position: the effect is somewhat absurd, however, and the lion fountain eventually appeared only in diminutive form in the lower right corner.[69] Cole's next idea was to include a statue of a rearing horse at the right of the composition, and he appealed to Durand to find him a miniature plaster cast of one in New York: '"A horse, a horse, a kingdom for a horse!" I do not want a tame

pony holding up one foot to shake hands with, but a rampant, rearing horse . . . If you cannot get a horse for me will you get a *man*.'[70] It was indeed the figure of a 'man', a version of the *Borghese Gladiator*, which eventually and most effectively filled this position, though whether Durand provided a plaster cast, a print or a drawing is not recorded. In his pose is an echo, albeit reversed, of the position of the savage bowman from the first canvas. As in *Consummation*, Cole borrowed copiously from printed sources in *Destruction*, directly quoting, for example, from an esoteric source, a frieze from the 'Monument to Lysicrates' reproduced in Stuart and Revett's *Antiquities of Athens*, for the figure of a man with a torch running beneath the colossal statue.[71]

Destruction was Cole's definitive statement of the apocalyptic Sublime, emulating earlier works by Martin and Turner. The vortex of swirling dark cloud is appropriated from Turner's *Snow Storm. Hannibal Crossing the Alps* (1812; fig.5), which Cole much admired when he saw it in 1829: 'a sublime picture', he noted, 'with a powerful effect of Chiaro scuro'.[72] As in Turner's work, the macrocosm of the elements comments on, and participates in, the conflict taking place below, though Cole's figures are not overwhelmed by nature to quite the same degree. Nonetheless, raging fires and a stormy swell in the estuary add to the drama. John Martin's dramatic mezzotint, *The Fall of Babylon* (1831), also belongs in the genealogy of Cole's image. *Destruction* undoubtedly relates to more popular manifestations of apocalyptic imagery, though we have only limited evidence concerning the panoramas, dioramas and stage performances of this period in London and New York. Robert Burford's panorama of *Pandemonium, from Milton's Paradise Lost*, shown in London during Cole's visit in 1829, included broadly similar effects, and was based on Martin's illustrations to *Paradise Lost*, which had earlier influenced Cole's *Expulsion from the Garden of Eden* (no.10). As Cole was working on the series, the new diorama building in New York was showing a huge *Departure of the Israelites out of Egypt*, and Hannington's 'Perestrephic Diorama' included a *Conflagration of Moscow* with lighting effects and moving mannequins.[73] Whether he relied directly on these works or not, Cole could be sure that his public had an appetite for scenes of chaos and destruction.

If *The Course of Empire* offered parallels with American history, then *Destruction* lay in the future. Nonetheless, aspects of Cole's calamitous scene were prefigured by events taking place as he worked on the canvas. On 16 and 17 December 1835 a huge fire swept through lower Manhattan, causing massive destruction in the Wall Street area. Luman Reed's house was unaffected, but Cole must have read of families losing their homes, of businesses destroyed and livelihoods ruined. One artist, Nicolino Calyo (1799–1884), was on hand and

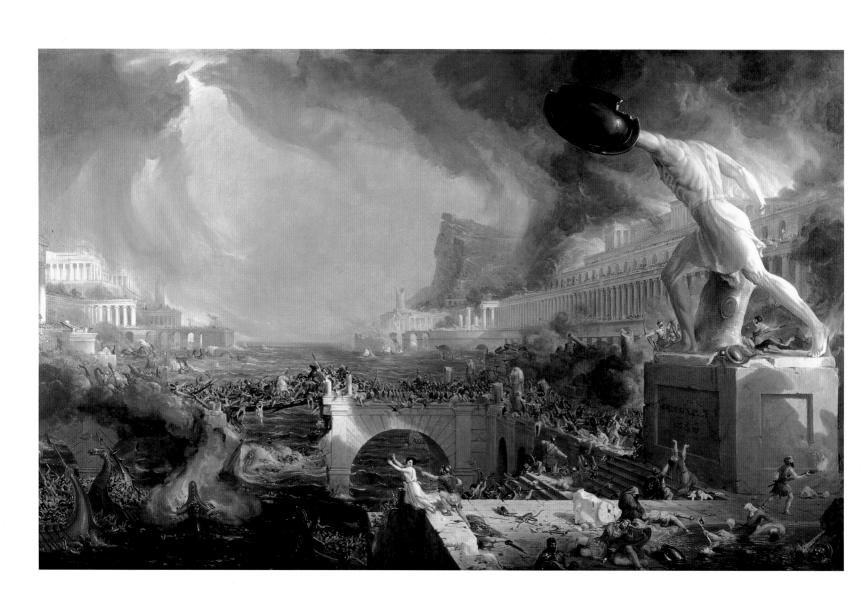

painted a pair of elaborate views in gouache, one (a scene of destruction) showing firemen attempting to tame the flames (fig. 45), and another (not quite a desolation) of 'The Ruins' the next day (1835; Metropolitan Museum of Art, New York). The fire was contained, and the city soon recovered, but the conflagration, known as the 'Great Fire of New York', lingered in the popular memory.

T B

45 Nicolino Calyo, *The Great Fire of 1835: The Fire in Wall Street seen from the top of The Bank of America, corner of Wall and William Streets*, 1837. Gouache on paper, 28.6 × 39.4 (11¼ × 15½). Collection of The New-York Historical Society, 1980.53

The Course of Empire: Desolation, 1836

Oil on canvas 99.7 × 161.3 (39 ¼ × 63 ½)
Inscribed lower right 'Cole.'
Lent by the New-York Historical Society. Gift of the New-York Gallery of Fine Arts, 1858.5

The final canvas of *The Course of Empire: Desolation*, presents a view of the ruins of the imperial city, somewhat reminiscent of that from which Cole derived 'some minutes of silent, mournful pleasure' overlooking the ruins of Rome in 1832, quoted on p.95. A tradition reaching back to Claude found in classical ruins the stimulus for meditation on the transience of worldly power and wealth, a sentiment encapsulated in the Latin phrase 'sic transit gloria mundi'. Cole's own rendering of this idea appears in his explanatory text: 'Violence and time have crumbled the works of man, and art is again resolving into elemental nature. The gorgeous pageant has passed, the roar of battle has ceased – the multitude has sunk into the dust – the empire is extinct.'[74] Human life has vanished, but nature is reclaiming the landscape; herons are nesting on the column and vegetation abounds, and a tiny deer and stag – barely discernible – appear near the water's edge in front of the ruined Doric temple. The cycle that opened with hunters pursuing deer in *The Savage State* has reversed itself, and the animals can now graze without fear of predators. It is evening, and the moon (in Cole's words) 'ascends into the twilight sky near the place where the sun rose in the first picture'.
T B

The Spirit of Peace, 1851

Oil on canvas 101.7 × 172 (44 × 67)
Woodmere Art Museum, Philadelphia. Bequest of Charles Knox Smith
PHILADELPHIA AND MINNEAPOLIS ONLY

A number of Cropsey's paintings reflect his strong admiration for Thomas Cole, both in their technique and in their subject matter. This is particularly true of his work of the early 1850s. 'He has left a spell behind him that is not broken,' Cropsey wrote in 1850, soon after Cole had died; '. . . we will feel more than ever the devotion, genius, and spirit of the man. Everything breathes so much candour of will, truth of purpose, and love of the refined and beautiful, that we feel a kind of reverence there.'[75] At times he attracted criticism for imitating Cole too slavishly.

This canvas forms a pair with another subject, The Spirit of War, in the National Gallery of Art, Washington DC, which is an example of Cropsey's work at its most Cole-like. He may in particular have had in mind Cole's The Departure and The Return of 1837 (1837; Corcoran Gallery of Art, Washington DC), or Past and Present (1838; Mead Art Museum, Amherst College, Massachusetts), a pair that features a medieval tower similar to that in The Spirit of War. Cole no doubt had in mind Turner's habit of pairing subjects like The Temple of Jupiter Panhellenius Restored and View of the Temple of Jupiter Panhellenius, with the Greek National Dance of the Romaika (1816; Private Collection, New York and Alnwick Castle, Northumberland),[76] which show, respectively, a Greek temple in ruins and as it was in ancient times. In the 1830s Turner was to resume the idea, with Ancient Italy and Modern Italy (1838; Private Collection and Glasgow Art Gallery)[77] and Ancient Rome and Modern Rome (1839; Tate Gallery, London and Private Collection, on loan to the National Gallery of Scotland, Edinburgh).[78] In 1842 he painted a pair entitled Peace and War (both Tate Gallery, London),[79] of which Cropsey may have been aware, although Turner is not the direct inspiration here. While The Spirit of War is set as a medieval fantasy echoing the novels and poems of Walter Scott, The Spirit of Peace uses the language of classical architecture and a balmy, tropical landscape to embody its Arcadian message, as does a closely related picture, The Millennial Age (no.17). The circular temple associated with a golden age is perhaps also a reminiscence of the henge that figures in Cole's Pastoral or Arcadian State of the Course of Empire (no.12).

AW

The Millennial Age, 1854

Oil on canvas 95.3 × 135.9 (37 ½ × 53 ½)
Inscribed lower right 'J.F. Cropsey | 1854', on banner held by a child in the sculpture 'ON EARTH PEACE',
and on book beside monument 'Isaiah II: 4' and 'Isaiah XI: 6'
Collection of the Newington-Cropsey Foundation, Hastings-on-Hudson
LONDON ONLY

Towards the end of his life Cole had been received into the Episcopal Church, being baptised in 1844, and thereafter his paintings were often concerned with Christian themes. Cropsey, who had been in England when Cole died in 1848, visited Cole's widow in 1850 and planned a picture, *Homage to Thomas Cole*, which was to have stressed the Christian symbolism that Cole incorporated into his late works.[80] He went on to complete several works in which the allegorising, Christian Cole is an evident influence. This canvas is one of them.

In its general mood it owes much to Cole's late cycle of four paintings, *The Voyage of Life* (1842; National Gallery of Art, Washington DC) and another, unfinished cycle, *The Cross and the World* (c.1846–8).[81] Cropsey also had in mind Cole's vision of an idyllic primitive age of the world in the *Pastoral or Arcadian State* of *The Course of Empire* (no.12). Cropsey's picture is, indeed, also known as *The Golden Age*. Here, however, the past is merged with a vision of the future, in which the prophecy of Isaiah has been fulfilled: 'The wolf also shall dwell with the lamb, and the leopard shall lie down with the kid, and the calf and the young lion and the fatling together; and a little child shall lead them.'

The elaborately designed sculptural monument that forms the principal focus of this scene illustrates these ideas. It is in the form of a colossal altar supported by female figures and children, one of whom holds up a luminous cross. The book open on the plinth beneath it cites the relevant Biblical texts. Four braziers burn at the corners of a stone plinth, and a shepherd family tends sheep in fields nearby, pointing up the reference to a timeless Arcadia. Cropsey invokes the Classical myth of a golden age as a parallel to that of the Christian vision of blessedness. In the foreground madonna lilies signify this beatific state and allude to the Resurrection, by virtue of which event such a state is to be attained. Cropsey had adumbrated these ideas in his slightly earlier picture, *The Spirit of Peace* of 1851 (no.16), which shows a similar landscape with ancient monuments and tombs. He was an architect by training and obviously enjoyed inventing the buildings and sculptures in these pictures. It is curious that his later work almost never incorporated significant architectural structures, as Cole's frequently did.

The landscape setting is not specifically American. It deliberately alludes to Middle Eastern, Biblical scenery; but, like Cole's *Course of Empire*, its scenery and architecture are intended to evoke universals that apply as much to America as to anywhere else. For Cropsey as for Cole, strongly held religious beliefs entailed a vivid sense of the moral and symbolic content of all landscape, and in works such as this he made explicit the spiritual significance of his experience of nature and civilisation both at home and in Europe.
AW

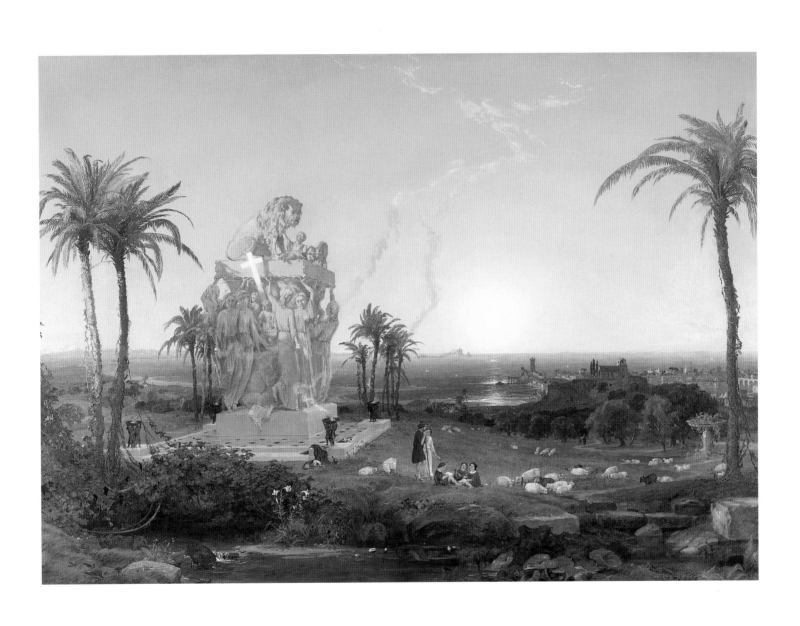

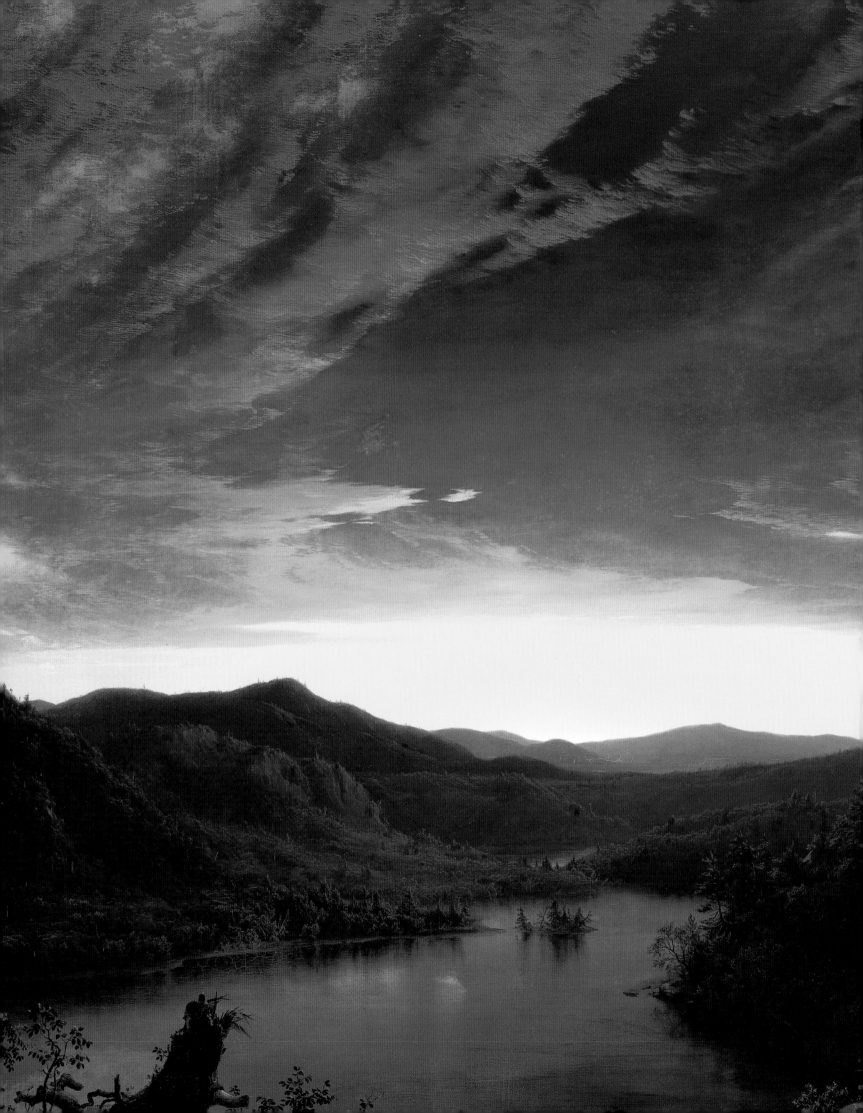

3 The Still Small Voice

Religion has always played a profound role in American culture. For Thomas Cole's only pupil, Frederic Edwin Church, the grandeur and beauty of American nature offered a glimpse of the divine. The silent spectacle of the sunset in the wilderness seemed charged with religious significance, and became a prominent subject in the 1850s. Church eagerly read the works of the English critic John Ruskin, who taught young artists that to observe nature closely was to 'follow the finger of God'. The scientific precision of Church's works can be compared with Pre-Raphaelite landscapes of the same period.

Like many of his contemporaries, Church firmly believed in economic progress as part of the divinely ordained destiny of the United States. Admiring the heroic efforts of pioneers in clearing the forests and creating new farmland, artists such as Church and Sanford Robinson Gifford nonetheless lamented the resulting destruction of the wilderness. The stumps of felled trees symbolised this cruel transformation. Only in remote northern states such as Maine, pictured in Church's *Mount Ktaadn* (no.24), could they still find what one contemporary called 'the fresh and natural surface of the planet earth'. *Twilight in the Wilderness* (no.25) is Church's great icon of America, celebrating a northern landscape innocent and untouched. Yet by 1860, when the painting was exhibited to great acclaim, the United States was only a year away from the Civil War. The political and economic tensions between the industrialised states of the North and the slave-owning South had become unsustainable. In retrospect it is possible to see Church's flaming vision as an apocalyptic portent of the violence that would soon engulf America.

Detail from *Twilight in the Wilderness* (no.25)

A Lake Twilight, 1861

Oil on canvas 40.6 × 96.5 (16 × 38)
Inscribed lower right 'S.R. Gifford 1861'
Private Collection

This picture was painted in the year that the Civil War broke out, and its almost surreal stillness has been interpreted as 'menacing quietude'.[1] The action of the hunter arranging the deer he has shot in the bottom of his canoe contributes to an uneasy sense of cruelty and foreboding. This reading seems hard to sustain. It is evident that Gifford had in mind Church's celebrated *Twilight in the Wilderness* (no.25) of the previous year, as did many artists who sought to represent dusk after that picture had appeared, and it is generally held that *Twilight in the Wilderness* is a foreboding reflection on the coming of war. But Gifford is altogether gentler in mood and imagery than Church. His palette is, indeed, sharper and richer than in, say, *The Wilderness* (no.32) but these qualities only serve to enhance the profound simplicity of the statement, which relies for its effect on a sensitive realisation of evening colour and light in a broad open space. The cloud formations are notably more schematic and serene than Church's, suggesting rest and quiet to come, rather than turbulence and storm.

The picture at one time bore the title 'In the Green Mountains, Vt', and the scene has been tentatively identified as Camel's Hump, in Vermont, near Lake Champlain. Another Vermont subject of 1861, *The Winooski Valley, Vermont* (untraced), perhaps confirms that Gifford spent time in that region in the summer of 1860.

AW

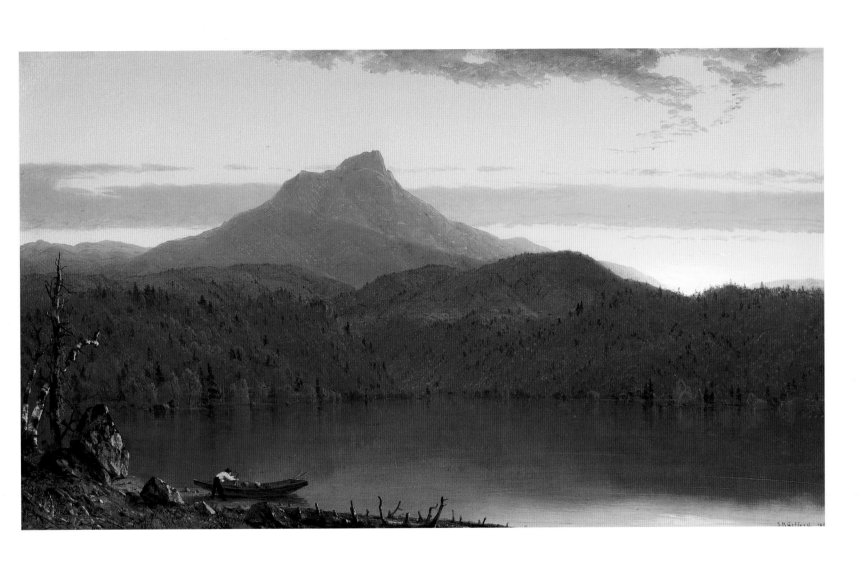

19 SANFORD ROBINSON GIFFORD 1823–1880
Autumn in the Catskills, 1861

Oil on canvas 36.2 × 61 (14¼ × 24)
Private Collection, New York

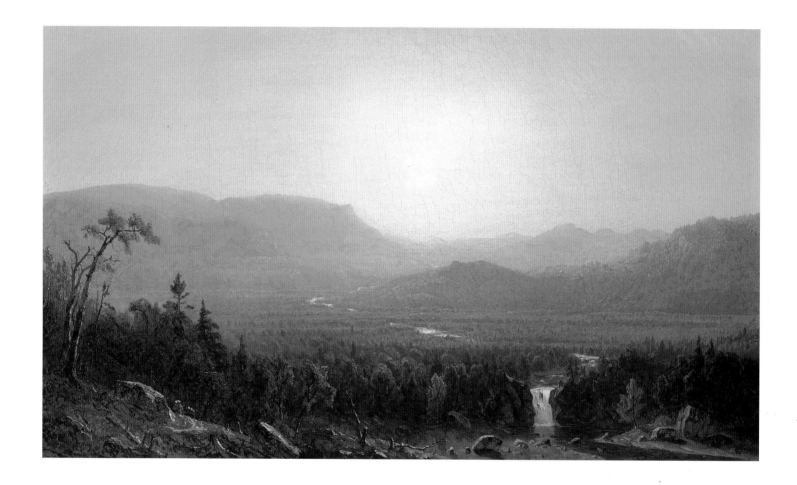

For Gifford, as for many artists based in New York, the Catskills were a perpetual inspiration; he travelled to the region regularly every year, visiting his mother in the town of Hudson. Several pictures in this exhibition derive from his experiences in the area.

This subject is a composite panorama, looking west across Kiskatom Flats to Kaaterskill Clove, with High Peak to the left and Hunter Mountain in the distance. The river that meanders across the landscape is Catskill Creek, dropping down to the Hudson River behind us. However, this is not a topographically literal account of the place: it is an essay in light and atmosphere, in which Gifford's characteristic mature style is very apparent: short dabs of pigment are built up to create an almost tangible atmosphere filled with misty light in which the forms of mountains and forests are dissolved, and the rich colours of a late autumn afternoon are muted. The open simplicity of the design emphasises the overriding importance of air itself in Gifford's work.

AW

20 SANFORD ROBINSON GIFFORD 1823–1880

Catskill Mountain House, 1862

Oil on canvas 23.7 × 47 (9⁵/₁₆ × 18½)
Private Collection, New York

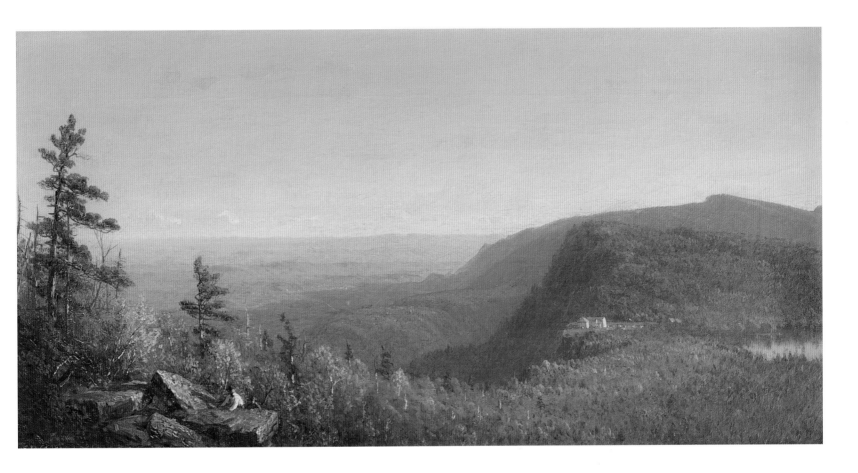

Gifford based this subject on pencil studies that he made in about 1861, in a sketchbook now in the Albany Institute, Albany, New York. The hotel on the South Mountain of the Catskills was a favourite subject for painters. Cole and Cropsey both made views of it (see no.8). Here, Gifford looks down on it from above, using a panoramic composition similar to that of his great *Mount Mansfield* of 1858 (no.31). The valley of the Hudson lies partly in shadow below the mountains as the evening sun sinks behind them. The place was one of which he was particularly fond, and he is known to have made at least three pictures of it, all apparently small, though this is the only one traced today. A further view of the *South Mountain, Catskills*, dated 1873, is in the St Johnsbury Athenaeum, St Johnsbury, Vermont, and a small

study or version of that subject is in a private collection. These preserve the general composition of the *Catskill Mountain House*.

Gifford lived with his family in the township of Hudson, close to the Catskill range. A fellow painter, Worthington Whittredge, remembered: 'The particular part of the Catskills which . . . pleased Gifford best was the summit, or the region round about the Mountain House. Upon the edges of the cliffs of North and South Mountains, overlooking the great plain of the Hudson River, how often his feet have stood! The very lichen there remember him.'[2] Other views in the Catskills by Gifford are nos.19, 21 and 33.

AW

Hunter Mountain, Twilight, 1866

Oil on canvas 77.5 × 137.5 (30⅝ × 54⅛)
Terra Foundation for the Arts, Daniel J. Terra Collection

Gifford made a pencil sketch of this scene in about September 1865, in a sketchbook now at Vassar College, Poughkeepsie, New York. He also executed two oil studies before embarking on the final picture. The pencil drawing includes all the principal features of the view, including the tree-stumps in the foreground, but in the painting itself the various elements are opened out into an expansive sweep of country under a daffodil-yellow sky flecked with red clouds. Like Church's *Mount Ktaadn* (no.24) and other evening scenes by Gifford (for instance *A Lake Twilight*, no.18), the picture is primarily concerned with the remoteness of the wilderness, conveying stillness and silence with palpable force. It is also a reflection on the fact that these qualities are only perceptible by those who experience them, in this case the backwoodsmen whose livelihood depends on the felling of trees. It has been suggested that, rather than being a general comment on the depredations of man in the wild, the conspicuous tree-stumps in the foreground here refer to the tanning industry: tanning made use of the bark of the hemlock, which contains tannin, and a large tannery was established in the neighbourhood of Hunter Mountain. Gifford would no doubt have been aware of this fact since his grandfather was a shoemaker and tanner. An oil sketch of *The Old Tannery in Kauterskill*

Clove is in a private collection. The denuded foreground of the picture, and the fading light in which the scene appears, may then be complementary elements in an elegy for the untouched wilderness of an America fast disappearing.

There is no direct evidence of Gifford's intention in painting the picture, nor do contemporary responses elucidate its meaning for its audiences at the time. Some details of the picture's early history may throw some light on the matter, however. Gifford sold the picture to a friend, the New York merchant James W. Pinchot, who lent it to the exhibition of the National Academy of Design in 1866. It was sent to Paris for the Exposition Universelle in 1867, where, overshadowed by more spectacular works by Church and Bierstadt, it attracted little attention, except for some generally appreciative remarks from the London *Art-Journal*. It has recently been pointed out that Pinchot took a lifelong interest in forestry, and inculcated conservationist ideas in his son, who himself became a forester and dubbed him 'the father of American forestry'. It is therefore likely that the artist was fully conscious of the point made by his brooding twilight subject, and very probably discussed it in detail with its first owner.
AW

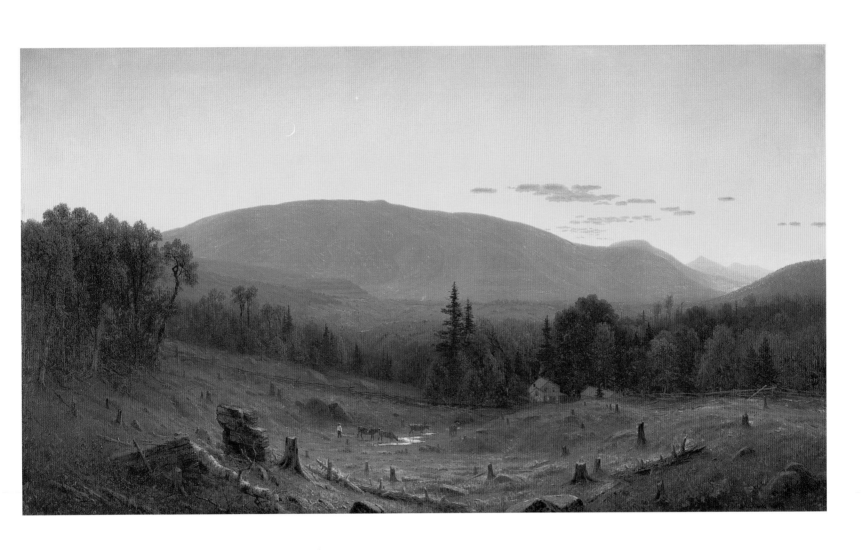

Twilight, 'Short Arbiter 'Twixt Day and Night', 1850

Oil on canvas 81.3 × 121.9 (32 × 48)
Inscribed lower centre 'F. E. CHURCH | – 50'
Collection of The Newark Museum, New Jersey. Purchase 1956, Wallace M. Scudder Bequest Fund
PHILADELPHIA AND MINNEAPOLIS ONLY

Twilight, 'Short Arbiter 'Twixt Day and Night' marked a new departure for Church in 1850, following the success of *West Rock, New Haven* (1849; Museum of American Art, New Britain, Connecticut) the previous year. In contrast to the clear sunlight and meticulously detailed finish of the earlier painting, *Twilight, 'Short Arbiter 'Twixt Day and Night'* is a dramatic and atmospheric work. The sky, filling with dark, heavy clouds, is illuminated by the last embers of the sunset and dominates the composition; only a few details stand out in the landscape below. Church was to paint a long sequence of sunset paintings of which three of the finest are this work (no.22), *Mount Ktaadn* (1853; no.24) and the great *Twilight in the Wilderness* (1860; no.25).

These represent Church's attempt to emulate his master, Thomas Cole, in the production of 'a higher style of landscape'[3] than straightforward topographical representation would allow. Yet having explored historical landscapes in Cole's manner early in his career (in, for example, *Christian on the Borders of the Valley of the Shadow of Death, Pilgrim's Progress*, 1847; Olana State Historic Site), Church attempted from 1850 onwards to engage with major issues of religion, science and national identity through pure landscapes whose mood is heightened by emotive effects of lighting. A notable feature, too, is the more heavily impasted and energetic brushwork in *Twilight, 'Short Arbiter 'Twixt Day and Night'*, most clearly visible in the sky, which contrasts strongly with the tightly worked surface of *West Rock, New Haven*, implying, perhaps, a greater emotional urgency. Church's finished works rarely exhibit this sketch-like, turbulent surface.

The title of no.22 is drawn from Milton's *Paradise Lost*:

> The sun was sunk, and after him the star
> Of Hesperus, whose office is to bring
> Twilight upon the earth, short arbiter
> 'Twixt day and night, and now from end to end
> Night's hemisphere had veiled the horizon round,
> When Satan, who late fled before the threats
> Of Gabriel out of Eden, now improved
> In meditated fraud and malice, bent
> On man's destruction, maugre what might hap
> Of heavier on himself, fearless returned.[4]

The passage quoted from is an ominous one: Milton's sunset is the prelude to the return of Satan, 'bent on man's destruction', about to sow the seeds of discontent in the Garden of Eden. Possibly Church simply took a resonant phrase from the poem and disregarded its context: his painting is, after all, a sensitively observed study of those few last fleeting moments of light before the sun disappears. The last of the sun is reflected in the windows of the farmstead, where a fire has already been lit. The day's work is done; there are no human figures in the fields but cattle are watering peacefully by a stream. All is contentment. However, the onset of darkness and the stormclouds overhead suggest that the tranquil, well-ordered agricultural landscape may be transformed by darkness into a more hostile environment.

Church derived the composition of *Twilight, 'Short Arbiter 'Twixt Day and Night'* from a freely painted oil sketch made in Vermont in 1849 and known as *Evening in Vermont* (1849; Vassar College Art Gallery, Poughkeepsie, New York).[5] Other elements were incorporated from a small finished painting, now known as *The Harp of the Winds* (Museum of Fine Arts, Boston).[6] From the latter work Church appropriated the rocky parapet to the extreme right, and the farmhouse in the centre. This vantage point could be a picturesque tourist's viewpoint or the spot from which the vengeful Satan glimpses the Garden of Eden. We are returned to the analogy drawn by Church's teacher, Thomas Cole, between America and Eden (see no.10); the happy scene of Vermont husbandry offers a Jeffersonian ideal of America's polity as made up of contented smallholders, each sharing equally in the political destiny of the nation, but left largely to his own devices. But the ominous sky surely implies that all is not well in this virtuous republic. It is possible that Church was responding to current events by adopting a more troubled view of the landscape than in earlier celebrations of New England. The year 1850 was one of great political moment: the Great Debate about slavery took place in Congress in February and March 1850, demonstrating deep divisions within the nation. Although on this occasion a compromise was reached between representatives of North and South, sophisticated and partisan observers such as Church must have felt a rising sense of unease.

Twilight, 'Short Arbiter 'Twixt Day and Night' was welcomed by critical opinion at the National Academy of Design exhibition in 1850. Before it was exhibited, the *Bulletin* of the American Art-Union announced that the painting 'is thought to be one of his best works'.[7] It was also exhibited by the Art-Union, which ran a regular lottery in which paintings formed the major prizes: no.22 was one of them.[8] This novel form of patronage was extremely important in the 1840s: founded in 1839 and named the American Art-Union in 1844, this group of wealthy New York patrons aimed to encourage American artists by purchasing their paintings, and at the same time to elevate the artistic taste of the public. By selling lottery tickets at a low price and offering engravings to all members, the Art-Union widened access to fine art, while firmly controlling which artists received patronage. Church's work was already popular with public and critics, and he became a favourite of the Art-Union.

TB

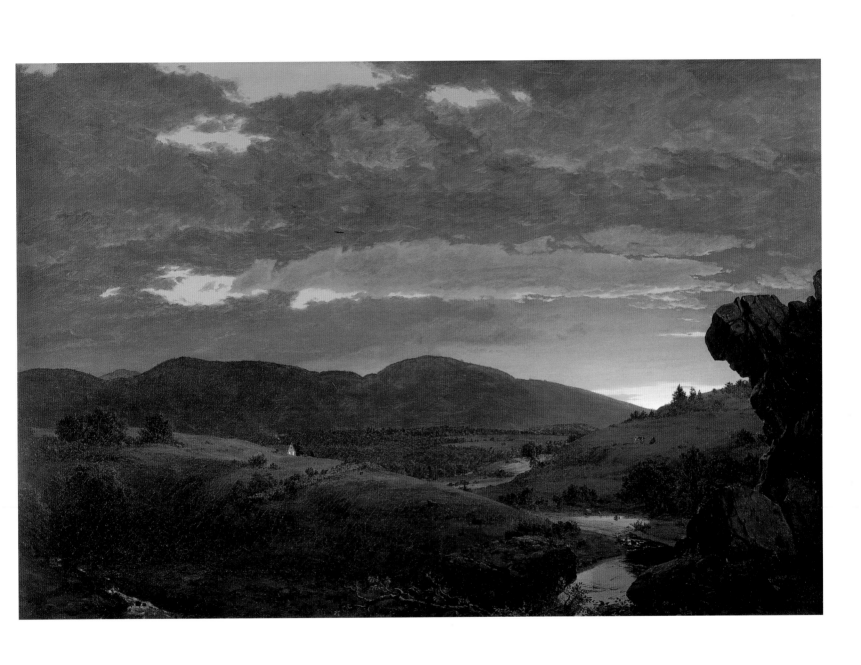

Lake Scene in Mount Desert Island, 1851

Oil on canvas 52.6 × 78.4 (20 11/16 × 30 7/8)
Inscribed lower right 'F. CHURCH – 51.'
Private Collection
LONDON AND PHILADELPHIA ONLY

Church made the first of his frequent visits to Mount Desert Island in 1850, when he was twenty-four, in the company of two older artist friends from New York, Richard Hubbard (1816–1888) and Régis Gignoux (1816–1882). The scenic island off the coast of Maine was already becoming popular with landscape painters such as John Frederick Kensett and Fitz Hugh Lane (see no.66); later it would become the favourite subject of Winslow Homer (1836–1910). Impressed with the scenery, Church sketched profusely on the 1850 trip: *Lake Scene in Mount Desert Island* derives from a detailed pencil sketch heightened with white chalk (Olana State Historic Site, OL.1977.65). Church's precise topographical outline drawing is followed very closely by the painting, which was completed the following spring. The central dark mass is Mount Penobscot, on the south of Mount Desert island, an outcrop of solid rock with little vegetation. Its dark bulk and forbidding, sheer rock faces form a menacing presence at the heart of the image, reflected in the still waters of the lake. Behind it, to the right, are a series of hills known as 'The Bubbles'; in the foreground is Little Long Pond, a small fresh-water lake separated from the sea by a spit of land.[9]

The painting, depicting the same dusk hour as *Twilight, 'Short Arbiter 'Twixt Day and Night'*, gives an even more unsettling impression than the earlier oil. Nothing in the pencil study of Mount Penobscot hints at such brooding intensity, described by the painting's only reviewer in 1851 as 'not altogether pleasant'.[10] The last of the sun catches the stems of birch trees in the right foreground, but dark clouds are massing overhead. The dead trees littering the foreground imply that this is an area of untouched wilderness – such good firewood would hardly have been left to rot in the tidy farmland of Vermont. However, the gloom is redeemed by the figure of a single oarsman, in a white shirt and red waistcoat, clearly out for pleasure. Mount Desert is, after all, inhabited, even if only by tourists in search of the Picturesque and Sublime.

Lake Scene in Mount Desert Island is painted more freely than *Twilight, 'Short Arbiter 'Twixt Day and Night'*, with patches of expressive, gestural brushwork in the sky. In painting the mountains, Church has scraped through the wet paint with the butt end of his brush, a technique familiar from his oil sketches, in order to articulate the contours of the rock surface. Indeed, no.23 is the finished work in which Church most fully adopts the visual language of the oil sketch.

TB

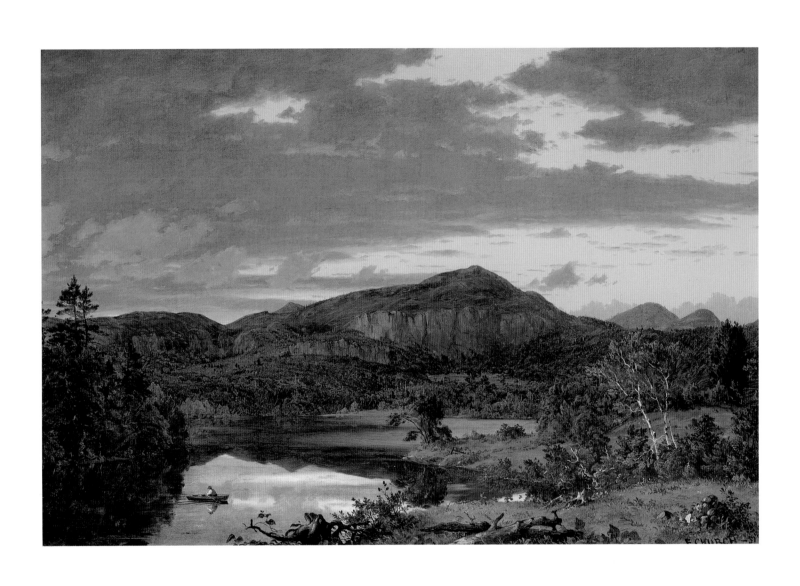

Mount Ktaadn, 1853

Oil on canvas 92.1 × 140.3 (36¼ × 55¼)
Inscribed lower middle 'F.E. Church'
Yale University Art Gallery, Stanley B. Resor, B.A., 1901, Fund

In the summer of 1852 Church visited Maine, exploring inland areas of almost untouched wilderness, in the company, according to one account, of 'a squad of lumbermen'.[11] He was determined to climb Mount Ktaadn – now spelled Katahdin – but heavy rain and difficult terrain apparently frustrated the ascent. At 5,268 feet (1,606 metres), Katahdin is the highest mountain in Maine, and its distinctive profile, rising out of low foothills, was thought by some of Church's contemporaries to identify it as an inactive volcano. Theodore Winthrop, Church's companion on a second, successful attempt to climb the mountain, noted the power of this motif: 'Purple precipice, blue pyramid . . . it is a simple image and a positive thought.'[12] In contrast to the peaceful, though mysterious, Maine coast explored by Cole, Lane, Kensett and Church, the landscape the artist confronted as he made his way to Mount Ktaadn was one of dense, primal forest. Only occasionally was this environment interrupted by new settlements, marked by hacked and burned tree-stumps and the beginnings of agriculture. Henry David Thoreau, the great observer of nature at Walden Pond, had visited the area in 1846 and was ambivalent in his response. The great American wilderness turned out to be virtually impassable, 'grim' and 'untrodden'; its 'tangled labyrinth of living, fallen and decaying trees only the deer and moose, and bear and wolf, can easily penetrate'.[13] The reality of the wilderness forced itself upon Thoreau in an unexpected and powerful way:

> Perhaps I most fully realized that this was primal, untamed, and forever untameable *Nature* . . . It is difficult to conceive of a region uninhabited by man . . . And yet we have not seen pure Nature unless we have seen her thus vast and drear and inhuman . . . Nature here was something savage and awful, though beautiful . . . It was not lawn, nor pasture, nor mead nor woodland, nor lea, nor arable, nor waste-land. It was the fresh and natural surface of the planet earth.[14]

On reaching the top of Katahdin (as Church was to do on many later occasions), Thoreau declared:

> Here not even the surface had been scarred by man, but it was a specimen of what God saw fit to make this world. What is it to be admitted to a museum, to see a myriad of particular things, compared with being shown some star's surface, some hard matter in its home![15]

The untouched wilderness, another planet, Eden: such was mid-nineteenth century Maine in the region of Mount Ktaadn.

Yet in Church's painting we encounter an entirely different world. Under a glowing mantle of pink-tinted clouds, the mountain makes an austere and dignified motif in the distance, with further peaks behind it. The foreground, however, completely contradicts Thoreau's account. Here we see a pastoral idyll: cattle are watering in a lake; a horse and trap are travelling along a well-kept road (perhaps a turnpike) which crosses a stream by way of a tidy bridge. Behind can be seen a large mill, probably a saw mill, with an elegant cupola; a dam and waterwheel harness the power of nature to productive ends. The glazed windows of the mill catch the last of the sun, in a direct echo of the windows of the ideal farmstead in *Twilight, 'Short Arbiter 'Twixt Day and Night'* (no.22). Further buildings, barns and fields can be seen in the middle distance. It is a scene of perfection: the founding fathers' American dream of small-scale agrarian communities hewn from the wilderness. The key to this image, as Franklin Kelly has suggested, is the boy under the tree in the extreme left. He occupies the characteristic position of the observer of the Picturesque, the leisured figure with whom we identify and through whose eyes we survey the scene. This painting is, in effect, a dream of the future. We are not witnessing the early stages of clearance of the wilderness, which were ugly and brutal; even the single tree-stump in the centre-left foreground seems the result of a tree's death at the hands of nature and not the axe. Church carefully presents a settled and peaceful community decades after the original clearance. The wilderness, still extant in fact (and still present in the background of the painting), has been transformed in the imagination. This parallels a typical gambit of imperial travel writing, identified by Mary Louise Pratt, in which the imagination of the explorer transforms a wilderness scene into an idyll of colonial civilisation.[16] In *Mount Ktaadn* Church revisits the transition between the first and second of Cole's *The Course of Empire* series, from *The Savage State* (no.11) to *The Pastoral or Arcadian State* (no.12); and perhaps the onset of industry, hinted at by the sawmill, implies an imminent transition to *Consummation* (no.13). Church's mastery of his materials is such that the scene is completely convincing. He finds tender and affecting beauty in the happy relationship between settlers and wilderness, between culture and nature. His magical evocation of evening light draws the entire scene – background and foreground, past and present – into a unified whole. The mirror-like surface of the lake mediates between the fantasy of settlement in the foreground and the untouched world beyond.

The mill, which can be seen alongside a dam to the right, was a common sight in more accessible parts of heavily wooded states such as Maine. Thoreau, for example, counted 250 sawmills on the Penobscot River in Maine in 1837. Church had been interested in this subject since the mid-1840s, when he worked on both drawings and paintings of mills. His *New England Landscape (Evening after a Storm)* of

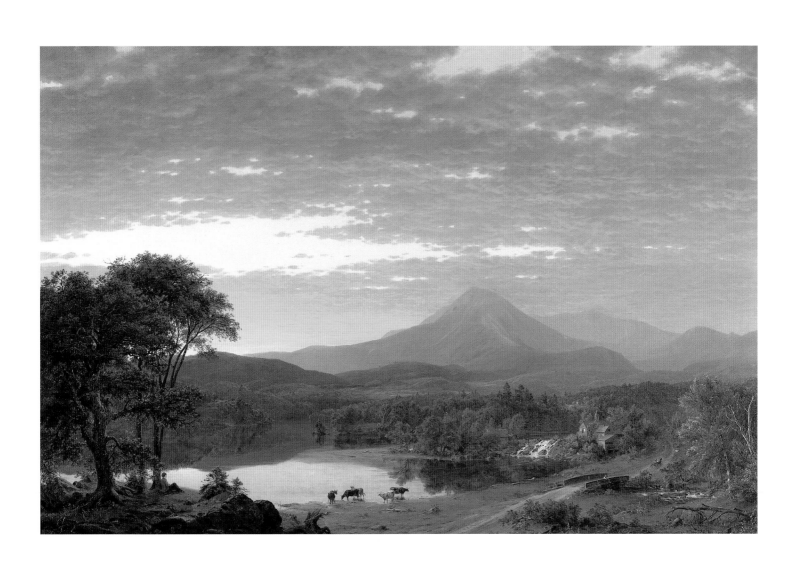

1849 (Amon Carter Museum, Fort Worth), offering a paradigm of the beauties and virtues of his own native landscape, prominently features a mill with water rushing down the sluice. But does the mill in *Mount Ktaadn* signify the taming and destruction of the wilderness, or the progress of civilisation? The water-powered mill may seem relatively wholesome in the light of later industrial developments – coal-fired steam power would soon supersede the non-polluting but less powerful waterwheel. However, many environmentally minded nineteenth-century writers considered (as their successors do today) the timber industry to be deeply destructive of the wilderness and interested only in easy profit. Church was particularly horrified by the extent to which the white pine, the most majestic of Maine's native trees, had already disappeared from the Penobscot region, its valuable timber transported to the Boston markets by the very lumber schooners painted by Fitz Hugh Lane (see no.72). Church's travelling companion of 1856, Theodore Winthrop, bemoaned the execution of 'his Majesty Pinus I, three centuries old . . . A little fellow with a little weapon had dethroned the quiet old king.'[17] Yet in *Mount Ktaadn* early industrial development is at harmony with the wilderness, and a balance has been struck between progress and preservation.

Church's painting was commended in *The Knickerbocker* for the '*correctness* of everything represented. An elm or an oak, six or eight miles off, is as individual as the model tree in the foreground, whether elm or oak.'[18] But the reviewer did not know, perhaps could not have known, that although he correctly recognised the elm and the oak in Church's painting, neither is typical of Maine woodland. The effect of Church's painting is so convincing, the atmosphere so evocative, that the viewer simply accepts the scene as 'true to nature'. The reason for including these trees may lie in their symbolic associations: the elm was thought of as a particularly American tree, and grew especially well at the edges of areas of clearance. The oak, by contrast, symbolised history and tradition, a remnant of the immemorial wilderness.

Mount Ktaadn was the largest of the four works that Church exhibited at the National Academy of Design in 1853. By the time the exhibition closed, Church had left for South America, opening up a new chapter in his career. *Mount Ktaadn* eloquently sums up the concerns of his early work in New England. It was owned by Marshall Roberts of New York until 1897 and passed through various private collections until its acquisition by Yale University Art Gallery in 1969. TB

25 FREDERIC EDWIN CHURCH 1826–1900
Twilight in the Wilderness, 1860

Oil on canvas 101.6 × 162.6 (40 × 64)
Inscribed 'F.E. CHURCH | -60-'
The Cleveland Museum of Art, Mr and Mrs William H. Marlatt Fund 1965.233

Twilight in the Wilderness marks the culmination of Church's passion for the American wild. A technical and imaginative *tour de force*, it brought to a climax the series of New England sunset paintings, including *Twilight, 'Short Arbiter 'Twixt Day and Night'* (1850; no.22) and *Mount Ktaadn* (1853; no.24), that had preoccupied Church throughout his career, and provides perhaps his definitive attempt to encapsulate American national identity in a single canvas.

Church seems to have observed a glorious sunset on the summer solstice of 1858, probably from the window of his studio on Tenth Street, New York City.[19] No sketches survive to document this, but soon afterwards he began work on a small painting, *Twilight, a Sketch* (Olana State Historic Site), featuring a dramatic sunset of pinks and purples, with great arcs of clouds catching the setting sun, and a shadowed lake scene underneath. In this small painting was contained the essence of *Twilight in the Wilderness*, and Church recognised its significance immediately. Contrary to convention, *Twilight, a Sketch* was exhibited at the National Academy of Design in 1859,[20] the only work he submitted between 1859 and 1861. His main focus during this period was on 'Great Pictures' which were exhibited in single-work exhibitions, for which an entrance fee was charged. Exhibited at the Academy in an elaborate gilt frame,[21] *Twilight, a Sketch* served as a marker, an announcement of his intention to paint a grandiose sunset painting to rival his recent triumph with *Niagara* (1857; fig.32). The *New York Times*, reviewing the National Academy's exhibition, described *Twilight, a Sketch* as 'a very striking and peculiar color-sketch of a rare and brilliant atmospheric effect'.[22] Although happy to use the National Academy's exhibition to promote his work-in-progress, Church evidently intended to exhibit the finished work separately. While his sketch was displayed at the Academy, moreover, *The Heart of the Andes* (1859; fig.14) was still on view as a 'Great Picture', a popular rival attraction that caused resentment among the Academicians.

The summer of 1859 saw Church travelling to the far north in search of icebergs, a well-publicised journey which raised expectations for a new 'Great Picture' in 1860 (see no.88). However, on his return Church became preoccupied with the acquisition and conversion of the property at Hudson, New York, which became his home, Olana. Rather than try to master the novel and difficult subject of the icebergs, Church decided instead to bring to fruition the American wilderness landscape project tacitly announced in his small sketch at the 1859 Academy. After several months' work, in April 1860 Church invited the New York reporter of the *Boston Evening Transcript* to examine the almost complete *Twilight in the Wilderness*.

> Observers of nature [began his report] are aware that some phases of the sunset sky, especially in autumn, are peculiar to North America . . . mottled fleecy clouds of crimson and saffron cluster in the west, halfway to the zenith, while along the horizon is a belt of opal, or what Allston calls 'apple green'; this splendid combination Church is now transferring to canvas, with his usual skill. It will be a grand and truly American sky-landscape.[23]

This announced important changes: the spring or early summer of *Twilight, a Sketch* has been replaced by autumn, adding a chill to the atmosphere and bringing forth a more sombre set of associations.

Years of observing and sketching the sunset – most fugitive of effects – had provided Church with the knowledge to orchestrate a spectacular sky, in which an extraordinary range of tones from blood red to cadmium yellow, from a brilliant blue to a pale golden yellow-green, are combined with perfect assurance. Drawing on his experience of Turner's works, such as *Staffa, Fingal's Cave* (fig.51) and *Fort Vimieux* (Private Collection), which were in the New York collection of James Lenox, Church creates an enveloping sense of atmosphere which unifies his composition. The application of paint, especially in the left side of the sky, is particularly reminiscent of Turner. Beneath, the landscape is densely wooded, like Maine as viewed from the top of Mount Ktaadn; hills, similar to the Catskills or Adirondacks of New York State can be seen in the distance. In the foreground carefully observed natural details – rocks and trees – firmly anchor the composition in observed reality. Each tree is of an identifiable species – hemlock, oak and larch – and (as Ruskin demanded) each has an independent history which can be 'read' by the viewer, in contrast to the often conventional, Rosa-esque trees in the work of Church's teacher, Thomas Cole. The rocks, too, speak of an ancient, geological history. A single bald eagle perches on the dead tree to the left, the proud bird of prey chosen as the nation's emblem.

Indeed, just as *The Heart of the Andes* had epitomised the South American landscape, and the iceberg painting was soon to epitomise the far north, so Church now provided an epitome of his own native New England. However, this was a New England completely without human inhabitants, or their traces. In contrast to the symbiosis of man and nature in *Mount Ktaadn*, for example, Church here completely excludes the human presence. Church evidently no longer believed that man in his fallen state (even the providentially blessed Americans) could inhabit this garden of Eden without destroying it. Such was the anxiety of the times that the essence of America could be found only in an area with no Americans, either indigenous people or settlers. No canoes or tepees can be seen (compare Kensett's idealised *Lake George*, no.26); there are no loggers' paths, no trappers' huts (as in *Twilight, a Sketch*); the land is impassable; access is barred by vegetation and fallen tree trunks. Nature follows its own cycles of death and renewal

without reference to human needs. This is a dramatic change from the Church of a decade earlier, whose belief in the providential civilising mission of America seemed unshakeable. A possible explanation can be found in Church's deep concerns about national politics. As Church and his contemporaries perceived, the rapid expansion of the United States westward, speeded by the Mexican War of 1846–8, made clear for the first time that, even in the massive continent of North America, land would eventually run out, leading to the complete despoliation of the wilderness. More immediate was the growing threat of civil strife between North and South, over the question of whether slavery should be extended into the newly acquired western territories. Church is known to have discussed these issues in regular, anguished conversations with his friend and fellow-traveller to Maine, Theodore Winthrop. Winthrop, convinced like Church of the rightness of the Unionist cause, was killed in the first year of the war. *Twilight in the Wilderness* is an icon of American national identity at a moment of growing crisis.

Church also found in the wilderness a powerful religious significance. This was God's handiwork in its unadulterated form; the New Testament taught that Christ retreated into the wilderness for forty days and nights of solitude, and the Old Testament recorded the wanderings of the Children of Israel in the wilderness after their captivity in Egypt. Church's favourite critic, the New York correspondent of the *Boston Evening Transcript*, provided just such a religious reading of *Twilight in the Wilderness*:

> Solitude reigns over the scene, and as the eye ever turns away from the wilderness below to gaze upon the brilliant canopy of the sky, the imagination whispers that he who was once 'led up of the spirit into the wilderness to be tempted,' must often at the twilight hour have turned his gaze from the gloom and loneliness of the forest to the brightness and beauty of those heavens which to his vision of faith were ever opened, revealing the 'Father of Lights'.[24]

In the foreground, silhouetted against the red reflections in the lake, is a tree-stump; nearby two shards of bark appear, unmistakably forming a cross. As with many of Church's symbols, this shape could simply result from a natural accident; but the placing of a cross in a similar position in the foreground of *The Heart of the Andes*, and the deployment of the cruciform mast of the shipwreck in *The Icebergs* (no.88), suggest that even in Church's troubled wilderness we are offered a vivid symbol of redemption through Christ.

Twilight in the Wilderness was exhibited at Goupil's Gallery in New York from 7 June 1860, and was immediately recognised as

a masterpiece to compare with *The Heart of the Andes*. The *Boston Evening Transcript* noted that

> As an American sky landscape this 'Twilight in the Wilderness' of Church is as true to nature and as skillfully executed as his 'Heart of the Andes'; less than half the size of that elaborate work, it derives fresh interest from the strong contrast it presents to the tropical beauty of its predecessor.[25]

The critical response was generally positive, many providing florid descriptions of the painting, and most comparing it to *The Heart of the Andes*. The *Evening Post* printed a long poem by 'W.G.D.' inspired by the painting, though of risible literary quality. The spiritual note on which it ended, however, probably reflects the kind of associations many visitors would have found in Church's American icon:

> This benison the picture shows,
> While parting day in beauty glows,
> That memory has a force divine,
> To make life's somber scenes to shine
> With light whose blended rays shall give
> Power in the joyful past to live,
> And that hope, also, can bestow
> A grace fulfilment cannot know.
> So 'Twilight in the Wilderness'
> Shall on the heart the lesson press
> Of patience, glorifying sorrow,
> And waiting for a blissful morrow.[26]

Twilight in the Wilderness demonstrated the full potential of an art of the American wilderness based on Ruskinian principles through which observation and imagination were combined to reveal nature's spiritual truths. It was directly influential on a whole generation of artists: Church's main competitor in the 1860s, Albert Bierstadt, began to attempt dramatic sunset imagery; traces of its impact can be found in the work of such contrasting figures as Sanford Robinson Gifford, Martin Johnson Heade and even Worthington Whittredge and George Innes. So ubiquitous had imitations of Church's work become by 1864 that James Jackson Jarves could claim that 'we are undergoing a virulent epidemic of sunsets'.[27]

Twilight in the Wilderness was purchased from the artist by William T. Walters of Baltimore; thereafter it passed through numerous private collections before its acquisition in 1965 by the Cleveland Museum of Art.

TB

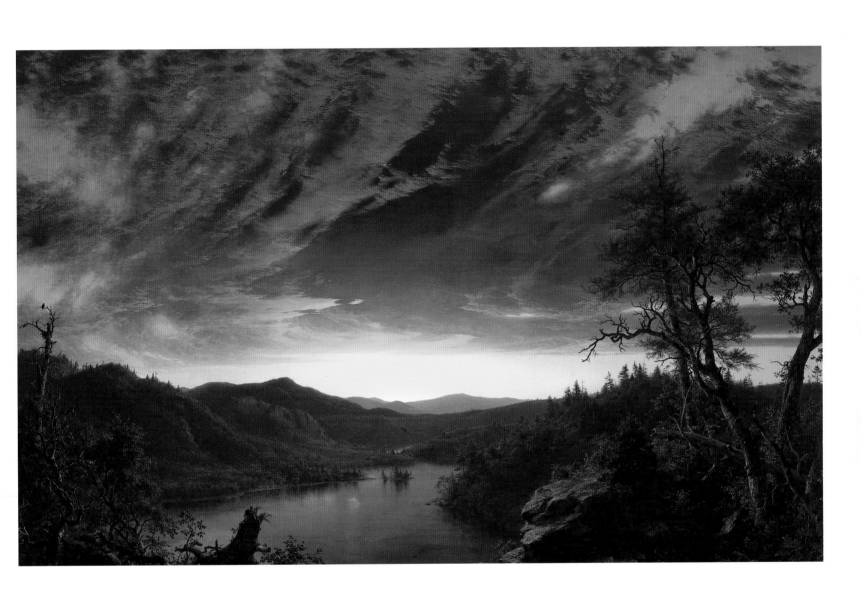

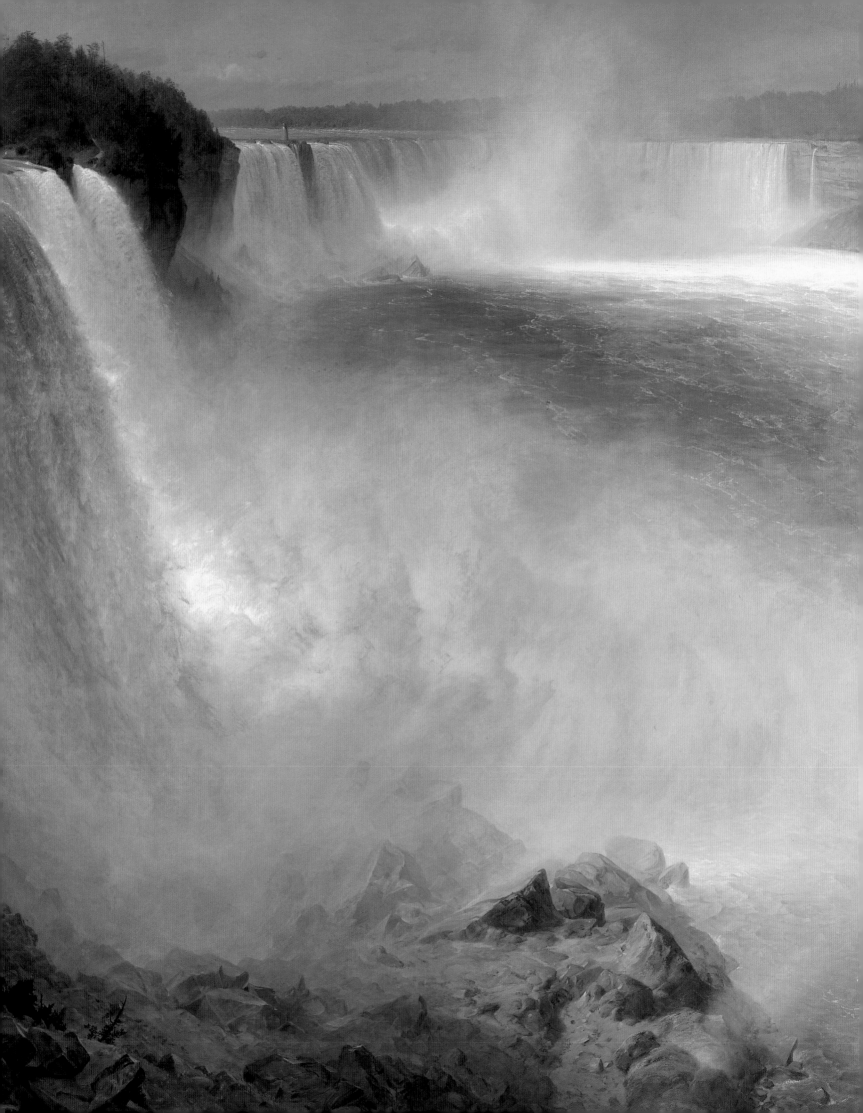

4 'Awful Grandeur'

According to the eighteenth-century British theorist Edmund Burke, 'Whatever is fitted in any sort to excite the ideas of pain or danger . . . is a source of the sublime.' It had long been agreed that the most spectacular of all American phenomena was Niagara Falls, which unleashes power beyond human control; to be washed over the fall would mean certain death. Generations of artists had painted the Falls, but none on the scale of Frederic Edwin Church. Critics and public in New York and London were thrilled by his two great canvases of Niagara. The second, painted in 1867 (no.35), includes a tiny, bearded figure – a tourist observing the Falls from a viewing platform, a detail emphasising the minute size of the individual in relation to God's creation. Grand, panoramic canvases were also used for more tranquil, though not less remarkable, scenery. Jasper Francis Cropsey painted *Autumn – on the Hudson River* (no.27) while in London, using sketches made on the spot. Seeing the finished work, Queen Victoria refused to accept that the colours could be true to nature. Proud of the vibrant 'Fall' foliage, Cropsey sent home for specimens to demonstrate his accuracy. Though the American subject is novel, *Autumn – on the Hudson River* follows the compositional formula established by the seventeenth-century French painter Claude Lorrain. The Claudean mode, with framing trees and receding central vista, was also favoured by J.M.W. Turner, whom Cropsey greatly admired. The American painter adopted a similar composition even when confronted by such an uncompromisingly modern structure as the Starrucca Viaduct (see no.28). Over 1,200 feet long, the viaduct belonged among the wonders of the railroad system which was swiftly transforming life in the USA.

Lake George, 1869

Oil on canvas 112.1 × 168.6 (44⅛ × 66⅜)
Inscribed lower right 'JF [monogram] K 1869'
Metropolitan Museum of Art, New York. Bequest of Maria DeWitt Jesup,
from the collection of her husband, Morris K. Jesup, 1914

Kensett's *Lake George* is one of the culminating works of the American tradition that began with Cole and Durand, both of whom had painted the lake. Its picturesque potential was recognised by early travel writers such as Theodore Dwight:

> This beautiful basin with its pure crystal water is bounded by two ranges of mountains, which in some places rising with a bold and hasty ascent from the water, and in others descending with a graceful sweep from a great height to a broad and level margin, furnish it with a charming variety of scenery, which every change of weather, as well as every change of position presents in new and countless beauties.[1]

Cole, who first visited in 1826, was attracted both to the picturesque scenery, and to the historical and literary associations of the lake, which had two historic forts – named William Henry and George – and had played a central role in James Fenimore Cooper's novel *The Last of the Mohicans*, though Cooper used its Indian name, Horican. Cole included in his 'Essay on American Scenery' a florid description that prefigures Kensett's composition:

> Steep and rugged mountains approach from either side, shadowing with black precipices the innumerable islets – some of which bearing a solitary tree, others a group of two or three, or a 'goodly company' seem to have been sprinkled over the smiling deep in Nature's frolic hour. These scenes are classic – History and Genius have hallowed them. War's shrill clarion once waked the echoes from these silent hills – the pen of a living master has portrayed them in the pages of romance – and they are worthy of the admiration of the enlightened and the graphic hand of Genius.[2]

Kensett made his first trip to Lake George in 1853 and from the first was impressed more with the scenic beauties of the site than its associations.[3] The next year he recalled the happy experience in a letter to his uncle:

> I directed my course towards that sheet of water which has a name par excellence among our American inland seas – Lake George . . . I selected a little unobtrusive spot called Bolton where there was a quiet inn upon the lake . . . where green hills swept boldly down to the water's edge. Twenty or thirty islands of varying size lay around . . . It was among these islands with a light boat fortified with my basket of provisions & my painting materials that I spent the greater part of the day . . . I had some of the most delightful and unobtrusive hours of the summer.[4]

Perhaps the recollection of this idyllic afternoon stayed with Kensett, who returned many times to Lake George, making sketches in oil and in pencil, and produced a long series of finished paintings of the subject, six of which were exhibited at the National Academy of Design between 1859 and 1869. In the last summer of his life he was still producing studies of Lake George, which may result either from years of memories, or from a valedictory trip to the familiar site. This *Lake George*, the most impressive version, is based on the view from Bolton Landing on the western shore of the Lake, looking toward the Narrows. The mountains in the background, although not seen in their natural configuration, can be identified; the tallest peak, dominating the composition, is Mount Erebus.

Lake George is among Kensett's largest and most impressive paintings. In 1848 he had returned from a long period in Europe, and while in England had greatly admired the scenery of the Lake District, which bears considerable similarities to the Adirondack and White Mountain landscapes. English painting, too, had caught his attention. During his trip, Kensett had studied the work of the English painter Henry John Boddington (1811–1865) with particular care, and his mastery of the current English landscape idiom can be seen in works such as *The Langdale Pike* (1858; Cornell Fine Arts Center, Winter Park, Florida) and *Lakes of Killarney* (1857; Milwaukee Art Museum).[5] In comparison with those decorative and explicitly picturesque scenes, however, *Lake George* is a far more impressive achievement, though perhaps lacking the extreme originality of his late paintings of the shoreline. It compares closely, though favourably, with the large Scottish, Welsh and Lake District scenes exhibited at the Royal Academy in London in the 1860s and 1870s by such painters as Horatio McCulloch, Peter Graham, John Everett Millais and Benjamin Williams Leader. Kensett deliberately avoided the more grandiose and melodramatic approach of his contemporaries Church and Bierstadt, but in this work he has moved away from the tradition of Cole and Durand celebrated in *A Reminiscence of the White Mountains* (no.6).

The one concession to the picturesque tradition is the tiny figure of an Indian in a canoe (fig.46), possibly a reference to Cooper's novel *The Last of the Mohicans*, whose ultimate subject is the violent clash between Indian and European culture. The Indian population had long disappeared from this region; the visitor in 1869 was more likely to see the Fort George steam ferry, which had been running since 1825.[6] Perhaps Kensett longed for an era before the advent of tourism. This hint at an era long past may also indicate a wish on Kensett's part to escape the implications of the Civil War, and the period of extreme economic expansion that followed it.

Lake George is by no means a documentary, topographical

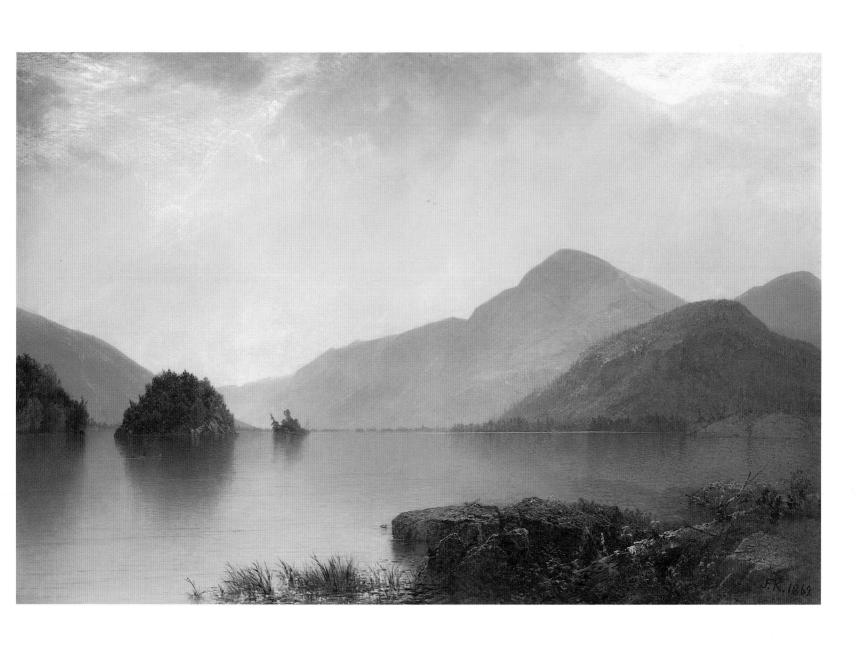

landscape, but rather a highly sophisticated synthesis of observed elements. Although each form is convincingly naturalistic, many incidental details are omitted in order to create a balanced and unified composition. The palette is restricted to a limited range of muted colours: pale greens, blues and greys and the oppressive atmosphere of the summer sun diffused through clouds are lovingly evoked. Detail in the foreground is hinted at through a mass of small brushstrokes but not enumerated in detail, as an adherence to John Ruskin's theory, laid out in *Modern Painters* (1843–60), would demand, though Kensett's work echoes Ruskin's interest in the representation of water and of reflections. Rather than emphasising details, Kensett allows the larger forms in the composition to emerge mostly unadorned. The sense of solitude is overwhelming.

Lake George was immediately recognised as a masterpiece, and was welcomed as 'one of the noblest pictures in the gallery' when exhibited at the National Academy of Design in 1869.[7] It sold to the banker Morris K. Jessup for the large sum of $3,000, an indication both of Kensett's high opinion of the work and of Jessup's endorsement of this. Jessup's widow presented it to the Metropolitan Museum in 1915.
TB

46 John Frederick Kensett, *Lake George*, 1869 (detail)

Autumn – on the Hudson River, 1860

Oil on canvas 152.4 × 274.3 (60 × 108)
Inscribed bottom centre 'Autumn – on the Hudson River | J. F.Cropsey and London 1860'
National Gallery of Art, Washington DC. Gift of the Avalon Foundation 1963.9.1

On 28 July 1858 Cropsey, who had been living in London for two years, made an entry in his journal: 'Yesterday I commenced the largest picture I have yet undertaken. It is 5 × 9 ft. to be an Autumn on the Hudson River – I got in a few outlines. I spent two hours with it in the evening by gas light. I feel very impatient to work on it – but at present I fear I must persevere with other things and leave this for odd moments.' On 22 August the entry ends: 'This week at odd times I have been engaged upon my large picture 5 × 9 "Autumn on the Hudson". It is now ready for painting on.' The 12 September entry notes: 'On Thursday last I commenced the sky of my large picture "Autumn on the Hudson River". By working very hard the few weeks previous I gained time enough to spare a few days on it. I made a successful beginning.' He was working from drawings he had made on sketching trips in America; a complete thumbnail composition study is in the Newington-Cropsey Foundation.[8] He also made various small oil studies in preparation for the work.

On 11 December Cropsey wrote a gloomy entry which he annotated 'dark days': he was short of money and disillusioned with the promises of patronage that London had seemed to offer him. 'I have just been at my large picture Autumn on the Hudson (which is so successfully commenced, that all my friends say have you done anything more to it) feeling that if some good luck would come along that I could go on. I should be so happy.'

The picture was finally ready for exhibition in the summer of 1860. It shows a wide prospect, in the words of Cropsey's explanatory pamphlet, from hills 'on the west bank of the Hudson looking towards its mouth [that is, southwards], about sixty miles from New York, between Newburgh and West Point. The time of year is the month of October.' The pamphlet sums up the 'object of the painter', which was 'chiefly to convey an idea of the vastness and magnitude of the American landscape, the clearness and beauty of the atmosphere, and the richness and variety of colour in the foliage during the "Indian Summer" period of the year'. In the foreground are men resting on a grassy knoll during a hunting expedition; their guns lie nearby. Further off there are figures crossing a wooden bridge, a horseman, a zigzag picket fence; cattle are watering; sheep dot the landscape. The village of New Windsor lies on the edge of the river; beyond is the Hudson, with Storm King Mountain prominent on the right, the river 'studded with steamers and other craft', as Cropsey pointed out. 'The time of day is about 3 o'clock in the afternoon of a dreamy, warm day.' Its elusive, almost nostalgic intensity is attributable to the fact that it was painted when Cropsey was a long way from home, and often afflicted with a sense of being out of his depth in London. He had executed other American subjects in England, but the sheer scale of this canvas makes it a powerful tribute to an idea of American scenery, an ecstatic memory: home thoughts from abroad. On a more practical level his motive was a desire to communicate his pride in the landscape beauties of his country to a British audience. With its theme of national pride, its Claudean composition, and its broad river landscape subject, it may have been influenced by Turner's picture of *England: Richmond Hill, on the Prince Regent's Birthday* (1819), which by the late 1850s was on exhibition in London.

He first showed the picture in his studio in Kensington, and it aroused considerable attention, partly on account of the publicity for American painting that had been generated in 1857 and 1859 by the arrival in London of Church's *Niagara* (fig.32) and *The Heart of the Andes* (fig.14). He printed an explanatory leaflet, and displayed leaves from American trees to prove that his colours were not exaggerated. So successful was this exhibition that he arranged for the picture to be shown in a gallery in Pall Mall, with a second pamphlet containing a fuller description of the scene depicted. The information he supplied was picked up eagerly by journalists. The *Art-Journal* devoted several columns to the work. 'At first, we are well-nigh startled at the red and golden gorgeousness of those trees of slender and perhaps somewhat wayward growth which rise on each hand, and range away in the middle distance towards the lake-like river.' The *Athenaeum* actually thought the picture showed 'the mouth of the great and beautiful river just where the Catskill Mountains come down to the sea'. The 'remarkable vegetation' occasioned much comment, and many critics refused to believe that the colour of the foliage was faithful to reality. Cropsey had in fact already shown an American autumn scene in London, at the Royal Academy in 1857: *An Indian Summer Morning in the White Mountains, America* (Currier Gallery of Art, Manchester, New Hampshire) had been hailed by the Art-Journal as 'the work of an excellent American painter recently settled in London: it is highly coloured, and every incidental line in the mountains has been signalised'.[9]

Cropsey made a point of mentioning that his picture showed 'hills which are rendered classic to the American by Washington Irving having resided among them, and by the present residence of . . . other literary people'. (Washington Irving had in fact died while the picture was being painted, in 1859.) Some English critics found it reassuring that the subject was not entirely wilderness, but was the scene of heroic episodes in the War of Independence – 'perfect classic ground already', as the *Art-Journal* put it.[10] The same critic likened Cropsey's work to Turner's: 'And by this we mean specially that the composition – the arrangement, the proportion, the shape of the masses –

is unusually elegant and beautiful; and that there is a refined feeling for aerial tenderness, and light, and repose throughout.'

In November, the *Art-Journal* published a poem on 'Cropsey's "Autumn on the Hudson"', signed by W.C. Bennett and addressed to J.T. Field, of Boston:

Forgot are summer and our English air;
Here is your Autumn in her wondrous dyes;
Silent and vast your forests round us rise:
God, glorified in nature, fronts us there,
In His transcendent works as heavenly fair
As when they first seemed good unto His eyes.
See, what a brightness on the canvas lies!
Hues, seen not here, flash on us everywhere;
Radiance that Nature here from us conceals;
Glory with which she beautifies decay
In your far world, this master's hand reveals,
Wafting our blest sight from dimmed streets away, –
With what rare power! – to where our awed soul kneels
To Him who bade these splendours light the day.[11]

Cropsey's success was marked by his presentation to Queen Victoria in June 1861, and in 1862 the picture appeared in the London Exhibition of the Industry of All Nations (as no.2871), and on 10 November he recorded in his journal that 'Mr Sturgis . . . was kind enough to lend me £50 – till I can get paid for my "Autumn on the Hudson" which I have been so fortunate as to sell'. The purchaser was Thomas Slattery, who paid him £400 for it. On 16 November he wrote: 'saw Mr Slattery again in regard to my "Autumn on the Hudson". He is to pay for it and take it away from the international exhibition on Tuesday.' The price was modest in relation to the time Cropsey had spent on the picture, and in the context of poor sales generally:

the small sum I am compelled to accept viz £400 for my picture which has cost me so much labour, and this, too, to embrace the copyright excepting a few engravings he will give me in the event of its being engraved, is so painful to me, and my wife that yesterday when we went to take a last look at the picture, and the exhibition she could not but shed tears, while I felt too sad and stolid for even that. I cannot but ask myself the question 'why might I not sell my pictures advantageously' as so many others do whose work does not command near the admiration.

This was, nevertheless, more than any price that he had so far received for a single work. He goes on to record that:

the other day while talking with Mr Slattery, just as I had accepted his offer a gentleman came up, who knew the place, and had spent some time in America. He asked me the price – when Mr S. at once replied that he had just purchased the picture and that the price was a £1000. So it goes, rich men come in with their mouths full of praise – their pockets full of money and think they are doing one a great favour when straightway they make large profits out of worthy and weary toil of poor men.

Cropsey was to make America's autumnal colours a leitmotif of his output, and in 1866 returned to the theme on a large scale in *Indian Summer* (Detroit Institute of Arts), which captures a similar atmosphere and measures some 135 × 241 cm (53 × 95 in); see also *Greenwood Lake* (no.30).

Autumn – on the Hudson River passed from Slattery (or the purchaser Cropsey mentions buying it from Slattery) to the 6th Earl of Arran, and was in his sale at Sotheby's on 11 July 1951 as no.150; it was in an American private collection before 1959, and entered the collection of the National Gallery of Art in Washington DC in 1963.
AW

Starrucca Viaduct, 1865

Oil on canvas 56.8 × 92.4 (22⅜ × 36⅜)
Inscribed lower right 'J. F. Cropsey | 1865'
Lent by the Toledo Museum of Art, Toledo, Ohio; Purchased with funds from the
Florence Scott Libbey Bequest in Memory of her Father, Maurice A. Scott

Cropsey painted several views of the Starrucca valley, and its famous viaduct, having made a detailed drawing of the view in 1853; an oil sketch establishing substantially the composition of this picture is in the Newington-Cropsey Foundation, and has been dated to 1856. The first completed oil painting of the subject dates from 1864. What was apparently the most important of them was destroyed in the great Chicago fire of 1871. It was said to measure a remarkable 8 feet by 14 feet, and although that seems unlikely – it would be much in excess of Cropsey's largest surviving canvases – there is every reason to suppose that this composition was intended for development on a very grand scale. It bears all the hallmarks of Cropsey's most ambitious ideas, and the railway enters into a modern dialectic with the natural scenery that complements the presence of historical and literary associations in *Autumn – on the Hudson River* (no.27).

Starrucca Viaduct, in the valley of the Susquehanna River near Lanesboro, Pennsylvania, was one of the marvels of nineteenth-century American engineering. It had been built in 1848 for the New York and Erie Railroad, and is over 1,200 feet (365 metres) long, and consists of seventeen arches, some 114 feet (34.75 metres) in height. This viewpoint was a popular one, and easily accessible since trains regularly stopped here to allow passengers to admire the scene. Travellers were encouraged to do so in the autumn, the season Cropsey most loved to paint, and with which his name was especially

associated. 'What a beautiful view from the R.R. bridge looking over the Susquehanna,' he wrote, 'how green and delightful were the meadows – how luxuriant and beautiful were the trees – how white and tidy were the houses and how many wealthy looking cottages among them.'[12]

Much has been made of the fact that this subject, celebrating a modern structure and the technology of the railway, echoes Claudean compositional types. The point to be made, however, is that the view was admired at least partly because it naturally conformed to the principles of picturesque design, that is, principles that were in any case derived from the example of Claude. The viaduct itself was likened to 'a colossal piece of statuary in a green park'.[13] It no doubt suggested parallels, too, with the ruins of ancient aqueducts in the Roman Campagna. The Claudean model was one that Cropsey employed as a matter of course, ringing such changes on it as he thought fit. It is a staple of his technique, perhaps more distinctively so than for most of his American contemporaries. The force of the tradition is well illustrated by the striking similarities between Cropsey's design and that of some of Cézanne's views of Mont Sainte-Victoire: notably *Mont Sainte-Victoire from Bellevue* in the Metropolitan Museum of Art, New York, and *Mont Sainte-Victoire with Large Pine* in the Courtauld Gallery, London (fig.47). The view across a plain with farmhouses and a river, with viaduct and mountain in the distance and a framing tree, is comparable in all three.

Some of Cropsey's most important patrons were industrialists and businessmen who would have looked on this subject with particular favour, presenting as it does technological innovation in the form of a welcome and harmonious addition to the American landscape. Cropsey may well have borne in mind this sector of his clientele, and the number of times he replicated the subject suggests that there was a vigorous market for it. But his wish to paint such a striking scene was to be explained in purely aesthetic and creative terms; whether he admired Turner's *Rain, Steam, and Speed* of 1844 (National Gallery, London) or not – and Ruskin, whom Cropsey knew and respected, did not – he was no doubt aware of it, having either seen the original in London, or studied the engraving in the widely disseminated collection of reproductions titled *The Turner Gallery* (1859 – 61). Nothing is known of the earliest owners of the present painting, but a work of the same dimensions entitled *View across a wide valley with a railway viaduct crossing a river* was in Brigadier-General H. Clifton Browne's sale at Sotheby's on 26 February 1947, the year this picture was given to the Toledo Museum of Art.

AW

47 Paul Cézanne, *Mont Sainte-Victoire with Large Pine, c.*1887. Oil on canvas, 66.8 × 92.3 (26 5/16 × 36 5/16). Courtauld Gallery, Courtauld Institute, London

Dawn of Morning, Lake George, 1868

Oil on canvas 51.4 × 82.6 (20¼ × 32½)
Inscribed lower left 'J. F. Cropsey 1866'
Albany Institute of History and Art, Albany, New York

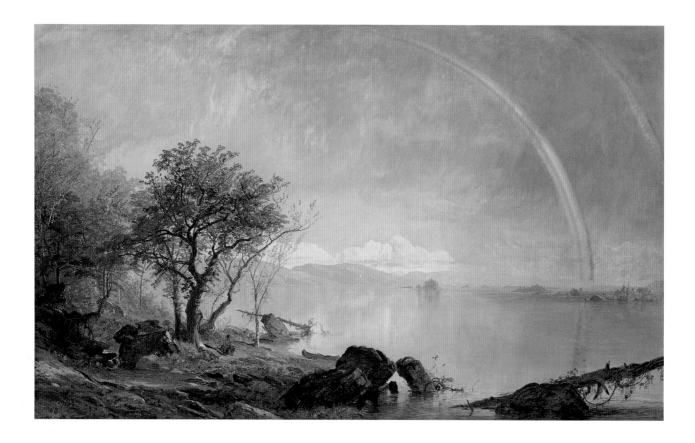

Cropsey was no doubt attracted to Lake George for reasons similar to those that prompted him to paint *Autumn – on the Hudson River* (no.27): it was a place that combined characteristic American scenery with famous historical events. It is one of the most celebrated beauty spots in the state of New York. French Jesuit missionaries christened it the Lac du Saint Sacrament, and it was the location of battles fought in the eighteenth century between the Americans and the French. It also had literary associations, playing an important part in James Fenimore Cooper's *Last of the Mohicans* (1826). John Frederick Kensett had become especially associated with it, with pictures like *Lake George* (no.26) here.

Gerald Carr has suggested that the prominent rainbow in Cropsey's view of the lake was inspired by Church's *Rainy Season in the Tropics* (no.87), which Cropsey knew.[14] The use of the grand double bow arching out of the picture suggests a larger panorama than the view we actually see, and hints at an altogether larger work than this relatively modest canvas.

It is possible that this picture was conceived as one of a pair; Cropsey often adopted Cole's habit of painting balancing subjects, such as *The Spirit of War* and *The Spirit of Peace* (1851; National Gallery of Art, Washington and Woodmere Art Museum, Philadelphia, no.16 here). He sold two pictures, titled *Dawn of Morning* and *Lake George, Evening*, to James L. Brumley for $800 on 27 March 1868 which were presumably intended to be read as a pair, though they were apparently pure landscapes, without overt historical or allegorical content.[15] The present canvas may be the first of these. But when we begin to analyse the intention behind this picture we are struck by the conspicuous presence of a grand rainbow at a time of day when such phenomena are somewhat unusual. Rainbows are usually associated with late afternoon or early evening. Might the two titles have been confused at some stage in the history of the pair? The whereabouts of the other is not known. It should be noted that Lake George was the subject of several pictures that can be linked in pairs: for example *Lake George, Sunset* (1867; IBM Corporation, New York) and *Lake George, Sunrise* (1868; New-York Historical Society, on loan to The New York Public Library).

AW

Greenwood Lake, 1870

Oil on canvas 97 × 174 (38 1/16 × 68 ½)
Inscribed lower right: 'J. F.Cropsey | 1870'
Museo Thyssen-Bornemizsa, Madrid
LONDON ONLY

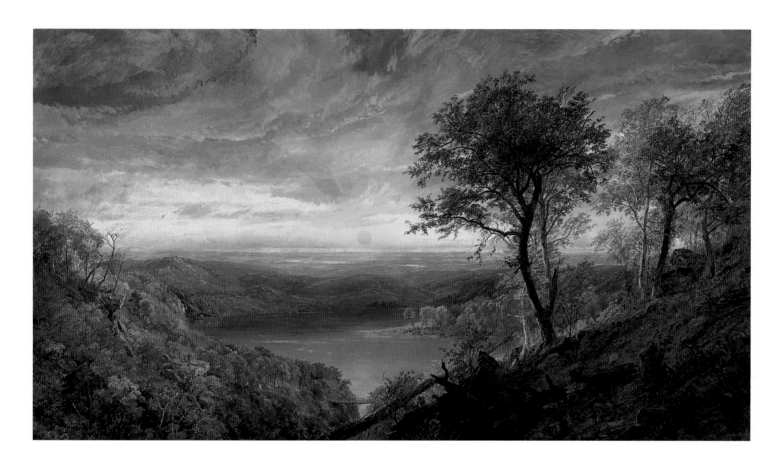

Greenwood Lake, on the border of New Jersey and New York states, was a place of importance in Cropsey's life. He first visited it in 1843 when, as a young architect, he was encouraged to go there by the New York art dealer John Ridner. In 1847 he married Maria Cooley whom he had met at the lake, and he kept a studio on its shores until 1869. His wife's family there ensured that close ties were maintained even when the couple were in England. In October 1858, for instance, Cropsey noted in his journal: 'Next morning brought a letter from Greenwood Lake mentioning the death of Mrs. Cropsey's cousin – an hale, splendid looking young man, cut down in a few days by fever.' The scenery of the lake recurs in views made throughout Cropsey's career.

This composition is also a recollection of *Autumn – on the Hudson River* (no.27), with its prominent framing trees and hot fall colours. Kenneth Maddox has drawn attention to the use Cropsey makes here of an earlier lake view, his *Lake Ontario* of 1856 (Newington-

Cropsey Foundation), which has a similar composition, and is in its turn based on a famous early work of Church, *New England Scenery* (1851; fig.11).[15] The sequence of influences points directly back to Claude, whom Church's picture consciously imitates. Cropsey's *Greenwood Lake*, on the other hand, takes its warmth of palette and simplicity of structure from Turner. The suppression of narrative incident (noticeably reduced from *Lake Ontario* for instance) contributes to a mood of contemplative and even philosophical calm. The only anecdotal detail is provided by two small figures admiring the view from a rocky ledge in the lower left middle distance: a pair, as Novak suggests, reminiscent of Durand's figures of Cole and Bryant in *Kindred Spirits* (no.1), and very likely a conscious allusion to that work. If that is the case, the poetical-philosophical framework in which we are intended to contemplate the scene is made explicit.
AW

Mount Mansfield, 1858

Oil on canvas 77.5 × 153 (30½ × 60¼)
Manoogian Collection

This is one of Gifford's largest canvases, a work that he designated a 'Chief Picture' in his output, by which he meant that it embodied important ideas in a grand and striking way. It belongs to a critical moment in his career, when he had just returned from a long tour of Europe and was full of the landscapes and works of art that he had seen there, and anxious to incorporate those experiences into a valid American landscape art.

The picture also breaks new ground topographically. When Gifford toured the Green Mountains of Vermont in the summer of 1858, they were as yet little known to tourists and artists. The Catskills of New York and the White Mountains of New Hampshire were much more frequented. This picture was one of the first to make use of Vermont's grand scenery, though by coincidence another view from the summit was painted in the same year, and both were exhibited at the National Academy of Design in 1859.[17] The other work, *Belated Party on Mansfield Mountain* (Metropolitan Museum of Art, New York), was by Jerome B. Thompson (1814–1886), who took a very similar viewpoint, but introduced considerably larger figures, in the spirit of an outdoor genre subject. Gifford's picture is less concerned with the details of tourist dress or picnic hampers than with the broad golden light of the westering sun, as it hangs over distant Lake Champlain, obscuring the Adironack Mountains in a diffused haze. Like Thompson, Gifford includes clearly delineated figures, but they are present simply to link us to the experience of the view and not to supply subject matter in their own right. It is difficult not to suppose that Gifford's intention was to present in terms of American landscape the brilliant light that he had seen in Italy during his European journey of the preceding two years. He had completed a view of Lake Nemi, for instance, in 1856–7 (Toledo Museum of Art, Ohio), in which we stare into a low sun in much the same way, and the landscape is half obscured by its brilliance. His travelling companion Richard Hubbard, another painter, is thought to have written a description of the scene, which appeared in *The Knickerbocker* for April 1860: 'There I beheld the orb of day go down gorgeously on a serene night . . . [with] lingering reflections upon the floating clouds, the long streaks of light, the appearance of islands, all bathed with lustre, and the reluctant dying of day in the west exceeded all which I had conceived of Italian skies.' Gifford must also have seen and been impressed by Church's *The Andes of Ecuador* (no.85), painted only three years earlier and equally concerned with diffused sunlight across a wide panorama.

There exist several oil sketches related to Gifford's visit to Mount Mansfield in 1858; a sketch that closely anticipates the composition of the large picture is in the George Walter Vincent Smith Art Museum, Springfield, Massachusetts. A small replica is in the St Johnsbury Athenaeum, St Johnsbury, Vermont. When the large picture was exhibited at the National Academy of Design in 1859, it had already found a buyer in Joseph Harrison Jr., an important collector in Philadelphia, who submitted it to the exhibition himself.
AW

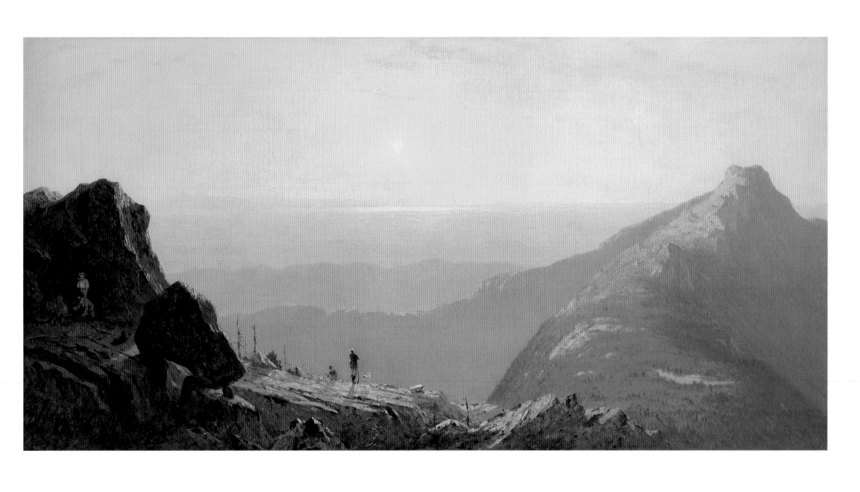

The Wilderness, 1860

Oil on canvas 76.2 × 138 (30 × 54¼)
Inscribed lower left 'S.R. Gifford 1860'
Lent by the Toledo Museum of Art, Toledo, Ohio; Purchased with funds from the
Florence Scott Libbey Bequest in Memory of her Father, Maurice A. Scott

Gifford showed this canvas at the National Academy of Design in 1860 with an appended quotation: 'Home of the red-brow'd hunter race' (see p.50). The view is of Mount Katahdin, or Ktaadn, in the northern part of Maine, a peak that symbolised for many painters the remoteness and inaccessibility of the most beautiful and evocative American landscape. Church had painted it as an emblem of the wilderness in 1853 (no.24), showing an imaginary pioneering homestead as an evocation of the moment at which settlers first encountered the landscape they were about to colonise. Gifford lays stress on the emptiness of the scene, and uses the figures of Indians rather than white men as foils. They are tiny, dwarfed by the immensity of the panorama, with perhaps an implication of their impending removal from the place altogether. The woman, with her papoose close by, watches her husband returning across the lake to the tepee. The evening light bathes everything in soft golds and pinks, and as in Church's picture there is a palpable hush. It has been suggested that

The Wilderness can be seen as an American equivalent of the 'savage state' at the beginning of Cole's cycle *The Course of Empire* (nos.11–15), though as usual with Gifford the picture is more concerned with effects of atmosphere than with tangible or narrative elements.

Gifford had been on a long journey of exploration in July and August 1859, with the intention of discovering for himself the 'forest primeval' of Nova Scotia, inspired by the descriptions of the region in Longfellow's famous poem *Evangeline* of 1847 (line 1).[18] But Nova Scotia proved unappealingly bare and bleak when it was reached, with 'no sign' of the forest: in the painter's view Longfellow had misdescribed it. It is to be supposed that the journey north took the artist through Maine, and that he saw Mount Katahdin on that occasion, though no drawings survive from that section of the trip and there would have been other opportunities for him to have sketched it.

AW

October in the Catskills, 1880

Oil on canvas 92.2 × 74.1 (36 $^{5}/_{16}$ × 29 $^{3}/_{16}$)
Inscribed on original panel backing 'October in the Catskills | By S. R. Gifford 1880'
Los Angeles County Museum of Art, Gift of Mr and Mrs J. Douglas Pardee,
Mr and Mrs John McGreevey, and Mr and Mrs Charles C. Shoemaker
PHILADELPHIA AND MINNEAPOLIS ONLY

In 1862 Gifford had painted a view of *Kauterskill Clove* (Metropolitan Museum of Art, New York) in the Catskill Mountains that summed up much of his sense of excitement in the place.[19] An upright composition saturated in the golden light of a late afternoon sun, it showed the expanse of the wooded hills towards the west, with a rocky ledge in the left foreground surmounted by a tall tree. As in his *Mount Mansfield* (no.31), Gifford placed the sun in the centre of the composition, directing the eye to it so that the effect was of a dazzling glare. The picture derived from drawings and oil sketches made in 1860, just before Gifford was enlisted into the Seventh Regiment of the National Guard, and drafted to Baltimore. The radiant atmosphere has been

seen as a nostalgic reminiscence of a place where Gifford had been brought up and to which he felt he specially belonged.[20] That he attached particular importance both to the place and to his representation of it is borne out by the fact that he made numerous replicas and variants of it during the remainder of his life. This is one of two known to have been painted in his last year; the other is in a private collection. In it, the composition is reversed, with the ledge and tree on the right instead of the left.[21] A sketch also datable to 1880 is in the Art Institute of Chicago.

AW

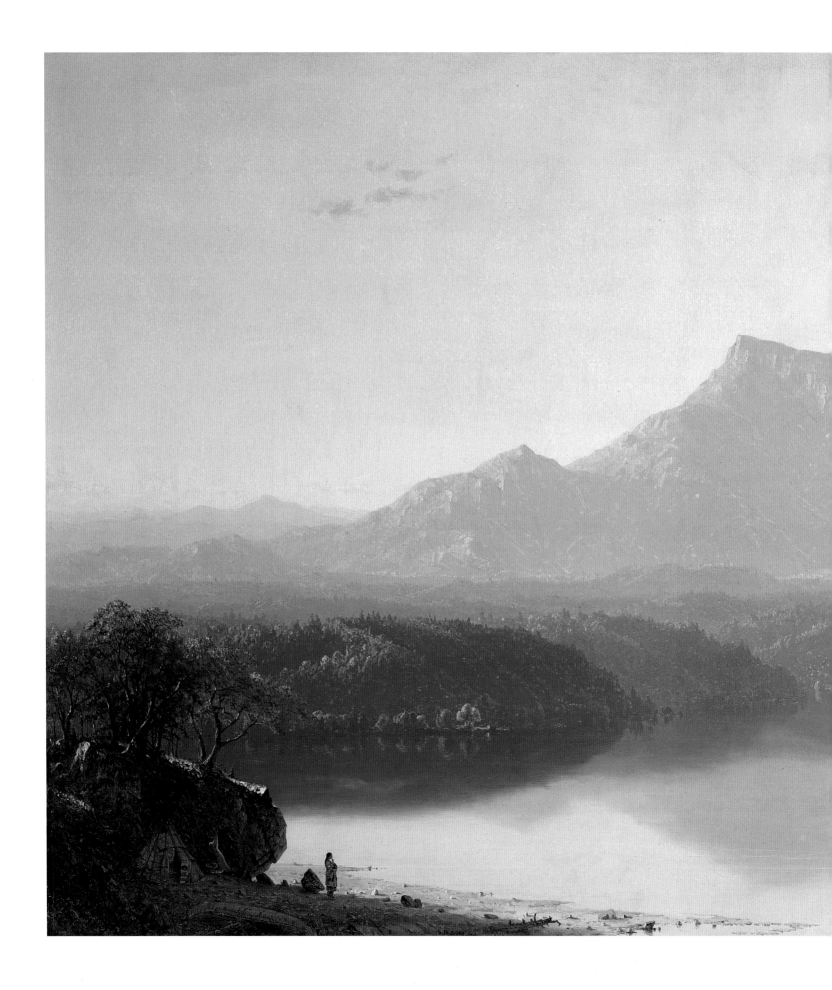

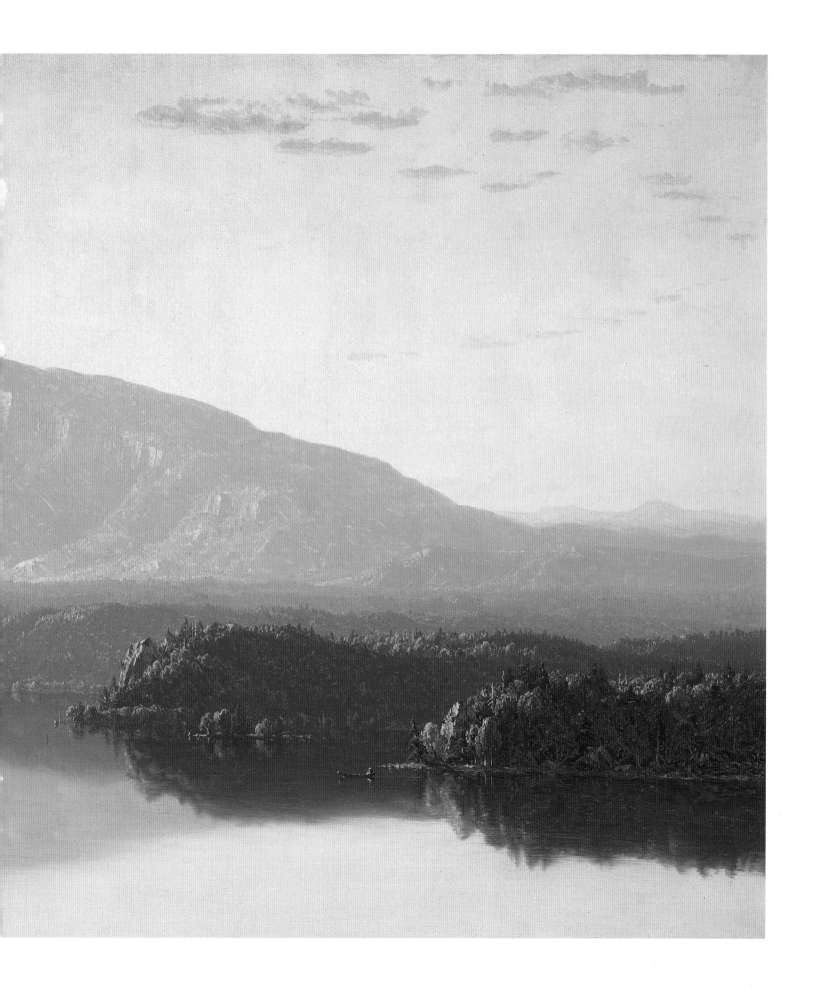

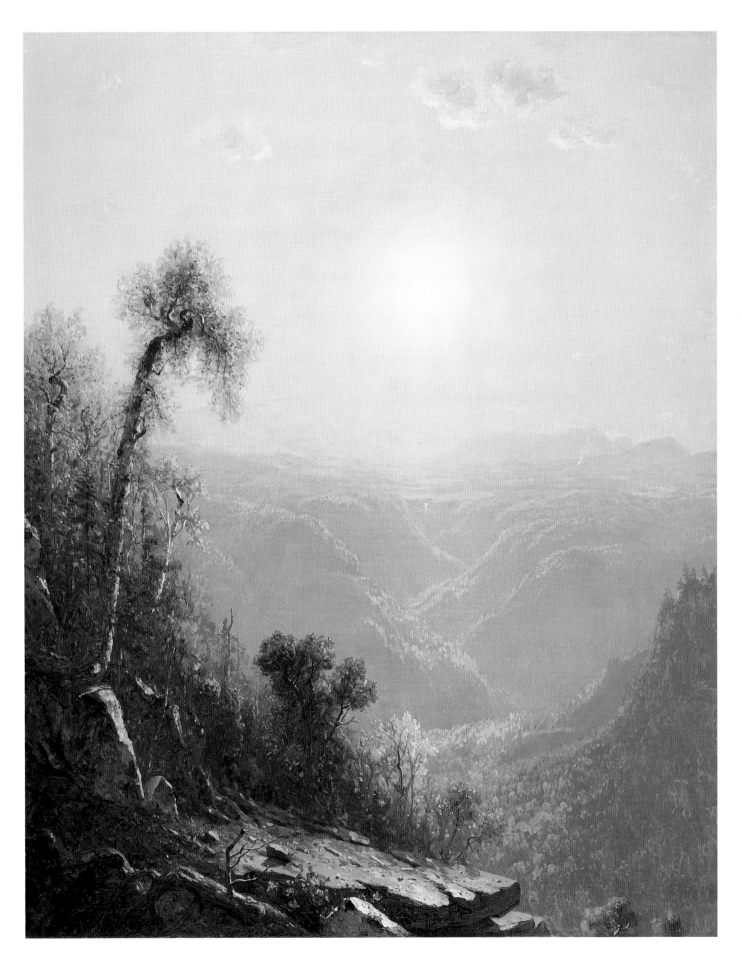

Coast Scene, Mount Desert, 1863

Oil on canvas 86.7 × 121.9 (34⅛ × 48)
Inscribed lower right centre 'F.E. Church 1863.'
Wadsworth Atheneum, Hartford, Connecticut. Bequest of Mrs Clara Hinton Gould

Coast Scene, Mount Desert was Church's last major work to derive from the landscape of Maine. It is based on a study made several years earlier, now known as *Surf Pounding against Rocky Maine Coast* (c.1855–60; Cooper-Hewitt Museum, New York, 1917-4-1234). Throughout all his visits to Maine, Church retained an abiding fascination for 'the beating of the storm on the rocky shore and the wild precipice'[22] at Schooner Head and other places on the exposed eastern shore of Mount Desert Island. *Surf Pounding against Rocky Maine Coast*, as the title (added later) suggests, is a thrilling rendering of the crashing of waves against dark cliffs; the paint is applied with tremendous vigour and swiftness. This painting of 1863, however, has an altogether different character. While it maintains a sense of spontaneity, the finished work is a highly sophisticated exercise, displaying Church's mastery of the medium. Details such as the water on the rock in the centre foreground, catching the veiled sunlight, are rendered with great virtuosity. Dramatic flashes of light enliven the work, particularly through Church's careful orchestration of such details as the seagulls in the centre right standing out against the dark cliffs. Although many elements of the composition follow the study closely, the effect of the sun through clouds pays homage to Turner, the artist from whom Church had learned the most. Critics had hailed Church's *Niagara* (fig.32) as the natural successor to the work of Turner when it was exhibited in London in 1857, and Church had read Ruskin's defence of Turner in *Modern Painters* (1843–60) with enthusiasm. Turner's *Staffa, Fingal's Cave* (1832; fig.51) and *Fort Vimieux* (1831; Private Collection) were in the collection of Colonel James Lenox in New York from 1845. Lenox was also the purchaser of Church's *Cotopaxi* (no.86). *Staffa, Fingal's Cave* depicts a rough sea, cliffs, and the sun setting; in *Fort Vimieux* is found a vivid sunset over the shore; and while there is no direct formal link between these

works and *Coast Scene, Mount Desert*, Church could certainly be seen as attempting to emulate Turner. The *New York Times* echoed earlier criticisms of the English painter when it described *Coast Scene, Mount Desert* as 'another offspring of the mist mania'.[23] Another possible influence is Andreas Aschenbach (1815–1910), the Düsseldorf-trained American artist, whose *Clearing Up, Coast of Sicily* (1847; Walters Art Gallery, Baltimore) attained celebrity in New York after being exhibited at the National Academy in 1849. Aschenbach's highly theatrical painting has a Gothic sensibility that belongs to an earlier era than Church's triumphantly Ruskinian seascape.[24]

Church returned to Maine with his wife Isabel for two final visits, in 1860 and 1862. The Civil War, which had begun in 1861, overshadowed all other events, and it seems likely that Church's turbulent composition acknowledges the national crisis. Church's decision to make an exhibition picture from an earlier sketch emphasising the pounding of the waves on the rocky New England shore perhaps relates to the conflict. New England was rock solid Unionist territory and Church was a keen proponent of the Yankee cause as is vividly apparent from such paintings as *Our Banner in the Sky* (1861; Musée d'Art Américain, Giverny). It would be a mistake to consider *Coast Scene, Mount Desert* an allegory, but it is no surprise that an artist of such deep political and regional affiliations should produce troubled imagery at this time.

Coast Scene, Mount Desert was exhibited at the National Academy of Design in 1863, but by that time had already been sold to the New York businessman Marshall O. Roberts, owner of *Mount Ktaadn* (no.24), whose wealth greatly increased as a result of war profiteering. In 1864 the painting was co-opted for the war effort, being exhibited at the Albany Sanitary Fair, which raised money for the precursor of the Red Cross, caring for wounded Unionist soldiers.

TB

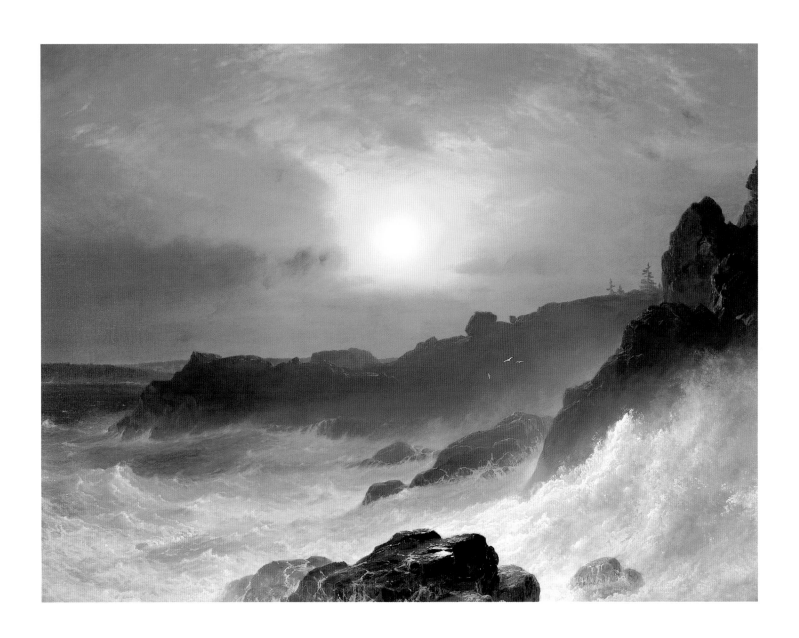

Niagara Falls from the American Side, 1867

Oil on canvas 257.5 × 227.3 (101 ⅜ × 89½)
Inscribed 'F.E. Church 1867'
National Gallery of Scotland, Edinburgh; Presented by John S. Kennedy 1887
LONDON ONLY

This work is the successor to Church's panoramic view of *Niagara* from 1857 (fig.32), itself based on a small painting, *Niagara Falls* (no.43). The *Niagara* of 1857 became one of the most successful of all American paintings. Rapturously received in New York and in London, where it was admired by John Ruskin, it made Church America's most famous artist and established an international reputation for American landscape painting. American critics particularly emphasised the importance of Niagara as a national icon (despite the fact that Church chose to paint the Canadian, or British, side of the Falls). As an effusive correspondent of the *Home Journal* claimed, 'this *is* Niagara, *with the roar left out*'.[25] After this triumph any attempt to return to the subject would surely run the risk of anti-climax. Church waited for nine years before beginning to paint *Niagara Falls from the American Side*, choosing a quite different view of the Falls, and adopting an upright format, eschewing the broad, panoramic canvas that had served him so well in 1857. American responses to the later painting were relatively muted, though it was well received in London. *Niagara Falls from the American Side* has been discussed relatively little in the voluminous literature on Church, perhaps because it is his only major work in a European collection.[26] It is among his most dramatic productions, and deserves reconsideration.

In September 1866 Church received a commission of $15,000 from the New York dealer Michael Knoedler to paint a major canvas for inclusion in the 1867 Paris Exposition Universelle, for which Knoedler was on the American selection committee. This was the largest commission Church ever received, and, returning to Niagara for a subject, he re-examined sketches he had made from the famous Prospect Point on his trip in October 1856, his third and final visit before painting the 1857 *Niagara*.[27] The canvas is among the largest Church attempted, standing 8½ feet by 7½ feet; the upright format is unique in his output on this scale.

The formidable scale and grandeur of *Niagara Falls from the American Side* belong to a long tradition; Prospect Point provided one of the major touristic viewpoints of the Falls, and the same basic view had been painted by a long line of artists reaching back to Thomas Wentworth in 1821.[28] Both the American Falls (to the left, seen at an angle) and the Horseshoe Falls (in the distance) appear in the composition. An almost exact precedent can be found in Robert W. Weir's *Niagara Falls* of 1853 (Private Collection).[29] However, Church's effects are far grander and more sophisticated than those of his predecessors, and he was relying solely on his own pencil drawing of October 1856 (Cooper-Hewitt Museum, New York), every detail of which is carefully repeated in the painting. At this stage a novel device was employed by Church. In order to envision

the colour scheme for the work, he acquired a sepia photograph of Niagara from this well-known viewpoint, which was probably available commercially. He then painted over the photograph in oil colours, making a kind of composite oil sketch. There are no other surviving preparatory works for *Niagara Falls from the American Side*.

The resulting work, though larger in area, is perhaps less ambitious than the earlier *Niagara*, choosing to provide the last word on a standard view of the Falls, rather than offering a novel perspective. Less dramatic than the earlier work (the spectator is not in danger of being swept over the top of the Falls), it does, nonetheless, employ many of the characteristic devices of painters of the Sublime, to exciting effect. The inclusion of a small wooden viewing gantry on the left, with tiny figures of a bearded man and a woman in a red dress taking in the scene, allows the viewer firstly to identify with the smallness of the respectable couple and then, with a shock, to marvel at the hugeness of the spectacle in front of them. The figures may, in fact, represent Church's friend Erastus Dow Palmer and Palmer's daughter Madelaine.[30] They are silhouetted against the raging torrent of the falls, painted with Church's customary mastery. Particularly impressive in this image is the effect of foam and spray in the middle-ground at the base of the American Falls, which is echoed by the spray of the Canadian Falls in the distance. In the foreground is a wonderful study of rocks drenched and glistening with spray, somewhat reminiscent in style of the work of Albert Bierstadt, who was at the peak of his fame in the mid-1860s. In a virtuoso touch Church throws the left foreground into dark shadow, but illuminates the right, showing the base of a rainbow against the brilliant green of algae growing on the rocks. As in the earlier Niagara picture (and in contrast to Kensett's version, no.37) the sky counts for almost nothing in *Niagara Falls from the American Side*, owing to the very high horizon.

The painting was intended to form an important part of the American display in the Fine Arts section of the Exposition Universelle held in Paris in 1867. However, the American selection committee (which included Knoedler) decided in the end to include the 1857 version of *Niagara*, perhaps in order to avoid controversy about the exhibition of a work still in the hands of a dealer and member of the committee. The 1857 painting proved to be one of the sensations of the exhibition.[31]

In 1868, *Niagara Falls from the American Side* was exhibited at McLean's Gallery in the Haymarket, London. The British audience was extremely enthusiastic: 'Future generations,' claimed one London critic, 'may come to this picture as a splendid page of the

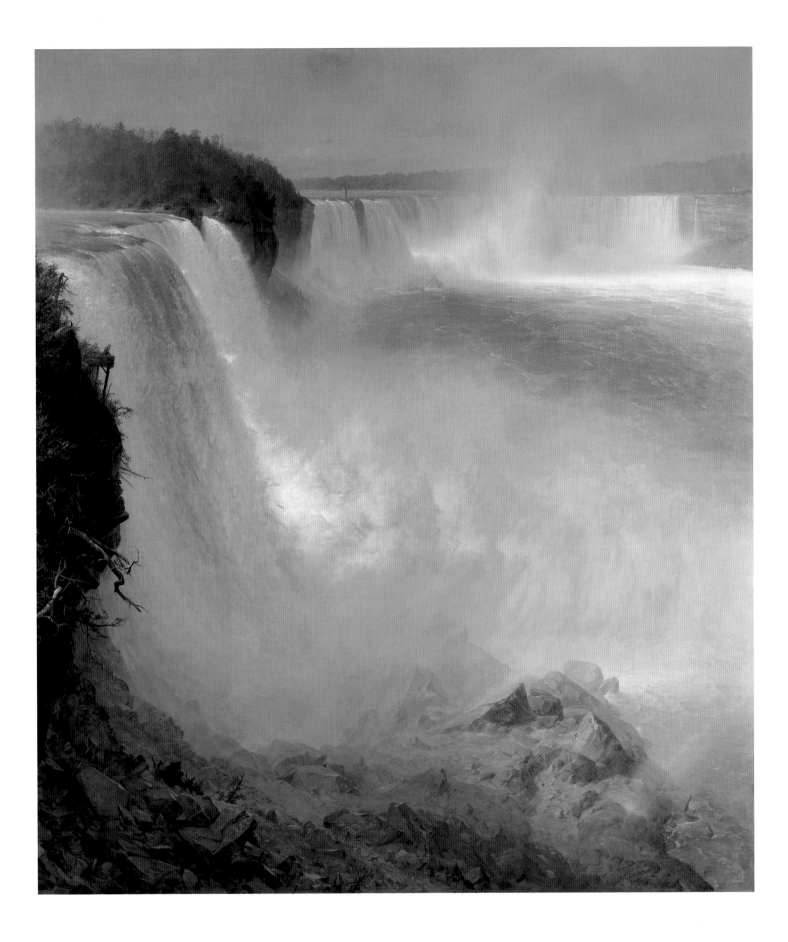

world's physical history, a true and faithful record of a great marvel.'[32] Another found Church to be:

> a delicate and accurate draughtsman, a patient student of nature under her most difficult and perplexing aspects, a pure and brilliant colorist, and a master of that supreme art of composition which can never be taught and never be acquired, but which is to the painter what melody is to the musician, and taste to the critic, – a gift, an instinct, an inspiration.[33]

For the *Illustrated London News*, the painting was 'more masculine' than previous renderings of the scene: 'It is not only free from the previous tendency to conventional ornamentalism, but evinces what may be termed more scientific . . . observation of natural phenomena.'[34] When it came to the painting of water, this Ruskinian critic went into raptures:

> The laws obeyed by falling water are thoroughly mastered and explained by the painter in a way which would carry conviction of the truth of his representation to those who have never seen a great cataract. You may watch, with an ever growing sense of the stupendous reality, the mighty river gliding above smooth as a mirror and swift as an arrow to the verge of the awful precipice, when it leaps in a graceful curve, compact and smooth and firm

as crystal; then comes a slight tremor, quickly quivering into a broad, wavering pattern on the columnar avalanche, as sharply defined as a Byzantine zig-zag, whilst a few stray streaks, baffled by the air, break into a ragged fringe of watery flakes.[35]

Church had achieved a remarkable semblance of reality, though at the cost of some of the sublime drama of the earlier painting.

The painting, like most of Church's 'Great Pictures', was chromolithographed in London before being returned to the USA, where it was first exhibited in Boston, at the private gallery of Williams and Everett. A pamphlet explained that 'the artist climbed a tree at the end of the arc of a circle and found that the view thence embraced the whole of the cataract'. The artist 'cut away foliage to secure a free sight, clung to the top of the tree, and made his sketch'.[36] The dealers' brochure recommended that the viewer should try examining the work inch by inch, in order to achieve an uninterrupted reality effect; 'examined through a tube, the illusion is complete to one familiar with the Falls'.[37]

The New York department-store owner A.T. Stewart purchased the work from Church in 1868. In 1886, when Stewart's collection was dispersed, the Scottish-American magnate John S. Kennedy acquired it for $7,050 and presented it to the National Gallery of Scotland.[38]
TB

Niagara, *c.*1869

Oil on paper laid on to canvas 48.3 × 68.6 (19 × 27)
Inscribed lower left 'A Bierstadt'
Private Collection
LONDON AND PHILADELPHIA ONLY

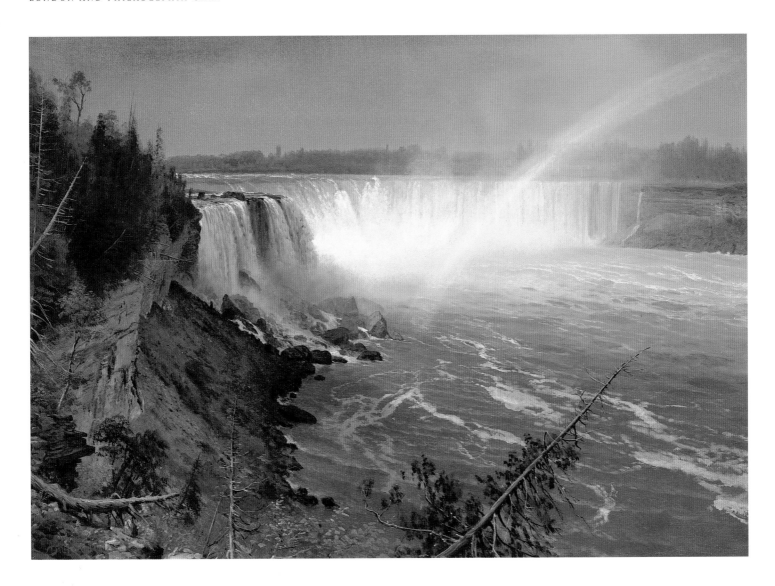

Like the similar-sized canvas of *Moat Mountain, Intervale, New Hampshire* (no.63), this elaborately worked-up view has the character of an open-air sketch. Here, however, the support is paper, which reinforces the idea that it was executed on the spot. Bierstadt was in Europe for much of 1869, but returned in the autumn, and was at Niagara at some point. It is worth noting that the leaves here are fully green, which would suggest a time a little earlier in the year; it is possible the work records another visit to the Falls. For instance, he was reported as 'studying Niagara' in September 1865.[39]

Bierstadt will inevitably have had in mind Church's famous views of Niagara, especially that of 1857, from the Canadian shore (fig.32),

but also no doubt the later view from the American side, painted in 1867 (no.35), whose composition this partly repeats. It is noteworthy that Bierstadt never essayed a full-scale picture of Niagara; he evidently felt that Church had made the subject his own, although many other painters tackled it in these years. Nevertheless this shows him bringing all his technical powers to bear on rendering the scale and grandeur of the scene, with typically impressive results. Kensett's studies of Niagara, done in the early 1850s (see no.37), also adopt a high viewpoint and furnish an interesting precedent for Bierstadt's approach.

AW

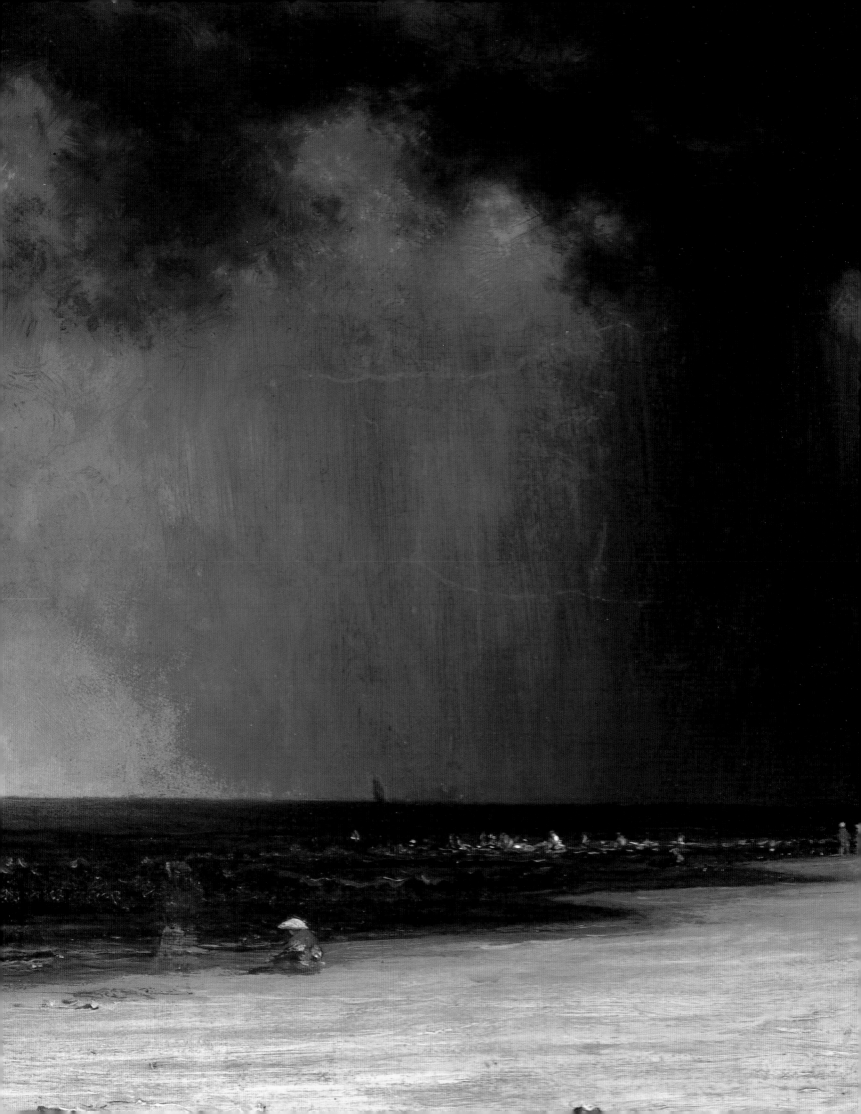

5 Painting from Nature

The practice of sketching informally in front of the subject out of doors became common in Europe in the first decade of the nineteenth century, when the Romantic generation of landscape painters, exemplified by John Constable, sought engagement with nature at a more personal and intense level. In America Cole, following European custom, executed small-scale oil studies in preparation for more elaborate compositions, and occasionally sketched in oil out of doors. From him Church and Durand learned to do the same. There was little or no formal training in the techniques of painting, and outdoor oil sketching established itself as an important if spontaneous discipline. In the 1850s it became a normal part of the landscape painter's practice, and artists like Sanford Robinson Gifford and John Frederick Kensett travelled to their summer sketching grounds up the Hudson or in the mountains of Vermont, New Hampshire and Maine armed with oil paints and easel, as well as with sketchbooks, pencils and watercolours. Church made especially prolific use of the medium, taking his implements to South America, Jamaica or the Arctic (nos.54–9), and continued to do so until late in his life, producing some of the most beautiful of all landscape studies in oil. Many of these record the spectacular scenery round his home, 'Olana', perched above the Hudson opposite the Catskills (nos.48–53). Albert Bierstadt's approach to the oil sketch was influenced by his time as a student at Düsseldorf, where the academic value of a rigorous technique was central to the training. His oil studies range from sketches of animals – bear, buffalo, cattle – to mountain peaks, trees, Indian encampments and surveying parties on the trail (nos.60–1). He also produced more elaborate subjects on a relatively small scale, which although fresh and directly observed 'are not sketches, nor are they studies – they are pictures' (nos.63–4).[1]

Niagara Falls and the Rapids, *c*.1851–2

Oil on canvas 41.6 × 61.6 (16⅜ × 24¼)
Museum of Fine Arts, Boston. Gift of Martha C. Karolik for the M. and M. Karolik Collection
of American Paintings, 1815–1865. 48.439

Since the eighteenth century Niagara Falls had rightly been considered one of the great sights of America, attracting as many as 30,000 visitors per year in 1845.[2] Many artists had attempted to capture its grandeur, including John Vanderlyn (as early as 1802), John Trumbull, Thomas Cole (in 1829) and Jasper Francis Cropsey; the popularity of the Falls grew in the 1840s and 1850s. Church's definitive rendering of the subject (fig.32) was still six years away when Kensett first visited in 1851. It was an unusual subject, however, for an artist of Kensett's temperament, who favoured tranquil over dramatic scenery. Accordingly, he painted Niagara from the least dramatic viewpoint, looking down from a high perspective, and reducing the great Horseshoe Falls to a small triangular intervention in the lower left of the composition. Terrapin Tower, on Goat Island, provided the most dramatic views and can be seen to the extreme left, but reduced to a tiny scale. Kensett concentrated instead on the contrast between the disturbed surface of the rapids and the tranquil vista of the river beyond. Already in this early work Kensett has begun to explore the characteristic flat horizon and pale, subtly evoked skies which were to become a hallmark of his later work. Although their force and majesty led one commentator to described the Falls as 'a glorious emblem of the majesty of God',[3] Kensett found greater religious sentiment in the calm distant prospect of sky and water.

Niagara Falls and the Rapids can be seen hanging, unframed, on the wall in a well-known photograph of Kensett in his New York studio, made by Peter Juley and Sons in about 1864.[4] More carefully finished than a swift on-the-spot sketch, the work is nonetheless not a finished exhibition picture. Perhaps it was displayed thus because Kensett planned to develop it into a major work; but it is just as likely that he simply found the image compelling in its own right. Kensett's friend George W. Curtis remarked that 'his sketches were so vivid and faithful and delicate that there was no wall in New York so beautiful as that of his old studio, upon which they were hung in a solid mass'.[5]
TB

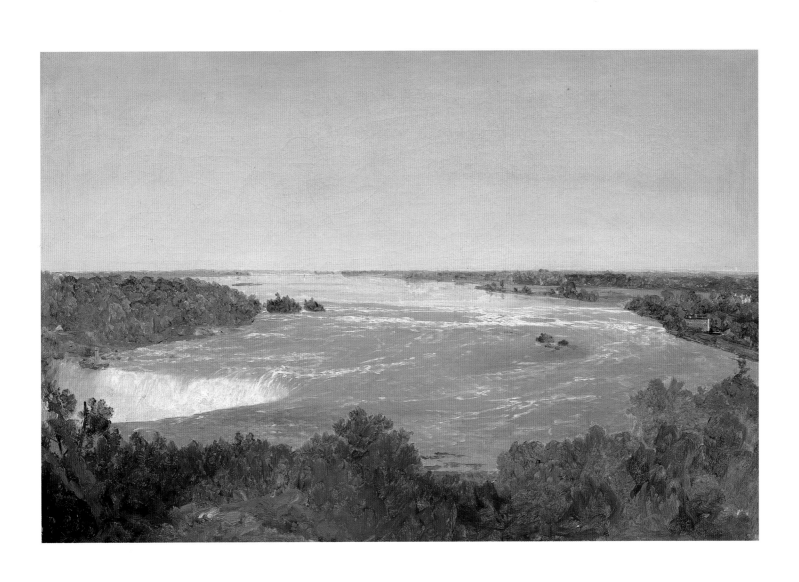

Thunderstorm at the Shore, *c.*1870–1

Oil on paper on canvas, mounted on wood panel 24 × 46.7 (9½ × 18⅜)
Inscribed lower right 'M. J. Heade 7[. . .]'
Carnegie Museum of Art, Pittsburgh; Howard N. Eavenson Memorial Fund, for the
Howard N. Eavenson Memorial Collection 1972

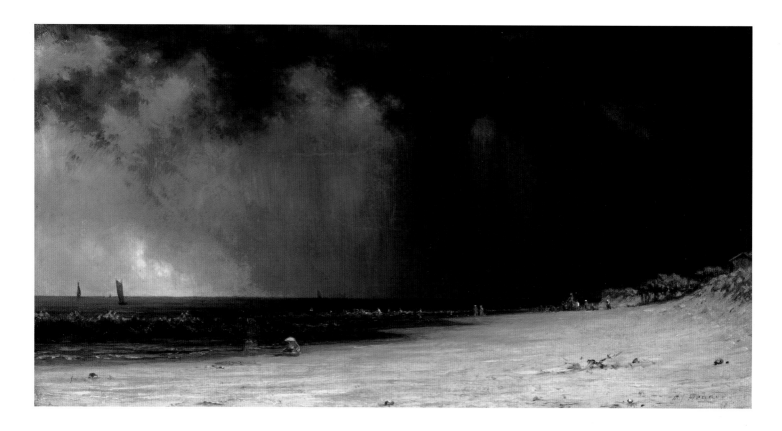

Although this is a signed work, and bears a date (rubbed and only partly legible: it has been read variously as 1867, 1870 and 1871), this small but powerful picture is in effect an oil sketch. It reverts to a theme that Heade had addressed on a larger scale twice before: the intense blackness of a stormy sky seen across a light-filled space. What gives it the character of a sketch or study, more than its small size, is its comparative lack of narrative or symbolic content. The boats and figures are very small, testifying to the presence of human life but hardly defining specific activities. The storm is studied on its own account, as a fine effect of nature. This sense of the immediacy of the reporting has led at least one commentator to suggest the influence of French painting: the work of the Barbizon artists was beginning to be admired and collected in the United States, and Heade may well have taken note of their practices.[6] A study of 1866 by Gustave Courbet (1819–1877) showing a rainstorm over the sea,

known as *The Waterspout* (Philadelphia Museum of Art), is often cited in connection with Heade's storm subjects, and in its concise directness bears some comparison with this picture. One might also refer to the coastal subjects of Constable, one of whose views of *Weymouth Bay* in stormy conditions was mezzotinted by David Lucas (1802–1881) and issued as a plate in Constable's *English Landscape Scenery* in June 1830. It is highly likely that Heade had access to a copy of this work although he probably knew few original pictures by Constable. The rich black of Lucas's mezzotint gives emphasis to the drama of the stormy sky over the curving beach, which is caught in a gleam of sunshine. Interestingly, Constable's picture itself was bought for the Metropolitan Museum of Art, New York, in 1872, but went to Paris and was presented to the Louvre the following year.
AW

39 JASPER FRANCIS CROPSEY 1823–1900

Storm with Sunburst over the Catskills, 1876

Oil on canvas 20.3 × 37.5 (8 × 14¾)
Inscribed lower left 'J. F. Cropsey | 1876'
Collection of the Newington-Cropsey Foundation, Hastings-on-Hudson

Like the other Cropsey sketch here (no.40), this small study takes as its focus a burst of light in an otherwise sombre landscape. Here, however, the horizon is broad, and the air is tinged with the warm colour of a stormy sunset. Cropsey had always taken an interest in the oil sketch, producing many examples at all stages of his career. Those from the latter part of his life are among his most intense. This example is no doubt a spontaneous note of an effect seen on a sketching expedition, but it carries overtones of some of the great New York landscape paintings of earlier decades: Church's *Twilight in the Wilderness* (no.25), for instance, or Worthington Whittredge's *Twilight on the Shawungunk Mountains* of 1865 (Manoogian Collection, Detroit).

AW

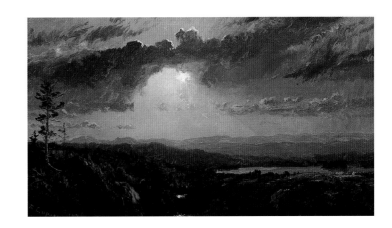

40 JASPER FRANCIS CROPSEY 1823–1900

Winter on the Hudson, 1887

Oil on canvas 28.6 × 49.5 (11¼ × 19½)
Inscribed lower right 'J. F. Cropsey | 1887'
Collection of the Newington-Cropsey Foundation, Hastings-on-Hudson

Cropsey moved to Hastings-on-Hudson in 1885, having sold his large house at Warwick, New York, for financial reasons. He called his new home Ever Rest. Like Church's at Olana further north, it enjoyed fine views of the river, which he painted frequently in the last years of his life. This study, which is signed in Cropsey's usual fashion and was evidently intended to be considered as an independent work, demonstrates his interest in subdued effects of winter light, an interest that some critics found surprising in view of his well-known penchant for sunny autumnal subjects. The forceful, direct handling is typical of his work, and enhances the sombre grandeur of the scene, with its foreground of fragmented ice on the river, and the looming wall of the Palisades beyond against a pallid gleam of wintry sunlight. The Palisades were described in the mid-nineteenth century as being at their 'most picturesque' opposite Hastings.[7] They extend for some 35 miles (56 kilometres) along the west bank of the Hudson, a sheer cliff of trap-rock between 300 and 600 feet (90–180 metres) high: 'Viewed from the river this range presents a forbidding aspect; and little does the traveller dream of a fertile, smiling country at the back of this savage front.'[8]

AW

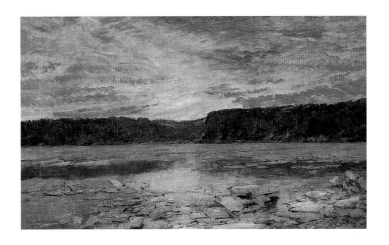

A Coming Storm on Lake George, *c.*1866

Oil on canvas mounted on board 25.4 × 45.8 (10 × 18)
Private Collection. Courtesy Berry-Hill Galleries, New York
LONDON AND PHILADELPHIA ONLY

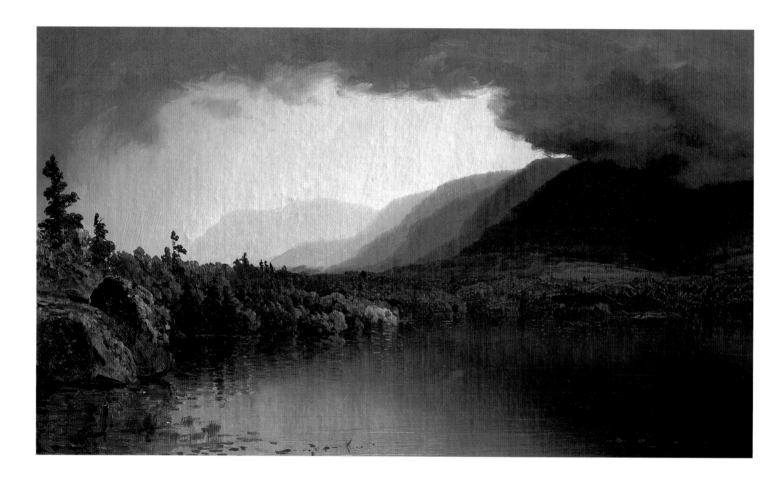

This study has been dated to about 1866; its very broad handling and dramatic effect of light are characteristic of Gifford's mature small-scale work, but the impact of the picture is unusual: the intensity of the blacks and the sparse glimmers of golden foliage make for one of his most powerful studies of the New York landscape.

At the same time they demonstrate Gifford's linear desecent from the Picturesque Sublime of work by Thomas Cole such as *Landscape with Tree Trunks* (no.4).
AW

42 SANFORD ROBINSON GIFFORD 1823–1880

Mist Rising at Sunset in the Catskills, *c.*1861

Oil and pencil on canvas 17.2 × 24.1 (6¾ × 9½)
The Art Institute of Chicago, Gift of Jamee J. and Marshall Field

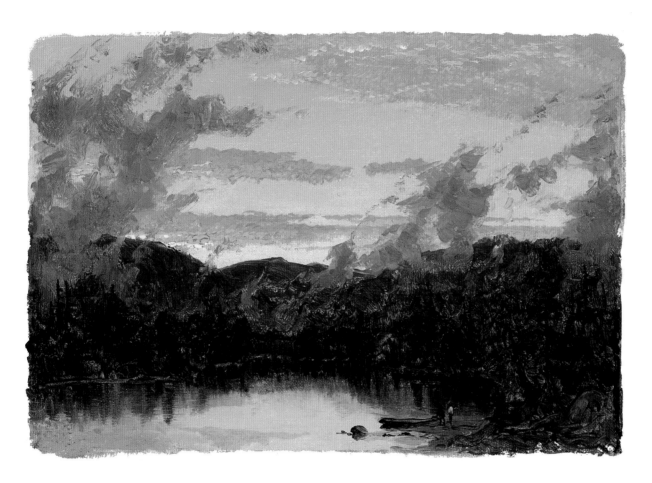

This striking study has been associated with Gifford's trip to Lake Mohonk in the Shawungunk Mountains, a range of the eastern Catskills, in September 1861. He was accompanied by three other artists, Worthington Whittredge, Jervis McEntee (1828–1891) and John White. Sketches in a book used by Gifford between 1860 and 1863 suggest that Gifford witnessed the effect he recorded here on the evening of 15 September. McEntee also made a study of the evening sky over the mountains, with grey mist floating across the view; it is larger but in other ways similar.[9] Both are striking and evocative, but it is noteworthy that whereas the McEntee study is consistently handled with broad dabs of the brush, Gifford has incorporated into his small canvas a detail of two men with a boat at the edge of the lake which, with its refined precision of drawing, gives the work a finished character. However, the extreme freedom of handling in the depiction of the isolated wisps of mist and distant hills, and the immediacy with which the fleeting atmospheric effect is conveyed, suggest that this is a study done from memory almost immediately after the event. The figures would then have been inserted, perhaps some time later, to indicate the scale of the landscape.

Swiftly executed sketches in oil often share similarities, whoever the artist; but it is worth noting the striking parallels between studies by both Gifford and McEntee and sketches by the English Pre-Raphaelite landscapist John William Inchbold (1830–1888), in particular a study in oil on paper of *Peat-Burning* made in 1866, in which both palette and handling are alike;[10] the Gifford canvas is almost exactly the same dimensions as Inchbold's paper.
AW

Niagara Falls, 1856

Pencil and oil on paper mounted on canvas 30.3 × 44.8 (11¹⁵/₁₆ × 17⅝)
Inscribed 'F Church 56.'
Wadsworth Atheneum, Hartford, Connecticut. Gift of Miss Barbara Cheney
LONDON AND PHILADELPHIA ONLY

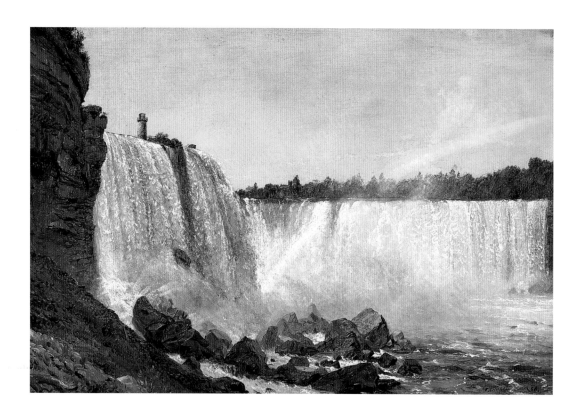

Although Church had copied a painting of Niagara Falls by his master, Thomas Cole, in *c*.1844–6, he first sketched at Niagara only in March 1856.[11] The winter was a particularly cold one, and the Falls must have been surrounded by ice. Church, possibly in the company of John Frederick Kensett, who was also sketching at the Falls that frozen March, produced a series of small studies in pencil and in oils, nearly all from the American side of the Falls. He went back to New York after only a short period, but returned in July, under very different weather conditions. It was then that he painted no.43. This small study made as Church searched for a composition for a major work – which would eventually emerge as *Niagara* of 1857 (fig.32) – depicts the American, rather than the Canadian, side of the falls. The viewpoint is the traditional one from below the Falls, familiar from prints such as William James Bennett's *American Fall from the Foot of the Staircase*, 1829.[12] As in the 1857 painting, a rainbow rises from the bottom of the Falls, caused by the sunshine passing through the fine spray given off by the Falls.

Niagara Falls (no.43) is based on a detailed pencil drawing, heightened with white bodycolour, made on the spot on 7 July (Cooper-Hewitt Museum, New York), but it is possible that Church also worked on this oil painting outdoors.[13] On the pencil sketch he made colour notations which testify to his search for perfect fidelity to nature: 'Where the water washes the rock the colour is lightish yellowish brown warm dry rock – grey and brownish but warm.'[14] Church was more fluent with paint than with words, however, and the resulting work in oils is luminous. Church attempted to represent the Falls in a scientifically accurate manner, an aspiration which may have derived from his enthusiastic response in 1856 to volumes III and IV of John Ruskin's *Modern Painters*. Most relevant to Church's work at Niagara, however, is Ruskin's description of the sublime qualities of water from the first volume of *Modern Painters*, which had appeared in 1843: 'Of all inorganic substances acting in their own proper nature, water is the most wonderful . . . It is to all human minds the best emblem of unwearied, unconquerable power.'[15] In this small painting, however, the moving water of the Falls is still depicted in a stylised fashion deriving ultimately from Cole. By the time of the major 1857 painting of Niagara, Church had evolved a completely novel, and uncannily convincing, method of representing the motion of torrents of water plunging into the chasm. This study remained in the artist's family until 1971 when Church's grand-niece, Miss Barbara Cheney, gave it to the Wadsworth Atheneum.

T B

44 FREDERIC EDWIN CHURCH 1826–1900
At the Base of the American Falls, Niagara, 1856

Oil on paper laminate 29.5 × 35 (11 ⅝ × 13 ¾)
Cooper-Hewitt, National Design Museum, Smithsonian Institution, Gift of Louis P. Church, 1917-4-1353

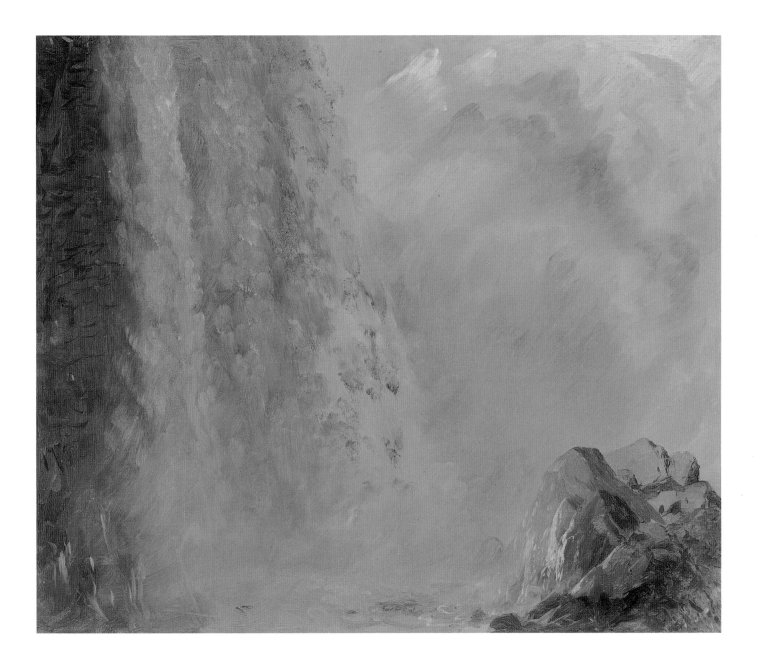

Of all Church's Niagara sketches, this most vividly captures the artist's response to the drama of the Falls. Sketched at the base of the American Falls, which would provide the subject for his large upright canvas of 1867 (no.35), this dramatic study finds Church at his most gestural, applying paint with astonishing speed and virtuosity to capture the contrast between sheets of falling water and the rising spray. The water on the rocks is meticulously observed, while in the extreme right a rainbow appears to be forming; or perhaps Church was merely noting the colours he observed in the rainbow that rises from the Falls. Almost exactly the same colours are used in the rainbow effect in the large painting of 1867.
TB

Horseshoe Falls, Niagara, 1856–7

Oil on two pieces of paper, joined together, mounted on canvas 29.2 × 90.5 (11½ × 35⅝)
Olana State Historic Site, New York State Office of Parks, Recreation and Historic Preservation

An impressive study in its own right, *Horseshoe Falls, Niagara* played an important role in the genesis of Church's masterpiece *Niagara* (1857; fig.32). Adopting a more dramatic perspective than in the small painting of 1856 (no.44), Church chose the vertiginous and spectacular panorama of the Horseshoe Falls from the Canadian side, looking south. The unusual format of the painting – its height only a third of its width, as opposed to the usual two-thirds – draws attention to an unusual aspect of the Falls: rather than emphasising the height from which the water descends (as in no.35), Church celebrates the sheer expanse of the great Horseshoe Falls, and the immense amount of water which surges over it. From this vantage point, the rapids, the main subject of John Frederic Kensett's oil sketch of *c*.1851–2 (no.37), can be seen to the right, but Church offers a far more spectacular view of the Horseshoe Falls than the understated Kensett. The human presence is signalled by the inclusion of Terrapin Tower at the far left, but the tiny structure only emphasises the magnitude of the untameable force of nature.

The present work seems to have been completed between December 1856 and early January 1857. It was discussed by several critics before Church moved on to tackle the larger painting. A reporter from the *Home Journal* was allowed a preview of no.45 in December, and clearly received information from the artist himself:

> Church passed several weeks at Niagara to great advantage. He has succeeded in making the most comprehensive view of the Falls yet achieved; and we hazard nothing in predicting that, when transferred to a large canvas and finished, it will be the most satisfactory view of the cataract ever made.[16]

By January 1857 Church was confident enough of no.45 to exhibit it in his space at the Tenth Street Studio Building. The *Crayon* carried the following glowing notice:

> Mr CHURCH, as one of the results of his summer studies, exhibits a sketch of Niagara Falls, which more fully renders

the 'might and majesty' of this difficult subject than we ever remember to have seen these characteristics of it on canvas. The point of view is happily chosen, and its impressiveness seems to be produced by an admirable drawing aided by a skillful subordination of accessories; the eye is not diverted, led away as it were, from the soul of the scene by diffuse representation of surrounding features. We shall look forward to the picture to be made from this sketch with much interest, as we believe Mr Church intends to reproduce it on a more extended scale.[17]

Satisfied that he had arrived at an ideal composition, Church set to work on a large canvas: *Niagara* (fig.32) was apparently completed in as little as two months.[18]

In the larger painting Church pulls back a little from the Falls, allowing slightly more foreground to appear. The sky is expanded and the distant Canadian shoreline of the river is less prominent. Nonetheless, most of the major features, such as the conjunction of the two convex curves of the Falls in the centre of the composition, are retained.[19] Completed with spontaneous, free brushwork, no.45 is nonetheless rigorously disciplined. Church was able to achieve the same level of spontaneity in the larger version, while adding a higher degree of finish. The surface could bear close and detailed examination, but the work was also effective from a great distance. The large canvas was immediately recognised as Church's masterpiece when it appeared before the public as a 'Great Picture' at the private gallery of Williams, Stevens and Williams in 1857.

Horseshoe Falls, Niagara stayed in Church's studio for perhaps ten years, before being transferred to Olana, his home near Hudson, New York, where it remains as part of the Olana State Historic Site collection. It has generally occupied the same position, over a window in the Sitting Room, since Church's lifetime.

TB

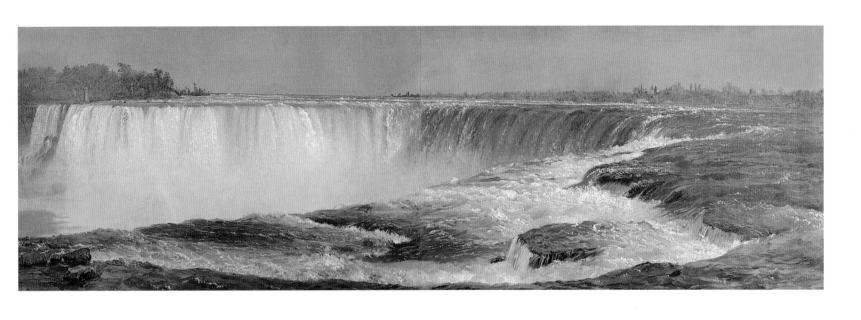

Schoodic Peninsula from Mount Desert, Sunrise, *c.*1850–5

Oil on thin board 22.8 × 35 (9 × 13¾)
Cooper-Hewitt, National Design Museum, Smithsonian Institution, Gift of Louis P. Church, 1917-4-332

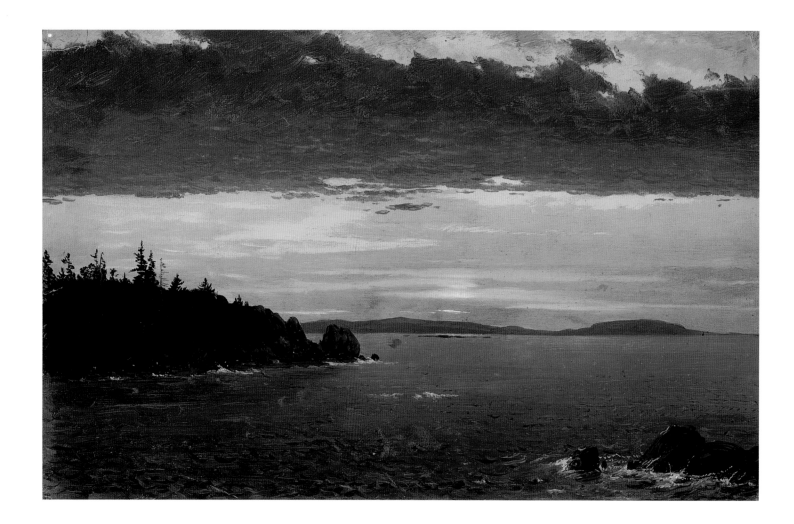

Church's visits to the Maine coast produced a large number of oil sketches, several of which were later developed into finished paintings (see no.34). In the more precisely finished *Sunset, Bar Harbor* (no.47) Church investigated the possibilities of a vivid sunset with bands of horizontal cloud catching the last of the sun. His explorations of this motif would culminate in *Twilight in the Wilderness* (no.25). This remarkable study depicting a sunrise also emphasises the range of effects which can be achieved with parallel, horizontal forms. Giving

each careful attention, Church glories in the colours and textures of water with a slight swell: the dark outlines of the Schoodic Peninsula in the distance; the golden and duck-egg blue of the distant sky; and finally the crimson clouds overhead. The sunrise recorded in this sketch was later utilised by Church in his enigmatic major painting *Beacon off Mount Desert Island* (1851; Private Collection).[20]
TB

Sunset, Bar Harbor, 1854

Oil on paper 25.7 × 43.8 (10 ⅛ × 17 ¼)
Olana State Historic Site, New York State Office of Parks, Recreation and Historic Preservation

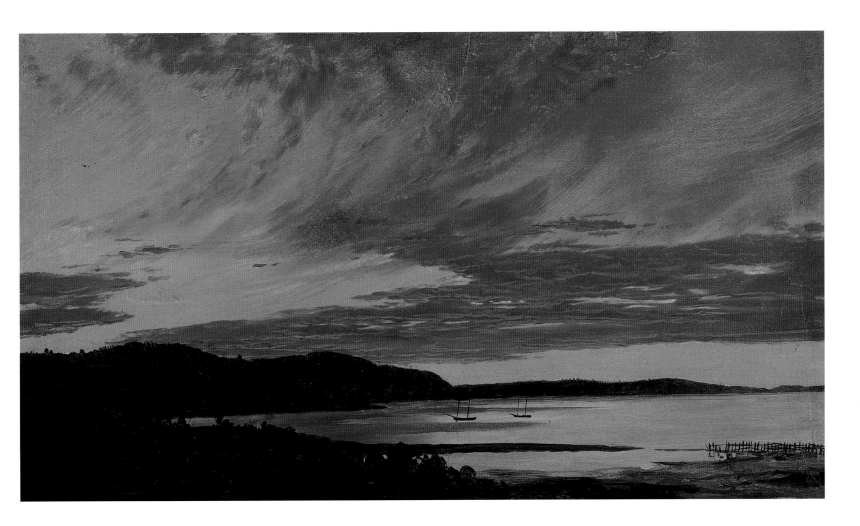

Bar Harbor, on Mount Desert Island, Maine, became one of Church's favourite sketching grounds. This intense, small painting, probably dating from September 1854, shows the harbour with an arm of Frenchman Bay in the distance, under the sunset conditions which Church extensively explored at this time. The geography of the area is described in William Cullen Bryant's *Picturesque America*. Bar Harbor is reported as

> on the eastern shore, opposite the Porcupine Islands, and derives its name from a sandy bar, visible only at low water, which connects Mount Desert with the largest and northernmost of the Porcupine group. The village at this harbor is known as East Eden and here tourists and summer visitors principally reside.[21]

The painting is closely based on a drawing (Olana State Historic Site, OL.1980.1448) made on the spot in pencil, with scribbled pencil

annotations.[22] Church's words (moving from the top of the image to the bottom) are as vivid as the colours in the oil version of the composition:

> Mottled clouds in regular ranks | Mottled | Duller blue as if in shadow | green gold brilliant | Brilliant | dark to blackness | Splendid | orange | cooler . . . Splendid silvery blue – ruffled by wind . . . Illuminated with rich orange and lake light in parallel lines but dim compared with open sky – | Also broken with openings showing the cool bright sky | shadow tint brownish purple.[23]

The painting, though completed with greater deliberation than Church's oil sketches made on the spot, was probably made in his Maine studio shortly after he experienced the sunset. It preserves an astonishing freshness and conviction. *Sunset, Bar Harbor* provided

a starting point for a much larger work, *Sunset* (1856; Munson-Williams-Proctor Institute, Utica). The success of these paintings in which horizontal bands of cloud catch the colour of the setting sun must have encouraged Church to produce his grandest variation on the theme, *Twilight in the Wilderness* (1860; no.25).[24] Church's study of a Maine sunset with two vessels, only slightly indicated, suggests how different were his priorities to those of Fitz Hugh Lane, whose

carefully finished painting of *Lumber Schooners at Evening on Penobscot Bay* (1863; no.72) is wrought from similar basic ingredients. In contrast to Lane's Maine images, introspective and enigmatic, Church responded to the spectacular sunset with a painting at once theatrical and religious in feeling.

TB

Landscape with Sunset *c.*1860–70

Oil and pencil on thin cream board 22.7 × 33 (9 × 11)
Cooper-Hewitt, National Design Museum, Smithsonian Institution, Gift of Louis P. Church, 1917-4-1261

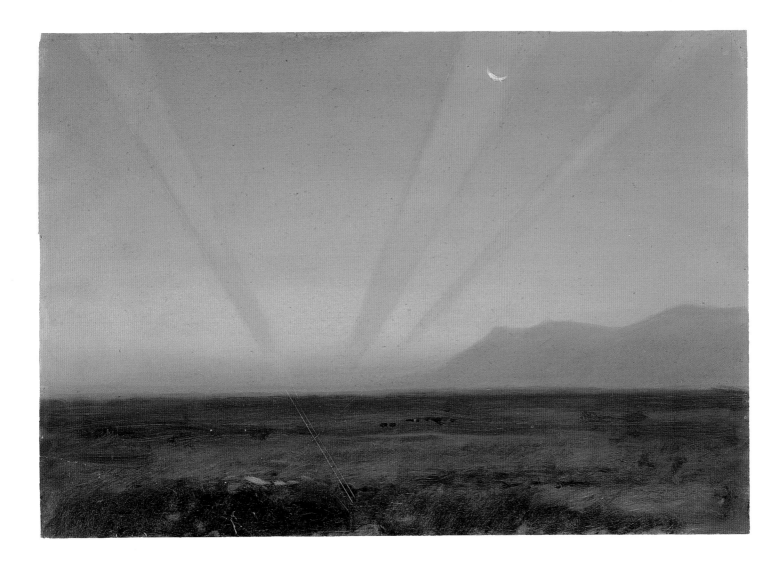

This most striking of Church's oil sketches captures the effect of an unusual sunset. Three bold, blue-green beams of light stand out sharply against the tan-coloured sky, with the thumbnail moon captured in the central beam. Below, an indistinct landscape can be identified as the Hudson Valley near Church's home at Olana, looking west, with the Catskill Mountains seen silhouetted to the right. Church must have witnessed this unusual spectacle and noted it swiftly; but in working on this study he used a ruler to ensure the geometric precision of the shafts of sunlight, slightly blurring the outlines to create a naturalistic representation of a remarkable meteorological phenomenon. One of Church's most dramatic works of this period is *Aurora Borealis* (1865; Smithsonian American Art Museum, Washington DC), and no.48 was until recently misidentified as a sketch for that work. However, the westward view, the Hudson River setting and similarities to the shafts of light in Church's oil sketch *Sunset in Jamaica* (Olana State Historic Site, OL.1981 26A and B) indicate that this is, in fact, a sunset rather than the more opalescent effect of the northern lights, or aurora borealis.[25]

TB

49 FREDERIC EDWIN CHURCH 1826–1900

Clouds Over Olana, 1872

Oil on off-white paper 22.1 × 30.8 (8 ¹¹/₁₆ × 12 ⅛)
Inscribed lower middle 'F.E.C. Aug – 1872'
Olana State Historic Site, New York State Office of Parks, Recreation
and Historic Preservation

Church dedicated much of his time during 1870 and 1871 to
overseeing the construction of Olana, the Orientalist fantasy which
became the home of the Church family in 1872. Perched on top of
a steep hill (known as Sienghenberg) near Hudson, New York, it
commands superb views of the Hudson Valley (see fig.26) and
overlooks the village of Catskill where Thomas Cole, Church's mentor,
had lived and died. On 19 August 1872 Church wrote to Erastus Dow
Palmer noting the 'splendid sky effects',[26] and perhaps it was that day
on which the present quick sketch was made. Church's deft and swift
brushstrokes captured an unusual cloud formation which, catching
the pinkness of the sunset, seemed to mimic the shape of the hill with
the newly erected Olana sitting proudly on top of it. Scratched hastily
into the wet paint with the end of his brush is the inscription 'F.E.C.
Aug – 1872'. The same inscription appears on another wonderfully
spontaneous oil sketch (*Nightfall near Olana*, 1872; Cooper-Hewitt
Museum, New York) probably painted only minutes later as the sky
darkened, leaving just one patch of pinkness among the clouds.[27]
TB

50 FREDERIC EDWIN CHURCH 1826–1900

The Bend in the River from Olana, *c.*1870–3

Oil on off-white academy board 25.6 × 32.7 (10 ¹/₁₆ × 12 ⅞)
Olana State Historic Site, New York State Office of Parks, Recreation and Historic Preservation

The view from Olana of the distant bend in the Hudson River became
a favourite subject for Church's sketches. This is among the most
spare and gestural of all of them, possibly made to demonstrate the
potential of a few broad sweeping brushstrokes.[28] The tonalities are
less spectacular than in Church's sunset images, but the blue-grey
effect eloquently suggests an overcast afternoon in the Hudson Valley.
TB

Sunset across the Hudson Valley, 1870

Oil and pencil on thin board 32.2 × 35.2 (12 ¹¹/₁₆ × 13 ⅞)
Inscribed lower right 'Sep | 70'
Cooper-Hewitt, National Design Museum, Smithsonian Institution, Gift of Louis P. Church, 1917-4-582C

Church must have worked on this bold and dramatic study in the studio, on the basis of observations made on his estate at Olana. The view across the Hudson River at sunset to the cloud-capped Catskill Mountains is closer in feeling than most of Church's sketches to the work of his teacher, Thomas Cole, who lived and died in the village of Catskill. The vivid brushwork is impassioned after Cole's manner, and the dramatic contrasts of light and shade – especially where golden sunlight penetrates the black and purple stormclouds – recall the earlier artist's work. Church is less formulaic than Cole in his treatment of foliage and even in a sketch is able, through a remarkable variety of brushstrokes, scumbling and scraping-out of paint, to evoke the different textures of woodland, brush, grass and distant forest.

TB

Sunset across the Hudson Valley, Winter, *c.*1870–80

Oil and pencil on thin paperboard 25.3 × 32.8 (10 × 12 ⅞)
Cooper-Hewitt, National Design Museum, Smithsonian Institution,
Gift of Louis P. Church, 1917-4-330A

The view from the Olana estate provided Church with the subject
for numerous sketches, most of which were not preparatory works
but self-contained exercises in observation. This study records
the moment before the sun disappears over the distant Catskill
Mountains. The full range of Church's mark-making is apparent,
from the richly impasted passages in the foreground depicting the
untouched snow to the contours of the distant mountain, where the
wet paint has been scraped off, possibly with a dry brush, to reveal
the cream-coloured cardboard underneath. By the simplest means
Church is able to evoke the complex textures of the Hudson Valley
floor, lightly covered in snow. As in many of Church's major works,
notably *Twilight in the Wilderness* (no.25), the sky plays a dominant role
in the composition, and here the brushstrokes are more vigorous
and gestural. The thickest paint, as so often in the works of Turner,
is reserved for the molten yellow of the setting sun.
TB

Hudson River Valley in Winter Looking Southwest from Olana, *c.*1870–80

Oil and pencil on thin board 29.3 × 44.1 (11 ⁹⁄₁₆ × 17 ⅜)
Cooper-Hewitt, National Design Museum, Smithsonian Institution,
Gift of Louis P. Church, 1917-4-330B

Like nos.51 and 52, this work derives from Church's habitual practice
of sketching the atmospheric effects to be observed from his home,
Olana. The combination of river and mountain scenery, both visible
in this study, provided an inexhaustible inspiration for the artist.
Although the valley was quite populous by this time, and the Hudson
River busy with traffic, Church preferred to reduce the scene to its
natural components, as if it were still a wilderness. His favourite
moment was the twilight when mist gathered in the darkening
valley and brilliant colours illuminated the sky.
TB

54 FREDERIC EDWIN CHURCH 1826–1900
Cotopaxi Seen from Ambato, Ecuador, 1853

Oil and pencil on paperboard 17.3 × 29 (6 ³/₁₆ × 11 ⁷/₁₆)
Cooper-Hewitt, National Design Museum, Smithsonian Institution, Gift of Louis P. Church, 1917-4-773

Church made the first of his two tours to South America in 1853, with his friend Cyrus West Field. The trip lasted from April to October and took them to New Granada (Colombia) and Ecuador, where he took a particular interest in the volcanoes, notably Cotopaxi, Pichincha and Chimborazo. An important stimulus for him in making the journey was the work of the great German naturalist and explorer Alexander von Humboldt, whose magnum opus, *Cosmos*, had been translated into English more than once with the subtitle 'Sketch of a Physical Description of the Universe'; Church owned several copies. Humboldt had explored the northern regions of the South American continent between 1799 and 1804, collecting huge quantities of specimens and surveying the mountains and rivers. His detailed descriptions of these discoveries occupied him for many years afterwards. Church was,

then, following in the footsteps of a great scientist, in a spirit of serious enquiry. His studies of what he saw on his travels were thus, as in the case of Constable's sky studies, a form of experiment. The ideas of John Ruskin were equally pertinent and influential.

This study was made in September 1853 during Church's first South American tour. It demonstrates the precise naturalism of his approach, and in general effect is very close to Ruskin's studies (which are usually in watercolour), combining a subtle feeling for light with a searching interest in geology. The details of the subject are painted with a fine brush on a pale yellow-green ground, which Church used for many of his Ecuadorean sketches.

AW

Erupting Volcano, Cotopaxi, South America, 1853

Oil on paper 24.5 × 41.3 (9 ⅝ × 16 ¼)
Inscribed 'Erupting volcano, S. America'
Cooper-Hewitt, National Design Museum, Smithsonian Institution, Gift of Louis P. Church, 1917-4-1332A

Cotopaxi was considered the most beautiful and the 'most formidable' of the South American volcanoes, with its regular cone coated with snow.[29] Humboldt himself singled it out as the most perfect 'among all the volcanoes that I have seen in the two hemispheres'.[30] This study was made during Church's first journey to South America (see no.54), in September 1853. It seems to have played an important part in the development of his first major painting of Cotopaxi, the canvas of 1855 now in the Smithsonian American Art Museum, Washington DC.[31] In that picture the volcano is seen from approximately the same viewpoint as in the study, with a plume of smoke blowing to the left. The foreground is a largely empty expanse of low hills and ridges, beyond a green plain with a few scattered buildings. As in the study, the picture is firmly divided by a horizontal line that corresponds both to the horizon and to the snow-line of the peak. The suggestion of imminent eruption in the glow of red at the mouth of the volcano is suppressed in the final work, which presents Cotopaxi as benign, presiding quietly over a peaceful landscape.

When he first tackled the South American volcanoes, Church will have been conscious of Thomas Cole's painting of *Mount Etna from Taormina* (1843; fig.48). Cole was following a well-established convention in painting Etna from Taormina: numerous artists of the eighteenth century had done so. Cole's treatment of the snow-covered cone with its trail of white smoke against the sky, and rocky lower slopes spreading down into the hilly plain below, prefigures in general presentation, and in many details, Church's view of Cotopaxi. The telling difference is that Cole's foreground is taken up with the ruins of the famous Roman theatre at Taormina, while Church's Ecuadorean plain is empty save for a scattering of farms. It seems that Church may have intended the parallel, and the contrast, to be noted: this is the New World, whose antiquity is manifest in its ancient geological forms rather than in man-made edifices. In 1862 Church exhibited another, grander view of Cotopaxi (no.86) in which these ideas about the geological history of the continent are developed much further.

Church's present view of Cotopaxi also has an interesting English

48 Thomas Cole, *Mount Etna from Taormina*, 1843. Oil on canvas, 199.7 × 306.4 (78 ⅝ × 120 ⅝). Wadsworth Atheneum, Hartford, Connecticut. Purchased from the Artist by Daniel Wadsworth for the Wadsworth Atheneum, assisted by Alfred Smith 1954.268

precursor in Joseph Wright of Derby's *View of Mount Etna and a nearby Town* of about 1775, in the Tate Gallery.[32] Wright does not adopt the usual Grand Tour vantage point at Taormina but paints Etna from across its lava-ridged plain, probably to the south. Here, too, the foreground is a flat expanse, and the composition is dominated by a strong horizontal line dividing the dark volcanic plain from the snowy cone and blue sky. Church cannot have had access to any version of Wright's picture, however, and it is unlikely that Cole did either. The topography of such regions imposes certain forms on the artist, and Church used a similar sparse compositional layout in his study of *Puresé, Columbia* (Olana State Historical Site),[33] and reverted to it again in his 1857 study of *Mount Chimborazo at Sunset* (Olana State Historical Site).[34]

AW

Distant View of the Sangay Volcano, Ecuador, 1857

Oil and pencil on thin board, varnished 22.7 × 36.4 (8 15/16 × 14 5/16)
Cooper-Hewitt, National Design Museum, Smithsonian Institution, Gift of Louis P. Church, 1917-4-402

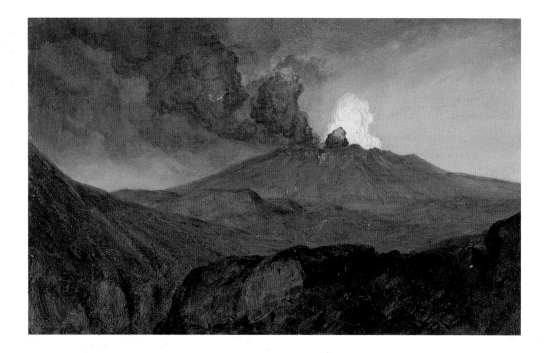

Church did not visit Sangay on his first visit to Ecuador in 1853, and indeed it was a little-known volcano, having only been explored scientifically as recently as 1849. It had a reputation for violent eruptions, 'the most terrible volcano in the world', as Church wrote in a letter to friend, written on his way there in 1857. He was encouraged by these and other sensational rumours to visit Sangay for himself during his second tour in South America. The journey occupied him between May and August; he travelled with the painter Louis Remy Mignot (1831–1870), who was to become perhaps the closest of his followers. On the evening of 11 July they had come within 20 miles (32 kilometres) of Sangay, and Church climbed a hill to draw it from that distance:

> Dense clouds hung over the mountain tops everywhere and I looked in vain for a glimpse of Sangai or its smoke. Its proximity, though, was evident enough from the regular, impressive shaking of the earth and the tremendous peals which marked every explosion . . . Gradually the clouds broke away, and the sun shone and gilded with refined gold every slope and ridge that it could touch . . . I turned my face, and lo! Sangai, with its imposing plume of smoke stood clear before me. I was startled. Above a serrated, black, rugged group of peaks which form the crater, the columns arose, one creamy white against an opening of exquisitely blue sky, delicate white, cirrus formed, flakes of

vapor hung about the great cumulus column and melted away into azure. The other, black and sombre, piled up in huge, rounded forms cut sharply against the dazzling white of the columns of vapor and piling up higher and higher, gradually was diffused into a yellowish tinted smoke through which would burst enormous heads of black smoke which kept expanding, the whole gigantic mass gradually settling down over the observer in a way that was appalling.

> I commenced a sketch of the effect, but constant changes rapidly followed and new beauties were revealed as the setting sun crested the black smoke with burnished copper and the white cumulous [sic] cloud with gold.[35]

He made various pencil studies[36] and, presumably a little later, this fine oil sketch. He never finished a large picture in which Sangay featured, but his drawings and this study of its dense smoke catching the pinkish light of the sunset must have played its part, as Carr suggests, in the conception of *Cotopaxi* (no.86).[37] Unlike the study of *Cotopaxi Seen from Ambato, Ecuador* (no.54), this view places the volcano in its wider surroundings: the hilly foreground that intervenes between us and the mountain suggests the arduous journeys that Church, following in the footsteps of Humboldt, was accustomed to make in his exploration of this tropical landscape.
AW

57 FREDERIC EDWIN CHURCH 1826–1900
Thunder Clouds, Jamaica, 1865

Oil on cream board 18.3 × 29.9 (7¼ × 11¾)
Cooper-Hewitt, National Design Museum, Smithsonian Institution, Gift of Louis P. Church, 1917-4-407B

Church's tour to Jamaica in 1865 took him away from New York from April to August, immediately following the deaths of his two-year-old son and a five-month-old daughter. His wife and several friends accompanied him. The sketches that he made there often record sweeps of hilly country with few or no distinguishing features, as if he were immersing himself in an undifferentiated medium that would absorb him and distract him from grief. This study of clouds over the forests, probably made in the Blue Mountains, is one of several that celebrate the stormy skies of the island. It is less a record of material for inclusion in a finished picture than a meditation on the gentle grandeur of the world. Others, in the collection of the Cooper-Hewitt, National Design Museum (1970-4-351A, 351C), show broader expanses of forest under lowering banks of dark cloud.[38] But Jamaica did not inspire Church to many finished statements. Apart from *The After Glow* of 1867 (Olana State Historic Site; see comments under no.86), he painted only one major Jamaican picture, also finished in 1867, *The Vale of St Thomas* (Wadsworth Atheneum, Hartford, Connecticut),[39] a panoramic subject which perhaps reflects the artist's state of mind in its dual perspective and climatic uncertainty.

AW

58 FREDERIC EDWIN CHURCH 1826–1900
Floating Iceberg, 1859

Oil and pencil on thin board 18.7 × 37.7 (7⅜ × 14 ¹³⁄₁₆)
Inscribed on verso 'Iceberg | $200 | by F.E. Church'
Cooper-Hewitt, National Design Museum, Smithsonian Institution, Gift of Louis P. Church, 1917-4-296A

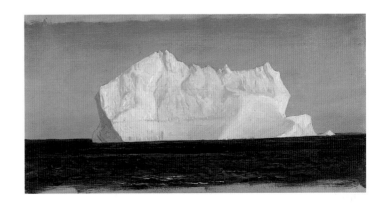

This strikingly stark study was painted directly from the motif in June or July 1859 during Church's trip to the coast off Newfoundland in preparation for *The Icebergs* (no.88). It captures the artist's awe in the face of the monumental scale of the icebergs, while also noting such details as the brilliant turquoise colour produced when the waves lapped against the ice. The iceberg has a geological solidity, as if Church were still relying on his experience of painting snow-capped mountains in order to translate the unfamiliar structure into paint. The documentary approach of the sketch contrasts with the elaborately orchestrated composition of the final painting. See entry for no.88 for a full account of the development of *The Icebergs*.

TB

Icebergs and Wreck in Sunset, c.1860

Oil on paperboard mounted on canvas 21 × 33.6 (8 ¼ × 12 ¼)
Thyssen-Bornemisza Foundation, Lugano

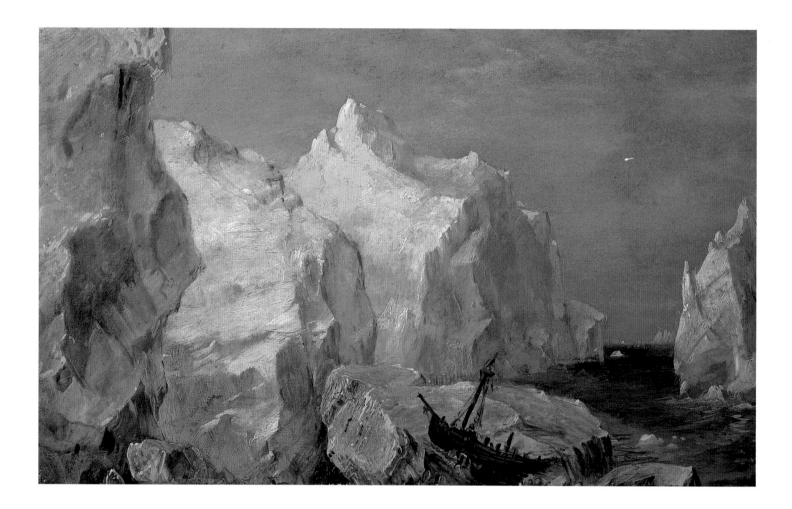

This elaborate sketch is a study for the major painting *The Icebergs*, first exhibited in 1861, which Church based on studies made off the coast of Newfoundland in 1859 (see full discussion of the genesis of *The Icebergs*, no.88). It represents an intermediate stage between on-the-spot sketches (such as no.58) and the final composition.[40] Although some elements are in place – for instance the rock face to the left (which was to be reduced in size in the final version) – Church had not yet decided to focus on a single, massive iceberg, but at this stage was exploring a more diffuse composition. The shipwreck in the foreground (here rather unconvincingly portrayed) was not included in the large painting on its first exhibition in New York in 1861. Church did, however, reintroduce the motif, in much altered form, before exhibiting the definitive version of the painting in London in 1863.
TB

60 ALBERT BIERSTADT 1830–1902

Surveyor's Wagon in the Rockies, *c.*1859

Oil on paper mounted on masonite 19.7 × 32.7 (7¾ × 12⅞)
Inscribed lower right 'ABierstadt'
The Saint Louis Art Museum, Gift of J. Lionberger Davis

Albert Bierstadt's first journey to the Far West of the United States was with a Government survey headed by Frederick W. Lander. He was accompanied by another artist, Francis Shedd Frost (1825–1902). They set out in April 1859. At that date little was known of the geography of the West; part of Lander's mission was to confirm that the 'Rock' mountains were indeed as spectacular as rumour made them. This was therefore a turning point in the perception of American landscape, and by joining the expedition Bierstadt ensured that it was also a turning point in his career. He met the party at Saint

Joseph, Missouri, in May, and did not return to the East until the middle of September. At first the country was very flat, but in early June they saw the mountains, which, he said, 'as seen from the plains . . . resemble very much the Bernese Alps'.[41] In this letter to the New York *Crayon* he mentioned that the expedition had with it a 'spring-wagon and six mules'.[42] Here the wagon and four of the mules rest among the yellow-flowering sage-brush with the mountains looming pale and distant beyond a sparsely occupied plain.

AW

61 ALBERT BIERSTADT 1830–1902
Nebraska, Wasatch Mountains, 1859

Oil on paper mounted on board 33 × 48.3 (13 × 19)
Inscribed on verso 'Nebraska: Warcatch [sic] Mountains'
Arthur J. Phelan, Jr.

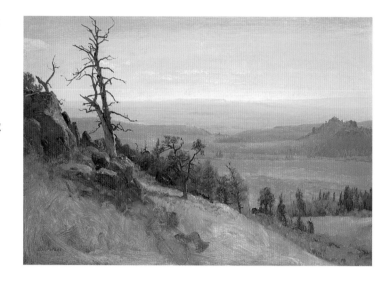

The Lander party (see no.60) stayed for some time in the mountains at
South Pass, in what was then Nebraska territory and is now western
Wyoming. Bierstadt made a number of studies there, which capture
the expansive landscape seen from heights diversified with rocky
outcrops. This example is especially free and immediate, bearing little
sign of having been worked up later, as Bierstadt was in the habit of
doing. The Wasatch Range runs north–south down into Utah, forming
a grand backdrop to the Mormon settlement of Salt Lake City. Several
finished pictures resulted from these studies, prominent among them
the *View from Wind River Mountains, Wyoming* (1860) in the Boston
Museum of Fine Arts, which preserves the contrast between rugged
upland on the left and broad plain beyond.
AW

62 ALBERT BIERSTADT 1830–1902
Fir Trees and Storm Clouds, 1859 or later

Oil on paper mounted on canvas 35 × 47 (13¾ × 18½)
The Cleveland Museum of Art, Mr and Mrs William H. Marlatt Fund, 1982.57

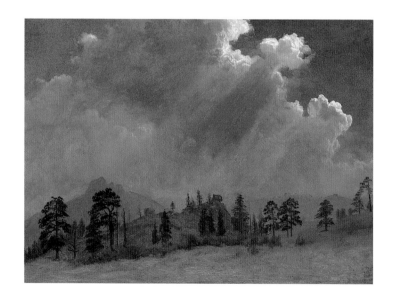

This atmospheric study has been associated with Bierstadt's first
Western journey, in 1859, but it is possible that it belongs to a later
trip, perhaps made in about 1870. With its low horizon and vividly
observed sky it is in the European tradition of *plein-air* oil sketching
from Constable onwards. Even though the landscape occupies a
relatively small portion of the subject, the different species of trees
are carefully distinguished, and the rocky outcrops are noted as
characteristic of the terrain through which he was travelling.
AW

Moat Mountain, Intervale, New Hampshire, *c.*1862

Oil on canvas 48.6 × 66.4 (19⅛ × 26⅛)
Inscribed lower right 'ABierstadt'
The Currier Gallery of Art, Manchester, New Hampshire, 1947.3

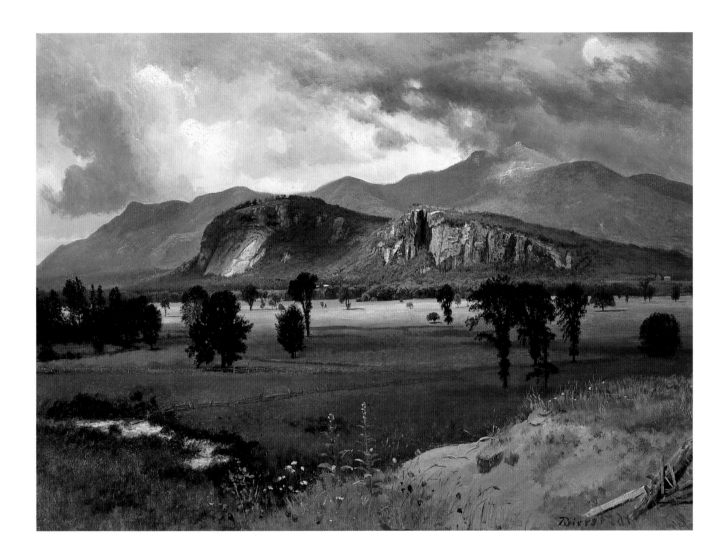

In the summer of 1862 Bierstadt, frustrated in his attempts to obtain permission to travel under army protection to the Far West, spent several weeks in the White Mountains of New Hampshire, a more traditional resort for landscape artists (see Cole's *Crawford Notch*, no.5). On 14 August the *Boston Transcript* reported that he was in North Conway, 'making studies of the scenery for a large picture'. It was later noted that 'an entire wall' of his New York studio was covered with the studies that he had made in New Hampshire. A splendidly broad oil sketch of a fire among the hills presumably dates from this stay (Gilcrease Museum, Tulsa, Oklahoma).[43] He also completed a substantial finished picture, measuring some 91 by 147 centimetres (35⅞ × 57⅞ inches), of *Mount Washington* (Private Collection) this year.[44] Another 'large picture', of similar size, appeared two years later, in 1864: *Haying, Conway Meadows*, (also known as *Field near Conway, N.H.*; Manoogian Collection) is one of Bierstadt's most lyrical and pastoral subjects.[45]

This smaller but fully worked-up canvas shares these characteristics, but takes a higher vantage point so that the eye sweeps across flat meadows for a great distance to the range of mountains beyond. Bierstadt characteristically measures the recession of the land by the placing of well-observed trees, and the space is articulated, too, by alternating patches of shadow and sunlight. There are no figures, and despite its finish the picture has the immediacy and freshness of an outdoor sketch, an effect enhanced by the skilfully noted plants growing on a sandy outcrop in the foreground.
AW

Cathedral Rocks, Yosemite Valley, California, 1872

Oil on paper 35.2 × 48.6 (13⅞ × 19⅛)
Inscribed on verso with title
Private Collection, Houston, Texas
LONDON AND PHILADELPHIA ONLY

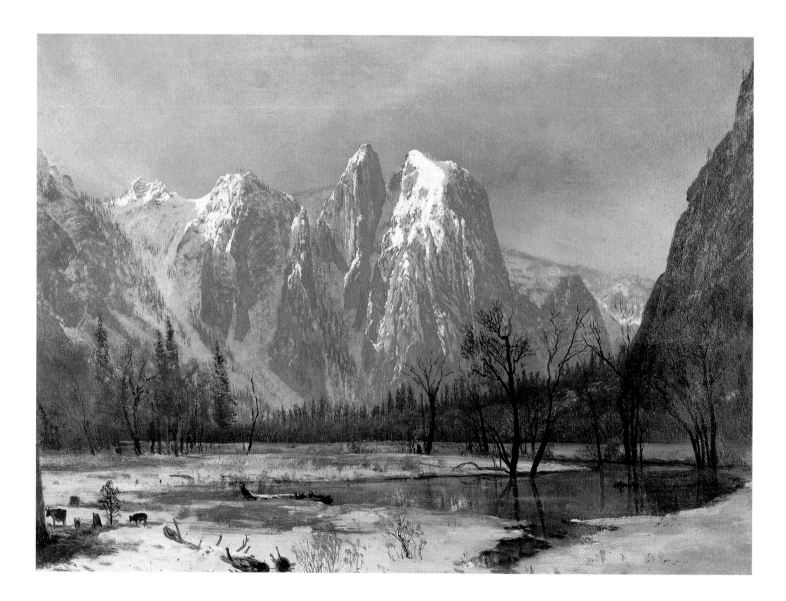

Bierstadt first saw Yosemite in 1863 (see no.90). He returned there in February and March of 1872, when the valley was still under snow. He went 'with characteristic enterprise . . . to make sketches of the winter aspects of its unequalled scenery, when the peaks and cliffs are covered deep with snow, and the falls tumble amid icicles and ice-sheeted rocks'.[46] He was enterprising at least partly because most artists found the weather too cold to draw, let alone make sketches in oil, at such a season. He made some finished pictures from these notes, and sent one of *Cathedral Rocks in Winter* to the San Francisco Art Association where it was shown at a reception in June of the same year, when he was once more at Yosemite in more favourable conditions for a further sketching trip. A canvas entitled *Yosemite Winter Scene* (1872) is in the University Art Museum, Berkeley, California.[47]
AW

65 THOMAS MORAN 1837–1926

Stranded Ship on East Hampton Beach, 1894–5

Oil on canvas 76.2 × 152.4 (30 × 60)
Inscribed lower left '1895 | TM[monogram]ORAN.1894'
The Hevrdejs Collection

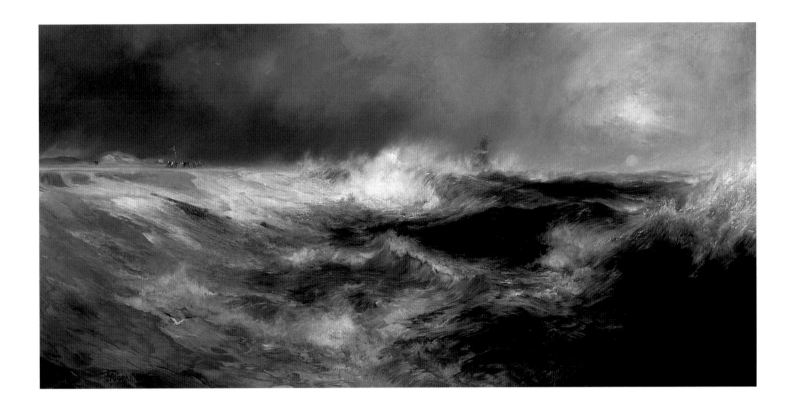

Moran had signalled his accomplishment as a painter of the sea in his Turnerian tour de force, *'Fiercely the red sun descending'* (no.97), and he produced a number of fine pictures that take the ocean as their theme during the later decades of his career. In 1884 he built himself a holiday studio near the shore at East Hampton, Long Island, and several marines reflect his experiences there. *The Much Resounding Sea* (1884; National Gallery of Art, Washington DC)[48] is a study of breakers, in a wide format somewhat reminiscent of Kensett, Heade and contemporaries like William Stanley Haseltine (1835–1900) and Alfred Thomson Bricher (1837–1908), though with none of the serenity with which those painters imbue even their roughest seas. Moran gave the same title to an etching of 1886,[49] where the subject includes figures and boats in the spirit of one of Turner's shore scenes; for instance *Wreckers – Coast of Northumberland, with a Steam-Boat Assisting a Ship off Shore* (1834; Yale Center for British Art, New Haven, Connecticut).[50] This example by Moran, also known as *Long Island Shipwreck*, has a similar theme. It is possible that Moran had seen in England the coastal studies and finished paintings of James Clarke Hook (1819–1907),

Henry Moore (1831–1895), John Brett (1831–1902)[51] and other Victorian sea-painters; but the turbulence of this subject suggests that Turner was the more immediate inspiration, and he will have relied mainly on his own powers of observation. A powerful essay in the same vein is a view of the *Rapids above Niagara* (1885; Collection of Dr Donald and Kathryn O'Connor Counts).[52] In 1891 he completed his grandest marine, *Spectres from the North* (Gilcrease Museum, Tulsa, Oklahoma)[53] which takes icebergs for a theme, following the example not only of Church (see nos.58 and 88) but also of the highly successful specialist in iceberg subjects William Bradford (1823–1892), who made a name for himself in England as well as America, and painted a work acquired by the Prince of Wales. A photograph of Moran in his studio with *Spectres from the North* either in progress or recently finished and a small framed study of breakers not unlike the present work is reproduced in the catalogue of the exhibition of Moran's work held at the National Gallery of Art, Washington DC, in 1997.[54] Moran continued to paint the occasional seascape into the early years of the twentieth century.
AW

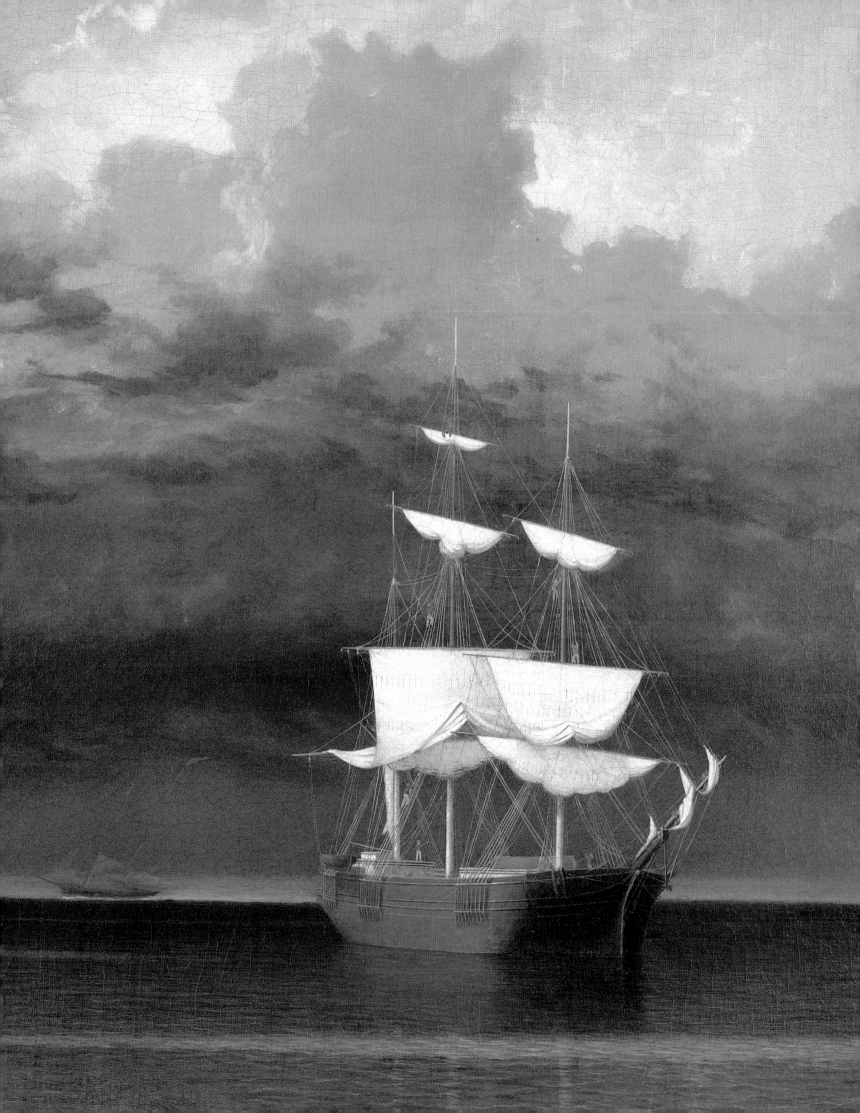

6 A Transcendental Vision

If American artists were excited by the grandeur of mountains and waterfalls, they also responded to the openness and silence of lakes and seas. Many were attracted to the coast of New England or New Jersey, celebrating the clarity of light and breadth of horizon such landscapes offered. Ralph Waldo Emerson, leader of the philosophical movement known as 'Transcendentalism', evoked a landscape of luminous spaces and infinite distances that 'leaves me nothing but perpetual observation, perpetual acquiescence and perpetual thankfulness'. This mood of sacramental calm informs the compositions of the mature Kensett, and of Martin Johnson Heade and Fitz Hugh Lane. Heade, an associate of Church, evolved a long horizontal format that enabled him to lay emphasis on the flat horizon, and brought a metaphysical intensity to bear on the permutations of an abstract pattern of hayricks (nos.81–3). Lane, based in the small fishing port of Gloucester, Massachusetts, was a topographical view-painter who crystallised the clarity of coastal light in his simple yet subtle records of the natural settings in which the seafaring community lived their practical lives. Both Heade and Lane depict a wide variety of climatic conditions, and sometimes choose to paint skies threatening violent storms (nos.70 and 80). The moment they select, however, is always one before the storm actually breaks, an ominous calm holding everything in breathless suspense, when the onlooker is forced into a state of heightened expectancy that is the very essence of transcendental sublimity.

Off Mount Desert Island, 1856

Oil on canvas 60.3 × 91 (23¾ × 35¹⁵/₁₆)
Inscribed lower left 'F.H. Lane 1856'
Brooklyn Museum of Art, Museum Collection Fund (47.114)

Fitz Hugh Lane first travelled north to the Maine coast in 1848, and made several trips there during the 1850s. The Maine shoreline, more rugged and desolate than that of Massachusetts and Connecticut, was particularly attractive to nineteenth-century artists and tourists. Its acknowledged climax was Mount Desert Island, a wooded outcrop of pink granite rising steeply from the ocean. Thomas Doughty had painted Mount Desert in 1836, Thomas Cole in 1844; John Frederick Kensett sketched there around 1850, and Frederic Church was a repeated visitor to the area from 1850 onwards. Although the area was still difficult of access, tourists arrived by sea and by road.[1] Lane arrived by sea from Gloucester, and found accommodation with relations of his Gloucester friend Joseph L. Stevens, Jr., in Castine. From there Stevens and Lane rented a small sailing-boat (known as a sloop) and explored the coastline. Because of partial paralysis probably caused by polio, Lane often remained on board ship, sketching the shoreline while his companions went rambling.[2] Lane and Stevens first reached Mount Desert, to which the artist became particularly attached, in 1850.[3] In an article for the *Gloucester Daily Telegraph* of 1853, Stevens described the 'grand sight approaching Mount Desert from the westward, to behold the mountains gradually open upon the view'.[4] The bare mountains put Stevens in mind of prehistoric times: 'it sometimes requires no great stretch of the imagination to fancy them [sic] huge mammoth and mastodon wading out from the main'.[5]

The secluded waterways around the island provided subjects perfectly adapted to Lane's austere later style. In 1855 Lane and Stevens returned to Mount Desert, where the artist sketched in the neighbourhood of Owl's Head, Somes Sound and Northeast Harbor. *Off Mount Desert Island* seems to be a composite landscape, formed from various sketches made on this trip. The portrayal of landscape is unusually emotive for Lane at this period, and may reflect the artist's response to a review published in 1854 by Clarence Cook praising 'the poetical treatment' in Lane's recent work, but finding his earlier paintings 'too hard and practical'.[6]

In this ambitious landscape, Lane adopts a complex and evocative lighting effect: the sun is setting and much of the foreground is already thrown into dark shadow. The last pinkness of the sunset – whose embers are seen to the right of the ship – is catching the rocky outcrops of Mount Desert. The richly coloured, raking light emphasises the geological structure, drawing attention to the volcanic origins, and glacial weathering, of this ancient rock face.[7] There are hints of human narrative in the work: a small rowing-boat ferries people to the ship moored to the right, while another schooner, only partially rigged for sailing, sits in a channel to the extreme left. In contrast to the barren regions in the distance, three groups of birds can be seen in the foreground. Curiously prominent in the composition are the stark outlines of dead trees, hinting, like the blasted oaks of Thomas Cole, at some recent natural disaster, such as a thunderstorm or severe frost. Although the scene is a tranquil one, the mood is not entirely restful: as Franklin Kelly has suggested, this work and *Sunrise off the Maine Coast* (Private Collection), also painted in 1856, are 'notable for their starkness, with rocky fore-grounds and middle-grounds so sharply defined by contrasting areas of light and dark as to become almost surreal, even ominous'.[8] In a few minutes this landscape, so peaceful while illuminated by the sunset, may become altogether more hostile.

The relationship with Church's Mount Desert paintings is a significant one. It has been suggested that Lane's increasing interest in atmospheric landscape painting derived from his awareness of Church's new style in the early 1850s, which emphasised dramatic effects of lighting. Although he had little personal knowledge of the New York art scene, and seems never to have met Church, many of Lane's patrons were familiar with the work of Cole, Durand and especially Church, providing a possible link between the two artists. Nonetheless, Lane's more contemplative, reclusive artistic personality contrasts with the evangelical certainties and bravura technique of the younger Church.

TB

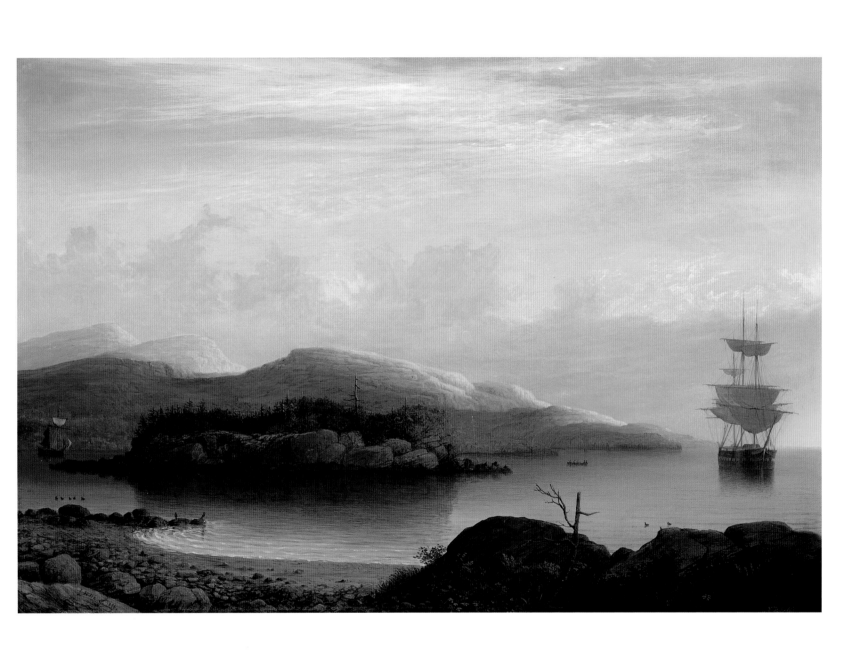

View of Gloucester Harbor, late 1850s

Oil on canvas 61.2 × 92 (24⅛ × 36¼)
Mr & Mrs Thomas H. Gosnell
LONDON AND PHILADELPHIA ONLY

Lane spent much of his life in the seaport of Gloucester, Massachusetts, where he was born the son of a sailmaker in 1804. He appears to have taught himself to draw in Gloucester, before leaving in 1832 to take up an apprenticeship with the Boston lithographer, William S. Pendleton. Even during these years, he often returned to his home town and began a series of accomplished views of the changing town and its maritime environs which continued throughout his career. He returned to Gloucester in 1848, becoming a prominent citizen at a time when the town was undergoing a boisterous economic transformation, as the fishing industry became more profitable and the population was increased by immigration from Ireland, then blighted by famine. The wealthy Gloucester middle class became Lane's main patron group, with which he shared a keen appreciation of the quiet beauties and historical associations of the coastal scenery of Gloucester and the surrounding area of Cape Ann.

By the 1850s Lane had turned from lithography to painting. His later views of Gloucester and its harbour move beyond the topographical rigour of the earlier works into a more imaginative and atmospheric realm. Accuracy was not sacrificed, however: a local newspaper review, at about the time when *View of Gloucester Harbor* was painted, noted of Lane's new works that 'they are not surpassed in beauty of finish by any of Lane's productions, and the accuracy with which every object . . . is delineated, will render them particularly interesting to the citizens of Gloucester and those familiar with its scenery'.[9]

The subject of shipping entering and leaving harbours was one of the mainstays of Lane's career, and his approach ultimately derived from that of the English marine painter Robert Salmon whom he had known in Boston (see entry for no.69). Lane painted harbour scenes in Baltimore, New York and especially Boston, but his preference was for the more intimate scale of Gloucester Harbor, a broad and deep natural inlet where the white sails of a few vessels stood up vividly against the low-lying shore.[10] Although his earlier views, notably two elaborate panoramic lithographs, drew attention to the busy commercial life of the port, Lane's later views of the harbour emphasise the tranquil view out to sea.[11] In the present work the emphasis is less on the modern shipping, despite the carefully observed figures of sailors at work, than on the sun and its reflections on the water. The view probably represents the sunrise over the ocean; a clear sky, with low clouds melting away, indicates good weather ahead – perhaps a little too calm – for the ships which are already in full sail. The work is a local man's affectionate tribute to a scene familiar to him since boyhood. Lane's decision not to include any steam-powered vessels in the image perhaps reflects a nostalgic wish to celebrate the great days of sail, which were coming to an end at exactly this time.

TB

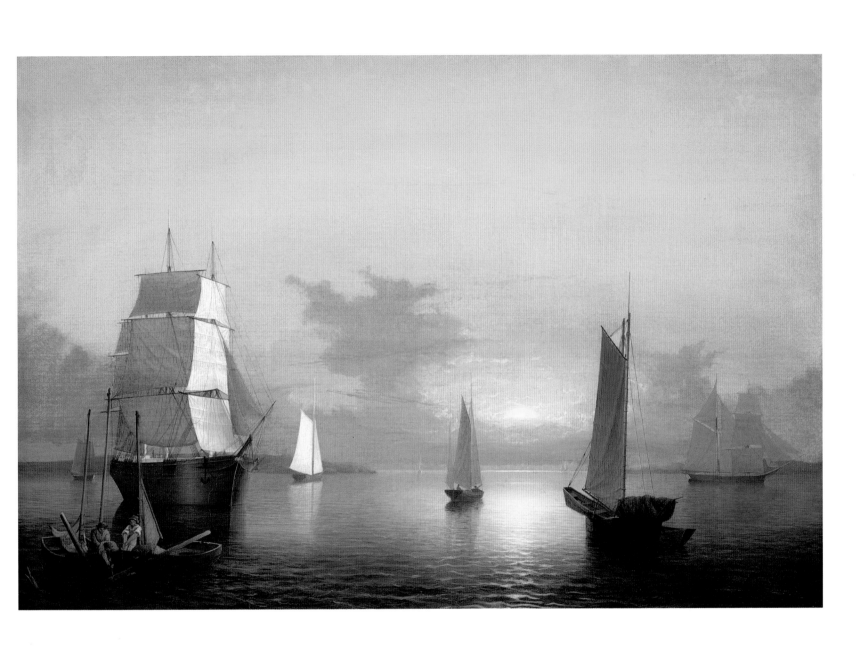

Becalmed off Halfway Rock, 1860

Oil on canvas 73.7 × 123.2 (29 × 48½)
Inscribed lower right 'F.H.Lane. 1860'
National Gallery of Art, Washington DC. Collection of Mr and Mrs Paul Mellon,
in honour of the Fiftieth Anniversary of the National Gallery of Art. 1992.51.8

Halfway, or Half Way, Rock marks the mid-point between Cape Ann and Boston, which lies close to Fitz Hugh Lane's home town of Gloucester, Massachusetts. The rock, 3 miles (5 kilometres) out to sea, rises 40 feet (12 metres) above the water and has long been used for navigation by fishing vessels and yachts. Fishermen would throw pennies on to it to ensure good luck with the day's catch.[12] Fitz Hugh Lane painted this prominent local landmark on at least three occasions. This final representation of the subject, completed in 1860, places the rock in the middle distance as a visual anchor, a focal point around which all other elements of the composition are arranged.

In *Becalmed off Halfway Rock* a range of vessels have been stranded by the lack of wind, and the resulting aquatic traffic jam provides a gazetteer of New England shipping of the period. The vessels have been identified with remarkable precision. To the left is a topsail schooner with a heavy cargo of timber, perhaps bound from Maine towards the lucrative Boston market. On the right, placed at a distance, is a merchant brig in full sail, while the two smaller craft are a double-ended schooner and, to the extreme right, a small fishing sloop.[13] The schooner, of a type known as a 'pinky', tows two small dories with fishing tackle, most likely intended for the catching of mackerel.[14] The word 'sloop', already archaic by the mid-nineteenth century, simply implies a shallow vessel close to the water, of the type that Lane and Stevens used for their Maine explorations (see no.66). In this case its sailors, engaged in a merry conversation, appear to be on the water purely for enjoyment.

The composition echoes that of Lane's *Boston Harbor at Sunset* (Museum of Fine Arts, Boston), and the presence of a coastline in the distance indicates that we are looking inland from the ocean, and thus that the sun here is also setting. Lane repeats from the Boston pictures the basic compositional elements of paired large groups of vessels set against a flat, low horizon, with a smaller craft in the centre left foreground. Here, however, the effect is more tranquil and mystical, purged of extraneous details. The composition is more horizontal in emphasis, the shipping reduced in size and its sails tinged with the pink-purple haze of the clouds over the distant shore. The scene is, as the title suggests, 'becalmed', the silence broken only by the creaking of the ships' timbers, the motion of the oarsman in the foreground and perhaps the merriment of the jovial quartet in the sloop.

TB

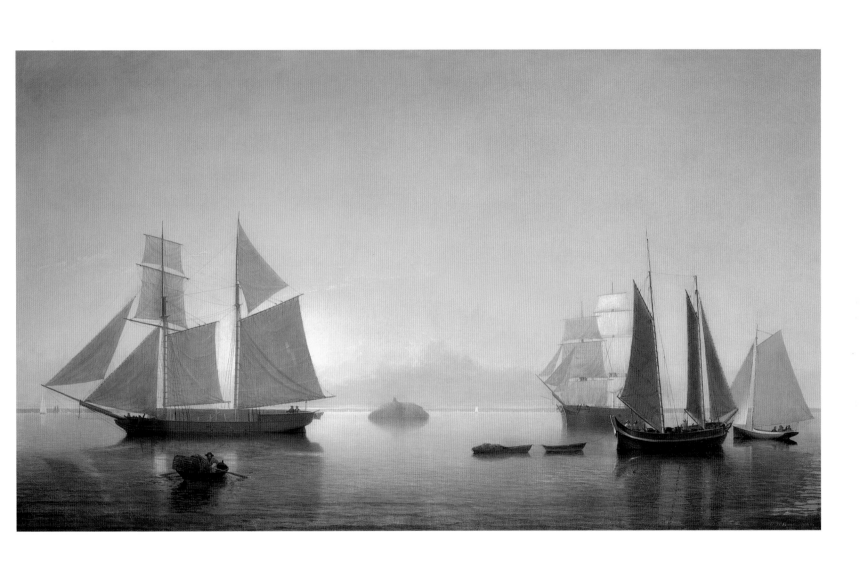

'Starlight' in Fog, 1860

Oil on canvas 76.2 × 127 (30 × 50)
Collection of The Butler Institute of American Art, Youngstown, Ohio
PHILADELPHIA AND MINNEAPOLIS ONLY

This mysterious work displays Lane's brilliance in adapting an inherited formula to unexpected, creative ends. The broad outlines of the composition of *'Starlight' in Fog* seem to derive from the work of the Anglo-Scottish artist, Robert Salmon (1775–*c*.1850), who lived in Boston from 1828 to 1842. Salmon, who had maintained a practice as a ship painter in Liverpool before emigrating to the United States, produced capable, if somewhat pedestrian, topographical views such as *Wharves of Boston* (1829; fig.49).[15] In Salmon's work a straightforward portrait of a ship, with every rope meticulously observed, is placed against a conscientious but not at all atmospheric representation of the wharves of Boston harbour. A small rowing-boat breaks up the foreground, which otherwise consists of rather regular and stylised waves. Such a composition is also typical of the popular maritime lithographs of the period. Lane was certainly the master of this type of imagery. The critic Clarence Cook noted in 1854: 'Lane knows the name and place of every rope on a vessel: he knows the construction, the anatomy, the expression – and to a seaman every thing that sails has expression and individuality – he knows how she will stand under this rig.'[16]

In Lane's *'Starlight' in Fog* we seem to see an extraordinary paraphrase of Salmon's quotidian scene, in which the imaginative faculties of the artist transform the simple ship painting without losing its basis in close observation. A mystical, Turnerian effect of light through vapour envelops the composition, even though several of the principal elements – the ship seen side on, the smaller craft approaching in the centre left – remain. The effect of light is strikingly reminiscent of Frederic Church's *Sunrise off the Maine Coast* (Wadsworth Atheneum, Hartford, Connecticut) of about the same date.[17] Although light is catching the top of the waves, as in Salmon's work, Lane

allows the viewer to see his light source, the sun diffused through mist, thus making sense of the effect. Most magical is the ghostly appearance of other tall ships through the fog, two each to both left and right. Thick fog presented dangers for mariners, severely restricting visibility and increasing the danger of collision or running aground in the busy waters off Gloucester and Boston. Although the vapour is already lifting around the *Starlight*, and some blue sky can be seen in the centre, the painting captures the eerie silence of fog over the water.

TB

49 Robert Salmon, *Wharves of Boston*, 1829. Oil on canvas, relined and cradled, 101.6 × 168.9 (40 × 66½). Courtesy of The Bostonian Society, Old State House, Boston, Gift of Henry P. Quincy from the Estate of Edmund Quincey (1894.94.62)

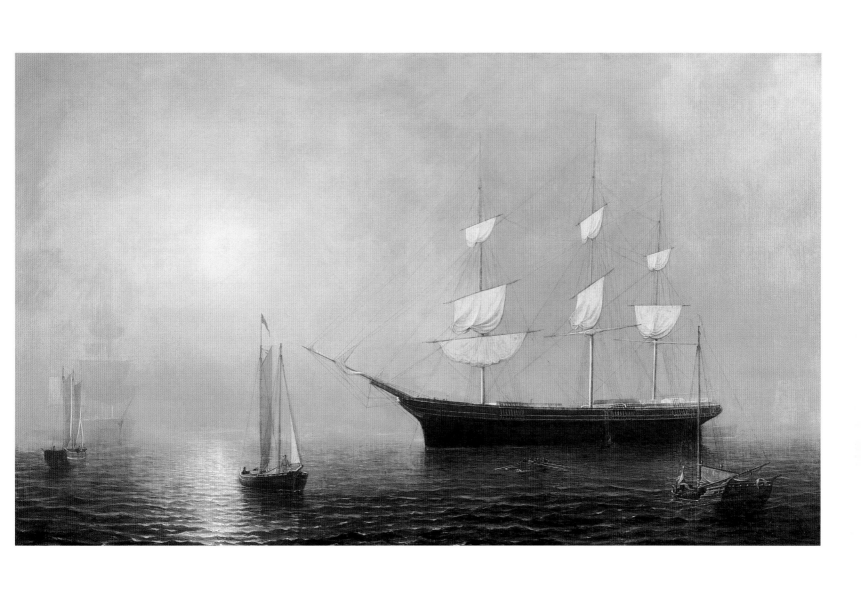

Schooners before an Approaching Storm off Owl's Head, 1860

Oil on canvas 61 × 100.5 (24 × 39⅝)
Private Collection
LONDON ONLY

Lane, normally a reticent painter, in terms both of the expressive qualities of the work and the application of paint, here creates the most dramatic image of his known *oeuvre*. For earlier artists, such as John Constable, the sky, as well as the subject of scientific study, formed 'the chief organ of sentiment'; the heavily impasted forms of clouds in his later works are deeply expressive of personal emotion.[18] Thomas Cole, too, applied paint in thick, vigorous strokes to create an atmosphere of turbulence. In *Schooners before an Approaching Storm off Owl's Head*, Lane, unusually, conforms to this tradition. A violently disturbed sky, in which thickly painted passages of black are juxtaposed with thinner areas of grey, contrasts with the brilliant white sails of a lumber schooner catching the last of the sun before the storm. As with all the finest effects in Lane's late work, *Schooners before an Approaching Storm off Owl's Head* reduces its subject to the most essential components. This is most clearly manifested in the colour scheme: the overall monochrome effect is relieved only by the brown wood of the ships and a hint of green in the waters of the foreground. The extensive use of black is highly unusual, paralleled in American art of this period only by Martin Johnson Heade's vivid *Approaching Thunder Storm* (1859; no.80), and the same artist's panoramic *Thunderstorm over Narragansett Bay* (1868; Amon Carter Museum, Fort

Worth). Although the former may have been exhibited at the National Academy of Design in 1860, it seems highly unlikely that Lane would have had any knowledge of it. Rather, the two artists were experimenting at the same time with new ways of exploring the eerie silence before the approach of a thunderstorm, enjoying the sublime spectacle of the impending deluge.

There is considerable human drama in *Schooners before an Approaching Storm off Owl's Head*. Tiny figures of men clamber in the rigging to bring down the sails before the wind and rain begin to buffet them; three mariners in a small and precarious-looking sloop to the left are also drawing in the sails. The boat in the centre has been identified as a bark, an ocean-going vessel built for international commerce or for trade with major ports in the USA.[19] Nonetheless, a severe storm could do terrible damage if the sails were left fully rigged. In the mysterious, silvery area in the distance where rain is already falling, three other vessels are listing helplessly, their sails billowing in the wind despite having been hastily furled. The plight of these ships, from the mighty schooner to the tiny fishing-boats, perhaps symbolises the precarious condition of man's life in the face of nature and the divine.

TB

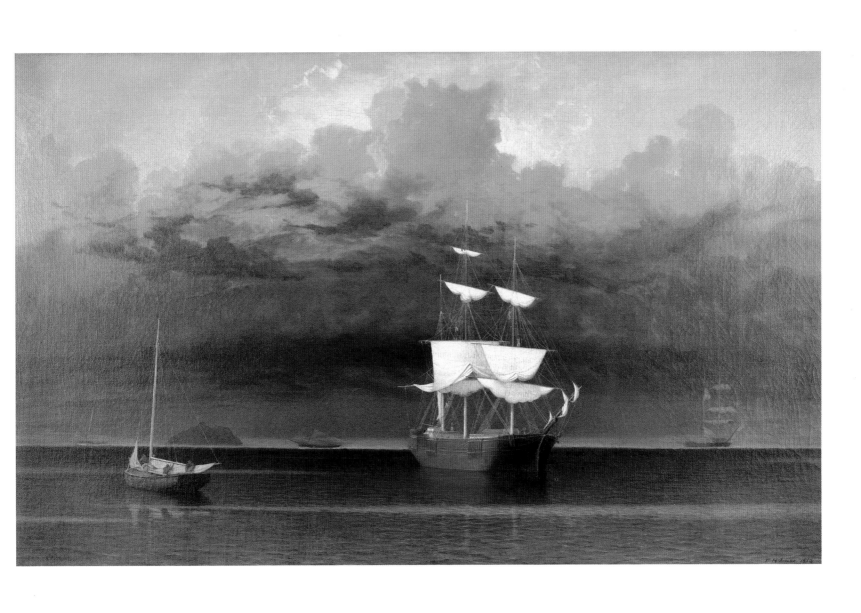

Owl's Head, Penobscot Bay, Maine, 1862

Oil on canvas 40 × 66.4 (15¾ × 26⅛)
Inscribed on verso 'Owl's Head – Penobscot Bay, by F. H. Lane, 1862.'
Museum of Fine Arts, Boston. Bequest of Martha C. Karolik for the M. and M. Karolik
Collection of American Paintings, 1815–1865. 48.448

Like Lane's other works from Maine, *Owl's Head, Penobscot Bay, Maine* transforms relatively simple elements into a landscape of mysterious and calm beauty. Lane's depiction of the view east across Penobscot Bay at sunrise is among the most precisely detailed, yet also the most rigorously simplified, of all his compositions. The subject is very close to that of an earlier work, whose title identifies the location precisely: *Entrance of Somes Sound from Southwest Harbor* (1852; Private Collection).[20] The earlier work was completed in his studio in Gloucester, Massachusetts, in 1852 on the basis of two sketches, one made from on board ship and the other from on the shore.[21] Lane's friend J.L. Stevens had moored his 'sloop', the small boat from which they were exploring the Maine coast, in order that Lane could sketch a 'beautiful prospect to wonder at and admire, now wafted along by light winds, then entirely becalmed for a time, we were carried into Southwest Harbor'.[22] Stevens threw down the anchor a few miles west of the harbour, allowing Lane to sketch the view seen in no.71 from on board ship.

Barbara Novak has drawn parallels between *Owl's Head, Penobscot Bay, Maine* and the work of the German Romantic painter Caspar David Friedrich.[23] Friedrich's deployment of a single figure in the landscape, most dramatically in *Monk by the Sea* (1808–10; Schloss Charlottenburg, Berlin), provides a surrogate for the viewer in contemplation of the immensity of nature. But the stolid, static figure of the boatman with a punt pole in the foreground of Lane's work

hardly resembles the rapt, self-consciously poetic figures among the German mists; rather, he is another lump of matter, like the rocks, ships and lighthouse. While it is suffused with a preternatural light which we might understand as bearing religious symbolism, Lane's work is the very antithesis of Friedrich's effusively expressive Romanticism. The artist's self is purged from the canvas as surely as the brushstroke.

A source far closer to home was *Lucas's Progressive Drawing Book* (Baltimore 1827), written by John H. Latrobe, who relied closely on John Varley's *A Treatise on the Principles of Landscape Design* (London 1816–21). Lane probably encountered this book in Boston, but may have acquired it when he visited Baltimore in 1850. The composition of *Owl's Head, Penobscot Bay, Maine* is strikingly similar to the plate *View on the Susquehannah* in Latrobe's book, though Lane characteristically transforms a stock picturesque image into a mysterious and suggestive work of art.[24]

Among the most celebrated of Lane's works, *Owl's Head, Penobscot Bay, Maine* was owned by Mrs John LeFavour Stanley in the artist's home town of Gloucester, Massachusetts; it passed to Mrs Louise S. Campbell of Montclair, New Jersey, and was acquired by M. and M. Karolik in 1943. It was presented with their collection to the Museum of Fine Arts in Boston in 1945.

TB

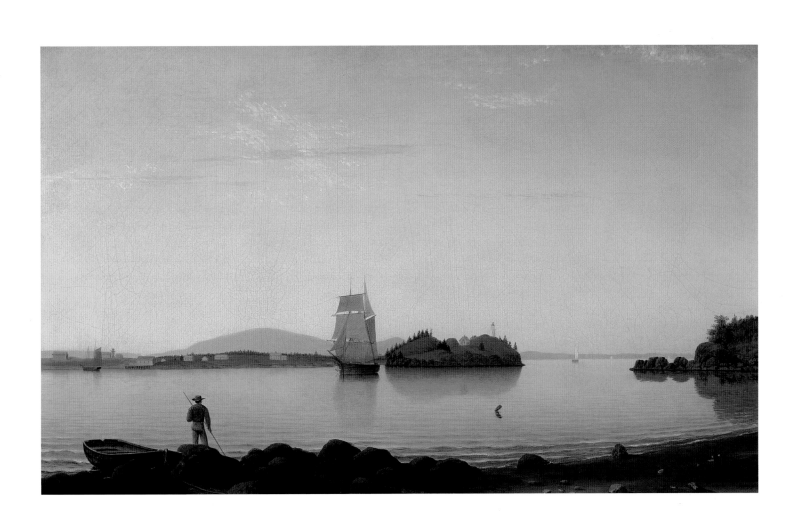

Lumber Schooners at Evening on Penobscot Bay, 1863

Oil on canvas 62.5 × 96.8 (24⅝ × 38⅛)
Inscribed lower right 'F.H. Lane 1863'
National Gallery of Art, Washington DC. Gift of Mr and Mrs Francis W. Hatch, Sr. 1980.29.1
LONDON ONLY

From simple elements Lane created in *Lumber Schooners at Evening on Penobscot Bay* a landscape of remarkable evocative and formal power, and of quiet beauty. Two motionless ships guide the eye diagonally across the water towards the embers of the dying sun. Most of the composition is taken up with calm water and a tranquil evening sky, set apart by the pale, blue-green silhouette of the shoreline. Compared with earlier works by Lane, the emptiness of the composition is striking; documentary qualities have become secondary to poetic ones. The simple scene is reduced to its essence; the four figures of sailors, about to enjoy the contentment of finishing a day's labour, are minute in relation to the wide vista of sea and sky. The sheer emptiness of the evening landscape, for all its beauty, inevitably lends the work a melancholy overtone.

Although until recently the work was dated to 1860, close examination of the inscription has revealed that the correct date is 1863, only two years before Lane's death, which was preceded by a period of severe ill health. It is possible that intimations of his own mortality subtly coloured Lane's vision of the end of the day in this work. Equally, Lane might be alluding with pious reverence to the beauty of the works of God. His work could, also, be seen in the context of mid-nineteenth century transcendentalism as glorying in the beauty of every object in the natural world. Our very limited knowledge of Lane's life and thought, which yields no clear sense of his artistic intentions for such a painting, allows all these avenues of interpretation to remain open.

The compositional elements from which Lane creates this memorable image are extremely straightforward. In the foreground sailors are lowering the sails of a schooner, heavily loaded with lumber, to moor her for the night; another schooner, its sails already down, can be seen in the distance. In the background is the low-lying coastline of Penobscot Bay, where the Penobscot River meets the Atlantic Ocean. The river, 350 miles (565 kilometres) in length, provided one of the main navigable routes into the richly wooded interior of Maine: accordingly it was busy with ships carrying timber out to the Atlantic coast, and from there, south to Boston. Maine white pine and spruce were in demand for ship-building and for domestic use in the growing northeastern cities.

Although Lane may have been influenced to some extent by Frederic Church's work of the period, notably the great sunset painting of 1860 *Twilight in the Wilderness* (no.25), he seems not to have been interested in pursuing the detailed, almost obsessive, naturalism of Church, or the younger artist's pursuit of ever more dramatic effects of light and atmosphere. Rather, Lane's last works reduce all elements – content, composition and surface – to the very minimum, creating effects of considerable originality. There is virtually no impasto on the surface of *Lumber Schooners at Evening on Penobscot Bay*; rather, the image seems insubstantial: its textures, like its meanings, are fugitive and suggestive.

Few of Lane's paintings have an established provenance from the nineteenth century, though many of the surviving works remained in private collections in Massachusetts. *Lumber Schooners at Evening on Penobscot Bay*, for example, was purchased by Francis W. Hatch, Sr., in Boston in the 1940s, at a time when Lane remained completely obscure. In recent years this work has been widely celebrated as a 'culminating achievement'.[25] It entered the collections of the National Gallery of Art, Washington DC, in 1980.

TB

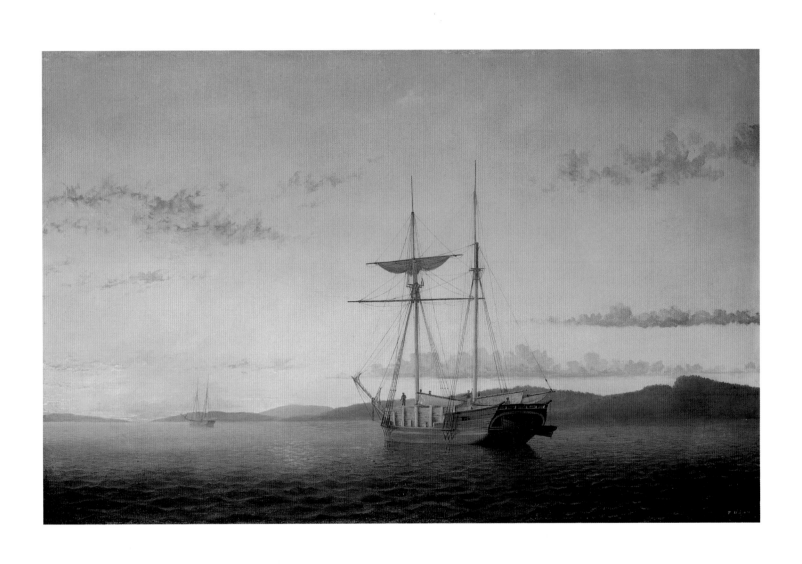

Brace's Rock, Brace's Cove, 1864

Oil on canvas 25.4 × 38.1 (10 × 15)
Terra Foundation for the Arts, Daniel J. Terra Collection

Brace's Rock, an inaccessible headland, marked the entrance to Brace's Cove near Lane's home in Gloucester, Massachusetts. Having already painted the subject once, Lane returned in 1863 to make a pencil sketch in which the small outcrop of pinkish rock, similar to Mount Desert Island, is seen across the cove, a flat stretch of coastline with small, reedy inlets. This insubstantial sketch provided Lane with the subject matter for a final series of works whose hallucinatory intensity transforms their simple content.[26] *Brace's Rock, Brace's Cove* is perhaps the most luminous and effective of the series. Radically anti-classical in composition, the work is made up of a series of horizontal elements disrupted only by the bare mast of the wrecked boat washed up on the beach. The work comprises a series of forceful contrasts between the deep brown of shadowed rock and the duck-egg blue of the sky, reflected in the mirror-like surface of the sea, which breaks into ripples only when it touches the beach. The scene is one of affecting tranquillity, yet also one of absolute desolation; the human presence is signified only by the skeletal vessel, its timbers protruding like

ribs. In the foreground of other (and probably earlier) versions of the composition, reeds and flowers run along the entire lower margin; here there is only one autumnal shrub, its leaves already dead and falling.

These works were painted in the middle of the Civil War, a time of massive bloodshed, when it appeared that the United States might permanently dismember itself. As the war raged, seemingly prophetic events occurred closer to home: February 1864 saw a devastating fire sweep through Gloucester, though Lane's house was spared.[27] In this year, too, Lane's health declined seriously. Despite a recovery the following spring, he died on 14 August 1865. Lane makes no explicit acknowledgement of historical events or of his own consciousness of mortality, but perhaps all these elements find some tacit recognition in the bleakness of his vision, and especially the pessimistic emblem of the deserted, wrecked ship on the shore, a timeless symbol of human frailty and the transience of life.[28]

TB

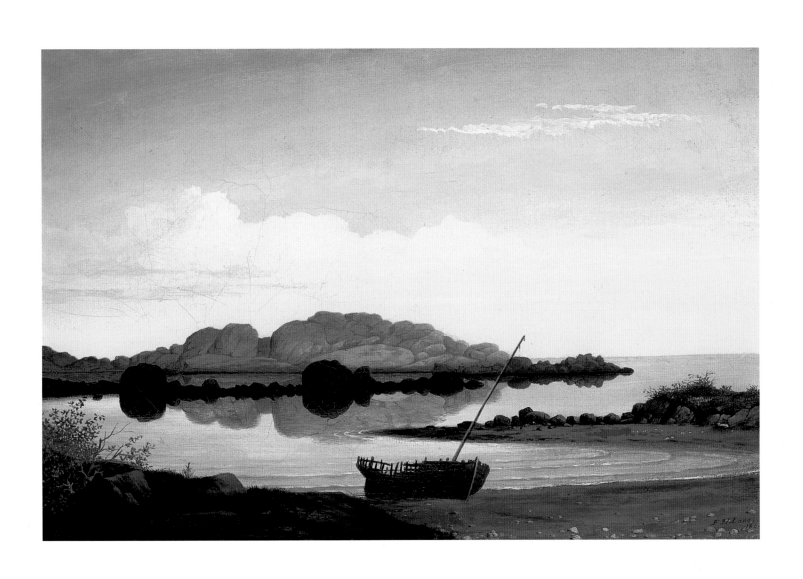

Shrewsbury River, New Jersey, 1859

Oil on canvas 47 × 77.5 (18 ½ × 30 ½)
Lent by the New-York Historical Society, the Robert L. Stuart Collection, on permanent
loan from The New York Public Library, S-229

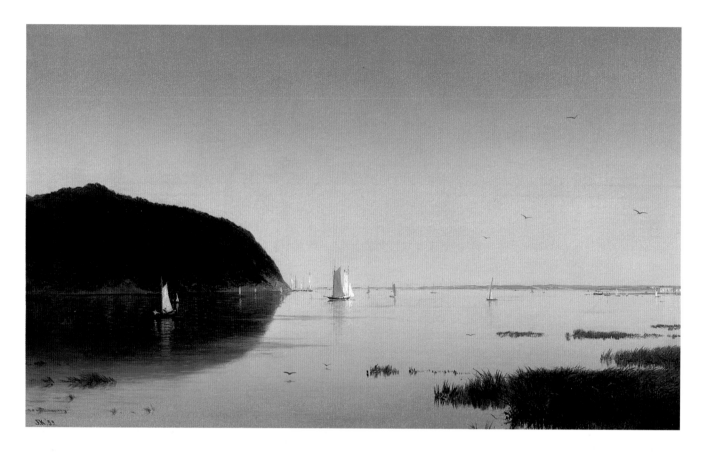

During the 1850s John Frederick Kensett developed a highly distinctive mature style. Abandoning the picturesque details and Claudean compositional formulae that had characterised his earlier work, he aimed at a greater simplicity of form and colour. By paring down the scene to its essential components without sacrificing careful observation, he created some of the most memorable images in American art. The individual brushstroke, so vividly apparent in the work of Thomas Cole, has all but disappeared, giving an air of calm objectivity to the scene. This new phase of Kensett's development coincided with a turn to new subject matter; moving away from the mountains and lakes which had fascinated his predecessors, he increasingly preferred the tranquil coastal scenery of the northeastern seaboard.

The estuary landscape of the Shrewsbury River near Red Bank, New Jersey, provided Kensett with ideal subjects: the bold, wooded promontory of the Navesink Highlands is juxtaposed with areas of calm, flat water, punctuated with reeds, and dotted with the white sails of pleasure craft. A series of five important oils dating from about 1853 to 1860 explores the formal possibilities of the same compositional

scheme.[29] The strong emphasis provided by the horizon, broken by the mass of the Navesink Highlands to the left, is strikingly unorthodox. Although there are parallels with seventeenth-century Dutch painting, Kensett's work appeals both to a modern optical sensibility and to a distinctively American nineteenth-century belief in the transcendental qualities of nature. The solid mass of the hillside on the left, quite without picturesque charm, contrasts with the glimpse of infinity, and perhaps divinity, which opens up to the right, just as the darkness of the wooded landmass contrasts with the radiance of the marine vista. Undoubtedly, *Shrewsbury River, New Jersey* painstakingly enumerates the paraphernalia of middle-class recreation: a boat-house and harbour are just discernible to the extreme right, and a lady in a red dress can be seen reclining in the boat closest to the viewer. But through his evocative handling of light, Kensett intimates that the connotations of this landscape are spiritual, rather than merely social. The distant boats seem curiously trivial and lightweight, perhaps tacitly indicating the impermanence of human existence in the face of divine nature.[30]

T B

Marine View of Beacon Rock, Newport Harbor, 1864

Oil on canvas 72.4.8 × 116.2 (28½ × 45¾)
The Cummer Museum of Art & Gardens, Jacksonville, Florida.
PHILADELPHIA AND MINNEAPOLIS ONLY

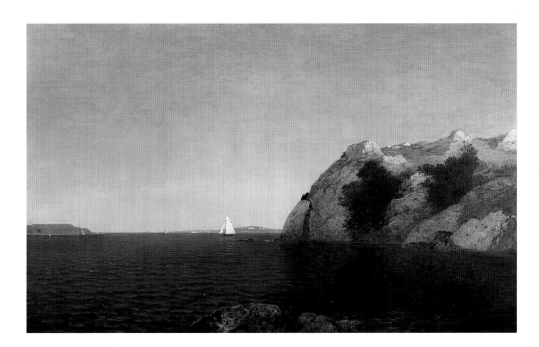

While he was engaged on the remarkable experiment of his Shrewsbury River series (see no.74), Kensett alighted in 1855 upon an ideal subject for a second, related set of images. The landscape of Brenton Cove in Newport Harbor, Rhode Island, shared many features with the Shrewsbury River estuary: both comprised a wide expanse of calm water with cliffs at one side. Unlike the wooded Navesink Highlands of New Jersey, however, Beacon Rock or Big Rock is a bleak and jagged rock formation which protrudes into the water. In earlier versions of the Newport subject the colour key is higher and waves lap the shore in the foreground. The final version, *Marine View of Beacon Rock, Newport Harbor*, painted in 1864, has a somewhat thicker paint surface and the colours are richer and deeper. A single rock in the centre foreground takes the place of a beach with lapping waves which appeared in the earlier canvases, and the colour of the water reaches an inky blue-black in the right foreground, creating a dramatic contrast with the white sails catching the sun in the middle-ground. The menacing, geometric outline of Fort Adams to the left of the harbour entrance contrasts with the natural forms in the foreground. All unnecessary detail has been excised: even the red-clad fisherman seen in one earlier version (*Beacon Rock, Newport Harbor*, 1857; National Gallery of Art, Washington DC) has disappeared.

Kensett visited Rhode Island regularly from 1854 onwards. This fashionable resort was accessible in a few hours from New York by steamboat.[31] The gentle climate and the brilliant quality of the light were much admired by nineteenth-century tourists, as was the city's long and distinguished history as a stronghold of American resistance to the British. It had long been home to a cultured elite. Kensett would have been familiar with the many historical associations of Newport, and of Brenton Cove in particular. 'Looking out from this cove,' noted the 1872 edition of William Cullen Bryant's *Picturesque America*, 'you might once have seen poor Burgoyne sailing for England after his sad defeat; Cook's famous ship Endeavour was condemned, dismantled, and left to decay upon these shores; the Macedonian, prize frigate of the United States, was brought to anchor here.'[32]

However, current events must have been uppermost in Kensett's mind in 1864 during the Civil War, an event that naturally troubled him deeply. As a believer in the Union and an avid opponent of slavery, he joined the Union League Club of New York City in 1863, which was formed in reaction to the election of the anti-abolitionist Horatio Seymour as Governor of New York in 1862. Kensett also became actively involved in the humanitarian mission of the United States Sanitary Commission (precursor of the Red Cross) as Chairman of the Art Committee and a member of the Men's Executive Committee. Kensett's concern with the unfolding tragedy of national events seems to have had little direct effect on his work, but perhaps an echo of the war can be found in the progressive darkening of his vision of Newport Harbor.

TB

Beach at Beverly, *c.*1869–72

Oil on canvas 55.9 × 86.4 (22 × 34)
National Gallery of Art, Washington DC. Gift of Frederick Sturges, Jr. 1978.6.5
LONDON ONLY

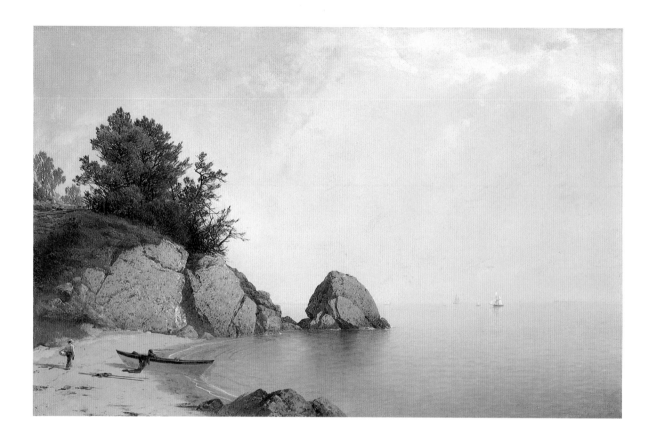

Beach at Beverly can confidently be dated to the last years of Kensett's career, though it is neither signed nor dated. The contrast between the rugged outline of the rock formation to the left, topped with trees, and the flat horizon of the Atlantic ocean, became an important motif in Kensett's later work, echoing his earlier fascination with coastal scenery at Beacon Rock, Newport Harbor and the Shrewsbury River estuary, but entering a more rarefied and abstracted mode.

Kensett spent much of his time painting in the areas chosen for vacations by his wealthy patrons, and made many trips to one such place, the North Shore of Massachusetts, between 1859 and 1872. Beverly, about 25 miles (40 kilometres) from Boston, was easy of access and accordingly a favourite vacation haunt for the city's fashionable elite. The rowing-boat on the beach is clearly a pleasure craft; a woman in it is arranging a vivid red rug, while her consort brings a picnic in a hamper. In the distance can be seen a handful of yachts but no commercial or steam traffic disturbs the atmosphere of tranquil escape. The calm lapping of the waves on the shore adds to the picture's restful effect, in contrast to the rougher swell in Kensett's

other versions of the same composition (such as *Coast Scene with Figures* (*Beverly Shore*), 1869; Wadsworth Atheneum, Hartford, Connecticut).

Kensett's late work combines precision of observation with extreme economy of form. Henry Tuckerman noted that although details of rocks and foliage were recorded 'with the literal minuteness of one of the old Flemish painters . . . this fidelity of detail is but a single element of his success. His best pictures exhibit a rare purity of feeling, and accuracy and delicacy, and especially a harmonious treatment, perfectly adapted to the subject.'[33] Kensett's unusual gift lay in his ability to combine an apparent commitment to the Ruskinian ideal of truth to nature with a refined compositional sensibility.

The paint layer is especially thin and delicate in Kensett's later work. In this case the white ground on which the work was painted has been used as a visible part of the image in both sky and water. The composition was originally drawn on to the canvas in pencil outline, and these graphite marks can be discerned on the horizon line between sea and sky.

TB

Passing off of the Storm, 1872

Oil on canvas 28.9 × 62.2 (11⅜ × 24½)
Metropolitan Museum of Art, New York, Gift of Thomas Kensett, 1874
LONDON ONLY

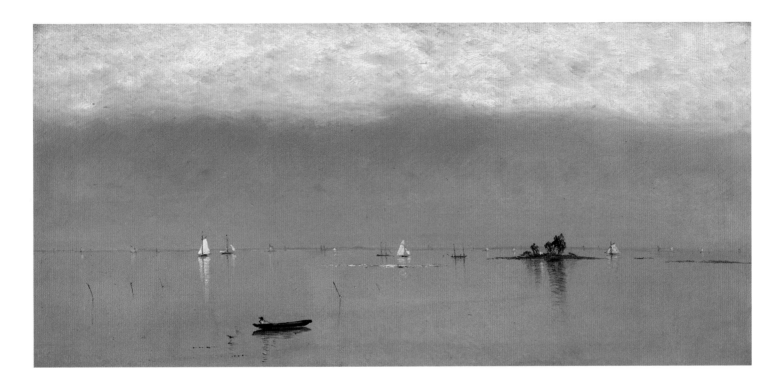

This small painting adopts an unusually wide format, and Kensett provides no compositional devices to mark the edges. It is as if a section has been plucked at random from a panorama. Only the sails and their reflections add vertical accents in an almost entirely horizontal composition. These dabs of white paint contrast with the dark emphases provided by the rowing-boat in the foreground (its inhabitant asleep, with his hat pulled over his face) and the tiny island whose scrubby trees cast a long reflection in the lagoon. Kensett's extreme sensitivity to gradations of tone is reminiscent of work from the same period by James Abbott McNeill Whistler (1834–1903). As with Whistler, content has been purged to a minimum and broad areas of pure colour are interrupted by calligraphic brushstrokes such as the four brown diagonal lines – sticks, posts or reeds? – which disturb the surface of the water to the left.

Unlike the earlier works, painted in the studio with many layers of glazes applied sequentially, here Kensett has applied paint directly in a stiff, paste-like form.[34] The paint is stippled to produce a subtle series of gradations from the horizon, through lighter and darker bands, to the white cloud in the upper register of the composition. The work was almost certainly painted in the open air, probably on or near Contentment Island, but the location is not recorded and is, indeed, of little significance.

TB

Eaton's Neck, Long Island, 1872

Oil on canvas 45.7 × 91.4 (18 × 36)
Metropolitan Museum of Art, New York, Gift of Thomas Kensett, 1874

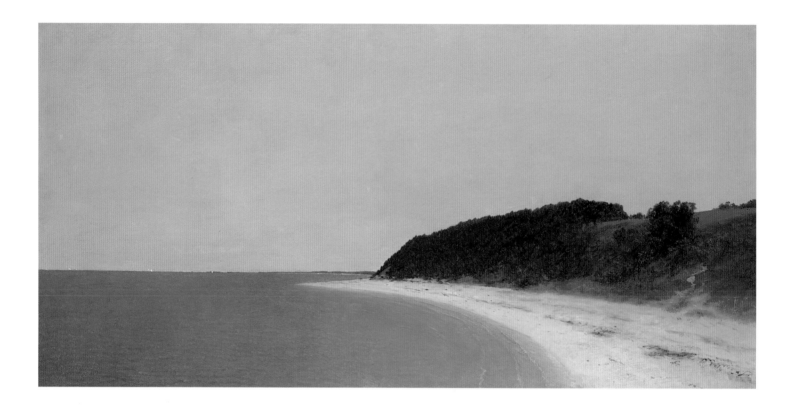

Like *Fish Island from Kensett's Studio on Contentment Island* (no.79), *Eaton's Neck, Long Island* derives from the last summer of Kensett's life, which was mainly spent at Contentment Island near Darien, Connecticut. It was a short ride by ferry across the Sound to Long Island, and Eaton's Neck is about 8 miles (13 kilometres) south of Contentment Island. It seems that the promontory was painted from the Long Island side of the water; if so, the land on the horizon is the Connecticut coastline.[35]

Despite the specificity of the title, the painting includes virtually no topographical or incidental detail; indeed, it is perhaps the most rigorously simplified and disciplined work Kensett was to produce. The composition is divided into only three massive blocks, corresponding to the sea, the land and the sky; there is virtually nothing to complicate the elemental dialogue of water, earth and air. Yet despite its apparent simplicity, this is a composition of astonishing sophistication. The scimitar-like curve of the sand, devoid of figures, reaches up to, but does not quite touch, the horizon, allowing an unexpected glimpse of the beach and the distant shore; the horizon line to the left, in a typical Kensett gesture, is relieved by tiny flecks of paint representing the white sails of boats. Although the light is even

and the sky pale and clear, the deep undertone moderated by a layer of lighter, scumbled paint in the foreground allows Kensett to achieve an astonishing variety in the surface of the water.

Some modern interpreters of *Eaton's Neck, Long Island* have argued that the painting is unfinished, and this may have been the belief of Kensett's contemporaries. It is unsigned, like most of the works dating from Kensett's final summer. Nonetheless, the addition of ships on the horizon, usually among Kensett's final touches, seems to indicate that the artist had completed the work.[36]

Eaton's Neck, Long Island was among the paintings – probably thirty-nine in number – created by Kensett in the last summer of his life, 1872, many of which depicted the Connecticut coast. They were first offered for sale. Subsequently, thirty-eight of them were presented to the Metropolitan Museum of Art by Thomas Kensett in 1874, in memory of his brother, who had played an active role in the founding of the museum. Nineteen of these works, including *Eaton's Neck, Long Island*, remain in the Metropolitan Museum.[37]

TB

Fish Island from Kensett's Studio on Contentment Island, 1872

Oil on canvas 45.7 × 92.1 (18 × 36 ¼)
The Montclair Art Museum, Museum Purchase; Lang Acquisition Fund, 1960.6

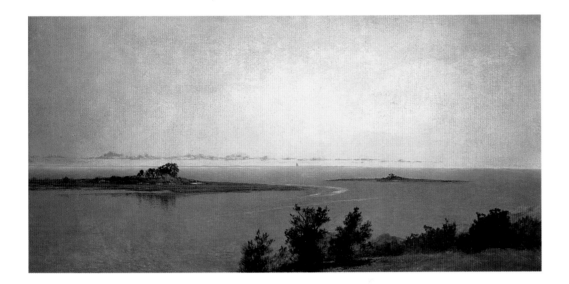

Fish Island from Kensett's Studio on Contentment Island was among the works painted in 1872 during his last, extraordinarily productive summer. Kensett had a studio on Contentment Island, near Darien, Connecticut.[38] The landscape of the Connecticut coast, whose flat beaches look out over the wide, calm waters of the Long Island Sound, is unspectacular and, unlike Kensett's earlier sketching grounds – Niagara, Lake George and Newport – was little frequented by tourists. Kensett was born in New Haven, Connecticut, and would thus have known this coastline all his life. The discovery of Contentment Island, however, he owed to his friend the artist Vincent Colyer, who in 1866 had made a trip by yacht from New York to New Haven in search of a site for a studio and house. The island, on the Connecticut side of Long Island Sound, was hardly separated from the mainland, and fell under the jurisdiction of the town of Darien, conveniently located on the New York to New Haven railway line. Collyer bought thirty-five acres, and subsequently sold nine acres of it to Kensett, who intended to build a studio on it.

The works produced on Contentment Island bring to ultimate fruition many of the tendencies implicit in Kensett's earlier work. These are well described by Oswaldo Rodriguez Roque as 'a pronounced simplification in compositional massing, an increased sophistication and abstract quality of the scumbling used to depict sea and sky, an observable flattening of pictorial space and the use of color to complement the mood of the scene'.[39] Although the overall effect of the work is one of smooth surfaces, Kensett's use of paint in a rather dry, paste-like form allows the individual brushstroke to be seen, often also revealing a layer of ground underneath it.

Like many of Kensett's most ambitious works, *Fish Island from Kensett's Studio on Contentment Island* is painted on a wide canvas; in this case the width of the painting is exactly twice its height, giving a panoramic effect reminiscent of the coastal prospects made by explorers and military artists.[40] The composition is bisected by the horizon, again an unusual strategy; the long, straight line dividing sea from sky is echoed by a thin strip of distant cloud, and punctuated a little to the right of centre by the masts of a distant ship. Kensett's masterly handling of perspective allows the eye to travel from the sandy dunes in the foreground through the channel beside Fish Island to the boat on the horizon. While this journey might simply be a topographical one, it may also have a spiritual connotation; just as Cole pursued subjects such as *The Voyage of Life* (1840; National Gallery of Art, Washington DC) through the emblematic structure of a boat being carried down a river, so the German Romantic painter Caspar David Friedrich (of whom little or nothing was known by most American artists in the nineteenth century) envisaged the voyage of a ship as a metaphor for the human life-journey, and for the road to salvation.[41] Although Kensett's work leans more towards the transcendental than to the symbolic, it is certainly possible to detect a valedictory note in these late works.

This work was among the thirty-eight paintings given to the Metropolitan Museum of Art by Thomas Kensett in 1874, but was sold by the Metropolitan and later acquired by the Montclair Art Museum.[42]

TB

Approaching Thunder Storm, 1859

Oil on canvas 71.1 × 111.7 (28 × 44)
Inscribed lower left 'M J Heade | 1859'
Metropolitan Museum of Art, New York, Gift of Erving Wolf Foundation
and Mr and Mrs Erving Wolf, 1975

This picture dates from a moment when Heade's work was undergoing a transformation, the result of his exposure to the paintings of Church and Kensett after moving to New York City late in 1858. Hitherto his landscapes had depended to a greater or lesser extent on conventional picturesque formulae, with trees forming repoussoirs or in other ways breaking up the main horizontal emphasis. In the later 1850s he began to show a preference for broad horizons, and in 1859, established in Manhattan and concentrating on landscape painting, he started to depict the low, uninterruptedly flat landscapes of the New England coastal marshes that were to be particularly associated with him (see nos.81–3). This subject is innovative as well in depicting an exceptionally dramatic effect of light. He was to return to the theme of the black thunderous sky in two later works, an important painting of 1868, *Thunder Storm on Narragansett Bay* (Amon Carter Museum, Fort Worth), and the small study of a *Thunderstorm at the Shore* of c.1870 (no.38).

Heade based the composition on pencil studies of thunderstorms that he had made in Narragansett Bay, Rhode Island, when developing his ideas for this picture. Two of these are in the now disbound and dispersed 'Housley' sketchbook, which the artist was using in the late 1850s and early 1860s. One study is a view looking across a harbour, inscribed 'nearly black | lighter here', 'Thunder Storm – very dark' and 'water blackish green'.[43] Another inscription is partly illegible, and reads '[Rocky] Point from Prudence Island'. The drawing includes two points of land at the western end of Prudence Island on the right of the painting, and one in between them on the left, which is actually the eastern tip of Patience Island close by. Also recorded in this drawing is a pier or jetty in the left foreground which does not figure in *Approaching Thunder Storm*. The foreground of the sketch is taken up with a line of shore diversified with large boulders and figures. The other inscriptions make it clear that Heade saw the view in stormy conditions. A slighter study on another page of the 'Housley' book is a similar view, taken from a slightly different point in Sheep Pen Cove, and much more schematic in treatment.[44] Heade's notes read: 'nearly black | warm | Thunder Storm – | very dark | [?white] | sun light' and 'water green <black> very dark'. These notes were clearly

of great importance in the evolution of the dramatic palette of the final picture, which Heade showed at the National Academy of Design in 1860 (no.436).

The first owner of the picture was the Revd Noah Hunt Schenk, minister at Emmanuel Church, Baltimore, until 1867 when he became an Episcopalian minister at St Anne's, Brooklyn. Another storm scene by Heade had been acquired by the Revd Henry Ward Beecher, and it has been plausibly suggested that there was a consciously perceived connection in the minds of artist and collector alike between Heade's storm subjects and the imagery of these preachers' sermons. The imagery of the thunderstorm was traditionally associated with the idea of divine wrath, and the symbolism was much employed by the apocalyptic painters of the early and mid-nineteenth century: by John Martin and Francis Danby in England, and by artists like Washington Allston and Asher Brown Durand in America; see for example Durand's vision of *God's Judgement upon Gog* (no.9). Like several other canvases of this period, Heade's picture seems to reflect the growing tensions of the years immediately preceding the outbreak of war. However, the atmosphere of contemplative calm that pervades this painting, with its foreground flooded with broad golden light, suggests a resolution of despair and hope that raises the image above specific contemporary problems and gives it an enduring serenity.

It has been suggested that Heade's storm pictures were 'unlike any earlier works, either American or European', and it is true that the combination of Heade's distinctive technique with the bold symbolism of his subject matter rarely appears in quite this form; but it is perhaps worth noting that the Norwegian painter Peder Balke (1804–1887) was producing shore scenes with similarly black stormy skies in the 1850s; for example *Storm on the Norwegian Coast* (c.1855; Nasjonalgalleriet, Oslo). There is no likelihood of Heade's having seen these. More plausible is the influence of the Irish artist Francis Danby, who made a speciality of serene seascapes or lakeside subjects with threatening skies or stormy sunsets, some of which were known in America through engravings.

AW

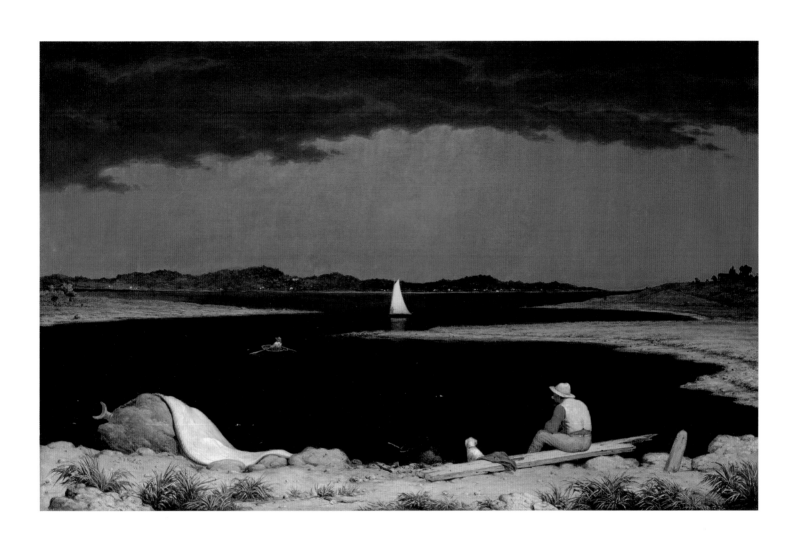

Sunrise on the Marshes, 1863

Oil on canvas 68 × 127.6 (26¾ × 50¼)
Inscribed lower right 'M.J. Heade 1863'
Collection of the Flint Institute of Arts, Gift of the Viola E. Bray Charitable Trust

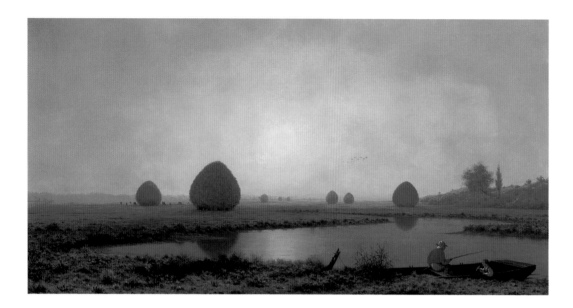

Heade was given to producing long, thematical sequences of pictures, work on which would extend over many years and overlap with his interest in other subjects. His paintings of humming-birds, orchids or magnolias do not concern us here, though in the 1860s he was certainly better known in Britain for his Brazilian subjects, and especially for the 'Gems of Brazil', a sequence of paintings of humming-birds that was chromolithographed and attracted some attention.

He began painting views of the salt marshes of the New England coast in about 1858 or 1859, and continued to do so until at least about 1890. Over 120 such subjects have been counted, amounting, according to Stebbins, to a fifth of his output.[45] They represent the extreme manifestation of the minimalist tendency in American landscape of the period, and much of their significance derives from the painstaking way in which Heade works and reworks a single abstract idea, the placing of round haystacks across a completely flat landscape, with an uninterrupted horizon. Variety is obtained not only through the rearrangement of the stacks; each view has its own weather conditions, its own light and time of day.

This subject is usually taken as the pair to another, known as 'Sunset on the Newbury Marshes' but now correctly titled *Haystacks on the Newburyport Marshes* (1862; Walters Art Gallery, Baltimore). There the bank with trees along it appears to the left, as does the creek, and instead of a late sunset glow with high wispy clouds the sky here is heavy with a dawn mist that occludes the sun itself, foreshadowing the grand effect of Heade's 1877 picture of York Harbor (no.84). The fore-

ground figures, a man and a boy in a flatboat, function rather as the seated man does in the *Approaching Thunder Storm* (no.80), providing a point of departure, both engaged and coolly dispassionate, for our contemplation of the scene. Far from serving a merely formal function, such staffage ensures that despite the self-consciously 'aesthetic' simplification of the design, it retains its power as palpable human experience. The deliberate restriction, the delight in formal variety and permutation has about it something of the eighteenth century's preoccupation with abstraction in landscape; it is reminiscent of Gainsborough's incessant reinvention of the basic elements of landscape in ever-changing relationships. Heade, however, restricts himself in his marsh subjects to an almost puritanical repertory of items: flat marsh, creek, distant ridge or hillock with trees, and the ambiguous forms of the haystacks, marching or straggling across the scene like lost invaders from another planet. They are both reassuring and oddly threatening, and in an example like this one seem to stand brooding over the fate of the land. A sense of the imminence and inevitability of change underlies these works: they celebrate an innocent rural way of life that was by this date disappearing. A painting of the same year as this, *Lynn Meadows* (Yale University Art Gallery, New Haven, Connecticut), takes as its central feature the line of a railroad which bisects the composition from one edge to the other. The uncompromising horizontality of this man-made intrusion into the landscape was inimical to Heade, who did not paint a railway again, though he continued to produce haystack subjects. Other examples are nos.82–3. AW

82 MARTIN JOHNSON HEADE 1819–1904

Sudden Shower, Newbury Marshes, *c.*1865–75

Oil on canvas 33.3 × 66.6 (13⅛ × 26¼)
Yale University Art Gallery, Gift of Theodore E. Stebbins, Jr., B.A. 1960, in memory of H. John Heinz, III, B.A. 1960,
and Collection of Mary and James W. Fosburgh, B.A. 1933, M.A. 1935, by exchange

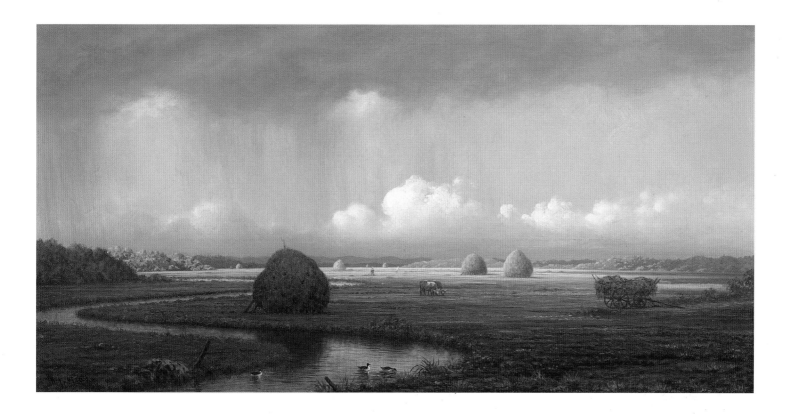

The weather supplies a principal ingredient in Heade's marsh subjects (see no.81). The long series of paintings showing flat, minimally variegated landscapes with emphatically wide straight horizons depends for its interest on two key subjects: the disposition of the haystacks in the empty space, and the play of light created by the cloud patterns and the changing climate. The land seems permanent, unmodified in its purpose and appearance, while the sky is constantly altered, providing a chronological dimension that reminds us that even the land suffers change, and that the apparently eternal haystacks will disappear under the impact of new ways of life and farming technology. Here the interplay of sun and shower is mirrored in the strong contrasts of light and shade across the marsh, so that one foreground haystack is in deep shadow while distant ones are bathed in sunshine. The pattern is similar to, though not so violent as, that in the *Approaching Thunder Storm* (no.80). The element of water, which is always present in these subjects, takes a different form here from that of the slightly earlier *Sunrise on the Marshes* (no.81): instead of being a broad river that almost fills the foreground it has become a narrow stream that winds sinuously from immediately in front of us into the far background of the view, a device that Heade frequently introduced into his later marsh subjects.

In addition to the meteorological diversity of the sky, with its dark rainclouds, sunlit bank of cumulus and glimpse of blue, the land too is full of incident. A hay-cart is prominent to the right, cows graze, ducks swim in the dyke, and farmers move about the marsh in the distance. This is not a landscape deserted by man: Heade seems to have been drawn to the Massachusetts salt marshes precisely because they represented the immutability of human occupations in a landscape that was stripped of accidents – blossoming trees, hunting parties and other such anecdotal details rarely occur. As Stebbins suggests, he may have felt that 'the drama of the marsh was somehow trivialized by the inclusion of charming objects in the foreground'.[46]

AW

83 MARTIN JOHNSON HEADE 1819–1904

Marshfield Meadows, *c.*1878

Oil on canvas 45.1 × 111.8 (17¾ × 44)
Inscribed lower left 'M.J. Heade'
The Currier Gallery of Art, Manchester, New Hampshire, 1962.13

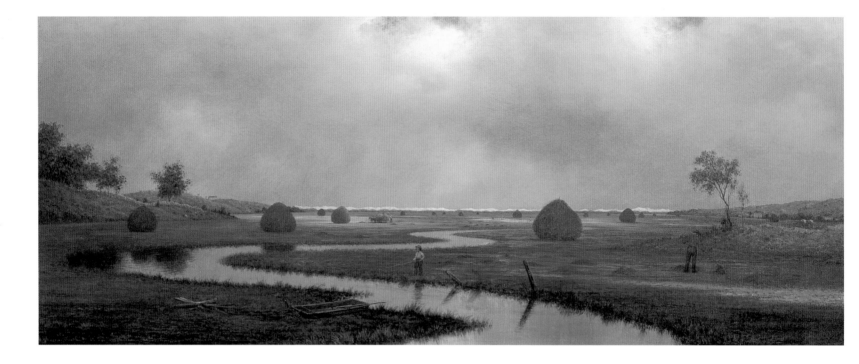

This pictures marks something of a climax in the succession of Heade's marsh subjects: a summation of the imagery that had pervaded a long series of similar compositions (see nos.81–2). It is one of the most sophisticated and subtle of the series, with its delicately varied light and beautifully managed recession. It shows the marshes south of Plymouth, Massachusetts, with a creek (probably that known as Cut River) running through them. The distant hay-cart, the man in a red shirt raking hay, the boy fishing, the punt and the pile of sticks

are all details that he had used in other treatments of the theme, brought into particularly satisfying harmony here. He continued to produce marsh subjects for the remainder of his career, but rarely equalled the achievement of this canvas again.

Heade was evidently pleased with the picture, since he sent it for exhibition at the Massachusetts Charitable Mechanics Association in Boston in 1878.
AW

York Harbor, Coast of Maine, 1877

Oil on canvas 38.7 × 76.8 (15¼ × 30¼)
The Art Institute of Chicago; Restricted gift of Mrs Herbert A. Vance; Americana, Lacy Armour
and Roger McCormick endowments; through prior gifts of Dr and Mrs R. Gordon Brown,
Emily Crane Chadbourne, George F. Harding Collection, Brooks McCormick, and James S. Pennington

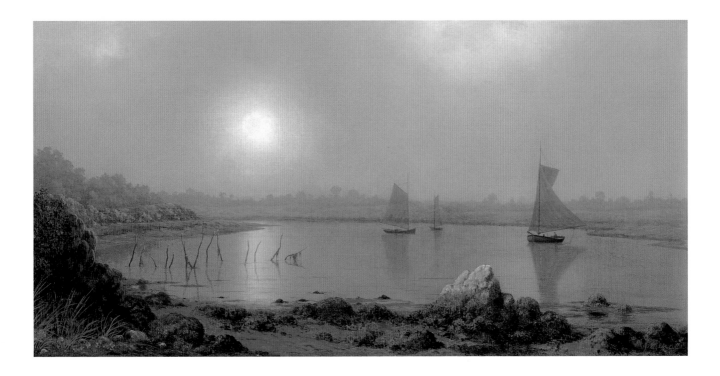

This picture was executed in the autumn of 1877. Stebbins suggests that it may be Heade's 'final marine composition', but points out that it is 'as much landscape as seascape'.[47] York Harbor is at the extreme south-western end of the Maine coast, an inlet surrounded by long, low spits of land. Stebbins notes a connection between the sloop to the right here and a pencil drawing in Heade's 'Jamaica' sketchbook, his only surviving intact book, now in the Boston Museum of Fine Arts. It dates to about 1870. However, the sketch is inscribed 'Rossville Staten Island', and shows the sloop from a different angle; it is therefore difficult to assess the exact connection between drawing and painting.

The picture was described in a Brooklyn newspaper of November 1877:

> The view was studied in the early morning, when the tide was low, and bright green patches of the salt meadow show here and there, and a fishing sloop, with the sails set, is anchored in the distance, as if awaiting the breeze which comes with the rising sun. In the background there is a headland veiled in a light fog. The subject . . . is painted with great subtlety and makes a fantastic picture.[48]

The long horizontal format is similar to that of most of Heade's coastal New England pictures, but its composition is unusual. It retains the low horizon of his marsh scenes (see nos.81–3), but uses the vertical forms of shipping more prominently than usual in his coastal subjects so that the familiar understatement of his landscapes is replaced by a more classically balanced structure.

The misty light that shines through half-translucent sails is reminiscent of the calms of Fitz Hugh Lane (see no.68), and it seems possible that this is a conscious response to Lane's work. As so often with Heade, the minimal content of the view draws attention to the formal sophistication of the composition: the delicate rhythm set up by the three masts towards the right counterpoints the more staccato line of the stakes in the water at the left, creating one of Heade's subtlest exercises in pictorial design. The way in which the viewer stares directly into the veiled orb of the sun is also somewhat uncharacteristic of Heade, who, with a few exceptions – usually sunsets – prefers to paint light irradiating from a hidden source. In adopting this motif he may have been thinking of Gifford, who frequently depicted the hazy sun itself, as in *Mount Mansfield* (no.31).
AW

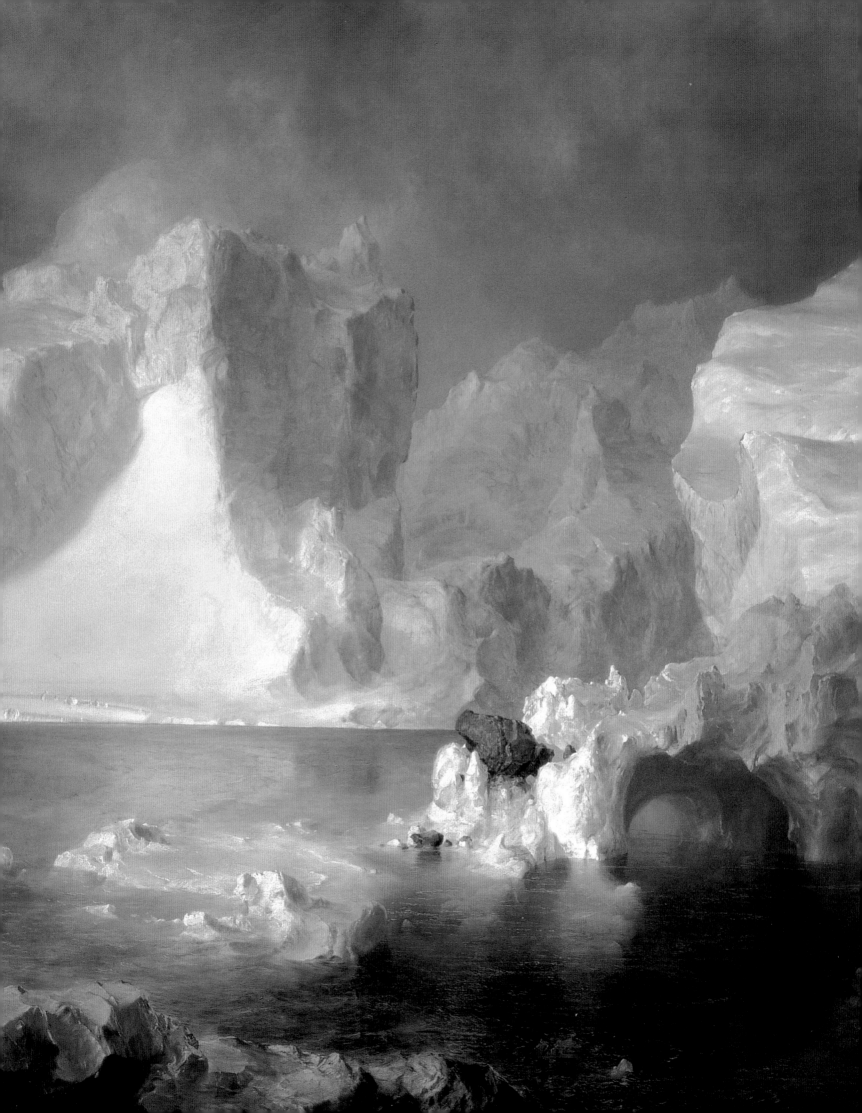

7 Explorations

Throughout the nineteenth century the limits of America were under negotiation: political, scientific and artistic interest was focused on territories to both the north and south of the United States. The German scientist and explorer Alexander von Humboldt provided authority for the endeavour of describing such regions in his comprehensive work on natural history, *Cosmos*, the first volume of which was published in 1845. It explained these virgin worlds as expressions of the infinite fecundity of God. Under that inspiration Church twice travelled in South America, in 1853 and 1857. He found there a realisation of the Biblical Paradise that Cole had only been able to imagine. Ecuador was dominated by its majestic volcanoes, Chimborazo, the 'giant of the west', Sangay and Cotopaxi (no.86), whose peaks seemed natural echoes of the transparent domes rising into the firmament in Cole's or John Martin's visions of Heaven. In *The Andes of Ecuador* (no.85) Church sought to present a panorama or summary of South American nature under its burning sun; Cotopaxi erupting shows 'Andean grandeur and energy'; and later, in *Rainy Season in the Tropics* (no.87), he created out of the national sense of relief at the conclusion of the Civil War a new image of God's Covenant with Noah: the rainbow uniting man and nature in an ecstatic bond of peace and deliverance. Humboldt had also described the Arctic, where nature took very different forms, beautiful to the eye of the naturalist seeking God's perfection in earthly wonders, and susceptible to meticulous scrutiny by such an observer as Church. His *Icebergs* (no.88) was the result of a trip to Newfoundland and Labrador in 1859. It is one of the supreme monuments of Ruskinian naturalism, a summation of many fine studies made on the spot (see nos.58–9) and a compendium of the natural history of ice – a subject that had preoccupied Henry David Thoreau in his famous book *Walden* (1854). Church followed a long tradition among painters of historical subjects in exhibiting his large canvases as spectacles, in specially lit and decorated rooms.

The Andes of Ecuador, 1855

Oil on canvas 121.9 × 190.5 (48 × 75)
Inscribed bottom centre 'F.E. Church 1855'
Reynolda House, Museum of American Art, Winston-Salem, North Carolina.
Original Purchase Fund from Mary Reynolds Babcock Foundation, Z. Smith Reynolds
Foundation, ARCA Foundation, and Anne Cannon Forsyth, 1966

After his first visit to South America in 1853, Church's finished pictures for exhibition became noticeably larger. In 1854 he painted an upright view, over 6 feet (1.8 metres) in height, of *Tequendama Falls, near Bogota, New Granada* (Cincinnati Art Museum, Cincinnati, Ohio);[1] and in the following year he produced *The Andes of Ecuador*, his largest canvas to date, preparing the way for his first international 'block-buster', the *Niagara* of 1857 (fig.32). The vast scale of South American scenery evidently had a direct influence on his perception of the function of size in painting. In its composition this subject reflects that preoccupation with scale. It is one of his least concrete pieces of topography: the rocks and mountains are pushed to the edges of the canvas by the light-laden atmosphere that intervenes between the eye and every object. In this Church follows the example of Turner, whose late paintings and watercolours are panoramas of light and air. In particular, he may have been immediately stimulated by a large engraving by Robert Wallis after one of Turner's late watercolour views on Lake Lucerne,[2] which was published in 1854 (fig.12). As in other Lucerne subjects of the 1840s, Turner dispenses with fore-ground, allowing the eye to drop swiftly to the level of the lake and its low-lying shores, beyond which the mountains rise in a haze. This supplies precisely the compositional format that Church adopts here. He concentrates on the establishment of a vast scale by vouchsafing glimpses of foreground detail, none of it very close at hand, beyond which the ostensible subject of the picture, the mountains themselves, is immersed in haze. Contemporaries were impressed by both the scale and the atmospheric effect: *Harper's Magazine* wrote:

> Wonderful hazy ridges of mountain-peaks, flooded with tropical sunlight. Sharp pinnacles, just tipped with eternal snow, soaring like white birds to heaven. Vast torrents, dashing over rocky ledges into bottomless ravines that gape for the silver waters. Faint gleams of tropical vegetation reddening the foreground, with all detail, all shape, lost in the neutral bloom over lonely places. Grandeur, isolation, serenity! Here there is room to breathe.[3]

Barbara Novak suggests that for Church this process was a realisation of Humboldt's view of nature as 'one great whole animated by the breath of life'.[4] She also associates this with the Transcendentalism of Emerson, quoting his 'fire, vital, consecrating, celestial, which burns until it shall dissolve all things into the waves and surges of an ocean of light'. The spiritual import of this imagery is clear. According to Emerson, the light that engulfs all creation enables us to 'see and know each other, and what spirit each is of'.[5] Henry Tuckerman, an art critic as close to Church as anyone, wrote of the picture in explicitly religious terms: 'Seldom has a more grand effect of light been depicted . . . It literally floods the canvas with celestial fire, and beams with glory like a sublime psalm of light.'[6] There has indeed been a consensus among American commentators that *The Andes of Ecuador* is, in the words of Gerald Carr, 'a sweeping Christianized panorama'.[7] As in many of Cole's landscapes, and notably in Church's own *Heart of the Andes* of 1859 (fig.14), there is a wayside shrine in one corner (the bottom left) of the view; but so thoroughly has this interpretation been explored that the composition itself is sometimes seen as a vision of the Cross.[8] The central vertical formed by the sun and its reflections on river and spray intersects a horizontal line of gold marking the upland plateau beyond the lower range of mountains. This 'Gold Cross' is sufficiently unobtrusive to remain a virtually subliminal commentary on the landscape, but if intended it would be a curious anticipation of the widespread interest shown a little later when the Mountain of the Holy Cross was discovered in the Far West (see p.28 for further comment on this picture). A comparable 'Cross' has been discerned in *Cotopaxi* (1862; no.86). Church exhibited *The Andes of Ecuador* at the National Academy of Design in 1857 as no.23.

AW

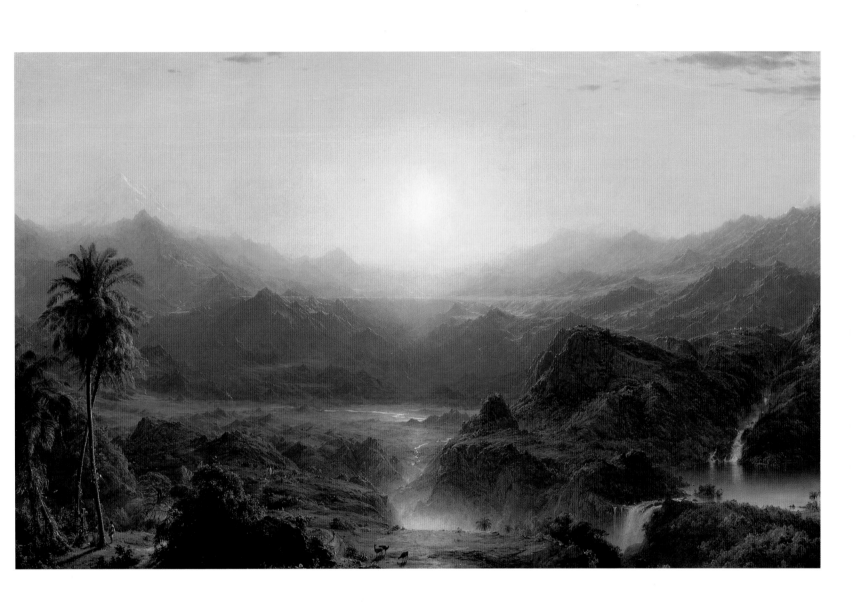

Cotopaxi, 1862

Oil on canvas 121.9 × 215.9 (48 × 85)
Inscribed lower right: 'F. E. Church 1862'
The Detroit Institute of Arts, Founders' Society Purchase, Robert H. Tannahill Foundation Fund,
Gibbs-Williams Fund, Dexter M. Ferry, Jr., Fund, Merrill Fund, Beatrice W. Rogers Fund, and Richard A. Manoogian Fund
LONDON AND MINNEAPOLIS ONLY

Church painted several views of Cotopaxi after his first visit to South America in 1853, and he saw the volcano again during his second tour of 1857. At 18,858 feet (5,478 metres) it is perhaps the most impressive of the South American volcanoes, and its cone was considered particularly perfect and beautiful (see no.55). It became for Church an important image of the workings of nature in an equatorial region. His early views show it in repose, the focus of a landscape embodying tropical luxuriance and harmony. In 1861 the New York collector James Lenox commissioned this very different account of the mountain. By that date the Civil War had begun, and Church's choice of a more violent motif has been interpreted as a direct reflection on the tragic turn of events. The picture has also been recognised as one of the most theatrical, even 'operatic' of Church's works: 'a vast stage set where good and evil meet in a final Armageddon' is one recent description.[9]

The picture has also been described as 'Church's greatest homage to Turner, a recasting in geological terms of the famous *The Fighting Temeraire, tugged to her last Berth to be broken up, 1838*.'[10] The parallels are not, however, immediately obvious. Turner's picture is a reminiscence of a war long since fought and won; it reflects on the passing of a glorious period in the naval history of the nation, and its replacement by an age very different in both attitudes and technology. Its sun, low over the horizon, ought for topographical reasons to be rising, but must, for symbolic reasons, be setting. The sun in Church's picture is rising, but is obscured by dark smoke – not the smoke of technology, but of nature 'at war with itself'.[11] If any period is succeeding another, it is one stage of the world gradually modifying itself into a different one by a long sequence of eruptions and tremors over a huge expanse of geological time: 'a world evolving out of the simultaneous processes of creation and destruction', as one commentator has put it.[12]

Church intended *Cotopaxi* to form one of a trio of South American subjects, with *Heart of the Andes* and the view of another volcano, *Chimborazo* (1864; Scott Gallery, Huntington Library, California).[13] His purpose was to paint a sequence of contrasting scenes that would present a comprehensive and scientifically verifiable account of the landscape of Ecuador. He regularly sought to achieve a balance between accuracy of record and pictorial drama: that balance is exceptionally subtle in *Cotopaxi*. In *Heart of the Andes* the overwhelming impression is of a mass of fascinating detail; in *The Andes of Ecuador* (no.85) the atmospheric effect is so strong that the exquisite details are (deliberately) almost lost. In *Cotopaxi* the details are conceived on a scale that contributes to the power of the whole design, subordinated as they are to a highly original and daring compositional plan. The whole of the lower half shows a flat plain, 50 miles (80 kilometres) from foreground to distance, interrupted by huge fissures and a lake. The vertical estab-

lished by the column of smoke rising from the lightly snow-covered volcano towards the left is echoed, though not literally continued, by the waterfall that takes the eye into a deep chasm. The horizon occurs almost exactly at the mid-point of the canvas, creating a bold cross-shape, while the symmetry of the arching cloud of smoke above and the undulating cliff-top beneath sets up a rhythm that moves both laterally across the picture and in depth from picture-plane to horizon. Enclosed by these huge curves, the reddened sun glimmers through the dark haze 'like the great eye of some Cyclopean monster', as a contemporary described it.[14] The glint of lurid light on the walls of rock, the minuscule birds flying far below us, the thunder of the falls and the opposition of black line of smoke to orange disc of sun are carefully controlled elements in a stupendous pictorial drama.

Cotopaxi was shown at Goupil's Gallery in New York, and in 1865 appeared in London at Henry McLean's Gallery, 26 Haymarket, along with *Chimborazo* and the *Aurora Borealis*. While it was still in New York, Church's staunch supporter the art critic Henry T. Tuckerman wrote that *Cotopaxi* 'is both in general effect and in authentic minutiae . . . absolutely and scientifically true to the facts of nature and the requirements of art'.[15] London critics too were enthusiastic:

> It is a scene of strange and solemn magnificence . . . And in these vapours of various kinds, there are magical feats of the pencil, such as we cannot remember seeing equalled of late by our own painters . . . We cannot recall in them anything of the kind so finely done as this transparency, or transpicuousness rather, looking through veils of smoke inflamed by the sun, upon the silvery eruptions of the dappled morning; or the pale mist and sultry haze lying before those huge heaps of earth-born darkness which the painter has rendered with no less aërial delicacy than grandeur.

The critic then writes of *Chimborazo* in terms that also apply to *Cotopaxi*:

> At length, here is the very painter Humboldt so longs for in his writings; the artist who, studying, not in our little hot-houses, but in Nature's great hot-house bounded by the tropics, with labour and large-thoughted particularity parallel to his own, should add a new and more magnificent kingdom of Nature to Art, and to our distincter knowledge.[16]

In 1865 Church made a small oil sketch (Private Collection)[17] in which he restated the composition of *Cotopaxi* with a much simplified landscape, enlarging the expanse of water and introducing an oddly homely picturesque foreground. Instead of the tiny group of a man with a llama in the left foreground of the large picture, reduced almost

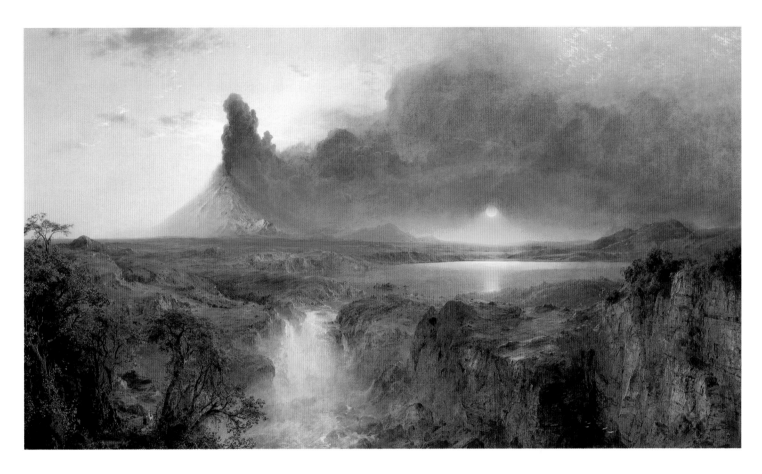

to invisibility by the immensity of the scene, he places two figures, one mounted, on a road passing a ruined building which suggests the legacy of abandoned Spanish churches in the region. This introduces a note of Christian contemplation somewhat at variance with the inimical wildness of the original design – though as with *The Andes of Ecuador* a 'hidden' Cross has been detected in the salient compositional elements of the prime version of *Cotopaxi*.[18] Church may have wished to emphasise the point after the deaths of his two young children early in 1865. As Gerald Carr points out, similar features occur in a finished painting, *The After Glow* (1867; Olana State Historic Site), completed just after the death of his younger sister in January 1867.[19] This is based on a study made on the trip to Jamaica in 1865 by which Church and his wife attempted to distract themselves from their grief; the study was treasured by Church as a work of special significance to him (see no.57).

The atmosphere of cosmic tragedy embodied in *Cotopaxi* is then to be read as both universal and personal. Church's phrase 'the newly risen sun', to which David C. Huntington has drawn attention,[20] may

well have been intended as a pun on the Christian idea of the Resurrection of the Son of God (Church was fond of puns), and it is hard to imagine an artist, steeped in Biblical lore as Church was, not intending an allusion, in the plume of smoke from the volcano, to the pillar of cloud that accompanied the Israelites in the desert. The connection between an epic journey across inimical terrain and an obscured sun also recalls Turner's famous *Snow Storm. Hannibal and his Army Crossing the Alps* of 1812 (fig.5), which Cole had seen in the original and admired for its sublimity, and which would have been known to Church through the engraving in the widely disseminated collection known as *The Turner Gallery* (1859–61). Church may well have thought of himself (and of Humboldt before him) as a conqueror of natural difficulties in the mould of Turner's Hannibal. But a connection with Turner may well have been in his mind for other reasons: the picture was painted at the instigation of Colonel James Lenox, the New York collector who first brought oil paintings by Turner to America: he owned *Fort Vimieux* of 1831 and *Staffa, Fingal's Cave* of 1832 (fig.51).
AW

Rainy Season in the Tropics, 1866

Oil on canvas 142.9 × 214 (56¼ × 84¼)
Inscribed lower left 'F E Church 1866' and lower right 'F E Church 1866'
Fine Arts Museums of San Francisco, Mildred Anna Williams Collection

Church started to paint this picture in 1864 and continued with it until 1866. He made use of a pencil sketch of the composition which he had drawn in 1863 (Cooper-Hewitt Museum, New York), but which he seems to have continued to elaborate as he progressed with the oil painting. In 1865 it was seen by an English visitor to New York, who reported on it to the *Art-Journal* in glowing terms as 'one of the finest works of this celebrated artist'.[21] By the time he had finished work on the canvas the Civil War was over, and the picture has been seen as a celebration of the return of peace, a sequel to the conflict embodied in *Cotopaxi* (no.86). The huge double rainbow, one of the most spectacular in the history of art, not only recalls God's Covenant with Noah after the Deluge, but also acts physically as a bond between the divided halves of the panorama, which is a synthesis of the contents of Church's previous grand statements about South America, *The Andes of Ecuador* (no.85), *Heart of the Andes* (fig.14) and *Cotopaxi* (no.86). A damaged study in the Cooper-Hewitt Museum (1917-4-1323) shows a flat landscape also straddled by an enormous bow that spans the width of the sheet. It is noteworthy that in his pencil sketch for the composition Church placed a building, which is evidently a religious structure, at the point from which the rainbow springs at the left of the view. This church (no doubt a pun on his own name, which he was fond of employing) has been eliminated from the final picture; instead the rainbow materialises against high barren cliffs that rise up from a deep gulf. On the right a mountain road takes travellers into a lush landscape with, in the distance, a fertile plain overlooked by a snowy pinnacle, appearing through curtains of dense rain.

The meticulous precision with which Church depicts details of geology, botany and meteorology is as controlled as ever; the rainbow itself is geometrically circular, having been drawn with compasses. The intrusion of mathematical accuracy into so wild and atmospheric a scene contributes to the dramatic shock that the bow creates. It has been suggested that in painting this subject in exactly the same

tightly controlled language as his pre-war works Church failed to respond to a fundamental change in cultural attitudes that had been accomplished by the War.[22] It is theatrical in a more literal way than, say, *Cotopaxi*, and seems to strain harder after its effects. To this extent it presages Church's fall from popular favour in the 1870s. But it is also testimony to his enduring technical skill and vivid invention.

There are two interesting Turnerian precedents for what Church does in this picture. One is a large watercolour of 1815, *The Battle of Fort Rock, Val d'Aouste, Piedmont 1796* (Tate Gallery, London),[23] in which the invasion of Italy by Napoleonic forces is enacted in a skirmish on a narrow mountain road. Beside the fighting men a deep gorge separates the left half of the composition from the right, where blank and hostile rocks rise vertically. In the distance, the snow-covered summit of Mont Blanc emerges from wreaths of cloud. It is highly improbable that Church knew of this work, which Turner himself neglected and which was never engraved; yet the unusual compositional structure of the design, reflecting as it does the horrors of war and the corresponding violence of nature, suggests that Church's mind was moving in a similar direction, and that his sense of the symbolism of landscape was very close to Turner's. It was also close to that of a contemporary of Church's, William Giles Dix, whose writings on South American scenery in New York and Boston newspapers, Gerald Carr has suggested, parallel Church's Andean paintings closely: 'The mountain-top is sacred from mortal touch. War's gory feet never climbed so far. Angels of peace guard the tops of the Andes.'[24] Another Turnerian precedent for *Rainy Season in the Tropics* is to be found in the great rainbow that Turner touched on in Daniel Maclise's (1806–1870) painting of *The Sacrifice of Noah after the Deluge* (1847; Leeds City Art Gallery); this provides a clear precedent for a rainbow spanning the entire subject, and may well have been known to Church since Maclise's picture was engraved.

AW

The Icebergs, 1861

Oil on canvas 163.5 × 185.8 (64 ¾ × 112 ½)
Inscribed 'F. E. Church | 1861'
Dallas Museum of Art, anonymous gift
LONDON ONLY

In June 1859 Church and his friend, the pastor Louis Legrand Noble, biographer of Church's teacher Thomas Cole, set sail from Boston, via Halifax Nova Scotia, bound for the Newfoundland Coast.[25] Their mission was to observe one of the wonders of nature: icebergs. Noble's charmingly titled account of the trip, *After Icebergs with a Painter* (1861), gives a detailed, if occasionally florid, account of the trip. When, on 21 June 1859, Church and Noble first saw an iceberg from on the deck of the steamship *Merlin*, they were genuinely awestruck:

> Distant and dim, it was yet very grand and impressive. Enthroned on the deep, in lonely majesty, the dread of mariners and the wonder of the traveller, it was one of those imperial creations of nature that awaken powerful emotions, and illumine the imagination. Wonderful structure fashioned by those fingers that wrought the glittering fabrics of the upper deep, and launched upon those adamantine ways into Arctic seas, how beautiful, how strong and terrible.[26]

The *Merlin* took them as far as St John's, but Church needed to get closer to his subject, and hired at his own expense the *Integrity*, a small schooner (a sailing vessel of 65 tons). This finally paid off on 1 July when the ship became surrounded by thirteen icebergs. Appearing quite unlike any other object in the natural world, the icebergs immediately set off a chain of associations in the mind of the clergyman and the artist – one resembling 'a cluster of Chinese buildings, then a Gothic cathedral, early style'. Together, the icebergs 'resembled the ruins of a marble city'.[27] After reaching Battle Island, Church and Noble took a small rowing boat and approached the icebergs more closely, even 'catching a panful of water, fresh from the great Humboldt glacier, quite likely'.[28] Church doubtless relished the reference to the great German scientist whose steps he had retraced among the Andes of Ecuador.

Church made a series of swift drawings in pencil, heightened with white chalk, which capture the strange geometry and the play of light and shade on the surface of the icebergs. From the deck of the *Integrity*, and from the small rowing-boat, he also executed a series of oil sketches (see no.58). Church was the master of this form of swift notation, using bold, expressive strokes of a loaded brush to capture colour, form and texture. Most unexpected was the range of vivid colours reflected in the iceberg; Church actually added the words 'strange, supernatural' to one sketch, as if to reinforce his visual perception.[29] In spite of his Ruskinian convictions of truth to nature, faced with this remote spectacle, Church could hardly believe his eyes. There are eighty-nine sketches of icebergs by Church in the Cooper-Hewitt Museum, which probably represent the bulk of the work carried out on the expedition.

Armed with these vivid studies, Church returned to New York, determined to produce another work whose reception would rival that accorded to his previous 'Great Pictures', *Niagara* (1857; fig.32) and *The Heart of the Andes* (1859; fig.14), both of which had been revealed to the public in hugely successful, special single-work exhibitions in New York and London.[30] However, personal matters intervened: early in 1860 he took possession of the land and buildings opposite Cole's former home near Hudson, New York, which he was to transform into 'Olana', his home for the rest of his life. Furthermore, in June 1860 he was married to Isabel Carnes. In addition, he was working on *Twilight in the Wilderness* (no.25), which was exhibited later that year at Goupil's Gallery on Broadway. Meanwhile, he was pondering what to make of the sketches from his northern trip. Late in 1860 he finally began working on ideas for the composition, which was to occupy a large canvas almost the same size as *The Heart of the Andes*. In two small oil sketches on paper made in 1860, the basic compositional formula is taking shape, and one (no.59) shows a wrecked ship,[31] an important element in the ultimate version, though these early versions do not yet focus on a single, monumental iceberg. A larger study on canvas resolved the composition, with a much firmer foreground providing a convincing position from which the viewer can survey the extraordinary scene. By December 1860 Church was ready to begin work on the portentously large canvas, whose panoramic proportions called for a dramatic, even theatrical treatment. Always an astute manipulator of the press, Church dribbled information to his contacts, a process that culminated in an editorial in the *New York Times* on 29 March 1861 announcing that Church's representation of 'intense solitude in the clear frozen North' was nearing completion.

The North: Church's Picture of the Icebergs (as it was then titled) first appeared before the public on 24 April 1861, by which time the Civil War had begun. The title 'The North' clearly alluded to Church's partisan advocacy of the Unionist cause, but the interpretative notes by the artist rigorously avoided any suggestion of a political or even a religious connotation for the work, preferring instead to stress – as Ruskin might have done – the fidelity with which each detail was represented, and its underlying physical cause.[32] The foreground is wet and glistening because it has risen from under the water; the changing level of the sea has left horizontal stains on the main iceberg. The brilliant blue veins in the iceberg are caused by water that has frozen in the cracks of a glacier. Church had observed the startling

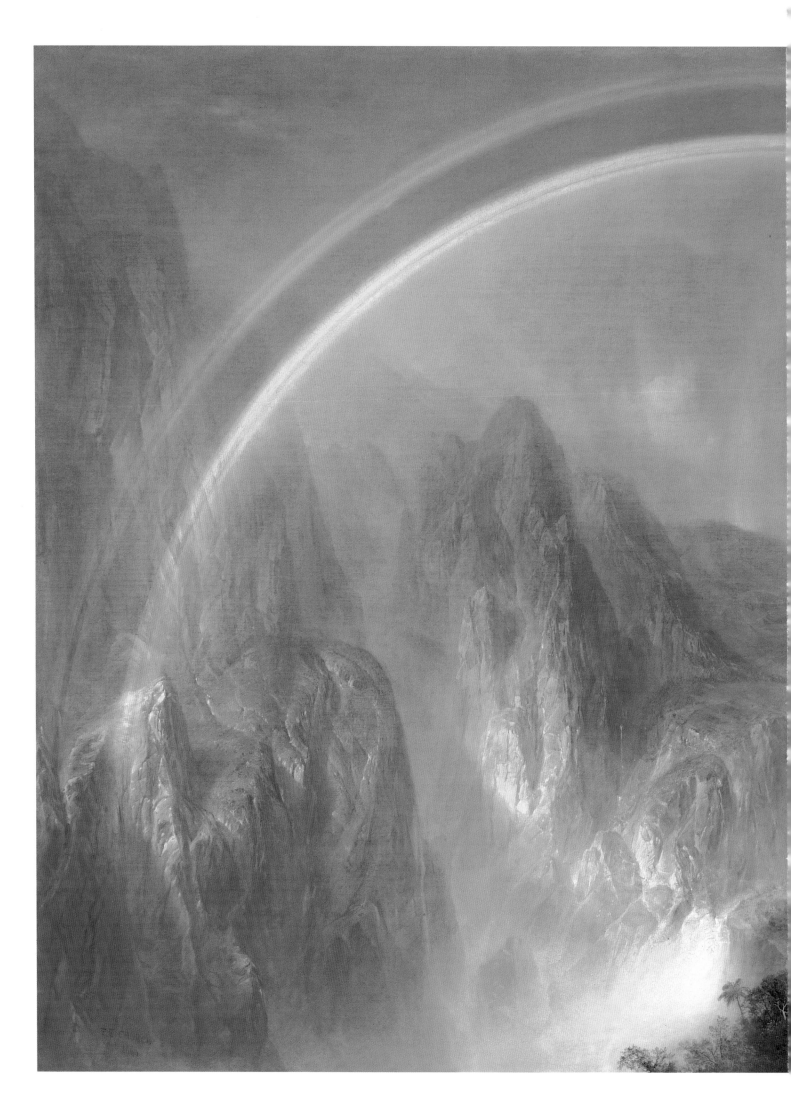

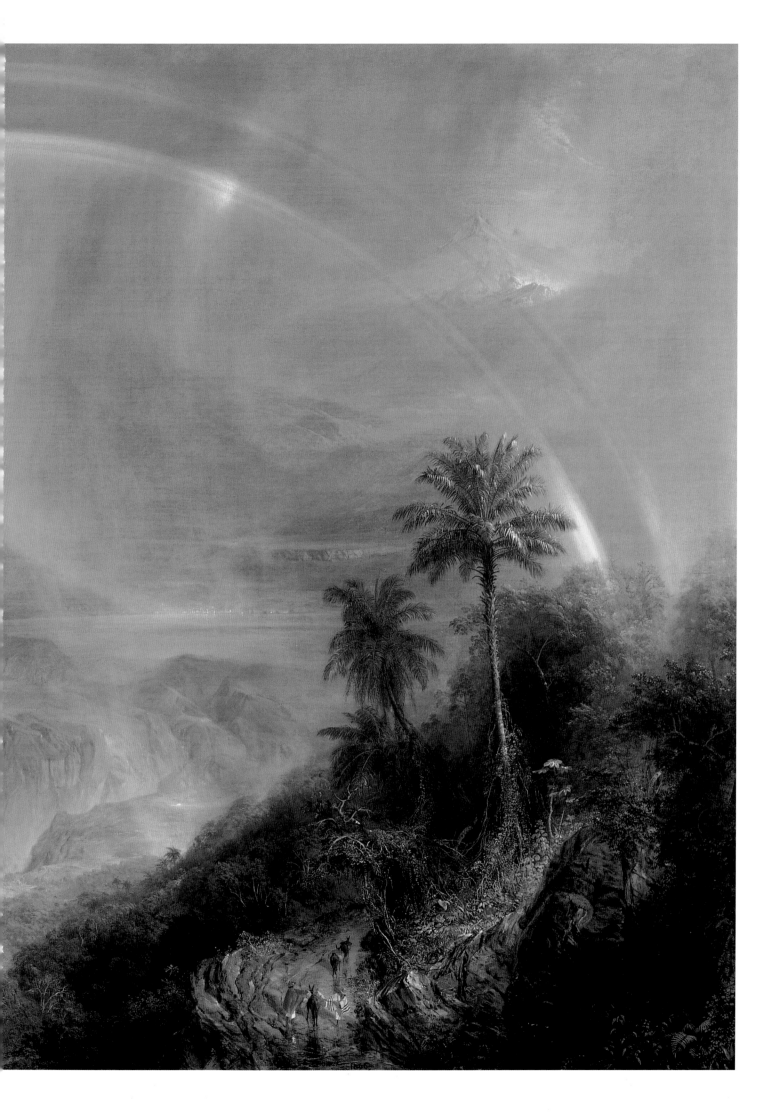

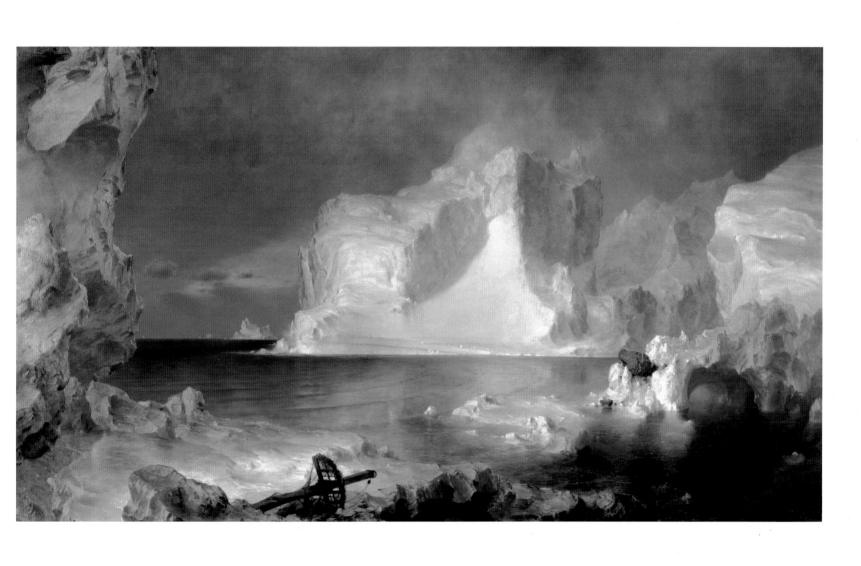

emerald greens 'where the sea comes in contact with the ice'.[33] Such a naturalised reading was possible despite carefully contrived elements in Church's composition: the repoussoir of ice at the left; the ripples in the water articulating the perspectival recession in the middle-ground; and the distant vista to the left with a pinkish sunset balancing the menacing darkness of approaching fog to the right.

Despite the distractions of the Civil War, critics were extravagant in their praise. One described it as 'the most splendid work of art that has yet been produced in this country',[34] while for another

> the 'Icebergs' lead us at once to the inner arcana of that mysterious temple which sits forever upon the forehead of the world. We can but stand at the base of that towering cliff of ice, broken into huge crystallizations of form, streaked with mingled tints of azure, emerald and gray, kindling here and there into cold, intense gleams of dazzling luster, and look out along the lazy folds of water towards white pinnacles, uplifted against the horizon, and confess the picture is above criticism.[35]

In addition to such tributes to the documentary value of the work, the more perceptive critics noted the sublime quality of the 'mysterious temple' of the Arctic. *The World* warned: 'we shall be surprised if those of acute sensibilities do not look upon it at first with a positive feeling of pain, akin to that which we sometimes feel in the presence of the terrible visions of sleep.'[36] Certainly there were hints of anthropomorphism in the painting of the ice; grotesque faces, a skull, and even the body of a woman could be discerned among the naturally sculpted surfaces of the icebergs. When the painting was exhibited at the Boston Athenaeum in February 1862, the *Christian Register* predicted that even for 'persons who never dreamed dreams', Church's painting would 'burst on their sense like a vision, it will follow them home and haunt them for weeks, it may open their minds to finer visions'. For this critic Church, truly a religious painter, 'aims to display the Lord's beauty, and not his own skill: his flowers bloom, ice shimmers, and waterfalls weave their rainbows, to the praise of nature, the glory of God'.[37] The central iceberg to many viewers resembled a Gothic cathedral, prompting a Ruskinian parallel between medieval architecture and natural forms. Geology, too, was a key interest of Ruskin and of Church during this period. But the icebergs presented a unique phenomenon by being ancient natural structures like rock faces which were, however, impermanent and constantly changing. These cathedrals in ice are melting before our very eyes, crumbling away and dissolving into the sea.

There can be no question that Church, like Ruskin and many of his contemporaries, found in the spectacle of nature the handiwork of God; scientific observation and religious observance were one and the same. Yet unlike *The Heart of the Andes*, in which a strategically placed cross lit by a beam of sunlight emphasises the religious message, *The North: Church's Picture of the Icebergs*, as exhibited in New York and Boston, bore no explicit reference to Christianity. By the time of the work's triumphant exhibition in London, however, it had been retouched, and a new, and crucial, element had entered the composition: the mast of a wrecked ship in the foreground that clearly takes the shape of a cross. This ambivalent emblem could be read as a pessimistic statement of the futility of human enterprise, restating the Turnerian theme of the 'Fallacies of Hope'. The history of Arctic exploration offered a profusion of disasters, notably that of the English explorer Sir John Franklin in 1845–7; the opening of the London exhibition of the work – now known simply as *The Icebergs* – on 20 June 1863 was indeed attended by Lady Franklin, widow of Sir John, and several veterans of past Arctic missions. However, judged in the context of Church's work, it is more likely that the mast was introduced to indicate that death is followed by redemption through Christ. Since versions of this feature appear in early oil sketches (see no.59), it seems clear that Church had intended an epic landscape once again to carry religious meaning.

The painting achieved its greatest success in London, where it could be seen as the successor to Alpine images by Turner, coastal scenes by Clarkson Stanfield and Francis Danby, and even religious works by John Martin. The British public was fascinated by the literature of exploration at this time, especially if – as with David Livingstone's best-selling *Missionary Travels* of 1857 – it had a religious overtone. The critics, however, still under the influence of Ruskin's *Modern Painters*, the final volume of which had been published in 1860, concentrated on 'the singularly truthful and delicate painting of the prismatic effects of light on these monstrous masses of opaque ice'.[38] Another found the subject to be 'treated with so much reality that we absolutely shiver before it'.[39] A superb colour lithograph of the work was made in 1864–5 by Charles Ridson of Charles Day & Son.

During the London exhibition the painting was purchased by Sir Edward Watkin, a Manchester railway entrepreneur and MP with extensive links in Canada and the USA. Watkin had himself seen icebergs off the Canadian coast while working on the Canadian Pacific Railroad, an endeavour which he described as a new 'North-west Passage', solving – or at least making redundant – the mystery that had led so many Arctic explorers to their deaths.[40] The painting was not exhibited again during Watkin's lifetime; after his death in 1901 it remained, unrecognised, in his home, Rose Hill at Northenden near Manchester, which became a Boys' Remand Home. After the

painting's rediscovery in 1979 its sale for $2.5 million, then the highest figure ever attained at an art auction in the USA, caused a sensation, announcing that American art of the nineteenth century should be taken as seriously as that of the European masters. As Gerald Carr noted in 1980, this echoed the original response to *The Icebergs*, when a critic had written: 'It is a thought of which an American can be proud, that a native artist, without even the sight of a "great master" has proved to all the world that genius dwells in our young country as well as in old, crowded, effete Europe.'[41]

TB

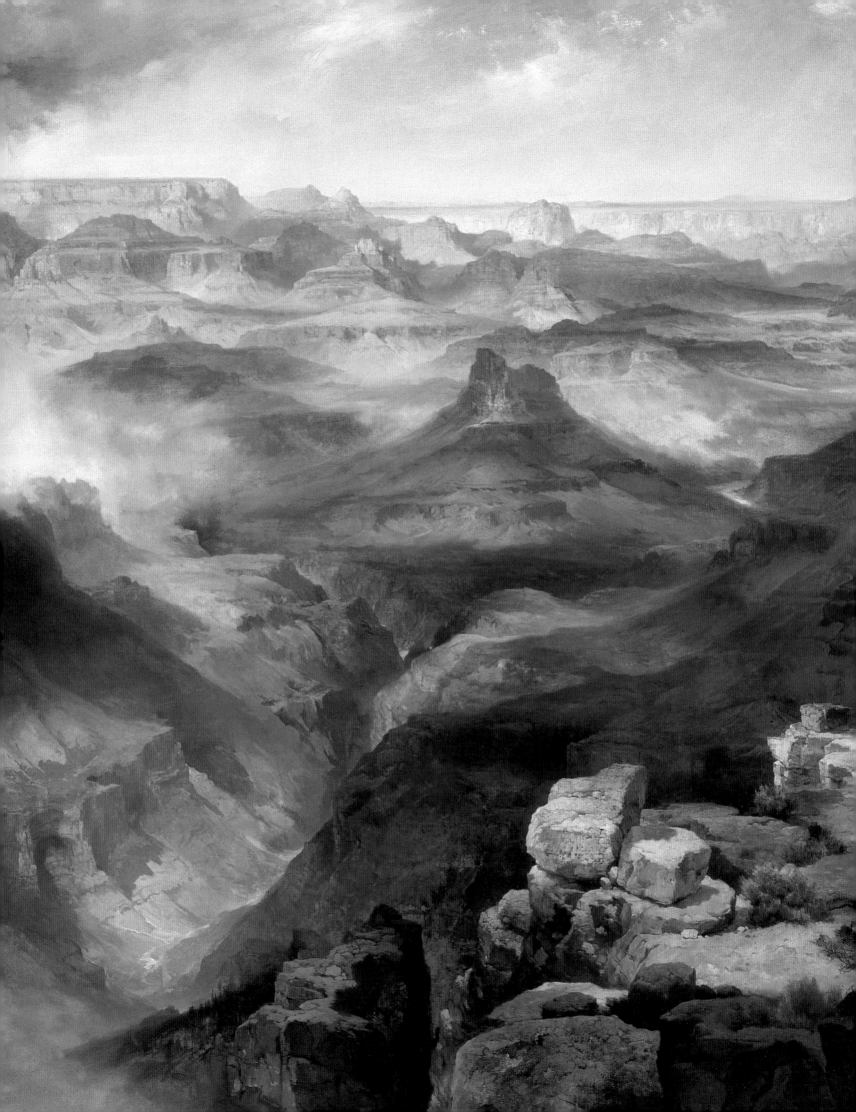

8 The Great West

Artists who wished to emulate Church's success with the 'Great Picture' were given the opportunity to explore new territory for their subject matter when the American government sent expeditions to the Far West to survey the vast territories now incorporated under Federal rule. Albert Bierstadt enlisted with Frederick West Lander's expedition in 1859, travelling through Kansas and Nebraska to the Rocky Mountains, taking photographs of American Indians *en route*. His first major Western subject showed an imaginary peak named after Lander; a smaller canvas featuring the peak in an epiphanic burst of light is no.89. A second journey west, in 1863, took Bierstadt and a companion, Fitz Hugh Ludlow, to Oregon and then south into California. They visited the Yosemite Valley in the Sierra Nevada, which was to supply him with many splendid subjects (nos.92–3). In 1866 he finished an enormous canvas, *Storm in the Rocky Mountains – Mt Rosalie* (no.91), in which another imaginary peak is named after his future wife, formerly married to Ludlow. Thomas Moran's first American journey of exploration was to the shores of Lake Superior in 1861, when he collected material that was later to be used in three meditations on scenes from Longfellow's poem *The Song of Hiawatha* (nos.95–7). He travelled to the Far West in 1871 with the expedition of Ferdinand Vandeever Hayden, whose objective was the region of the Yellowstone River, in north-west Wyoming. Here, under the influence of Ruskin, Moran was able to make detailed drawings of the geysers and hot springs, records used in evidence when Congress was debating the formation of the first National Park at Yellowstone in 1872. A huge painting of the *Grand Canyon of the Yellowstone* (fig.16) was bought by Congress, and this was followed by another showing *The Chasm of the Colorado* (fig.17) – the famous Grand Canyon of Arizona – the outcome of studies made on another expedition, led by John Wesley Powell, in 1873. Moran made many versions of these two subjects during the remainder of his long career (no.99), sometimes at the instigation of the railroad companies who sought advertising material for their lines creating new, modern links across the continent.

Rocky Mountains, 'Lander's Peak', 1863

Oil on linen 110.8 × 90.1 (43 ⅝ × 90.1)
Inscribed lower left 'A Bierstadt 63'
Fogg Art Museum, Harvard University Art Museums, Gift of Mrs William Hayes Fogg
LONDON ONLY

Bierstadt painted two pictures featuring a mountain named 'Lander's Peak' after Frederic Lander, leader of the expedition to the Rockies in 1859 in which the artist took part. Lander died in February 1862 from wounds received in action in the Civil War, and the christening of the peak was Bierstadt's personal tribute, not a formal geographical fact. (It had been common during earlier expeditions, such as that of Lewis and Clark in 1804–6, to name geographical features after members of the expedition; such names did not invariably survive later surveying and settlement.) The larger canvas appears to have been begun very soon after this event, and was exhibited privately in New York in January 1863. It is now in the Metropolitan Museum of Art, New York.[1]

This smaller one continues the same theme: a pioneer of the Far West and a hero of the War is commemorated in the very geography of America, as well as in the grand images that Bierstadt was creating. Both pictures represent not an actual mountain but an imaginary or 'ideal' peak in the Rockies, summarising the landscape of the region rather than depicting a particular portion of it. The burst of light evokes the spiritual connotations of high mountains; there is an implication that God Himself resides in these high places, and the Biblical instances of Sinai, where Moses received the Tablets of the Law, and the hill of the Transfiguration are implied references.
AW

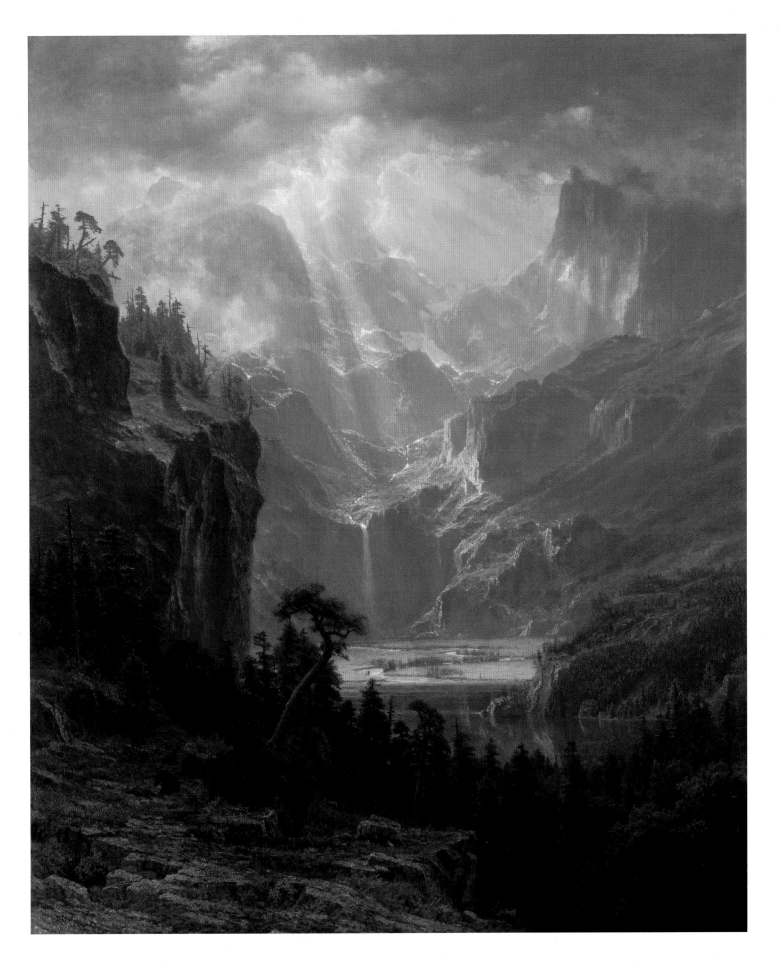

Looking Down Yosemite Valley, 1865

Oil on canvas 163.8 × 245.1 (64 ½ × 96 ½)
Inscribed lower left 'ABierstadt | 1865'
Collection of the Birmingham Museum of Art, Alabama; Gift of the Birmingham Public Library
LONDON ONLY

Bierstadt's first visit to Yosemite took place in the summer of 1863. His immediate inspiration to make the journey may have been an exhibition in December 1862 at Goupil's Gallery in New York, in which the photographer Carleton Watkins (1829–1916) displayed his large-scale images of California scenery, including fine views at Yosemite. He and a New York writer, Fitz Hugh Ludlow, saw these prints and 'gazed on them by the hour'.[2] Ludlow and Bierstadt crossed the continent to San Francisco, where they were welcomed as heroes, a renowned artist and writer from the East who would put California on the cultural map, 'make the old world open its eyes and send tourists out here, even before the Pacific Railroad is finished'.[3] They then journeyed inland to Mariposa Grove, to see the great sequoias there, before spending seven weeks in Yosemite, where Bierstadt spent 'every moment painting from nature'.[4] From Yosemite they travelled north into Oregon, and returned south along the coast to Panama, from where they sailed north, reaching New York in December. Yosemite is a spectacular gorge carved through granite rocks by glaciers and the Merced River. Its sides are bare rock, often almost vertical for many thousands of feet, their lower portions covered by scree and heaped boulders on which trees both evergreen and deciduous grow thickly. These spread down into the valley floor, across which the river meanders, with occasional lakes and broad areas of grassland. Ludlow wrote of the expedition's first impressions of Yosemite: 'Our eyes seemed spellbound to the tremendous precipice which stood smiling, not frowning at us, in all the serene radiance of a snow-white granite Boodha – broadly burning rather than glistening, in the white hot splendors of the setting sun.'[5]

Bierstadt began producing views of Yosemite immediately, finishing several in 1864 including one now in the Boston Museum of Fine Arts,[6] which is a fully worked-up preparation in oil on board for this view, and the slightly later one at Oakland (no.92). The following year he sent *Looking Down Yosemite Valley* to the Spring exhibition of the National Academy of Design. It was his largest treatment of the subject so far, and would only be outdone in size by the colossal *Domes of the Yosemite* (St Johnsbury Athenaeum, St Johnsbury, Vermont; see no.91) that he completed in 1867.[7] He was to repeat this composition on several occasions, varying it in detail, and especially in effects of light. Here the sunset glow irradiates the glacial formations, including El Capitan on the right, a sheer wall of rock 3,000 feet (914 metres) in height, and Sentinel Rock on the left, with the pinnacles of Cathedral

Rocks beyond in the haze. A closer view of Cathedral Rocks is no.64. In order to convey the scale of the landscape, Bierstadt chooses a viewpoint above the valley floor which enables him to look clear across a vast space dotted with trees that are dwarfed by the cliffs, achieving an expansiveness that corresponds to the sensations of the visitor, though not to the actual proportions of the place.

The critics were divided according to their place of operation. They acknowledged the justice of Bierstadt's high reputation, but those in the East accused him of gross exaggeration, of creating a 'great acre-and-a-half of slovenly and monstrous stage scenery' which 'might do credit . . . as the background of a melodrama',[8] or of being too vulgar, while those on the West Coast praised him for his truth:

> It looks as if it was painted in an Eldorado, in a distant land of gold, heard of in a song and story; dreamed of but never seen. Yet it is real. Why should our artists make their pilgrimages to the Alps for mountains, to Italy for skies, or to Chamouni Valley, when we have the mountains and skies of California, and the Valley of Yo-Semite.[9]

There were, however, dissenting voices even here: in 1869 it was reported that the picture had been destroyed, prompting one writer to rejoice:

> It is with grim satisfaction that we record the destruction by fire of Bierstadt's celebrated picture of Yosemite Valley. The painting has been a prolific parent of ten thousand abominations. We have had Yosemite in oils, in watercolor, in crayon, in chalk and charcoal until in our very dreams we imagine ourselves falling from the summit of El Capitan or descending in spray from the Bridal Veil cataract. Besides, that picture has incited more unpleasant people to visit California than all our conspiring hotel keepers could compel to return.[10]

In 1866 *Looking Down Yosemite Valley* was acquired by a Mr Crosby of Chicago, who sent it on a tour including Chicago, Milwaukee, Cincinnati and Philadelphia, advertising it as second prize, valued at $220,000, in the Crosby Opera House Lottery, Chicago. It was unsold. For comment on two slightly later treatments of this view, see nos.92 and 93.

AW

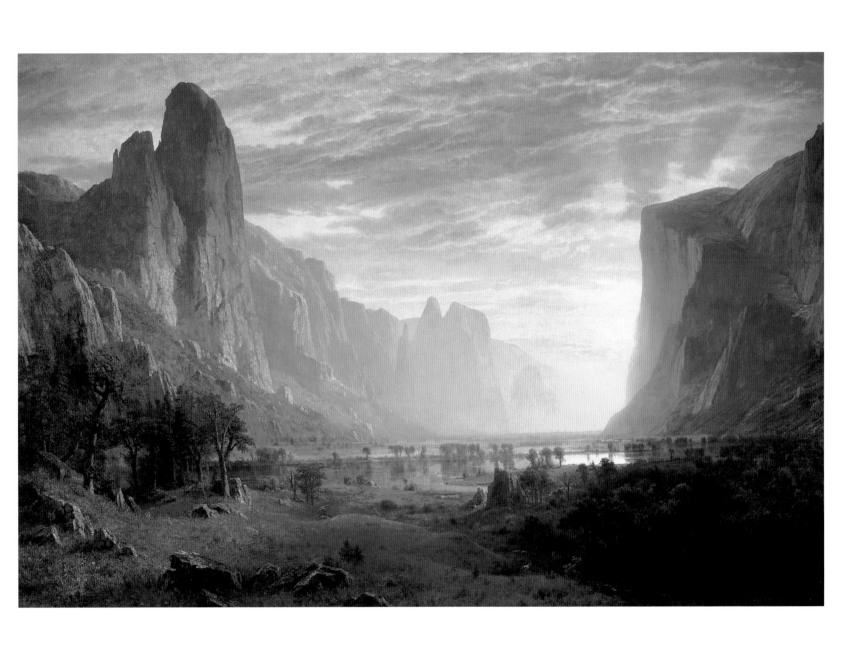

Storm in the Rocky Mountains – Mt Rosalie, 1866

Oil on canvas 210.8 × 361.3 (83 × 142¼)
Inscribed lower right 'ABierstadt | N.Y. 1866'
Brooklyn Museum of Art, Dick S. Ramsay Fund, Healy Purchase Fund B, Frank L. Babbott Fund, A. Augustus Healy Fund, Ella C. Woodward Memorial Fund, Carll H. de Silver Fund, Charles Stewart Smith Memorial Fund, Caroline A. L. Pratt Fund, Frederick Loeser Fund, Augustus Graham School of Design Fund, Museum Collection Fund, Special Subscription, and the John B. Woodward Memorial Fund; Purchased with funds given by Daniel M. Kelly and Charles Simon; Bequest of Mrs William T. Brewster, Gift of Mrs W. Woodward Phelps in memory of her mother and father, Ella M. and John C. Southwick, Gift of Seymour Barnard, Bequest of Laura L. Barnes, Gift of J. A. H Bell, and Bequest of Mark Finlay, by exchange 76.79

This stupendous canvas marks the high-water mark of Bierstadt's career. It is among his largest works, outstripped only by the exceptional *Domes of the Yosemite* (1867), which was executed shortly afterwards on a private commission for a specific site, the house of a financier, Le Grand Lockwood, at Norwalk, Connecticut. This later work measures 116 by 180 inches (294.6 by 457.2 centimetres), and is now housed in the St Johnsbury Athenaeum, St Johnsbury, Vermont.

Most of Bierstadt's Rocky Mountain subjects are, to a large extent, invented subjects, incorporating characteristic elements of the region rather than depicting identifiable places. This subject is no exception, but it seems to have a substantial basis in observed topography. He travelled through the Colorado Rockies in 1863, in the company of Fitz Hugh Ludlow, a New York journalist and man of letters. According to Ludlow, it was William N. Byers, a newspaper editor in Denver, who took them to the Chicago Lakes. Byers described Bierstadt's reaction to the view when he was shown it:

> He said nothing, but his face was a picture of intense life and excitement. Taking in the view for a moment, he slid off his mule, glanced quickly to see where the jack was that carried his paint outfit, walked sideways to it and began fumbling at the lash-ropes, all the time keeping his eyes on the scene up the valley . . . As he went to work he said, 'I must get a study in colours; it will take me fifteen minutes!' He said nothing more . . . Bierstadt worked as though inspired. Nothing was said by either of us. At length the sketch was finished to his satisfaction. The glorious scene was fading as he packed up his traps. He asked: 'There, was I more than fifteen minutes?' I answered: 'Yes, you were at work forty-five minutes by the watch!'[11]

Byers supplies a detailed description of the subject of Bierstadt's sketch

> It was indeed a notable, wonderful view. In addition to the natural topographic features of the scene, storm-clouds were sweeping across the great chasm from north-west to south-east. The north-west wall is serrated – a saw-tooth edge with sharp pinnacles and spires and masses of broken granite – and the clouds were so low that they were being torn and riven by these points. Eddies of wind from the great chasm following up the face of the cliff were again caught in the air-current at its crest and drove the broken clouds in rolling masses through the storm-drift. From the clouds sweeping across the gorge, rain, and large, soft hailstones were falling. Rays of sunlight were breaking through the broken, ragged clouds and lighting up in moving streaks the falling storm.[12]

Bierstadt named the distant snow-covered peak in his picture 'Mount Rosalie' or 'Monte Rosa' after Ludlow's wife, 'by right of first portrayal'.[13] She later became Bierstadt's wife. He was working on the huge canvas in the autumn of 1865, and finished it in January 1866. He showed it in February at the Miner and Somerville Gallery in New York with great financial success, though to mixed reviews. It then travelled to Baltimore, Boston, Chicago and Buffalo. It was quickly acquired by an Englishman, Mr Kennard, who had been introduced to Bierstadt's work by the English railway baron, James McHenry, the purchaser of *Rocky Mountains, 'Lander's Peak'* (see no.89), for which he paid $25,000. Kennard paid $20,000 for *Mt Rosalie*. In May 1867 the picture went on show in London at McLean's Gallery in the Haymarket, and later that year both *'Lander's Peak'* and *Mt Rosalie* were shown to Queen Victoria and her family at Osborne. In 1869 a chromolithograph of *Mt Rosalie* was exhibited at McLean's Gallery under the title *The Storm*, in company with a chromolithograph of *'Lander's Peak'*. The London *Art-Journal* published accounts of both subjects, pointing out that, like *'Lander's Peak'*,

> 'The Storm' is also a passage of Rocky Mountain scenery, showing a basin much like an exhausted crater; but striking as are the material parts of the subject, the immediate interest is centred in the sky, where we see an approaching thunder-storm, which has already burst on the peaks of the mountains. This picture may be presumed to set forth the solemn grandeur of the region, with the accompaniment of an episode, which, in imagination, carries us back to conditions of which we have as yet but imperfect ideas.[14]

AW

Yosemite Valley, 1868

Oil on canvas 91.4 × 137.2 (36 × 54)
Inscribed lower left 'A Bierstadt | 1868'
Oakland Museum of California, Gift of Miss Marguerite Laird in Memory of Mr and Mrs P.W. Laird
NOT EXHIBITED

The views of Yosemite that Bierstadt had produced in 1864 and 1865 were the first of a long line of similar subjects, which he continued to repeat into the 1870s and later. In 1868 he made two that use the same composition as *Looking Down Yosemite Valley* (no.90). They are both smaller than that canvas, but are almost the same size and, although they are not strictly a pair, may be thought of as composing a consecutive train of thought on the subject of Yosemite. This one repeats the serene sunset of no.90, though with a simplified foreground (the viewpoint being closer to the valley floor), while remaining sufficiently elevated to afford a grand general view. In the other picture, *Sunset in the Yosemite Valley* (no.93), the lurid blaze amid the gloom is reminiscent of the vengeful darts of light that flash through the rocky portal of Cole's *Expulsion from the Garden of Eden* (no.10). Bierstadt even sharpened the pinnacles of rock on the left of the valley to reflect the shape of Cole's central rock. If this allusion is a conscious one, the suggestion that Yosemite is an American Garden of Eden emerges clearly from the two works taken together and reflects retrospectively, perhaps, on the larger Yosemite picture of 1865. That the parallel was explicit in Bierstadt's response to the place is clear from a letter to John Hay, dated 22 August 1863: 'We are now here in the Garden of Eden I call it. The most magnificent place I was

ever in.'[15] It was noticed at the time they were first exhibited that these subjects do not include the human figures, whether white or Indian, that Bierstadt usually introduced. The implication is perhaps of a landscape unsullied by human presence, the landscape some Californians wanted to see returned to its primeval purity from the spoliation of the adventurers and tourists whom his own art had encouraged to flock there. There is then, also, a suggested reference to Cole's *Course of Empire* (nos.11–15) here: in this canvas we are presented with glorious nature before the defiling arrival of mankind, while *Sunset in the Yosemite Valley* (no.93) evokes a kind of 'desolation' following man's appearance. According to the London *Art-Journal*, the latter picture was painted in Rome, and it may be that both were executed there. One of them, apparently *Sunset in the Yosemite Valley*, was exhibited at the Langham Hotel, but the critic's description fits the present picture better: 'the golden haze spread over the granite "tors", as they are called in our own mountain districts, reminds us of Italy and Italian skies as they lingered on the memory of Claude Lorraine. It is a scenery entirely new to most Englishmen, and the artist who has penetrated these wilds has brought them vividly before the imagination.'[16]

AW

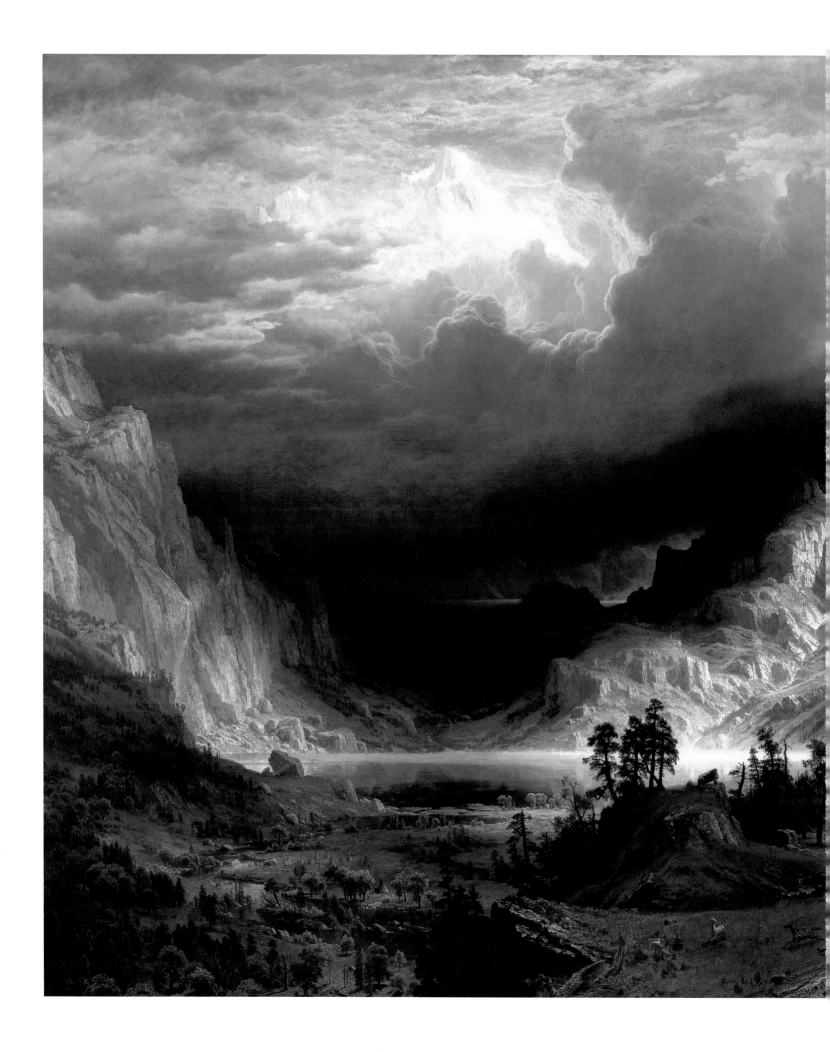

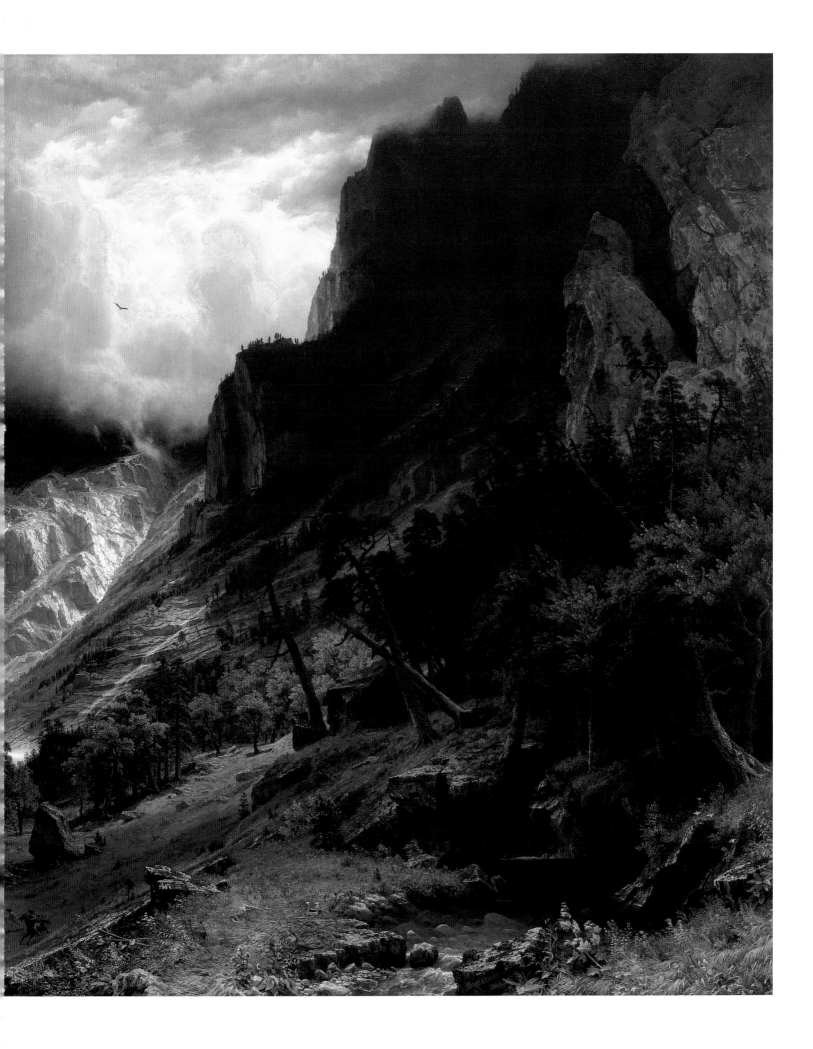

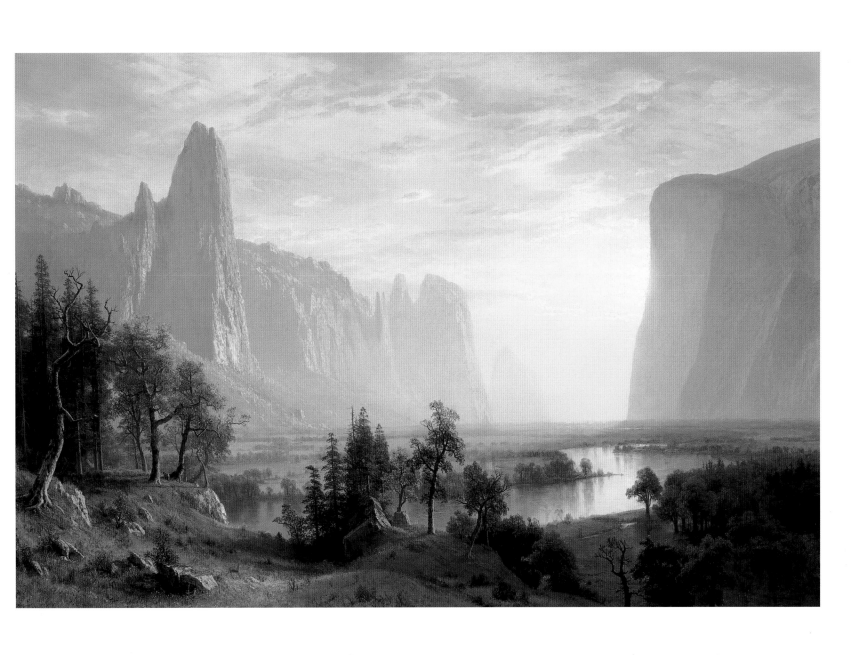

Sunset in the Yosemite Valley, 1868

Oil on canvas 91.2 × 132.7 (36¼ × 52¼)
Inscribed lower left 'ABierstadt | 1868'
Haggin Collection, Haggin Museum, Stockton, California
PHILADELPHIA AND MINNEAPOLIS ONLY

This picture was painted in Rome and shown in London on Bierstadt's return journey to America, in June and July 1868, along with a large canvas, *Among the Sierra Nevada Mountains, California* (Smithsonian American Art Museum, Washington DC)[17] and a dramatic view of *Mount Vesuvius at Midnight* (untraced).

The composition of this picture is almost identical to that of another Yosemite view of this year (no.92), but Bierstadt transforms it into an apocalyptic vision quite unlike any of his other views of the valley. The vast scale of the landscape is, if anything, even more exaggerated. The mannered simplification of the rock forms, already noticeable in no.92, is here taken to an extreme: the cliffs are presented as gleaming shards or blades, fitfully illuminated by a ferocious sunset. The benign glow of the sunsets in Bierstadt's preceding Yosemite subjects is replaced by a brooding darkness that largely obscures the rocks, and the light is projected forward into the valley by means of reflections from water and from ragged clouds which sweep low across the faces of the precipices like menacing birds. As suggested in the entry for no.92, the two subjects may have been conceived as a complementary pair, and the reminiscence in this picture of Cole's *Expulsion from the Garden of Eden* (no.10) may be a deliberate comment by the artist on the potential for destruction that the increase of visitors to places such as this might represent.

The imagery thus invoked also suggests the influence of John Martin, and the preponderance of black in Bierstadt's palette here seems to refer to the monochrome dramas of Martin's mezzotints, as does Moran's *Hiawatha* (no.95) of almost the same date. However, these overtones were not picked up by the critic of the *Art-Journal*, who, while acknowledging that 'It is a scenery entirely new to most Englishmen', was also impelled to invoke European models: 'the golden haze spread over the granite "tors", as they are called in our own mountain districts, reminds us of Italy and Italian skies as they lingered on the memory of Claude Lorraine.'[18] This almost incomprehensible comment (unless it was in fact prompted by no.92) perhaps illustrates better than any other the difficulty English commentators experienced in interpreting what they saw in these paintings.
AW

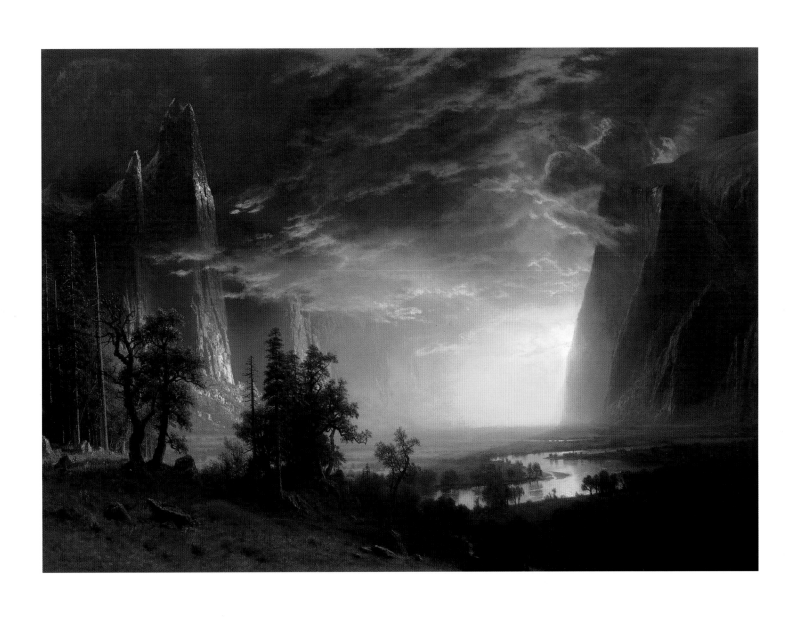

Puget Sound on the Pacific Coast, 1870

Oil on canvas 133.4 × 208.3 (52 ½ × 82)
Inscribed lower left 'A Bierstadt | 1870'
Seattle Art Museum, Seattle, Washington, Gift of the Friends of American Art at the
Seattle Art Museum, with additional funds from the General Acquisition Fund

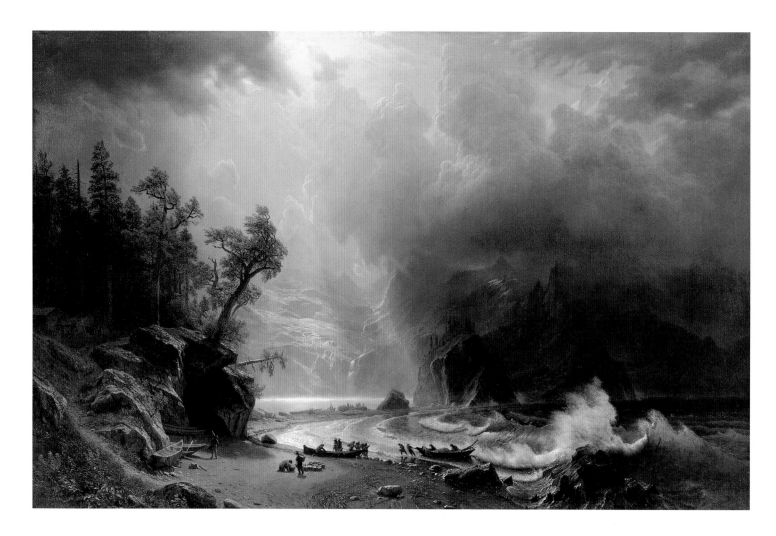

Puget Sound is that great inlet of the Pacific on which Seattle, Washington, now stands. It was the farthest distance from the East Coast that American pioneers reached, but by Bierstadt's day had been rendered accessible by the construction of the Northern Pacific Rail Road. It marked the westerly limit of American artists' ambitions at this date, and Bierstadt reached it on his tour of California, Oregon and Washington in 1863. This picture seems to celebrate the achievement of that limit, with its suggestion of the dangers of further exploration on this wild coast. The sea itself is swallowed up in blackness, while the land shimmers with light, and the peak of Mount

Olympia appears through the cloud-wrack in the top right corner. The motif of sunlight shining through emerald breakers was to be a favourite theme of Bierstadt's work in the next few years. The scene of Indians beaching their fishing-boats, to which Bierstadt accords a considerable degree of elaboration, reinforces the sense that this is an *ultima Thule* of the Americas.

The picture remained in private hands until very recently, when it was acquired by the Seattle Art Museum.

AW

Hiawatha, 1867–8

Oil on canvas 81.9 × 121.9 (32¼ × 48)
Museum Purchase, The Philbrook Museum of Art, Tulsa, Oklahoma

This is the first of three canvases that Moran painted under the inspiration of Henry Wadsworth Longfellow's *The Song of Hiawatha*. This long narrative poem had been published in 1855 and immediately became a classic, selling over 30,000 copies in its first year. Longfellow called it his 'Indian Edda', an epic myth of life among American Indians in a vividly described wilderness setting: 'The scene of the poem is among the Ojibways on the southern shore of Lake Superior, in the region between the Pictured Rocks and the Grand Sable.'[19] Lake Superior is Longfellow's 'Gitche Gumee', the 'shining Big-Sea-Water'. The scenic panorama stretches from New York state to the northern lakes and beyond across the western prairies to the mountains. The natural history of the country is lovingly described in detail, with named animals and birds taking part in the successive episodes. *Hiawatha* supplied what the North American landscape was still in need of, an indigenous legendary hero, half man, half god, and a *dramatis personae* of strongly characterised humans and supernatural beings. Longfellow incorporated stories gleaned from various sources, but purporting to constitute a genuine Indian mythology. This was a dimension not offered by James Fenimore Cooper's historical novels, scenes from which had provided subject matter for some of Cole's canvases.

Moran responded to *Hiawatha* by bringing out the mythopoeic significance of the poem in an ingenious way. He incorporated into his illustrations motifs from famous visual representations of European myths, subtly introducing the idea of a parallel between the two bodies of legend while never emphasising or insisting on them. The artist he chose to allude to was, naturally enough, J.M.W. Turner. He had been a lifelong admirer of Turner, and used his 1862 visit to England to become thoroughly acquainted with Turner's work. Among other studies, he made a large replica of Turner's famous painting of 1829, *Ulysses Deriding Polyphemus* (fig.50).[20] This replica has been lost, but a small oil sketch of the composition is in the Philbrook Museum of Art, Tulsa. Moran's intimate knowledge of Turner's picture reveals itself in the intricate way in which he paraphrases it in *Hiawatha*.

All three of Moran's subjects (nos.95–7) are taken from part IX of the poem, 'Hiawatha and the Pearl-Feather'. The first is the episode in which Hiawatha defeats the evil magician Megissogwon, the Pearl-Feather, by piercing his head with an arrow as he sits in the sky in his Shining Wigwam. The scene is set by Nokomis, Hiawatha's grandmother and foster-mother:

> Nokomis, the old woman,
> Pointing with her finger westward,

Spake these words to Hiawatha:
> 'Yonder dwells the great Pearl-Feather,
> Megissogwon, the Magician,
> Manito of Wealth and Wampum,
> Guarded by his fiery serpents,
> Guarded by the black pitch-water;
> You can see his fiery serpents,
> The Kenabeek, the great serpents,
> Coiling, playing in the water;
> You can see the black pitch-water
> Stretching far away beyond them,
> To the purple clouds of sunset!

She commands her grandson to destroy the cruel Megissogwon, who was responsible for her father's death:

> Take your bow, O Hiawatha,
> Take your arrows, jasper-headed,
> Take your war-club, Puggawaugun,
> And your mittens, Minjekahwun,
> And your birch canoe for sailing,
> And the oil of Mishe-Nahma,
> So to smear its sides, that swiftly
> You may pass the black pitch-water;
> Slay this merciless magician,
> Save the people from the fever
> That he breathes across the fenlands,
> And avenge my father's murder!

Like Turner's Polyphemus, the one-eyed cyclops who must be destroyed by being blinded, Megissogwon looms like a threatening shadow on a mountain peak, while Hiawatha fires an arrow at him from a point of land on the edge of the water, rather as Ulysses sends his insults across the water from his craft. High above Hiawatha flies 'the Keneu, the great war-eagle, Master of all fowls with feathers' who accompanies him in his exploits.

Moran's landscape is one of fantastical crags, like Turner's, but instead of the brilliant colour of the pristine world of mythological Greece, he shrouds his scene in an almost monochrome black, with stark white mountains rising into a cold light above. The inspiration here may have been the mezzotints of John Martin, which exploit the rich monochrome of the medium to exciting effect in several mountainous subjects, such as *Adam and Eve – Driven out of Paradise* (1827; fig.43).[21] The only colour to be introduced into the striking design is the red of a few isolated fires, suggesting cauldrons of

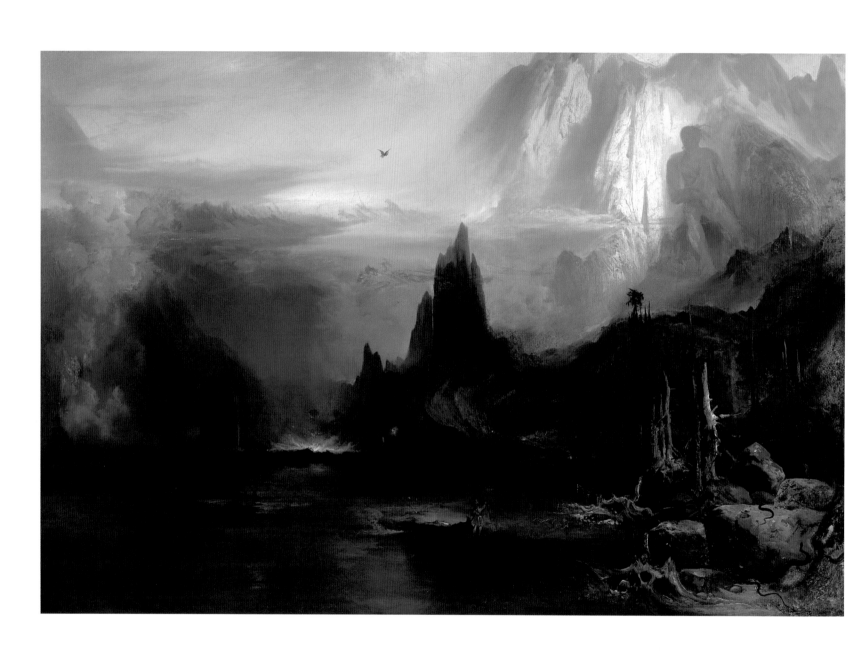

volcanic activity under the rocks. Turner also uses the image of fire issuing from rocks for a similar purpose in *Ulysses*: to evoke the primeval forces of nature and to associate them with the mythical strength of the defeated monster. There are other points of light, cold and icy, in Moran's landscape, and these too have a parallel in Turner's: around Ulysses' ship naiads sport in the water with stars glinting on their foreheads, an allusion, it has been supposed, to the phosphorescence of waves. Thus Moran suggests the weight and significance of the Hiawatha legend by invoking a comparable story from Greek mythology, and by couching his narrative in a pictorial language that subliminally alludes to Turner's, he makes a broader statement about the geography and geology of the American wilderness. In spite of the atmosphere of fantasy created by the dreamlike landscape (and a pentimento in the central pinnacle indicates that Moran deliberately emphasised the strangeness of it), he was able to claim some personal knowledge of the scenery of Lake Superior, which he had explored on a trip of 1860. On that occasion he made drawings that were to provide material for the *Hiawatha* pictures, which he used more literally as illustrations for a magazine article, 'The Pictured Rocks of Lake Superior', in a popular magazine, the *Aldine* (January 1873).

In the right foreground of the painting are dead and decaying tree-trunks, and writhing snakes that relate to the subject matter of the next picture in the sequence, *Hiawatha and the Great Serpent, the*

50 J.M.W. Turner, *Ulysses Deriding Polyphemus*, 1829. Oil on canvas, 132.7 × 203.2 (52¼ × 80). National Gallery, London (NG508)

Kenabeek (no.96). When he had painted this, he returned to *Hiawatha* to make changes: the two pictures seem to have been conceived as a pair of sorts, even though they vary considerably in size. *Hiawatha* was formerly known as 'The Spirit of the Indian'.
AW

Hiawatha and the Great Serpent, the Kenabeek, 1867

Oil on canvas 50.8 × 76.2 (20 × 30)
Inscribed lower left 'T Moran 1867'
The Baltimore Museum of Art: Friends of Art Fund (BMA 1967.17)

This canvas, although smaller than both *Hiawatha* (no.95) and its later sequel *'Fiercely the red sun descending'* of 1875–6 (no.97), takes its place naturally as one of the sequence of three paintings illustrating passages from part IX of Longfellow's poem. It continues and partly duplicates the imagery of *Hiawatha*, with the figure of the Indian hero in his small boat on the dark water, drawing his bow against a mysterious enemy: the Kenabeek or great serpents that infest the shores of Gitche Gumee. ('Kenabeek' is pronounced with the accent on the second syllable.) In the poem the episode actually precedes that of the shooting of Megissogwon:

> Soon he reached the fiery serpents,
> The Kenabeek, the great serpents,
> Lying huge upon the water,
> Sparkling, rippling in the water,
> Lying coiled across the passage,
> With their blazing crests uplifted,
> Breathing fiery fogs and vapours,
> So that none could pass beyond them.

As with the other subject there are parallels with Greek and Norse mythology: Hercules slaying the hundred-headed Hydra for instance, and Beowulf vanquishing the monster Grendel; in contemporary Europe the Norse legend of the Nibelungs was being revived by Richard Wagner, who in his libretto for *The Ring of the Nibelungs* (1850–60) described the hero Siegfried slaying the dragon Pfaffner. Moran will also have been aware of Turner's painting of 1811, *Apollo and Python* (Tate Gallery)[22] where the Sun God slays a serpent representing the powers of darkness in a gloomy gorge among rocks; and a similar subject, *Jason*, was a plate in Turner's widely disseminated *Liber Studiorum* which was available to every student.[23]

> Then the angry Hiawatha
> Raised his mighty bow of ash-tree,
> Seized his arrows, jasper-headed,
> Shot them fast among the serpents;
> Every twanging of the bow-string

> Was a war-cry and a death-cry,
> Every whizzing of an arrow
> Was a death-song of Kenabeek.
> Weltering in the bloody water,
> Dead lay all the fiery serpents,
> And among them Hiawatha
> Harmless sailed, and cried exulting:
> 'Onward, O Cheemaun, my darling!
> Onward to the black pitch-water!'[24]

Moran made a beautiful oil study of this subject (Gilcrease Museum, Tulsa, Oklahoma) which seems to allude more directly to the bright palette of Turner's *Ulysses Deriding Polyphemus* (fig.50) than that of *Hiawatha* does; but the mood of the final painting is sombre. The full moon rises behind a pall of cloud – an effect particularly associated with Turner, and especially with his *Snow Storm. Hannibal and his Army Crossing the Alps* (see also Church's *Cotopaxi*, no.86) – while the setting sun, behind the viewer, casts its warm pink light on cliffs and clouds that soar above the inky lake. As in *Hiawatha*, small lights appear menacingly from crevices in the rocks. High above, a grey cloud echoes the shape of the Keneu, the war-eagle, among wisps of cloud that imitate the writhing forms of the serpents. Serpents appear like oily ripples swimming in the lake towards Hiawatha's boat from the right foreground, while larger snakes writhe down the rocky slopes in front of him. The arched rock on the far left of the composition is a reminiscence of the rock formations in *Ulysses*, which themselves refer back to a rock arch in Claude's *The Origin of Coral* (Holkham Hall, Norfolk).

In the mid-1870s Moran executed a series of monochrome drawings in brush and black ink which were intended to illustrate an edition of the poem. He never completed the set, but one of those he did finish (Gilcrease Museum, Tulsa, Oklahoma)[25] relies heavily on this picture, and to some extent on no.95. His technique in these drawings is close to that of John Martin in his illustrations, and tends to confirm the impression, given especially by *Hiawatha*, that Martin was an influence of whom Moran was fully conscious.

AW

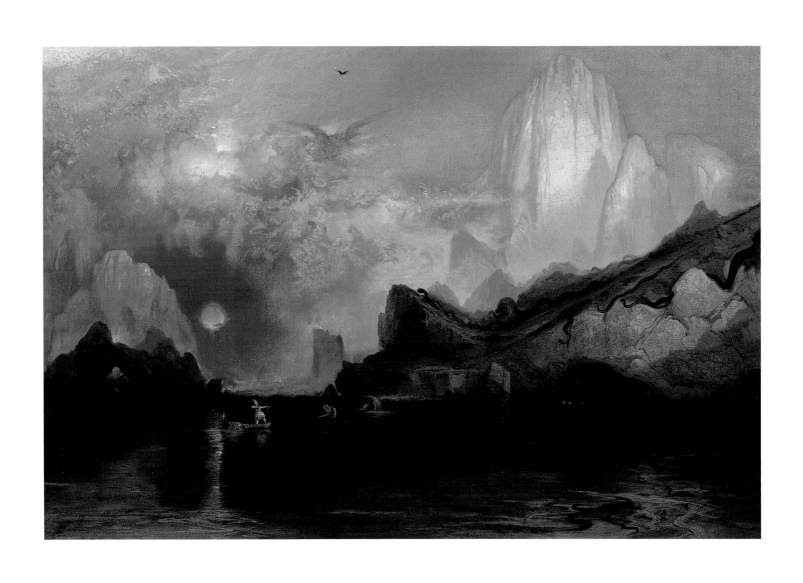

'Fiercely the red sun descending Burned his way along the heavens', 1875–6

Oil on canvas 84.8 × 127 (33 ⅜ × 50 ¹/₁₆)
North Carolina Museum of Art, Raleigh. Purchased with funds from the
North Carolina Art Society (Robert F. Phifer Bequest)

Having painted two subjects taken from part IX of Longfellow's *Song of Hiawatha* in the later 1860s (nos.95–6), Moran returned to the story in the mid-1870s, and made a series of illustrations for a proposed new edition of the poem. At about the same time he painted this picture. It is slightly larger than the first *Hiawatha* of 1867–8, but sufficiently close in size for it to function as a pair, or foil, rather more satisfactorily than the second canvas, *Hiawatha and the Great Serpent*, which repeats the palette of *Hiawatha* but is much smaller. The intense flame colours of '*Fiercely the red sun descending*' contrast dramatically with the dense blackness of *Hiawatha*. It is perhaps unnecessary to try to group the works, which form a loosely linked sequence on the theme of the poem rather than a precisely related triptych. What can be said for certain about this picture, however, is that it returns to the idea of the paraphrase of Turner, though places rather different emphases than the original *Hiawatha*. This subject is taken from the opening passage of part IX, immediately preceding the story of Hiawatha and the Pearl-Feather in which both the killing of Megissogwon and the battle with the Kenabeek occur. It does not illustrate a heroic moment from a myth but describes a sunset over Lake Superior:

> Fiercely the red sun descending
> Burned his way along the heavens,
> Set the sky on fire behind him,
> As war-parties, when retreating,

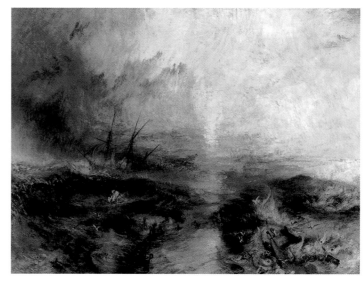

52 J.M.W. Turner, *Slave Ship (Slavers Throwing Overboard the Dead and the Dying, Typhoon Coming On)*, 1840. Oil on canvas, 90.8 × 122.6 (35 ¾ × 48 ¼). Courtesy Henry Lillie Pierce Fund, Museum of Fine Arts, Boston

> Burn the prairies on their war-trail;
> And the moon, the Night-Sun, eastward,
> Suddenly starting from his ambush,
> Followed fast those bloody footprints,
> Followed in that fiery war-trail,
> With its glare upon his features.

The mythic force of the sunset is set forth in Longfellow's elaborate simile, likening the sun's course to that of an Indian war-party, and the sky to a prairie set on fire. This is, then, a further description of the life of the American Indians as mythologised by Longfellow.

As in *Hiawatha*, Moran uses Turner's paintings as a point of reference, but this time instead of disguising his allusion he makes it very apparent by one of the most masterly exercises in pastiche ever performed. Turner was extensively copied and imitated in the nineteenth century, but never so intelligently and successfully as here. Two pictures seem to lie behind Moran's imitation: *Staffa, Fingal's Cave* of 1832 (fig.51) and *Slave Ship* of 1840 (fig.52). The former had been acquired by Colonel James Lenox of New York in 1845, and then belonged to the Lenox Library, later the New York Public Library, where it remained until the middle of the twentieth century. The latter belonged to Ruskin until 1872 when it left England for America, and was in New York in the collection of J.T. Johnston in 1873. It later moved to Boston, and has been in the Museum of Fine Arts since 1899.

51 J.M.W. Turner, *Staffa, Fingal's Cave*, 1832. Oil on canvas, 90.8 × 121.3 (35 ¾ × 47 ¾). Yale Center for British Art, Paul Mellon Collection

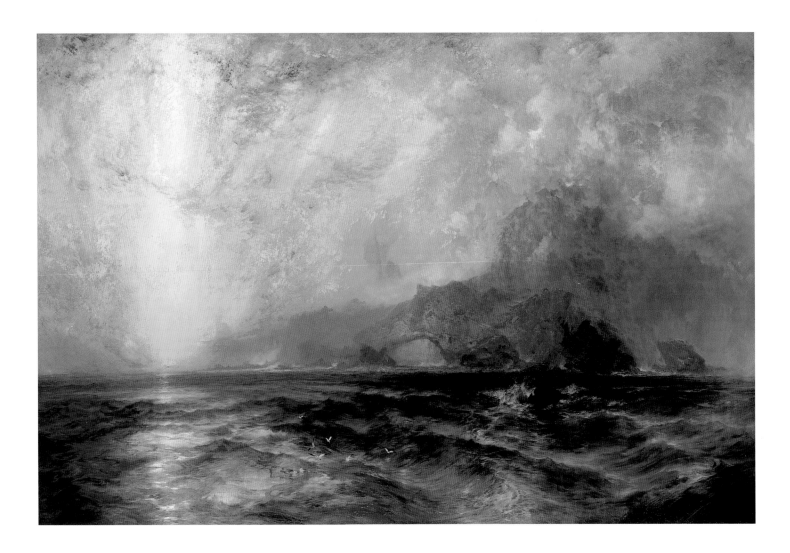

Moran may well have seen it in New York just before he painted this picture. Its fiery sunset supplies an obvious precedent for the extraordinary explosion of light in Moran's sky. The oily glint of the sea, too, owes much to the *Slavers*, but may also have been influenced by the treatment of the water in *Staffa*, where a white seabird skitters across its dark surface in a way that Moran takes up. The low stormy sun of *Staffa* and the rocks half obscured by atmosphere also suggest parallels. The Ossianic warrior prince, Fingal, who is celebrated in the name of the cave on Staffa (also commemorated in Mendelssohn's famous overture *The Hebrides*, first performed in London in 1832, the year Turner's picture was first exhibited), is an ancient British hero who occupied a place in legend rather similar to Hiawatha's; Moran may well have felt it an appropriate parallel to draw.

It is another question whether he wished to bring attention to the awkward similarity between the fate of Turner's African slaves and that of the American Indians whose world was being destroyed by white settlement and progress. Certainly the use of Turner's apocalyptic sky suggests a sense of tragedy; but it would be rash to impute a modern retrospective significance to what may, rather, be an exuberant celebration of one of Longfellow's most striking passages of natural description. Moran's addiction to dramatic sunsets was to become a hallmark of his output; compare the very different use he makes of sunset light in *Nearing Camp, Evening on the Upper Colorado River, Wyoming* (no.98), which however does find a precedent in the pink crags of *Hiawatha and the Great Serpent, the Kenabeek*.
AW

Nearing Camp, Evening on the Upper Colorado River, Wyoming, 1882

Oil on canvas 66 × 160 (26 × 63)
Inscribed lower left 'THOs. MORAN. | 1882' and on back of canvas 'Nearing Camp. | Evening on the Upper Colorado | Wyoming Terry. |
TM[monogram] ORAN | 1882'; also on stretcher 'Thomas Moran | Booth Theatre Bldg | New York USA' and 'price £300'; and on a label
on stretcher: 'Nearing Camp Evening on the Upper Colorado River Wyoming Territory USA'
Bolton Museum and Art Gallery
LONDON ONLY

This picture is one of several versions of a subject Moran associated with his first discovery of the Far West. On his journey west to join Hayden's survey expedition in 1871 he passed through the small town of Green River, on the river of that name, which is a tributary of the Colorado, near the southern border of Wyoming. He made a drawing of the buttes, or columnar cliffs, that rise out of the valley there. It is a quick pencil outline to which he added watercolour and gouache to suggest something of the strange colour of the rocks – a buff limestone topped with red volcanic deposit that has eroded and sunk into the supporting stone creating intriguing patterns. Moran inscribed it 'First Sketch Made in the West at Green River, Wyoming'; it is now in the Gilcrease Museum, Tulsa.[26] A more resolved watercolour of the subject was one of the group of drawings that he completed in the following year; it is now in the Boston Museum of Fine Arts.[27] He made further drawings of the Green River buttes on his journey of 1879, and in 1881 produced a large oil painting, a modified version of the view he had taken in his original sketch (Private Collection, USA). In 1882 he finished a smaller oil, in less panoramic format, which makes use of similar motifs, and this new treatment of the original subject on the large scale. In his usual fashion he continued to invent variations on the theme throughout the rest of his career.

The buttes that form the focus of this composition have been identified as the Castle and the Citadel, which are the cliffs immediately behind the town of Green River, to the north. This cannot be strictly correct, since the Citadel is an isolated and relatively small tower of rock. The masses that Moran depicts may derive at least in part from the spectacular sequence of bluffs and towers of the Eastern Buttes, along the southern bank of the river, much farther away from the town. In any case, Moran has eliminated all traces of the settlement, which had sprung up in the wake of the Union Pacific railway a few years before his first visit in 1871, and was rapidly becoming an important depot for the coal-mining industry. Likewise, the artist has peopled his landscape with a group of Indians on horseback, dwarfed by the vast space, making their way to a camp on the flood-plain of the river. Such picturesque staffage would not have been found in the region by the date of Moran's visit. From his 'First Sketch Made in the West', then, Moran has constructed a fantasy of the American desert, and of life there before the arrival of the white man.

As he had done in his *Hiawatha* pictures (nos.95–7), he reinforces his imagery by referring to another artist. This time, he is not thinking of Turner but of David Roberts, whose work as a painter of desert scenery was well known in America as well as Britain. Moran's treatment of details such as clouds or figures echoes Roberts's style closely, while in his use of a wide panoramic canvas he repeats a format that Roberts had employed with notable success. The way his landscape is lit, moreover, recalls Roberts, though other versions of the Green River subject have more striking parallels. They exaggerate the redness of the cliff-tops by having them bathed in a hot sunset light. This device is to be found in some of Roberts's views of Edinburgh and Rome, and in his *Remains of the Roman Forum* of 1861 (fig.18) the brilliant red glow on the upper parts of the buildings is allied to a cloud-flecked blue sky and a wide low format that is very similar to Moran's picture. By alluding in this way to Roberts, Moran evokes parallels between the wild spaces of Western America and the historically suggestive regions that Roberts had appropriated. The Green River buttes become an equivalent for the Pyramids, and the mountains of Colorado and Utah an American Moab or Arabia.

Moran came to England in 1882 with a large number of his works, for exhibition in Bolton and London. It has been suggested that the present picture dates from some years before this, possibly as far back as 1872, in which case it would be the first of the Green River subjects to have been painted. There is evidence of considerable retouching, however, especially in the centre foreground; this may have been done immediately after Moran's second visit to Green River in 1879 or, more probably, at the time of the visit to England in 1882. This latter date is made more likely by the inscription and date of 1882 on the back of the canvas. The reworking has resulted in some cracking of the more recent paint layer. There is also evidence of the canvas having been rolled up for transportation, presumably across the Atlantic.

Although this picture was among those that Moran seems to have intended for the Royal Academy's Summer Exhibition, it was never shown. It was, however, acquired almost immediately by an English collector, Llewellyn Longstaff, and belonged to the same family throughout the twentieth century. In 1999 it was acquired by Moran's native town of Bolton, which also possesses two pencil studies of the buttes, one of them seen from a viewpoint similar to that of the picture; both are dated 1882. Acknowledgements are due to Adrian Jenkins and Rebecca Hellen for information used in compiling this entry.

AW

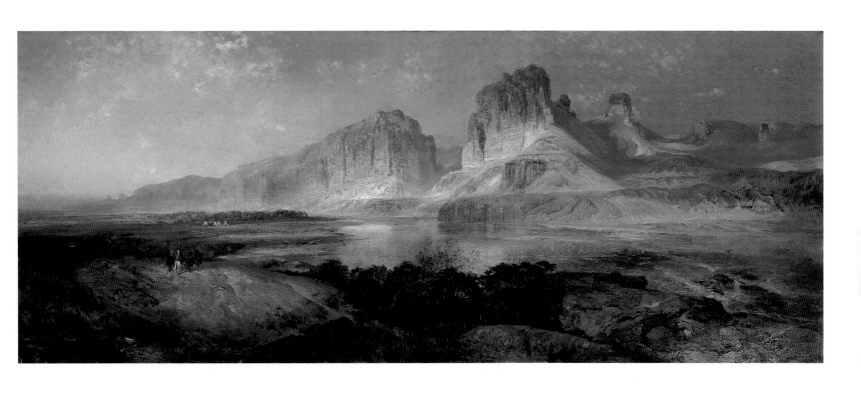

Grand Canyon of the Colorado, 1892 *(reworked 1908)*

Oil on canvas 134.6 × 238.7 (53 × 94)
Inscribed lower right 'TM [monogram]ORAN./1892–1908 Copyright'
Philadelphia Museum of Art: Gift of Graeme Lorimer, 1975

Moran first visited the Grand Canyon in August 1873 with the expedition of John Wesley Powell. The most important result of his time there was a colossal painting, *The Chasm of the Colorado* (fig.17) which was a sequel to the equally vast picture he had made of the gorge of the Yellowstone in 1872. He had been to Yellowstone with Hayden in 1871, and the numerous drawings he made of the geysers and geological features there were influential, along with Hayden's reports, in the decision of Congress to establish the Yellowstone region as a National Park, the first such park in the world. Soon after the passage of the Yellowstone Park Bill in May 1872, Congress bought for $10,000 Moran's large canvas of the *Grand Canyon of the Yellowstone* (fig.16), which he had cannily arranged to have exhibited in the Hall of Representatives. At this point he was planning a second trip to the West, to take in the geological phenomenon we generally know today as the Grand Canyon, that is, the gorge of the Colorado River in Arizona. The enormous publicity generated by the Yellowstone painting stimulated every prospective explorer to solicit his services on expeditions; after planning to return to the West with Hayden, in the end he went with Powell. Back in New York he set to work on a companion to his *Yellowstone*, completing it in April 1874. This work, *Chasm of the Colorado*, was, like its predecessor, an immense canvas, and measures 7 feet by 12 feet (2.14 by 3.67 metres). It, too, was purchased by Congress – for more on this work see pp.34–5.

The power of these images of an almost unimaginably distant and strange landscape to promote travel, exploration and tourism was quickly understood by the new railway barons, who commissioned from Moran pictures that they could use in advertising their services. In 1892 the Atchison, Topeka, and Santa Fe Railroad Company, which had been using his views in their publicity since 1877, supplied funding for Moran to visit the Grand Canyon. He travelled with his son and the photographer William Henry Jackson. The Canyon could not be reached directly by train until 1901, and the line took him only as far as Flagstaff, from which he went on by stagecoach. As payment, he assigned the company the copyright in this large picture, *Grand Canyon of the Colorado*. Although it is signed and dated 1892, it also bears a date of 1908, when, apparently, Moran retouched it at the Canyon. During at least some of the intervening period it was hung in the Santa Fe Company's hotel at the Canyon, El Tovar. Later it was

displayed in the United States Geological Survey headquarters in Washington. In 1919 it was acquired by the *Saturday Evening Post* and hung in its offices in Philadelphia.[28]

Kinsey analyses the important differences between the 1873–4 *Chasm of the Colorado* and this canvas, which is considerably smaller.[29] The earlier work makes use of a broad ledge of rock on which the viewer stands, while here we are poised in space over the gorge, in a position that Kinsey describes as 'a convenient scenic vista', 'a tourist's view', where we are free to 'descend or turn away'. However, there are in fact ledges of rock in the foreground of the composition, and they seem to offer the possibility of foothold. Despite them, the sense of hovering over an abyss is strong, and the relation of viewer to view is here somewhat parallel to that in Church's *The Andes of Ecuador* (no.85) or *Cotopaxi* (no.86), where the impulse to penetrate deep into the picture space is unimpeded by any necessity to walk. Rather than being in the age of the train, we are almost in the world of the aeroplane.

In 1904 Moran worked on a view of the *Grand Canyon of the Colorado* which he exhibited at the Century Club in New York with a new version of his *Grand Canyon of the Yellowstone*. The *East Hampton Star* reported that he had been engaged on both pictures, together with views in Yosemite and the Petrified Forest of Arizona, on Long Island that summer.[30] It seems possible that the *Grand Canyon of the Colorado* referred to was in fact not a new picture but the present canvas; the view at Yellowstone was presumably the picture now in the Honolulu Academy of Arts,[31] and although not strictly a pair, they are similar in their relationship to the two great originals from which they derive. He had already painted a second large version of the Yellowstone subject in the years 1893–1901 (Smithsonian American Art Museum, Washington DC), which at 8 feet by 14 feet (2.45 by 4.27 metres) outdid the first in size.

The Santa Fe Company had a chromolithograph of the *Grand Canyon of the Colorado* made as soon as it was painted, and used the image in many guises in its advertising. Moran himself painted numerous variants on his Grand Canyon theme, though never again on the scale of the original canvas, or indeed as large as this one.

AW

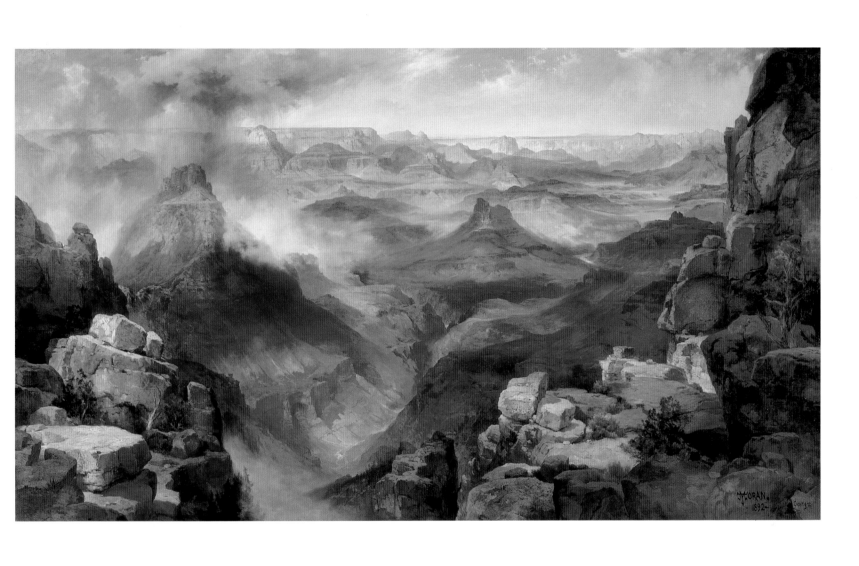

GRAHAM C. BOETTCHER

Biographies of the Artists

Asher Brown Durand

Born 21 August 1796, Jefferson Village (now Maplewood), Springfield
Township, New Jersey
Died 17 September 1886, Maplewood, New Jersey

The eighth of eleven children, Asher Brown Durand grew up
in Jefferson Village, New Jersey, a long-settled but rural area
seventeen miles from New York City. His father John Durand,
a farmer, had been trained as a watchmaker and silversmith.
Through the monogrammed watches and silverware crafted
by his family, Asher Brown Durand first encountered the art
of engraving, which would be his mainstay before he rose to
prominence as a painter. In 1812 Durand began a five-year
apprenticeship to Peter Maverick (1780–1831), a Newark
engraver. Durand excelled in Maverick's workshop and
eventually became his former master's business partner
in a New York firm (1817–20). An affiliate of various firms,
Durand enjoyed a growing reputation, marked by his role as
one of the founders of the National Academy of Design in 1826
(of which he would serve as president from 1845 to 1861). By
1831, despite his success, Durand became disenchanted with
engraving and turned to oil painting. With few exceptions
Durand's earliest canvases were likenesses of prominent
Americans, including a number of presidential portraits. By
1835, owing to the generous patronage of the New York grocer
Luman Reed, Durand was able to abandon engraving for
painting. Although he continued to paint portraits, Durand
also executed a number of genre scenes, some of which
included natural settings.

In the summer of 1837, following a sketching trip to Schroon
Lake in the Adirondacks with his close friend Thomas Cole,
Durand began to paint landscapes in earnest, beginning an

endeavour that ultimately proved his greatest legacy. Countless
drawings, oil sketches and watercolour studies made on
this and subsequent excursions to the Adirondack, Catskill
and White Mountains were transformed into finished pieces
in Durand's New York studio, and shown at the National
Academy of Design to great acclaim. Durand's landscapes not
only exhibit a Ruskinian truthfulness to nature, but are also
evidence of Durand's abiding belief in nature's inherent spiritu-
ality, convictions expressed in his 'Letters on Landscape
Painting' (1855), published in the *Crayon*, a New York art journal.
Durand's adherence to a natural religion suffuses *In the Woods*
(1855; Metropolitan Museum of Art, New York), in which
the vaulted forest interior resembles the nave of a Gothic
cathedral. From 1840 to 1841, in the company of three fellow
artists, Durand took the only European trip of his career,
visiting England, France, Germany, Switzerland and Italy. In
London Durand visited the American expatriate artist Charles
Robert Leslie (1794–1859), who introduced him to the work of
John Constable. Inspired by Constable's fidelity to nature,
Durand commented: 'I saw . . . one picture by Constable
evincing more of simple truth and naturalness than any
English landscape I have ever before met with.' (Durand 1894,
p.151). In 1848, following the death of Cole, Durand inherited
the mantle of America's foremost landscape painter. The
following year he immortalised his friends Thomas Cole and
William Cullen Bryant in *Kindred Spirits* (no.1). Durand devoted
himself almost exclusively to landscape painting in his later
career, although he combined an evocative natural setting with
a Biblical subject in *God's Judgement upon Gog* (1851–2; no.9).
Until retiring from painting in 1878, Durand continued to
make annual sketching trips to the mountains of the
Northeast. Upon Durand's death in 1886, his colleague Daniel

Huntington observed that Durand's *'love of nature was a passion, an enthusiasm always burning within him, but it was like a steady fire, not a sudden blaze quickly sinking to ashes.'* (Huntington 1887, p.46).

Select Bibliography

John Durand, *The Life and Times of A.B. Durand* [1894], New York 1970
Daniel Huntington, *Asher B. Durand: A Memorial Address*, New York 1887
David B. Lawall, *A.B. Durand: 1796–1886*, exh. cat., Montclair Art Museum, Montclair, New Jersey 1971

Thomas Cole

Born 1 February 1801, Bolton, Lancashire, England
Died 11 February 1848, Catskill, New York

Born in England, Thomas Cole, the son of an unsuccessful textile manufacturer, began his artistic career at the age of fourteen as an apprentice to an engraver of calico patterns. In 1818 Cole and his family emigrated to the United States, settling in Steubenville, Ohio. Cole received rudimentary training in oil painting from an itinerant portraitist in 1821 and soon began painting portraits himself, seeking work in towns along the Ohio River the following year. In 1823 he moved to Philadelphia to pursue his artistic career in earnest, studying at the Pennsylvania Academy of the Fine Arts, where he exhibited a landscape painting in 1824. Cole relocated to New York (where his family had moved the previous year) in 1825 and set up a studio in his father's house. He continued to paint landscapes, the sale of which provided him with the funds to make his first sketching excursion up the Hudson River to the Catskill Mountains. From the pencil sketches made on this trip, Cole painted several landscapes, which he offered for sale in New York. They were purchased by the artists Colonel John Trumbull (1756–1843), Asher Brown Durand and William Dunlap (1766–1839), who were instrumental in securing patrons (including Daniel Wadsworth, founder of the first public art museum in the United States) for the young painter, ensuring his rapid success. Only one year after being 'discovered', Cole became a founding member of the National Academy, where he exhibited three paintings. That summer Cole visited the Catskills and the Adirondacks, producing sketches which resulted in more successful

canvases, including *Falls of the Kaaterskill* (1826; Gulf States Paper Corporation, Tuscaloosa, Alabama). Although Cole had previously depicted some Biblical themes, in 1828 he exhibited his first major religious works, *The Garden of Eden* (1828; fig.42) and *The Expulsion from the Garden of Eden* (1827–8; no.10), at the National Academy. In 1829 he travelled to London where he met the painter and printmaker John Martin, the portraitist Sir Thomas Lawrence, John Constable and J.M.W. Turner. Cole's work received a muted reception in England: by the time he left for Paris in 1831, he had exhibited twice at both the Royal Academy and the British Institution, but the works were not displayed prominently. After a brief stay in Paris, where he visited the Louvre, Cole continued on to Rome, remaining there until 1832. During this time Cole travelled throughout southern Italy, becoming keenly interested in antiquity and ruins. After returning to New York, Cole met Luman Reed, a wealthy New York grocer, who commissioned several works, including *The Course of Empire* (nos.11–15). In 1835, while working on *The Course of Empire*, Cole gave a lecture on 'American Scenery' at the New York Lyceum (subsequently published as an essay) in which he lamented man's 'cultivation' of nature and extolled the virtues of the wilderness. The following year Cole explored this theme in a work exhibited at the National Academy, *View from Mount Holyoke, Northhampton, Massachusetts, after a Thunderstorm*, also known as *The Oxbow* (1836; fig.20). In the summer of 1837, Cole and Durand, accompanied by their wives, made a sketching trip to Schroon Lake in the Adirondacks. Although this and subsequent wilderness excursions yielded successful landscapes through the rest of his career, in the 1840s Cole's work became increasingly religious, owing perhaps to his conversion to the Episcopalian church, the American equivalent of Anglicanism. One result was the unfinished series, *The Cross and the World* of c.1846–8. In 1844 Cole accepted his first student, Frederic Edwin Church, who stayed with the older artist in Catskill, New York, until 1846. When Cole died suddenly in 1848, he was eulogised by the poet William Cullen Bryant; the following year, their friendship was commemorated in Durand's *Kindred Spirits* (no.1).

Select Bibliography

Thomas Cole, 'Essay on American Scenery', 1835, reprinted in John W. McCoubrey (ed.), *American Art: 1700–1960: Sources and Documents*, Englewood Cliffs, New Jersey 1965

Louis Legrand Noble, *The Course of Empire, Voyage of Life and Other Pictures by Thomas Cole, N.A.*, New York 1853; reprinted as *The Life and Works of Thomas Cole*, ed. Elliot S. Vessell, Hensonville, New York 1997

Ellwood C. Parry III, *The Art of Thomas Cole: Ambition and Imagination*, Newark 1988

William H. Truettner and Alan Wallach (eds.), *Thomas Cole: Landscape into History*, exh. cat., Smithsonian American Art Museum, Washington DC 1994

Fitz Hugh Lane

Born 19 December 1804, Gloucester, Massachusetts
Died 14 August 1865, Gloucester, Massachusetts

The son of a sailmaker, Fitz Hugh Lane was born in the fishing port of Gloucester, Massachusetts, northeast of Boston on Cape Ann. At the age of two, Lane acquired polio, which left his legs partially paralysed, requiring him to walk on crutches throughout his life. His travel as an adult was limited and infrequent. Lane's gift for drawing and painting became apparent at an early age; his first known work, a watercolour entitled *Burning of the Packet Ship 'Boston'* (1830; Cape Ann Historical Association, Gloucester, Massachusetts) already demonstrates Lane's lifelong predilection for maritime subjects. Despite his artistic leanings, Lane worked part-time as a cobbler until 1832, when, after a brief stint with a local printmaker, he was sent to Boston for formal instruction in the workshop of William S. Pendelton, a prominent lithographer. For the next decade, Lane prepared lithographs, eventually establishing his own shop, illustrating sheet music and trade cards and producing a number of panoramic town views. In 1840 he took up oil painting and by the following year was fully established as a marine painter, sending works for exhibition in Boston and New York. In 1845, Lane, now fully dedicated to the depiction of maritime and coastal subjects, painted *Yacht 'Northern Light' in Boston Harbor* (Shelburne Museum, Vermont). Closely based on a work by Robert Salmon, this canvas reveals the influence of the English marine painter, whom Lane probably met in Boston where Salmon was active from 1828 to 1842. In 1848 Lane returned to Gloucester to open a studio. That same year he made the first of several trips to Maine, which would provide him with some of his most successful subjects. In 1850 Lane travelled to New York and Baltimore,

and may have even visited San Juan, Puerto Rico, painting the city's harbour at each destination. By 1850 Lane was meeting with a limited amount of critical recognition: a correspondent for the Boston *Daily Evening Transcript* that year praised 'his sketches of Cape Ann seaside scenery, and all his salt-water and boating scenes' as being 'unequalled in their fidelity to the ocean's varying aspects' (*Daily Evening Transcript*, May 10 1850, quoted Wilmerding 1971, p.44). Lane's truthfulness to his natural subjects may have been influenced by John Ruskin, whose work the artist certainly encountered in subscriptions to numerous art publications, including the London *Art-Journal*. From 1850 to 1855 Lane made three sketching trips to the southern coast of Maine, visiting Mount Desert Island and Penobscot Bay, also beloved of Frederic Edwin Church. The scenery encountered on these and subsequent trips to Maine became the subject of numerous oil paintings, including *Off Mount Desert Island* (1856; no.66) and *Lumber Schooners at Evening on Penobscot Bay* (1863; no.72). Lane's late works are marked by their expansive, unobstructed skies. Lane continued to paint until he fell ill in July 1864. When he died the following year, obituaries in New York and Boston praised Lane's 'faithfulness' to nature.

Select Bibliography

John Wilmerding, *Fitz Hugh Lane*, New York 1971
John Wilmerding (ed.), *Paintings by Fitz Hugh Lane*, exh. cat., National Gallery of Art, Washington DC 1988

John Frederick Kensett

Born 22 March 1816, Cheshire, Connecticut
Died 14 December 1872, New York City

John Frederick Kensett, like his friend Asher Brown Durand, began his artistic career as an engraver. Kensett trained in his father's (Thomas Kensett, 1786–1829) workshop and was briefly apprenticed to the engraver Peter Maverick in New York, but returned to Connecticut after his father died in 1829 to work for his uncle (Alfred Daggett, 1799–1872), an engraver in New Haven. After leaving his uncle's employment in 1835, Kensett worked variously in New York, New Haven and Albany. Around 1840, probably influenced by Durand and another engraver-turned-painter, John Casilear (1811–1893), Kensett

took up oil painting. In 1840, in the company of three American artists, he embarked for Europe (one of at least four trips to Europe during his career). In London, he studied the Old Masters at the National Gallery and contemporary British painting at the Royal Academy. By August 1840 Kensett was in Paris, where he stayed until 1843, except for a brief sketching trip to England in the autumn of 1841 (where his subjects included such picturesque sites as Kenilworth Castle, Tintern Abbey and Stratford-upon-Avon). In Paris, Kensett visited the Louvre where he copied a painting by Claude Lorrain (*Seaport with the Landing of Cleopatra at Tarsus*, 1642), whose work he greatly admired. He also visited Thomas Cole and the American portraitist and history painter John Vanderlyn. Kensett returned to London in 1843, staying until 1845. During this time he continued to paint and engrave; made sketching trips to Windsor Castle, Richmond, and Hampton Court; and visited the genre painter William Powell Frith (1819–1909). Upon leaving England he returned briefly to France, then journeyed to Italy via the Rhine and Switzerland. Kensett stayed in Rome for two years, where he lived among a lively community of American artists. While in Rome, Kensett sold eight paintings to the American Art-Union. Perhaps owing to the merit of these and other paintings sent home during his seven-year European sojourn, Kensett enjoyed nearly instant success upon his return to the United States in late 1847. In 1848 he was elected an Associate of the National Academy of Design and a year later became an Academician. Between 1849 and 1853, Kensett made numerous summer drawing excursions to the mountains of the Northeast, including the Catskill, Berkshire, Adirondack and White Mountains, which yielded significant canvases, including *A Reminscence of the White Mountains* (1852; no.6). From 1854 Kensett spent several summers on Narragansett Bay in Newport, Rhode Island. There he painted a number of seascapes (a subject that would occupy much of his late career), including *Marine View of Beacon Rock, Newport Harbor* (1864; no.75). Kensett's interest in the effect of light on water was not limited to marine subjects: in 1856 he returned to Britain, where he expressed a special interest in lake scenery. In the summer of 1870, Kensett visited the Colorado Rockies with fellow painters Sanford Robinson Gifford and Worthington Whittredge. The same year Kensett played a major role in the founding of the Metropolitan Museum of Art

in New York. Kensett spent the summer of 1872 in Darien, Connecticut and worked prolifically, producing nearly forty paintings, including *Eaton's Neck, Long Island* (1872; no.78). That November Kensett developed pneumonia after trying to retrieve the body of a drowning victim. Greatly weakened, he succumbed to heart failure the following month.

Select Bibliography

John Paul Driscoll and John K. Howat (eds.), *John Frederick Kensett: An American Master*, exh. cat., Worcester Art Museum, Worcester 1985

Martin Johnson Heade

Born 11 August 1819, Lumberville, Pennsylvania
Died 4 September 1904, St Augustine, Florida

Martin Johnson Heade, the son of a farm and timber-mill owner, grew up in rural Buck's County, Pennsylvania, where he lived until 1842. Between 1837 and 1839 Heade received his first artistic training, studying with Edward Hicks (1780–1849), the Quaker minister-cum-painter known for his numerous depictions of the 'Peaceable Kingdom'. During this time Heade probably also studied with Edward Hicks's cousin, the portraitist Thomas Hicks (1823–1890). In the early 1840s, he made his first trip to Europe where he visited England, France and Italy, spending two years in Rome. Little is known about this trip, which began a pattern of frequent travel throughout Heade's career. Heade moved in 1843 to New York, where he exhibited a portrait at the National Academy of Design. Although his early work consisted primarily of portraits, he occasionally painted genre scenes, including *The Roman Newsboys* (1848; The Toledo Museum of Art, Ohio), which derives from his second trip to Italy in 1848–9. During the 1850s Heade moved constantly, living variously in Saint Louis, Missouri; Chicago, Illinois; Trenton, New Jersey; and Providence, Rhode Island. Although he continued to work as a portrait painter, in 1855, while in Rhode Island, Heade painted his earliest known landscape, *Rocks in New England* (1855; Museum of Fine Arts, Boston). The following year he exhibited a landscape for the first time, showing *Scene on Narragansett Bay* at the Pennsylvania Academy of the Fine Arts. Over the next several years Heade's wanderlust persisted,

taking him to New Hampshire, Chicago and the deep South, among other places. From 1858 to 1860 he resided in New York, where he kept a studio at the Tenth Street Studio Building, which was then occupied by many notable artists, including Sanford Robinson Gifford, John Frederick Kensett and Frederic Edwin Church. Close contact with Church during this time probably influenced the development of Heade's mature style. In 1859 he painted *Approaching Thunder Storm* (no.80), one of several dramatic storm scenes he depicted over the next decade. Also in 1859 Heade made the first of his many 'marsh paintings', depicting the salt marshes at Newburyport, Massachusetts, a locale that he would continue to paint through the 1870s, in works such as *Haystacks on the Newburyport Marshes* (1862; Walters Art Gallery, Baltimore) and *Newburyport Meadows* (c.1871–5; Metropolitan Museum of Art, New York). Heade became so interested in the subject that he eventually depicted coastal wetlands up and down the Eastern Seaboard. In the early 1860s, while continuing to paint landscapes, Heade began to create still-lifes and showed a great interest in painting hummingbirds and tropical flora, subjects that increasingly occupied his attention after several trips to South and Central America between 1864 and 1870. His interest in still-life was influenced by the English painters Annie Feray Mutrie (1826–1893) and Martha Darley Mutrie (1824–1885), whose work he admired at a Royal Academy exhibition while visiting London in 1864. The following year Heade exhibited one of his own pieces at the Royal Academy, a marsh painting entitled *Salt Meadow in America*. Heade's many tropical pictures of hummingbirds and orchids (which he continued to paint until his death in 1904) are intimate in scale and extremely detailed, displaying a Ruskinian 'truthfulness' to their subjects. Heade's landscapes have been credited with this same fidelity. From 1870 on, these landscapes are as diverse as Heade's travels, including scenes from South America, Jamaica, California, New Jersey, and Florida, where he spent the last two decades of his life. Never widely recognised in his lifetime, and only sporadically successful at selling his work, Heade's reputation burgeoned only in the last quarter of the twentieth century, when he came to be recognised as one of the most original American painters of his time.

Select Bibliography

Theodore E. Stebbins, Jr., *The Life and Work of Martin Johnson Heade: A Critical Analysis and Catalogue Raisonné*, New Haven and London 2000
Theodore E. Stebbins, Jr. (ed.), *Martin Johnson Heade*, exh. cat., Museum of Fine Arts, Boston 1999

Jasper Francis Cropsey

Born 18 February 1823, Rossville, Staten Island, New York
Died 22 June 1900, Hastings-on-Hudson, New York

Jasper Francis Cropsey displayed his artistic talent at an early age, filling the margins of his school books with architectural sketches. In 1837, after his model house (which took two years to build) won a diploma at a New York Mechanic's Institute fair, Cropsey began a five-year apprenticeship to the architect Joseph Trench in New York. In 1840 Trench hired the English artist Edward Maury to instruct Cropsey in watercolour. The following year, Cropsey took up oil painting, copying engravings by French masters. He was greatly encouraged by the Long Island genre painter William Sidney Mount (1807–1868), who, according to Cropsey, foretold his 'future greatness' (Cropsey, letter to C.E. Lester, 1846, Cropsey MSS). In 1843, the same year he opened an architectural office in New York, Cropsey exhibited his first painting at the National Academy of Design. Increasingly devoted to oil painting, Cropsey nonetheless continued to work as an architect, using the income to fund a two-week sketching excursion to Greenwood Lake, New Jersey, in the autumn of 1843. Three of the paintings resulting from the trip were exhibited at the National Academy of Design the following year, resulting in Cropsey's election as an Associate. By 1845 Cropsey had abandoned architecture to pursue landscape painting. In an address to the New-York Art Re-Union that year, entitled 'Natural Art', Cropsey advocated open-air painting, arguing that nature only partially reveals its beauty to the 'general observer'. His marriage in 1847 to Maria Cooley was followed by a two-year honeymoon in Europe. The Cropseys travelled throughout Britain before departing for Rome in September, where they took up residence in Thomas Cole's old studio, encountering a lively community of American and German artists. Cropsey remained in Rome nearly two years, making numerous sketching trips to southern Italy. In April 1849 he returned

to England via Northern Italy and France, where he sketched at Fontainebleau and Barbizon. Back in England, Cropsey visited Stonehenge and Kenilworth. On his return to America in August 1849 he resumed painting regional landscapes, but also made several large canvases after sketches made in Italy, including *The Coast of Genoa* (1854; Smithsonian American Art Museum, Washington DC). During this time, pursuing an interest in antique and medieval subjects acquired in Europe, Cropsey painted several allegorical landscapes, such as *The Spirit of War* (1851; National Gallery of Art, Washington DC) and *The Millennial Age* (1854; no.17). In 1856 Cropsey and his wife returned to England, where he became engaged in a lively social circle, which included John Ruskin, Sir Charles Eastlake, Lord Lyndhurst (son of John Singleton Copley) and the English painter John Linnell (1792–1882). During this time Cropsey made sketching excursions to Warwick Castle (1856), Dorset (1857), and the Isle of Wight (1859). Between 1857 and 1859 he exhibited five oils at the Royal Academy, London. However, Cropsey's greatest success came in 1860, when he exhibited *Autumn – on the Hudson River* (no.27) in his studio. The critic for the *Times* observed, 'Mr. Cropsey's *Autumn on the Hudson River* . . . is a perfectly faithful view of the locality.' The following year, now well-known in England, Cropsey was presented to Queen Victoria. Returning to America in 1863, he continued to paint autumnal scenes and renewed his interest in Greenwood Lake (*Greenwood Lake*, 1870; no.30). Cropsey resumed his architectural practice, building a Gothic Revival home for himself and designing fourteen stations for New York's Sixth Avenue Elevated Railway (1876). In 1885 he moved to Hastings-on-Hudson. Despite suffering a severe stroke in 1893, he continued to paint until his death in 1900, using water-colour to create small dramatic scenes of the Hudson Valley.

Select Bibliography

Peter Bermingham, *Jasper F. Cropsey 1823–1900, A Retrospective View of America's Painter of Autumn*, exh. cat., University of Maryland Art Gallery 1968

William S. Talbot, *Jasper F. Cropsey 1823–1900*, exh. cat., The Smithsonian Institution Press, Washington DC 1970

Sanford Robinson Gifford

Born 10 July 1823, Greenfield, New York
Died 24 August 1880, New York City

The son of a prosperous ironmaster, Sanford Robinson Gifford grew up in comfortable circumstances in Hudson, New York, near the Catskills. Gifford's first exposure to art probably occurred in his own home; his eldest brother Charles (1819–1861) covered his room with engravings of European masterpieces. Between 1842 and 1844, Gifford studied at Brown University, but left to pursue a career in art. Moving to New York in 1845, he studied drawing and perspective with the British artist John Rubens Smith (1775–1849) and attended anatomy lectures at a local medical college. Gifford also enrolled in antique and life drawing classes at the National Academy of Design. Although trained as a figure painter, he developed an intense interest in the landscapes of Thomas Cole and in the summer of 1846 made a sketching trip to the Berkshire and Catskill Mountains. On his return Gifford dedicated himself to landscape painting and showed his first canvases at the National Academy of Design the following year. Gifford subsequently enjoyed a growing reputation as a landscapist. In 1848 the American Art-Union exhibited eight of his works. He was elected an Associate of the National Academy in 1851, and made a full member three years later. From 1855 to 1857 Gifford made his first European trip. In England, he visited both Warwick and Windsor Castles, and several other picturesque sites, including Kenilworth and Stratford-upon-Avon. Gifford visited the major collections of London, where he studied the work of Constable and Turner, and met Ruskin at his home, Denmark Hill. The artist arrived in France in autumn of 1855, where he studied the work of Jean-François Millet (1814–1875), visiting Paris, Fontainebleau and Barbizon. From May 1856 Gifford travelled south through Europe, eventually arriving in Italy in mid-August. By October he was in Rome where he spent the winter in the company of Worthington Whittredge and Albert Bierstadt. Upon returning to America in late 1857 Gifford took a studio at the Tenth Street Studio Building in New York, where he worked till the end of his life. Over the next several years, Gifford made numerous sketching trips to the mountains of the northeastern United States, particularly the Catskills. The pencil drawings and oil sketches made on these excursions resulted in several major

paintings, including *Kauterskill Clove* (1862; Metropolitan Museum of Art, New York), on which his reputation ultimately rests. In 1861, at the outbreak of the Civil War, Gifford enlisted in the Seventh Regiment of the New York National Guard, spending the next three summers defending Washington DC. During this time Gifford returned to figure painting, depicting his comrades in such works as *Bivouac of the Seventh Regiment at Arlington Heights, Virginia* (1861; Seventh Regiment Armory, New York). In June 1868 Gifford again embarked for Europe, revisiting Italy, but also travelling to Greece and the Middle East before returning to the United States in the autumn of 1869. In 1870 Gifford made a trip to the Colorado Rockies with John Frederick Kensett and Worthington Whittredge, then trekked to Wyoming with Ferdinand V. Hayden's government survey party. In 1874 he again headed west, visiting the entire Pacific Coast from California to Alaska. Gifford died in 1881, after developing pneumonia on a trip to Lake Superior. That year his artistic contributions were celebrated in a memorial exhibition at the Metropolitan Museum of Art containing 160 paintings.

Select Bibliography

Nicolai Cikovsky, Jr., *Sanford Robinson Gifford (1823–1880)*, exh. cat., University of Texas, Austin 1970
Ila Weiss, *Poetic Landscape: The Art and Experience of Sanford R. Gifford*, Newark 1987

Frederic Edwin Church

Born 4 May 1826, Hartford, Connecticut
Died 7 April 1900, New York City

The son of a prosperous Hartford businessman, Frederic Edwin Church was afforded the chance to pursue art at an early age. From 1842 to 1843, Church studied drawing and painting with two local artists, but in 1844 Daniel Wadsworth, a friend of Church's family and a patron of Thomas Cole, arranged for the aspiring artist to study with Cole in Catskill, New York, where he remained until 1846. While under Cole's tutelage, Church made several summer sketching trips, including visits to East Hampton, Long Island; the Catskills; and the Berkshires. During this time, Church exhibited several landscapes at the National Academy of Design. His earliest

commercial success was a historical landscape, *Hooker and Company Journeying through the Wilderness in 1636 from Plymouth to Hartford* (1846; fig.31), which he sold to the Wadsworth Atheneum for $130. By the time his former teacher died in 1848, Frederic Edwin Church was established as a landscapist in his own right. In 1847 he moved to a studio in New York and took his first student, William James Stillman (1828–1901). The following year Church became an Associate of the National Academy, becoming a full Academician in 1849. From the late 1840s to the early 1850s he continued to make summer trips throughout New York and New England, using the pencil and oil sketches made on these excursions to complete large-scale canvases back in his Manhattan studio. In 1849 Church sold eight paintings to the American Art-Union, including *Above the Clouds at Sunrise* (1849; Gulf States Paper Corporation, Tuscaloosa, Alabama). This canvas, the result of sketches done in the Catskills, demonstrates the vivid colours and attention to atmospheric effects that became typical of Church's œuvre. In 1850 he made his first visit to Maine, where he would spend many summers over the next three decades, at Mount Desert Island and Mount Katahdin. These trips resulted in many important works, including *Mount Ktaadn* (1853; no.24). In 1853, and again in 1857, inspired by descriptive accounts written by the German naturalist Alexander von Humboldt, Church travelled to South America. There he made numerous sketches (particularly of the active volcano, Mount Cotopaxi, in Ecuador), which served as the basis for paintings into the 1880s. Between 1851 and 1852, and again in 1856, Church visited Niagara Falls on several occasions. In 1857 he exhibited *Niagara* (1857; fig.32), which became an instant sensation, establishing him as America's foremost landscape artist. When the painting toured Britain later that year, it drew even more praise, including the admiration of John Ruskin. The following year Church moved into the Tenth Street Studio Building, where he created other grand-scale paintings, including *The Heart of the Andes* (1859; Metropolitan Museum of Art, New York), which he sold for $10,000, then the highest price ever paid for a work by a living American artist. That same year, in search of more dramatic scenery, Church travelled with the Revd Louis Legrand Noble (later Cole's biographer) to Newfoundland and Labrador, where he sketched icebergs, resulting in a spectacular canvas entitled *Icebergs* (1861; no.88). Between 1867 and 1869 Church travelled extensively throughout Europe, North Africa, and the

Middle East. These travels undoubtedly influenced his plans for Olana, the Oriental mansion Church designed on a hilltop near Hudson, New York, between 1869 and 1872, with the help of architect Calvert Vaux. Around this time Church began to suffer from rheumatism, which prevented him from working on large-scale pictures. Although he continued to paint until 1895, much of his late work lacks the vigour of his earlier pieces; however, the brilliant oil sketches he made at Olana during these years form a notable exception.

Select Bibliography

Franklin Kelly, *Frederic Edwin Church*, exh. cat., National Gallery of Art, Washington DC 1989

Gerald F. Carr, *In Search of the Promised Land: Paintings by Frederic Edwin Church*, New York 2000

Albert Bierstadt

Born 7 January 1830, Solingen, Germany.
Died 18 February 1902, New York City

Born in Solingen, Germany, Albert Bierstadt's family moved to America when he was two years old, settling in New Bedford, Massachusetts, where his father found work as a cooper. From 1850 to 1853 Bierstadt worked as an art instructor, advertising lessons in 'monochromatic painting' in his hometown newspaper. Entirely self-taught, Bierstadt returned to Germany in 1853 to seek formal training in the Düsseldorf atelier of Johann Peter Hasenclever (1810–1853), a prominent painter and a cousin of Bierstadt's mother. Upon arrival Bierstadt learned of Hasenclever's recent death, but was quickly befriended by the American artists Emanuel Leutze and Worthington Whittredge. Although he never formally enrolled at the Düsseldorf Academy of Fine Arts, Bierstadt learned from his colleagues and was instructed by several Academicians, including the history painter Carl Friedrich Lessing (1808–1880) and the landscapist Andreas Achenbach (1815–1910). From 1853 to 1856, often accompanied by Whittredge, Bierstadt made numerous sketching trips within Germany. In 1856 he visited Switzerland with several fellow artists, and then continued on to Rome, where he spent much of the following year with Sanford Robinson Gifford, before returning to America at the end of the summer. In 1858 Bierstadt exhibited his first work,

Lake Lucerne (1858; National Gallery of Art, Washington DC), at the National Academy of Design, contributing an additional eight canvases the following year. That same year Bierstadt made his inaugural journey to the West, travelling with Colonel Frederick W. Lander's railway survey expedition to the Rocky Mountains, where he made numerous sketches and stereographs. By September 1859 Albert Bierstadt was back in New York where he moved into the Tenth Street Studio Building, inhabited by many old Düsseldorf colleagues and Frederic Edwin Church. The following year Bierstadt exhibited his first Rocky Mountain painting at the National Academy of Design, but his greatest success came three years later when he unveiled *Rocky Mountains, 'Lander's Peak'* (1863; no.89). The painting (which later sold for $25,000) travelled extensively (both at home and abroad) and garnered widespread recognition, firmly establishing Bierstadt as the premier painter of the American West. In 1863 Bierstadt again travelled west, where he spent nearly two months in the Yosemite Valley and toured the Pacific Northwest. Back in Bierstadt's studio, the numerous oil sketches made on this trip yielded several dramatic canvases, including *Looking Down Yosemite Valley* (no.90). In 1867 Bierstadt returned to Europe with his wife, where they travelled extensively over the next two years. In December of 1867, Bierstadt was granted an audience with Queen Victoria and the royal family at Osborne House on the Isle of Wight, where he showed the Queen *Rocky Mountains, 'Lander's Peak'* and *A Storm in the Rocky Mountains – Mt Rosalie* (1866; no.91), apparently to her approval. Of the encounter, Bierstadt wrote: 'Her Majesty is a very charming and agreeable lady, and makes one feel quite at home in her presence. She seemed much pleased with my works' (Bierstadt, letter to unidentified correspondent, *Boston Transcript*, 15 January 1868, quoted in Anderson, N. and Ferber 1990, p.184). In 1871 Bierstadt returned to California for two years, where he met the photographer Eadweard Muybridge (1830–1904). In the mid-1870s Bierstadt completed two history paintings for the United States Capitol. Despite the prestigious commission, the remaining years of his career were marked by a declining reputation as American tastes began to prefer smaller, more intimate canvases. Bierstadt travelled extensively in the subsequent decade, making numerous trips to Europe, the Bahamas, Canada, and the American West, visiting Yellowstone for the first time in 1881. Bierstadt's career effectively ended in 1889,

when *The Last of the Buffalo* (c.1888; fig.38) was rejected for exhibition at the Paris Exposition Universelle. Bierstadt continued to make frequent trips to Europe until his death in 1902.

Select Bibliography

Nancy K. Anderson and Linda S. Ferber, *Albert Bierstadt: Art and Enterprise*, exh. cat., Brooklyn Museum, New York 1990
Gordon Hendricks, *Albert Bierstadt: Painter of the American West*, New York 1988

Thomas Moran

Born 12 February 1837, Bolton, Lancashire, England
Died 26 August 1926, Santa Barbara, California

Born to a family of handloom weavers in the factory town of Bolton in England, Thomas Moran moved to the United States in 1844 with his mother and six siblings, where he joined his father who had settled in Philadelphia two years earlier. Moran's interest in art was largely due to the influence of his older brother Edward (1829–1901), a marine painter. In 1853 Thomas Moran commenced his apprenticeship to the Philadelphia engraving firm Scattergood & Telfer, which he left after just two years. In 1856 He moved to his brother's studio, where he received informal training not only from Edward, but also from several notable Philadelphia artists, including the Irish-born marine painter James Hamilton (1819–1878), the German landscapist Paul Weber (1823–1916), and the engraver John Sartain (1808–1897). In this circle of artists, Moran was probably first exposed, through engravings, to the work of J.M.W. Turner, which would have a profound effect on him throughout his career. It was from Hamilton, an accomplished watercolourist, that Moran probably received his initial instruction in this medium, of which he was to become a master. From 1856 he regularly exhibited his work at the Pennsylvania Academy of the Fine Arts, which resulted in his election as an Academician in 1861. The following year Thomas Moran (accompanied by Edward) travelled to England where he studied the work of Turner at the National Gallery and made sketching trips to Windsor and along the southern coast of England (including Arundel, Dover and Hastings). In February 1863, shortly after returning to the United States, Moran married Mary Nimmo (1842–1899), who became a

skilled etcher under her husband's tutelage. In 1866 Moran made his debut at the National Academy of Design with *Under the Trees* (also known as *The Autumnal Woods*, 1865; Manoogian Collection). That year Moran again travelled to Europe, where he remained for nearly a year, during which time he visited Jean-Baptiste-Camille Corot (1796–1875), exhibited at both the Exposition Universelle and Salon in Paris, and made a sketching trip to Rome.

In 1871 Moran made his first trip to the American West, accompanying the United States Geological and Geographical Survey of the Territories expedition to the Yellowstone region (present-day Wyoming and Montana), led by Ferdinand V. Hayden. Among the party was the photographer William Henry Jackson, whose photographs of the region were occasionally used by Moran to compose his paintings. After returning from the exhibition, Moran moved to Newark, New Jersey, where he painted his first grand-scale canvas of the West, *Grand Canyon of the Yellowstone* (1872; fig.16). It drew widespread acclaim when exhibited in New York and Washington DC, and established Moran as one of the nation's foremost landscape painters, a reputation bolstered when Congress purchased the painting in 1872 for the sum of $10,000. In August 1872 Moran and his wife travelled to the Yosemite Valley in California where he made a number of pencil-and-ink and watercolour sketches. In 1873, Moran again ventured west, this time with a government survey expedition of the Grand Canyon, led by John Wesley Powell. The sketches made by Moran on this journey resulted in *The Chasm of the Colorado* (1873–4; fig.17), a painting equal in size to his previous masterpiece. Moran continued to paint the West throughout his life, visiting the Rocky Mountains (1874); the Sierra Nevadas and the Teton Range (with his brother, Peter, in 1879); Mexico (1883); Yellowstone (1900); and re-visiting the Grand Canyon (often with his daughter Ruth) almost annually from 1901 until his death in 1926. Moran also made several more trips to Europe, most notably his 1882 trip to Great Britain, during which he sketched extensively in Scotland, Wales and England. During this trip, Moran's work drew the attention of John Ruskin who praised the artist's technique and purchased several of Moran's watercolours and etchings. Moran visited Venice in 1886 and again in 1890, when he purchased the poet Robert Browning's gondola for use at his summer home at East Hampton, Long Island, New York. Moran was elected an

Associate of the National Academy of Design in 1881, and elevated to Academician in 1883. In 1916 he moved his winter residence to California (first Pasadena, then Santa Barbara), although he continued to summer in East Hampton. By the end of the century Moran's critical reputation had faded, but through popular chromolithographic reproductions, Moran's work continued to be enjoyed by the public at large throughout the final decades of his life.

Select Bibliography

Nancy K. Anderson, *Thomas Moran*, exh. cat., National Gallery of Art, Washington DC 1997

William H. Gerdts, *Thomas Moran: 1837–1926*, exh. cat., The Picture Gallery, University of California, Riverside 1963

Joni Louise Kinsey, *Thomas Moran and the Surveying of the American West*, Washington DC 1992

Notes

The Sublime in the Old World and the New

1 Elliott Coues (ed.), *The History of the Lewis and Clark Expedition*, 1893; Dover ed., n.d., II, p.364, note 16

2 *Spectator*, June–July 1712

3 James Thomson, 'Winter', *The Seasons*, revised ed., London 1744, lines 94–105

4 The Revd M. Pilkington, M.A., *A Dictionary of Painters from the Revival of the Art to the Present Period*, 1770; new edition by Henry Fuseli, R.A, London 1810, p.457 note

5 *Spectator*, no.417, 28 June 1712

6 Edmund Burke, *Philosophical Enquiry*, 1757, p.13

7 Immanuel Kant, *Critique of Judgement*, 1790, trans. James Creed Meredith, Oxford 1928, p.98

8 Ibid., p.131

9 Ibid., p.94

10 Ibid., p.97

11 William Gilpin, *Three Essays: On Picturesque Beauty; On Picturesque Travel; and On Sketching Landscape*, 2nd ed., London 1794, p.6

12 William Gilpin, *Observations, relative chiefly to Picturesque Beauty, made in the year 1772, on Several Parts of England . . .* , 2 vols., London 1786, I, p.3

13 William Mason (ed.), *The Poems and Letters of Thomas Gray*, London 1820, p.70

14 For a classic statement of 'associationist' theory, see Archibald Alison, *Essays on the Nature and Principles of Taste*, 4th ed., 2 vols., Edinburgh 1815

15 Washington Irving, 'A Tour on the Prairies', *The Crayon Miscellany No. 1*, Philadelphia 1835, chapter 7. Compare a passage from Emerson's 'History' (*Essays*, 1841): 'No one can walk in a road cut through pine woods, without being struck with the architectural appearance of the grove, especially in winter, when the barrenness of all other trees shows the low arch of the Saxons. In the woods in a winter afternoon one will see as readily the origin of the stained glass window, with which the Gothic cathedrals are adorned, in the colours of the western sky seen through the bare and crossing branches of the forest.'

16 Cole 1835, pp.99–100

17 Alexander von Humboldt, *Personal Narrative of Travels to the Equinoctial Regions of America*, English translation, 7 vols., London 1814–29

18 'Humboldt embodied the ideals of the Enlightenment as well and as forcefully as any great intellectual – as Voltaire, as Goya, as Condorcet': see Stephen Jay Gould, 'Church, Humboldt and Darwin: the tension and harmony of Art and Science' in Kelly 1989, p.98

19 Alexander von Humboldt, *Cosmos*, I, New York 1850, p.24, cited in Novak 1995, p.69

20 Ibid., II, p.93, cited in Novak 1995, p.68

21 See William L. Pressly, *The Life and Art of James Barry*, New Haven and London 1981, pp.86–122, 132–4

22 Helmut von Erffa and Allen Staley, *The Paintings of Benjamin West*, New Haven and London 1986, no.401; the canvas measures 447 × 765 cm (168 × 301⅛ in). Another finished version of c.1796 is in the Detroit Institute of Arts

23 A version of Ker Porter's panorama, measuring approx. 110 × 290 cm (42 × 114 in), is now in Tippoo's palace in Srirangapattana (Seringapatam), Karnataka, Southern India

24 Most of the examples of panoramas mentioned here are discussed in Hyde, R. 1988, pp.62–70

25 Butlin and Joll 1984, no.126

26 A. J. Finberg, *The Life of J. M. W. Turner R.A.*, 2nd ed., Oxford 1961, pp.188–9

27 For a broader discussion of Turner's relationship with theories of the Sublime see A. Wilton, *Turner and the Sublime*, London 1980

28 Southampton Art Gallery. Another version is in the Walker Art Gallery, Liverpool

29 W. T. Whitley, *Art in England, 1800–1820*, Cambridge 1928, pp.71–2

30 Loutherbourg's *Battle of Camperdown* (1799) and *The Battle of the Nile* (1800) are both in the Tate Gallery, London; West's *The Battle of La Hogue* (1775–80) is in the National Gallery of Art, Washington DC. Turner's *Battle of Trafalgar* (1823–4) is in the National Maritime Museum, Greenwich (Butlin and Joll 1984, no.252); his *England: Richmond Hill, on the Prince Regent's Birthday* (1819) is in the Tate Gallery, London (Butlin and Joll 1984, no.140)

31 Tate Gallery, London; repr. William Feaver, *The Art of John Martin*, Oxford 1975, pl.7 (facing p.193), p.191 fig.147, p.199 fig.155

32 Munson-Williams-Procter Institute, Utica; repr. Truettner and Wallach 1994, pp.96–7 figs.115–18

33 See J. Dustin Wees, *Darkness Visible: The Prints of John Martin*, exh. cat., Sterling and Francine Clark Art Institute, Williamstown, Massachusetts 1986

34 National Gallery of Ireland, Dublin; repr. in Eric Adams, *Francis Danby: Varieties of Poetic Landscape*, New Haven and London 1973, pl.48

35 For details of this exhibition and a discussion of American responses to British art in the 1850s see Ferber and Gerdts 1985

36 See Flexner 1962, pp.103–8

37 For the large corpus of prints after Turner see Anne Lyles and Diane Perkins, *Colour into Line: Turner and the Art of Engraving*, exh. cat., Tate Gallery, London 1989. For David Lucas's mezzotints after Constable see Leslie Parris, *John Constable and David Lucas*, exh. cat., Salander-O'Reilly Galleries, New York 1993

38 See Harvey 1998, p.33. Many of Church's sketches are housed in the Cooper-Hewitt Museum in New York, and at Olana State Historic Site, the artist's house at Hudson, New York; the latter collection is catalogued in Carr 1994

39 See Harvey 1998; also Stebbins 1978. I am grateful to Gerald L. Carr for advice on Church and his techniques

40 There is a photograph in the Gilcrease Museum, Tulsa, Oklahoma of the canvas of his large view of *The Chasm of the Colorado* (fig.17) when it was at this stage; repr. Kinsey 1992, p.97

41 See Andrew Wilton and Anne Lyles, *The Great Age of British Watercolours*, exh. cat., Royal Academy, London 1993, pp.176–80

42 For a survey of early landscape painting in America see Nygren 1986

43 Washington Allston, *Lectures on Art and Poetry*, ed. Richard H. Dana, New York 1850; reprinted in McCoubrey 1965, p.67

44 Washington Irving, 'Rip Van Winkle', *The Sketch-Book of Geoffrey Crayon, Gent.*, May 1819

45 William Cullen Bryant, 'Thanatopsis' in Bryant 1894, pp.21–3, lines 137–45

46 Ibid., lines 66–73

47 For an account of Cole's early life see Powell 1990, pp.12–19

48 Thomas Cole, *Sketchbook*, Detroit Institute of Arts, no.1 (39.558), p.8

49 Chrysler Museum, Norfolk, Virginia; repr. in Truettner and Wallach 1994, p.46 fig.49

50 Cole 1835

51 Ibid., p.100

52 Ibid., p.101

53 Ibid., p.98

54 Ibid., p.99

55 Ibid., p.105

56 See Truettner and Wallach 1994, p.28

57 Cole 1835, p.106

58 National Gallery, London (Butlin and Joll 1984, no.131) and Tate Gallery, London (Butlin and Joll 1984, no.135)

59 Jasper Francis Cropsey, Journals, Saturday 20 March 1858, MS, Newington-Cropsey Foundation, Hastings-on-Hudson, New York State

60 John I.H. Baur (ed.), 'The Autobiography of Worthington Whittredge', *Brooklyn Museum Journal*, vol.1, 1942, pp.55–6, cited in McCoubrey 1965, p.120. For a full survey of the painters comprehended by the term 'Hudson River School' see Howat 1987

61 Cleveland Museum of Art; repr. Kelly 1989, p.17

62 Amon Carter Museum, Fort Worth; repr. Kelly 1989, p.21

63 Musée d'Art Américain, Giverny; repr. Kelly 1989, p.20

64 Gulf States Paper Corporation, Tuscaloosa, Alabama; repr. Kelly 1989, p.22

65 For an account of Church's early paintings see Kelly and Carr 1987

66 Cited in Flexner 1962, p.145

67 A significant exception in British Romantic landscape painting is Constable's *The Cenotaph* (1833–6; National Gallery, London), showing the monument to Sir Joshua Reynolds at Coleorton, in which the idea of fall is elegiac and symbolic of death (but also of rebirth and immortality). But Constable makes no major aesthetic point by means of autumn colouring, which appears more emphatically in Turner's small canvas of 1822 *What You Will!* (Butlin and Joll 1984, no.229). Here a scene from Shakespearean comedy is played out amid flaming red and gold foliage. Autumn was to become a more popular subject in later nineteenth-century British painting, but it was still most often presented as a time of decay rather than of 'mellow fruitfulness'

68 Reported in the *Guardian*, 6 June 1860, cited in William S. Talbot, *Jasper F. Cropsey, 1823–1900*, New York 1977, p.154 note

69 Ralph Waldo Emerson, 'Nature', *The Complete Prose Works*, London 1889, p.311

70 John I.H. Baur, 'American Luminism', *Perspectives USA*, no.9, Autumn 1954, pp.90–8. 'Luminism' was further defined by Barbara Novak in Novak 1969, especially chapter 5; and a large exhibition at the National Gallery of Art, Washington DC, in 1980, *American Light: The Luminist Movement 1850–1875*, attempted to bring a huge range of disparate works of the period under the 'luminist' umbrella. See Wilmerding 1980

71 Miller, A. 1993, p.244ff

72 Ralph Waldo Emerson, 'Nature', *The Complete Prose Works*, London 1889, p.313. The relationship between Emerson and the 'luminist' painters is usefully discussed by Wilmerding in Wilmerding 1980, p.98

73 Ibid.

74 Ibid., p.311

75 Ibid.

76 Ibid.

77 See Stebbins 2000

78 Amon Carter Museum, Fort Worth; repr. Cash 1994, p.11 pl.1; p.18 pl.8

79 Ralph Waldo Emerson, 'Nature', *The Complete Prose Works*, London 1889, p.314

80 Ibid.

81 Ralph Waldo Emerson, 'An Address delivered before the Senior Class in Divinity College, Cambridge, Sunday Evening, July 15, 1838', *The Complete Prose Works*, London 1889, p.342

82 'Transcendental' is a term that has been applied to many pictures that do not fall into the category described here; Church's *Niagara* (fig.32), for instance, has often received the epithet; see for instance Adamson 1981 *passim*. On the occasion of the *American Light* exhibition at Washington DC in 1980, *Niagara* was accounted 'luminist' 'only in its structure and moral sense of American nature', being 'too painterly and action-filled' to qualify fully. See Wilmerding 1980, p.120

83 New-York Historical Society, New York; repr. Kelly 1989, p.92

84 Washington University Gallery of Art, St Louis, Missouri; repr. Carr 2000, p.183 pl.67

85 See Miller, A. 1993, p.204

86 See Kelly 1989, p.50; and the obituary of Church in the *New York Times*, cited by Kelly 1989, p.50

87 Olana State Historic Site, New York State; repr. Kelly p.24

88 See Kelly 1989, pp.57–8; Avery 1993

89 *Art-Journal*, September 1859, p.297

90 Ibid., p.298

91 *Atlantic Monthly*, vol.6, August 1860, p.239, cited in Lillian B. Miller, *Patrons and Patriotism: The Encouragement of the Fine Arts in the United States, 1790–1860*, Chicago 1966

92 See Ferber and Gerdts 1985

93 See Kelly 1989, p.52

94 A photograph of the falls from the American side, composed almost exactly like the Edinburgh painting, and touched by Church with oil paint, is in the Cooper-Hewitt Museum, New York (1917-4-1350)

95 Smithsonian American Art Museum, Washington DC

96 John Ruskin, *Lectures on Landscape delivered at Oxford in Lent Term, 1871*, Orpington 1897; reprinted in *The Works of John Ruskin*, ed. E.T. Cook and A. Wedderburn, London 1903–12, XXII, p.16

97 The transition was not entirely a sudden one; the work of Sir Charles Lyell and others earlier in the century had begun to alert people to the antiquity of the earth; but in America there were Fundamentalist traditions even stronger than those of the Old World to erect ideological walls against the new thought. See Novak 1995 *passim*

98 *Art-Journal*, November 1858, p.337

99 *Art-Journal*, September 1862, p.187

100 National Gallery of Art, Washington DC; repr. Anderson, N. and Ferber 1991, p.131 no.6

101 Metropolitan Museum of Art, New York; repr. Anderson, N. and Ferber 1991, p.195

102 Examples can be seen in a sketchbook in the possession of the Brooklyn Museum, on loan to the Mabee-Gerrer Museum of Art, Shawnee, Oklahoma

103 Smithsonian American Art Museum, Washington DC; repr. Anderson, N. and Ferber 1991, p.209 no.48

104 *Art-Journal*, August 1868, p.159

105 Southwest Museum, Los Angeles; repr. Anderson, N. and Ferber 1990, p.86 fig.55

106 *Art-Journal*, January 1870, p.29

107 *Saturday Review*, 15 June 1867, p.754

108 Albert Bierstadt, letter to John Hay, 22 August 1863, cited Anderson, N. and Ferber 1991, p.178

109 Fogg Art Museum, Harvard; repr. Ferber and Gerdts 1985, p.108 pl.5. Moran met Ruskin on a visit to England in 1882, and the critic bought some of his work; see Anderson, N. 1997, pp.120–1

110 See Helen Guiterman and Briony Llewellyn, *David Roberts*, exh. cat., Barbican Art Gallery, London 1986

111 Hyde, R. 1988, p.60

112 *Boston Transcript*, 25 May 1872, cited in Anderson, N. 1997, p.203

113 Kinsey 1992, pp.53–8

114 Cited in Kinsey 1992, p.111

115 Autry Museum of Western Heritage, Los Angeles; repr. Anderson, N. 1997, p.106

116 For example, Church showed *Valley of the Lebanon* in New York in 1869, *Jerusalem from the Mount of Olives, The Mountains of Edom, Syrian Landscape* and *Damascus* in 1870, *Syria by the Sea* in 1873 and *El Khasné, Petra* in 1874

117 See Richard P. Townsend, '"A Lasting Impression": Thomas Moran's Artistic Dialogue with J.M.W. Turner' in Townsend 1998, pp.15–36

118 Fine examples are Hill's *Great Canyon of the Sierra – Yosemite* (1871; Crocker Art Gallery, Sacramento) and Keith's *King's River Canyon* (1878; Oakland Museum, Oakland, California)

The Course of Empires

Acknowledgement: I would like to thank John L. Bell, Jules Prown, Alex Nemerov, Jason Rosenfeld and Andrew Wilton for their generous comments on earlier versions of this essay. Remaining errors and eccentricities are entirely my responsibility.

1 Jarves 1866, p.231

2 De Witt Clinton, 1816, quoted Cummings 1865, p.12. Clinton's words derive from an address to the American Academy of Art. For a discussion see Nash 1967, p.70

3 Cole 1835, p.102

4 For a fuller version of this argument, see Barringer 2001

5 On Constable see Parris and Fleming-Williams 1991, pp.301–5 and Rosenthal 1981, pp.171–8. A comparison between Constable's painting and Durand's *The Beeches* appears in Howat 1987, pp.104–6, catalogue entry by Barbara Dayer Gallati

6 Cole 1835, p.102

7 On American artists in Düsseldorf, see Harding and Witthoft 1982

8 Recent historical research has revealed that the 'industrial revolution' took a more piecemeal course than previously assumed; nonetheless, there were significant changes in manufacturing and the financial system which distinguish this period. See Hudson 1993

9 Moran's father came from a line of hand-loom weavers, the classic case of an entire occupational group of manual labourers made redundant by technological changes. Cole's father, from a slightly higher social class, abandoned Lancashire after the failure of various small-scale entrepreneurial schemes. See Wallach 1994, pp.24–5, and Anderson, N. 1997, pp.20–3

10 Hemingway 1992, especially pp.29–47

11 Stephanson 1995, p.33. The US census figure of 5.3 million in 1800 included almost 900,000 slaves. The number of slaves had grown to 3,953,760 by 1860, more than one tenth of the population

12 See Sellers 1991

13 On America at the London Crystal Palace, see Auerbach 1999, pp.122–3, 187–9

14 Karl Marx, letter to Friedrich Engels, 13 October 1851, in Saul K. Padover (ed.), *Karl Marx on America and the Civil War*, New York 1972, p.37, quoted Auerbach 2001, p.100

15 For a superb representation of the New York Crystal Palace, see John Bachmann, artist, printer and publisher, *Bird's Eye View of the New York Crystal Palace and Environs* (1853; lithograph printed in colours with hand colouring; Museum of the City of New York. The Clarence J. Davies Collection. 29.100.2387; repr. Voorsanger and Howat 2000, p.467)

16 See Bruce Robertson, 'Venit, Vidit, Depinxit: The Military Artist in America' in Nygren 1986, pp.83–103

17 See Nygren 1986 and McKinsey 1985

18 Deak 1988; Nygren 1986, pp.46–50 and 289–90

19 See Shaw 1820–5, unpag.

20 Ibid., introductory letterpress, unpag.

21 Shaw's claims to complete originality need to be tempered somewhat. Many of the scenes he depicted had been represented by earlier artists; George Isham Parkyns (1749–1820), for example, painted *Falls of the Schuylkill* in 1800 (Private Collection; repr. Nygren 1986, p.115)

22 Shaw 1820–5, introductory letterpress, unpag.

23 It is also possible that there was no market for expensive series of prints, though the diversity of prints recorded in Deak 1988 militates against this argument

24 Although often described as 'aristocratic', in European terms they were a gentry class, privileged by inheritance and income: the American Constitution had, of course, rejected the idea of an aristocracy on the European model with that of monarchy. See Wallach 1981. Wallach gives a succinct account of his use of the term 'aristocracy' in Wallach 1994, p.34. My account here relies heavily on his compelling analysis of Cole's patrons

25 'The Patroon' was an informal title deriving from his ancestry among the first Dutch settler-landowners of New York State

26 Over a hundred labourers were employed to maintain the grounds of Monte Video. See Saunders 1981, pp.17–22

27 DeLana 1992, pp.25–30

28 Lady Emmeline Stuart-Wortley, *Travels in the United States etc. during 1849 and 1850*, New York 1851, p.13

29 Frances Trollope, *Domestic Manners of the Americans*, 2nd ed., London 1832, II, pp.189 and 188

30 The city had been laid out in a modified grid plan by the original Dutch colonists, and in 1811 the land of Manhattan was divided into a geometric system on which would rise streets and avenues as the century proceeded. See Upton 2000, p.6

31 Dickens 1869, p.96. For an analysis of Dickens's response to the American landscape, see Lawson-Peebles 1989

32 Quoted from E. E., 'Letters Descriptive of New-York, written to a Literary Gentleman in Dublin', no.11, *The New-York Mirror and Ladies' Literary Gazette*, 6 January 1827, p.187, by Upton 2000, p.4

33 See Peck 2000

34 For an early example see Wilentz 1984, pp.3–4

35 Metropolitan Museum of Art, New York; repr. Avery and Fodera 1988, between pp.24 and 25

36 Oettermann 1997, p.315. See also Avery and Fodera 1988 and Voorsanger and Howat 2000, pp.38–9

37 Private Collection; repr. William Feaver, *The Art of John Martin*, Oxford 1975, pl.3 (facing p.65). A smaller version is in the Yale Center for British Art, New Haven, Connecticut

38 Avery 1999, pp.3–4 and p.11, note 9. For the history of Martin's painting and the diorama made from it in London, see Hyde, R. 1988, p.123

39 Tate Gallery, London. See Carr 1980, p.27

40 National Gallery of Ireland, Dublin. See Barratt 2000, pp.54–5

41 See Wallach 1998, p.301

42 The surviving 500-foot section of the panorama is held by the York Institute, Saco, Maine

43 See Avery 1999 and Montclair 1999, *passim*

44 On patronage in antebellum New York, see Howat 2000

45 See Rebora 1990 and Barratt 2000, pp.50–5. The American Academy of the Fine Arts was founded in 1802 under the title 'New York Academy of Arts', adopting the final form of its name only in 1816. Many of the paintings from its collection are now in the Wadsworth Atheneum, Hartford, Connecticut. On the British Institution see Ann Pullan, 'Public Goods or Private Interests: The British Institution in the early nineteenth century' in Hemingway and Vaughan 1998, pp.27–44

46 National Academy 1943, p.xi

47 See Goodyear 1976

48 Fitz Hugh Lane and Martin Johnson Heade were not members

49 The Art-Union (so named after 1844) began under the name of the 'Apollo Association' which was created as a result of discussions among a group of philanthropic art patrons in 1839 and was registered as a charity in 1840. See Hills 1998, p.316. Its sudden demise in 1852 after it was ruled to be an 'illegal lottery' came at the time of its greatest influence. See Troyen 1991, p.21

50 Quoted Troyen 1991, p.26

51 Durand 1894, p.169, quoted Troyen 1991, p.26

52 *Transactions of the Apollo Association*, 1843, p.8, quoted Hills 1998, p.319. See also Troyen 1991

53 William Cullen Bryant served as the Union's President from 1844

54 *Catalogue of the New-York Gallery of the Fine Arts*, New York 1844, pp.2, 4, quoted Wallach 1998, p.305. The New-York Gallery of Fine Arts was founded largely in order to preserve as a whole the Luman Reed collection, including Cole's *Course of Empire*

55 'Rip Van Winkle' appeared in Washington Irving's *The Sketch-Book of Geoffrey Crayon, Gent.* (1819–20), which appeared under the pseudonym 'Geoffrey Crayon'

56 'Minutes of the Sketch Club' quoted Callow 1967, pp.18–19

57 Regulations of the Century Club, reprinted in *The Century 1847–1946*, New York 1947, quoted Weiss 1987, p.88

58 Howat 1985, pp.36–7. The names 'Century Club' and 'Century Association' seem to have been used interchangeably. See also Weiss 1987, pp.88–9 on Gifford at the Century Club

59 See Blaugrund 1997; Harvey 1998, pp.70–1; Sweeney 1999, pp.141–3

60 See Howard 1991, chapter 5, pp.80–101. Among the painters of southern England, John Linnell, the Williams family, Benjamin Williams Leader and George Vicat Cole were among the most prominent in the period from 1850 to 1880. There was also a vogue for Scottish landscape, especially after Queen Victoria and Prince Albert began making regular trips to Balmoral. Other favourite subjects of the Romantic generation, such as the Lake District and the Welsh mountains, fell from favour

61 See Robertson 1986, pp.199–204, and Myers 1987, pp.31–2

62 Parry 1988, p.165

63 Avery 1987. Kevin Avery demonstrates that the phrase was intended to be disparaging, and was coined only in the late 1870s when the work of these artists had come to seem dated. The phrase 'Hudson River School' is now used in a celebratory fashion, though its parameters remain somewhat indistinct

64 Myers 1987, *passim*

65 Ferber 1990, p.35. The villa, at Irvington, was suburban rather than rural, within easy commuting distance from New York by train. Originally known as 'Hawkrest', it was later renamed 'Malkasten'. Grandiose in scale, it soon became a financial drain even for Bierstadt, one of the most financially successful artists of his day

66 On Olana, see Carr 1989

67 Cole 1835, p.102

68 Marshall Tymn (ed.), *Thomas Cole: The Collected Essays and Prose Sketches*, St Paul, Minnesota 1980, p.131, quoted Wallach 1994, p.51. In his 'Letters on Landscape Painting' of 1855, Durand was even more insistent: 'Go not abroad [he advised young artists] then in search of material for the exercise of your pencil, while the virgin charms of our native land have claims on your deepest affections . . . America's untrodden wilds yet spared from the pollutions of civilization afford a guarantee for a reputation of originality that you may elsewhere long seek and find not.' Asher B. Durand, 'Letters on Landscape Painting: Letter II', *Crayon*, vol.1, 1855, pp.34–5

69 François-René de Chateaubriand, *Recollections of Italy, England and America*, Philadelphia 1816, quoted Nash 1967, p.50

70 The term 'Indian' derives ultimately from Columbus's belief that he had reached India. See the comment of Barbara Groseclose, quoted Fryd 1992, p.5

71 See Trenton and Houlihan 1989, p.11

72 Andrew Jackson's Second State of the Union Address to Congress, 6 December 1830, quoted Schimmel 1991, p.160

73 Catlin 1841, pp.255–6

74 On Catlin, see especially Truettner 1979 and Dippie 1990

75 See, for example, *Omai* (c.1775–7; Royal College of Surgeons, London; repr. Smith 1985, pl.12). The *locus classicus* of the genre is Joshua Reynolds's portrait of Omai, a native of Huahine, who was brought to London with Captain Furneaux in 1775. See Smith 1985, pp.80–4. Cook himself landed on the west coast of America in 1778, this time with the artist John Webber on board. For Webber's representations of the Nootka Indians, at Vancouver Island, now British Columbia, Canada, see Trenton and Houlihan 1989, pp.141–5. There are several examples at the Yale Center for British Art, New Haven, Connecticut

76 See Dippie 1990, pp.103, 107 and pl.5, and Truettner 1979, p.296. The portrait of Little Wolf was singled out for praise by Charles Baudelaire at the Salon of 1846; see Truettner 1979, p.124. Little Wolf is seen wearing two medals, which sit somewhat uneasily amongst his traditional dress and ornamentation, symbolising his acknowledgement of the authority of Europeans

77 Anderson, N. 1997, p.182

78 See for example Thomas Crawford, *The Dying Chief Contemplating the Progress of Civilisation* (c.1855–6; New-York Historical Society, New York; repr. Prown 1992, p.101)

79 The source of this quotation has not been identified; see however Weiss 1987, p.356, note 61, where Lydia Sigourney's phrase 'red-brow'd kings' is noted (Lydia Sigourney, *Poems*, Boston 1827, p.26)

80 See Weiss 1987, p.221

81 Winthrop 1863, p.55, quoted Kelly and Carr 1987, p.70. See full catalogue entry (no.24)

82 Quoted Murphy 1983, p.21

83 De Tocqueville 1971, p.399

84 Cole 1835, p.98

85 Thomas Cole, letter to Robert Gilmor, 21 May 1828, quoted Kelly 1994, p.17

86 Cole's debts to Martin are discussed in Wallach 1994, pp.81–2

87 Foshay 1990, pp.58–62 and 130–40; Wallach 1994, pp.90–5; Miller, A. 1993; Daniels 1993, pp.158–61

88 Cole 1835, p.100

89 Thomas Cole, letter to Luman Reed, 7 September 1835, quoted Parry 1988, p.188. Cole was probably referring here to the wanton destruction of Dutch colonial buildings in New York, which was the subject of much controversy at the time. The term 'improvements' thus had an ironic double meaning. I am grateful to Jules Prown for this insight

90 Quoted Stansell and Wilentz 1994, p.15

91 Wallach 1994 and Miller, A. 1993

92 Cole 1835, p.109

93 Basil Hall, *Travels in North America, in the Years 1827 and 1828*, 3 vols., Edinburgh 1829, I, p.129, quoted Anderson, N. 1992, p.20

94 Cole 1835, pp.101–2

95 Thomas Cole, letter to Luman Reed, 2 March 1836, quoted Parry 1988, p.172

96 See Porther 1999, especially p.204. Subject to various forms of 'apprenticeship' all slaves across the British Empire were to be freed by 1840

97 Quoted Stephanson 1995, p.19

98 See Wallach 1994, pp.91–2

99 Ruskin 1851, p.17

100 The bridge was opened by the Prince Regent (the future George IV) on 18 June 1817; Constable made pencil sketches on the spot and a series of oil studies in subsequent years, exhibiting the finished work only in 1832. An ardent patriot and royalist, Constable may have been seeking patronage from the Prince Regent. Like Cole, he was also undoubtedly referring to Claude's seaport paintings, such as *Seaport with the Embarkation of Saint Ursula* (1641; National Gallery, London). See Parris 1991, pp.206–10. It is possible that Cole might have learned of Constable's projected painting during his visit to England, but I am not asserting a direct connection with *Consummation of Empire*

101 Smiles 1994, pp.165–93

102 For a full discussion see Paley 1986. Cole had, indeed, visited Turner in 1829, when he saw *Snow Storm: Hannibal and his Army Crossing the Alps* (1812; Tate Gallery, London), 'a sublime picture with a powerful effect of Chiaro scuro' (Noble 1853, p.81). While Cole was critical of Turner's technique, this work was surely a decisive influence upon the *Destruction* scene in *The Course of Empire*

103 On 12 December 1829, shortly before his visit to Turner's studio, Cole penned a memorandum in his sketchbook describing 'a series of pictures . . . illustrating the mutation of Terrestrial things'; there follows a description of 'The Course of Empire' quoted on pp.95–7. See Parry 1988, p.116

104 Cole 1835, p.108

105 A series of articles on Cole's works ran in the *New-York Mirror* between 18 April and 12 November 1836. Quoted Wallach 1994, p.95

106 Marx 1988, p.186

107 Maddox 1986

108 National Gallery, London

109 *The Knickerbocker*, vol.42, 1 July 1853, p.95, quoted Roque 1987, p.41

110 Huntington 1980, p.155

111 Wallach 2001 proposed and developed this interpretation

112 McKinsey 1985

113 Adam Badeau, 'American Art', *The Vagabond*, New York 1859, quoted Miller, A. 1993, p.218

114 Tuckerman 1867, p.371

115 Adamson 1981, p.38. On chromolithography see Marzio 1979

116 Henry T. Cheever, *Voices of Nature to her Foster-Child, the Soul of Man: A Series of Analogies between the Natural and the Spiritual World*, New York 1852, p.229, quoted Adamson 1981, p.362

117 Humboldt's multi-volume work which began to appear in German in 1845, with English editions following shortly afterwards. Gould 1988, p.97

118 Smithsonian American Art Museum, Washington DC

119 *Art-Journal*, September 1865, quoted Manthorne 1989, p.69

120 See May 1975

121 Horace Bushnell, *Reverses Needed: A Discourse Delivered on the Sunday after the Disaster of Bull Run, in the North Church, Hartford*, Hartford 1861, quoted Huntington 1980, p.178

122 Huntington 1980, p.180. See Manthorne 1985; Manthorne 1989, pp.67–89; Miller, A. 1993, pp.129–34

123 Musée d'Art Américain, Giverny

124 See Buell 1973

125 Ralph Waldo Emerson, 'Nature', *The Complete Prose Works*, London 1889, p.311, quoted Novak 1969, p.110

126 John Winthrop, 'Conclusions for a Plantation in New England', 1629, quoted Nash 1967, p.31. The Biblical text is from Genesis 1:28

127 William Gilpin, *The Mission of the North American People: Geographical, Social and Political*, Philadelphia 1873, p.99, quoted Nash 1967, p.41

128 John Louis O'Sulllivan, *United States Magazine and Democratic Review*, July 1845, quoted Stephanson, p.xi. My italics

129 Stereochrome was a variation on the waterglass fresco technique developed in Germany. Leutze was born in Germany but emigrated to America. Like Bierstadt he returned to Düsseldorf for his artistic training. See Fryd 1992, p.209

130 For a full discussion of Leutze's image, see Fryd 1992, pp.209–13

131 For a full exposition of this thesis, see Boime 1991

132 Leutze's explanation of the mural, quoted Fryd 1992, p.210

133 Tonson 1752, p.187

134 Tate Gallery, London

135 Eugene Lies, 'Westward, Ho!', *The United States Magazine and Democratic Review*, new series, vol.24, January 1849, p.43, quoted Boime 1991, pp.43–5. A later stanza follows Berkeley by underlining the shifting focus of historical destiny:

> Europe's noon hath long been past;
> All her vain insignia cast
> > Lengthening shadows on her brow;
> Soon she'll mourn in darkness shrouded,
> For her blue sky dimly clouded,
> > Ev'n as Asia mourneth now.

A painting by John Gast, *Westward Ho (American Progress)* (1872; Library of Congress, Washington DC) explores the allegorical possibilities of this poem, resulting in an unfortunate – and unintentionally comical – image

136 The 390,143 square miles of land added also included some of present-day New Mexico and Colorado

137 The Oregon Territory of 285,580 square miles included the modern states of Oregon, Washington and Idaho

138 The total area gained was a massive 529,017 square miles

139 See 'Exploring the Land', chapter 5 of White 1991, and, on the British in Africa, Pratt 1992

140 See Colley 1995, pp.5–7. The great proponent of the 'frontier thesis' of American history was Frederick Jackson Turner; see Faragher 1994. As Linda Colley points out, Turner may have been influenced by reading Sir John Seeley's *The Expansion of England* (London 1883), which drew the comparison between British overseas expansion and the American empire in the west

141 On the interaction between pictorial and literary rhetoric and the history of exploration in America, see Furtwangler 1993, especially chapter 3, 'The American Sublime', pp.23–51

142 Trenton and Hassrick 1983; Haltman 1998

143 Sweeney 1999, pp.134–5. Cole's friend Henry Cheever Pratt travelled to the South West in his place

144 Mitchell 1994, p.10

145 *Magazine of Art*, February 1882, pp.89–93, quoted Anderson, N. 1997, p.234

146 Bierstadt was by no means the first landscape painter to venture into the Western wilderness. Karl Bodmer (1809–1883), Alfred Jacob Miller (1810–1874) and John Mix Stanley (1814–1872) had preceded him, though the resulting works do not compare with the grandeur and ambition of Bierstadt's. See Anderson, N. 1990, p.70

147 Bierstadt 1859, quoted Anderson, N. 1990, p.73

148 Ibid., quoted Anderson, N. 1990, p.73

149 The Düsseldorf style was disparaged by the American devotee of Ruskin, Clarence Cook, as revealing 'too little geology and too much bristle'. See Clarence Cook, *The New Path*, 1864, p.161, quoted Ferber 1990, p.28

150 See for example, William Hodges, *A View of Matavi Bay in the Island of Otaheite* (1776; National Maritime Museum, London; repr. Smith 1985, p.69)

151 Metropolitan Museum of Art, New York

152 *New York Tribune*, 12 March 1864, quoted Anderson, N. and Ferber 1990, p.194. The excellent primary research conducted by Nancy Anderson and Linda Ferber into the reception of Bierstadt's work in the press gives us a uniquely full insight into the reception of an American nineteenth-century painter

153 Henry Tuckerman, quoted Trenton and Hassrick 1983, p.139

154 *Chicago Times*, 31 May 1865, quoted Anderson, N. 1990, p.77

155 *Daily National Intelligencer*, Washington DC, 10 March 1866, quoted Anderson, N. and Ferber 1990, p.204

156 The largest of all Bierstadt's paintings, *The Domes of the Yosemite* (1867; St Johnsbury Athenaeum, St Johnsbury, Vermont) was viewed at the Tenth Street Studio Building from specially constructed galleries, to heighten the illusion of looking down into the valley. The result was 'not unlike that of a set in a theater' according to the *New York Post*, 7 May 1867, quoted Anderson, N. 1990, p.90

157 *New York Leader*, 2 April 1864, quoted Anderson, N. 1990, p.78

158 For Stewart's impact on New York, see Domosh 1996, pp.55–9

159 *Rocky Mountains, 'Lander's Peak'* was bought by railway entrepreneur James McHenry for $25,000; *Storm in the Rocky Mountains – Mt Rosalie* sold to Thomas William Kennard, also a rail entrepreneur, for $20,000. Yet another British railwayman, Edward William Watkin, had bought Church's *Icebergs*. Ferber 1990, p.26

160 Noakes 1985, p.155. Lear bought a set of photographs by Samuel Bourne as an addition to the sketches he made on the spot in the winter of 1874. See Deheja 1989, pp.26–9

161 *Bombay Pioneer*, 11 December 1876, Kipling Papers, University of Sussex

162 On Australia see Johns et al. 1998 and Smith 1985; for New Zealand and the Maori, see especially Bell 1992

163 Louis Agassiz, letter to Frederick Billings, summer 1864, quoted Hambourg 1999, p.10

164 Ryan 1997, chapters 2 and 3

165 Hyde, A. 1990, p.82

166 Ryan 1997, p.48. Both Samuel Bourne and Francis Frith (1822–1898) sold substantial numbers of landscape photographs across Europe and the British Empire, often with an explanatory text

167 See Ryan 1997, pp.47–61, and Sampson 2000. For a comparison, see Edward Lear's visual responses to Simla in Deheja 1989, pp.38–45

168 New York *Leader*, 20 May 1865; San Francisco *Golden Era*, 23 July 1865, both quoted Anderson, N. and Ferber 1990, pp.200–1

169 Frederick L. Olmsted, 'The Yosemite Valley and the Mariposa Big Trees: A

Preliminary Report' (1865), quoted Sweeney 1999, p.135

170 The following relies on the excellent account in Anderson, N. and Ferber 1990, especially pp.46–53

171 F. V. Hayden, 'The Wonders of the West II: More about the Yellowstone', *Scribner's Monthly Magazine*, vol.3, February 1872, p.396

172 W. H. Jackson, 'Famous American Mountain Paintings, I: With Moran in Yellowstone', *Appalachia*, vol.21, 1936, p.157, quoted Anderson, N. 1997, p.53

173 Clarence Cook, 'Art in America in 1883', *Princeton Review*, vol.11, May 1883, pp.312–13, quoted Avery 1987, p.6

174 Anderson, N. 1990, p.100

175 Anderson, N. 1990, p.103. Divisions of the US army charged with exerting control over the Plains Indians found that the slaughter of buffalo, the primary source of food for these people, was more effective than military combat. See also Anderson, N. 1992, pp.18–20

176 On the development of the famous New York skyline at the turn of the century, see Domosh 1996, pp.76–98

177 Buscombe 1993, p.22 and *passim*

1 Wilderness

1 *New-York Evening Post*, 19 February 1848, quoted Sweeney 1994, p.113

2 William Cullen Bryant, 'Thanatopsis', in Bryant 1894, pp.21–3, quotation from p.21

3 For the friendship of Bryant, Cole and Durand see Foshay and Novak 2000; Callow 1967

4 Asher Brown Durand, letter to Maria Cole, 18 February 1848, quoted Lawall 1966, p.517

5 Bryant 1848, p.37

6 See Foshay 1990, p.195. Sturges presented *Kindred Spirits* to Bryant, explaining: 'I requested Mr Durand to paint a picture in which he should associate our departed friend and yourself as kindred spirits . . . a token of gratitude for the labor of love performed on that occasion.' Quoted Lawall 1966, pp.517–18

7 Bryant II 1993, p.33

8 John Keats, 'Sonnet VII', Keats 1895, pp.43–4

9 Bryant 1848, p.40

10 Bryant II 1970, pp.881–2

11 Durand's portrayal of the relationship between Bryant and Cole emphasises the intensity of male friendships during this period; artists' sketching trips were rituals of homosocial bonding. Keats's sonnet does not specify the gender of the 'innocent mind' whose 'sweet converse' could be shared in solitude's haunts; it is a safe assumption that he had a male friend in mind, although much of the sonnet's imagery derives from the conventions of love poetry. The inscription of names in the bark of trees, as in the English Pre-Raphaelite painter Arthur Hughes's *The Long Engagement* (1854–9; Birmingham City Museums and Art Galleries) was a time-honoured element in courtship, and its use here as a labelling device to convey the intellectual and emotional comradeship of Bryant and Cole is striking

12 All topographical information derives from the detailed research of Myers 1987, pp.66–72

13 Asher Brown Durand, *A Tree and a Limb*, 1848; pencil on grey paper, 25.2 × 35.6 (9¹⁵⁄₁₆ × 14); New-York Historical Society

14 Durand and Casilear lodged at the Catskill Mountain House from about 10 September until 23 September, and stayed in the region after that at a boarding house in nearby Palenville. Myers 1987, p.70

15 William Cullen Bryant, 'Forest Hymn' in Bryant 1894, pp.79–82, quotation from pp.80–1. See also Lawall 1966, p.538

16 *New-York Evening Post*, 6 June 1848, quoted Sweeney 1994, p.113

17 See Charles Robert Leslie, *Memorials of John Constable, Esq, RA*, London 1843; Ferber and Gerdts 1985, p.255. See also Barbara Dayer Gallati, 'The Beeches', in Howat 1987, pp.105–7

18 On Durand and Ruskin, see especially Lawall 1966, reprinted New York and London 1977, pp.365–7. Durand owned a set of *Modern Painters*, which was included in his executors' sale in 1887. See Lawall 1966, p.662. On the tendency of the critical literature to deny Ruskin's links to Durand, see Lawall 1966, p.663

19 See Foshay and Novak 2000 for examples

20 *Cincinatti Art Museum Bulletin*, vol.8, no.4., October 1968, p.4

21 See Parry 1988, p.46, and Merritt 1969, pp.23–4

22 See Parry 1988, pp.48–9

23 Ibid., p.37, pl.15

24 For speculation along these lines see Wolf 1982, p.182

25 Wolf 1982, p.177

26 Truettner 1994, p.139

27 McNulty 1983, p.45; see also Parry 1988, p.82

28 Parry 1988, p.58, reproduces an etching of this work by Joseph Goupy (possibly after Rosa) from *c*.1740. It represents an improbably large and anthropomorphic tree. See also Wallace 1979

29 See fuller discussion in the essay by Tim Barringer, pp.49–50

30 Parry 1988, p.83

31 Lawall 1971, p.25

32 Parry 1988, p.218

33 Cole 1835, p.103

34 Ibid., p.103

35 The relationship between tourism and art in the White Mountains is discussed in Avery 2000, pp.109–33, esp. pp.114–19

36 Wallace 1980, pp.17–40; see also Avery 2000, p.115

37 Noble 1853, p.67. See Avery 2000, p.116

38 Cole, autumn journal entry, 1828, quoted Kelly 1996, p.89

39 Theodore Dwight's book *Sketches of Scenery and Manners in the United States* (1829) included an etching by Daniel Wadsworth depicting the avalanche, 'a course which no human power could have resisted, and before which the pyramids of Egypt might have been shaken if not swept away'. Theodore Dwight, *Sketches of Scenery and Manners in the United States*, New York 1829, quoted Avery 2000, p.115

40 This paragraph relies on Bedell 1998, pp.189–90

41 Quoted Kelly 1996, p.89

42 Cole 1835, pp.108–9

43 *The Knickerbocker*, vol.13, June 1839, p.545, quoted Parry 1988, p.223. Parry suggests that this unsigned article was probably written by Lewis Gaylord Clark

44 See Driscoll 1985, p.63

45 See Kelly 1989a, pp.20–1

46 [George William Curtis], 'The Fine Arts: Exhibition of the National Academy, II', *New-York Tribune*, 1 May 1852, p.3. This discovery was made by Franklin Kelly, who quotes the passage in Kelly 1989a, p.20

47 Willis Gaylord Clark, quoted in Revd David Murdoch (ed.), *The Scenery of the Catskill Mountains as Described by Irving, Cooper, Bryant, Willis Gaylord Clark, N. P. Willis, Miss Martineau, Tyrone Power, Park Benjamin, Thomas Cole, and Other Eminent Writers*, 1846, p.15; quoted Howat 1987, p.203

48 Howat 1987, p.205

2 The Course of Empire

1 Ezekiel 38: 20–1

2 Ezekiel 39: 4

3 See Sweeney 1994, pp. 114–15

4 *Home Journal*, 8 May 1852, quoted Lawall 1978, p.92

5 See Sweeney 1994, p.121

6 Quoted Lawall 1978, p.91

7 *The Knickerbocker*, vol.39, 6 June 1852, p.566. Quoted Lawall 1978, p.91

8 *Home Journal*, 8 May 1852, quoted Lawall 1978, p.92

9 Quoted Durand 1894, p.175

10 Quoted Kelly 1994, p.17

11 McNulty 1983, p.33

12 Ibid., p.37

13 Reproduced and discussed by Kelly 1994, pp.29–35

14 See catalogue entry by Kenneth W. Maddox in Novak 1986, pp.58–61

15 See Pointon 1973

16 Quoted Parry 1988, p.73

17 Quoted Parry 1988, p.73

18 *American Monthly Magazine*, 1 August 1833, p.402, quoted Wallach 1994, p.82

19 Cole 1835, p.109

20 Shaw 1820–5, unpag.

21 Repr. Kelly 1994, p.31, and discussed p.30

22 *New-York Mirror*, 28 May 1828, p.367, quoted Parry 1988, p.76

23 See Thomas Cole, letter to Robert Gilmor, 21 May 1828, quoted Noble 1853, pp.64–5

24 McNulty 1983, p.42

25 Boston 1949, pp.192–4. See also Truettner 1994, pp.137–60, esp. pp.139–42

26 James Fenimore Cooper, letter to Louis Noble, 6 January 1849, reprinted Noble 1853, p.166

27 Noble 1853, pp.111–12

28 Quoted Parry 1988, p.116

29 Thomas Cole, letter to Robert Gilmor, 29 January 1832, Cole Papers, quoted Burgard 1990, p.130

30 Cole originally offered ten paintings for $2,500. See Burgard 1990, p.131

31 Thomas Cole, letter to Luman Reed, 18 September 1833, quoted Foshay 1990a, p.60

32 Wilton 1990, pp.61–8

33 Thomas Cole, letter to Luman Reed, 18 September 1833, quoted Parry 1988, p.140

34 Alan Wallach has suggested that Cole might have encountered Berkeley's poem in Dunlap 1834, I, p.23. The date of this poem, often given as 1729, is established by A. A. Luce as 1726 – see Luce and Jessop 1955, p.369. The poem remained unpublished until its appearance in 1752 and the quotation is from Tonson 1752, p.187. I am grateful to John Wells for his help with George Berkeley

35 Cole's literary sources are discussed in Burgard 1990, pp.131–2; Parry 1988, pp.140–2; and Wallach 1968, pp.375–9. The frontispiece to Volney's *Les Ruines*, engraved by P. Martini after an unidentified artist, is reproduced in Parry 1988, p.141

36 Wallach 1968, pp.377–8

37 Parry 1970, p.117

38 Theodore Allen, letter to Thomas Cole, 27 December 1836, quoted Burgard 1990, p.139

39 *Catalogue of the New-York Gallery of the Fine Arts*, New York 1844, pp.2 and 4; quoted Wallach 1998, p.304

40 See *Study for the Savage State* (1833–4; Fine Arts Collection of the Hartford Steam Boiler Inspection and Insurance Co.); *Study for the Savage State* (1834; Art Museum, Princeton University)

41 Thomas Cole, *The Course of Empire*, published for the public exhibition at the National Academy of Design, New York 1836, quoted Parry 1970, p.193

42 See Haskell and Penny 1981, pp.221–4. The likeness is not exact, notably with regard to the position of the head, and Parry 1988, p.157, has suggested as a source the Apollo Belvedere, mediated by Rubens's painting *The Government of Marie de' Medici* (1622–5; Louvre, Paris). The position of both arms and legs exactly matches the *Gladiator*, however, a far more vigorous and animated body type

43 Hobbes 1996, pp.91 and 89

44 Thomas Cole, *The Course of Empire*, published for the public exhibition at the National Academy of Design, New York 1836, quoted Parry 1970, p.193

45 Rousseau 1994, pp.54–5. Cole's circle was well aware of Rousseau's ideas: his younger friend John Frederick Kensett picked flowers at Rousseau's grave on 22 September 1847 and preserved them for the rest of his life. See Driscoll 1985, p.55

46 See Parry 1998, pp.154, 156

47 An excellent discussion of this material can be found in Stocking 1987

48 See for example John Glover's *Western View of Mountains* (1833; Tasmanian Museum and Art Gallery; repr. Smith 1985, p.267)

49 Quoted Parry 1988, p.159

50 Vasari 1965, p.57. See Parry 1988, pp.162–3 and Wallach 1994, pp.23–4

51 Smiles 1994, pp.165–93

52 William Dunlap, 'In Praise of Coles Recent Pictures', *New-York Mirror*, 6 December 1834, quoted Parry 1988, p.162

53 Cole's description (followed by all subsequent commentators) describes the conqueror's robe as 'purple', which would be symbolically appropriate for an imperial victor, but its present appearance is closer to crimson. See Cole quoted Parry 1988, p.168

54 All quotes are from Cole's prose description of the series, quoted Parry 1988, p.168

55 Malthus 1798

56 Thomas Cole, letter to Luman Reed, 30 November 1835, quoted Parry 1970, p.99

57 Thomas Cole, letter to Luman Reed, 19 February 1836, quoted Burgard 1990, p.135

58 Thomas Cole, letter to Luman Reed, 2 March 1835, quoted Parry 1970, p.101

59 An exhaustive study of possible sources can be found in Parry 1988, pp.167–71 and Parry 1970, pp.98–113

60 Thomas Cole's London Sketchbook, 1829, Cole Papers, quoted Burgard 1990, p.134

61 See Butlin and Joll 1984, nos.131 and 135

62 See *Reconstruction of the Porch of the Maidens, Erectheum*, from James Stuart and Nicholas Revett, *Antiquities of Athens*, II, London 1787, chapter II, pl.XVI, repr. Parry 1970, pl.125B

63 See Pevsner 1952, p.204. Henry Inwood published an illustrated description of *The Erectheion at Athens* in 1827, which provides another possible source for Cole's image

64 *New-York Mirror*, 4 Nov 1836, vol.14, p.150, quoted Burgard 1990, p.135

65 Wallach 1994, pp.94–5; Miller, A. 1989

66 Thomas Cole, letter to Asher Brown Durand, 30 August 1836, quoted Parry 1970, p.117

67 Thomas Cole, letter to Luman Reed, probably 14 January 1836, quoted Parry 1970, p.117

68 Cole's prose description of the series, quoted Parry 1988, p.181

69 Thomas Cole, *1st Sketch for the 4th Picture of the Course of Empire* (c.1835–6; pen and brown ink over pencil on paper, 17.8 × 26.5 (7 × 10 7/16); Detroit Institute of Arts. 39.352)

70 Thomas Cole, letter to Asher Brown Durand, 7 June 1836, Durand Papers, quoted Burgard 1990, p.136

71 James Basire, *Section of the Frieze from the Monument to Lysicrates*, engraving, published in James Stuart and Nicholas Revett, *Antiquities of Athens*, I, London 1762, repr. Parry 1988, p.182

72 Thomas Cole's sketchbook, 1829, quoted Parry 1970, p.117

73 Born 1948, pp.81–3; Parry 1970, p.119

74 Cole's prose description of the series, quoted Parry 1988, p.184

75 Jasper Francis Cropsey, letter to Maria Cropsey, 7 July 1850; typescript transcription in Newington-Cropsey Foundation, Hastings-on-Hudson, New York

76 Butlin and Joll 1984, nos.133 and 134

77 Ibid., nos.375 and 374

78 Ibid., nos.378 and 379

79 Ibid., nos.399 and 400

80 See Truettner and Wallach 1994, pp.114–16; Cropsey's oil study for the picture, repr. Truettner and Wallach 1994, is in the Thyssen-Bornemisza Collection

81 Four studies for this exist: one in the Albany Institute, New York; two in the Smithsonian Institution, Washington DC; and one in the

Thyssen-Bornemisza Collection in Lugano; repr. Earl A. Powell III, *Thomas Cole*, New York 1990, pp.123–5

3 The Still Small Voice

1 Howat 1987, p.221
2 *The Century*, New York 1880, p.44, quoted Howat 1987, p.226
3 Quoted Kelly 1994, p.17
4 The quotation is from the opening of Book Nine. See Gerdts 1977, p.9
5 See Foshay and Mills 1983, pp.4–42; Kelly and Carr, pp.136–7
6 Kelly 1988, p.32
7 'Movements of Artists', *Bulletin of the American Art-Union*, April 1850, p.15, quoted Kelly and Carr 1987, p.108
8 See Hills 1998, pp.314–39. See also Troyen 1991
9 Topographical information derives from Kelly and Carr 1987, pp.112–14 and 154–5
10 *New York Tribune*, 10 May 1851, quoted Kelly and Carr 1987, p.5
11 Winthrop 1863, p.55, quoted Kelly and Carr 1987, p.70
12 Ibid. 1863, p.99, quoted Belanger 1999, p.75
13 Henry David Thoreau, 'Ktaadn and the Maine Woods', *The Union Magazine* (1848), reprinted in *The Maine Woods*, New York 1961, quoted Kelly 1988, p.67. My reading of this painting relies heavily on Kelly's detailed and compelling discussions, which themselves draw on earlier work by David Huntington and Theodore Stebbins. See Kelly 1988, pp.67–77. See also Stebbins 1971, p.16
14 Henry David Thoreau, 'Ktaadn and the Maine Woods', *The Union Magazine* (1848) reprinted in *The Maine Woods*, New York 1961; quoted Kelly 1988, p.68
15 Henry David Thoreau, 'Ktaadn and the Maine Woods', *The Union Magazine* (1848) reprinted in *The Maine Woods*, New York 1961, p.93, quoted Wilmerding 1988, p.115
16 Pratt 1985, p.153
17 Winthrop 1863, p.22, quoted Belanger 1999, pp.79–80
18 *The Knickerbocker*, vol.42, July 1853, p.94, quoted Kelly 1988, p.72
19 See Kelly 1988, p.103
20 See Harvey 1998, pp.170–1
21 See Carr 1994, II, pl.19
22 *New York Times*, 20 April 1859, quoted Carr 1994, p.255
23 *Boston Evening Transcript*, 7 April 1860, quoted Kelly 1988, p.113
24 'Art Matters in Baltimore', *Boston Evening Transcript*, 4 March 1861, quoted Carr 1980, p.16
25 *Boston Evening Transcript*, 5 June 1860, reprinted Kelly 1988, p.130
26 'W.G.D.', 'Mr Church's Picture "Twilight in the Wilderness"', *Evening Post*, 21 June 1860, quoted Kelly 1988, p.134
27 Jarves 1866, p.232

4 'Awful Grandeur'

1 Dwight 1825, pp.92–7, quoted Avery 2000, p.113
2 Cole 1835, pp.103–4
3 Carol Troyen suggests that his first visit might have been made as early as 1850; Carol Troyen, 'Lake George', in Howat 1987, pp.156–7
4 John Frederick Kensett, letter to J. R. Kensett, 30 March 1854, quoted Spassky 1985, p.35
5 Both works are reproduced in Driscoll and Howat 1985, pp.124–5, pls.28 and 29
6 Avery 2000, p.111
7 *New-York Evening Post*, 27 April 1869, quoted Spassky 1985, p.36
8 Repr. Kelly 1996, p.120
9 *Art-Journal*, 1857, p.173
10 *Art-Journal*, July 1860, p.199
11 *Art-Journal*, November 1860, p.336
12 Jasper Francis Cropsey, letter to his wife, 5 August 1852, quoted Foshay and Finney 1987, p.82

13 New York *Independent*, 12 January 1854, quoted Howat 1987, p.211
14 Oral communication from Gerald Carr
15 Talbot 1970, p.440
16 Kenneth W. Maddox in Novak 1986, pp.78–80
17 See Franklin Kelly in *Paintings from the Manoogian Collection*, National Gallery of Art, Washington DC 1989, p.44
18 Henry Wadsworth Longfellow, *Evangeline, A Tale of Acadie*, Boston 1847, line 1
19 Repr. Howat 1987, p.223
20 See Howat 1987, pp.222–4
21 Repr. Ilene Susan Fort and Michael Quick, *American Art: A Catalogue of the Los Angeles County Museum of Art Collection*, Los Angeles 1991, p.183
22 Diary of Charles Tracy, 9 August 1855, quoted Belanger 1999, p.82
23 *New York Times*, 24 June 1863, quoted Belanger 1999, p.82
24 Repr. Voorsanger and Howat 2000, p.407
25 *Home Journal*, 9 May 1857, quoted Huntington 1960, p.86
26 The exception is Adamson 1981, II, pp.571–8, on which this account largely relies
27 See Adamson 1981, II, p.573, and Edinburgh 1980, unpag.
28 See Adamson 1981, II, p.572, and Adamson 1985, p.37
29 See Adamson 1981, II, p.572, and IV, illus.165
30 Edinburgh 1980, unpag.
31 Troyen 1984, p.5
32 'Mr Church's New Picture of Niagara', *Saturday Review*, London, n.d., quoted Adamson 1985, p.70
33 A London critic quoted in *The New Niagara by Frederic E. Church*, Boston, n.d., quoted Huntington 1960, p.94
34 *Illustrated London News*, 7 March 1868, p.238, quoted Adamson 1981, II, p.583
35 Ibid.
36 *The New Niagara by Frederic E. Church*, Boston, n.d., quoted Huntington 1960, p.94
37 Ibid., p.95
38 See *Weekly Scotsman*, 30 April 1887, transcript, National Gallery of Scotland files, Edinburgh
39 *Round Table*, 9 September 1865, quoted Anderson, N. and Ferber 1990, p.181

5 Painting from Nature

1 'Inigo' (Charles Henry Webb), 'Bierstadt's Sketches', San Francisco *Golden Era*, 27 September 1863, p.5, cited Harvey 1998, p.78
2 Sullivan 1981, p.104. See also McKinsey 1985, p.74 and *passim*, and Adamson 1981, I, pp.60–215
3 James Dixon, 1849, quoted Sullivan 1981, p.106
4 Repr. Harvey 1998, p.70
5 George W. Curtis, 'Editor's Easy Chair', *Harper's New Monthly Magazine*, vol.46, March 1873, pp.611–12, quoted Harvey 1998, p.70
6 Cash 1994, p.37
7 *Art-Journal*, August 1861, p.242
8 Ibid.
9 Repr. Harvey 1998; p.215
10 Tate Gallery, London; repr. Christopher Newall, *John William Inchbold*, exh. cat. Leeds City Art Gallery 1993, p.38
11 Adamson 1981, II, p.308
12 William James Bennett, *American Fall from the Foot of the Staircase*, 1829; aquatint; Public Archives, Canada; repr. McKinsey 1985, p.83
13 Adamson 1981, II, p.322; Johns et al. 1998, p.164 (entry by Amy Ellis); Kornhauser 1996, I, p.201–4
14 Transcribed Kornhauser 1996, I, p.202
15 John Ruskin, Section V, 'Of Truth and Water', Chapter 1, 'Of Water, As Painted by the Ancients' in *Modern Painters*, I, 1843; reprinted in *The Works of John Ruskin*, ed. E. T. Cook and A. Wedderburn, London 1903–12, p.494. Partially quoted Kornhauser 1996, I, p.202
16 *Home Journal*, 3 January 1857, quoted Adamson 1981, II, p.330

17 *Crayon*, 4 February 1857, quoted Carr 1994, I, p.232. See also Harvey 1998, p.162, and Adamson 1981, II, p.331

18 'Our Private Correspondence', *Home Journal*, 9 May 1857, p.2, cited Kelly 1989, p.51

19 See Carr 1994, I, pp.230–3 for an extended discussion

20 See Belanger 1999, pp.59–60. See also Kelly and Carr 1987, no.21, p.135

21 Bryant 1872, I, p.2

22 For the relationship between painting and sketch see Carr 1994, I, nos.351 and 352, pp.215–17

23 Transcribed by Gerald L. Carr, see CARR1994, I, pp.215–6

24 For an important discussion of this series of works, see Kelly 1988. *Sunset, Bar Harbor* is reproduced as *Study for a Sunset, c.*1854–5, and discussed on p.87

25 See Carr 1994, I, p.293 for clarification of this issue

26 Frederic Edwin Church, letter to Erastus Dow Palmer, 19 August 1872, Albany Institute, New York, quoted Carr 1994, I, p.382

27 See Carr 1994, I, pp.381–2; *Nightfall near Olana*, 1872; Cooper-Hewitt Museum, New York, 1917-4-587; repr. Stebbins 1978, p.104

28 See Carr 1994, I, pp.354–5, no.504 for a discussion of the possible role in Church's teaching

29 See Carr 2000, p.63

30 Alexander von Humboldt, *Cosmos*, I, New York 1850, p.24; cited in Novak 1995, p.70

31 Repr. Kelly 1989, p.84

32 Repr. Egerton 1990, p.179; another version is untraced

33 Carr 1994, no.345

34 Carr 1994, no.385; repr. in colour Carr 2000, p.145, pl.24

35 Frederic Edwin Church, Sangay Diary, cited Carr 1994, p.243

36 See for instance Carr 1994, no.384; and Cooper-Hewitt, National Museum of Design, New York, 1917-4-401A, repr. Carr 1994, p.244, fig.77

37 Carr 1994, p.244

38 Repr. Harvey 1998, p.178

39 Repr. Kelly 1989, p.118

40 See Carr 1980, *passim*, and Katherine E. Manthorne, 'Icebergs and Wreck in Sunset' in Novak 1986, pp.96–8

41 Bierstadt 1859, cited Anderson, N. and Ferber 1990, p.145

42 Bierstadt 1859, cited Harvey 1998, p.238

43 Repr. Anderson, N. and Ferber 1990, p.169, no.32

44 Repr. Anderson, N. and Ferber 1990, p.31, fig.8

45 Repr. Anderson, N. and Ferber 1990, p.191, no.34

46 *San Francisco Daily Evening Bulletin*, 5 March 1872, cited in Anderson, N. and Ferber 1991, p.236; see also Harvey 1998, p.258

47 Repr. Anderson, N. and Ferber 1990, p.225

48 Repr. Anderson, N. 1997, p.136

49 Repr. Anderson, N. 1997, p.296

50 Butlin and Joll 1984, no.357

51 See *John Brett: A Pre-Raphaelite on the Shores of Wales*, National Museum of Wales, Cardiff 2001

52 Repr. Anderson, N. 1997, p.138

53 Repr. Anderson, N. 1997, p.140

54 Repr. Anderson, N. 1997, p.250

6 A Transcendental Vision

1 For a full discussion see Belanger 1999, pp.29–45

2 See Carbone 1998, pp.66–7

3 The trips to Mount Desert were made in 1850, 1851, 1852, 1855 and 1863; see Belanger 1999, p.90

4 *Gloucester Daily Telegraph*, 17 September 1853, quoted Wilmerding 1971, p.52

5 Ibid.

6 Quoted Gerdts 1985, pp.49 and 48

7 On nineteenth-century geologists' responses to Mount Desert, see Wilmerding 1988a, pp.108–10. See also Barbara Novak, 'The Geological Timetable: Rocks' in Novak 1995, pp.47–77

8 Kelly 1988a, p.148

9 Undated press clipping, Cape Ann Historical Association, Gloucester, Massachusetts; quoted Oaks 1989, p.20

10 See Ellis 1998 for a detailed discussion of the topography and its impact on, and appearances in, Lane's work

11 For an example of Lane's panoramic lithographs, see *View of the Town of Gloucester, Mass.* (1836; repr. Ronnberg 1988, p.84). See also *Gloucester Harbor* (1852; Cape Ann Historical Association, Gloucester, Massachusetts) in which modern buildings such as the Pavilion, a garish new hotel, can clearly be seen

12 Kelly 1996, I, p.411

13 Ibid., p.412. For further details of these craft see Ronnberg 1988

14 Ronnberg 1988, p.89

15 The juxtaposition is made in Wilmerding 1980, pp.58–9, pls.7 and 8

16 Quoted Gerdts 1985, pp.47–9

17 See Wilmerding 1971, p.83

18 See Barbara Novak's discussion of the work in Novak 1995, pp.96–7. Constable's phrase appears in his letter to John Fisher of 23 October 1821, reprinted in Charles Harrison and Paul Wood, *Art in Theory, 1815–1900: An Anthology of Changing Ideas*, Oxford 1998, p.118

19 Ronnberg 1988, pp.61–104; see esp. p.96

20 See Belanger 1999, p.91

21 The drawings are titled *West Harbor and Entrance of Somes Sound* and *Southwest Harbor, Mount Desert* (both 1852; Cape Ann Historical Association, Gloucester, Massachusetts)

22 Frederic Alan Scharf, 'Fitz Hugh Lane: Visits to the Maine Coast, 1848–1855', *Essex Institute Historical Collections*, no.98, April 1962, p.112, quoted Belanger 1999, pp.91–2

23 Novak 1995, pp.255–60; 266–73

24 These connections are fully explored by Davis 1993, pp.18–23

25 Wilmerding 1988, p.104

26 From an inscription on the sketch it seems that Lane received five commissions for oils of the subject, of which three can be traced today, all on canvases of 10 x 15 inches. The other extant versions are *Brace's Rock*, 1864, oil on canvas, Collection of Mr and Mrs Harold Bell; *Brace's Rock*, 1864, Private Collection; both reproduced Wilmerding 1988, pp.36–7

27 Wilmerding 1971, pp.89–90

28 For a sophisticated discussion of 'The Iconology of Wrecked or Stranded Boats in Mid to Late-Nineteenth Century American Culture', see Miller, D. 1993, esp. pp.192–4

29 See Driscoll 1985, pp.102–3 and 190, note 74. Other versions are in the Jane Voorhees Zimmerli Art Gallery, Rutgers, New Jersey, and in three private collections

30 See Huntington 1980, p.166

31 Sullivan 1981, p.133

32 T. M. Clarke, 'Newport', in Bryant 1872, I, p.366, quoted Kelly 1996, p.392

33 Tuckerman 1867, p.511, quoted Sullivan 1981, p.75

34 See Dwyer 1985, p.170

35 This suggestion is Carol Troyen's. See 'Eaton's Neck, Long Island' in Howat 1987, pp.160–2

36 For a contrary view see John Wilmerding's assertion that the painting is unfinished in 'The Luminist Movement: Some Reflections', in Wilmerding 1980, p.115

37 See Roque 1985

38 The following paragraph relies on Roque 1985, pp.144–5

39 Roque 1985, p.148

40 See for example William Hodges, *View of the Islands of Otah and Bola Bola* (National Maritime Museum, London); repr. Smith 1985, p.26

41 See for example Caspar David Friedrich, *Mondaufgang am Meer*, 1822 (Nationalgalerie, Berlin), in Foster-Hahn 2001, pp.69–70

42 Roque 1985, p.140

43 Stebbins 2000, no.620.13; the page numbered '25' by Heade
44 Ibid., no.620.28; numbered '50' by Heade
45 Stebbins 1999, p.29
46 Stebbins 2000, p.41
47 Ibid. 2000, p.112
48 *Brooklyn Daily Eagle*, 12 November 1877

7 Explorations

1 Repr. Kelly 1989, p.83
2 Wilton 1979, no.1547
3 *Harper's Magazine*, 30 May 1857, p.339, cited Huntington 1980, p.155
4 Alexander von Humboldt, *Cosmos*, I, New York 1850, p.48; cited in Novak 1995, p.74
5 Ralph Waldo Emerson, 'The Over-Soul', *The Complete Prose Works*, London 1889, p.72
6 *The Knickerbocker*, vol.48, July 1856, p.33, cited in Kelly 1989, p.50
7 Carr 2000 p.66
8 See for instance Huntington 1980, pp.156–7 and 177
9 Miller, A. 1993, p.133
10 Kelly 1989, p.61
11 Miller, A. 1993, p.130
12 Ibid., p.129
13 Repr. Kelly 1989, p.60 fig.31
14 Quoted Carr 2000, p.68
15 Tuckerman 1867, p.371, cited in Novak 1995, p.50
16 *Art-Journal*, September 1865, p.265
17 Repr. Carr 2000, pl.28
18 Huntington 1980, p.180
19 Carr 2000, p.70
20 Huntington 1980, p.180. David Huntingon's essay 'Church and Luminism: Light for America's Elect' is an important investigation of Christian imagery in the work of Church and his contemporaries
21 *Art-Journal*, December 1865, p.362
22 Miller, A. 1993, pp.135–6
23 Wilton 1979, no.399
24 Cited in Carr 2000, p.68
25 What follows relies on the exhaustive account provided by Carr 1980, pp.43–54
26 Noble 1861, p.28.
27 Ibid., pp.84 and 85, quoted Carr 1980, p.44
28 Ibid., p.166, quoted Carr 1980, p.48
29 Carr 1980, p.44
30 See Carr 1980, pp.22–4
31 Repr. Carr 1980, p.69
32 A photocopy of the broadside published in Boston in 1862 exists among the Church papers at Olana. Quoted and paraphrased in Carr 1980, p.82
33 Frederic Edwin Church, *The North*, broadside, Boston 1862, quoted Carr 1980, p.82
34 *New-York Daily Tribune*, 24 April 1861, p.7, quoted Carr 1980, p.82
35 *The World*, New York, 29 April 1861, quoted Carr 1980, p.20
36 Ibid., quoted Carr 1980, p.82
37 *Christian Register*, 22 February 1862, p.26, quoted Carr 1980, p.85

38 *Manchester Guardian*, 19 June 1863, quoted Carr 1980, p.90
39 Review of the chromolithograph of *The Icebergs* by Charles Ridson, *Art-Journal*, March 1865, p.96, quoted Carr 2000, p.83
40 Carr 1980, p.96
41 Unidentified newspaper review from Church's cutting book, of which a photocopy survives at Olana, quoted Carr 1980, p.22

8 The Great West

1 Repr. Anderson, N. 1990, p.195
2 Fitz Hugh Ludlow, *The Heart of the Continent*, New York 1870, p.412, cited in Anderson, N. and Ferber 1990, p.79
3 San Francisco *Golden Era*, cited Anderson, N. 1985, pp.232
4 Albert Bierstadt, letter to John Hay, 22 August 1863, cited Anderson, N. and Ferber 1990, p.178
5 Fitz Hugh Ludlow, cited in Hendricks 1988, p.16
6 Karolik Collection 1815–1865, 47.1236; repr. Anderson, N. and Ferber 1990, p.199
7 Repr. Anderson, N. and Ferber 1990, p.90 fig.58
8 New York *Leader*, 20 May 1865, cited Anderson, N. and Ferber 1990, p.200
9 San Francisco *Golden Era*, 26 July 1865, cited Anderson, N. and Ferber 1990, p.201
10 Ambrose Bierce, cited in John and LaRee Caughey, *California Heritage; an anthology of history and literature*, Los Angeles 1962, p.328
11 William Newton Byers, 'Bierstadt's Visit to Colorado', *Magazine of Western History*, 11 (January 1890), pp.237–40; cited Anderson, N. and Ferber 1990, p.89
12 Ibid.
13 Fitz Hugh Ludlow, 'Reminiscences of an Overlander', San Francisco *Golden Era*, 28 February 1864; cited Anderson N. and Ferber 1990, p.88
14 *Art-Journal*, September 1869, p.289
15 Albert Bierstadt, letter to John Hay, 22 August 1863, cited Anderson, N. and Ferber 1990, p.178
16 *Art-Journal*, August 1868, p.159
17 Repr. Anderson, N. and Ferber 1990, p.209, no.48
18 *Art-Journal*, August 1868, p.159
19 Longfellow's note on *Hiawatha* in *The Poetical Works of Longfellow Including Recent Poems*, London n.d., p.615
20 Butlin and Joll 1984, no.330
21 See David Blayney Brown, 'Imitation and Independence: Turner, Moran, and Historical Landscape' in Townsend 1998, p.47
22 Butlin and Joll 1984, no.115
23 The picture is Butlin and Joll 1984, no.19; the print is no.6 in W. G. Rawlinson, *Turner's Liber Studiorum, A Description and a Catalogue*, 1878, pp.17–19
24 'Cheemaun' is Hiawatha's birch canoe
25 Repr. Townsend 1998, p.23, fig.21
26 Repr. Anderson, N. 1997, p.62, no.10
27 Repr. Anderson, N. 1997, p.73, no.23
28 See Kinsey 1992, pp.132–4
29 Ibid.
30 *East Hampton* Star, 4 November 1904, cited in Anderson, N. 1997, p.268
31 Repr. Anderson, N. 1997, p.268

Bibliography

ADAMSON 1981 Jeremy Elwell Adamson, *Frederic Edwin Church's 'Niagara': The Sublime as Transcendence*, 4 vols, Ph.D. dissertation, University of Michigan 1981, published Ann Arbor 1983.

ADAMSON 1985 Jeremy Elwell Adamson, 'Nature's Grandest Scene in Art', in Adamson et al. 1985, pp.11–81.

ADAMSON et al. 1985 Jeremy Elwell Adamson, Elizabeth McKinsey, Alfred Runte and John F. Sears, *Niagara: two centuries of changing attitudes, 1697–1901*, exh. cat., Corcoran Gallery of Art, Washington DC 1985.

ANDERSON, B. 1983 Benedict Anderson, *Imagined Communities: Reflections on the Origin and Spread of Nationalism*, London 1983.

ANDERSON, N. 1985 Nancy K. Anderson, 'Albert Bierstadt: The Path to California, 1830–1874', unpublished Ph.D. dissertation, University of Delaware 1985.

ANDERSON, N. 1990 Nancy K. Anderson, '"Wondrously Full of Invention": The Western Landscapes of Albert Bierstadt', in Anderson N. and Ferber 1990.

ANDERSON, N. 1992 Nancy K. Anderson, '"Curious Historical Artistic Data": Art History and Western American Art', in Prown 1992, pp.1–36.

ANDERSON, N. 1997 Nancy K. Anderson, with contributions by Thomas P. Bruhn, Joni L. Kinsey, and Anne Morand, *Thomas Moran*, exh. cat., National Gallery of Art, Washington DC 1997.

ANDERSON, N. and FERBER 1990 Nancy K. Anderson and Linda S. Ferber with a contribution by Helena E. Wright, *Albert Bierstadt: Art and Enterprise*, exh. cat., Brooklyn Museum, New York 1990.

ANDERSON, P. 1984 Patricia Anderson, *The Course of Empire: The Erie Canal and the New York Landscape*, exh. cat., Memorial Art Gallery of the University of Rochester, Rochester NY 1984.

AUERBACH 1999 Jeffrey Auerbach, *The Great Exhibition of 1851: A Nation on Display*, New Haven 1999.

AUERBACH 2001 Jeffrey Auerbach, 'The Great Exhibition and Historical Memory', *Journal of Victorian Culture*, vol.6, no.1, Spring 2001, pp.89–112.

AVERY 1987 Kevin J. Avery, 'The Historiography of the Hudson River School', in Howat 1987, pp.3–20.

AVERY 1993 Kevin J. Avery, *Church's Great Picture: 'The Heart of the Andes'*, exh. cat., Metropolitan Museum of Art, New York 1993.

AVERY 1999 Kevin J. Avery, 'Movies for Manifest Destiny', in Montclair 1999, pp.1–12.

AVERY 2000 Kevin J. Avery, 'Selling the Sublime and the Beautiful: New York Landscape Painting and Tourism', in Voorsanger and Howat 2000, pp.109–33.

AVERY and FODERA 1988 Kevin J. Avery and Peter L. Fodera, *John Vanderlyn's Panoramic View of the Palace of Versailles*, New York 1988.

BAIGELL and KAUFMAN 1981 Matthew Baigell and Allen Kauffman, 'Thomas Cole's *The Oxbow*: A Critique of American Civilization', *Arts*, vol.55, January 1981, pp.136–9.

BARRATT 2000 Carrie Rebora Barratt, 'Mapping the Venues: New York City Art Exhibitions', in Voorsanger and Howat 2000, pp.47–65.

BARRINGER 2001 Timothy Barringer, 'National Myths and the Historiography of Nineteenth-Century American Landscape Painting: A European Perspective', in Thomas Schmutz and Peter Schneemann (eds.), *Masterplan*, Bern 2001.

BEDELL 1998 Rebecca Bedell, 'Thomas Cole and the Fashionable Science', in Meyers 1998, pp.176–206.

BELANGER 1999 Pamela J. Belanger, *Inventing Arcadia: Artists and Tourists at Mount Desert*, exh. cat., Farnsworth Art Museum, Farnsworth ME 1999.

BELL 1992 Leonard Bell, *Colonial constructs: European images of Maori, 1840–1914*, Carlton, Victoria 1992.

BERCOVITCH 1975 Sacvan Bercovitch, *The Puritan Origins of the American Self*, New Haven 1975.

BERMINGHAM 1968 Peter Bermingham, *Jasper F. Cropsey 1823–1900, A Retrospective View of America's Painter of Autumn*, exh. cat., University of Maryland Art Gallery 1968.

BIERSTADT 1859 Albert Bierstadt, 'Letter from the Rocky Mountains', letter dated 10 July in *Crayon*, vol.6, September 1859, p.287.

BLAUGRUND 1997 Annette Blaugrund, *The Tenth Street Studio Building: Artist-Entrepreneurs from the Hudson River School to the American Impressionists*, exh. cat., Parrish Art Museum, Southampton NY 1997.

BOIME 1991 Albert Boime, *The Magisterial Gaze: Manifest Destiny and American Landscape Painting, c.1830–1865*, Washington and London 1991.

BORN 1948 Wolfgang Born, *American Landscape Painting: An Interpretation*, New Haven 1948.

BOSTON 1949 Boston, Museum of Fine Arts, *The M. and M. Karolik Collection of American Paintings, 1815 to 1865*, Cambridge MA 1949.

BRYANT 1848 William Cullen Bryant, *A Funeral Oration occasioned by the death of Thomas Cole, delivered before the National Academy of Design, 4 May 1848*, New York 1848.

BRYANT 1872 Willam Cullen Bryant, *Picturesque America, or, The land we live in*, New York 1872.

BRYANT 1894 H. C. Edwards (ed.), *The Complete Poems of William Cullen Bryant*, New York c.1894.

BRYANT II 1970 William Cullen Bryant II, 'Poetry and Painting: A Love Affair of Long Ago', *American Quarterly*, vol.22, 1970, pp.881–2.

BRYANT II 1993 William Cullen Bryant II, *Highlands Sketches: The Hudson River in the Eye of the Beholder*, Nelsonville NY 1993.

BUELL 1973 Lawrence Buell, *Literary Transcendentalism: Style and Vision in the American Renaissance*, Ithaca 1973.

BURGARD 1990 Timothy Anglin Burgard, 'The Luman Reed Collection: Catalogue', in Foshay 1990, pp.121–92.

BURNS 1989 Sarah Burns, *Pastoral Inventions: Rural Life in Nineteenth-Century American Art and Culture*, Philadelphia 1989.

BURROWS and WALLACE 1999 Edwin G. Burrow and Mike Wallace, *Gotham: A History of New York to 1898*, New York and Oxford 1999.

BUSCOMBE 1993 Edward Buscombe (ed.), *The British Film Institute Companion to the Western*, London 1993.

BUTLIN and JOLL 1984 Martin Butlin and Evelyn Joll, *The Paintings of J. M. W. Turner*, 2 vols, revised ed., New Haven and London 1984.

CALLOW 1967 James T. Callow, *Kindred Spirits: Knickerbocker Writers and American Artists, 1807–1855*, Chapel Hill 1967.

CARBONE 1998 Teresa A. Carbone, 'Fitz Hugh Lane, *Off Mount Desert Island*', in *Masterpieces of American Painting in the Brooklyn Musuem*, exh. cat., Jordan-Volpe Gallery, New York 1998, pp.66–7.

CARR 1980 Gerald L.Carr, *Frederic Edwin Church: The Icebergs*, Dallas 1980.

CARR 1989 Gerald L. Carr, *Olana Landscapes: The World of Frederic E. Church*, New York 1989.

CARR 1994 Gerald L. Carr, *Frederic Edwin Church: Catalogue Raisonné of Works of Art at Olana State Historic Site*, 2 vols, Cambridge 1994.

CARR 2000 Gerald L. Carr, *In Search of the Promised Land: Paintings by Frederic Edwin Church*, New York 2000.

CASH 1994 Sarah Cash, *Ominous Hush: The Thunderstorm Paintings of Martin Johnson Heade*, exh. cat., Amon Carter Museum, Fort Worth 1994.

CATLIN 1841 George Catlin, *Letters and Notes on the Manners, Customs, and Condition of the North American Indians*, first published in 2 vols, 1841, reprinted New York 1973.

CAUGHEY AND CAUGHEY 1962 John and Laree Caughey, *California Heritage: an Anthology of History and Literature*, Los Angeles 1962.

CIKOVSKY 1970 Nicolai Cikovsky, Jr., *Sanford Robinson Gifford (1823–1880)*, Austin, Texas 1970.

CIKOVSKY 1979 Nicolai Cikovsky, Jr., '"The Ravages of the Axe": Meaning of the Tree Stump in Nineteenth-Century American Art', *The Art Bulletin*, vol.61, no.4, December 1979, pp.611–26.

CLARK 1954 Eliot Clark, *History of the National Academy of Design, 1825–1953*, New York 1954.

COLE 1835 Thomas Cole, 'Essay on American Scenery', 1835, reprinted in McCoubrey 1965, pp.98–109.

COLLEY 1995 Linda Colley, *The Significance of the Frontier in British History*, Austin, Texas 1995.

CUMMINGS 1865 Thomas S. Cummings, *Historic Annals of the National Academy of Design*, Philadelphia 1865.

DANIELS 1993 Stephen S. Daniels, *Fields of Vision: Landscape Imagery and National Identity in England and the United States*, Princeton NJ 1993.

DANLY and MARX 1988 Susan Danly and Leo Marx (eds.), *The Railroad in American Art: Representations of Technological Change*, Cambridge MA 1988.

DAVIS 1993 Elliot Bostwick Davis, *Training the Eye and Hand: Fitz Hugh Lane and Nineteenth-Century American Drawing Books*, Gloucester MA 1993.

DEAK 1988 Gloria Gilda Deak, *Picturing America: Prints, Maps and Drawings bearing on the New World Discoveries and on the Development of the Territory that is now the United States*, Princeton NJ 1988.

DEE 1992 Elaine Evans Dee, *Frederic E. Church: Under Changing Skies. Oil sketches from the collection of the Cooper-Hewitt, National Museum of Design*, Philadelphia 1992.

DEHEJA 1989 Vidya Deheja, *Impossible Picturesqueness: Edward Lear's Indian Watercolours, 1873–1875*, New York 1989.

DEHEJA 2000 Vidya Deheja, *India Through the Lens: Photography 1840–1911*, exh. cat., Freer Gallery of Art, Washington DC 2000.

DELANA 1992 William G. DeLana, '"Foremost upon this continent": A History of the Wadsworth Atheneum', in L. Ayres (ed.), '*The Spirit of Genius': Art at the Wadsworth Atheneum*, Hartford CT 1992, pp.11–24.

DE TOCQUEVILLE 1971 Alexis de Tocqueville, *Journey to America*, transl. George Lawrence, ed. J. P. Mayer, New York 1971.

DICKENS 1869 Charles Dickens, *American Notes* [1842], 2 vols, Cambridge MA 1869.

DIPPIE 1990 Brian W. Dippie, *Catlin and his Contemporaries: The Politics of Patronage*, Lincoln 1990.

DOMOSH 1996 Mona Domosh, *Invented Cities: The Creation of Landscape in Nineteenth-Century New York and Boston*, New Haven 1996.

DRISCOLL John Paul Driscoll, 'From Burin to Brush: The Development of a Painter', in Driscoll and Howat 1985, pp.46–135.

DRISCOLL and HOWAT 1985 John Paul Driscoll and John K. Howat (eds.), *John Frederick Kensett: An American Master*, exh. cat., Worcester Art Museum, Worcester 1985.

DUNLAP 1834 William Dunlap, *History of the Rise and Progress of the Arts of Design in the United States*, 1st ed., 1834, reprinted New York 1969.

DURAND 1894 John Durand, *The Life and Times of A. B. Durand* [1894], New York 1970.

DWIGHT 1825 Theodore Dwight, *The Northern Traveller, Containing the Routes to Niagara, Quebec and the Springs; with Descriptions of the Principal Scenes, and Useful Hints to Strangers*, New York 1825.

DWIGHT 1829 Theodore Dwight, *Sketches of Scenery and Manners in the United States*, New York 1829.

DWYER 1985 Diane Dwyer, 'John F. Kensett's Painting Technique', in Driscoll and Howat 1985, pp.163–80.

EDINBURGH 1980 *A Closer Look at Painters and Painting 1: Frederic Church's 'Niagara Falls'*, Edinburgh 1980.

EGERTON 1990 Judy Egerton (ed.), *Wright of Derby*, exh. cat., Tate Gallery, London 1990

ELLIS 1988 Elizabeth Garrity Ellis, 'Cape Ann Views', in Wilmerding 1988, pp.19–44.

FARAGHER 1994 John Mack Faragher, *Rereading Frederick Jackson Turner*, New York 1994.

FERBER and GERDTS 1985 Linda S. Ferber and William H. Gerdts, *The New Path: Ruskin and the American Pre-Raphaelites*, exh. cat., Brooklyn Museum, New York 1985.

FERBER 1990 Linda S. Ferber, 'Albert Bierstadt: The History of a Reputation', in Anderson N. and Ferber 1990, pp.21–68.

FLEXNER 1962 James Thomas Flexner, *That Wilder Image (The Native School*

from Thomas Cole to Winslow Homer), History of American Painting, III, New York 1962.

FOSHAY 1990 Ella M. Foshay (ed.), *Mr Luman Reed's Picture Gallery: A Pioneer Collection of American Art*, New York 1990.

FOSHAY 1990a Ella M. Foshay, 'Luman Reed: New York Patron and his Picture Gallery' in Foshay 1990, pp.19–71.

FOSHAY and FINNEY 1987 Ella M. Foshay and Barbara Finney, *Jasper F. Cropsey: Artist and Architect Paintings, Drawings and Photographs from the Collection of the Newington-Cropsey Foundation and the New-York Historical Society*, New York 1987.

FOSHAY and MILLS 1983 Ella M. Foshay and Sally Mills, *All Seasons and Every Light: Nineteenth-Century American Landscapes from the Collection of Elias Lyman Magoon*, exh. cat., Vassar College Art Gallery, Poughkeepsie 1983.

FOSHAY and NOVAK 2000 Ella M. Foshay and Barbara Novak, *Intimate Friends: Thomas Cole, Asher B. Durand, William Cullen Bryant*, New York 2000.

FOSTER-HAHN 2001 Françoise Foster-Hahn et al., *Spirit of an Age: Nineteenth-Century German Paintings from the Nationalgalerie, Berlin*, exh. cat., National Gallery, London 2001.

FRYD 1992 Vivien Green Fryd, *Art & Empire: The Politics of Ethnicity in the United States Capitol, 1815–1860*, New Haven 1992.

FURTWANGLER 1993 Albert Furtwangler, *Acts of Discovery: Visions of America in the Lewis and Clark Journals*, Urbana, Illinois 1993.

GERDTS 1977 William H. Gerdts, 'Early American Paintings from the Newark Museum', in *Aspects of a Collection: 18th and 19th Century American Paintings from the Newark Museum*, New York 1977.

GERDTS 1985 William H. Gerdts, '"The Sea is his Home": Clarence Cook visits Fitz Hugh Lane', *American Art Journal*, vol.17, no.3, Summer 1985, pp.44–9.

GOETZMANN 1978 William H. Goetzmann, *Exploration and Empire: The Explorer and the Scientist in the Winning of the American West*, New York 1978.

GOODYEAR 1976 Frank H. Goodyear, Jr., 'American Landscape Painting, 1795–1875', in *In This Academy: The Pennsylvania Academy of the Fine Arts, 1805–1976*, exh. cat., Pennsylvania Academy of Fine Arts, Philadelphia 1976, pp.122–37.

GOULD 1989 Stephen Jay Gould, 'Church, Humboldt, and Darwin: The Tension and Harmony of Art and Science', in Kelly 1989, pp.94–107.

HALTMAN 1998 Kenneth Haltman, 'The Poetics of Geologic Reverie: Figures of Source and Origin in Samuel Seymour's Landscapes of the Rocky Mountains', in Meyers 1998, pp.131–75.

HAMBOURG 1999 Maria Morris Hambourg, 'Carleton Watkins: An Introduction', in Nickel 1999, pp.8–17.

HARDING and WITTHOFT 1982 Annelise Harding and Brucia Witthoft, *American Artists in Düsseldorf, 1840–1865*, exh. cat., Danforth Museum, Frammingham MA 1982.

HARRIS 1966 Neil Harris, *The Artist in American Society*, New York 1966.

HARVEY 1998 Eleanor Jones Harvey, *The Painted Sketch: American Impressions from Nature, 1830–1880*, exh. cat., Dallas Museum of Art, Dallas 1998.

HASKELL and PENNY Francis Haskell and Nicholas Penny, *Taste and the Antique: The Lure of Classical Sculpture, 1500–1900*, New Haven 1981.

HEMINGWAY 1992 Andrew Hemingway, *Landscape Imagery and Urban Culture in Early Nineteenth-Century Britain*, Cambridge 1992.

HEMINGWAY and VAUGHAN 1998 Andrew Hemingway and William Vaughan (eds.), *Art in Bourgeois Society, 1790–1850*, Cambridge 1998.

HENDRICKS 1988 Gordon Hendricks, *Albert Bierstadt: Painter of the American West*, New York 1988.

HILLS 1998 Patricia Hills, 'The American Art-Union as patron for expansionist ideology in the 1840s', in Hemingway and Vaughan 1998, pp.314–39.

HOBBES 1996 Thomas Hobbes, *Leviathan*, ed. Richard Tuck, Cambridge 1996.

HOWARD 1991 Peter Howard, *Landscapes: The Artists' Vision*, London 1991.

HOWAT 1985 John K. Howat, 'Kensett's World', in Driscoll and Howat 1985, pp.12–45.

HOWAT 1987 John K. Howat (ed.), *American Paradise: The World of the Hudson River School*, exh. cat., Metropolitan Museum of Art, New York 1987.

HOWAT 2000 John K. Howat, 'Private Collectors and Public Spirit: A Selective View', in Voorsanger and Howat 2000, pp.83–107.

HUDSON 1993 Pat Hudson, *The Industrial Revolution*, London 1993.

HUGHES 1997 Robert Hughes, *American Visions: The Epic History of Art in America*, New York 1997.

HUNTINGTON 1887 Daniel Huntington, *Asher B. Durand: A Memorial Address*, New York 1887.

HUNTINGTON 1960 David C. Huntington, 'Frederic Edwin Church: Painter of the Adamic New World Myth', Ph.D. dissertation, Yale University 1960, published Michigan 1991.

HUNTINGTON 1980 David C. Huntington, 'Church and Luminism: Light for America's Elect', in Wilmerding 1980, pp.155–90.

HYDE, A. 1990 Anne Farrar Hyde, *An American Vision: Far Western Landscape and National Culture, 1820–1920*, New York 1990.

HYDE, R. 1988 Ralph Hyde, *Panoramania!*, London 1988.

JARVES 1866 James Jackson Jarves, *The Art-Idea: Sculpture, Painting, and Architecture in America*, New York 1866.

JOHNS et al. 1998 Elizabeth Johns, Andrew Sayers, Elizabeth Mankin Kornhauser with Amy Ellis, *New Worlds from Old: Nineteenth-Century Australian and American Landscapes*, exh. cat., National Gallery of Australia, Canberra 1998.

KEATS 1895 John Keats, 'Sonnet VII', in *Poetical Works*, ed. H. Buxton Foreman, New York 1895.

KELLY AND CARR 1987 Franklin Kelly and Gerald L. Carr, *The Early Landscapes of Frederic Edwin Church, 1845–1854*, Fort Worth 1987.

KELLY 1988 Franklin Kelly, *Frederic Edwin Church and the National Landscape*, Washington 1988.

KELLY 1988a Franklin Kelly, 'Lane and Church in Maine', in Wilmerding 1988, pp.129–57.

KELLY 1989 Franklin Kelly, *Frederic Edwin Church*, exh. cat, National Gallery of Art, Washington DC 1989.

KELLY 1989a Franklin Kelly, 'Landscape (A Reminiscence of the White Mountains) 1852', in *Paintings from the Manoogian Collection*, National Gallery of Art, Washington DC 1989, pp.20–1.

KELLY 1994 Franklin Kelly, *Thomas Cole's Paintings of Eden*, exh. cat., Amon Carter Museum, Fort Worth 1994.

KELLY et al. 1996 Franklin Kelly et al., *American Paintings of the Nineteenth Century*, Washington DC 1996.

KETNER and TAMMENGA 1984 J. D. Ketner and M. J. Tammenga, *The Beautiful, the Sublime and the Picturesque*, exh. cat., Washington University Art Gallery, St Louis MI 1984.

KEYES 1980 Donald D. Keyes (ed.), *The White Mountains: Place and Perceptions*, exh. cat., Art Galleries of the University of New Hampshire, Durham NH 1980.

KINSEY 1992 Joni Louise Kinsey, *Thomas Moran and the Surveying of the American West*, Washington DC 1992.

KLEIN 1995 Rachel N. Klein, 'Art and Authority in Antebellum New York City: The Rise and Fall of the American Art-Union', *Journal of American History*, vol.81, no.4, March 1995, pp.1534–61.

KOJA 1999 Stephan Koja (ed.), *America: The New World in 19th-Century Painting*, exh. cat., Österreichishe Galerie Belvedere, Vienna 1999.

KORNHAUSER 1996 Elizabeth Mankin Kornhauser, *American Paintings before 1945 in the Wadsworth Atheneum*, New Haven and London 1996.

KORNHAUSER 1998 Elizabeth Mankin Kornhauser, 'All Nature Here is New to Art: Painting the American Landscape, 1800–1900', in Johns et al. 1998, pp.71–91.

LAWALL 1966 David B. Lawall, *Asher Brown Durand: His Art and Theory in Relation to his Times*, Ph.D. dissertation, Princeton University 1966, published New York and London 1977.

LAWALL 1971 David B. Lawall, *A. B. Durand: 1796–1886*, exh. cat., Montclair Art Museum, Montclair NJ 1971.

LAWALL 1978 David B. Lawall, *Asher B. Durand: A Documentary Catalogue of the Narrative and Landscape Paintings*, New York and London 1978.

LAWSON-PEEBLES 1989 Robert Lawson-Peebles, 'Dickens Goes West', in Lawson-Peebles and Gidley 1989, pp.111–28.

LAWSON-PEEBLES and GIDLEY 1989 Robert Lawson-Peebles and Mick Gidley, *Views of American Landscapes*, Cambridge 1989.

LUCE AND JESSOP 1955 A. A. Luce and E. T. Jessop (eds.), *The Works of George Berkeley, Bishop of Cloyne*, VII, London 1955.

McCLELLAND 1998 Linda Flint McClelland, *Building the National Parks: Historic Landscape Design and Construction*, Baltimore 1998.

McCOUBREY 1965 John W. McCoubrey (ed.), *American Art 1700–1960: Sources and Documents*, Englewood Cliffs NJ 1965.

McKINSEY 1985 Elizabeth McKinsey, *Niagara Falls: Icon of the American Sublime*, Cambridge 1985.

McNULTY 1983 J. Bard McNulty (ed.), *The Correspondence of Thomas Cole and Daniel Wadsworth*, Hartford CT 1983.

MADDOX 1986 Kenneth Maddox, 'Thomas Cole and the Railroad: Gentle Maledictions', *Archives of American Art Journal*, vol.26, no.1, 1986, reprinted in vol.30, 1990, 'A retrospective selection of articles', pp.146–54.

MALTHUS 1798 Revd Thomas Robert Malthus, *An Essay on the Principle of Population, or, A View of its Past and Present Effects on Human Happiness*, first published 1798, 2nd ed., London 1803.

MANTHORNE 1985 K. E. Manthorne, *Creation and Renewal: Views of Cotopaxi by Frederic Edwin Church*, exh. cat., National Museum of American Art, Washington DC 1985.

MANTHORNE 1989 K. E. Manthorne, *Tropical Renaissance: North American Artists Exploring Latin America*, Washington DC 1989.

MARX 1964 Leo Marx, *The Machine in the Garden: Technology and the Pastoral Ideal in America*, New York 1964.

MARX 1988 Leo Marx, 'The Railroad-in-the-Landscape: An Iconological Theme in American Art', in Danly and Marx 1988, pp.183–208.

MARZIO 1979 Peter Marzio, *Chromolithography, 1840–1900: The Democratic Art; Pictures for a Nineteenth Century America*, Boston 1979.

MAY 1975 Ernest R. May, *The Making of the Monroe Doctrine*, Cambridge 1975.

MERRITT 1969 Howard S. Merritt, *Thomas Cole*, Rochester Memorial Art Gallery of the University of Rochester 1969.

MEYERS 1998 Amy R. W. Meyers (ed.), *Art and Science in America: Issues of Representation*, San Marino CA 1998.

MILLER, A. 1989 Angela Miller, 'Thomas Cole and Jacksonian America: The Course of Empire and political allegory', *Prospects*, vol.14, 1989, pp.65–92.

MILLER, A. 1993 Angela Miller, *The Empire of the Eye: Landscape Representations and American Cultural Politics, 1825–1875*, Ithaca and London 1993.

MILLER, A. 1998 Angela Miller, 'Landscape Taste as an Indicator of Class Identity in Antebellum America', in Hemingway and Vaughan 1998, pp.340–61.

MILLER, D. 1993 David C. Miller (ed.), *American Iconology: New Approaches to Nineteenth-Century Art and Literature*, New Haven and London 1993.

MILLER, P. 1967 Perry Miller, *Nature's Nation*, Cambridge MA 1967.

MITCHELL 1994 W. J. T. Mitchell, 'Imperial Landscape', in W. J. T. Mitchell (ed.), *Landscape and Power*, Chicago 1994, pp.1–34.

MONTCLAIR 1999 *The Grand Moving Panorama of Pilgrim's Progress*, exh. cat., Montclair Art Museum NJ 1999.

MURPHY 1983 Francis Murphy, *The Book of Nature: American Painters of the Natural Sublime*, exh. cat., The Hudson River Museum, Yonkers NY 1983.

MYERS 1987 Kenneth Myers, *The Catskills: Painters, Writers and Tourists in the Mountains 1820–1895*, exh. cat., The Hudson River Museum, Yonkers NY 1987.

NASH 1967 Roderick Nash, *Wilderness and the American Mind*, New Haven and London 1967.

NATIONAL ACADEMY 1943 *National Academy of Design Exhibition Record, 1826–1860*, New York 1943.

NICKEL 1999 Douglas R. Nickel, *Carleton Watkins: The Art of Perception*, exh. cat., San Francisco Museum of Art, San Francisco 1999.

NOAKES 1985 Vivien Noakes, *Edward Lear 1812–1888*, exh. cat., Royal Academy of Arts, London 1985.

NOBLE 1853 Louis Legrand Noble, *The Life and Works of Thomas Cole*, first published 1853, reprinted, ed. Elliot S. Vessell, Hensonville NY 1997.

NOBLE 1861 Louis Legrand Noble, *After Icebergs with a Painter: A Summer Voyage to Labrador and Around Newfoundland*, first published 1861, reprinted New York 1971.

NOVAK 1969 Barbara Novak, *American Painting of the Nineteenth Century*, New York 1969.

NOVAK 1986 Barbara Novak (ed.), *Nineteenth-century American Painting: The Thyssen Bornemisza Collection*, New York 1986.

NOVAK 1995 Barbara Novak, *Nature and Culture*, New York 1995.

NYGREN 1986 Edward J. Nygren, with Bruce Robertson, *Views and Visions: American Landscapes before 1830*, exh. cat., Corcoran Gallery of Art, Washington DC 1986.

OAKS 1989 Martha Oaks, *Gloucester at Mid-Century: The World of Fitz Hugh Lane, 1840–1865*, Gloucester MA 1989.

OETTERMANN 1997 Stephen Oettermann, *The Panorama: History of a Mass Medium*, transl. Deborah L. Schneider, New York 1997.

PALEY 1986 Morton D. Paley, *The Apocalyptic Sublime*, New Haven 1986.

PARRIS and FLEMING-WILLIAMS 1991 L. Parris and I. Fleming-Williams, *Constable*, exh. cat., Tate Gallery, London 1991.

PARRY 1970 Ellwood C. Parry III, *Thomas Cole's 'The Course of Empire': A Study of Serial Imagery*, Ph.D. dissertation, Yale University 1970, published Ann Arbor 1991.

PARRY 1988 Ellwood C. Parry III, *The Art of Thomas Cole: Ambition and Imagination*, Newark 1988.

PEARCE 1967 Roy Harvey Pearce, *Savagism and Civilization: A Study of the Indian and the American Mind*, Baltimore 1967.

PECK 2000 Amelia Peck, 'The Products of Empire: Decorations in New York City', in Voorsanger and Howat 2000, pp.259–85.

PERRY 1999 Claire Perry, *Pacific Arcadia*, New York 1999.

PEVSNER 1952 Nikolaus Pevsner, *London (Except the Cities of London and Westminster)*, The Buildings of England, VI, Harmondsworth 1952, p.204.

POINTON 1973 Marcia R. Pointon, *Milton and English Art*, Manchester 1973.

PORTER 1999 Andrew Porter, 'Trusteeship, Anti-Slavery and Humanitarianism', in Andrew Porter (ed.), *The Oxford History of the British Empire: The Nineteenth Century*, Oxford 1999, pp.624–50.

POWELL 1988 Earl A. Powell III, 'The Boston Harbor Pictures', in Wilmerding 1988, pp.47–60.

PRATT 1985 Mary Louise Pratt, 'Scratches on the Face of the Country: or, What Mr Barrow Saw in the Land of the Bushmen', in Henry Louis Gates (ed.), *Race, Writing and Difference*, Chicago 1985.

PRATT 1992 Mary Louise Pratt, *Imperial Eyes: Travel Writing and Trans-Culturation*, London 1992.

PROWN 1992 Jules D. Prown (ed.), *Discovered Lands, Invented Pasts*, New Haven and London 1992.

RAWLINSON 1913 W. G. Rawlinson, *The Engraved Work of J. M. W. Turner, R.A.*, 2 vols, London 1913.

REBORA 1990 Carrie Rebora, 'The American Academy of the Fine Arts, 1802–1842', 2 vols., unpublished Ph.D. dissertation, City University of New York 1990.

ROBERTSON 1986 Bruce Robertson, 'The Picturesque Tourist in America', in Nygren 1986, pp.189–211.

RONNBERG 1988 Erik A. R. Ronnberg, Jr., 'Images and Types of Vessels', in Wilmerding 1988, pp.61–104.

ROQUE 1985 Oswaldo Rodriguez Roque, 'The Last Summer's Work', in Driscoll and Howat 1985, pp.137–61.

ROQUE 1987 Oswaldo Rodriguez Roque, 'The Exaltation of American Landscape Painting', in Howat 1987, pp.21–48.

ROSENTHAL 1981 Michael Rosenthal, *Constable: The Painter and his Landscape*, New Haven and London 1981.

ROUSSEAU 1994 Jean-Jacques Rousseau, *Discourse on Political Economy* and *Social Contract*, transl. and ed. Christopher Betts, Oxford 1994.

RUSKIN 1851 John Ruskin, *The Stones of Venice*, I, first published 1851, reprinted in *The Works of John Ruskin*, IX, ed. by E. T. Cook and A. Wedderburn, London 1903.

RYAN 1997 James R. Ryan, *Picturing Empire: Photography and the Visualization of the British Empire*, London 1997.

SAMPSON 2000 Gary D. Sampson, 'Photographer of the Picturesque: Samuel Bourne', in Deheja 2000, pp.163–98.

SAUNDERS 1981 Richard Saunders, with Helen Rae, *Daniel Wadsworth: Patron of the Arts*, exh. cat., Wadsworth Atheneum, Hartford CT 1981.

SCHAMA 1995 Simon Schama, *Landscape and Memory*, New York 1995.

SCHIMMEL 1991 Julie Schimmel, 'Inventing "the Indian"', in Truettner 1991, p.149–89.

SELLERS 1991 Charles Sellers, *The Market Revolution: Jacksonian America, 1815–1846*, New York 1991.

SHAW 1820–5 Joshua Shaw, *Picturesque Views of American Scenery (Engraved by J. Hill)*, Philadelphia 1820–5.

SMILES 1994 Sam Smiles, *The Image of Antiquity: Ancient Britain and the Romantic Imagination*, New Haven and London 1994.

SMITH 1985 Bernard Smith, *European Vision and the South Pacific*, New Haven 1985.

SPASSKY 1985 Natalie Spassky, *American Paintings in the Metropolitan Museum of Art*, II, Metropolitan Museum of Art, New York 1985.

STANSELL and WILENTZ 1994 Christine Stansell and Sean Wilentz, 'Cole's America: An Introduction', in Truettner and Wallach 1994, pp.3–21.

STEBBINS 1971 Theodore E. Stebbins, Jr., 'American Landscape: Some New Acquisitions at Yale', *Yale University Art Gallery Bulletin*, no.33, Autumn 1971.

STEBBINS 1978 Theodore E. Stebbins, Jr., *Close Observation: Selected Oil Sketches by Frederic E. Church*, Washington DC 1978.

STEBBINS 1999 Theodore E. Stebbins, Jr. (ed.), *Martin Johnson Heade*, exh. cat., Museum of Fine Arts, Boston 1999.

STEBBINS 2000 Theodore E. Stebbins, Jr., *The Life and Work of Martin Johnson Heade: A Critical Analysis and Catalogue Raisonné*, New Haven and London 2000.

STEPHANSON 1995 Anders Stephanson, *Manifest Destiny: American Expansion and the Empire of Right*, New York 1995.

STOCKING 1987 George Stocking, Jr., *Victorian Anthropology*, New York 1987.

STUART and REVETT 1762 James Stuart and Nicholas Revett, *The Antiquities of Athens*, London 1762.

SULLIVAN 1981 Mark White Sullivan, *John F. Kensett: American Landscape Painter*, Ph.D. dissertation, Bryn Mawr College 1981, published Michigan 1983.

SWEENEY 1994 J. Gray Sweeney, 'The Advantages of Genius and Virtue: Thomas Cole's influence, 1848–1858', in Truettner and Wallach 1994, pp.113–35.

SWEENEY 1999 J. Gray Sweeney, 'An "Indomitable Explorative Enterprise": Inventing National Parks', in Belanger 1999, pp.130–56.

TALBOT 1970 William S. Talbot, *Jasper F. Cropsey 1823–1900*, Washington DC 1970.

THOMPSON 1963 E. P. Thompson, *The Making of the English Working Class*, Harmondsworth 1963.

THOREAU 1848 Henry David Thoreau, 'Ktaadn and the Maine Woods', *The Union Magazine*, 1848, reprinted in *The Maine Woods*, New York 1961.

TONSON 1752 J. and R. Tonson and S. Draper (eds.), *A Miscellany, containing several tracts on various subjects*, London and Dublin 1752, p.187.

TOWNSEND 1998 Richard P. Townsend, *J. M. W Turner, 'The Greatest of Landscape Painters'*, exh. cat., The Philbrook Museum of Art, Tulsa OK 1998.

TRENTON and HASSRICK 1983 Patricia Trenton and Peter H. Hassrick, *The Rocky Mountains: A Vision for Artists in the Nineteenth Century*, Norman OK 1983.

TRENTON and HOULIHAN 1989 Patricia Trenton and Patrick T. Houlihan, *Native Americans: Five Centuries of Changing Images*, New York 1989.

TROYEN 1984 Carol Troyen, 'Innocents Abroad: American Painters at the 1867 Exposition Universelle, Paris', *American Art Journal*, vol.16, no.4, Autumn 1984, pp.2–29.

TROYEN 1991 Carol Troyen, 'Retreat to Arcadia: American Landscape and the American Art-Union', *American Art Journal*, vol.23, no.1, 1991, pp.20–37.

TRUETTNER 1979 William H. Truettner, *The Natural Man Observed: A Study of Catlin's Indian Gallery*, Washington DC 1979.

TRUETTNER 1991 William H. Truettner, *The West as America: Reinterpreting Images of the Frontier, 1820–1920*, Washington DC 1991.

TRUETTNER 1994 William H. Truettner, 'Nature and Native Tradition: The Problem of Two Thomas Coles', in Truettner and Wallach 1994, pp.137–60.

TRUETTNER and WALLACH 1994 William H. Truettner and Alan Wallach (eds.), *Thomas Cole: Landscape into History*, exh. cat., Smithsonian American Art Museum, Washington DC 1994.

TUCKERMAN 1867 Henry H. Tuckerman, *American Artist Life comprising biographical and critical sketches of American artists, preceded by an historical account of the rise and progress of art in America*, 2nd ed., New York 1867, p.28.

UPTON 2000 Dell Upton, 'Inventing the Metropolis: Civilization and Urbanity in Antebellum New York', in Voorsanger and Howat 2000, pp.4–45.

VASARI 1965 G. Vasari, *Lives of the Artists*, transl. and ed. George Bull, Harmondsworth 1965.

VOORSANGER and HOWAT 2000 Catherine Hoover Voorsanger and John K. Howat (eds.), *Art and the Empire City: New York, 1825–1861*, exh. cat., Metropolitan Museum of Art, New York 2000.

WALLACE 1979 Richard W. Wallace, *Salvator Rosa in America*, exh. cat., Jewett Arts Centre, Wellesley MA 1979.

WALLACE 1980 R. Stuart Wallace, 'A Social History of the White Mountains', in Keyes 1980, pp.17–40.

WALLACH 1968 Alan Wallach, 'Cole, Byron and The Course of Empire', *Art Bulletin*, no.50, December 1968, pp.375–9.

WALLACH 1973 Alan Wallach, 'The Ideal American Artist and the Dissenting Tradition: A Study of Thomas Cole's Popular Reputation', unpublished Ph.D. dissertation, Columbia University 1973.

WALLACH 1981 Alan Wallach, 'Thomas Cole and the Aristocracy', *Arts Magazine*, vol.56, no.3, November 1981, pp.84–106.

WALLACH 1993 Alan Wallach, 'Making a Picture of the View from Mount Holyoake', in Miller, D. 1993, pp.80–91.

WALLACH 1994 Alan Wallach, 'Landscape and the Course of American Empire', in Truettner and Wallach 1994, pp.23–111.

WALLACH 1998 Alan Wallach, 'Long-term visions, short-term failures: art institutions in the United States, 1800–1860', in Hemingway and Vaughan 1998, pp.297–313.

WALLACH 2001 Alan Wallach, 'Thematics of a Modernizing Vision in Frederic Church's *Niagara*', paper presented at the College Art Association Conference, Chicago, February 2001.

WEISS 1986 Ila Weiss, *Sanford Robinson Gifford*, New York 1986.

WEISS 1987 Ila Weiss, *Poetic Landscape: The Art and Experience of Sanford R. Gifford*, Newark 1987.

WHITE 1991 Richard White, *'It's Your Misfortune and None of My Own': A New History of the American West*, Norman 1991.

WHITLEY 1928 W. T. Whitley, *Art in England 1800–1820*, Cambridge 1928.

WILENTZ 1984 Sean Wilentz, *Chants Democratic: New York City & the Rise of the American Working Class, 1788–1850*, New York and Oxford 1984.

WILMERDING 1971 John Wilmerding, *Fitz Hugh Lane*, New York 1971.

WILMERDING 1971a John Wilmerding, *Robert Salmon: Painter of Ship and Shore*, Boston 1971.

WILMERDING 1980 John Wilmerding (ed.), *American Light: The Luminist Movement 1850–75*, exh. cat., National Gallery of Art, Washington DC 1980.

WILMERDING 1988 John Wilmerding (ed.), *Paintings by Fitz Hugh Lane*, exh. cat., National Gallery of Art, Washington DC 1988.

WILMERDING 1988a John Wilmerding, 'The Lure of Mount Desert and the Maine Coast', in Wilmerding 1988, pp.107–26.

WILTON 1979 Andrew Wilton, *The Life and Work of J. M. W. Turner*, London 1979.

WILTON 1980 Andrew Wilton, 'Washington: American Light: The Luminist Movement, 1850–75', *Burlington Magazine*, vol.122, no.931, October 1980, pp.715–16.

WILTON 1980a Andrew Wilton, *Turner and the Sublime*, exh. cat., British Museum, London 1980.

WILTON 1990 Andrew Wilton, *Painting and Poetry: Turner's 'Verse Book' and his work of 1804–1812*, London 1990.

WINTHROP 1863 Theodore Winthrop, *Life in the Open Air and other papers*, Boston 1863.

WOLF 1982 Bryan Jay Wolf, *Romantic re-vision: culture and consciousness in nineteenth-century American painting and literature*, Chicago 1982.

Lenders and Credits

Lenders

PRIVATE COLLECTORS

Mr & Mrs Thomas H. Gosnell 67
The Hevrdejs Collection 65
Manoogian Collection 6, 31
Arthur J. Phelan, Jr. 61
Private Collection 18
Private Collection 23, 36
Private Collection 70
Private Collection, Houston, Texas 64
Private Collection Courtesy Berry-Hill Galleries, New York 3, 41
Private Collection, New York 19, 20

PUBLIC INSTITUTIONS

Albany Institute of History & Art, Albany, New York 29
Baltimore Museum of Art 96
Birmingham Museum of Art, Alabama 90
Bolton Museum and Art Gallery 98
Museum of Fine Arts, Boston 10, 37, 71
Brooklyn Museum of Art, New York 66, 91
The Butler Institute of American Art, Ohio 69
Carnegie Museum of Art, Pittsburgh 38
Chrysler Museum of Art, Norfolk, Virginia 9
Art Institute of Chicago 42, 84
Cincinnati Art Museum 2
The Cleveland Museum of Art 25, 62
Cooper-Hewitt, National Design Museum, Smithsonian Institution 44, 46, 48, 51, 52, 53, 54, 55, 56, 57, 58
The Cummer Museum of Art & Gardens, Jacksonville, Florida 75
The Currier Gallery of Art, Manchester, New Hampshire 63, 83
Dallas Museum of Art 88
The Detroit Institute of Arts 86
National Gallery of Scotland, Edinburgh 35
Flint Institute of Arts 81
Fogg Art Museum, Harvard University Art Museums 89
Haggin Collection, Haggin Museum, Stockton 93
Los Angeles County Museum of Art 33
Metropolitan Museum of Art, New York 26, 77, 78, 80
The Minneapolis Institute of Arts 79
The Montclair Art Museum 79
The New-York Historical Society 11, 12, 13, 14, 15, 74

The New York Public Library 1
The Newark Museum 22
Newington-Cropsey Foundation, Hastings-on-Hudson 17, 39, 40
North Carolina Museum of Art, Raleigh 97
Olana State Historic Site, New York State Office of Parks, Recreation and Historic Preservation 45, 47, 49, 50
Olana State Historic Site is one of 36 historic properties administrered and operated by New York State Office of Parks, Recreation and Historic Preservation; George E. Pataki, Governor.
Philadelphia Museum of Art 99
The Philbrook Museum of Art, Tulsa 95
Reynolda House, Museum of American Art, North Carolina 85
Rhode Island School of Design, Providence 4
The Saint Louis Art Museum 7, 60
Fine Arts Museums of San Francisco 87
Seattle Art Museum 94
Terra Museum of American Art, Chicago 21, 73
Thyssen-Bornemisza Foundation, Lugano 59
Museo Thyssen-Bornemisza, Madrid 30
Toledo Museum of Art 28, 32
Wadsworth Atheneum, Hartford 34, 43
National Gallery of Art, Washington DC 5, 27, 68, 72, 76
Woodmere Art Museum, Philadelphia 16
Yale University Art Gallery, New Haven 24, 82

Photographic Credits

CATALOGUE ILLUSTRATIONS

Albany Institute of History & Art
The Baltimore Museum of Art
Berry-Hill Galleries, New York
The Birmingham Museum of Art, Alabama
Bolton Museum and Art Gallery
Museum of Fine Arts, Boston. Reproduced with permission. © 2000 Museum of Fine Arts, Boston. All Rights Reserved
Brooklyn Museum of Art
The Butler Institute of American Art, Youngstown, Ohio

Carnegie Museum of Art / Peter Harholdt
The Art Institute of Chicago. Photograph © 2001, The Art Institute of Chicago. All Rights Reserved
Chrysler Museum of Art © Chrysler Museum of Art, Norfolk, VA
Cincinnati Art Museum, The Edwin and Virginia Irwin Memorial
The Cleveland Museum of Art
Cooper-Hewitt Museum, Smithsonian Institution / Art Resource, NY
The Cummer Museum of Art & Gardens, Jacksonville, Florida
The Currier Gallery of Art, Manchester, New Hampshire / Bill Finney
Dallas Museum of Art © Dallas Museum of Art
The Detroit Institute of Arts © 1985 The Detroit Institute of Arts
The National Gallery of Scotland / Antonia Reeve
Ali Elai – Camerarts Studio
Collection of the Flint Institute of Arts
The Fogg Art Museum. Photograph © President and Fellows of Harvard College / Katya Kallsen
Mr & Mrs Thomas H. Gosnell
The Haggin Museum, Stockton, California
Greg Heins, Boston
The Hevrdjes Collection
A.J. Kollar Fine Paintings, Seattle, Washington
Los Angeles County Museum of Art. Photograph © 2001 Museum Associates / LACMA
Manoogian Collection
The Metropolitan Museum of Art. Photograph © 1992 The Metropolitan Museum of Art
Photograph © 1988 The Metropolitan Museum of Art
Photograph © 1984 The Metropolitan Museum of Art
The Minneapolis Institute of Arts
The Montclair Art Museum, Montclair, NJ
Collection of The Newark Museum
Newington-Cropsey Foundation
Collection of The New-York Historical Society © Collection of the New York Historical Society
The New York Public Library, Astor, Lenox and Tilden Foundations
North Carolina Museum of Art, Raleigh

Oakland Museum of California / M. Lee Fatherree
Olana State Historic Sit, New York State Office of Parks, Recreation and Historic Preservation
Adrian Panaro
Philadelphia Museum of Art / Graydon Wood, 1993
The Philbrook Museum of Art, Tulsa, Oklahoma
Reynolda House, Museum of American Art, Winston-Salem, NC, USA
Museum of Art, Rhode Island School of Design
The Saint Louis Art Museum
Fine Arts Museums of San Francisco
Seattle Art Museum / Howard Giske
Terra Foundation for the Arts, Chicago
Museo Thyssen-Bornemisza. Madrid. Photograph © Museo Thyssen-Bornemisza. Madrid
Thyssen-Bornemisza Collection, Lugano
The Toledo Museum of Art
Wadsworth Atheneum, Hartford
National Gallery of Art, Washington. Photographs © 2001 Board of Trustees
National Gallery of Art, Washington
The Westmoreland Museum of American Art
Collection of Woodmere Art Museum, Philadelphia, PA
Yale University Art Gallery

FIGURE ILLUSTRATIONS

Amon Carter Museum, Fort Worth, Texas 42
Birmingham Museum of Art, Alabama 18
Birmingham Museums & Art Gallery 2, 10
Museum of Fine Arts Boston. Reproduced with permission © 2000 Museum of The Fine Arts, Boston. All Rights Reserved 52
Bostonian Society 49
The Corcoran Gallery of Art, Washington DC 32, 38
Courtauld Gallery, Courtauld Institute, London 47
Detroit Institute of Arts. Photograph © 1968 The Detroit Institute of Arts 44
Fenimore Art Museum, Cooperstown, New York. Photograph © New York State Historical Association, Cooperstown, NY 3
Fogg Art Museum. Photograph

© President and Fellows of Harvard College 8
The J. Paul Getty Museum, Los Angeles. Photograph © The J. Paul Getty Museum 36
National Gallery, London. Photograph © 2000 National Gallery, London. All Rights Reserved 19, 50
The Metropolitan Museum of Art. 46
Photograph © 1995 The Metropolitan Museum of Art 20
Photograph © 1980 The Metropolitan Museum of Art 23
Collection of the New-York Historical Society © Collection of the New-York Historical Society 13, 14, 34, 45
The New York Public Library, Astor, Lenox and Tilden Foundations 21, 25, 40
Olana State Historic Site, New York State Office of Parks, Recreation and Historic Preservation 26
The Pennsylvania Academy of the Fine Arts, Philadelphia 4
The Art Museum, Princeton University. Photograph © 2001 Trustees of Princeton University / Clem Fiori 41
The Howard and Jane Ricketts Collection / Tate Photography / Rodney Tidnam 37
Saco Museum of the Dyer Library Association Photograph © Saco Museum 24
George Walter Vincent Smith Collection, George Walter Vincent Smith Art Museum, Springfield, MA 11
Smithsonian American Art Museum, Washington DC. Photograph © Smithsonian American Art Museum, Washington DC / Art Resource, NY 16, 17, 27, 33
Tate Photography 12, 15
Tate Photography / Mark Heathcote & Rodney Tidnam 29
Tate Picture Library 5, 6, 7, 28
Wadsworth Atheneum, Hartford, Connecticut 31, 48
Wadsworth Atheneum, Hartford, Connecticut / David Stansbury 22
The Wallace Collection. Photograph © The Trustees of the Wallace Collection, London 1
The Warner Collection of Gulf States Paper Corporation, Tuscaloosa, Alabama 30
Washington County Museum of Fine Arts, Hagerstown, Maryland 39
Yale Center for British Art 35, 43, 51
Yale University Art Gallery 9

Index

3M